NEGRO
ANTHOLOGY MADE BY
NANCY CUNARD
1931-1933

Abridged Edition

Albatross Publishers

Naples, Italy

2017

Originally Published in London, Nancy Cunard at Wishart & Co, 1934

ISBN 978-1-946963-59-8

©2022 *Albatross Publishers*

NEGRO

ANTHOLOGY MADE BY

NANCY CUNARD

1931-1933

Published by
Nancy Cunard at Wishart & Co
9 John Street · London · W·C·2
1934

Dedicated to
Henry Crowder
my first Negro friend

Foreword

IT was necessary to make this book—and I think in this manner, an Anthology of some 150 voices of both races—for the recording of the struggles and achievements, the persecutions and the revolts against them, of the Negro peoples.

The book is composed of seven parts. The reader finds first in this panorama the full violence of the oppression of the 14 million Negroes in *America* and the upsurge of their demands for mere justice, that is to say their full and equal rights alongside of their white fellow-citizens. At no other time in the history of America have there been so many lynchings as in the past 2 years, so many "legal" murders, police killings and persecutions of coloured people. The Scottsboro frame-up is more than an attempt to electrocute 9 innocent black Alabamians—it is part of the effort to force into the dumbest and most terrorised form of subjection all Negro workers who dare aspire to live otherwise than as virtual slaves. Forty-eight lynchings of Negroes in 1933—crowned by the broadcast sanction of and encouragement to lynching from the Governor of the State of California.

The spirit and determination in the Negro to break through the mountain of tyranny heaped on him is manifested in his rapid evolution, since Emancipation in 1863, of his own cultural organisations, as is shown in every sphere of activity—literature, education, business, the law, the press, the theatre, etc.

A brief outline of the history of the black race has been given. Amongst many other subjects are writings on literature, education, social conditions and personal contacts. Zora Neale Hurston has contributed some studies which portray the background of Negro folk-imagination, the poetic and rhythmic intensity of their religious expression, the sole emotional outlet that was permitted in slavery days.

But the Negro is no longer preoccupied solely by religion. Progressive members of the race are aware that they must fight every way they can to advance and to maintain what-soever they have already achieved against inconceivable opposition. There are certain sections of the Negro bourgeoisie which hold that justice will come to them from some eventual liberality in the white man. But the more vital of the Negro race have realised that it is Communism alone which throws down the barriers of race as finally as it wipes out class distinctions. The Communist world-order is the solution of the race problem for the Negro. James Ford, Negro worker and intellectual, was nominated by the Communist Party as candidate for Vice-President of U.S.A. in 1932.

What shall I say of the miraculous *Theatrical* and *Musical* Negro firmament ? That here are only the pictures and descriptions of all too few ; that it is high time a separate book were made to do justice to a people so utterly rich in natural grace and beauty, a people who have produced the diverse genius of the spirituals and blues, the superb Negro choirs of America, the syncopation and tap-dancing, the dramatic and musical excellence of several first-rate actors and singers, the as yet in our white hemisphere almost unknown and unrecorded splendour of African rhythms.

Foreword

There is no laughter in any of the *Poetry* here, for facts have made it, and the reflector of life a poet is supposed to be is, in the case of the coloured poet, doubly sensitive. Perforce he carries the burden of his race, it is mostly his theme. Sterling Brown is the most racial of the poets, his subject and his tone are as fine as a saga. Langston Hughes is the revolutionary voice of liberation.

In the *West Indies and South America* the prevailing though " subtler " forms of prejudice have been studied, and this mainly by coloured writers. The myth that latins have no prejudice can no longer stand. As a Cuban author says : in America they would like to kill off the black man—here they intend to absorb him, though the so-called opprobrium of a dark skin exists. Here too the intensity of the Negro's struggle against economic discrimination is a constantly recurring subject.

From the beginning of the Anti-Slavery struggle to the present-day official and social obstructions of the Colour-bar there have been voices to protest against the infamous treatment of coloured people. There have been honest defenders, admirers of the Negro on an exactly equal footing. The writings in the *European* section are mainly on this theme. And it is shown how Soviet Russia, encompassing some 130 different racial groups, has once and for all solved the " problem " of races, turning instilled conflicts into co-operation, wiping out the false concept of " inferiority." To-day in Russia alone is the Negro a free man, a 100 per cent. equal.

What is *Africa*? A continent in the iron grip of its several imperialist oppressors. To some of these empires' sons the Africans are not more than " niggers," black man-power whom it is fit to dispossess of everything. At one time labelled en bloc " cannibals," " savages," who have never produced anything, etc., it is now the fashion to say that the white man is in Africa for the black man's *good*. Reader, had you never heard of or seen any African sculpture I think the reproductions in this part would suggest to you that the Negro has a superb and individual sense of form and equal genius in his execution. The writings of Michelet and Feuilloley will demonstrate that the African has an adequate enough soul (somewhat different from your own though it be), and had also (though that too was different from yours) a social organisation perfectly adapted to the conditions of his own continent. The studies by George Padmore, and others, of the economic, inter-racial, social and political systems implanted by the different imperialist masters assuredly throw an arc-light strong enough on the irrefutable truth. The truth is that Africa is tragedy.

" The White Man is killing Africa "

I have ended the book with this—I cannot say : I have ended it on this *note*, for the chord of oppression, struggle and protest rings, trumpet-like or muffled, but always insistent throughout. In this present day it is not possible to write otherwise of the Negro, and to write with truth.

Nancy Cunard

CONTENTS

Contents

Contents

POETRY

vii

Contents

Contents

NEGRO SCULPTURE and ETHNOLOGY

ACKNOWLEDGMENTS (1933)

I make here most grateful acknowledgment to all the collaborators of both races who by their essays, studies, poems, notes, letters, musical compositions and transcriptions have built up this record; to all those, individuals, museums, organisations and papers, who have made, given or lent me photographs and pictures to reproduce, and to the editors who have allowed me to quote from articles.

My thanks and appreciation are particularly due to my chief collaborator, Raymond Michelet, who worked with me during the two years of collecting and editing this Anthology. And to Edgell Rickword, who facilitated and greatly aided in the work of production and proof-reading.

N.C.

AMERICA

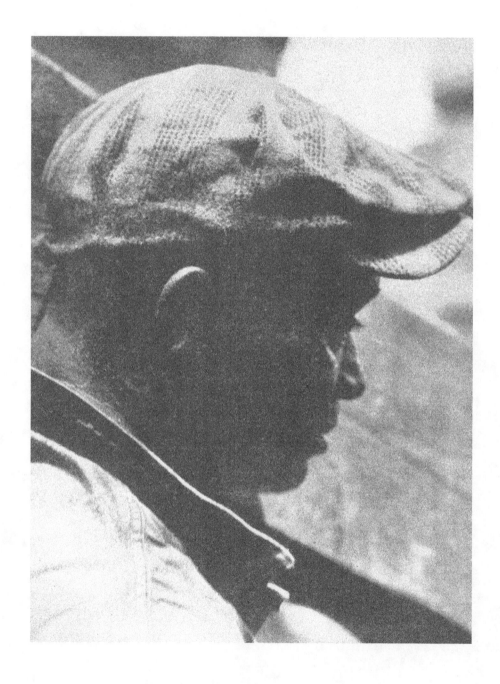

An American Beast of Burden
Photo by Howard Lester, New York, by courtesy of the artist

"I, Too"

I, too, sing America.
I am the darker brother.
They send me to eat in the kitchen
When company comes ;
But I laugh,
And eat well,
And grow strong.
Tomorrow
I'll sit at the table
When company comes,
Nobody'll dare
Say to me,
" Eat in the kitchen "
Then.
Besides, they'll see how beautiful I am
And be ashamed—
I, too, am America.

LANGSTON HUGHES.

A Brief Outline of Negro History
in the U.S. until Abolition

(Taken from " A School History of the Negro Race in America," by Edward A. Johnson, LL.B.)

Edward A. Johnson

"THE first Negroes landed at Jamestown, Virginia. In the year 1619 a Dutch trading vessel, being in need of supplies, weighed anchor at Jamestown, and exchanged fourteen Negroes for food and supplies. The Jamestown people made slaves of these fourteen Negroes, but did not pass any law to that effect until the year 1662, when the number of slaves in the colony was then nearly 2,000, most of whom had been imported from Africa.

"The Jamestown colony early discovered the profits of the tobacco crop, and the Negro slaves were largely employed in this industry, where they proved very profitable. They were also enlisted in the militia, but could not bear arms except in defence of the colonists against the Indians. The greater part of the manual labour of all kinds was performed by the slaves.

"The Jamestown slaves were doomed to servitude and ignorance both by law and by custom; they were not allowed to vote, and could not be set free even by their masters, except for 'some meritorious service.' Their religious service was of an inferior order, and slaves were sometimes given to the white ministers as pay for their services. The Free Negroes of Jamestown were in a similar condition to that of the slaves. They could vote and bear arms in the defence of the colony but not for themselves. They were taxed to bear the expenses of the government, but could not be educated in the schools they helped to build. Some of them managed to acquire some education and some property.

"When John Smith became governor of the Jamestown colony, there were none but white inhabitants; their indolent habits caused him to make a law declaring that 'he who would not work should not eat.' Prior to this time the colony had proved a failure and continued so until the introduction of the slaves, whose labor soon made it grow prosperous.

THE NEW YORK COLONY

"The enslavement of the Negro seems to have commenced in the New York colony about the same time as at Jamestown. The slaves were used on the farms, and became so profitable that about the time the English took the colony from the Dutch, 1664, there was a great demand for slaves, and the trade grew accordingly.

"The privileges of the slaves in New York were, for a while, a little better than in Virginia. They were taken into the church and baptized, and no law was passed to prevent them getting an education. But the famous Wall Street, now the financial centre of the New World, was once the scene of an auction block where Indians and persons of Negro descent were bought and sold. A whipping boss was once a characteristic officer in New York City.

"The riot of 1712 shows the feeling between the master and servant at that time. The Negro population being excluded from schools, not allowed to own land, even when free, and forbidden to 'strike a Christian or a Jew' in self-defence, and their testimony excluded from courts, arose in arms and with the torch; houses were burned and many whites killed, before the militia suppressed them. Many of the Negroes of New York were free, and many came from the Spanish provinces.

"The treatment of the slaves in these colonies (New England) at this time was regulated by laws which classed them as property, 'being rated as horses and hogs.' They could not bear arms nor be admitted to schools. They were baptized in churches, but this did not make them freemen, as it did with white serfs. Better treatment was given the slaves as the colonies grew older and were threatened with wars. It was thought that the slaves might espouse the cause of the enemy, and for this reason some leniency was shown them, and the conscience of the people was being aroused."

In Delaware and Pennsylvania the Quakers were opposed to slavery, and William Penn proved friendly to the Negroes, yet slavery continued.

4

A Brief Outline of Negro History in the U.S. until Abolition

In North Carolina "large communities of free Negroes lived in this state prior to the Civil War, and as late as 1835 could vote. Prior to the Civil War there were schools for these free people. Some of them owned slaves themselves. In this colony the slaves were worked, as a rule, on small farms, and there was a close relation established between master and slaves, which bore its fruits in somewhat milder treatment than was customary in colonies where the slaves lived on large cotton plantations governed by cruel overseers, some of whom were imported from the North.

" The Eastern section of North Carolina was thickly peopled with slaves, and some landlords owned as many as 2,000. The increase and surplusage of the slave population in this State was sold to the more Southern colonies, where they were used on the cotton plantations."

In South Carolina the soil and the climate were very propitious to rice. Slaves were in great demand and built up the riches of this colony. The Spaniards at this time would bribe the slaves to run away and join their forces. The punishment for this was branding, and cutting the ham-string of the leg; and so many other terrible cruelties took place that a general and widespread discontent ensued. Just before the war with England the slave-holders were alarmed at the thought of the slaves going over to the enemy. "England offered freedom and money to slaves who would join her army. The people of South Carolina did not wait long before they allowed the Negroes to enlist in defence of the colonies, and highly complimented their valour. If a slave killed a Briton, he was emancipated; if he were taken prisoner and escaped back into the province, he was also set free."

In Georgia at first there had been no slaves. This colony failed until they were introduced for the cultivation of cotton, rice and sugar-cane in 1750. During the war of the Revolution Negroes had fled into the everglades of Florida and remained in these swamps for forty years baffling all attempts at capture. " Many of those who planned the escape were now dead, and their children had grown up to hate the lash and love liberty. Their parents had taught them that to die in the swamps with liberty was better than to feast as a bondman and a slave. When Blount's Fort was abandoned and taken possession of by these children of the swamp there were 311 of them, out of which not more than 20 had ever been slaves. They were joined by other slaves as chance permitted. The neighbouring slave-holders attempted to catch these people but failed. They finally called on the President of the United States for aid." Colonel Clinch was sent to take the fort, but his sympathies being with these rebels he marched to it and returned reporting that it was inaccessible by land. The next attempt turned out differently. In 1816 two boats went up the Apalachicola river, and after demanding the surrender of the Negroes, who refused to return to slavery, they turned their guns on the fort and killed all but fifteen, who were taken aboard in chains. " As the two boats moved away from this scene of carnage the sight weakened the veteran sailors on board, and when the officers retired these weather-worn sailor veterans ' gathered before the mast, and loud and bitter were the curses uttered against slavery and against the officers of the government who had thus constrained them to murder innocent women and helpless children, merely for their love of liberty.' The dead remained unburied in the fort. The wounded and dying were not cared for, and all were left as fat prey for the vultures to feast upon. For fifty years afterward the bones of these brave people lay bleaching in the sun. Twenty years after the murder a representative in Congress from one of the free States introduced a bill giving a gratuity to the perpetrators of this crime; the bill passed both houses."

At the beginning of the Revolutionary War, Lord Dunmore, governor of Virginia, offered freedom to every slave that would join the British forces. This greatly alarmed the colonies, who began to allow the Negroes to enlist, and paid their masters for them out of the public treasury. It was proposed to raise three or four battalions, though the public opinion of that time (which repeated itself later in the Civil War) was that the Negro was too inferior all round to make a good soldier! However, George Washington and Congress decided to enlist the slaves. The masters were to be compensated " at the rate of $1,000 apiece for each ' able-bodied Negro man of standard size, not exceeding 35 years of age, who shall be enlisted and pass muster. That no pay be allowed to the said Negroes, but that they be clothed and subsisted at the expense of the United States; that every Negro who shall well and faithfully serve as a soldier to the end of the present war, and shall then return his arms, shall be emancipated and receive the sum of 50 dollars.' " It is now that that famous name in Negro annals occurs: Crispus Attucks, the first man who died for American " liberty." In 1770 the British were marching through the streets of Boston as through a conquered city; along with other citizens Attucks was riled by their insolence, a fight ensued, the troops shooting into what they termed the " mob," and in the " Boston Massacre " it was Crispus Attucks, Negro, who first fell.

A Brief Outline of Negro History in the U.S. until Abolition

Throughout the whole war some 5,000 Negroes fought on the side of the colonies, and about 50,000 on the side of England.

"Did the Negro soldiers get their freedom after the war of Revolution was over? We may say yes, so far as the Northern colonies are concerned, but not without much opposition in the courts and legislatures. Virginia also passed an act in 1783 emancipating the slaves who had fought in the Revolution. Many individual slaves were emancipated by special acts of the legislatures for their courage and bravery.

"George Washington set his slaves free by his will, and many slave-owners did the same. The slaves who joined the British army were subjected to all sorts of horrors. Thousands died with smallpox and other contagious diseases. A great number were sent to the West Indies in exchange for 'rum, sugar, coffee and fruit.'

"Lafayette, the brilliant young Frenchman, and Kosciusko, the generous Pole, volunteered their services in behalf of freedom for the Americans during the Revolution. They fought, though, for the freedom of all Americans. Lafayette said in a letter to a Mr. Clarkson: ' I would never have drawn my sword in the cause of America, if I could have conceived that thereby I was founding a land of slavery.' While visiting America in 1825, he expressed a warm desire to see some of the many soldiers whom he ' remembered as participating with him in many skirmishes.' He believed in freedom for all men, and to put in practice his anti-slavery ideas he bought a plantation in French Guiana. There he collected all the ' whips and other instruments of torture and punishment, and made a bonfire of them in the presence of the assembled slaves.'

"He gave one day in each week to the slaves, and as soon as one could earn enough he might purchase another day, and so on until he gained his freedom. Kosciusko expressed great sorrow to learn that the colored men who served in the Revolution were not thereby to gain their freedom. He left $20,000 in the hands of Thomas Jefferson, to be used in educating colored children."

EFFORTS FOR FREEDOM

" The Abolitionists who were opposed to slavery furnished many brave hearts and strong minds from their ranks. Their work began very early in the history of the colonies; it continued with slow growth for awhile, but was nevertheless certain and effectual. The Quakers of Pennsylvania were foremost in the work of abolition. They set nearly all their slaves free. Anti-slavery societies were formed in nearly all the Northern States.

"Benjamin Lundy is mentioned as the earliest leader of the Abolitionists. He published a paper called *The Genius of Universal Emancipation*. He visited nineteen States of the Union, travelled upwards of five thousand miles on foot, and more than twenty thousand in other ways, and held more than two hundred public meetings. Lundy's paper was not regarded as very dangerous to the institution of slavery; but the *Journal of the Times* became the inveterate foe to slavery under the editorship of William Lloyd Garrison, who was mobbed in the streets of Boston, and imprisoned for libel in Baltimore for denouncing the crew of the ship ' Francis Todd,' on board of which were many ill-treated slaves bound for the slave-marts of New Orleans. Garrison and Lundy united in getting out *The Genius of Universal Emancipation* at Baltimore.

"Arthur Tappan, before this, paid Garrison's fine, and the enemy to slavery commenced his war with more vigour and zeal than before. In 1831 *The Liberator* was first published by Garrison, and, as was his desire, it continued till ' every slave in America was free.' A colored man, James Forten, sent $50 among the first twenty-five subscriptions that came to *The Liberator*. Garrison thought it his duty to obey God rather than man, and he denounced the Constitution of the United States as being ' A covenant with death and an agreement with hell,' because he held that it supported slavery.

"The National Anti-Slavery Convention, white, was held in 1836; they had delegates from ten States, and 1,006 anti-slavery societies existed in the different States. The free colored people of the North also held an anti-slavery convention in 1831. *Their first work was to get recognition from the white organizations, who shut them out.*" [1]

At this time arose Frederick Douglass, the greatest name in the past history of the Negro race. Born in slavery in Maryland he escaped to New Bedford, Mass., where his burning oratory and his passionate denunciations of slavery and demands for abolition soon won him and the cause thousands of new adherents. Douglass came to Ireland and England in 1845-6; it was not long since England

[1] My emphasis. ED.

had abolished her own slavery in the West Indies, and his appeals to the public brought in much money, and in general roused a great wave of sympathy for the cause of the slaves. His oratory was rated amongst the highest of the times, " and his presence was sufficient to draw a crowd in the bitterest pro-slavery community." After the end of the Civil War Douglass was made Recorder of Deeds in the District of Columbia, and later, Minister to Hayti.

ANTI-SLAVERY AGITATION

" The census of 1850 gave a population of 3½ million slaves in America. Soon after this New Jersey, Delaware, and Maryland freed their slaves. The political parties were forced to take up the slavery question. The politicians were wily, and yielded to both sides for policy's sake. The South opposed every legislative act that favoured the abolition of slavery. The great Daniel Webster hesitated to take a decided stand either way, and in 1858 Charles Sumner, a staunch anti-slavery man, came to the Senate from Massachusetts in Webster's place. He said more and did more for the freedom of the slave than any of the great statesmen of his time. He offered no compromise, and asked only for *liberty* for the slaves.

" The Fugitive Slave Law allowed masters to capture their slaves in any State of the Union. (It was chief justice Taney who, in giving his decision on this law in the Dred-Scott case, said : ' A Negro has no rights which a white man is bound to respect.') Hence arose the Underground Railroad, which was a secret system for transporting runaway slaves into Canada. Some slaves were sent in boxes, and some carried in the night from one person to another until they reached the Canadian line. A great many runaway slaves made good their escape through this system.[1]

" New States coming into the Union caused great discussion as to whether they should come in as free States or slave States. Civil war broke out in Kansas between the inhabitants of that territory who wanted, and those who did not want, slaves. The anti-slavery people were led by John Brown, afterwards the leader in an attempt to capture the arsenal at Harper's Ferry, Virginia, and arm the slaves. He was hung as an insurrectionist in 1859.

" Opposition in the North to the abolitionists was manifested by the commercial people, who saw nothing in the whole question but the dollars and cents which they hoped to make out of the slave's products of cotton, tobacco, sugar and rice. But the agitation continued.

" Abraham Lincoln, endorsed by the anti-slavery people, was proposed as the Republican candidate for President in 1860, whereupon South Carolina declared if Lincoln was elected she would secede from the Union. Lincoln was elected, and accordingly South Carolina seceded, and was soon followed by the other slave-holding States."

This was the signal for war. After the first defeat of the North by the South at Bull Run " Lincoln issued a proclamation for 75,000 volunteers. But the motto was, *no blacks need apply. There was great prejudice in the North against the Negro's enlisting to fight for his freedom, and the President was also opposed to it.*" [2] Later, owing to the way the Northerners were getting beaten, the Negro was judged good enough to be sent out to get killed for his own freedom and in the service of the Union. Even Lincoln, the emancipator (and never was this name given with less reason, as any student of history must agree[3]), was obliged to reconsider his opinion. The South, however, was forming Negro troops ; many free Negroes enlisted in its service at New Orleans and Memphis, and thereby fought against liberty and against their own race. " They were highly spoken of by the Southern papers (!) But the North seemed to think still that to put the Negro in the Union blue would disgrace that uniform " !

The exigencies of so many defeats for the Union in the beginning of the war forced Lincoln and Congress to allow black men to enlist. " A difficulty arose in getting sufficient arms for all the colored troops ; *and a further difficulty was to be met in selecting white officers who had the courage to brave public sentiment and take the command of Negro troops. . . .*[4] 1863 found over 100,000 Negroes in the Union ranks, and over 50,000 armed and equipped on the fields of battle.

" *Their pay was 7 dollars per month, with board and clothing. The whites received 13 dollars per month, with board and clothing.*[5] Thus the former slave went forth to meet his master on the battle-field, sometimes to capture or be captured ; sometimes to fall side by side, one pierced with the Southern, one with the Northern bayonet."

EMANCIPATION PROCLAMATIONS

" Two proclamations were issued by Lincoln. The first, on Sept. 22, 1862, defined the issue of the war to be ' for the object of practically restoring the constitutional relation between the United States

[1] See Still's *Underground Railroad* (Philadelphia, 1871).　　　　[2] Emphasis mine. ED.

[3] See the correspondence after the Proclamation of Emancipation, p. 21.　　[4] Emphasis mine. ED.　　[5] *Ibid.*

and each of the States, and the people thereof.' It offered, first, to pay the masters for their slaves and colonize them in America or Africa. Second, it proposed to free the slaves of those persons and States then engaged in actual rebellion. Third, it offered to pay from the Federal treasury loyal masters who had lost their slaves in and during the rebellion.

"The second proclamation was issued Jan. 1, 1863, and is the one we celebrate. This measure was urged upon Lincoln by the Abolitionists and those who wished the Negro free. It did not free all the slaves. Some counties were left out. Though the Abolitionists saw in the proclamation the consummation of their prayers and hopes, Lincoln and his cabinet evidently regarded the proclamation as a war measure, very necessary under the circumstances, to shorten the war. The South would have surrendered in half the time had not a large number of slaves remained on the plantations raising supplies for the Confederate army, and supporting and protecting their masters' families."

An idea of Northern anti-Negro prejudice in the same year of emancipation is given by the Draft Riot, which broke out in New York in July 1863. "An order came from Washington, authorizing soldiers to be drafted in New York City. The Democratic newspapers ridiculed the idea of the people's being drafted into service ' to fight the battles of niggers and Abolitionists.' General Wood finally put down the riot after killing thirteen of the rioters, wounding eighteen and taking twenty-four prisoners. ' They had burned the Colored Orphans Asylum, hung colored men to lampposts, and destroyed the property of this class of citizens with impunity.' "

Here is an episode in the Civil War taken by Dr. E. A. Johnson from *Civil War—Song and Story*. " A colored man named Dabney drifted into the Union lines one day from a neighbouring farm, and soon proved to be very useful because of his full knowledge of the topography of the country. He was given employment as ' cook and body servant.' He became much interested in the system of army signals employed, and begged to have them explained to him. This was done, and he learned them readily. His wife soon came over, and after staying awhile was allowed to return as servant to a ' secesh woman '[1] whom General Hooker was about to send to her friends on the other side. She went over and took a place as laundress at ' the headquarters of a prominent rebel general.' Dabney, her husband, was on the Union side, and soon began to know all about what was to take place in the Confederate camp. An hour or two before any movement took place he could tell about it, and it always turned out as he said. The wonder and puzzle to the Union men was how he got his information, as he didn't seem to neglect his work to go off for any information, and did not converse with the scouts. After numerous questions and many requests he finally took one of the officers to a prominent point nearby, and pointed out a cabin on the banks of the river in the suburbs of the enemy's camp. He asked the officer if he saw a clothes-line with clothes hanging on it. The officer replied ' Yes,' whereupon Dabney said: ' Well, that clothes-line tells me in half an hour just what goes on in their camp. You see, my wife over there, she washes for the officers, and cooks and waits around, and as soon as she hears of any movement or anything going on she comes down and moves the clothes on that line so I can understand it in a minute. That there gray shirt is Longstreet, and when she takes it off it means he's gone down about Richmond. That white shirt means Hill, and when she moves it up to the west end of the line, Hill's corps has moved up-stream. That red one is Stonewall. He's down on the right now, and if he moves she will move that red shirt.' One morning Dabney came in and reported a movement over there but said it ' Don't mean anything, they are only making believe.' An officer went out to look at the clothes-line telegraph through his field-glass. There had been quite a shifting over there of the army flannels. ' But how do you know but there's something in it?' ' Do you see those two blankets pinned together at the bottom?' said Dabney. ' Yes, but what of it?' said the officer. ' Why, that's her way of making a fish-trap, and when she pins the clothes together that way, it means that Lee is only trying to draw us into a fish-trap.' "

By the end of the war some 186,000 Negro soldiers had fought on the Union side, and about 6,000 only on the Confederate side. " But all over the South, while their masters were away at war, the Negro women and men were enlisted in the ranks of the private duties of the Southern soldiers' homes, which, ever be it remembered to the honor and credit of the Negro race of America, they protected faithfully and industriously. The opportunity for outrage and plunder was open on every side, but not a hurtful hand was laid on the thousands of white widows, orphans and aged, who lay defenceless in the Negroes' power. . . . Some plantations, on the contrary, were found in better trim on the return of their masters from the war than when they left them."

[1] A Secessionist or Southerner.

A Brief Outline of Negro History in the U.S. until Abolition

The war was over in 1865, the South had been beaten. The North was going to draw back the rebel States into the Union. Provisional governments were instituted in these several States, the new constitutions of which were to be made to conform with that of the United States.

" The right to vote was denied the colored people. Exclusion from public places was established by law. 39 lashes was the penalty for keeping fire-arms. When white persons were implicated, colored people could not testify in the courts. The 13th amendment to the Constitution, making the race citizens, was virtually made null and void by the legislatures of the reconstructed States. So it became necessary to pass the *Civil Rights Bill*, giving the colored people the right to enter public places, and ride on first-class railroad cars. This bill has been declared unconstitutional by our Supreme Court. Owing to the attempts of the Ku Klux Klan to prevent colored people from voting, the 15th amendment was passed guaranteeing to them the right to vote and to have their votes counted. Thus, the 11 Southern States were reconstructed on a basis of universal suffrage."

Thus, in 1865. Now, and soon after abolition, disfranchisement and jim-crowing[1] are universal throughout the South—engrained by custom, a flat denial of the 15th amendment and a flat and unpunished insult to the Constitution of the U.S.A.

Three Great Negro Women

by GLADIS BERRY ROBINSON

PHILLIS WHEATLEY

Gladis B. Robinson

THE name her African mother gave her, no one knows. Up to her landing in America, Phillis remembers nothing of her former life except the pouring of water on the ground each morning at sunrise by her mother. And so when Mr. and Mrs. John Wheatley, wealthy New Englanders, purchased Phillis in 1761 in Boston, they gave her the name of Phillis—Wheatley was merely attached to that name because she belonged to the Wheatleys. Likewise we do not know the date of her birth.

Phillis was made the personal slave of the Wheatley children, older than she, but very fond of her, to the extent that they undertook to educate her. She was a precocious child, exceedingly patient and over-studious, the last attribute greatly undermining her health. Her perception proved so extraordinary that after only sixteen months of study, she had so mastered the English language as to compose and to set down in 1770 her first poem. Her ambition was stimulated; she became acquainted with grammar, history, ancient and modern geography, astronomy, and studied Latin with such precocity that she read Horace with both ease and enjoyment. The study of Latin had considerable influence upon her literary tastes, and the choice of her subjects of composition.

Three Great Negro Women

A general interest was felt in the prodigy; the best libraries in Boston were opened to her; and she had opportunities for conversation with the most accomplished and distinguished persons in the city. Phillis was no longer a slave of menial tasks; her beautiful and loving disposition, her extraordinary literary improvements won for her the companionship of the elder Wheatley.

In 1772, because of failing health, she was taken by the Wheatley son to England. While in England, contrary to an oft-time repeated belief that a white skin is indispensable to justice and recognition, Phillis was introduced to many of the nobility and gentry and would have been received at court, had not a message from America stating the illness of her mistress caused Phillis such sorrow that she begged to be allowed to return to America. However, 'twas from England in 1773 that was published her first volume of poems under the patronage of the Countess of Huntington and dedicated to her. Due to the damnable iterations of prejudice and injustice, the unpleasant task of attestation became necessary, and with the little volume Mr. John Wheatley published a letter written by himself. The letter reads in part:

To the Public:

As it has been repeatedly suggested to the publisher, by persons who have seen the manuscript, that numbers would be ready to suspect that they were not really the writings of Phillis, the writer has procured the following attestation from the most respectable citizens in Boston, that none might have the least ground for disputing their originality.

This letter was endorsed by the Governor of Massachusetts, the Lieutenant-Governor, and sixteen others, including her master and lifelong friend and benefactor—John Wheatley. Thus the volume, entitled *Poems on Various Subjects, Religious and Moral*, was given to the literary world, read, disputed, finally accepted and enjoyed, often referred to now by historians and critics of literature, but sad to say in most cases cast aside and forgotten.

Happily for Phillis' literary attainments she landed and lived in Boston, the reputed cradle of all that is refined in American manners and letters; but more happily for her she was the companion of a staunch Christian woman, since through her exemplary living Phillis became a member of the congregation of the Old South Church of Boston. Her mind proved peculiarly susceptible to religious impressions, and with that same quiet piety which marks all of her writings she composed the lines:

'Twas mercy brought me from my Pagan land,
Taught me, benighted soul, to understand
That there's a God, that there's a Saviour too.
Once I redemption neither sought nor knew,
Some view our sable race with scornful eye,
Their color is a diabolic dye—
Remember, Christians, Negroes black as Cain
Can be refined and join the Angelic train.

Nor would I be doing my duty should I fail to point out her loyalty to the American Colonies. Despite the fact that she was lauded in all England, that she supped with England's best, that it was largely under the influences of an Englander, as I have afore shown, that her first volume of poems was published in 1773, still she sang of America of the period all Americans are proud to celebrate, and it is remarkable that she stands with few others as a unique example in the very days when there was a birth of a new nation, singing her meed of praises to the great Washington, as shown by her poem in the *American Monthly Museum* for April 1776, entitled "His Excellency, General George Washington," in which she pens to him:

Thee, first in peace and honor we demand
The grace and glory of that martial band
Famed for thy valor, for thy virtues more;
Hear every tongue thy guardian aid implore.

About this time Mr. and Mrs. Wheatley passed into eternity; Phillis found herself alone and destitute, as the son had remained in Europe. 'Tis no wonder then that Phillis turned for companionship and solace to marriage. Her husband was Mr. Peters, a gentleman, yes—even a learned gentleman— a lawyer by profession, but too trifling to give to a delicate, sensitive, endowed wife the love and protection required. Her books were sold to pay his debts. Revolution broke out, the Peters with others fled to Newburyport. After the conflict Phillis returned to Boston, and was cared for with her child

in the home of a niece of the Wheatleys. Soon her husband came and took her away to a squalid home where he made no pretence at caring for the wants of her declining health. The thread of life attenuated by long suffering at last snapped suddenly. Peters did not notify the Wheatley niece of the death of his wife, not even others of her closest friends.

Thus on December 5, 1794, passed away this lovely woman who had stood honored and respected in the presence of the wise and the good of that country which was hers by adoption or rather compulsion, who had graced the halls of Old England and had rolled in the splendid equipages of the proud nobles of Britain; numbering her last hours in a state of the most abject misery surrounded by all the emblems of squalid poverty. They laid her in her solitary grave, without a stone to tell that one so gifted sleeps beneath.

May we view the opinion of critics: what of the poetry and prose of Phillis? Her prose is in the form of letters. Heartman has published them with remarks, as have several others. They are amusing, original, abreast of the times, live wires sparkling with genius and wit. These letters were first published in the Massachusetts Historical Society's *Proceedings* for 1863–1864.

Her poetry appears to be the more remarkable when one recalls her own words about it in the preface to her first volume: " The following poems were written originally for the amusement of the author, as they were the products of her leisure moments. She had no intention ever to have published them nor would they now make their appearance, but at the importunity of many of her best friends." Notwithstanding, the poems of this Negro girl afford one of the most singular cases of precocity known to literature. They rank with the best of the American echoes of the English classicists. We must remember that her first poems were published five years before the dawn of the American Revolution, and nearly thirty years before the French Revolution and the birth of German idealism. She wrote before the mighty outburst of human spirit which gave rise to Goethe, Schiller and Heine in Germany; to Wordsworth, Byron, Keats and Shelley in England. Her poetry was a poetry of the eighteenth century, when Pope and Gray reigned supreme; and that her poetry compared favorably with the other American poetry of the age is by no means to her discredit. There was no great American poetry in the eighteenth century, and Phillis Wheatley's was as good as the best American poetry of her age, as critics now reluctantly confess. With the exception of a very small number her poems do not lend themselves to reading—as a rule they are written to someone such as: " To the University of Cambridge"; " To the King's Most Excellent Majesty"; " To a Lady on the Death of her Husband."

When we read her we must take into consideration the disadvantages under which the writer labored —'tis not the poetical heights to which she soared but the depths from which she came which make her worthy to be praised by all posterity. That she was a pioneer in American literature makes her merit a place in that field; that she was the first Negro in America to tempt the Muse secures the commemoration of the entire Race; that she first styled George Washington " first in peace and honors " should have entitled her to a sacred place in the bicentennial celebration of America's first president; that she reached an intellectual eminence known to few of the females of either the eighteenth or the nineteenth centuries and with this accomplishment maintained her same exemplary humble piety justly merits that her name should be that of so many Christian Homes for girls in America.[1]

Sojourner Truth

Of Isabella (Sojourner) Truth (1777(?)–1883) it has been truly written: " Her parallel exists not in history. She stood by the closing century like a twin sister. Born and reared by its side. What it knew, she knew; what it had seen, she had seen."

Very little is known of her early life. She had served five masters up to the time of her emancipation, with all the hardships common to slaves of that period. Before her liberation in 1817 she had been married, and her five children had been sold into slavery. Up to this time she was called " Isabella." Then she tells us she prayed for a new name. Because of her wanderings " Sojourner " was given her, and " Truth " because she felt herself called to preach the truth about slavery as well as because she said, " God is my Master and His name is Truth, and Truth shall be my abiding name until I die."

It was singular to what dizzy heights in the lecture world this woman reached. By nature optimistic, persuasive and eloquent, it was her rare good fortune to sway, with her homely renderings of the gospel, audiences untouched by the eloquence of the learned. Says Harriet Beecher Stowe: " I never knew a

[1] See also further writing on Phillis Wheatley by A. A. Schomburg, in *Racial Integrity*, further on.

person who possessed so much of that subtle, controlling power called presence as Sojourner Truth." Wendell Phillips says that he has known a few words from her to electrify an audience and affect them as he never saw persons affected by another.

And let it long be remembered that Negroes, both North and South, fought for their own freedom in the Civil War only because the visits to the White House and the importunities of this " irresistible presence " at last broke down both Lincoln and Congress, and gained their consent. In 1861 we find her in Washington caring for the wounded soldiers, instructing and providing for the homeless, half-naked, half-starved, ill-kept newly emancipated slaves.

It is remarkable that at the close of the war, although well advanced in years (90 years old), this match-less character continued to travel and to lecture for her people. It was with pride that the best received her everywhere—presidents, senators, judges, authors and lecturers. By many of these she has been deified; she is the Libyan Sibyl of Harriet Beecher Stowe, and the ideal Sibilla Libica which the chisel of the eminent sculptor, Mr. Story, has given to the world.

Not only did Sojourner Truth labor with William Lloyd Garrison, Wendell Phillips, Frederick Douglass, Harriet Beecher Stowe, and other patriots, in the cause of freedom, but equally zealous did she struggle with the earnest advocates for the enfranchisement of women. In the Suffrage Convention of Akron, Ohio, 1851, Sojourner Truth is credited as having caught the ball on the rebound and as having saved the day for the women.

Despite her inability to read or write, she counted among her most cherished possessions a tiny auto-graph book; among the many extracts, testimonials, and names of distinguished persons found therein are the following:

For Aunty Sojourner Truth, A. Lincoln, October 9, 1864.
Sojourner Truth, U. S. Grant, March 31, 1870.

The memory of this splendid woman is very prodigious. She testifies that she easily recalled the " dark day " of New England in 1870. She remembered having witnessed the *Ulster Gazette* brought in draped in mourning on the death of George Washington, December 14, 1799. She was extremely witty; and thus it is no wonder that she records the following humorous memory: when the first steam-boat moved up the Hudson River in 1809, the Dutchmen were very angry because it frightened away the fish.

The sale of her biographies and her photographs, one of which bears one of her characteristic sayings, " I sell the shadder to support the substances," increased by her own industry and personal gifts enabled her to purchase a modest little home in Battle Creek, Michigan, where she lived and labored for more than twenty-five years.

One of her biographers records having visited her in her home in Michigan. When departing Sojourner Truth remarked, " I isn't goin' to die, honey, I'se goin' home like a shootin' star." And true to her prediction, her eventful life was quietly and quickly snuffed out, November 26, 1883. She is buried in Oakhill Cemetery, Battle Creek, Michigan.

Harriet Tubman (1820–1913)

Among the biographical sketches written concerning race women of distinction we find the following of Harriet Tubman:

"This historic character is in a class to herself. She had the skill and boldness of a commander, the courage and strategy of a general. A picturesque figure standing boldly against the commonplace dark background of a generation in which her lot was cast. Stranger than fiction have been her escapes and exploits in slavery. She was called ' Moses ' because of her success in guiding her brethren out of their Land of Egypt. She was also called ' General Moses '—an Amazon in strength and endurance, and is described as a woman of no pretensions, a most ordinary specimen of humanity. Yet in point of courage, shrewdness and disinterested exertions to rescue her fellow men she had no equal.

" Harriet appears to have been a strange compound of practical shrewdness and of a visionary enthu-siasm. She believed in dreams and omens warning and instructing her in her enterprises. At times she would break forth into wild and strange rhapsodies which to her ignorant hearers seemed the work of inspiration, to others a power of insight beyond what is called natural, to excel in the difficult work she had chosen for herself. The first twenty-five years of her life were spent as a slave on a Maryland plantation."

Three Great Negro Women

Harriet Tubman developed at work in the fields in youth a most extraordinary muscular strength and physical endurance, as well as great mental fortitude. Little wonder then, that after effecting her own freedom, she successfully made those (thirteen) perilous trips back and forth over the great network of sympathisers to conduct four hundred slaves to liberty, although $12,000 at one time was the reward offered for this evasive " black shadow."

> Swamps and tangled brush their bed at night, preferring the company of the wild things of the forest, even venomous reptiles, to the infuriated slave catcher. Foot-sore and weary with her sacred and hunted cargo, she forged ahead with an unconquerable spirit truly heroic in her sacrifice for her fellow creatures.

This great Underground Railroad system, as it was styled, in direct defiance of the omnipotent Fugitive Slave Laws of 1850, grew out of the demands of the time. Levi Coffin and Robert Purvis were the " Presidents " of the road. Various routes were known as " lines," stopping places were called " stations," those whose aid and vigilance along the stages meant so much were called " conductors." And the most picturesque of these " conductors " was " General Harriet Tubman." Their charges were known as " packages " or " freight." The system was an elaborate network, reaching from Kentucky to Virginia, across Ohio, and from Maryland across Pennsylvania and New York or New England. The system, initiated by the friendly Pennsylvania Quakers under Thomas Garrett (1789–1871) (who alone conducted 2,700 slaves to freedom), is credited authentically with having liberated 40,000 to 100,000 slaves.

William Still in his *The Underground Railroad* [1] assures us that Harriet Tubman was a most trusted confederate, indifferent to personal safety, but highly mindful of her " packages."

Hardly had she recovered at the age of six from severe attacks of infantile diseases, when her master injured her skull with an iron weight, an injury the result of which, by pressure on the brain, caused her to fall asleep at the most unfavorable moments and in the most inauspicious places. Notwithstanding this unfortunate physical handicap her followers had full faith in her, and likewise stood in fear of her slogan : " A live runaway slave can do great harm by going back, but a dead one can tell no tales."

A precious volume has been lost to posterity inasmuch as only one complete story, " The Story of Joe," of her hazardous proceedings over the Underground Railroad, and her peculiar methods of escape, has been recorded. It was Miss Pauline Hopkins, eulogising the subject of this sketch, who so truly wrote : " Harriet Tubman, though one of earth's lowliest ones, displayed an amount of heroism in her character rarely possessed by those of any station of life. Her name deserves to be handed down to posterity side by side with those of Grace Darling, Joan of Arc, and Florence Nightingale ; no one of them has shown more courage and power of endurance in facing danger and death to relieve human suffering than did this woman in her successful and heroic endeavors to reach and to save all whom she might of her oppressed people."

In personal appearance our heroine was homely and ordinary almost to the point of active aversion ; but somehow the empty stare, and the pure African type that she was, was offset by her patience, foresight, tenacity, loyalty and sagacity. She counted among her warmest friends all the leaders of the abolition movement. Among her rarest possessions she cherished letters sent to her by patriots like Governor Andrews of Massachusetts, William H. Seward, and other persons of distinction. We are told that out East, the reputed cradle of all that is refined in American manners and traditions, a warm welcome always awaited her, for in Concord alone were some of her fondest admirers : Lowell, Emerson, Alcott, and Mrs. Horace Mann.

Largely through the efforts of the Honorable William H. Seward, through personal donations, through the publication of her life story (written by the philanthropic Mrs. Sarah H. Bradford of Geneva) and through the untiring interest and financial support of the Empire State Federation, Harriet Tubman was able to build a cabin for her parents, and a home for aged and indigent colored people on her own tract of land in Auburn, New York.

Mrs. Elizabeth Lindsay Davis, founder of the great Phillis Wheatley Home movement in America, tells me in glowing words of the visits made by Harriet Tubman to the biennial conventions of the National Association of Colored Women. We are reminded that her last words to the Federation sisters were: " Tell the women to stick together ; God is fighting for them, and all is well."

The city of Auburn has adorned one of its public buildings with a tablet which bears silent testimony

[1] Published by Still in Philadelphia. This is an immense and admirable document of the escape of a very great number of slaves.

of the high esteem with which that city reveres Harriet Tubman, a woman whose charity was unlimited, whose sagacity, integrity and patriotism enabled her to make the most supreme sacrifices in the liberation of her people.

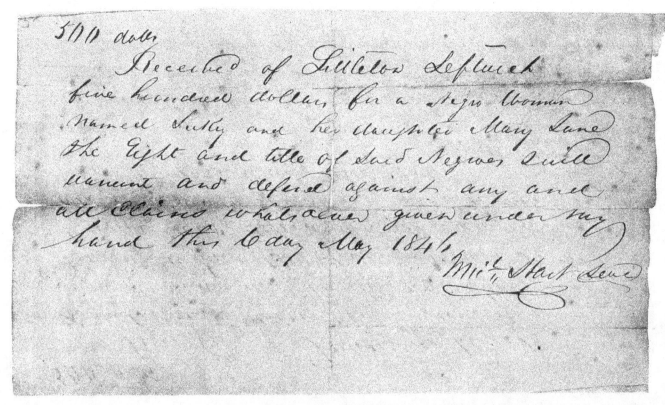

Photostat of an Original Bill of Sale for Negro Slaves

" 500 dolls

Received of Littleton Lefluret five hundred dollars for a Negro Woman named Suky and her daughter Mary Jane the right and title of said Negroes I will warrant and defend against any and all claims whatsoever given under my hand this 6 day May 1846,

Mic'l Hart sen."

Proclamation of Emancipation
of the Slaves

HERE is the text of Lincoln's Proclamation of Emancipation wherein it actually concerns the destiny of the slaves. Three long paragraphs in purely administrative language concerning representation in Congress of the revolted States have been omitted:

. . . That on the 1st day of January, 1863, all persons held as slaves within any States or designated part of a State, the people whereof shall then be in rebellion against the United States, shall be thenceforward and forever free; and the Executive Government of the United States, including the military and naval authority thereof, will recognise and maintain the freedom of such persons, and shall do no act or acts to repress such persons, or any of them, in any efforts they may make for their actual freedom. . . .
And by virtue of the power and for the purpose aforesaid, I do order and declare that all persons held as slaves

Proclamation of Emancipation of the Slaves

within the said designated States, and parts of States, are, and henceforward shall be, free; and that the Executive Government of the United States, including the military and naval authorities thereof, will recognise and maintain the freedom of said persons.

And I hereby enjoin upon the people so declared free to abstain from all violence, unless it is necessary in self defence; and I recommend to them that, in all cases when allowed, they labor faithfully for reasonable wages.

And I further declare and make known that such persons, of suitable condition, will be received into the armed service of the United States, to garrison forts, positions, stations and other places, and to man vessels of all sorts in said service.

And upon this act, sincerely believed to be an act of justice, warranted by the Constitution upon military necessity, I invoke the considerate judgement of mankind, and the gracious fear of Almighty God.

In testimony whereof, I have hereunto set my name and caused the seal of the United States to be affixed.

ABRAHAM LINCOLN,
Jan. 1, 1863. Washington.

And that is all. That is the document of the freeing " thenceforward and forever free " of the Negro race. Not very much of the personality of the " benefactor " of the black race is seen herein; the document is a purely State matter. Let us look at Lincoln in a less official moment.

Extracts from correspondence with the Hon. Horace Greeley, 1862 (when the question of emancipation was being weighed, and debated, advocated, and put off):

> My paramount object is to save the Union, and not to either save or destroy slavery.
> If I could save the Union without freeing any slave I would do it—if I could save it by freeing all the slaves, I would do it—and if I could do it by freeing some and leaving others alone, I would also do that.
> What I do about slavery and the colored race, I do because I believe it helps to save the Union; and what I forbear, I forbear, because I do not believe it would help to save the Union.

Greeley's desire was that the slaves should be freed, but Lincoln's sole preoccupation was to " save the Union." As he wrote: " The paramount idea of the Constitution is to preserve the Union . . ." and, if we are to believe his own words, there can be no doubt that Lincoln simply *was not* in favour of emancipation: " I can now most solemnly assert that I did all in my judgment that could be done to restore the Union *without interfering*[1] with the institution of slavery. We *failed*,[1] and the blow at slavery was struck ! " Are these the words a man even merely sympathetic to the cause of abolition would choose when it had become an accomplished fact?

Previous to the Proclamation of Freedom on January 1, 1863, the issuing of Lincoln's preliminary proclamation of emancipation aroused and disturbed the public mind. It was declared that the object of the war was to abolish slavery and not to secure restoration of the Union. Lincoln, however, proclaimed and declared in unequivocal terms (as has just been seen) that the freeing of the slaves was a quite subordinate factor in the saving of the Union. This is not a question of reading between the lines, we read the very words he used. Horace Greeley had charged him with remissness in deciding the question in the *New York Tribune* of August 19, 1862, but after Lincoln's answer the main body of the loyalists was content. It appears thus, that far from being a willing liberator, Lincoln was practically forced into the freeing of the slaves by an influential party of Northerners who insisted that the crushing of the rebellion would ensue from the crushing of slavery.

> " I admit that slavery is at the root of the rebellion, or at least it's a *sine qua non*. The ambition of politicians may have instigated them to act, but they would have been impotent without slavery as their instrument. I will also concede that *emancipation would help us in Europe, and convince them that we are incited by something more than ambition*." [1] And again, that by emancipation " some additional strength would be added in that way to the war, and then unquestionably it would weaken the rebels by drawing off their laborers, which is of great importance, *but I am not so sure we could do much with the blacks*." [1]

And yet Lincoln is known as the great benefactor, the great emancipator for whom the Negro race had been waiting for 244 years.

These are what the French so aptly call *les dessous de l'histoire*—the underneath of history that comes out, years later, yet that has been in the records, all along, for all to see—quite shameless, revelatory, convicted out of its own mouth.

[1] Italics mine. ED.

Dr. Booker T. Washington

NEGRO EDUCATIONALIST AND FOUNDER OF THE TUSKEGEE INSTITUTE
by THE REV. ARTHUR E. MASSEY

THE late Dr. Booker T. Washington, Founder and, up to the day of his death in 1916, Principal of the Tuskegee Normal and Industrial Institute, was born in slavery on a plantation in Franklin County, Virginia. He knew little or nothing of his birth, but as nearly as it was possible to ascertain presumed it took place in 1858 or 1859. With but slight knowledge of either father or mother he had practically no schooling whilst a slave. His first acquaintance with his state of bondage was when the freedom of the slaves was being discussed early one morning before day, when he was awakened by his mother kneeling over her children and fervently praying that Lincoln and his armies might be successful and her children might be free. While a mere child, his stepfather put him and his brother to work at a salt furnace, where he began work as early as four o'clock in the morning. It was whilst thus employed he made his first acquaintance with book knowledge, and soon after by dint of persistence learned to read.

As a result of patient importunity he was at last permitted to attend school in the day for a few months, with the understanding that he was to rise early in the morning and work in the furnace till nine o'clock, returning immediately after school closed in the afternoon for at least two more hours of work. From the salt furnace he went to work in a coal mine, and from thence to serve in the house of a Mrs. Ruffner for about a year and a half, and then proceeded to Hampton Institute, where he paid part of the cost of his board with hard work. General Armstrong very kindly persuaded Mr. S. Griffiths Morgan, of New Bedford, Mass., to defray the cost of his tuition during the whole time he was at Hampton.

After finishing the course he entered upon his life work at Tuskegee. Here he began to teach in a very dilapidated shanty. On one occasion it is recorded his landlady held an umbrella over him while he ate his breakfast. A less courageous and determined individual would never have contended with the almost insuperable difficulties that faced him on every hand.

Booker T. Washington

Dr. Booker T. Washington

But Booker T. Washington had an ideal in view; he realised that illiteracy and ignorance were the bane of his race, and like Moses he set out to lead them to the Land of Promise. Inconveniences, privations and hardships could not deter him from his promise. His early struggles hardened him for the fray, and his motto in effect was *Nil Desperandum*! Difficulties and obstacles tended only to urge him on to more persistent effort. He had made his plans for the work which was ultimately to transcend his most optimistic dreams. The foundation of his life's work had been laid. The school was opened July 4, 1881; thirty students reported for admission, and Booker T. Washington was the only teacher. From these early modest beginnings sprang the great Normal and Industrial Institute. Tuskegee town lies between Opelika and Montgomery, in central Alabama. It is reached by a narrow-gauge road from Chehaw. An old conservative town, it stands aloof from the Negro Institute, but one can guess it cannot refrain from viewing with curiosity and interest so great an undertaking in which it has no part.

The Institute is a mile beyond the town. It stands on an eminence from which one looks into broad valleys and off to pine-clad hills. I was told there is no more beautiful location in America.

The buildings, all erected by students, stand in 800 acres of campus and farm land, and are conveniently placed along the principal avenue and upon roads crossing it, giving it the appearance of a little town by itself. The architectural design, the making and laying of brick, the carpentering and much of the furnishing are all the work of the students. Even the tasteful oak set and writing desks in the boarding hall of the senior girls came from the school carpenter shop. Landscape gardening is taught, and trees and shrubbery abound. The roads are exceedingly well made and are dry and hard at all seasons. Neatness, order, efficiency and taste are everywhere set before the students in the external features of the Institute. Highly qualified coloured men and women are engaged as instructors and teachers, and the class-room accommodations are excellent. Tuskegee's crown and glory are undoubtedly the industrial departments; to go over the different shops and listen to the careful and courteous explanations of the different directors is not only a sheer delight but an education in itself.

I was commissioned by a member of a wealthy North American family to study the possibilities of co-operative communal life among the Negroes of the South, and for that purpose entered the Institute as an ordinary theological student, partly paying my board by services rendered, over a period of several months. During my stay I had the privilege and honour to meet and converse with Dr. Booker T. Washington, the worthy successor of Frederick Douglass as a leader of a wonderfully progressive people. Judging from their state of partial freedom since the emancipation, progress has been little short of phenomenal.

I have never met a more well-balanced man than Booker T. Washington. He not only lived up to his ideals, but always made the best of adverse conditions, environment and people. He lived to do good. Always dignified, broad-minded, humorous and thoughtful, he taught his students not to deem any task—however irksome or unpleasant—unworthy of their best efforts. I have seen him take on an unpleasant duty in order to shame the hesitancy of a raw student, instead of enforcing obedience by compulsion, and he always succeeded.

The Negro is passionately fond of oratory. The ideal of the more advanced and intelligent type is to become an orator or a good preacher. He encouraged them in this; they had elocution classes and periodical meetings for debate and discussion, also a mock Congress. He was himself a perfect orator; his eloquence, pathos and power of appeal were simply marvellous. After listening to him lecturing in a class-room on Psychology I could never again forget the keenness of his intellect and his remarkable talent for teaching. His periodical talks to the whole body of students were unforgettable, for he was truly a father to all under his care, always the personification of kindness and goodwill.

In matters of religion there was not a vestige of narrowness or bigotry about him. His simple Christian faith was marked with a sympathetic toleration towards all who differed with him—a trait which might well be cultivated by men in more pretentious positions of authority.

There was also something almost uncanny about his intuitive powers, always so amazingly keen and accurate. In conversing with him one felt one was being read through and through. His subconscious reasoning powers were also developed to a surprising degree, and one realised that, no matter how stupendous the undertaking, it was safe and assured in the hands of such a superman. His capacity and powers of endurance for work seemed inexhaustible, and in the end he paid the inevitable toll for working as if there were really no end to his resources.

The moment he learned of my mission to Tuskegee he gave me a free hand. I did not want the students to meet me as a superior in any sense of the word, and it was therefore at my own suggestion that I entered the Institute as an ordinary Normal student, taking my place in the class-room, in the

garden, and road work. Every week the young men and women students would have a social amity meeting in a parlour kept for that purpose.

On one of these occasions my attention was called to a young coloured student of good appearance who seemed to be labouring under some great emotion. On questioning him I learned that he had just received the news that his sister, who lived with her parents some considerable distance from Tuskegee, had been brutally outraged by some white men in a wood. I remarked : " Of course they will be brought to justice and punished? " " No," came the answer, " it will all be hushed up because she is ' only a nigger,' " and he burst into tears. Such is the code of justice and honour in the Southern States.

On another occasion I was walking along a road not far from the Institute when a dog owned by a Negro in a cottage nearby began to bark. I should not have paid any attention but for the fact that a white man passing by suddenly stopped, leaned over the fence, and in angry tones commanded the owner to " stop that dog barking or I'll shoot it ! " The Negro mumbled something to the effect that he could not help it and that the dog was doing no harm. " If you don't stop him you'll have a bullet as well," came the rejoinder. Such is the inane attitude of many white people in the South towards the helpless Negro.

Many lynchings take place without the slightest semblance of reason. A Negro manservant in the house of a white woman told me he worked from morning till night just for his board and lodging (he slept in an out-house), and that he dare not grumble at any indignity or humiliation to which he might be subjected, for, said he, " the mistress has only to hint at an attempted assault and my life would be doomed."

I was riding one day in a buggy with a prosperous old Negro farmer in Georgia. Suddenly a white man appeared in the distance driving a phæton, and as he neared us my companion with a fierce jerk reined in his horse to a standstill while the phæton rolled by. " Why did you do that? " I asked. " We have to do it here, he might easily have put a bullet into me had I ignored him." On another occasion, whilst in Georgia, a number of Negroes were in the habit of amusing themselves by playing cards in a shed at night by candle-light. A group of white men, under the pretence of suppressing gambling (but really as an excuse to " kill niggers "), quietly surrounded the shed one dark evening and ruthlessly fired their revolvers into the midst of their victims, without threat or warning.

Race hatred in the South is appalling ; there is positively no justice for the Negro. As one who has travelled in the Southern States and lived in Alabama and Georgia, I can assert without fear of contradiction that the spirit responsible for the unjust condemnation of those nine helpless Scottsboro victims of colour prejudice in Alabama has reigned continuously over a very long period in the Southern States.

With regard to race prejudice Booker Washington dealt with it as an obstacle to be surmounted rather than something to be railed at and attacked. This was his attitude towards most difficulties and was really the secret of his success.

Concerning the much-talked-of " legal segregation "—it is a deliberate insult and humiliation to the Afro-American. The last article written for publication by Booker Washington appeared posthumously in the *New Republic*, N.Y.C., Dec. 4, 1915, entitled " My Views of Segregation Laws," in which he gave out in no uncertain terms his views on the Southern Laws of Segregation. At the conclusion of the article he said : " Summarizing the matter in the large, segregation is ill-advised because—

" 1. It is unjust.

" 2. It invites other unjust measures.

" 3. It will not be productive of good because practically every thoughtful Negro resents its injustice and doubts its sincerity.

" 4. It is unnecessary.

" 5. It is inconsistent. The Negro is segregated from his white neighbour, but white business men are not prevented from doing business in Negro neighbourhoods.

" 6. There has been no case of Negroes in the United States that has not widened the breach between the two nations. Wherever a form of segregation exists it will be found that it has been administered in such a way as to embitter the Negro and harm more or less the moral fibre of the white man. That the Negro does not express this constant sense of wrong is no proof that he does not feel it.

" In the long run, no individual and no race can succeed which sets itself at war against the common good ; for in the gain or loss of one race all the rest have equal claim."

The attitude of North and South differs considerably towards Tuskegee Institute ; much genuine interest and practical sympathy comes from the North, but so far as I could ascertain little else than

Dr. Booker T. Washington

toleration and cold patronage was evinced by the Southerner, and in some cases open hostility. A surprising characteristic of the Southerner was his swell-headed sense of superiority over the Negro, and this in the lowest and most degraded type of white! The Negro rightly terms them " white trash."

While I was at the Institute the late President McKinley paid us an official visit. Booker T. Washington drove his car to the station to meet the President, who on arrival immediately seated himself by the side of Washington. In Tuskegee proper, elaborate preparations had been made to welcome their distinguished visitor with speeches, etc. But to the horror, dismay and indignation of the officials and white townspeople, the car with its occupants drove straight to the Institute. President McKinley had inflicted upon his would-be admirers a well-merited taste of the humiliation to which the Negro was continually subjected. To read the press reports on the following day was an eye-opener; one began to wonder how the President succeeded in returning to the White House in his skin! He, the President of the United States of America, had actually dared to fraternise with a " nigger "!!

The passing of Booker T. Washington on November 14, 1916, was an irreparable loss to the Afro-American people. The incalculable benefits he had achieved for his people have been permanently secured, not only in the great educational Institute at Tuskegee, but in the many thousands of educated men and women it has distributed all over America, who are carrying on the good work in schools, churches, professions, on farms and in the domestic circle. With all of his fame, success and popularity, Booker T. Washington remained to the end humble, unassuming and lovable. He was undeniably a great soul, too great to allow any bitterness or small-mindedness to find a lurking place in his character. Without a vestige of ill-feeling or malice, and brimming over with charity, he loved all men, and all men who contacted him learned to love him. His influence for good is doubtless just as strong among the students at Tuskegee today as in the past, when his genial and stimulating presence was the very life of the Institute.

The so-called " inferiority of the Negro " has been proved to be a myth by the labours of such heroes as Washington. When we take into consideration the comparatively short interval of time between the days of ignorance and slavery and the period of opportunity for self-improvement that followed, the results are truly amazing. The Negro, in fact, appears to be more like a sort of superman! With about one-fifth or one-tenth of what the whites receive for their education, the Negro has succeeded in proving his abilities and fitness to occupy a dignified place in the sun. Taking the Southern States as a whole, about $10.23 *per capita* is spent in educating the average white boy or girl in the States, and the sum of $2.82 *per capita* in educating the average black child. Despite all his disabilities and stumbling blocks the American Negro is leading his race to better and higher conditions. He has made the greatest cultural progress of all Negroes.

Colour and racial prejudice is a lamentable hindrance to progress, and it is unfortunately not confined to America, for a blatant " anti-nigger " tendency has been spreading throughout the British Empire for some considerable time, in India and Egypt as well as in Africa. It is a well-known fact that young officers are frequently heard calling even Hindoos, Syrians and Arabs " Niggers "!

" I was reared in an atmosphere of admiration, almost of veneration for England," says Dr. DuBois. " I had always looked on England as the best administrator of coloured peoples, and laid her success to her system of justice," but he has since been disillusioned by the new story of Hindoos and Arabs, and the Negroes of South Africa and West Africa. Booker T. Washington was an entirely different type of leader to that of Dr. W. E. Burghardt DuBois. " Our Booker T.," as the Negroes lovingly referred to him, was a man of peace, although in no sense lacking in courage or outspokenness in regard to the wrongs of his race. Perhaps, had he been otherwise, the Tuskegee Normal and Industrial Institute would never have materialised as an educational movement of such national importance as it undoubtedly is today. His work, like the rippling brook, " goes on for ever."

In this brief sketch I make no pretence to having done justice to either Booker T. Washington or to his great educational work among the Afro-Americans, but if I have in any small degree succeeded in arousing the interest and sympathy of thinking people for the coloured people of the world, and for their fair recognition as equal partners in the great commonwealth of humanity, I shall be more than content.

My wanderings in the Southern States of Florida, Georgia, South Carolina, and my stay at Tuskegee, helped me to see in the Negro great and unlimited possibilities. He has refused to be vanquished in the evolutionary process, and is emerging into what God intended him to become, even though " tried as by fire." We have to remember that one-tenth of the population of the United States is Negro, and that he has developed more in sixty years than did the Anglo-Saxon in six centuries. The problem of colour

Dr. Booker T. Washington

was of little if any importance when no Negroes were educated. Education is, however, rapidly increasing among the Afro-Americans, and enough of them are sufficiently cultured to make the colour problem one of the most important of the day. And the more stringent the law of emigration from Europe becomes, the more complicated and difficult will the problem be.

It is sad and regrettable that so few professors of the Christian faith really believe that God " hath made of one blood all nations of men." Americans certainly do not, for even in their churches they segregate Negro worshippers from the rest of the congregation. Perhaps some day, in their enlightenment they will look back with shame on their inane prejudices and cruelties.

.

When I was a child Booker T. Washington had dinner at our house. My father, who was interested in Negroes, had invited him to dine at eight, and at ten to open a Negro social settlement. The young Negro servants left because a Negro was eating with the whites. One stayed, the odd-job man. He looked like Uncle Tom, and was an ex-slave. He said it was an honor and asked to drive the guest to his train.

(This note on the mentality of the younger Negro servants was sent me by Janet Flanner—she said this incident took place at her home, which was then at Indianapolis. Ed.)

The American Congo—Burning of
Henry Lowry

by WILLIAM PICKENS

William Pickens

THE valley of the Mississippi river from Memphis to the great delta may properly be termed the " Congo " of America. It includes the States of Arkansas, Louisiana, Mississippi, western Tennessee, and eastern Texas. The quest of this Congo is not for rubber and ivory, but for cotton and sugar. Here labor is forced, and the laborer is a slave. The slavery is a cunningly contrived debt-slavery, to give the appearance of civilisation and the sanction of law. A debt of a few hundred dollars may tie a black man and his family of ten as securely in bondage to a great white planter as if he had purchased their bodies. If the Thirteenth Amendment, which has never been enforced in this region, means anything, it is that a man's body cannot be held for an honestly contracted debt; that only his property can be held; and that if a contracting debtor has no property, the creditor takes the risk in advancing credit. Otherwise a law abolishing slavery could be easily evaded, for the wealthy enslaver could get the poor victim into debt and then hold his body in default of payment. Wages could then be so adjusted to expenses and the costs of " keep " that the slavery would be unending. The only way for this debt-slave to get free from such a master is to get someone else to pay this debt; that is, to sell himself to another, with added charges, expenses of moving and bonuses. By this method the enslaver gets his bondmen cheaper than in a regular slave system, for in the debt-system he does not have to pay the full market price of a man. The effect is to allow the ignorant and the poor unwittingly and unwillingly to sell themselves for much less than an old slaveholder would have sold them. The debt-master has other advantages, in that he is free from liabilities on account of the debtor's ill-health or the failure of his crops. The debtor takes all the risk; and in case of misfortune or crop failure, gets deeper into debt—more securely tied in bondage.

This is the system that obtains in the great Mississippi Valley, and it has not been modified for thirty years or more. The evil of this system is responsible for all of the massacres of colored people and for nearly all of the horrible lynchings and burnings of individual Negroes that have lately taken place in this region. The recent most barbarous of all burnings of a human being, that of Henry Lowry, at Nodena, Arkansas, near Memphis, Tennessee, is directly and immediately traceable to this debt-slave system. The newspapers of that section, which described in great detail the Negro " murderer's " deed of killing a white planter and the savage torture which the farmers inflicted upon the slayer, either pretend not to know the cause of all this or deliberately ignore it. Some of the newspapers, whose representatives saw members of the white planter's family and found out everything else, said that " no reason could be ascertained " as to why the Negro shot the white man. And other papers invented or accepted a beautiful little fiction : that Lowry had chased a colored woman for a mile or more trying to kill her ; that this colored woman finally ran into the home of O. T. Craig, the planter, for protection ; that the planter stepped out to " remonstrate " with Lowry, when the latter shot him dead, incidentally killing his daughter, a Mrs. Williamson, who stood near him, and wounding his two sons, Hugh Craig, thirty-five years old, and Richard Craig, twenty-seven years old. As we know the South, we should have to be very simple-minded to believe this, even if we had not gone immediately to the section and found the facts otherwise. For a Negro in Arkansas to do what the papers of Memphis say Lowry did, *that* Negro would have to be a maniac ; and so the papers tried to be consistent by asserting that he was " drunk," one even going so far as to report that a still had been found at his house.

Let us look at the facts. We should always bear in mind when there is trouble across the color line

that we never read the side of the colored people in these papers, and also that many white people say over their dinner tables and to a few of their colored servants what they will not say in public. About two years ago Henry Lowry, the Negro, came from the State of Mississippi to work on the farms of O. T. Craig, a large planter in Mississippi County, Arkansas. With him came his wife and a six-year-old daughter. He was well-behaved and industrious, and knew nothing of whiskey and stills. Even the Memphis newspapers admitted finally that he was an honest, hard-working, inoffensive Negro. They admitted this to make it sound reasonable to assert that he ran a still and got drunk!

O. T. Craig, the planter, owned all the land thereabout. The colored tenants could own nothing, and Craig controlled everything. He hired, paid and fired the colored school teacher, for such schooling as he allowed. His son Hugh was his farm manager. His son Richard, "Mr. Dick," was a "bad man" to the colored people. He was postmaster and clerk of court. As the Lowry case proves, the mail of the colored tenants could be opened at any time, and they got such "justice" as the landlords willed. Craig and his household, therefore, were about all the "government" the black tenants knew. The Constitution does not follow them into the backwoods of Arkansas.

A few weeks before Christmas Henry Lowry ran afoul of the policies of the debt-slave system by going to Craig and asking for a *settlement*; that is, a summing up of the debits and credits for the two years or so. and a delivery to Lowry of the balance due, if any. Christmas was coming, and it is thought also that Lowry wanted to move away, which the Craigs perhaps knew, as they controlled the mails. And Lowry knew that if he attempted to move away without having written evidence that he was debt-free, all his household goods would be "attached," and he and his family might be attached too. But although Craig could have "settled" on his own *ex parte* figures, as is the rule, he refused to have any settlement at all. That would be bad policy; to concede these Negro tenants a reckoning might lead to other presumptions on their part. Who knows? If they can ask for a settlement once in two years and get it, they might come to ask for monthly statements, with bills and receipts. And what would become of debt-bondage if the debt-master must keep true and actual accounts? Craig would not settle. Moreover, any presumptuous Negro who insisted upon a settlement must be answered—*emphatically*. So Richard Craig struck Lowry and admonished him not to come again for a settlement, for there would be no settlement.

Lowry was a man of forty years or more, and, being indignant, he said among his fellow-blacks that he would go back again and insist upon a settlement. Now, there was a woman named "Bessie," who was cook for the Craigs, about twenty-five years old, and on perfectly friendly terms with "Mr. Dick." She is the principal in the fiction about the colored woman who was being "protected" from Lowry by the Craigs. She had reported that Lowry had said he would "come back," and on Christmas Day, when she saw him coming, she simply ran into the house where the Craigs and their guests were at dinner and reported that Lowry was coming. She was not chased a mile, for she was the cook, and the Craigs were eating her Christmas dinner.

When Lowry arrived on the porch he announced that he had come again to ask for a settlement, and the senior Craig, with appropriate language, told him to leave the place, and emphasised his remark with a billet of wood which he hurled through the door, striking Lowry. And as Craig and his family and guests came pressing through the door, Lowry was backing off the porch as if fearing and seeking to escape from bodily harm, when bad-tempered "Dick" rushed out of the door and shot Lowry. It is said that others also were menacing the Negro with guns. But not until he was shot at and, as he himself claims, hit by a bullet from the Craigs, did Lowry pull his gun and shoot—unfortunately killing the father and the married daughter and wounding the two sons.

Immediately the newspapers, especially those of the nearby city of Memphis, began to work up a lynching by advertising the "outrage," the "Negro murderer," and "bad whiskey"—without one word of explanation or one syllable of editorial comment upon the underlying cause of all this. Lowry had escaped and was caught in El Paso, Texas, on January 19, being traced through a letter which he had written to a friend in an effort to get news to his wife and child, who had been moved into the Craig back yard for "protection." The colored people whom Lowry mentioned in this letter as his friends were thrown into jail, with others whom he did not mention but who were known to be officers of the Odd Fellow Lodge to which he belonged. Two wives were jailed with their accused husbands.

Governor McRae, of Arkansas, tried to forestall a lynching by ordering the deputy sheriffs who had gone to Texas to bring Lowry to Little Rock. The governor had said that Lowry would have a fair trial. The nearest route from El Paso to Little Rock would lie through Dallas and Texarkana and would not pass anywhere near the scene of the original trouble. But the deputies took Lowry several hundred

The American Congo—Burning of Henry Lowry

miles out of the way, down through New Orleans, so as to bring him to the waiting mob in Mississippi County. The mob leader received a telegram from New Orleans to meet a certain train in Sardis, Miss.

We have here a good example of the contempt for local law, and a good indication of the incapacity of the counties and States to protect prisoners who are the objects of mob feeling or to punish those who are guilty of inter-racial lynchings. This mob paraded itself unhindered through three States; going from Arkansas through Tennessee to Mississippi, announcing its purpose boldly to the officers of another State, then waiting leisurely at the railway station and a hotel, " overpowering " the deputies in the face of the public, and parading again with its victim through three States past the great city of Memphis to the spot in Arkansas where the burning was scheduled to take place. Some of the mob even stopped at a principal Memphis hotel, tipped off the news so that the afternoon papers could announce the exact hour when the lynching and burning would take place, and " celebrated " with a good dinner. The papers announced the burning for 6 P.M. and it actually took place at 6.30. The spirit of all the news in the papers tended to make heroes out of these lynchers, who had captured a handcuffed Negro from conniving officers. The papers spoke of them as being " all men."

Meanwhile all law was prostrate, as if it were non-existent. Everybody seemed to know just when and where the burning was to take place, except the sheriff of that county. The papers say that there were six hundred lynchers and sightseers from all the surrounding communities. The Memphis papers even had a correspondent on the scene to cover the affair for them. But there was no evidence of the power of the State or the nation to protect, not Lowry but civilised law. The torturers burned the victim for nearly an hour before he died. They began with his feet, sprinkling dry leaves by the handful on a slow fire. But after they had thus burned off all the lower part of his body and his abdomen began to burn, they decided to prevent the anti-climax of a slowly breathed-out life; they poured gasoline over all the upper part of the body so that the victim expired in a great flame.

According to the sheriff of the county, who managed to be absent when the burning took place, " every man, woman and child," white of course, in that county wanted that burning to take place. And yet some Southern members of Congress got wrathy when a witness before the Census Committee testified recently that in some communities of the South the majority of the white population is lawless in its attitude toward Negroes.

Seven other colored people, two of them perfectly innocent women, would have met the same fate in that same hour if the Arkansas roads had not been so bad. These others were in jail in Mississippi County, accused or merely suspected of having helped Lowry to escape. Indeed, the afternoon papers had almost jubilantly announced that at least three would be burned at 6 P.M., and maybe " an even half dozen." But the automobiles of the mob sank in the mud to the hub, so that they could not reach the jailed Negroes that night, and the next day the governor had two of the prisoners hurried across the State line into Missouri and had five others brought to Little Rock and incarcerated in the State penitentiary. For once bad roads proved to be the best roads for bad civilisation. As an excuse for the antici-pated murder of these prisoners, the papers had said that Lowry had " confessed " that they helped him, and they told much about his talking and " joking " with the mob all the way from Mississippi to Arkansas and that he had talked and answered questions even while they were burning his limbs off up to his abdomen. We learn from better sources that the Negro said never a word except when the mob brought his wife and little daughter to see him burning. He spoke to them. Several times he did try to eat hot ashes or fire and die, but the kindly mob would kick the embers out of his hands and out of his reach. Even members of the mob admitted to colored people: " He was the gamest nigger— never said a damned word!" All this newspaper talk about his answering questions and eating and jesting is an evident attempt to lend an air of romance to a bestial crime.

In one respect this murder did not reach the low depth of barbarism usually attained in orgies of this kind. The mob did not fumble in the ashes for the charred bones and other " souvenirs " as is usual in such Southern Roman holidays. This charming custom incidentally is commentary on a civilisation that is trying to work up a feeling of righteous indignation about alleged instances of cannibalism in Haiti. There is no evidence that these exist. If they did, however, it is questionable whether, as a visitor to our shores remarked not long ago, " it would not be somewhat less revolting, in view of the utilitarian motive involved, than the sadistic carnival which has become an approved and established ritual in the South at regular intervals throughout the year."

Characteristics of Negro Expression

by ZORA NEALE HURSTON

DRAMA

Zora Neale Hurston

THE Negro's universal mimicry is not so much a thing in itself as an evidence of something that permeates his entire self. And that thing is drama.

His very words are action words. His interpretation of the English language is in terms of pictures. One act described in terms of another. Hence the rich metaphor and simile.

The metaphor is of course very primitive. It is easier to illustrate than it is to explain because action came before speech. Let us make a parallel. Language is like money. In primitive communities actual goods, however bulky, are bartered for what one wants. This finally evolves into coin, the coin being not real wealth but a symbol of wealth. Still later even coin is abandoned for legal tender, and still later for cheques in certain usages.

Every phase of Negro life is highly dramatised. No matter how joyful or how sad the case there is sufficient poise for drama. Everything is acted out. Unconsciously for the most part of course. There is an impromptu ceremony always ready for every hour of life. No little moment passes unadorned.

Now the people with highly developed languages have words for detached ideas. That is legal tender. " That-which-we-squat-on " has become " chair." " Groan-causer " has evolved into " spear," and so on. Some individuals even conceive of the equivalent of cheque words, like " ideation " and " pleonastic." Perhaps we might say that *Paradise Lost* and *Sartor Resartus* are written in cheque words.

The primitive man exchanges descriptive words. His terms are all close fitting. Frequently the Negro, even with detached words in his vocabulary—not evolved in him but transplanted on his tongue by contact—must add action to it to make it do. So we have " chop-axe," " sitting-chair," " cook-pot " and the like because the speaker has in his mind the picture of the object in use. Action. Everything illustrated. So we can say the white man thinks in a written language and the Negro thinks in hieroglyphics.

A bit of Negro drama familiar to all is the frequent meeting of two opponents who threaten to do atrocious murder one upon the other.

Who has not observed a robust young Negro chap posing upon a street corner, possessed of nothing but his clothing, his strength and his youth? Does he bear himself like a pauper? No, Louis XIV could be no more insolent in his assurance. His eyes say plainly " Female, halt! " His posture exults " Ah, female, I am the eternal male, the giver of life. Behold in my hot flesh all the delights of this world. Salute me, I am strength." All this with a languid posture, there is no mistaking his meaning.

A Negro girl strolls past the corner lounger. Her whole body panging[1] and posing. A slight shoulder movement that calls attention to her bust, that is all of a dare. A hippy undulation below the waist that is a sheaf of promises tied with conscious power. She is acting out " I'm a darned sweet woman and you know it."

These little plays by strolling players are acted out daily in a dozen streets in a thousand cities, and no one ever mistakes the meaning.

WILL TO ADORN

The will to adorn is the second most notable characteristic in Negro expression. Perhaps his idea of ornament does not attempt to meet conventional standards, but it satisfies the soul of its creator.

In this respect the American Negro has done wonders to the English language. It has often been

[1] From " pang."

24

stated by etymologists that the Negro has introduced no African words to the language. This is true, but it is equally true that he has made over a great part of the tongue to his liking and has had his revision accepted by the ruling class. No one listening to a Southern white man talk could deny this. Not only has he softened and toned down strongly consonanted words like " aren't " to " aint " and the like, he has made new force words out of old feeble elements. Examples of this are " ham-shanked," " battle-hammed," " double-teen," " bodaciously," " muffle-jawed."

But the Negro's greatest contribution to the language is: (1) the use of metaphor and simile; (2) the use of the double descriptive; (3) the use of verbal nouns.

1. METAPHOR AND SIMILE

One at a time, like lawyers going to heaven.
You sho is propaganda.
Sobbing hearted.
I'll beat you till: (a) rope like okra, (b) slack like lime, (c) smell like onions.
Fatal for naked.
Kyting along.
That's a lynch.

That's a rope.
Cloakers—deceivers.
Regular as pig-tracks.
Mule blood—black molasses.
Syndicating—gossiping.
Flambeaux—cheap café (lighted by flambeaux).
To put yo'self on de ladder.

2. THE DOUBLE DESCRIPTIVE

High-tall.
Little-tee-ninchy (tiny).
Low-down.
Top-superior.
Sham-polish.
Lady-people.
Kill-dead.

Hot-boiling.
Chop-axe.
Sitting-chairs.
De watch wall.
Speedy-hurry.
More great and more better.

3. VERBAL NOUNS

She features somebody I know.
Funeralize.
Sense me into it.
Puts the shamery on him.
'Taint everybody you kin confidence.
I wouldn't friend with her.

Jooking—playing piano or guitar as it is done in Jook-houses (houses of ill-fame).
Uglying away.
I wouldn't scorn my name all up on you.
Bookooing (beaucoup) around—showing off.

NOUNS FROM VERBS

Won't stand a broke.
She won't take a listen.
He won't stand straightening.

That is such a compelment.
That's a lynch.

The stark, trimmed phrases of the Occident seem too bare for the voluptuous child of the sun, hence the adornment. It arises out of the same impulse as the wearing of jewelry and the making of sculpture —the urge to adorn.

On the walls of the homes of the average Negro one always finds a glut of gaudy calendars, wall pockets and advertising lithographs. The sophisticated white man or Negro would tolerate none of these, even if they bore a likeness to the Mona Lisa. No commercial art for decoration. Nor the calendar nor the advertisement spoils the picture for this lowly man. He sees the beauty in spite of the declaration of the Portland Cement Works or the butcher's announcement. I saw in Mobile a room in which there was an over-stuffed mohair living-room suite, an imitation mahogany bed and chifferobe, a console victrola. The walls were gaily papered with Sunday supplements of the *Mobile Register*. There were seven calendars and three wall pockets. One of them was decorated with a lace doily. The mantel-shelf was covered with a scarf of deep home-made lace, looped up with a huge bow of pink crêpe paper. Over the door was a huge lithograph showing the Treaty of Versailles being signed with a Waterman fountain pen.

It was grotesque, yes. But it indicated the desire for beauty. And decorating a decoration, as in the case of the doily on the gaudy wall pocket, did not seem out of place to the hostess. The feeling back of such an act is that there can never be enough of beauty, let alone too much. Perhaps she is right. We

25

each have our standards of art, and thus are we all interested parties and so unfit to pass judgment upon the art concepts of others.

Whatever the Negro does of his own volition he embellishes. His religious service is for the greater part excellent prose poetry. Both prayers and sermons are tooled and polished until they are true works of art. The supplication is forgotten in the frenzy of creation. The prayer of the white man is considered humorous in its bleakness. The beauty of the Old Testament does not exceed that of a Negro prayer.

ANGULARITY

After adornment the next most striking manifestation of the Negro is Angularity. Everything that he touches becomes angular. In all African sculpture and doctrine of any sort we find the same thing.

Anyone watching Negro dancers will be struck by the same phenomenon. Every posture is another angle. Pleasing, yes. But an effect achieved by the very means which an European strives to avoid.

The pictures on the walls are hung at deep angles. Furniture is always set at an angle. I have instances of a piece of furniture in the *middle* of a wall being set with one end nearer the wall than the other to avoid the simple straight line.

ASYMMETRY

Asymmetry is a definite feature of Negro art. I have no samples of true Negro painting unless we count the African shields, but the sculpture and carvings are full of this beauty and lack of symmetry.

It is present in the literature, both prose and verse. I offer an example of this quality in verse from Langston Hughes:

> I aint gonna mistreat ma good gal any more,
> I'm just gonna kill her next time she makes me sore.
>
>
>
> I treats her kind but she don't do me right,
> She fights and quarrels most ever' night.
>
>
>
> I can't have no woman's got such low-down ways
> Cause de blue gum woman aint de style now'days.
>
>
>
> I brought her from the South and she's goin on back,
> Else I'll use her head for a carpet track.

It is the lack of symmetry which makes Negro dancing so difficult for white dancers to learn. The abrupt and unexpected changes. The frequent change of key and time are evidences of this quality in music. (Note the St. Louis Blues.)

The dancing of the justly famous Bo-Jangles and Snake Hips are excellent examples.

The presence of rhythm and lack of symmetry are paradoxical, but there they are. Both are present to a marked degree. There is always rhythm, but it is the rhythm of segments. Each unit has a rhythm of its own, but when the whole is assembled it is lacking in symmetry. But easily workable to a Negro who is accustomed to the break in going from one part to another, so that he adjusts himself to the new tempo.

DANCING

Negro dancing is dynamic suggestion. No matter how violent it may appear to the beholder, every posture gives the impression that the dancer will do much more. For example, the performer flexes one knee sharply, assumes a ferocious face mask, thrusts the upper part of the body forward with clenched fists, elbows taut as in hard running or grasping a thrusting blade. That is all. But the spectator himself adds the picture of ferocious assault, hears the drums and finds himself keeping time with the music and tensing himself for the struggle. It is compelling insinuation. That is the very reason the spectator is held so rapt. He is participating in the performance himself—carrying out the suggestions of the performer.

The difference in the two arts is: the white dancer attempts to express fully; the Negro is restrained,

Characteristics of Negro Expression

but succeeds in gripping the beholder by forcing him to finish the action the performer suggests. Since no art ever can express all the variations conceivable, the Negro must be considered the greater artist, his dancing is realistic suggestion, and that is about all a great artist can do.

NEGRO FOLKLORE

Negro folklore is not a thing of the past. It is still in the making. Its great variety shows the adaptability of the black man : nothing is too old or too new, domestic or foreign, high or low, for his use. God and the Devil are paired, and are treated no more reverently than Rockefeller and Ford. Both of these men are prominent in folklore, Ford being particularly strong, and they talk and act like good-natured stevedores or mill-hands. Ole Massa is sometimes a smart man and often a fool. The automobile is ranged alongside of the oxcart. The angels and the apostles walk and talk like section hands. And through it all walks Jack, the greatest culture hero of the South; Jack beats them all—even the Devil, who is often smarter than God.

CULTURE HEROES

The Devil is next after Jack as a culture hero. He can out-smart everyone but Jack. God is absolutely no match for him. He is good-natured and full of humour. The sort of person one may count on to help out in any difficulty.

Peter the Apostle is the third in importance. One need not look far for the explanation. The Negro is not a Christian really. The primitive gods are not deities of too subtle inner reflection ; they are hard-working bodies who serve their devotees just as laboriously as the suppliant serves them. Gods of physical violence, stopping at nothing to serve their followers. Now of all the apostles Peter is the most active. When the other ten fell back trembling in the garden, Peter wielded the blade on the posse. Peter first and foremost in all action. The gods of no peoples have been philosophic until the people themselves have approached that state.

The rabbit, the bear, the lion, the buzzard, the fox are culture heroes from the animal world. The rabbit is far in the lead of all the others and is blood brother to Jack. In short, the trickster-hero of West Africa has been transplanted to America.

John Henry is a culture hero in song, but no more so than Stacker Lee, Smokey Joe or Bad Lazarus. There are many, many Negroes who have never heard of any of the song heroes, but none who do not know John (Jack) and the rabbit.

Examples of Folklore and the Modern Culture Hero

WHY DE PORPOISE'S TAIL IS ON CROSSWISE

Now, I want to tell you 'bout de porpoise. God had done made de world and everything. He set de moon and de stars in de sky. He got de fishes of de sea, and de fowls of de air completed.

He made de sun and hung it up. Then He made a nice gold track for it to run on. Then He said, " Now, Sun, I got everything made but Time. That's up to you. I want you to start out and go round de world on dis track just as fast as you kin make it. And de time it takes you to go and come, I'm going to call day and night." De Sun went zoonin' on cross de elements. Now, de porpoise was hanging round there and heard God what he tole de Sun, so he decided he'd take dat trip round de world hisself. He looked up and saw de Sun kytin' along, so he lit out too, him and dat Sun !

So de porpoise beat de Sun round de world by one hour and three minutes. So God said, " Aw naw, this aint gointer do ! I didn't mean for nothin' to be faster than de Sun ! " So God run dat porpoise for three days before he run him down and caught him, and took his tail off and put it on crossways to slow him up. Still he's de fastest thing in de water.

And dat's why de porpoise got his tail on crossways.

ROCKEFELLER AND FORD

Once John D. Rockefeller and Henry Ford was woofing at each other. Rockefeller told Henry Ford he could build a solid gold road round the world. Henry Ford told him if he would he would look at it and see if he liked it, and if he did he would buy it and put one of his tin lizzies on it.

ORIGINALITY

It has been said so often that the Negro is lacking in originality that it has almost become a gospel. Outward signs seem to bear this out. But if one looks closely its falsity is immediately evident.

27

Characteristics of Negro Expression

It is obvious that to get back to original sources is much too difficult for any group to claim very much as a certainty. What we really mean by originality is the modification of ideas. The most ardent admirer of the great Shakespeare cannot claim first source even for him. It is his treatment of the borrowed material.

So if we look at it squarely, the Negro is a very original being. While he lives and moves in the midst of a white civilisation, everything that he touches is re-interpreted for his own use. He has modified the language, mode of food preparation, practice of medicine, and most certainly the religion of his new country, just as he adapted to suit himself the Sheik hair-cut made famous by Rudolph Valentino.

Everyone is familiar with the Negro's modification of the whites' musical instruments, so that his interpretation has been adopted by the white man himself and then re-interpreted. In so many words, Paul Whiteman is giving an imitation of a Negro orchestra making use of white-invented musical instruments in a Negro way. Thus has arisen a new art in the civilised world, and thus has our so-called civilisation come. The exchange and re-exchange of ideas between groups.

IMITATION

The Negro, the world over, is famous as a mimic. But this in no way damages his standing as an original. Mimicry is an art in itself. If it is not, then all art must fall by the same blow that strikes it down. When sculpture, painting, acting, dancing, literature neither reflect nor suggest anything in nature or human experience we turn away with a dull wonder in our hearts at why the thing was done. Moreover, the contention that the Negro imitates from a feeling of inferiority is incorrect. He mimics for the love of it. The group of Negroes who slavishly imitate is small. The average Negro glories in his ways. The highly educated Negro the same. The self-despisement lies in a middle class who scorns to do or be anything Negro. " That's just like a Nigger " is the most terrible rebuke one can lay upon this kind. He wears drab clothing, sits through a boresome church service, pretends to have no interest in the community, holds beauty contests, and otherwise apes all the mediocrities of the white brother. The truly cultured Negro scorns him, and the Negro " farthest down " is too busy " spreading his junk " in his own way to see or care. He likes his own things best. Even the group who are not Negroes but belong to the " sixth race," buy such records as " Shake dat thing " and " Tight lak dat." They really enjoy hearing a good bible-beater preach, but wild horses could drag no such admission from them. Their ready-made expression is : " We done got away from all that now." Some refuse to countenance Negro music on the grounds that it is niggerism, and for that reason should be done away with. Roland Hayes was thoroughly denounced for singing spirituals until he was accepted by white audiences. Langston Hughes is not considered a poet by this group because he writes of the man in the ditch, who is more numerous and real among us than any other.

But, this group aside, let us say that the art of mimicry is better developed in the Negro than in other racial groups. He does it as the mocking-bird does it, for the love of it, and not because he wishes to be like the one imitated. I saw a group of small Negro boys imitating a cat defecating and the subsequent toilet of the cat. It was very realistic, and they enjoyed it as much as if they had been imitating a coronation ceremony. The dances are full of imitations of various animals. The buzzard lope, walking the dog, the pig's hind legs, holding the mule, elephant squat, pigeon's wing, falling off the log, seabord (imitation of an engine starting), and the like.

ABSENCE OF THE CONCEPT OF PRIVACY

It is said that Negroes keep nothing secret, that they have no reserve. This ought not to seem strange when one considers that we are an outdoor people accustomed to communal life. Add this to all-permeating drama and you have the explanation.

There is no privacy in an African village. Loves, fights, possessions are, to misquote Woodrow Wilson, " Open disagreements openly arrived at." The community is given the benefit of a good fight as well as a good wedding. An audience is a necessary part of any drama. We merely go with nature rather than against it.

Discord is more natural than accord. If we accept the doctrine of the survival of the fittest there are more fighting honors than there are honors for other achievements. Humanity places premiums on all things necessary to its well-being, and a valiant and good fighter is valuable in any community. So why hide the light under a bushel? Moreover, intimidation is a recognised part of warfare the world over, and threats certainly must be listed under that head. So that a great threatener must certainly be considered an aid to the fighting machine. So then if a man or woman is a facile hurler of threats, why

should he or she not show their wares to the community? Hence the holding of all quarrels and fights in the open. One relieves one's pent-up anger and at the same time earns laurels in intimidation. Besides, one does the community a service. There is nothing so exhilarating as watching well-matched opponents go into action. The entire world likes action, for that matter. Hence prize-fighters become millionaires.

Likewise love-making is a biological necessity the world over and an art among Negroes. So that a man or woman who is proficient sees no reason why the fact should not be moot. He swaggers. She struts hippily about. Songs are built on the power to charm beneath the bed-clothes. Here again we have individuals striving to excel in what the community considers an art. Then if all of his world is seeking a great lover, why should he not speak right out loud?

It is all in a view-point. Love-making and fighting in all their branches are high arts, other things are arts among other groups where they brag about their proficiency just as brazenly as we do about these things that others consider matters for conversation behind closed doors. At any rate, the white man is despised by Negroes as a very poor fighter individually, and a very poor lover. One Negro, speaking of white men, said, " White folks is alright when dey gits in de bank and on de law bench, but dey sho' kin lie about wimmen folks."

I pressed him to explain. " Well you see, white mens makes out they marries wimmen to look at they eyes, and they know they gits em for just what us gits em for. 'Nother thing, white mens say they goes clear round de world and wins all de wimmen folks way from they men folks. Dat's a lie too. They don't win nothin, they buys em. Now de way I figgers it, if a woman don't want me enough to be wid me, 'thout I got to pay her, she kin rock right on, but these here white men don't know what to do wid a woman when they gits her—dat's how come they gives they wimmen so much. They got to. Us wimmen works jus as hard as us does an come home an sleep wid us every night. They own wouldn't do it and its de mens fault. Dese white men done fooled theyself bout dese wimmen.

" Now me, I keeps me some wimmens all de time. Dat's whut dey wuz put here for—us mens to use. Dat's right now, Miss. Y'all wuz put here so us mens could have some pleasure. Course I don't run round like heap uh men folks. But if my ole lady go way from me and stay more'n two weeks, I got to git me somebody, aint I? "

THE JOOK

Jook is the word for a Negro pleasure house. It may mean a bawdy house. It may mean the house set apart on public works where the men and women dance, drink and gamble. Often it is a combination of all these.

In past generations the music was furnished by " boxes," another word for guitars. One guitar was enough for a dance; to have two was considered excellent. Where two were playing one man played the lead and the other seconded him. The first player was " picking " and the second was " framming," that is, playing chords while the lead carried the melody by dexterous finger work. Sometimes a third player was added, and he played a tom-tom effect on the low strings. Believe it or not, this is excellent dance music.

Pianos soon came to take the place of the boxes, and now player-pianos and victrolas are in all of the Jooks.

Musically speaking, the Jook is the most important place in America. For in its smelly, shoddy confines has been born the secular music known as blues, and on blues has been founded jazz. The singing and playing in the true Negro style is called " jooking."

The songs grow by incremental repetition as they travel from mouth to mouth and from Jook to Jook for years before they reach outside ears. Hence the great variety of subject-matter in each song.

The Negro dances circulated over the world were also conceived inside the Jooks. They too make the round of Jooks and public works before going into the outside world.

In this respect it is interesting to mention the Black Bottom. I have read several false accounts of its origin and name. One writer claimed that it got its name from the black sticky mud on the bottom of the Mississippi river. Other equally absurd statements gummed the press. Now the dance really originated in the Jook section of Nashville, Tennessee, around Fourth Avenue. This is a tough neighbourhood known as Black Bottom—hence the name.

The Charleston is perhaps forty years old, and was danced up and down the Atlantic seaboard from North Carolina to Key West, Florida.

The Negro social dance is slow and sensuous. The idea in the Jook is to gain sensation, and not so much exercise. So that just enough foot movement is added to keep the dancers on the floor. A

tremendous sex stimulation is gained from this. But who is trying to avoid it? The man, the woman, the time and the place have met. Rather, little intimate names are indulged in to heap fire on fire.

These too have spread to all the world.

The Negro theatre, as built up by the Negro, is based on Jook situations, with women, gambling, fighting, drinking. Shows like " Dixie to Broadway " are only Negro in cast, and could just as well have come from pre-Soviet Russia.

Another interesting thing—Negro shows before being tampered with did not specialise in octoroon chorus girls. The girl who could hoist a Jook song from her belly and lam it against the front door of the theatre was the lead, even if she were as black as the hinges of hell. The question was " Can she jook? " She must also have a good belly wobble, and her hips must, to quote a popular work song, " Shake like jelly all over and be so broad, Lawd, Lawd, and be so broad." So that the bleached chorus is the result of a white demand and not the Negro's.

The woman in the Jook may be nappy headed and black, but if she is a good lover she gets there just the same. A favorite Jook song of the past has this to say :

> *Singer :* It aint good looks dat takes you through dis world.
> *Audience :* What is it, good mama?
> *Singer :* Elgin [1] movements in your hips
> Twenty years guarantee.

And it always brought down the house too.

> Oh de white gal rides in a Cadillac,
> De yaller gal rides de same,
> Black gal rides in a rusty Ford
> But she gits dere just de same.

The sort of woman her men idealise is the type that is put forth in the theatre. The art-creating Negro prefers a not too thin woman who can shake like jelly all over as she dances and sings, and that is the type he put forth on the stage. She has been banished by the white producer and the Negro who takes his cue from the white.

Of course a black woman is never the wife of the upper class Negro in the North. This state of affairs does not obtain in the South, however. I have noted numerous cases where the wife was considerably darker than the husband. People of some substance, too.

This scornful attitude towards black women receives mouth sanction by the mud-sills.

Even on the works and in the Jooks the black man sings disparagingly of black women. They say that she is evil. That she sleeps with her fists doubled up and ready for action. All over they are making a little drama of waking up a yaller [2] wife and a black one.

A man is lying beside his yaller wife and wakes her up. She says to him, " Darling, do you know what I was dreaming when you woke me up? " He says, " No honey, what was you dreaming? " She says, " I dreamt I had done cooked you a big, fine dinner and we was setting down to eat out de same plate and I was setting on yo' lap jus huggin you and kissin you and you was so sweet."

Wake up a black woman, and before you kin git any sense into her she be done up and lammed you over the head four or five times. When you git her quiet she'll say, " Nigger, know whut I was dreamin when you woke me up? "

You say, " No honey, what was you dreamin? " She says, " I dreamt you shook yo' rusty fist under my nose and I split yo' head open wid a axe."

But in spite of disparaging fictitious drama, in real life the black girl is drawing on his account at the commissary. Down in the Cypress Swamp as he swings his axe he chants :

> Dat ole black gal, she keep on grumblin,
> New pair shoes, new pair shoes,
> I'm goint to buy her shoes and stockings
> Slippers too, slippers too.

Then adds aside : " Blacker de berry, sweeter de juice."

To be sure the black gal is still in power, men are still cutting and shooting their way to her pillow. To the queen of the Jook!

Speaking of the influence of the Jook, I noted that Mae West in " Sex " had much more flavor of the

[1] Elegant (?). [2] Yaller (yellow), light mulatto.

turpentine quarters than she did of the white bawd. I know that the piece she played on the piano is a very old Jook composition. "Honey let yo' drawers hang low" had been played and sung in every Jook in the South for at least thirty-five years. It has always puzzled me why she thought it likely to be played in a Canadian bawdy house.

Speaking of the use of Negro material by white performers, it is astonishing that so many are trying it, and I have never seen one yet entirely realistic. They often have all the elements of the song, dance, or expression, but they are misplaced or distorted by the accent falling on the wrong element. Every one seems to think that the Negro is easily imitated when nothing is further from the truth. Without exception I wonder why the black-face comedians *are* black-face; it is a puzzle—good comedians, but darn poor niggers. Gershwin and the other " Negro " rhapsodists come under this same axe. Just about as Negro as caviar or Ann Pennington's athletic Black Bottom. When the Negroes who knew the Black Bottom in its cradle saw the Broadway version they asked each other, " Is you learnt dat *new* Black Bottom yet? " Proof that it was not *their* dance.

And God only knows what the world has suffered from the white damsels who try to sing Blues.

The Negroes themselves have sinned also in this respect. In spite of the goings up and down on the earth, from the original Fisk Jubilee Singers down to the present, there has been no genuine presentation of Negro songs to white audiences. The spirituals that have been sung around the world are Negroid to be sure, but so full of musicians' tricks that Negro congregations are highly entertained when they hear their old songs so changed. They never use the new style songs, and these are never heard unless perchance some daughter or son has been off to college and returns with one of the old songs with its face lifted, so to speak.

I am of the opinion that this trick style of delivery was originated by the Fisk Singers; Tuskeegee and Hampton followed suit and have helped spread this misconception of Negro spirituals. This Glee Club style has gone on so long and become so fixed among concert singers that it is considered quite authentic. But I say again, that not one concert singer in the world is singing the songs as the Negro song-makers sing them.

If anyone wishes to prove the truth of this let him step into some unfashionable Negro church and hear for himself.

To those who want to institute the Negro theatre, let me say it is already established. It is lacking in wealth, so it is not seen in the high places. A creature with a white head and Negro feet struts the Metropolitan boards. The real Negro theatre is in the Jooks and the cabarets. Self-conscious individuals may turn away the eye and say, " Let us search elsewhere for our dramatic art." Let 'em search. They certainly won't find it. Butter Beans and Susie, Bo-Jangles and Snake Hips are the only performers of the real Negro school it has ever been my pleasure to behold in New York.

DIALECT

If we are to believe the majority of writers of Negro dialect and the burnt-cork artists, Negro speech is a weird thing, full of " ams " and " Ises." Fortunately we don't have to believe them. We may go directly to the Negro and let him speak for himself.

I know that I run the risk of being damned as an infidel for declaring that nowhere can be found the Negro who asks " am it? " nor yet his brother who announces " Ise uh gwinter." He exists only for a certain type of writers and performers.

Very few Negroes, educated or not, use a clear clipped " I." It verges more or less upon " Ah." I think the lip form is responsible for this to a great extent. By experiment the reader will find that a sharp " I " is very much easier with a thin taut lip than with a full soft lip. Like tightening violin strings.

If one listens closely one will note too that a word is slurred in one position in the sentence but clearly pronounced in another. This is particularly true of the pronouns. A pronoun as a subject is likely to be clearly enunciated, but slurred as an object. For example : " You better not let me ketch yuh."

There is a tendency in some localities to add the " h " to " it " and pronounce it " hit." Probably a vestige of old English. In some localities " if " is " ef."

In story telling " so " is universally the connective. It is used even as an introductory word, at the very beginning of a story. In religious expression " and " is used. The trend in stories is to state conclusions ; in religion, to enumerate.

I am mentioning only the most general rules in dialect because there are so many quirks that belong only to certain localities that nothing less than a volume would be adequate.

Conversions and Visions

by ZORA NEALE HURSTON

THE vision is a very definite part of Negro religion. It almost always accompanies conversion. It always accompanies the call to preach.

In the conversion the vision is sought. The individual goes forth into waste places and by fasting and prayer induces the vision. The place of retirement chosen is one most likely to have some emotional effect upon the seeker. The cemetery, to a people who fear the dead, is a most suggestive place to gain visions. The dense swamps with the possibility of bodily mishaps is another favorite.

Three days is the traditional period for seeking the vision. Usually the seeker is successful, but now and then he fails. Most seekers " come through religion " during revival meetings, but a number come after the meeting has closed.

Certain conversion visions have become traditional, but all sorts of variations are interpolated in the general framework of the convention, from the exceedingly frivolous to the most solemn. One may go to a dismal swamp, the other to the privy house. The imagination of one may carry him to the last judgment and the rimbones of nothing, the vision of another may hobble him at washing collard greens. But in each case there is an unwillingness to believe—to accept the great good fortune too quickly. So God is asked for proof. One man told me that he refused to believe that he had truly been saved and said : " Now, Lord, if you have really saved my soul, I ask you to move a certain star from left to right." And the star shot across the heavens from the left hand to the right. But still he wouldn't believe. So he asked for the sun to shout and the sun shouted. He still didn't believe. So he asked for one more sign. But God had grown impatient with his doubtings and told him sharply that if he didn't believe without further proof that He'd send his soul to hell. So he ran forth from his hiding and proclaimed a new-found savior.

In another case, a woman asked that a tree be moved and it stepped over ten feet, and then she asked for the star and God told her He had given her one sign and if she couldn't believe and trust Him for the balance He'd send her soul to torment.

Another woman asked for a windstorm and it came. She asked for the star to move and it did. She asked for the sun to shout and God grew angry and rebuked her like the others.

Still another woman fell under conviction in a cow lot and asked for a sign. "' Now, Lord, if you done converted my soul, let dat cow low three times and I'll believe.' A cow said, ' Mooo—oo, moo—oo—oo, moo—ooo—ooo '—and I knowed I had been converted and my soul set free."

Three is the holy number and the call to preach always comes three times. It is never answered until the third time. The man flees from the call, but is finally brought to accept it. God punishes him by every kind of misfortune until he finally acknowledges himself beaten and makes known the call. Some preachers say the spirit whipped them from their heads to their heels. They have been too sore to get out of bed because they refused the call. This never ceased until the surrender. Sometimes God sends others to tell them they are chosen. But in every case the ministers refuse to believe the words of even these.

We see that in conversion the sinner is first made conscious of his guilt. This is followed by a period called "lyin' under conviction " which lasts for three days. After which Jesus converts the supplicant, and the supplicant refuses to believe without proof, and only gives in under threat of eternal damnation. He flees from this to open acknowledgment of God and salvation. First from the outside comes the accusation of sin. Then from within the man comes the consciousness of guilt, and the sufferer seeks relief from Heaven. When it is granted, it is at first doubted, but later accepted. We have a mixture of external and internal struggles.

The call to preach is altogether external. The vision seeks the man. Punishment follows if he does not heed the call, or until he answers.

In conversion, then, we have the cultural pattern of the person seeking the vision and inducing it by isolation and fasting. In the call to preach we have the involuntary vision—the call seeking the man.

COMING THROUGH RELIGION

I went out to pray in my back yard. I had done prayed and prayed but didn't know how to pray. I had done seen vision on top of vision, but still I wouldn't believe. Then I said: " Lord, let my head be a footstool for you." He says: " I plant my feet in the sea, follow after me. Your sins are forgiven and your soul set free.

Conversions and Visions

Go and tell the world what a kind Saviour you have found." I broke out the privy and went running and the voice kept following: " I set your feet on the rock of eternal ages; and the wind may blow and the storm may rise, but nothing shall frighten you from the shore."

I carried them messages.

" Jesus." " I am Jesus." " Father!" " I am the Father, and the Father is in me." It just continued and He sent me to the unconverted. I had some more visions. In one of them I laid down and a white man come to me all dressed in white and he had me stretched out on de table and clipped my breath three times and the third time I rose and went to a church door and there was a weeping willow. There was a four-cornered garden and three men knelt with me in the four corners. And I had to pray, to send up a prayer.

The next vision I had a white woman says: " I am going home with you." I didn't want her to go. My house was not in order. Somebody stopped her. When I got home, a tall white man was standing at my door with a palmetto hat. I noticed he was pale-like. He was looking down on my steps. They was washed with redding.[1] He says: " I have cleaned your house. How do you like it? " I looked down on it and after he was gone I said: " I don't like that. It looks too much like blood." After I was converted it come to me about the blood and I knew it was Jesus, and my heart was struck with sorrow that to think I had been walking upon His precious blood all this time and didn't believe.

(Mrs. Susanna Springer.)

I was a lad of a boy when I found Jesus sweet to my ever-dying soul. They was runnin p'tracted meetin and all my friends was gettin religion and joinin de church; but I never paid it no mind. I was hard. But I dont keer how hard you is, God kin reach you when He gits ready for you. One day, bout noon, it was de 9th day of June, 1886, when I was walkin in my sins, wallerin in my sins, dat He tetched me wid de tip of His finger and I fell right where I was and laid there for three long days and nights. I layed there racked in pain under sentence of death for my sins. And I walked over hell on a narrer foot log so I had to put one foot right in front de other, one foot right in front de other wid hell gapped wide open beneath my sin-loaded and slippery feet. And de hell hounds was barkin on my tracks and jus before dey rushed me into hell and judgement I cried: " Lawd, have mercy," and I crossed over safe. But still I wouldnt believe. Then I saw myself hangin over hell by one strand of hair and de flames of fire leapin up a thousand miles to swaller my soul and I cried: " Jesus, save my soul and I'll believe, I'll believe." Then I found myself on solid ground and a tall white man beckoned for me to come to him and I went, wrapped in my guilt, and he 'nointed me wid de oil of salvation and healed all my wounds. Then I found myself layin on de ground under a scrub oak and I cried: " I believe, I believe." Then Christ spoke peace to my soul and de dungeon shook and my chains fell off, and I went shoutin in His name and praising Him. I put on de whole armor of faith and I speck to stay in de fiel till I die.

(Deacon Ernest Huffman.)

First thing started me—it come to me dat I had to die. And worried me so I got talkin wid an old Christ man —about seventy years old. I wasn't but twentyone. And I started out from his instruction and I heered people say in my time dat de speerit would command you to de graveyard (to pray). And I ast de Lawd not to send me dere cause I wuz skeered uh de graveyard. But every answer I got commanded me to the graveyard.

One cold night, March de twentieth, 1867, at night, de speerit command me to de graveyard and I didn't go. And de Lawd sent Death after me and when I knowed anything I was on my way to de graveyard. And when I got dere I fell. I fell right between two graves and I saw Him when He laid me upon a table in my vision. I was naked and He split me open. And there was two men there—one on each side of de table. I could hear de knives clicking in me, inside. And after dey got through wid me, they smothed they hand over de wound and I wuz healed. And when I found myself I wuz standin naked beside de table and there was three lights burnin on de table. De one in de middle wuz de brightest. I wuzn't between de two graves no more. When I got up from between de two graves, I tracked my guide by de drops of blood. I could hear de blood dripping from Him before me. It said as it dropped: " Follow me." And I looked at de three lights and dey tole me to reach forth wid my right hand and grasp de brightest one and I did. It wuz shining like de Venus star. And they tole me it wuz to be my guidin star. I found myself before I left de table wid five white balls in each hand. " Them is the ten tablets I give you." And I put my hands to my breast and I put the balls inside me. Then He slapped something on my breast and said: " Now, you are breastplated and shielded." He pointed: " Go to yonder white house. You will find there one who will welcome you." And when I got to de steps I thowed my foot on de first step and de house rang and a lady come out and welcomed me in. And when I got inside, as far as mortal eye could behold, the robes was hanging level and touched my head as I passed under. Then I found myself robed in the color of gold. Then I commenced shouting. And when I commenced shouting I found myself leaving the graveyard. And He told me that was my robe for me bye and bye. In dat swamp where dat graveyard was there was catamounts and panters and wild beasts but not a one of 'em touched me and I laid there all night.

[1] Brick dust is used in New Orleans to seam steps. It leaves them reddish.

Now He tole me, He said: " You got the three witnesses. One is water, one is spirit, and one is blood. And these three correspond with the three in heben—Father, Son and Holy Ghost."

Now I ast Him about this lyin in sin and He give me a handful of seeds and He tole me to sow 'em in a bed and He tole me: " I want you to watch them seeds." The seeds come up about in places and He said: " Those seeds that come up, they died in the heart of the earth and quickened and come up and brought forth fruit. But those seeds that didn't come up, they died in the heart of the earth and rottened.

" And a soul that dies and quickens through my spirit they will live forever, but those that dont never pray, they are lost forever."

(Rev. Jessie Jefferson.)

Shouting

by ZORA NEALE HURSTON

THERE can be little doubt that shouting is a survival of the African " possession " by the gods. In Africa it is sacred to the priesthood or acolytes, in America it has become generalised. The implication is the same, however. It is a sign of special favor from the spirit that it chooses to drive out the individual consciousness temporarily and use the body for its expression.

In every case the person claims ignorance of his actions during the possession.

Broadly speaking, shouting is an emotional explosion, responsive to rhythm. It is called forth by (1) sung rhythm; (2) spoken rhythm; (3) humming rhythm; (4) the foot-patting or hand-clapping that imitates very closely the tom-tom.

The more familiar the expression, the more likely to evoke response. For instance, " I am a soldier of the cross, a follower of the meek and lowly lamb. I want you all to know I am fighting under the blood-stained banner of King Jesus " is more likely to be amen-ed than any flourish a speaker might get off. Perhaps the reason for this is that the hearers can follow the flow of syllables without stirring the brain to grasp the sense. Perhaps it is the same urge that makes a child beg for the same story even though he knows it so well that he can correct his parents if a word is left out.

Shouting is a community thing. It thrives in concert. It is the first shout that is difficult for the preacher to arouse. After that one they are likely to sweep like fire over the church. This is easily understood, for the rhythm is increasing with each shouter who communicates his fervor to someone else.

It is absolutely individualistic. While there are general types of shouting, the shouter may mix the different styles to his liking, or he may express himself in some fashion never seen before.

Women shout more frequently than men. This is not surprising since it is generally conceded that women are more emotional than men.

The shouter always receives attention from the church. Members rush to the shouter and force him into a seat or support him as the case might be. Sometimes it is necessary to restrain him to prevent injury to either the shouter or the persons sitting nearest, or both. Sometimes the arms are swung with such violence that others are knocked down. Sometimes in the ecstasy the shouter climbs upon the pew and kicks violently away at all; sometimes in catalepsis he falls heavily upon the floor and might injure himself if not supported, or fall upon others and wound. Often the person injured takes offense, believing that the shouter was paying off a grudge. Unfortunately this is the case at times, but it is not usual.

There are two main types of shouters: (1) Silent ; (2) Vocal. There is a sort of intermediary type where one stage is silent and the other vocal.

The silent type take with violent retching and twitching motions. Sometimes they remain seated, sometimes they jump up and down and fling the body about with great violence. Lips tightly pursed, eyes closed. The seizure ends by collapse.

The vocal type is the more frequent. There are all gradations from quiet weeping while seated, to the unrestrained screaming while leaping pews and running up and down the aisle. Some, unless restrained, run up into the pulpit and embrace the preacher. Some are taken with hysterical laughing spells.

The cases will illustrate the variations.

(1) During sermon. Cried " well, well," six times. Violent action for forty seconds. Collapsed and restored to her seat by members.

34

(2) During chant. Cried " Holy, holy! Great God A'mighty! " Arose and fell in cataleptic fit backwards over pew. Flinging of arms with clenched fists, gradually subsiding to quiet collapse. Total time: two minutes.

(3) During pre-prayer humming chant. Short screams. Violent throwing of arms. Incoherent speech. Total time: one minute thirty seconds.

(4) During sermon. One violent shout as she stood erect: two seconds. Voiceless gestures for twenty-nine seconds. She suddenly resumed her seat and her attention to the words of the preacher.

(5) During sermon. One single loud scream: one and one-half seconds.

(6) During singing. Violent jumping up and down without voice. Pocket book cast away. Time: one minute forty seconds.

(7) During prayer. Screaming: one second. Violent shoulder-shaking, hat discarded: nineteen seconds.

(8) During sermon. Cataleptic. Stiffly back over the pew. Violent but voiceless for twenty seconds. Then arms stiff and outstretched, palms open stark and up. Collapse. Time: three minutes.

(9) During sermon. Young girl. Running up and down the aisle: thirty seconds. Then silence and rush to the pulpit: fourteen seconds; prevented at the altar rail by deacon. Collapse in the deacon's arms and returned to seat. Total time: one minute fifteen seconds.

(10) During chant after prayer. Violent screams: twelve seconds. Scrambles upon pew and steps upon the back of pew still screaming: five seconds. Voiceless struggle with set teeth as three men attempt to restore her to seat. She is lifted horizontal but continues struggle: one minute forty-eight seconds. Decreasing violence, making ferocious faces: two minutes. Calm with heavy breathing: twenty-one seconds.

(11) During sermon. Man quietly weeping: nineteen seconds. Cried " Lawd! My soul is burning with hallow-ed fire! " Rises and turns round and round six times. Carried outside by the deacons.

(12) During sermon. Man jumping wildly up and down flat-footed crying " Hallelujah! ": twenty-two seconds. Pulled back into his seat. Muscular twitching: one minute thirty-five seconds. Quiet weeping: one minute. Perfect calm.

The Sermon

as heard by ZORA NEALE HURSTON from

C. C. LOVELACE, AT EAU GALLIE IN FLORIDA, MAY 3, 1929

INTRODUCTION (*spoken*)

" Our theme this morning is the wounds of Jesus. When the Father shall ast, ' What are these wounds in thine hand? ' He shall answer, ' Those are they with which I was wounded in the house of my friends.' (Zach. xiii. 6.)

" We read in the 53rd Chapter of Isaiah where He was wounded for our transgressions and bruised for our iniquities; and the apostle Peter affirms that His blood was spilt from before the foundation of the world.

" I have seen gamblers wounded. I have seen desperadoes wounded; thieves and robbers and every other kind of characters, law-breakers, and each one had a reason for his wounds. Some of them was unthoughtful, and some for being overbearing, some by the doctor's knife. But all wounds disfigures a person.

" Jesus was not unthoughtful. He was not overbearing. He was never a bully. He was never sick. He was never a criminal before the law and yet He was wounded. Now a man usually gets wounded in the midst of his enemies; but this man was wounded, says the text, in the house of His friends. It is not your enemies that harm you all the time. Watch that close friend. Every believer in Christ is considered His friend, and every sin we commit is a wound to Jesus. The blues we play in our homes is a club to beat up Jesus; and these social card parties . . ."

35

The Sermon

THE SERMON

Jesus have always loved us from the foundation of the world.
When God
Stood out on the apex of His power
Before the hammers of creation
Fell upon the anvils of Time and hammered out the ribs of the earth
Before He made ropes
By the breath of fire
And set the bounderies of the ocean by gravity of His power
When God said, ha!
Let us make man
And the elders upon the altar cried, ha!
If you make man, ha!
He will sin.
God my master, ha!
Christ, yo' friend said
Father!! Ha-aa!
I am the teeth of Time
That comprehended de dust of de earth
And weighed de hills in scales
Painted de rainbow dat marks de end of de departing storm
Measured de seas in de holler of my hand
Held de elements in a unbroken chain of controllment.
Make man, ha!
If he sin, I will redeem him
I'll break de chasm of hell
Where de fire's never quenched
I'll go into de grave
Where de worm never dies, Ah!
So God A'mighty, ha!
Got His stuff together
He dipped some water out of de mighty deep
He got Him a handful of dirt, ha!
From de foundation sills of de earth
He seized a thimble full of breath, ha!
From de drums of de wind, ha!
God my master!
Now I'm ready to make man
Aa-aah!
Who shall I make him after? Ha!
Worlds within worlds begin to wheel and roll
De Sun, Ah!
Gethered up de fiery skirts of her garments
And wheeled around de throne, Ah!
Saying, Ah, make man after me, Ah!
God gazed upon the sun
And sent her back to her blood-red socket
And shook His head, ha!
De Moon, Ha!
Grabbed up de reins of de tides
And dragged a thousand seas behind her
As she walked around de throne—
Ah-h, please make man after me
But God said, No.
De stars bust out from their diamond sockets
And circled de glitterin throne cryin
A-aah! Make man after me
God said, No!
I'll make man in my own image, ha!

36

The Sermon

I'll put him in de garden
And Jesus said, ha!
And if he sin,
I'll go his bond before yo mighty throne
Ah, He was yo friend
He made us all, ha!
Delegates to de judgement convention
Ah!
Faith hasnt got no eyes, but she's long-legged
But take de spy-glass of Faith
And look into dat upper room
When you are alone to yourself
When yo' heart is burnt with fire, ha!
When de blood is lopin thru yo veins
Like de iron monasters (monsters) on de rail
Look into dat upper chamber, ha!
We notice at de supper table
As He gazed upon His friends, ha!
His eyes flowin wid tears, ha!
" My soul is exceedingly sorrowful unto death, ha!
For this night, ha!
One of you shall betray me, ha!
It were not a Roman officer, ha!
It were not a centurion soldier
But one of you
Who I have choosen my bosom friend
That sops in the dish w th me shall betray me."
I want to draw a parable.
I see Jesus
Leaving heben with all of His grandeur
Disrobin Hisself of His matchless honor
Yieldin up de sceptre of revolvin worlds
Clothing Hisself in de garment of humanity
Coming into de world to rescue His friends.
Two thousand years have went by on their rusty ankles
But with the eye of faith I can see Him
Look down from His high towers of elevation
I can hear Him when He walks about the golden streets
I can hear 'em ring under his footsteps
Sol me-e-e, Sol do
Sol me-e-e, Sol do
I can see Him step out upon the rim bones of nothing
Crying I am de way
De truth and de light
Ah!
God A'mighty!
I see Him grab de throttle
Of de well ordered train of mercy
I see kingdoms crush and crumble
Whilst de arc angels held de winds in de corner chambers
I see Him arrive on dis earth
And walk de streets thirty and three years
Oh-h-hhh!
I see Him walking beside de sea of Galilee wid His disciples
This declaration gendered on His lips
" Let us go on the other side "
God A'mighty!
Dey entered de boat
Wid their oarus (oars) stuck in de back
Sails unfurled to de evenin breeze
And de ship was now sailin

The Sermon

As she reached de center of de lake
Jesus was 'sleep on a pillow in de rear of de boat
And de dynamic powers of nature become disturbed
And de mad winds broke de heads of de western drums
And fell down on de Lake of Galilee
And buried themselves behind de gallopin waves
And de white-caps marbilized themselves like an army
And walked out like soldiers goin to battle
And de ziz-zag lightning
Licked out her fiery tongue
And de flying clouds
Threw their wings in the channels of the deep
And bedded de waters like a road-plow
And faced de current of de chargin billows
And de terrific bolts of thunder—they bust in de clouds
And de ship begin to reel and rock
God A'mighty!
And one of de disciples called Jesus
" Master!! Carest thou not that we perish? "
And He arose
And de storm was in its pitch
And de lightnin played on His raiments as He stood on the prow of the boat
And placed His foot upon the neck of the storm
And spoke to the howlin winds
And de sea fell at His feet like a marble floor
And de thunders went back in their vault
Then He set down on de rim of de ship
And took de hooks of his power
And lifted de billows in His lap
And rocked de winds to sleep on His arm
And said, " Peace be still."
And de Bible says there was a calm.
I can see Him wid de eye of faith
When He went from Pilate's house
Wid the crown of 72 wounds upon His head
I can see Him as He mounted Calvary and hung upon de cross for our sins.
I can see-eee-ee
De mountains fall to their rocky knees when He cried
" My God, my God! Why hast thou forsaken me? "
The mountains fell to their rocky knees and trembled like a beast
From the stroke of the master's axe
One angel took the flinches of God's eternal power
And bled the veins of the earth
One angel that stood at the gate with a flaming sword
Was so well pleased with his power
Until he pierced the moon with his sword
And she ran down in blood
And de sun
Batted her fiery eyes and put on her judgement robe
And laid down in de cradle of eternity
And rocked herself into sleep and slumber.
He died until the great belt in the wheel of time
And de geological strata fell aloose
And a thousand angels rushed to de canopy of heben
With flamin swords in their hands
And placed their feet upon blue ether's bosom and looked back at de dazzlin throne
And de arc angels had veiled their faces
And de throne was draped in mournin
And de orchestra had struck silence for the space of half an hour
Angels had lifted their harps to de weepin willows
And God had looked off to-wards immensity

38

The Sermon

And blazin worlds fell off His teeth
And about that time Jesus groaned on de cross and said, " It is finished "
And then de chambers of hell explode
And de damnable spirits
Come up from de Sodomistic world and rushed into de smoky camps of eternal night
And cried " Woe! Woe! Woe! "
And then de Centurion cried out
" Surely this 's the Son of God."
And about dat time
De angel of Justice unsheathed his flamin sword and ripped de veil of de temple
And de High Priest vacated his office
And then de sacrificial energy penetrated de mighty strata
And quickened de bones of de prophets
And they arose from their graves and walked about in de streets of Jerusalem.
I heard de whistle of de damnation train
Dat pulled out from Garden of Eden loaded wid cargo goin to hell
Ran at break-neck speed all de way thru de law
All de way thru de prophetic age
All de way thru de reign of kings and judges—
Plowed her way thru de Jurdan
And on her way to Calvary when she blew for de switch
Jesus stood out on her track like a rough-backed mountain
And she threw her cow-catcher in His side and His blood ditched de train,
He died for our sins.
Wounded in the house of His friends.
Thats where I got off de damnation train
And dats where you must get off, ha!
For in dat mor-ornin', ha!
When we shall all be delegates, ha!
To dat judgement convention, ha!
When de two trains of Time shall meet on de trestle
And wreck de burning axles of de unformed ether
And de mountains shall skip like lambs
When Jesus shall place one foot on de neck of de sea, ha!
One foot on dry land
When His chariot wheels shall be running hub-deep in fire
He shall take His friends thru the open bosom of a unclouded sky
And place in their hands de hosanna fan
And they shall stand round and round His beatific throne
And praise His name forever.

Amen.

Mother Catherine

by ZORA NEALE HURSTON

ONE must go straight out St. Claude below the Industrial Canal and turn south on Flood Street and go almost to the Florida Walk. Looking to the right one sees a large enclosure walled round with a high board fence. A half-dozen flags fly bravely from eminences. A Greek cross tops the chapel. A large American flag flies from the huge tent.

A marsh lies between Flood Street and that flag-flying enclosure, and one must walk. As one approaches, the personality of the place comes out to meet one. No ordinary person created this thing.

At the gate there is a rusty wire sticking out through a hole. That is the bell. But a painted notice on the gate itself reads : " Mother Seal is a holy spirit and must not be disturbed."

One does not go straight into the tent, into the presence of Mother Catherine (Mother Seal). One is conducted into the chapel to pray until the spirit tells her to send for you. A place of barbaric splendor,

39

of banners, of embroideries, of images bought and images created by Mother Catherine herself; of an altar glittering with polished brass and kerosene lamps. There are 356 lamps in this building, but not all are upon the main altar.

The walls and ceilings are decorated throughout in red, white and blue. The ceiling and floor in the room of the Sacred Heart are striped in three colors and the walls are panelled. The panels contain a snake design. This is not due to Hoodoo influence but to African background. I note that the African loves to depict the grace of reptiles.

On a placard: *Speak so you can speak again.*

It would take a volume to describe in detail all of the things in and about this chapel under its Greek cross. But we are summoned by a white-robed saint to the presence.

Mother Catherine holds court in the huge tent. On a raised platform is her bed, a piano, instruments for a ten-piece orchestra, a huge coffee urn, a wood stove, a heater, chairs and rockers and tables. Backless benches fill the tent.

Catherine of Russia could not have been more impressive upon her throne than was this black Catherine sitting upon an ordinary chair at the edge of the platform within the entrance to the tent. Her face and manner are impressive. There is nothing cheap and theatrical about her. She does things and arranges her dwelling as no occidental would. But it is not for effect. It is for feeling. She might have been the matriarchal ruler of some nomad tribe as she sat there with the blue band about her head like a coronet; a white robe and a gorgeous red cape falling away from her broad shoulders, and the box of shaker salt in her hand like a rod of office. I know this reads incongruous, but it did not look so. It seemed perfectly natural for me to go to my knees upon the gravel floor, and when she signalled to me to extend my right hand, palm up for the dab of blessed salt, I hurried to obey because she made me feel that way.

She laid her hand upon my head.

" Daughter, why have you come here? "

" Mother, I come seeking knowledge."

"Thank God. Do y'all hear her? She come here lookin for wisdom. Eat de salt, daughter, and get yo mind with God and me. You shall know what you come to find out. I feel you. I felt you while you was sittin in de chapel. Bring her a veil."

The veil was brought and with a fervent prayer placed upon my head. I did not tell Mother then that I wanted to write about her. That came much later, after many visits. When I did speak of it she was very gracious and let me photograph her and everything behind the walls of her manger.

I spent two weeks with her, and attended nightly and Sunday services continuously at her tent. Nothing was usual about these meetings. She invariably feeds the gathering. Good, substantial food too. At the Sunday service the big coffee urn was humming, and at a certain point she blessed bread and broke it, and sprinkled on a bit of salt. This she gave to everyone present. To the adults she also gave a cup of coffee. Every cup was personally drawn, sweetened and tasted by her and handed to the communicants as they passed before the platform. At one point she would command everyone to file past the painted barrel and take a glass of water. These things had no inner meaning to an agnostic, but it did drive the dull monotony of the usual Christian service away. It was something, too, to watch the faith it aroused in her followers.

All during her sermons two parrots were crying from their cages. A white cockatoo would scream when the shouting grew loud. Three canary birds were singing and chirping happily all through the service. Four mongrel dogs strolled about. A donkey, a mother goat with her kid, numbers of hens, a sheep—all wandered in and out of the service without seeming out of place. A Methodist or Baptist church—or one of any denomination whatever—would have been demoralised by any one of these animals. Two dogs fought for a place beside the heater. Three children under three years of age played on the platform in the rear without distracting the speaker or the audience. The blue and red robed saint stood immobile in her place directly behind the speaker and the world moved on.

Unlike most religious dictators Mother Catherine does not crush the individual. She encourages originality. There is an air of gaiety about the enclosure. All of the animals are treated with tenderness.

No money is ever solicited within the enclosure of the Manger. If you feel to give, you may. Mother wears a pouch suspended from her girdle. You may approach the platform at any time and drop your contribution in. But you will be just as welcome if you have nothing. All of the persons who live at the Manger are there at Mother Catherine's expense. She encourages music and sees that her juveniles get off to school on time.

Mother Catherine

There is a catholic flavor about the place, but it is certainly not catholic. She has taken from all the religions she knows anything about any feature that pleases her.

Hear Mother Seal: " Good evening, Veils and Banners!

" God tells me to tell you (*invariable opening*) that He holds the world in the middle of His hand.

" There is no hell beneath this earth. God wouldn't build a hell to burn His breath.

" There is no heaven beyond dat blue globe. There is a between-world between this brown earth and the blue above. So says the beautiful spirit.

" When we die, where does the breath go? Into trees and grass and animals. Your flesh goes back to mortal earth to fertilise it. So says the beautiful spirit.

" Our brains is trying to make something out of us. Everybody can be something good.

" It is right that a woman should lead. A womb was what God made in the beginning, and out of that womb was born Time, and all that fills up space. So says the beautiful spirit.

" Some are weak to do wisdom things, but strong to do wicked things.

" He could have been born in the biggest White House in the world. But the reason He didn't is that He knowed a falling race was coming what couldn't get to no great White House, so He got born so my people could all reach.

" God is just as satisfied with the damnation of men as He is with their salvation. So says the beautiful spirit.

" It is not for people to know the whence.

" Don't teach what the apostles and the prophets say. Go to the tree and get the pure sap and find out whether they were right.

" No man has seen spirit—men can see what spirit does, but no man can see spirit."

As she was ready to grant blessings an evil thought reached her and she sat suddenly on a chair and covered her face with her hands, explaining why she did so. When it passed she rose, " Now I will teach you again."

Here the food was offered up but not distributed until the call came from the spirit.

St. Prompt Succor brought the basin and towel at a signal. She washed her hands and face.

It is evident that Mother Seal takes her stand as an equal with Christ.

No nailing or building is done on Friday. A carpenter may saw or measure, but no nailing or joining.

She heals by the laying on of hands, by suggestion and copious doses of castor oil and Epsom salts. She heals in the tent and at great distances. She has blessed water in the barrel for her followers, but she feels her divinity to such an extent that she blesses the water in the hydrants at the homes of her followers without moving out of her tent.

No one may cross his legs within the Manger. That is an insult to the spirit.

Mother Catherine's conception of the divinity of Christ is that Joseph was his foster father as all men are foster fathers, in that all children are of God and all fathers are merely the means.

All of her followers wear her insignia. The women wear a veil of unbleached muslin; the men, an arm-band. All bear the crescent and M.C.S. (Mother Catherine's Saints). They must be worn everywhere.

In late February and early March it rained heavily and many feared a flood. Mother Seal exhorted all of her followers to pin their faith in her. All they need do is believe in her and come to her and eat the blessed fish she cooked for them and there would be no flood. " God," she said, " put oars in the fishes' hands. Eat this fish and you needn't fear the flood no more than a fish would."

All sympathetic magic. Chicken, beef, lamb are animals of pleasing blood. They are used abundantly as food and often in healing. A freshly killed chicken was split open and bound to a sore leg.

All of her followers, white and colored, are her children. She has as many of one race as the other.

" I got all kinds of children, but I am they mother. Some of 'em are saints; some of 'em are conzempts (convicts) and jailbirds; some of 'em kills babies in their bodies; some of 'em walks the streets at night—but they's all my children. God got all kinds, how come I cain't love all of mine? So says the beautiful spirit."

" Now y'all go home in faith. I'm going to appear to you all in three days. Don't doubt me. Go home in faith and pray."

There is a period in the service given over to experiences.

One woman had a vision. She saw a flash of lightning on the wall. It wrote, " Go to Mother Seal." She came with pus on the kidneys and was healed.

A girl of fourteen had a vision of a field of spinach that turned to lilies with one large lily in the middle. The field was her church and the large lily was Mother Catherine.

Most of the testimony has to do with acknowledging that they have been healed by Mother's power, or relating how the wishes they made on Mother came true.

Mother Catherine's religion is matriarchal. Only God and the mother count. Childbirth is the most important element in the creed. Her compound is called the Manger, and is dedicated to the birth of children in or out of wedlock.

Over and over she lauds the bringing forth. *There is no sinful birth.* And the woman who avoids it by abortion is called a " damnable extrate."

Mother Catherine was not converted by anyone. Like Christ, Mohammed, Buddha, the call just came. No one stands between her and God.

After the call she consecrated her body by refraining from the sex relation, and by fasting and prayer.

She was married at the time. Her husband prayed two weeks before he was converted to her faith. Whereupon she baptised him in a tub in the backyard. They lived together six months as a holy man and woman before the call of the flesh made him elope with one of her followers.

She held her meetings first on Jackson Avenue, but the crowds that swarmed about her made the authorities harry her. So some of her wealthy followers bought the tract of land below the Industrial Canal where the Manger now is.

God sent her into the Manger over a twelve-foot board fence—not through a gate. She must set no time for her going but when the spirit gave the word. After her descent through the roof of the chapel she has never left the grounds but once, and that was not intentional. She was learning to drive a car within the enclosure. It got out of control and tore a hole through the fence before it stopped. She called to her followers to " Come git me ! " (She must not set her foot on the unhallowed ground outside the Manger.) They came and reverently lifted her and bore her back inside. The spot in the yard upon which she was set down became sacred, for a voice spoke as her feet touched the ground and said, " Put down here the Pool of Gethsemane so that the believers may have holy water to drink." The well is under construction at this writing.

Uncle Monday

by ZORA NEALE HURSTON

PEOPLE talk a whole lot about Uncle Monday, but they take good pains not to let him hear none of it. Uncle Monday is an out-and-out conjure doctor. That in itself is enough to make the people handle him carefully, but there is something about him that goes past hoodoo. Nobody knows anything about him, and that's a serious matter in a village of less than three hundred souls, especially when a person has lived there for forty years and more.

Nobody knows where he came from nor who his folks might be. Nobody knows for certain just when he did come to town. He was just there one morning when the town awoke. Joe Lindsay was the first to see him. He had some turtle lines set down on Lake Belle. It is a hard lake to fish because it is entirely surrounded by a sooky marsh that is full of leeches and moccasins. There is plenty of deep water once you pole a boat out beyond the line of cypress pines, but there are so many alligators out there that most people don't think the trout are worth the risk. But Joe had baited some turtle lines and thrown them as far as he could without wading into the marsh. So next morning he went as early as he could see light to look after his lines. There was a turtle head on every line, and he pulled them up cursing the 'gators for robbing his hooks. He says he started on back home, but when he was a few yards from where his lines had been set something made him look back, and he nearly fell dead. For there was an old man walking out of the lake between two cypress knees. The water there was too deep for any wading, and besides, he says the man was not wading, he was walking vigorously as if he were on dry land.

42

Uncle Monday

Lindsay says he was too scared to stand there and let the man catch up with him, and he was too scared to move his feet; so he just stood there and saw the man cross the marshy strip and come down the path behind him. He says he felt the hair rise on his head as the man got closer to him, and somehow he thought about an alligator slipping up on him. But he says that alligators were in the front of his mind that morning because first, he had heard bull 'gators fighting and bellowing all night long down in this lake, and then his turtle lines had been robbed. Besides, everybody knows that the father of all 'gators lives in Belle Lake.

The old man was coming straight on, taking short quick steps as if his legs were not long enough for his body, and working his arms in unison. Lindsay says it was all he could do to stand his ground and not let the man see how scared he was, but he managed to stand still anyway. The man came up to him and passed him without looking at him seemingly. After he had passed, Lindsay noticed that his clothes were perfectly dry, so he decided that his own eyes had fooled him. The old man must have come up to the cypress knees in a boat and then crossed the marsh by stepping from root to root. But when he went to look, he found no convenient roots for anybody to step on. Moreover, there was no boat on the lake either.

The old man looked queer to everybody, but still no one would believe Lindsay's story. They said that he had seen no more than several others—that is, that the old man had been seen coming from the direction of the lake. That was the first that the village saw of him, way back in the late 'eighties, and so far, nobody knows any more about his past than that. And that worries the town.

Another thing that struck everybody unpleasantly was the fact that he never asked a name nor a direction. Just seemed to know who everybody was, and called each and every one by their right name. Knew where everybody lived too. Didn't earn a living by any of the village methods. He didn't garden, hunt, fish, nor work for the white folks. Stayed so close in the little shack that he had built for himself that sometimes three weeks would pass before the town saw him from one appearance to another.

Joe Clarke was the one who found out his name was Monday. No other name. So the town soon was calling him Uncle Monday. Nobody can say exactly how it came to be known that he was a hoodoo man. But it turned out that that was what he was. People said he was a good one too. As much as they feared him, he had plenty of trade. Didn't take him long to take all the important cases away from Ant Judy, who had had a monopoly for years.

He looked very old when he came to the town. Very old, but firm and strong. Never complained of illness.

But once, Emma Lou Pittman went over to his shack early in the morning to see him on business, and ran back with a fearsome tale. She said that she noticed a heavy trail up to his door and across the steps, as if a heavy, bloody body had been dragged inside. The door was cracked a little and she could hear a great growling and snapping of mighty jaws. It wasn't exactly a growling either, it was more a subdued howl in a bass tone. She shoved the door a little and peeped inside to see if some varmint was in there attacking Uncle Monday. She figured he might have gone to sleep with the door ajar and a catamount, or a panther, or a bob-cat might have gotten in. He lived near enough to Blue Sink Lake for a 'gator to have come in the house, but she didn't remember ever hearing of them tracking anything but dogs.

But no; no varmint was inside there. The noise she heard was being made by Uncle Monday. He was lying on a pallet of pine-straw in such agony that his eyes were glazed over. His right arm was horribly mangled. In fact, it was all but torn away from right below the elbow. The side of his face was terribly torn too. She called him, but he didn't seem to hear her. So she hurried back for some men to come and do something for him. The men came as fast as their legs would bring them, but the house was locked from the outside and there was no answer to their knocking. Mrs. Pittman would have been made out an awful liar if it were not for the trail of blood. So they concluded that Uncle Monday had gotten hurt somehow and had dragged himself home, or had been dragged by a friend. But who could the friend have been?

Nobody saw Uncle Monday for a month after that. Every day or so, someone would drop by to see if hide or hair could be found of him. A full month passed before there was any news. The town had about decided that he had gone away as mysteriously as he had come.

But one evening around dusk-dark Sam Merchant and Jim Gooden were on their way home from a squirrel hunt around Lake Belle. They swore that, as they rounded the lake and approached the footpath that leads towards the village, they saw what they thought was the great 'gator that lives in the lake

Uncle Monday

crawl out of the marsh. Merchant wanted to take a shot at him for his hide and teeth, but Gooden reminded him that they were loaded with bird shot, which would not even penetrate a 'gator's hide, let alone kill it. They say the thing they took for the 'gator then struggled awhile, pulling off something that looked like a long black glove. Then he scraped a hole in the soft ground with his paws and carefully buried the glove which had come from his right paw. Then without looking either right or left, he stood upright and walked on towards the village. Everybody saw Uncle Monday come thru the town, but still Merchant's tale was hard to swallow. But, by degrees, people came to believe that Uncle Monday could shed any injured member of his body and grow a new one in its place. At any rate, when he reappeared his right hand and arm bore no scars.

The village is even sceptical about his dying. Once Joe Clarke said to Uncle Monday, " I'god, Uncle Monday, aint you skeered to stay way off by yo'self, old as you is ? "

Uncle Monday asked, " Why would I be skeered ? "

" Well, you liable to take sick in de night sometime, and you'd be dead befo' anybody would know you was even sick."

Uncle Monday got up off the nail keg and said in a voice so low that only the men right close to him could hear what he said, " I have been dead for many a year. I have come back from where you are going." Then he walked away with his quick short steps, and his arms bent at the elbow, keeping time with his feet.

It is believed that he has the singing stone, which is the greatest charm, the most powerful " hand " in the world. It is a diamond and comes from the mouth of a serpent (which is thought of as something different from an ordinary snake) and is the diamond of diamonds. It not only lights your home without the help of any other light, but it also warns its owner of approach.

The serpents who produce these stones live in the deep waters of Lake Maitland. There is a small island in this lake and a rare plant grows there, which is the only food of this serpent. She only comes to nourish herself in the height of a violent thunderstorm, when she is fairly certain that no human will be present.

It is impossible to kill or capture her unless nine healthy people have gone before to prepare the way with THE OLD ONES, and then more will die in the attempt to conquer her. But it is not necessary to kill or take her to get the stone. She has two. One is embedded in her head, and the other she carries in her mouth. The first one cannot be had without killing the serpent, but the second one may be won from her by trickery.

Since she carries this stone in her mouth, she cannot eat until she has put it down. It is her pilot, that warns her of danger. So when she comes upon the island to feed, she always vomits the stone and covers it with earth before she goes to the other side of the island to dine.

To get this diamond, dress yourself all over in black velvet. Your assistant must be dressed in the same way. Have a velvet-covered bowl along. Be on the island before the storm reaches its height, but leave your helper in the boat and warn him to be ready to pick you up and flee at a moment's notice.

Climb a tall tree and wait for the coming of the snake. When she comes out of the water, she will look all about her on the ground to see if anyone is about. When she is satisfied that she is alone, she will vomit the stone, cover it with dirt and proceed to her feeding ground. Then, as soon as you feel certain that she is busy eating, climb down the tree as swiftly as possible, cover the mound hiding the stone with the velvet-lined bowl and flee for your life to the boat. The boatman must fly from the island with all possible speed. For as soon as you approach the stone it will ring like chiming bells, and the serpent will hear it. Then she will run to defend it. She will return to the spot, but the velvet-lined bowl will make it invisible to her. In her wrath she will knock down grown trees and lash the island like a hurricane. Wait till a calm fair day to return for the stone. She never comes up from the bottom of the lake in fair weather. Furthermore, a serpent who has lost her mouth-stone cannot come to feed alone after that. She must bring her mate. The mouth-stone is their guardian, and when they lose it they remain in constant danger unless accompanied by one who has the singing stone.

They say that Uncle Monday has a singing stone, and that is why he knows everything without being told.

Whether he has the stone or not, nobody thinks of doubting his power as a hoodoo man. He is feared, but sought when life becomes too powerful for the powerless. Mary Ella Shaw backed out on Joe-Nathan Moss the day before the wedding was to have come off. Joe-Nathan had even furnished the house and bought rations. His people, her people, everybody tried to make her marry the boy. He loved

Uncle Monday

her so, and besides he had put out so much of his little cash to fix for the marriage. But Mary Ella just wouldn't. She had seen Caddie Brewton, and she was one of the kind who couldn't keep her heart still after her eye had wandered.

So Joe-Nathan's mama went to see Uncle Monday. He said, " Since she is the kind of woman that lets her mind follow her eye, we'll have to let the snake-bite cure itself. You go on home. Never no man will keep her. She kin grab the world full of men, but she'll never keep one any longer than from one full moon to the other."

Fifteen years have passed. Mary Ella has been married four times. She was a very pretty girl, and men just kept coming, but not one man has ever stayed with her longer than the twenty-eight days. Besides her four husbands, no telling how many men she has shacked up with for a few weeks at a time. She has eight children by as many different men, but still no husband.

John Wesley Hogan was another driver of sharp bargains in love. By his own testimony and experience, all women from eight to eighty were his meat, but the woman who was sharp enough to make him marry her wasn't born and her mama was dead. They couldn't frame him and they couldn't scare him.

Mrs. Bradley came to him nevertheless about her Dinkie. She called him out from his work-place and said, " John Wesley, you know I'm a widder-woman and I aint got no husband to go to de front for me, so I reckon I got to do de talkin' for me and my chile. I come in de humblest way I know how to ast you to go 'head and marry my chile befo' her name is painted on de signposts of scorn."

If it had not made John Wesley so mad, it would have been funny to him. So he asked her scornfully, " 'Oman, whut you take me for? You better git outa my face wid dat mess! How you reckon *I* know who Dinkie been foolin roun wid? Don't try to come dat mess over *me*. I been all over de North. I aint none of yo' fool. You must think I'm Big Boy. They kilt Big Boy shootin after Fat Sam so there aint no mo' fools in de world. Ha, ha! All de wimmen *I* done seen! I'll tell you like de monkey tole de elephant—don't bull me, big boy! If you want Dinkie to git married off so bad, go grab one of dese country clowns. I aint yo' man. Taint no use you goin runnin to de high-sheriff neither. I got witness to prove Dinkie knowed more'n I do."

Mrs. Bradley didn't bother with the sheriff. All he could do was to make John Wesley marry Dinkie; but by the time the interview was over that wasn't what the stricken mother wanted. So she waited till dark, and went on over to Uncle Monday.

Everybody says you don't have to explain things to Uncle Monday. Just go there, and you will find that he is ready for you when you arrive. So he set Mrs. Bradley down at a table, facing a huge mirror hung against the wall. She says he had a loaded pistol and a huge dirk lying on the table before her. She looked at both of the weapons, but she could not decide which one she wanted to use. Without a word, he handed her a gourd full of water and she took a swallow. As soon as the water passed over her tongue she seized the gun. He pointed towards the looking-glass. Slowly the form of John Wesley formed in the glass and finally stood as vivid as life before her. She took careful aim and fired. She was amazed that the mirror did not shatter. But there was a loud report, a cloud of bluish smoke and the figure vanished.

On the way home, Brazzle told her that John Wesley had dropped dead, and Mr. Watson had promised to drive over to Orlando in the morning to get a coffin for him.

ANT JUDY BICKERSTAFF

Uncle Monday wasn't the only hoodoo doctor around there. There was Ant Judy Bickerstaff. She was there before the coming of Uncle Monday. Of course it didn't take long for professional jealousy to arise. Uncle Monday didn't seem to mind Ant Judy, but she resented him, and she couldn't hide her feelings.

This was natural when you consider that before his coming she used to make all the " hands " around there, but he soon drew off the greater part of the trade.

Year after year this feeling kept up. Every now and then some little incident would accentuate the rivalry. Monday was sitting on top of the heap, but Judy was not without her triumphs.

Finally she began to say that she could reverse anything that he put down. She said she could not only reverse it, she could throw it back on *him*, let alone his client. Nobody talked to him about her boasts. People never talked to him except on business anyway. Perhaps Judy felt safe in her boasting for this reason.

Then one day she took it in her head to go fishing. Her children and grandchildren tried to discourage

45

her. They argued with her about her great age and her stiff joints. But she had her grandson to fix her a trout pole and a bait pole and set out for Blue Sink, a lake said to be bottomless by the villagers. Furthermore, she didn't set out till near sundown. She didn't want any company. It was no use talking, she felt that she just must go fishing in Blue Sink.

She didn't come home when dark came, and her family worried a little. But they reasoned she had probably stopped at one of her friend's houses to rest and gossip, so they didn't go to hunt her right away. But when the night wore on and she didn't return, the children were sent out to locate her.

She was not in the village. A party was organised to search Blue Sink for her. It was after nine o'clock at night when the party found her. She was in the lake. Lying in shallow water and keeping her old head above the water by supporting it on her elbow. Her son Ned said that he saw a huge alligator dive away as he shined the torch upon his mother's head.

They bore Ant Judy home and did everything they could for her. Her legs were limp and useless and she never spoke a word, not a coherent word, for three days. It was more than a week before she could tell how she came to be in the lake.

She said that she hadn't really wanted to go fishing. The family and the village could witness that she never had fooled round the lakes. But that afternoon she *had* to go. She couldn't say why, but she knew she must go. She baited her hooks and stood waiting for a bite. She was afraid to sit down on the damp ground on account of her rheumatism. She got no bites. When she saw the sun setting she wanted to come home, but somehow she just couldn't leave the spot. She was afraid, terribly afraid down there on the lake, but she couldn't leave.

When the sun was finally gone and it got dark, she says she felt a threatening, powerful evil all around her. She was fixed to the spot. A small but powerful whirlwind arose right under her feet. Something terrific struck her and she fell into the water. She tried to climb out, but found that she could not use her legs. She thought of 'gators and otters, and leeches and gar-fish, and began to scream, thinking maybe somebody would hear her and come to her aid.

Suddenly a bar of red light fell across the lake from one side to the other. It looked like a fiery sword. Then she saw Uncle Monday walking across the lake to her along this flaming path. On either side of the red road swam thousands of alligators, like an army behind its general.

The light itself was awful. It was red, but she never had seen any red like it before. It jumped and moved all the time, but always it pointed straight across the lake to where she lay helpless in the water. The lake is nearly a mile wide, but Ant Judy says Uncle Monday crossed it in less than a minute and stood over her. She closed her eyes from fright, but she saw him right on thru her lids.

After a brief second she screamed again. Then he growled and leaped at her. " Shut up ! " he snarled. " Part your lips just one more time and it will be your last breath ! Your bragging tongue has brought you here and you are going to stay here until you acknowledge my power. So you can throw back my work, eh ? I put you in this lake ; show your power and get out. You will not die, and you will not leave this spot until you give consent in your heart that I am your master. Help will come the minute you knuckle under."

She fought against him. She felt that once she was before her own altar she could show him something. He glowered down upon her for a spell and then turned and went back across the lake the way he had come. The light vanished behind his feet. Then a huge alligator slid up beside her where she lay trembling and all her strength went out of her. She lost all confidence in her powers. She began to feel if only she might either die or escape from the horror, she would never touch another charm again. If only she could escape the maw of the monster beside her ! Any other death but that. She wished that Uncle Monday would come back so that she might plead with him for deliverance. She opened her mouth to call, but found that speech had left her. But she saw a light approaching by land. It was the rescue party.

Ant Judy never did regain the full use of her legs, but she got to the place where she could hobble about the house and yard. After relating her adventure on Lake Blue Sink she never called the name of Uncle Monday again.

The rest of the village, always careful in that respect, grew almost as careful as she. But sometimes when they would hear the great bull 'gator, that everybody knows lives in Lake Belle, bellowing on cloudy nights, some will point the thumb in the general direction of Uncle Monday's house and whisper, " The Old Boy is visiting the home folks tonight."

Harlem Reviewed

by NANCY CUNARD

Is it possible to give any kind of visual idea of a place by description? I think not, least of all of Harlem. When I first saw it, at 7th Avenue, I thought of the Mile End Road—same long vista, same kind of little low houses with, at first sight, many indeterminate things out on the pavement in front of them, same amount of blowing dust, papers, litter. But no; the scale, to begin with, was different. It was only from one point that the resemblance came to one. Beginning at the north end of Central Park, edged in on one side by the rocky hill of Columbia University and on the other by the streets that go to the East River, widening out more and more north to that peculiarly sinister halt in the town, the curve of the Harlem River, where one walks about in the dead junk and the refuse-on-a-grand-scale left in the sudden waste lots that are typical of all parts of New York—this is the area of Harlem. Manhattan and 8th Avenues, 7th, Lenox, 5th and Madison Avenues, they all run up here from the zone of the skyscrapers, the gleaming white and blond towers of down-town that are just visible like a mirage down the Harlem perspective. These avenues, so grand in New York proper, are in Harlem very different. They are old, rattled, some of them, by the El on its iron heights, rattled, some of them, underneath, by the Sub in its thundering groove.

Why is it called Harlem, and why the so-called capital of the Negro world? The Dutch made it first, in the 17th century; it was "white" till as recently as 1900. And then, because it was old and they weren't rebuilding it, because it's a good way from the centre, it was more or less "left" to the coloured people. Before this they lived in different parts of New York; there was no Negro "capital." This capital now exists, with its ghetto-like slums around 5th, bourgeois streets, residential areas, a few aristocratic avenues or sections thereof, white-owned stores and cafeterias, small general shops, and the innumerable "skin-whitening" and "anti-kink" beauty parlors. There is one large modern hotel, the Dewey Square, where coloured people of course may stay; and another, far larger, the Teresa, a few paces from it, where certainly they *may not*! And this is in the centre of Harlem. Such race barriers are on all sides; it just de-

Mr. Ezell Dunford and his beautiful Packhard car. Harlem

pends on chance whether you meet them or no. Some Negro friend maybe will not go into a certain drug-store with you for an ice-cream soda at 108th (where Harlem is supposed to begin, but where it is still largely "white"); "might not get served in there" (and by a coloured server at that—the white boss's orders). Just across the Harlem River some white gentlemen flashing by in a car take it into their heads to bawl, "Can't you get yourself a white man?"—you are walking with a Negro, yet you walk down-town with the same and meet no such hysteria, or again, you do.

In his book, *Black Manhattan*, James Weldon Johnson has made a map of Harlem showing the rapid increase of Negro occupation. This of course cannot be taken otherwise than as percentage, as there are some whites living in all parts of it. The Negro population is always increasing, but the houses do not expand; hence overcrowding in all but the expensive apartments and the middle-class lodgings. These last are pretty similar to our own Bloomsbury kind. And why then do the Negroes continue to flock

47

Harlem Reviewed

to Harlem? Because in most other parts of New York they simply " don't let to coloured," at least never *en masse*. More and more of the " white " streets on the fringes of Harlem " go black " and become part of it. It happens this way. A coloured family or two get houses in such or such a street. Prejudiced white neighbours remonstrate with the landlord, who may not care—the more so as he knows that other coloured families will be wanting to move in. The whites have complained of his houses, demanded repairs. He won't make them, and for Negroes he can *double the rent* (this is invariably so), and no repairs need, or will, ever be made. The Negroes come, up go the rents, and the whites abandon that street. One of the reasons why Harlem is so concentrated is that this procedure takes some time; in housing themselves, as in every single other thing, they have to fight and fight; they are penalised for being black or coloured in every imaginable way, and, to the European, in many unthinkable ones.

Some 350,000 Negroes and coloured are living in Harlem and Brooklyn (the second, and quite distinct, area in greater New York where they have congregated). American Negroes, West Indians, Africans, Latin Americans. The latter, Spanish-speaking, have made a centre round 112th St. and Lenox Avenue. Walk round there and you will hear—it is nearly all Spanish. The tempo of the gestures and gait, the atmosphere, are foreign. It is the Porto-Ricans, the Central Americans and the Cubans. Nationalisms exist, more or less fiercely, between them and the American Negro—as indeed does a jealous national spirit between American Negro and black Jamaican. The latter say they are the better at business, that

A group of Cuban Negroes at Pelham Park, just out of New York, where all races mix on the beach and in the park—that is, more or less, for here too you observe a coloured section filled with whites, but no Negroes in the preponderant white parts

the coloured Americans have no enterprise. (Are we to see here the mantle of the British as a nation of shopkeepers on West Indian shoulders?) The American Negro regards the Jamaican or British West Indian as " less civilised " than himself; jokes about his accent and deportment are constantly made on the Harlem stage. And so they are always at it, falling out about empty " superiorities " and " inferiorities," forgetting the white enemy.

The Jamaican is " a foreigner "—and yet it was Marcus Garvey, from Jamaica, who, more than any living Negro, roused the black people of America just after the war with his " Back to Africa " movement. This sort of Zionism, after a lightning accumulation of millions of dollars, collapsed entirely. " Back to Africa " was held out to all the Negroes in the American continent, a Utopian impossibility at both ends—for how can 12,000,000 transport themselves *en masse*, as Garvey urged them to do, and in what part of Africa would the white imperialists allow such, or even a small part of such, a settlement? Apart from this, the Africans were, not surprisingly, angered by Garvey's self-given title of "Provisional Emperor of Africa." The African country chosen by Garvey was Liberia, which, as is known to everyone, is really an American (Firestone) colony. There is an anomaly now in the position of the Garvey movement. Though he is himself discredited, his followers (and there are several inter-factions too) disavow him but continue to call themselves Garveyites and proclaim his doctrine. Those extraordinary half salvation army, half British military uniforms that you see in the streets occasionally are Garvey's men; you come across them speaking at street corners, holding a large crowd. But it is all hot air. It is not organised in any direction or built on anything solid. Individually they have not the drive of the black Communist orator, for they are not speaking of anything serious; Garvey's theory was " all-black "; he wanted his people to be independent of, to cut away from, the white race entirely. The wrong kind of pride; a race pride which stopped at that, and paid no heed to the very real and concrete misery, oppression and struggles of the Negro toiling millions throughout the States.

If you are " shown " Harlem by day you will inevitably have pointed out to you the new Rockefeller apartments, a huge block towering above a rather sparse and visibly very indigent part of 7th Avenue. These were built by the millionaire of that name, supposedly to better the conditions of Negro workers by providing clean and comfortable lodging for them, but inhabited, however, by those who can afford

48

Harlem Reviewed

to pay their rents. The Y.M.C.A. and the newly built Y.W.C.A.—more institutes for " uplift." The Harlem Public Library, with its good collection of books on Negro matters, and just a few pieces of African art, so few that the idea strikes one vexingly : why, in this capital of the Negro world, is there no centre, however small, of Africanology ? The American Negroes—this is a generalisation with hardly any exceptions—are utterly uninterested in, callous to what Africa is, and to what it was. Many of them are fiercely " racial," as and when it applies to the States, but concerning their forefathers they have not even curiosity.

At night you will be taken to the Lafayette Theatre, the " cradle of new stars " that will go out on the road all over America and thence come to Europe. It is a sympathetic old hall, where, as they don't bother ever to print any programmes, one supposes that all the audience know all the players; it has that

feeling too. Some of the best wit I heard here, and they can get away with a lot of stiff hot stuff. Ralph Cooper's orchestra was playing admirably that night they had " the street " in. This was to give a hearing to anyone who applied. They just went on the stage and did their stuff. And the audience was *merciless* to a whole lot of these new triers, who would have passed with honour anywhere out of America. The dancing of two or three of the street shoe-blacks, box on back, then set down and dancing round it, was so perfect that the crowd gave them a big hand. No-one who has not seen the actual dancing of Harlem in Harlem can have any idea of its superb quality. From year to year it gets richer, more complicated, more exact. And I don't mean the unique Snake-Hips and the marvellous Bo-Jangles, I mean the boys and girls out of the street who later become " chorats " and " chorines " (in the chorus), or who do those exquisite short numbers, as in music the Three Ink Spots (a new trio), adolescents of 16 or 17 perhaps, playing Duke Ellington's *Mood Indigo* so that the tears ran down one's face.

There was a new dance too, one of the sights of the world as done at the Savoy Ballroom, the Lindy-Hop. The fitting third to its predecessors, Charleston and Black Bottom. These were in the days of short skirts, but the Lindy is the more astounding as it is as violent (and as beautiful), with skirts sweeping the floor. Short minuet steps to begin, then suddenly fall back into an air-pocket, recover sideways, and proceed with all the variations of leaves on the wind. For the Lindy is Lindbergh, of course, created by them in honour of his first triumph. These Tuesday nights at the Savoy are very famous, as is the Harlem " Drag Ball "

" *Jessie*," who toured the world with a theatrical company and who was the charming hostess in a " speak-easy " when I knew her in Harlem

that happens only once a year. To this come the boys dressed as girls—some in magnificent and elaborate costumes made by themselves—and of course many whites from down-town. A word on the celebrated " rent-party " that the American press writes up with such lurid and false suggestions. This is no more nor less than an ordinary evening dance in someone's house. The " rent " part is its reason for being, for the guests give about 50 cents to come in, thereby helping pay the rent, and they buy liquor there which, as everywhere in dry America (and doubtless it will go on even if prohibition is entirely abolished), is made on the premises or by a friend. The music, as like as not, comes from a special kind of electric piano, a nickel a tune, all the best, the latest ones.

But it is the zest that the Negroes put in, and the enjoyment they get out of, things that causes one more envy in the ofay.[1] Notice how many of the whites are unreal in America; they are *dim*. But the Negro is very real ; he is *there*. And the ofays know it. That's why they come to Harlem—out of curiosity and jealousy and don't-know-why. This desire to get close to the other race has often nothing honest

Ofay : white.

49

about it ; for where the ofays flock, to night-clubs, for instance, such as Connie's Inn and the Cotton Club and Small's, expensive cabarets, to these two former the coloured clientèle is no longer admitted ! To the latter, only just, grudgingly. No, you can't go to Connie's Inn with your coloured friends. The place is *for whites*. " Niggers " to serve, and " coons " to play—and later the same ofay will slip into what he calls " a coloured dive," and there it'll be " 'Evening, Mr. Brown," polite and cordial, because this will be a real coloured place and the ofay is not sure of himself there a-tall. . . .

This applies of course to the mass of whites who treat Harlem in the same way that English toffs used to talk about " going slumming." The class I'm thinking of is " the club-man." They want entertainment. Go to Harlem, it's sharper there. And it doesn't upset their conception of the Negro's social status. From all time the Negro has entertained the whites, but never been thought of by this type as possibly a social equal. There are, however, thousands of artists, writers, musicians, intellectuals, etc., who have good friends in the dark race, and a good knowledge of Harlem life, " the freedom of Harlem," so to speak.

" You must see a revival meeting," they said to me. " It's nothing like what it is in the South, but you shouldn't miss it."

Beforehand I thought I wouldn't be able to stand more than ten minutes of it—ten minutes in any church. . . . When we got into the Rev. Cullen's on 7th Avenue (the Rev. is the father of the poet, Countee Cullen) a very large audience was waiting for the " Dancing Evangelist " (that is Becton's title, because of his terrific physical activity). A group of " sisters " all in white spread itself fan-wise in the balcony. There was a concert stage with deacons and some of Becton's 12 disciples, and the 7 or 8 absolutely first-class musicians who compose the orchestra, of whom Lawrence Pierre, a fine organist and a disciple. Nothing like a church, an evening concert.

The music starts, a deep-toned Bach piece, then a short allocution, and then the long spirituals, the robust soloist that a massed chorus, the audience, answers back. They begin to beat time with their feet too. The " spirit " is coming with the volume of sound. At this point Becton enters quietly, stands silent on the stage, will not say a word. They must sing some more first, much more ; they must be ripe ground. How do they reconcile Becton's exquisite smartness (pearl-grey suit, top hat, cane, ivory gloves, his youthful look and lovely figure), the whole sparkle about him, with the customary ponderousness of the other drab men of God? A sophisticated audience? No, for they appear to be mainly domestic workers, small shop workers, old and young, an evidently religious public, and one or two whites.

A new spiritual has begun ; the singing gets intenser, foot-beating all around now, bodies swaying, and clapping of hands in unison. Now and again a voice, several voices, rise above the rest in a single phrase, the foot-beat becomes a stamp. A forest shoots up—black, brown, ivory, amber hands—spread, stiffened-out fingers, gestures of *mea culpa*, beating of breasts, gestures of stiff arms out, vibrating extasy. Far away in the audience a woman gets " seized," leaps up and down on the same spot belabouring her bosom. It comes here, there—who will be the next? At one moment I counted ten women in this same violent trance, not two with the same gestures, yet *all* in rhythm, half-time or double time. A few men too, less spectacular. Then just behind me, so that I see her well, a young girl. She leaps up and down after the first scream, eyes revulsed, arms upstretched—she is no longer " there." After about a minute those next to her seize her and hold her down.

The apex of the singing has come ; it is impossible to convey the scale of these immense sound-waves and rhythmical under-surges. One is transported,

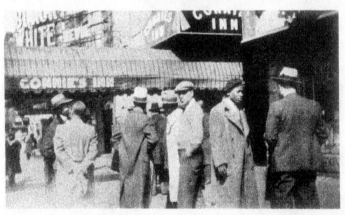

Connie's Inn, 7th Avenue, in the heart of Harlem, a smart Negro night-club, which panders so entirely to the prejudice of its white clientèle that coloured people are actually excluded as guests ; the only Negroes inside are, of course, menials, and the coloured entertainers. No better example than this of the poison of Jim-Crow carried into the very centre of the Negro town ; an example, too, of the incapacity of American whites in keeping away from the despised " niggers "

Harlem Reviewed

completely. It has nothing to do with God, but with life—a collective life for which I know no name. The people are entirely out of themselves—and then, suddenly, the music stops, calm comes immediately.

In this prepared atmosphere Becton now strides about the stage, flaying the people for their sins, leading their ready attention to this or that point of his argument by some adroit word, a wise-crack maybe. He is a poet in speech and very graceful in all his movements. His dramatisation is generous—and how they respond . . . " yeah man . . . tell it, tell it." Sin, he threatens, is " cat-foot," a " double-dare devil." And the sinner? " A double-ankled rascal," thunders this " adagio dancer," as he called himself that night, breaking off sharp into another mood, an admonishment out of " that inexpressible something by which I raise my hand." There are whirlwind gestures when he turns round on himself, one great clap of the palms and a sort of characteristic half-whistle-half-hoot before some point which is going to be emphasised—and the eloquence pours out in richer and richer imagery. Becton is the personification of expressionism, a great dramatic actor. You remember Chaliapine's acting of Boris Godounov; these two are comparable.

Then, " when the millenniums are quaking it's time to clap our hands." It is the moment for the " consecrated dime," and the singing begins again, but the trances are over; other preachers may speak

Elder Becton, " The dancing evangelist "

later. This ritual goes on from eight till after midnight, about four nights a week, and sometimes both the faithful and the evangelist are so indefatigable that it goes on for 24 hours. These services, really superb concerts, are the gorgeous manifestation of *the emotion* of a race—that part of the Negro people that has been so trammelled with religion that it is still steeped therein. A manifestation of this kind by white people would have been utterly revolting. But with the Negro race it is on another plane, it seems positively another thing, not connected with Christ or bible, the pure outpouring of themselves, a nature-rite. In other words, it is the fervour, intensity, the stupendous rhythm and surge of singing that are so fine—the christianity is only accidental, incidental to these. Not so for the assembly of course, for all of it is deeply, tenaciously religious.

Becton is the most famous evangelist of the coloured race in America. He has a following of more than 200,000, from New York to Florida, from Baltimore to Kansas. Like Christ he has 12 disciples. " The reason I have my party comprised of all men is because Jesus' disciples were all men, and if it was right for him it is right for me." He is one of the most elegantly dressed men in the world. Another comparison : " If Jesus were alive he would dress like me," for " if I came out in a long black coat, a collar turned backwards and looked downcast and forlorn, people would say that if they have got to look like that to be christians, they don't want to join the church." Some other sayings of Becton's which fetch the religious are : " I work for God on contract and he keeps his bargain." " I told you, Lord, before I started out that I was a high-priced man, but you wanted me." " God ain't broke ! " The " consecrated dime " and its fellows of course supply all Becton's needs. His organisation is called " The World's Gospel Feast," which publishes a quarterly called *The Menu*, the motto of which is : " A Square Deal for God " !

I have given all this detail about the revivalist meeting because it is so fantastic, and, *aesthetically* speaking, so moving. But when one considers the appalling waste of this dynamic force of people, and this preying on the prayers and fervours of old-fashioned, misguided, religious Negroes, it is tragic. Some time during this last summer (1933), after a new point in horror had been reached in the Scottsboro case at the Decatur " retrial," a young Negro minister frankly voiced his realisation of the truth ; he said that the Communists were the only ones to defend his race, that they had proved it unquestionably

throughout the whole history of Scottsboro; he said that for this reason although he was a man of God he was a Communist. Had Becton been honest, had he spoken thus, he would have swept the land. His followers would have had the same faith in these new words as in all his past " heavenly messages." But his was an individual racket.

I went to see Becton. A very handsome and courteous man. During our talk he leant forward earnestly: " In what manner do *you* think will come the freeing of my race ? " " Only by organised and militant struggle for their *full* rights, side by side with Communism." He smiled. " And in what way do you think ? " I asked him. " I think it will be by prayer," he murmured. I wanted to shout at him " Be honest *now*. Use your great dramatic gift for the right thing ; you could be a giant in the freeing of your people." He spoke of the new million-dollar temple he was going to build. " I have not the money, but I shall get it "—and no doubt he would have been able to collect it all by these consecrated dimes. . . . But now, one year after I saw him, Becton is dead. " Bumped off " suddenly and brutally by some gangsters, shot in a car.

Another spectacular man of God is the Rev. Father Devine, who that year was having a hard time with the authorities for what, in Jamaica, used to be called " night noises." The fervent assembled in too great numbers and their exaltation was too loud. Sensational vengeance followed Father Devine's arrest ; the judge who condemned him died the next day.

It may seem odd that one's thoughts stay so long with these black priests and their terrific hold over their large following. But religion amongst the Negroes, those that have it (for the younger generation is shaking off its weight, and replacing this by a desire for, an acquisition of, racial and economic facts), their reaction to religion cannot be dissociated in my mind from their past collective reaction to tribal ceremony and custom in Africa. They are *honest* and at home in their belief ; that is the whole difference as compared with whites. A white audience in church lifts one's heart in utter disgust ; with the Negroes one longs for this collective force to be directed towards the right things, solidarity with those whites who are struggling for their rights too against the super-brutality of American " democracy."

The Negro ministers and churches vary in their attitude to the more and more violent struggle for Negro rights. Since the Scottsboro case and other equally vicious frame-ups, some have helped the International Labor Defence, the organisation which is fighting these cases ; some have refused all aid. The same applies to the Negro newspapers. Scandals have occurred, such as misuse of funds collected by *The Amsterdam News*, an important Harlem paper, for the great march on Washington this spring by over 4,000 Harlem Negroes, protesting against the new legal lynch verdict on Heywood Patterson at Decatur.

The Harlem Liberator is the only honest Negro paper in the States, and there are some four or five hundred. . . . Controlled by jacks-in-office at the beck and call of American white money and black philanthropic support, this Negro bourgeoisie sits giving praise to each new president and each party that promises that " new deal to the Negro " that never comes (and will never come from Republican, Democrat or Labour), launching out frantic and crassly ignorant attacks on the Communists (see particularly the so-called " Symposium " of a dozen or so Negro editors in one of the spring 1932 numbers of *The Crisis*). They are worse than the black imperialist lackeys in colonial countries, for they are not without money and some power, neither of which is ever applied to the crying needs of the race. There is not one paper (except *The Harlem Liberator*) that can be called a proper " Race " paper. Although they deal almost entirely with Negro doings, these doings are found to be mainly social events and functions. The coloured stage is much spoken of, which is very much to the good, for the white papers scarcely mention any Negro achievement ; yet there is hardly a star who is not at some time or other of his or her career literally pulled to pieces by some scandal of press-invention. As to writing sanely about any inter-racial friendships or associations . . . one might be reading a Southern white rag.

Confusion (and confusing the minds of its readers) is a strong newspaper characteristic. I say confusion, but it is by design. Example : on several pages you will read vulgar, ignorant and abusive articles on Negro " reds " ; misrepresentations, and every attempt at discredit. (For instance, the *Pittsburgh Courier* printed a baseless and indescribably vicious attack on Ruby Bates, one of the two white State witnesses in the Scottsboro case, because she admitted having lied in the first trial, thus being part responsible for 9 innocent black boys being in jail under death-sentence for 2½ years, and because now she was speaking all over the country showing up the Southern lynch-terror and race-hate, on the same platform as Communist organisers.) And on another page will be found an honest account of some event in connection with these same Negro comrades. What is the explanation ? The editor has been forced into this last by the remonstrances of militant Negroes who are bitterly aware of the sempiternal treacheries

Harlem Reviewed

of the black bourgeoisie all along the line, but nowhere as vilely so as in their newspapers. The Negro race in America has no worse enemy than its own press.

If treachery and lying are its main attributes so is snobbery flourishing in certain parts of Harlem. " Strivers Row " ; that is what 139th Street has been called. An excellent covering-name for " those Astorperious Ethiopians," as one of their own wits put it. There are near-white cliques, mulatto groups, dark-skinned sets who will not invite each other to their houses ; some would not let a white cross their thresholds. The Negro " blue-bloods " of Washington are famous for their social exclusivity, there are some in Harlem too. I don't know if a foreign white would get in there, possibly not. The snobbery around skin-colour is terrifying. The light-skins and browns look down on the black ; by some, friendships with *ofays* are not tolerated, from an understandable but totally unsatisfactory reaction to the general national attitude of white to coloured on the social equality basis. A number of the younger writers are race-conscious in the wrong way, they make of this a sort of forced, *self*-conscious thing, give the feeling that they are looking for obstacles. All this, indeed, is Society with a vengeance ! A bourgeois ideology with no horizon, no philosophical link with life. And out of all this, need it be said, such writers as Van Vechten and Co. have made a revolting and cheap lithograph, so that Harlem, to a large idle-minded public, has come to mean nothing more whatsoever than a round of hooch [1]-filled night-clubs after a round of " snow " [2]-filled boudoirs. Van Vechten, the spirit of vulgarity, has depicted Harlem as a grimace. He would have written the same way about Montparnasse or Limehouse and Soho.

On the Corner 129th St. and 7th Ave. Harlem

Do places exist, or is life itself as described by Paul Morand (another profiteer in coloured " stock ") ? Claude MacKay has done better. The studies in inter-colour relationships (in *Ginger Town*) are honest. But his people, and himself, have also that wrong kind of race-consciousness ; they ring themselves in, they are umbrageous. The " Negro Renaissance " (the literary movement of about 1925, now said to be at a halt, and one wonders on whose authority this is said) produced many books and poems filled with this bitter-sweet of Harlem's glitter and heart-break.

This is not the Harlem one sees. You don't see the Harlem of the romancists ; it is romantic in its own right. And it is *hard* and *strong* ; its noise, heat, cold, cries and colours are so. And the nostalgia is violent too ; the eternal radio seeping through everything day and night, indoors and out, becomes somehow the personification of restlessness, desire, brooding. And then the gorgeous roughness, the gargle of Louis Armstrong's voice breaks through. As everywhere, the real people are in the street. I mean those young men on the corner, and the people all sitting on the steps throughout the breathless, leaden summer. I mean the young men in Pelham Park ; the sports groups (and one sees many in their bright sweaters), the strength of a race, its beauty.

[1] Drink. [2] Cocain.

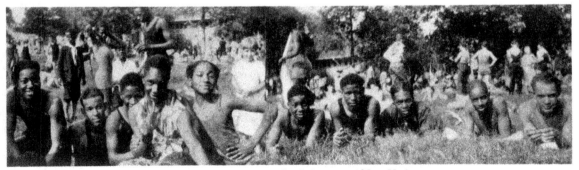

Young men in Pelham Park, just out of New York

Harlem Reviewed

The Sweetvendor. Harlem

For in Harlem one can make an appreciation of a race. Walk down 7th Avenue—the different types are uncountable. Every diversity of bone-structure, of head-shape, of skin colour; mixes between Orientals and pure Negroes, Jews and Negroes, Red Indians and Negroes (a particularly beautiful blend, with the high cheek-bones always, and sometimes straight black hair), mulattoes of all shades, yellow, "high yaller" girls, and Havana-coloured girls, and, exquisitely fine, the Spanish and Negro blends; the Negro bone, and the Negro fat too, are a joy to the eye. And though there are more and more light-coloured people, there is great satisfaction in seeing that the white American features are absorbed in the mulatto, and that the mulatto is not, as so often in England, a coloured man with a white man's features and often expression as well. The white American and the Negro are a good mix physically. The pure black people—there are less of these (more than two-thirds of the race now being mixed with white). These are some of the new race that Embree has written of in his *Brown America*; they are as distinct from the African as they are from the nordic.

The major part of Harlem's inhabitants are of course the Negro workers. Since the depression began the proportion of those that are unemployed is very much higher than that even of the white workers. They have been, they are being sacked, and their wretchedly underpaid jobs given to the whites. Unable to pay the rent, not a week goes by without numerous evictions, they are thrown out into the street. Bailiffs come and move out the few belongings they have. And it is here that the Communists have put up a strong and determined defence. Black and white comrades together go where the evictions are taking place and move the things back. Police and riot squads come with bludgeons and tear-bombs, fights and imprisonments, and deaths too, occur. In every form the oppression that the governing class carries out increasingly becomes more brutal as the need of the unemployed makes stronger and stronger demand for food, work and wages.

There is no finer realisation than that of knowing that the black and white proletariat is getting more and more together now on the only real basis that must be established and consolidated for ever : the equal rights of both under the Communist programme. And when this is in practice the full and final abolition of this artificially-bred race-hatred on the part of the whites, bred out of the enslaving of blacks, will be arrived at. In this and in no other way. There is no colour *problem*. The existence of the Negro race is not a problem, it is *a fact*. And in America, as in all other imperialist countries, this use of a wrong word is neither more nor less than a vicious lie on the part of the ruling class in urging the workers of each country into thinking that the Negro, the coloured race, was created by nature as a *menace*. The growing volume of the Communist consciousness among the black workers, and in some of the Negro intellectuals, dates chiefly from five years ago, and has in that time made, and is making, rapid increase. It is something new, *more and more tangible*, as here in England now, in the street as I go by I am immediately aware of a new expression in some of the faces, a look of purpose and responsibility.

One of the first things I was impressed by, the best thing that remains of Harlem, was the magnificent strength and lustiness of the Negro children. As I walked from end to end

Harlem Dustmen

of it, down the length of 7th Avenue, the schools were just out. The children rushed by in rough leather jackets in the cold wind, some of them playing ball on roller skates, shouting and free. May these gorgeous children in their leathers be the living symbol of the finally liberated Negro people.

Up with an all-Communist Harlem in an all-Communist United States!

Children on 7th Avenue, Harlem

"Malicious Lies Magnifying the Truth"

by TAYLOR GORDON

IT was years ago that an old Southerner tried to sell me a silver watch. We met along the railroad track in sunny Florida. He was a shabbily dressed man, with a long white stringy mustach hanging to his peaked face. The tips of this mustach were stained with tobacco juice. He wore a sweat-stained, wide-brimmed, black Stetson hat, pulled down over his eyes.

As he approached me and stopped walking, there was a long spurt of tobacco juice from his rather small mouth into the palmetto—like people expectorate off the sidewalk in a clean city.

He spoke to me slowly in a high-pitched voice.

" Hello . . . Nigger. . . . Don't you want to buy a good watch?" He had put his hand to his vest pocket, but hesitated to remove the timepiece until I answered him.

" I don't know; what kind of a watch is it?" I asked him. Then the stranger put his long bony fingers into his well-worn, gray vest pocket and brought out a seven-jewelled " Elgin " watch, with a scratched nickel-plated case.

55

" Malicious Lies Magnifying the Truth "

Taylor Gordon

" Here it *tise* . . . solid silver! The best there is! That's an *Elgin*! . . . None better made," he said, and handed me the watch to look at. I turned it over in my hand, put it to my ear, studied a few seconds, then I asked him how much he wanted for it.

" It's worth fifty dollars new, but I'll sell it to you for twenty ; that's less than half what I paid for it. Putty cheap; I hain't carried it over a year. Wouldn't sell it now but I gotta get upta Tampa to my sick daughter."

We stood in silence a second or two, then I told him I thought that twenty dollars was a steep price for the watch.

" You hain't owned a watch as good as that in your life! Tell the truth now, because it takes a good mem'ry to tell a lie." I don't know why that stranger's last remark struck me so forcibly. Perhaps because I realised that he had expected me to tell him a lie. Or was it because I knew he was lying about the value of the watch, even tho' I had never owned one as good until that time? But I had seen and priced many a watch far better in the big cities of the North years before I had gone to Florida. And I knew that particular kind of an Elgin watch to be worth $17.50, new.

I had a difficult time being tactful in refusing my insistent salesman. At one time he acted as if, had he thought I really had twenty dollars on my person, he would have taken it from me. (Patting my pockets.) I wanted to thank him for the compliment, but I decided it wasn't the best thing to do. In the event that I had of had that amount of money, and he took it from me. Perhaps it would have been tough for me to prove that I was not trying to rob him. Because in the sunny southland any white man's word is the omniscient utterance of all mankind. Especially when the black man is involved.

They tell me that there was a time in these United States that the great white court only condemned the blacks by the single testimony of the whites " when the fair woman had been wronged." But this year 1931 of our depression we find a self-appointed court of thousands condemning the blacks on the slightest imaginary offence conceived by the caucasian mind.

The caucasians [1] are queer people. They think that any other people that can't see things as they do are to be pitied and cared for. That if there's ever an eternal peace among men, it will be because of their generosity.

I have found this trend of thought seeping into the educational treatises of all whites wherever I go. But perhaps the greatest source of prejudice against the black man in the world comes from the millions of morons [2] in these United States of America.

People in every walk of life, rich and poor, are working themselves into an early grave worrying about the advancement of the dark races. Some are even spending their hard-earned millions of cash to try and dam the great advance of dark clouds they see mounting from the horizon.

Up until the last great war there wasn't much prejudice spread in foreign countries about the Negro by the white Americans. Perhaps the reason now for the infection of American fob in the new lands among broadminded people is due to the fact that up till then only the best Americans travelled extensively abroad.

Usually these people were rich and had blue-blooded pedigrees that ran back to the Boston Tea Party. Their status was set amid " class " in the white world. Apparently no blacks could ever demand the comfort they had, so why discuss them when Whistler, Beethoven, Shakespeare and the Russian Ballet were more annoying?

But here came 1914 with its magic wand waving about the world giving everybody the gold mania. " Send men, women and children to our cities; we have gold to give them." They didn't state what kind of men. It's possible that if they had to do it again they'd cry for only white men.

The cities were filled with teeming millions. Gold was more plentiful than wheat. Worth less than meat. Piles of it could be had for a barrel of sugar. Some used it as fast as they got it. Others used it sparingly and hoarded plenty. Much more than the rich wanted them to hoard. Because gold is a strong servant; as faithful as a good dog.

The war ended, and by 1920 people of all colors were running about the world. They seemed to have lost all of their inhibitions. Each one was able to pay someone to do something for him. They

[1] Caucasian, in America, is what certain whites call themselves—Caucasian race. [2] Signifying, in this case, *cretin*, idiotic.

walked and strutted about the place with the haughty expressions of kings and queens. The slightest discomfort to anyone caused them to talk loud and demanding. Hotels and public places of the best were infested by people that the minor but exclusive set didn't think should be enjoying such comforts. This exclusive set talked about it but failed to make any outward cry. After all, why should they? Didn't they still have their clubs and private homes where those newly rich couldn't enter yet and probably never will? Unless they can trace their birth back at least two or three hundred years, with the right religion, to support the analysis. So off to the clubs and hound-hunts the old rich went. Leaving the public places filled with the conglomeration of newly rich.

Morning after morning these people would come downstairs into the lobbies and dining-rooms to mingle. They looked at each other's misfitting but costly wearing apparels. They discovered that there were many blacks among them. The thought came to all, " Who is the best among us? " The whites said, " Why should these black skunks be here hobnobbing with us? " And the blacks said to themselves, " Well, here I have got all this gold that I might have the best with Mr. Eddie and Miss Ann,[1] and I can't find a damn one of them in these places. I'm still along with these stringy-haired Pecks." [2] There's something funny about a blooded white person's hair by which Negroes think they can distinguish when they have some birth class. They say that it's almost impossible for the unpedigreed whites to train both their hair and carriage in a way that they can't be distinguished from the pedigreed.

The newly rich whites were in the majority. They decided that something must be done. " We must set a standard. We must have a white supremacy." In less than a year the greatest organisation to spread prejudice in modern history was functioning. Lynchings grew and American black people were discharged from work as though they carried the bubonic plague.

Articles appeared in all languages about the great black menace. Immigrants and school children were given special instructions, as how to avoid coming in contact with the great black devils. The young and voluptuous women were told so many frightening tales about the ravishings of these blacks that ninety per cent. of their dreams were turned into struggling nightmares with some big husky buck.

This went on until some of the exalted rulers were found to have collected too many millions of dollars from the poor thoughtless people, and the higher courts had to intervene. Then the nation's best newspapers published the names and persecutions of the leading demagogues, whom the morons had been supporting so bounteously. After that the followers dropped, like flies from the ceiling of a burning fish-house. They will now admit that none of the dreadful, terrible and painful things prophesied by the demagogues that the " vicious blacks " were to do to them, ever happened.

Probably never in the history of the world has the Negro had such publicity. I'll admit that it wasn't the most soothing to my nerves that I have ever read. But I do know that it caused people in every walk of life to give the Negro a closer study. And to my surprise, many have told me of their astonishment to learn that the Negro is the most reliable citizen in the U.S.A. regardless of his economic standard. That the law has fewer to punish for major crimes than among any other race of people here.

But still these good reports can't sufficiently persuade certain people to cause them to stop their malicious propaganda about the dark-skinned brother. They have even made up their minds that not only shall America be freed of the " menace of the blacks," but that Europe shall not know their sting either. They send their money to European cities to build schools, with the conditions that no dark people shall ever study there.

They tell hotel managers and heads of businesses that they will not spend their money with them if they see a Negro about the place, except in the capacity of a servant.

They have printed in the papers that they control statements that refer to Europeans' inferiority, because they tolerate the presence of the blacks, in their hospitality. " *Tolerate*." Can you imagine life in either America or Europe without the presence of any blacks? . . . But there are Europeans that have money and standard enough to judge for themselves, and who don't give a damn for the American demagogue's noise.

It's a pity that the people who are governed by the thoughts of America's demagogues can't get a chance to read what the Negro really thinks. I don't know one Negro writer in America that can honestly put down what he would like to on paper and get it published here. Therefore the white public will remain in darkness for many years to come, because of the " *Don't's* " in the laws for the black writers.

Immigrants to these United States of America, I have come to the conclusion, are from three classes. The cultured, skilled, and illiterate.

[1] " Classy " whites. [2] *Pecks* (or *peckerwoods*) are inferior or common white people.

" Malicious Lies Magnifying the Truth "

People I consider cultured are not always rich and in comfortable circumstances, nor do they have to come from the best schools their country affords. But they must have a fair knowledge of the world and its inhabitants. They must know that color and creeds were not created in a day, a week, or years.

Cultured people are those who realise that peace might be had when everyone is willing to give and take. It is the cultured class of immigrants that causes the Negro the least trouble in the U.S.A. And these people come from all countries, as well as do the other classes. But they're in the great minority.

Next we have the skilled class. I have had some arguments about a skilled man being cultured. Yes, I will say : in some one or two things that he does he is alright. After that, let him die. I have come in contact with some of America's most skilled men and women, enough to learn that they're far from being cultured. That is if we are to take the meaning of the word " Culture " from the dictionary. " *Culture* : the training, improvement, and refinement of the mind, morals, or taste."

Skilled workers are to be pitied in America. They are harangued by everyone, from their wives to the factory owners. And the foreman on the job is always holding some kind of a loadstick above their heads. Then there are the Unions that even take their money to keep them in bondage.

The Unions spread more prejudice against the blacks in the skilled class than is spread in all the other conditions conceivable in America. They preach that if the white workers are allowed to work side by side with the black, that the blacks will demoralise both the workers and the Union.

Can you imagine such a remark by supposed cultured leaders? Anyone that has ever had the slightest experience with the dark races knows better than that. It's the biggest kind of poppycock.

I have found that the dark races are the only people on this earth that really get true enjoyment out of their work. Each one strives to be the best in his line, even with the handicaps they are dragging along.

If the Negroes were allowed to work side by side with the skilled workers in all lines, America would be the most comfortable, irresistible spot in our modern civilisation. Blacks believe that money should roll while you're living, because they realise their bodies are a long time dead. Prejudice is the foundation of depression.

The third and last class are the " morons." These immigrants are of the least interference to the American Negroes. Because they both work together at all earthly labor. They pull down the old houses. Dig the big ditches. Excavate the subways. Work in the mines. Anywhere that a life isn't worth a quarter. They have been killed by dozens, and were it not for the stinking of their dead bodies that would interfere with the progress of the work to be accomplished the community wouldn't pay the slightest bit of attention to them.

This is the only group that has little prejudice. Because they realise they have to be taught the American ways and they're willing to learn from anyone. Many of these people can't read or write in any language. Therefore, they feel and see, system has to be used in their education.

The Negroes that work with this type of immigrant take great pleasure in *hollering* at them, " That's a crowbar ! Not a pick, you dumb bastard ! " And the foreigner thanks them for the instructions.

Most all of these people will tell you of their great Negro friend, or vice versa. They can tell you how gallantly they saved each others' lives in some catastrophe. You find this group intermingling with their families. And there have been no few of them intermarrying.

Individually their children usually make good honest citizens and they are very broadminded after they are promoted into the skilled classes.

I find that individually all immigrants to these United States are looking for a chance to advance themselves. I have not found one single case where a foreigner came here and lived when he or she was comfortably fixed in the home-land. They all come here with the idea of some day going back where they came from with a large bank roll and showing the folks that stayed at home what a successful person looks like.

It is natural that the darker races are the most prejudiced towards the American Negroes. They feel that if it were not for the American Negroes they would have a free rein in all American enterprises. Well, to be frank, when they have intelligence they do have this. But every now and then some of these people come with a very dark skin, and they are insulted in the streets and shops. When this happens they always curse the American Negro as the cause. Now can you tell me how the American Negroes have anything to do with the rest of the world's dark skins? Sometimes I think people are inclined to over-estimate the Negro's ability. The white man takes credit for everything but mixing the races. There's a spot in the Bible that says God started all this thing called " Prejudice." And if he created life, I think he did. But those who have read my autobiography, *Born To Be*, know my opinion about that.

" Malicious Lies Magnifying the Truth "

The dark South Americans, Cubans, Porto Ricans and Philippinos, lead in personal grievance and hatred towards the Negro, because of the American prejudices.

The Greeks are a type of immigrants that come to my home-land who have a dislike for my people which I have never been able to figure out, except for their strong belief in their superiority to all the white races. These people seldom change even when their existence is in the hands of the Negro, which many times it is while they're in the United States.

The German, English and Hebrew immigrants don't voice their points of view on prejudice so openly, for fear that they will lose some opportunity to seize some material gain. But I have yet to find the white man that doesn't think that he and his kind are far better than any other man in all the darker races. And if you give him time and opportunity he'll say it in some way, regardless of the facts.

This rule holds good for the darker races as well. Individually they have inferiority complexes. Collectively they think they're the monkey's glands.

Not long ago I was standing in front of one of Harlem's best clubs and overheard a bigtime gambler rebuke one of his fellow-men, who told him he was at the mercy of the caucasian race. The tall, lean cocoa-brown-skinned man, who wore glasses with large tortoiseshell rims, and dressed like a fashion plate, retorted:

" Why, you dumb black bastard! The white man is my servant! You see that automobile standing there? Who made it? The white man! Who built the house you live in? The Ofay [1] man! Where'd I get this suit of clothes from? These Pecks down the street here! I just gave you money to fill your fat belly full of steak and greens—who brought the *Chow* into New York City? The Red Neck! [2] This time next month the snow can be up to your *ass*, and cold enough to freeze the whiskers off a brass monkey—who'll bring the coal to keep your gal's hinnie from chilling? The Ebo man! When the express trains on any line in the country lay down on their sides, as they take a curve, to keep from flyin' the track, and the engineer blows the whistle . . . Woow—Woow, wowpt! . . . there's a white man carryin' his woman to some Jasper, [3] but he don't know it. The ofay ain't smart. He only thinks he's the professor's ferret, but he's really the pettifogger's skunk! A dumber feller never lived! " he said rapidly, with a staccato accent.

The fat dark man who had tried to picture the advantages of the white man, and his mercy shown to the dark races, was flabbergasted. He leaned up against the steel post that supports the green awnings projecting over the side-walk. The neat gambler went on to show his point of view, why the white man wasn't intelligent because he is so gullible. He repeated things I have heard time and time again from the darker races. And if you put the thousands of remarks into the boiling pot for an answer, the stew will give up the meaning: " Governments who deny their subjects equality enslave themselves."

Out in California we have the most peculiar sets of prejudices. The white people there are from all parts of the United States. The dark races are thickly represented there also. They are from Mexico, Japan, China, and the American Negro has settled there in great numbers.

The white people have their own personal dislikes for each of these groups. So you find every new political force that gets into power makes laws to circumscribe the particular dark race he dislikes. And it's a battle-royal picnic to see and hear the electioneers in action. All have a point that they argue, wherein, if they are elected, they'll do some special favor for some one of the dark races, Mexican, Negro, Japanese or Chinese. It depends upon the group that happens to be the largest in their district.

They all seem to try and stir up one of the darker races against the other. In the shops and theatres the managers give either one race or the other the breaks. All of these people run in color from white skins to the blackest of black people.

Light skin is the main point at issue. So it's a common thing to hear mothers discussing their children's possibilities from the point of the shades of their skins.

Passing for white is the big ace-in-the-hole, in the land of the movies. These women are a queer group. They flounce themselves about arrogantly. Hypnotising themselves, and believing that God was on his vacation when he designed their bodies, with the short waist, big hips, small legs and protruding bust.

They say that Shakespeare wrote his plays based on stories that were true life; and he says, " Cleopatra was a dark but comely woman." I have never seen a white man's portrayal of her but what she wasn't a very white woman, or a raving blond. Negroes paint her as a black woman. I'm a great believer in Shakespeare.

[1] White. [2] Southern white. [3] Negro.

"Malicious Lies Magnifying the Truth"

If I were a psychoanalyst, perhaps I could tell you why the white woman feels so superior to other women, when she thinks the darker races of women have the most S.A. And why these dark women flounce themselves about with conceit, constantly waving a flag, signalling that they have it! But remain inactive, with this tremendous power, while they crave social equality, and a better standard of living.

When the black and white women, who have secret lovers, demand open recognition of the fact and the right to live free and happy, as a passing couple, not as walking museum exhibits, the race problem will be settled in these United States of America.

One of the funniest things in the world is that the Southerners will sit and look at a black man or woman acting with whites on the screen. But won't allow them to work together on the stage.

Equally funny is that the English Government won't permit the showing of a movie where a white man is kicking a white woman's dog around, in any of her black possessions.

If the treatment of all women could be universally known to all, it would help the progress of mankind. Men won't admit it, but women have set the standard of living that has developed the culture in the world today.

So you see this thing called "PREJUDICE" is just a matter of culture. We find it in all forms of life. The trees have it; grasses have it; fish have it; the birds of the fields have it; the beasts of the forest have it; man has it. And of course there's no reason why anyone should object to him having it, if he wants to live like the rest of the dumb life on this earth.

Prejudice has a firm grip on all forms of life. But man may free himself from it, along with his malicious lies magnifying the truth.

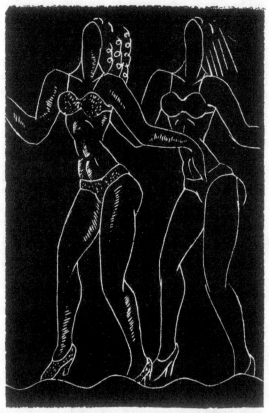

Chorines (ballet dancers)

A drawing by Zell Ingram

America's Changing Color Line

by HEBA JANNATH

WHEREVER one race or nation has conquered another, the dominant group has always raised as many barriers to legal intermixture as possible. This is often simply in the form of social taboos, as in the West Indies, the South Sea Islands, and parts of Africa and the Orient controlled by whites. But sometimes, as in the case of twenty-eight and a half States of the United States (Colorado is divided on the question), laws have been enacted making intermarriage illegal.

Laws against intermarriage hinder the passage of property (power) out of the hands of the conquerors into those of the under group. At the same time, the conquerors have always used the women of the oppressed people for concubinage. Since children always belong to their mother's race, the issue of these matings, temporarily at least, belongs to the inferior (powerless) group. This arrangement puts off the recognition of, but does not prevent, amalgamation.

Eventually, despite all legal precautions, the half-breed population which arises will blur the dividing lines of the two main groups, and in time, working backward and forward, merge them into a homogeneous mass. Thus, Rome absorbed her black slaves, Portugal and Spain theirs, South America is fast mixing European with Indian and Negro. And notwithstanding her anti-intermarriage laws, taboos and the white

America's Changing Color Line

mobs which punish by lynching miscegenation of white women and black men, the United States is steadily growing darker in complexion.

This change of complexion is due to six main causes:

(1) Miscegenation by white man and colored woman.

(2) The passing, like a shuttle, of their mulatto offspring back and forth between the races, spiritually and physically weaving them together.

(3) Education of the Negro and the opportunities which accompany it that enable him to accumulate power of his own.

(4) Emancipation of the white woman, her resulting freedom in sex (the eventual necessity of protecting her colored offspring by repealing anti-intermarriage laws).

(5) Our growing colonial possessions, unlike Britain's African colonies, most of them having large groups of educated colored people.

(6) Virtual stoppage of immigration.

Reuter and other historians have informed us that miscegenation has proceeded apace here ever since 1630 (the first boatload of slaves arrived in Jamestown, Va., in 1619), or for some fifteen generations. For although intermarriage was very early made illegal in the slave-holding States, nothing has ever stopped intermixture.

Assuming that there were, in 1630, 1,000 cases of intermixture, their descendants would now number some 32,000,000. As people of *known* Negro ancestry in the last census numbered only 12,000,000, there must be millions of persons in the white group with distant Hamitic ancestry. That thousands of octoroons yearly cross the color line is shown by the discrepancy in the decennial rate of expected Negro population growth. A few years ago a prominent Negro clergyman loudly complained in the Negro press " that approximately 5,000 octoroons yearly disappeared from the Negro group." Charles Johnson, an authority on the subject, places the number at from 10,000 to 20,000.

The first " passing " was made possible through the assistance of Southern white fathers, who sent their mulatto offspring North to be educated at the best colleges there, and later set them up in business. W. P. Dabney of Cincinnati, in *Cincinnati's Colored Citizens* (Dabney Pub. Co., Cincinnati, Ohio), p. 174, tells us that:

> Before, during and immediately after the (Civil) war this city was a fertile field for miscegenation and the products thereof. . . . Mulatto children and adults abounded in this vicinity, for those not born here were often sent by their white fathers. To the wealthy white man of the South, his colored children, his own flesh and blood, were sacred. Other colored children, of course, were " niggers." He provided them with money, and if they were fair enough " they passed for white," married white, and so in the veins of some of our most aristocratic white families here the Negro blood has added to their strength and beauty, if not to their pride. . . . A mulatto woman came up on a boat. With her were her two sons. She passed as their nurse. Twenty-five years later they were among the leaders here in society and business. Their offspring shows the fallacy of the theory that descendants of the Negro and white are sometimes born black. Instead, they frequently become white. . . .

Mr. Dabney goes on to list the families which he personally knew to have sprung from Southern white fathers and colored mothers. Some of Thomas Jefferson's colored descendents live, he says, within a few blocks of his home. Moreover, right after the Civil War many colored men married white wives; these, Mr. Dabney further declares, did, when possible, exactly as did the colored children of white men, they became " white."

Passing from one group to another is now of such common occurrence that it has lately become the subject of much popular fiction. Within the last few years *Plum Bun, Passing, Flight, White Girl, Gulf Stream, Love Fetich* and *Bright Skin*, all novels dealing with this so-called recent development in American society, have been published. But, as we have seen, passing successfully out of the Negro group into that of the white has been going on here for centuries. (See *Brown America*, by Edwin Embree.)

Actually, it is far easier to " pass " than our novelists would have us believe. There are, of course, many white Negroes who are too timorous for such an adventure, and there are also many superior persons of remote Negro connection who, because of group loyalty and a sense of duty, refuse to leave the Negro race. But the vast majority, that is the average octoroon, has a practical and unsentimental view of the situation. He rightfully feels he is entitled to his share of white opportunities. The families of the latter usually aid rather than hinder the passage out of their group. They are glad to have their light-skinned relations escape the insults and economic disadvantages whose deadening and tragic effects they know only too well.

America's Changing Color Line

The task of passing, especially in our great cities, is not so difficult as is supposed. I know or have heard of dozens of people who have passed successfully but who occasionally run up to Harlem to see some less fortunate relation. One charming blond octoroon, who hails from New Orleans, stops when in New York City at the best white hotels and trots around among white and colored alike, passing when it pleases or amuses her to do so, and in general has a wonderful time.

The octoroons who " pass " are usually past masters at detecting the slightest change in the thoughts and emotions of the people around. They usually, too, have great self-control, and, on the whole, prove to be very charming and sophisticated people. They obtain a view of both races denied most of us, and, full of ambition as they usually are, they emulate the best points of both groups.

The colored offspring of some few powerful white fathers " pass " into their father's race without any secrecy or fear of exposure. I know of two such cases and there must be others.

A powerful French banker in New Orleans sent his granddaughter, who was slightly colored but who resembled any dark French girl, to the Sacred Heart Convent there. The Sisters knew her ancestry, as did the parents of many of the wealthy white girls who attended the school; the children themselves were kept ignorant of the fact until they grew to the age of discretion. The young lady, after leaving the convent, married a prominent Southern white man who was fully aware that his wife's grandmother had been a black woman.

An Englishman in South Texas, owner of an immense plantation, kept his black mistress in luxury. He brought a tutor from England to educate his colored children. Later, one of them went North, married white, and one of the children of this marriage returned to Texas and married one of the children of the tutor.

Another woman of my acquaintance has married two wealthy white men. She keeps her mulatto parents in luxury and secretly visits them once or twice a year. As she is also a very excellent wife, she does not see that she is doing anyone any harm. I know of at least one prominent " white " Broadway actress who has kinship with Africa, while one of our women movie stars of the last decade, but now retired, who carefully guarded her past and who spoke and looked like a Creole, was suspected by her few intimates to have been an octoroon from Louisiana. Just recently, an American Army officer killed himself in California. His white mistress, who was with him at the time of his suicide, declared that he had become afraid that his Negro ancestry, which he had successfully hidden for a dozen years, would become known.

In every woman's college in the North there are numbers of octoroons passing for white, or at any rate simply keeping quiet about their ancestry. I was recently told of a case of a blond girl possessing some of the " fatal drops " of Negro blood, who entered Barnard College and roomed with a Southern white girl who was fanatical on the race question. The white girl confided to her room-mate that as a child she had had a very unpleasant experience with a colored person and that for this reason she could sense a Negro anywhere, no matter how light the individual was. (This is a fond belief among Southerners in general.) For four years the two girls remained fast friends, but when commencement came the octoroon calmly informed her room-mate that she came of Negro stock. It was only when her mother, who was considerably darker, arrived to see her graduate, that her friend would be convinced.

Often these young college women confide the fact of their Hamitic connection to their white room-mates, then for convenience' sake it is kept secret between them. Frequently during vacation the girl who is passing visits her friend, is introduced to the young men of her circle, and sometimes finds her husband among them. In one case of which I heard, the friends travelled for a year in Europe together, and the octoroon eventually married a prominent white man with his full knowledge and approval of her darker relations.

It must be borne in mind that passing for something which one is not is a very common practice in America. Jews and Mexicans often pass for Spaniards (since to be Spanish is thought more desirable here). Jews, Russians, Germans, Italians and Irish frequently change their names into " acceptable " Anglo-Saxon, the business world and the movies are full of such transformations. But because of America's particularly fierce taboo on the Negro, we have come to think that " passing " pertains only to him.

Envy and jealousy are everywhere to be met with in the racial situation, from the white man who keeps a Negro mistress and will lynch a black man should he look too long at a white woman, to the Negro woman with a white protector, who will greatly resent the presence of lighter skins within her own group. Many octoroons with white fathers and grandfathers who have wanted, but feared for some reason, to pass out of the Negro group, are loudest in denunciation of whites. Hatred of whites is

euphemised by them into " race pride." To hear such people, who often have extremely Nordic features and coloring, talk about " We of the Black race " is ludicrous in the extreme. Negroes, to be sure, are somewhat justified in hating the race which has gone to such elaborate lengths to persecute and penalise them. Nevertheless, it is absurd for them to denounce race prejudice in whites on the one hand while entertaining it themselves so righteously.

Many octoroons who have passed successfully, as far as whites and their own immediate families are concerned, out of the Negro race, are betrayed by friends and acquaintances who have been less successful.

Several years ago a young woman with remote colored ancestry obtained a choice position with the Metropolitan Life Insurance Company in New York City. A darker woman of her acquaintance went to the trouble of writing her employer and telling him that he had a " nigger " in his office. The young woman, who had given excellent service, was promptly discharged.

Whites sometimes find it convenient to pass for Negroes. A young woman of my acquaintance, who is a mixture of white and Indian blood, but whose relatives have on the Indian side intermarried with Negroes, passes herself off as a Negro in order to teach in a Southern colored college which would otherwise be barred to her. She possesses very straight blond hair and is in the habit of going to a white hairdresser in the city where her school is located. Once, she says, the head woman instructor, overhearing her make an appointment with the white beauty parlor, severely reprimanded her. Teachers and pupils alike, when the news of this heresy leaked out, bitterly denounced her for " trying to act white."

The wife of an octoroon physician in Harlem, who is herself a beautiful quadroon, tells me a strange story about a recent visit she paid to her husband's family in Florida. Her mother-in-law is a quadroon, and was the mistress of the most prominent white man in the locality. He kept his mistress and their children in his own mansion, with black servants to wait upon them. He is now dead, but his colored family were well provided for before his death. Despite the usual procedure in the South of lumping all persons with the slightest Hamitic ancestry together as " niggers," their position in the town is that of the mulatto in the West Indies. They are considered far above the unmixed blacks, though still beneath the whites. Their situation is full of subtle but bitter tragedies. They refuse to mix with, or marry among the blacks in the town, and the despised blacks hate them as cordially as they hate the whites. My informant, who was born in New York City, and is sane upon the color question, was amazed and amused by the number of petty intrigues that came under her observation. She returned North as soon as possible for fear that she too might become " crazy " in such an atmosphere.

As Dr. Einstein, during his visit to New York in 1931, told a Negro reporter who was interviewing him, most of America is crazy on the race question. This insanity is witnessed among the majority of both groups. The average Negro and the average white hold almost identically unsound opinions upon the race problem. Ask the average Negro what he thinks of social equality and racial intermarriage and he will grow as indignant as a white man. He will hotly deny that he wants either, and believe that it is because he is too proud to want any relationship with whites. Let him talk a while and he will unwittingly reveal that he really feels himself inferior. He will ridicule someone who is darker than himself and praise someone lighter. He will talk about " good " (straight) and " bad " (kinky) hair. He will not go with a certain girl because " he's not dealing in coal." The other morning, an elderly black woman who wished to hire herself to me as nurse, emphatically declared " that she suttinly did like to take keer of nice white chillun," but that she wouldn't have anything to do with " no ole black chillun at no price cose they was jes' nachally mean an' evil."

If, according to the Behaviorists, thought is entirely a matter of conditioning rather than of reason, the Negro, developed by the same culture as the white, must necessarily " think white." Subjected as he has been to torture, slavery, disfranchisement and discrimination, he would have had to be more than human not to have acquired a profound, if bitter, respect for the power that could do such things to him. This respect, making the Negro emulate everything " white " (black women want light-skinned babies and black men seek the fairest women they can with safety obtain), hastens amalgamation.

Our nine millions of diluted Aframericans (there are left about 3,000,000 " pure " Negroes) are almost entirely the product of white men and black women in illegal unions. There have been, of course, many exceptional cases where the parties were wed. Since the first appearance of the Negro on these shores, many black men in the North have had white wives. White bondswomen in the early days frequently married Negro slaves. While in deepest Dixie, clandestine affairs between white women and black men have, to some extent, always gone on. But, generally speaking, the mulatto among us has been the issue of black concubines and white men.

This would necessarily be the case since, until the World War, the white woman was almost as much a serf in Dixie as the black man. There is an old American saying to the effect that the only free people in the United States were the white man and the Negro woman. But the political emancipation of American women at the beginning of the last decade, and the wartime migration of Negroes North for better jobs, considerably altered the inter-racial situation.

Frequently, during the last ten years, the white press has blazoned forth in scare headlines about intermarriages between white women and Negro men. Although white men had always had relationship with Negro women, it had been heatedly maintained by Negrophobes that the white woman (except possibly the lowest type) would never " stoop " to intimacy with the Negro man. This " reassuring " belief went with the old-fashioned notion that the female was more spiritual than the male, and " superior " (different) from him in all sexual matters. This notion has been so frequently exploded since 1920 that even the Anglo-Saxon Society would now not have the temerity to mention it. The latest defiance of this ancient taboo came from Carmel, California, where the Jean Toomer-Margaret Latimer nuptials took place under the auspices of the mayor and many well-known intellectuals.

In fact, the majority of the cases recorded in the papers show that most of the young women who have lately crossed the color line have been college graduates and daughters of so-called " good " families.

George S. Schuyler, in a booklet entitled *Racial Inter-Marriage in the United States* (No. 1387, Haldeman-Julius Blue Book), says there are as many as 10,000 inter-racial marriages now, four-fifths of which are the white-woman-black-man variety. A questionnaire sent by him to representative people in all the large cities in the " free " territory (where intermarriage is not a crime), elicited information upon nearly four thousand such legally united couples. In answer to the question concerning the reputation and character of the people in these marriages, Mr. Schuyler quotes the following replies as typical:

Cincinnati, Ohio. " They attract but little attention owing to the fact that they are reputable, quiet people."
Cleveland, Ohio. " Good. About the average."
New York City. " Many persons of exceptional education."
Salt Lake City, Utah. " Very good. Stay to themselves."
San Francisco and Oakland, Calif. " Very good in the majority of cases."
Minneapolis and St. Paul, Minn. " Above the average of the other unmixed groups and much more inconspicuous."

No exhaustive statistics have, of course, been obtained upon the subject. Owing to the controversial nature of the matter the parties are always anxious to keep out of the public print. Many of them employ an effective way of avoiding publicity. A white woman when applying for a marriage license has simply to state that she has remote Negro ancestry and the press and pulpit, always so eager to denounce such alliances, are silenced.

So general is the belief in the racial inferiority of the Negro in America, that one apparently has but to admit remote colored ancestry to be left unmolested. Negroes, being shrewder in such matters, are not so easily taken in. But even in the Deep South this method of safeguarding inter-racial relationships has been, and still is, employed. It would be impossible, therefore, to obtain the exact figures upon intermarriage any more than upon intermixture.

Not only has the white woman been said to be immune to the attraction of black men but, in Aframerica, there is an equally reassuring myth to the effect that black men do not want white women.

In spite of what most of the " Uncle Tom " Negro leaders say, the Negro man, being a man, is usually willing enough to be a party to a mixed affair. To say so openly, however, would jeopardise the patronage of white philanthropists who are willing to help the Negro solve the racial problem in every way except the natural one.

J. A. Rogers, who for the last five years has been doing research work in Europe on European race mixtures, says that the first thing which a " race " conscious Negro leader does on his arrival in the capitals abroad is to seek the white houses of pleasure. On the other hand, says Mr. Rogers (who acts as a guide to Americans in Paris and Berlin), the first thing a white Southerner, equally " race " conscious, wants to observe is a mixed resort where ebony ladies from the Congo are featured.

However, because of the severe penalties attached to the black-man-white-woman relationships in America, the Negro man is more the pursued than the pursuer in these affairs. Since the post-war glorification of Negro virility in literature, it has become ultra-smart among certain fashionable white women to have Negro lovers. *Sweet Man*, by Gilmore Millen (Viking Press, New York, 1930), is the first novel to picture this modern tendency of the white woman to indulge in the forbidden.

America's Changing Color Line

I have myself seen white women, college graduates holding responsible positions in the business world, make the flimsiest excuses in order to meet some important Negro man. Most white women have the mistaken idea that Negro men are easier to hold than white men. They imagine that the competition which they must face in their own group will disappear with a Negro. They do not realise that there are hundreds of beautiful and cultivated octoroons who have just as much to offer the Negro man as they have, with the additional advantage of safety.

The Negro group displays almost as much hostility to mixed marriages as the white does; especially where it is a black-man-white-woman union. If it is a colored woman and a white man the Negro seems to feel a certain triumph which softens his disapproval. The difference in attitude among Aframericans toward the Alice and Kip Rhinelander affair and the two marriages of Jack Johnson to white women was marked. They are proud of the former alliance, though it ended disgracefully, but Jack Johnson's preference for white wives greatly annoys them.

Negro women take the lead in the criticism of such matches. They greatly fear the competition of white women. They have been accustomed in the past to have the men of both groups, the one for lovers, the other for husbands, and dislike having the situation changed. My father, a member of the original Klan in Texas, tells me that the organisation was formed in his section at the behest of Negro women, who, after the Civil War, feared the white woman as a competitor.[1]

Late in the spring of 1928 two teachers in New York City, one a Negro man, the other a white woman, married. Mainly through the efforts of a colored woman, also a teacher, the marriage acquired a painful publicity and they were asked to resign. Later they were reinstated.

The *Amsterdam News*, May 20, 1925, reported that Mrs. Helen Croute, white, complained in Washington Heights Court that Negro women neighbors persecuted her because she was married to a Negro.

William Pickens made public the case of a Negro dentist of Portland, whose wife is white but of distant Negro extraction. She had never attempted to " pass " for anything but a Negro; nevertheless, the Negroes boycotted her husband, because they believed his wife to be legally white.

The greatest objection to white wives in Aframerica comes usually from Southern Negroes, just as it comes from Southern whites. When they move into free territory they bring their prejudices with them. Negroes who will resent a white wife will, however, feel no resentment against her offspring, since by the old law of the fatal drops of blood, her children have become Negroes. Indeed such offspring are greatly favored.

Grace Richardson, a white woman, writing in the *Messenger Magazine* for February 1928, says that the curiosity to know whether the baby will be cream color or chestnut is an alluring and exciting question to the white wife, making motherhood doubly interesting.

It has been loudly proclaimed by certain spokesmen of both races in America, that mulatto offspring are inferior to the parent stock of either side, and that, moreover, after the third generation mixed bloods are sterile. The habit of " passing " into the white race after the third generation of mixing gave a semblance of truth to the latter objection. Jean Finot, in *Race Prejudice*, pp. 156, 161 and 163, replies thus :

> In studying the origins of superior individuals in every country one notices with astonishment that nearly all are the result of crossed marriages.
> Where did Tylor find the most beautiful women in the world? At Tristan da Cunha . . . among the descendants of whites and Negroes.
> Cross-breeding has been facilitated by the complete fecundity of half-breeds and the sexual concord between representatives the furthest removed from one another.

Opinion upon racial intermixture is now undergoing a subtle change in America. Many anthropologists now say that there is no such thing as a " pure " race, and that the more mixed a people becomes, the more progressive it is liable to be. E. A. Hooton, of Harvard University, in *Up From the Ape* says :

> Every civilization grows up, to a great extent, from the borrowings and accretions of other cultures. The more isolated the habitat of a race or people the more disadvantageous is their situation from this point of view.

He does not think that sixty-five years of emancipation under conditions of economic, political, and social oppression, furnishes a fair basis for estimating the capacity of the Negro for civilisation nor for testing his individual intelligence. On p. 593 he continues :

[1] This is typical of the particular kind of lie the white Southern gentlemen put out. ED.

America's Changing Color Line

What possibilities of cultural achievement would an educated Roman living in Britain in the fourth century A.D. have attributed to the native inhabitants of that island? How much of "racial" or ethnic ability would Pericles have granted to contemporary Romans? How much intelligence and capacity for culture-building would Minos have assigned to the Athenians? What do you suppose Cheops thought of the Cretans? How did Europeans estimate the Japanese fifty years ago?

Dr. S. D. Porteus, of the University of Hawaii, in a cable to the *New York Times*, April 8, 1931, was quoted as saying:

> Some writers affirm that the results of race mixtures are extremely unfavorable, the children of such unions tending to inherit the worst features of the parent races.
> As far as our results throw any light on the question, this does not seem to be true. Such unfavorable opinions must have been formed in countries where children of racial mixtures tend to be of extremely inferior social status.

Dr. Charles Hill-Tout, speaking before the Royal Society of Canada, in Toronto, May 22, 1931, denied that a mixture of races usually retains the vices of both and the virtues of neither, declaring that mixed breeds were merely the victims of cultural prejudice.

The changing opinion toward intermixture may be due to the waning Anglo-Saxon element in our country. Louis Dublin, writing in the *New York Times*, Sunday, April 17, gives the following figures: in the census of 1890 the percentage of Nordic blood in the white population here was: British 13·2, Irish 23·3, Scandinavian 7·5, German 33·2, Canadian-Others 6·1. By 1930 it had declined to: British 9·4, Irish 9·8, Scandinavian 8·3, German 17·7, Canadian-Others 5·8. That is, from 83·3 to 51, a loss of 32·3.

According to an article by Raymond Leslie Buell (*New York Times*, April 24, 1932) the total area of our colonial empire and our "spheres of interest" (possessions that we "boss" but do not admit we own) amount to more than a million square miles and embrace a total population of 29,427,418.

This includes the Philippines, Porto Rico, Hawaii, Panama Canal Zone, Virgin Islands, Guam, American Samoa, Cuba, Dominican Republic, Haiti, Panama, Costa Rica, Nicaragua, Honduras, Salvador, Guatemala, Liberia and Alaska. With the exception of the latter (59,000 population, many of them Indians), these Colonials are predominantly colored and will exert much pressure upon our future opinions. Add to the Colonials 12,000,000 Negroes residing within the States, and the extent to which America is becoming dark can readily be seen.

With immigration practically ended, we cannot expect any great influx of Nordics, or of any whites whatsoever, in numbers sufficiently large enough to maintain our former division of color. The darker the white group grows, the more ridiculous color prejudice becomes. There being neither religious nor educational differences but only color differences between the races here, prejudice will disappear with the erasure of strongly contrasting peoples.

A less virulent prejudice is always to be found in our cities which have large numbers of dark whites. San Antonio, El Paso, San Diego, with large Oriental populations, are far less prejudiced than Boston, that prides itself on Abolitionist tradition. New York City is the least prejudiced place in the United States, due to the presence there of millions of dark whites like the Jews, Italians, Greeks, French, Slavs, South Americans, and of Orientals and East and West Indians.

America's darkening complexion will bring with it a train of cultural advantages:

A greater tolerance—therefore a more civilised attitude toward life. Less bastardy and lynching—therefore finer ethics. Better educational facilities in the South—hence less monkey-shines about evolution and science and less "old time religion." Finally, that future war between the white and colored races, which is always being dolefully predicted, may be averted.

It is the opinion of Dr. Oliveira Lima, former Minister of Brazil in Washington, who himself hails from a country of mixed races, that free racial intermixture is not only safer for a nation, but is an excellent thing. Says Dr. Lima, writing in the *Missionary Review of the World*, July 1924:

> Racial intermarriage, if permitted, might put an end to the "black peril" (in the United States), which may become a most pressing and serious matter. . . . As a Brazilian white man I cannot help rejoicing that such a problem is not to be found in Hispanic America and that from such intermarriage no evil consequences have resulted. . . . In South America our experience of centuries has taught us that there is no real understanding except the one that comes through the fusion of races.

From "Three Thousand Miles on a Dime in Ten Days"

by PAULI MURRAY

(They were stranded in San Francisco and they had a dime. Pete's mother was desperately ill in New York and calling for him; so they "jumped the rails"[1] all the way back.)

Pete

SOME of the fellows crowded round us when they found out we wanted to go to New York, and each one gave us a different route back. Some said go south and pick up the Santa Fé trail, some said go north to Seattle, others suggested Butte, Montana; still others proposed riding the freights out of the S.P. yards that night. The boys got interested in us, took us up to a Seamen's Mission on Pine St., and gave us some kind of hard pastry with icing like white rock. Then a hobo with a mean reputation told us he'd show us how to catch a train out that night for Chicago, if we had the nerve to jump it. Pete said we had the nerve.

.

The guy who promised to help us catch the freight got squeamish —he said he didn't like to see such young kids on the road alone, and told us to wait a couple of days and go east with him. Pete was going to catch that train tonight. We went down to the edge of the town and lay around in the weeds, watching for the headlights to show up.

My heart was knocking in my chest. I had never tried to catch a freight, and now the stories of hoboes who had lost their lives trying to jump trains flashed through my mind. I wondered how nervous Pete was. I couldn't tell, for he sat there joking with the other bums like a veteran. I didn't tell him I was scared.

By and by a whistle screeched from around the bend, two short—a " high-ball," the departing signal. Two other fellows were catching the same freight. They showed us how it was done. At first I thought it would be hard. Car after car rattled past before I got enough nerve to run along beside the train. It went faster. Pete had already swung up and was climbing to the top rail. I could scarcely see my pal in the dusk. I leaped at the rail with both hands, caught on, felt my feet thrown out in front, got a walloping impact from the side of the car, and then realised I was dangling in the air. I put one foot on the rung, then started to climb up. I got on top and found Pete stumbling back to meet me.

We crawled to the end of my car and sat there for hours. Lights streamed past us. I ducked and lay flat on my face whenever we passed a signal station, but the other two fellows just sat upright. Sometimes they waved at the watchmen.

When the train stopped the guides up front climbed down. We followed. They found an " empty "[2] and climbed into it. We squeezed in behind them, in pitch blackness. One guy lighted a match in his corner and peered at us new-comers. We saw about twenty other " passengers " in the shadows.

We rode the old thing for more than 70 miles, and she rattled the meat off our bones. Sometimes a finger of light from some town crossing would travel down the car, a finger that spotted each hunching bum—some sprawled the length of their packs, some puffing a dead pipe, some rolling paper for cigarettes, some staring at the rafters, others curled up like cocoons fast asleep. At times the train threw us half across the splintered floor. Often her shoulders sagged and creaked and swayed until I wanted to yell for fear they would cave in.

.

When we got to Roseville we hopped off outside the yards and tramped through the town. On the other side we ran into about thirty other " stiffs "[3] all waiting to catch the four o'clock freight to Reno. As the hours passed more guys kept drifting in; bums from everywhere—jail-birds, veteran hoboes, suckers, gamblers, murderers, cowboys, Mexicans, Spaniards, half-breeds, and baby-faced youngsters, going east, to home and mother.

Just before she signalled to pull out, we all hid behind a shack below the depot, and lay thick as flies

[1] As stowaways on the trains. [2] An empty box-car. [3] Hobo, tramp.

in the tall grass away from the " bulls' " [1] eyes. She packed 130 cars and two engines, the rear one pulling some lumber cars and the caboose. Two " bulls " rode on top, one armed and in uniform, the other in plain clothes.

Some of the boys ran out to catch the front, but the first " dick " [1] kicked them off. That flustered the rest of us. We could see the " dicks " were hostile. It might mean a fight. We fell back in the weeds to outwit them. The second " dick " passed us about twenty cars from the caboose, running up to catch two boys who tried to re-board. The old sister started picking up speed. We had to grab her or stay behind. We ran for her. Right in the face of a " dick " I caught the back end of a box car, the most dangerous thing I could have done. She swung me around under the wheels, my ribs crashed into a rod but my feet hung clear. I got to the flat in time to glimpse the " bull " just behind me. Two " brakies " [2] were running up from the rear. I jumped from one flat on to another, took a leap and found myself lying on top of Pete underneath a car-load of hot new machines.

When it got so dark we couldn't see the countryside we all rolled up together, arms, legs and hands entangled, and slept. When we woke we were pulling into the Reno yards, at 1.30 in the morning. I fell, hopping from the flat, and cut my left palm on a rock. It took us a long time to find a place to wash in and then beg something to eat.

We fooled about the streets of Reno and dropped into a gambling joint. There we watched 'em play the dice, spin the roulette wheel and chuck their dimes to the fortune spin. One hard-faced girl and a slim blond fellow had a stack of roulette chips. They must have been " con men " [3] for the house. A few red-eyed women played desperately down to their last chip, then slunk away. Nobody seemed particular about cashing in.

We drifted to the back where the card tables were curtained off from the rest of the joint. They were pretty well filled with bottles and " big-shots." [4] Everybody stared at Pete and me so funny till we got nervous and stuck close to our buddie. They didn't say anything. We found out later that kids under 21 weren't allowed in gambling joints, but we didn't join in the games, so they let us stay.

The next make-up station was Sparks, five miles away. We had to walk all the way. When we got to the yards a fire off in the fields lured us. Two colored boys were cooking potatoes between some bricks. They said they were on their way to " Gaiguh." We looked about for firewood and came back with wet feet and empty hands. As the first grey streaks shot across the sky a loaded fruit express crawled toward the desert. We saw it a quarter-mile across the field. When we caught it, it was picking up fast. We hung on in the cold for more than an hour. My lefty twinged and I decided my feet had been cut off.

Daylight found us running back over the tops looking for an open " reefer." [5] After examining ten or more cars we found the ice cell of an orange car, steel-plated and floored with corrugated bars, with two air shafts on top. The cell was just large enough for three to stretch out.

By god! we rode in that prison across the desert for 18 hours without food, water or cigarettes. Finally we got so hungry we explored every inch of the cell for an opening in the orange crates. Pete kept a lookout while Oklahoma and I investigated. We loosened the slats on the bottom and worked our fingers underneath and through to the crates. One twist and our buddie had ripped open the end of a packing-case in the next compartment. I stuck my hand through and managed, by much scraping and bruising, to work out some of the fruit. We collected fifteen oranges apiece, which we quartered with our knives and sucked greedily. When we finished we wrapped the peelings up in the tissue covers and threw them out of the opening over the sides.

We had to ride the rails for a hundred miles. When we'd get to a town we'd jump off, run through the main street, around the yards, and pick the train up again as she came through. Sometimes in order to get to her we'd have to hop over two or three rows of freights, some standing still, some shifting. When they were moving, we'd have to jump them, climb over them and jump down on the other side. This was scary business because often the yards were big, and if the train threw you, you might land under the nose of a moving switch engine.

It was a cold windy night, the yards were full of brakies, and the headlights of switch engines played on our flattened bodies. The wind almost blew us off the tops. The only shelter we found was a " flat " [6] loaded with bridge wood. Pete and I crawled into the crevices made by the packing. There, sheltered

[1] The cops, also *dick*. [2] Brakeman, one of a freight crew. [3] Confidence man in a gambling house.
[4] Professional gambler. [5] Ice cell of a refrigerator car. [6] Flat car with no sides, used for hauling wood, etc.

Three Thousand Miles on a Dime in Ten Days

from the wind, we slept—and how good it was to sleep. Next morning when we woke up we noted that the heavy beams shifted with each lurch of the train and thus provided us with our crevices. We realised our danger. Had there come a lurch strong enough, some of the beams would have lost balance and crashed down on top of us.

From Cheyenne to Omaha it was a hit-and-run game with division " bulls." Now at each town we hopped a fast-mover, rushed through and grabbed her at the other end of the yards. In the larger divisions when the " bulls " caught a bum they sent him to work from two to thirty days with the rock pile gang. We were lucky enough to manœuvre without being spotted. Our game was slow, cautious, but sure. We rode cattle trains, fruit-butter-and-egg trains, " manifestoes " [1] and " hotshots." [2]

.

Pete hadn't mentioned his mother to me on the trip, but I knew nothing would stop him from trying for that train. He was too close to home to hang around now. He had always had a secret ambition to do some expert train-nabbing and cop-dodging. He wouldn't be satisfied until he could boast of nailing a freighter on the fly under the nose of a " bull." He had wanted to catch the *Twentieth Century Flyer* out of Chicago, but our Oklahoma buddie wouldn't think of it.

Funny thing about that Oklahoma guy—in the West he was at home, he knew the lines inch by inch, but in the East he was nervous and hesitant. He had never been east of the Mississippi and now the thought of going to New York must have frightened him.

The next fellow who drifted in told a wild tale about a " dick " who kicked a colored boy off a freight at just this spot a few weeks ago, then shot at him. The wounded man in turn pumped him with six bullets from a hidden gun. The cop rolled off dead. Since then the whole country was hostile to " niggers." A second fellow said two fellows had been lynched at Marion, Ohio, on this line a couple of hundred miles up the road, not along ago.

.

Finally, after much planning and whispering, many false alarms, and the filtering of twenty vagabonds along the track, we heard the " high-ball." The boys got ready. Pete tightened his belt and slung his pack. I began to shake. My heart thundered in my neck.

There she came, long, sleek, many-colored, steaming up the track. Sure enough two " dicks " were astride her, one in front and one in the back. Ranks broke, the bums ran for her. Pete, my buddie and I walked off into the field to escape notice and watch for our chance. The front copper saw us and jumped down parallel to us. He waited about ten cars and then reboarded, blocking our plan. Way up front several fellows made her. The copper started after them over the tops, shooting and yelling.

Pete leaped the fence. I followed—our Oklahoma buddie hesitated and in that moment of indecision lost all chance of making her. I jumped her on the fly—she threw me. I hung on desperately with one hand. My legs swung against the wheel bumpers, then back into the air. They numbed and hung limp. My cap fell off when my head hit the side. It sailed in the wind and landed by the rail a couple of cars back. I thought I was dying. I couldn't use my feet. Every second I expected the copper to shoot at me. I felt myself going, my hand was slipping. If I let go, it was sure death. I called to Pete—no answer. The train was flying now and things were spinning around before my eyes. I went off into a daze for a second. Then things cleared. My legs woke up and I found the footrail. For fifteen miles I rode flattened against the outside of the car for fear of detection.

.

Late evening brought us into the Jersey City yards. A ride through the Holland Tunnel with some kind motorists and we were dumped outside the Seventh Avenue subway. With our Lucky Dime between us we got two nickles and pushed through the turnstiles, the last lap which brought us uptown and home. We'd seen our bit of the world, we were worried, weary, starved and exhausted, but there lingered a song in our hearts:

The Song of the Highway

I am the Highway,
Long, white, winding Highway,
Binding coast to coast
And people to people;
I am the spine of the earth.

Over the hills I glide
And then, come swooping down
To some deserted spot.
Over river and lake I stride—
Through farm and field, and town,
Through desert sands, white-hot.

[1] Non-stop fast express freight.

[2] Fast express freight.

I laugh when the brooklets laugh,
And weep with wayside trees
So bent—so broken by the wind.
Sometimes the birds and flowers
Fill my path with song and bloom;
Sometimes a fragrant breeze
Leaves me drenched with faint perfume.

I hear the sounds of earth—
The low of cattle on the plains,
Clatter of hoof, sound of horn,
Rustling fields of rye,
Of wheat, of tassled corn ;
Sweet sounds, so dear—
As through the year
Life marches on.

I am old—sad things I know,
Ache of road-worn travelers,
Lonely hours; the tragedy of pioneers
Who trudged through scorching lands,
Through rain—and snow,
Who bartered with famine—thirst—
And death—to give me birth.

But on I go in silence,
For those who know my life
Will sing my song,
Song of the Highway,
Long, white, winding Highway.

The Colored Girls of Passenack—
Old and New

by WILLIAM CARLOS WILLIAMS

GEORGIE ANDERSON came to our home in 1895, or thereabouts, when my brother and I were from ten to twelve years old. She cannot have been more than eighteen herself, a strong, slim girl for whom both of us had the greatest affection and admiration. She was full of fun, loved rough-house games and told stories to us of her life down South before coming to work in the vicinity of New York. Left-handed, she could stand in our backyard and peg a stone into the top of a big chestnut tree two houses below us along the street. We ourselves could just about reach its middle.

Georgie was black. Sometimes they'd send her up a mess of chincopins, which she said grew on bushes down in Carolina. We were much impressed.

I can still remember how in the evenings we'd rush to get through supper and pile out into the kitchen where she and her attentive admirer, Adolf, would be sitting. We couldn't get there fast enough for the talk and the fun.

My father's half-brother, Godwin, enjoyed Georgie also—but he was more bent on teasing her than anything else. He was a little queer in the head, so that the spooks of which he was continually talking became finally very real to us. But Georgie professed not to believe in such trifles. Godwin, however, enjoyed his game and kept at it for weeks, giving Georgie many accounts of his prowess in the spirit world.

Once after supper, when we were all sitting together, Godwin told Georgie he felt a spirit very strongly within him that night. He'd shake his head and make a growling sound with his lips, saying that it was the spook trying to get hold of him. Georgie kept answering, " Aw gwan," as usual, but we were all intently watching my uncle. The gas flare was as bright as always, when suddenly he looked fixedly at an alarm clock among other things on the shelf over our kitchen range. " Do you see that clock? " said my uncle to Georgie. " Yes," she answered, " I sees it." " Well, if I tell that clock to jump off that shelf," said my uncle, " it will do so." " Go wan," said Georgie, " let's see you do it." " Do you want me to make that clock jump off the shelf? " said my uncle. " Yes, that's jus' what I want." So with that my uncle made a few passes with his hand and talked to the clock, while all our eyes were fastened on it with vivid fascination. He kept on talking slowly, then, at the end, loudly and firmly he said to the clock, " Jump ! " and as he raised his hands the clock leaped into the air and landed with a crash at our feet. Georgie let out a wild yell and fled through the back door into the dark. My brother and I, though mystified, were not quite convinced, but struggled heroically between laughter and amazement. My father came into the room at the crash and gave Godwin a disgusted call-down after telling him he would have to pay for the clock. He had had a black thread tied from one of its feet around his right wrist.

The Colored Girls of Passenack—Old and New

Georgie was wild as a cat. More than once she would return at dawn from a night out and climb up over the grape arbor on to the rear roof to gain access through the bathroom window to the attic stairs and her room.

She liked my father, who knew colored people from his West Indian days, but she had a holy respect for him. He didn't say much to her, but when he did you could see she felt it. One day she was late with breakfast as usual. As she came into the room he turned to her and said, " Come on, you Virginia Creeper, get a move on you." That mortally offended Georgie. No sir, she didn't mind being cussed, but no man was going to call her no Virginia Creeper. What associations the term had in her mind I could never imagine.

Girls were paid twelve dollars a month in those days. God knows they didn't deserve more. Georgie was a vile cook and a sloppy washwoman, but I imagine even my parents rather forgave her her worthlessness for the sheer vitality and animal attractiveness there was in her. She had a queer trick too, which my father caught her at one day. She seems to have belonged to a religious group known as " Clay Eaters " back home. He went down in the cellar one day and there she stood calmly eating a little heap of earth which she had gathered for herself. He asked her what she was doing. She told him quite simply that she was eating dirt, that the Bible said we all had to eat a peck of dirt in our day, and that she was eating hers little by little.

Naturally she was to us boys, like the rest of femininity, a source of sexual curiosity. For myself, I know that I desired nothing on this earth as I did a sight, a mere sight, of a naked female. I even prayed at night for knowledge of the sort. I begged God, I pleaded, I promised all sorts of virtuous abstinences if only I could clap my eyes upon a girl naked before me. My wish went no further at that time, save perhaps that I might talk to her, stroke her, make her understand my desire.

Some of the boys at school were more daring, however. One day we had two of that sort up in the attic. It was a rainy day, we had been playing tops, slamming them down hard on the attic floor.

I remember the names of the two ringleaders : Willie Harris and Joe Hedges. No doubt we had been swapping smutty cracks of one sort or another, when we heard Georgie come up and go into her room. This room was made of heavy canvas only, which my father had calsomined on the inside. It was our servant girl's room. There was our chance !

As it happened, Georgie had come up to give herself a bath. She knew we were there, she even spoke to us while we were up to our smart trick ; I think she surely saw each eye clapped to the hole in turn, but she went on with what she was doing just the same. I remember my own turn at the peep-hole as if it were this morning. I suppose Georgie was the first woman I ever saw naked—the first young woman anyway. She had nothing but a china basin to wash herself in. This she had placed on the floor. She was standing in it, facing me, fully naked, and washing herself down with a sponge. My view was not too good—I was half lying on the floor with the others pulling at me to take their turn also—but it was a thrilling picture.

I remember one other colored woman, many years later, who had come to my office for a pretended examination, stripping herself naked before me. She was built in the style of Goya's Muja Desnuda, but her laughter and gestures were pure Africa. Mabel Watts her name was, she cared little for her own race, due, no doubt, to the great success she had had with white men about town. She liked me and I liked her greatly, having cared for her many years through the greatest misfortunes. She would tell me "everything," always coming to me for advice and assistance when she was in trouble. She must have had a magnificent constitution, for, in spite of the most harrowing experiences, she never seemed to grow older or to lose her flashing smile and good nature. My wife, too, admired her for her intelligence and ability as a maid. Her service at table was a delight, her washing, which she did like lightning, was perfect in every way. But she knew too much—and, well, she just wasn't wanted around too long where men were likely to be.

But she wasn't fresh. She offered and, when refused, laughed it off without a word. " Why don't you go on the stage, Mabel? " I asked her. " No, I don't want to end up in a ditch with a knife in my back," was her reply. " And, anyhow, it's too much work."

I delivered her of two children, a boy and a girl. She lived in a little clean house near the railroad. Her husband left her after that, and she took in a boarder who gave her a venereal disease. I had her operated on for that, and, after she was well, she took another boarder, who, I am certain, strangled and killed her small daughter—who, he said, had had a convulsion while he was alone with her.

Mabel quit her place then and took a job in the house of a friend of mine, sending her boy to a charity school in the southern part of the State. She paid for his keep there, sent him presents and visited him occasionally, especially when he would be ill. Meanwhile, when my friend's wife went west with her

71

The Colored Girls of Passenack—Old and New

two children, Mabel kept house for the husband. He didn't want her to leave when the wife came back, but Mabel thought it was better that she go—I agreed with her, and it was so ordered.

It took her a long time to get her divorce from the man who had run away, but finally she succeeded in paying a lawyer the two hundred necessary. She worked hard all the while and kept herself immaculate on the street; her aprons were like snow, her dresses, usually black, were well cut; while on her hair, which she dressed, not as they do today—all slicked down—but up in some peculiar high and convoluted fashion, she would place a maid's pure white and crisply starched top piece.

Everybody knew her and liked her. She was always independent, always smiling, an individual by herself—never in the least subservient in her manner. Yet never pushing or insolent. She'd stop the policemen and talk with them, but, when passing older and more decorous citizens whom she knew, she was serious and respectful.

She told me many times of being picked up by fellows in cars or on motor cycles and taken for a ride, but she always had the fear of being stuck in the back with a knife and landing in a ditch, so this game didn't attract her overly.

She married finally a colored minister at least ten years older than herself, but I don't think she has stuck it out with him. She doesn't seem to have grown a day older during the past eighteen years—though she is a bit heavier—as she told me in the office recently.

The colored girls today have learned the trick of dress very ably. It's curious that in one generation they have changed so much, but their very bodies do not seem what they were when I was a child. Perhaps it is the dress, but I do not think so. Many of them have exceptionally fine features. And the vivacity, the awareness in their manner is like nothing the white can offer. The American white girl today is shop-worn compared to the Negro girl—at her liveliest. All the simplicity of mind which " virtue " should imply lies with the Negro girl. It is not easy to give accurate values to what I am attempting.

Put it this way: about New York City the old-fashioned Negro woman is gone—or almost gone. In her place we have the wives and children of employed men who can own their own houses, often keenly intelligent individuals who live entirely apart from the rest of us. The release which the taboo against the race induces comes out sometimes in the faces of the young girls as a princely and delicate beauty—which with the manner of their walk, the muscular quality of their contours, the firmness, makes most white girls clumsy, awkward, cheap beside them. There is nothing much in the depths of most white girls' eyes. Colored girls—a few of them—seem a racial confessional of beauty—lost today anywhere else.

I've seen tremendous furnaces of emotional power in certain colored women unmatched in any white —outside perhaps the devotional females who make up society, whose decadent fervors are so little understood. There, in the heat of " entertainments " of pleasure perhaps the Negro woman can be matched. Perhaps the fervent type is more accessible in the colored race because it is not removed to socially restricted areas. I don't know. But I do know that I have had my breath taken away by sights of colored women that no white women could equal.

Once I went to call on a patient in a nearby suburb. As the door opened to my ring, a magnificent bronze figure taller than I, fairly vibrant with a sullen attentiveness, stood before me. She said not a word, but stood there till I told her who I was. Then she let me in, turned her back and walked into the kitchen. But the force of her—something, her mental alertness coupled with her erectness, muscular power, youth, seriousness, her actuality—made me want to create a new race on the spot. I had never seen anything like it. I asked the lady of the house sometime later what had become of the girl. " Oh," she said, " she was a married woman. Her husband is a smart caterer. They got mixed up with the law somehow, bootlegging I suppose, and had to beat it. I once caught her with her hand right in my purse. When I spoke to her, she merely closed the purse and handed it to me as if nothing had happened. There was nothing more said about it."

A wide-eyed alert girl who worked for us a short time this year—another magnificent physical specimen—had recently obtained a divorce from her husband. " Oh, there are too many girls after him," she told my wife. " He don't have to work." She had a baby which she was boarding with a neighbor when she went out in the morning. She told of having worked in a Chinese laundry during the past year. The Chinamen had several of these girls ironing in the front of the shop behind the window facing the street. All they did was iron the shirt fronts and sleeves, the Chinamen themselves did the cuffs and collars.

But this man began to make advances to her, so that she had to leave the shop one day and send her husband to collect her back pay, which he did. She said that one of her friends who had worked in the

72

The Colored Girls of Passenack—Old and New

same shop had been taken ill once and that the Chinaman had taken her in a cab to New York to the hospital—and that was the last they saw of her.

One of my patients told me that her laundress—herself a young colored woman—told her that if any colored girl in Passenack of sixteen or over said she was a virgin, you could put her down for a liar. One day this same colored laundress told my friend in the middle of the morning that she had to go home. " But you can't do that, Julie," said my friend to her. " Why the work isn't finished." " I'm sorry, Mrs. R., but I gotta go," replied the laundress. " I just had a hunch that he ain't alone in bed the way I left him this morning."

So the woman went away—nothing could stop her—and in a couple of hours she returned. " Well," said my friend, " did your hunch work out the way you thought it would? " " Yes, just the way I thought," said the woman. " I knew he was lying to me." " What happened? " asked my friend. " Oh, nothin' special, only when I got there he was sittin' on the edge of the bed with one of those girls down there I was tellin' you about. He said they weren't doin' nothin', but I know better."

" And what did the girl do when you arrived? " asked my friend.

" She? She didn't do nothin'," said the laundress. " She just set there. I told her to git on out of my house, but she just laughed at me."

" What? And is she still there? "

" Yes, ma'm. You don't know them young colored women. They're all banded together. What they likes best is married men, the young married men mostly, and they all sticks together and, if we married women gets in their way, they don't stop at nothin'. That's what ruins husbands—when a lot of young girls just keeps 'em for their pleasure."

From "Racial Integrity":
A Plea for the Establishment of a Chair
of Negro History

by ARTHUR A. SCHOMBURG

Secretary of the Negro Society for Historical Research.

Arthur A. Schomburg

THE earliest record of one of our educated men born in America and credited with having studied at a university is that of the poet Francis Williams. "This remarkable person was named Francis Williams, the son of John and Dorothy Williams, free Negroes. Francis, who was a lively, intelligent lad, was selected as the subject of an experiment by the Duke of Montague, who was anxious to know whether a Negro lad, trained at a grammar school and then at a university, would be found equal in literary attainments to a white man. Francis graduated from Cambridge University with the degree of Bachelor of Science, returned to Jamaica and opened a school in Spanish Town, where he imparted a classical and mathematical education." (Gardner's *History of Jamaica*.)

Blumenbach, the famous ethnologist, was the first European to have collected a library of Negro authors. And among the books that he deemed interesting was that of our poetess, Phillis Wheatley, who had no contemporary in America. And in Thomas Clarkson's famous *Essay on the Slavery of the Human Species* her poems are used to good purpose. The Abbé Grégoire, General George Washington and Thomas Jefferson, who said "that religion only could produce a Phillis Wheatley"—these, the mighty pens of the world in those days, have set down the deeds of our first poetess. And no professor of English literature can pull off the halo or the crown of laurel leaves which beatify her maidenly brow.

Juan Latino sang the praises of Don Juan of Austria at the battle of Lepanto; his book, which was printed at Granada in 1573 (one of the most remarkable and rarest of books), can be seen and read at the Boston Public Library in the Ticknor collection of Spanish literature. Latino's life is full of romantic episodes for a slave. He applied for the degree of Doctor of Arts at the University of Granada, and the preceptors who opposed him were the first after his successful examination to publicly acclaim him the most learned in the Latin language. When the chair of Poetry became vacant he came out ahead of his competitors and won the cathedra. Antonio, in his *Bibliotheca Nova*, pays an excellent tribute to his learning and wisdom. It should be remembered that Juan took the name Latino when he applied for his degree and it was not given him as a nickname as some writers claim.

Anthony William Amo was born on the coast of Guinea and studied at Halle, Saxony, and at the University of Wittenberg. He was learned in Greek, Latin, and spoke Hebrew, Dutch, French and German. He is well remembered by Blumenbach and Grégoire. He wrote two books, one a philosophical dissertation on the *Want of Feeling*, which obtained the approbation of the University and won the doctor's degree for him. The other was a philosophical treatise containing a succinct discussion of those sensations which pertain both to the mind and to the living organic body. These volumes were published in the year 1734.

J. E. J. Capitein was also born in Africa and studied at the Hague, whence he entered the University of Leyden and took his degree during 1740. He published a treatise on the Calling of the Gentiles, *De Vocatione Ethnicorum*, which he divided into three parts. This was a pro-slavery work, and ran through three editions. There is still extant by the same author a book of sermons in Dutch, which was printed in Amsterdam in 1742.

We are indebted to Mr. Joseph Jekyll for a sketch of Ignatius Sancho's life. Among other things he says: "The display those writings exhibit of epistolary talent, of rapid and just conception, of wild patriotism and universal philanthropy may well apologize for the protection of the Great, and the friend-

ship of the literary." The late Duchess of Queensbury and Northumberland pressed forward to serve the author. Garrick and Sterne were well acquainted with Ignatius Sancho. Two pieces were constructed for the State, *The Theory of Music* was discussed, published and dedicated to the Royal Princess, and painting was so much within the circle of Ignatius Sancho's judgment and criticism that Mortimer came often to consult him. Such was the man whose species philosophers and anatomists have endeavoured to degrade as a deterioration of the human; and such was the man Fuller with a benevolence and quaintness of phrase peculiarly his own accounted " God's image in ebony." The first edition of 2 volumes of Ignatius Sancho's letters was published in London, 1782. They have run through 10 known editions, the last edition being in one volume. It has a picture of Gainsborough engraved by Bartolozzi.

J. Ludolph's *History of Æthiopia* was written in Latin and Coptic and published in four folio volumes from 1681–1694. " In the compilation," says the Rev. Dr. J. Lewis Kraft, " Ludolph received great assistance from Abbas Gregorius, the Amharic Patriarch, whose portrait is prefixed to the second, and who resided with Ludolph for a short time at the court of the ancestor of the Prince Consort, Duke Ernest of Saxe-Gotha." (Kraft's *Abyssinia*.) " Many Abyssinians have curly hair as the famous Abbas Gregorius, whose handsome likeness," says Blumenbach, " which Heiss engraved in 1691 after Van Sand, I have before me." Even Ludolph in his description of the patriarch says he had " curly hair like other Æthiopians."

The narrative of Gustavus Vassa of Esaka, Africa, was first published in two volumes in 1784. It has run through 10 English, 1 German and 4 American editions. A most commendable work, it does not only relate to slavery in the United States and elsewhere, but to the important part he played in the Abolition of the Slave Trade. His dealings with Granville Sharp, his petition to the House of Parliament and the fact that he was the first Negro to have gone in quest of the North Pole in the Luisberg 1758 expedition as an attendant, are eloquently told in the narrative.

Phillis Wheatley was our peerless poetess. Her first book of poems was printed in London in 1773; it was followed by a second London edition in the same year. Another edition was printed in Walpole, N.H., in 1802, then followed a Philadelphia, Albany and several other issues, with a short biography during the years 1834-5-6-7-8, at Boston. Still another edition was published at Denver, Colorado, in 1887. The first edition published by a Negro was by R. R. Wright, Jr., at Philadelphia. Mr. Deane published an edition of 100 copies of her letters in 1864, which was read before the Mass. Historical Society. Individual broadside poems preceded her book. After her marriage many of her poems were published under the name of Phillis Peters.

The Poems of a Slave, by George M. Horton of North Carolina, the author of *Praises of Creation*, and on whose behalf Joshua Coffin took great interest to purchase his freedom, is a booklet of unusual merit, and deserves the consideration of disinterested racial men who will reprint it for the better appreciation of this generation.

The poets Whitefield of Buffalo, Islay Walden, the blind poet of North Carolina, and Whitman of Florida are additional evidences of the mental ability of our men to scale the heights of Mount Olympus.

The late Frances E. Watkins Harper, a novelist as well as a poetess and lecturer, whose lyre was always tuned in defence of righteousness and who ever pleaded for as clean a ministry as for our rights, should be remembered. Mr. J. J. Thomas, the author of the *Creole Grammar*, says, " But it is as a poet that posterity will hail her in the coming ages of our race; for pathos, depth of spiritual insight, and magical exercise of a rare power of self utterance, it will hardly be questioned that she has surpassed every competitor among females—white or black—save and except Elizabeth Barrett Browning, with whom the gifted African stands on much the same plane of poetic excellence." (*Froudacity*, p. 259.)

In far Demerara, British Guiana, there lived " Leo " the poet (Egbert Martin). He was much revered and loved. One of the stanzas in the British national anthem is his. It was put there after a commission had invited the entire British Empire to participate. *Leo's Poems* was printed in London during 1888.

The poetical works of D. A. Payne, Charlotte Forten Grimke, J. Madison Bell, and other stars of different degrees of magnitude are entitled to meritorious consideration by our learned men. Paul Laurence Dunbar's work needs no fulsome praise from me.

Walker's Appeal was a remarkable brochure. Very few persons of this generation know of it, and those of the past have expressed a cold desire to inspect its pages. It was written by a Negro named David Walker, formerly of Wilmington, N.C., but at that time of Boston, Mass. His pamphlet was circulated

wherever that stain of slavery was apparent, it ran through three editions. And the Rev. Henry Highland Garnet republished it and had it added to a lecture he gave in 1844. It created the wildest feeling in the Southern States and every effort was made by the Southern executives to quench the spirit that animated *Walker's Appeal*. Samuel J. May in his *Recollections of our Anti-Slavery Conflict* (p. 163) says: " In September 1829 he published his ' Appeal ' to the colored citizens of the world, in particular and very expressly to those of the United States. . . . It was a pamphlet of more than 80 octavo pages, ably written, very impassioned and well adapted to its purposes. The 2nd and 3rd editions of it were published in less than 12 months, and to them Mr. Walker devoted himself until his death, which happened soon after his appeal to colored men." *Walker's Appeal* is one of the rarest anti-slavery tracts. Here is an illustration of a Negro sending seditious literature to disseminate the ghastly truth of the debasing influence of slavery, or as Crummell had said, the " bold outcry." So is the Rev. Coker's *A Dialogue between a Virginian and an African Minister*, printed in Baltimore, Maryland.

The slave narratives offer a vast field to select from ; they represent a collection of facts mingled with pain. The anguish and the vicissitudes are related with candor and pathos. And yet there is much of invaluable use, pertaining to different States, telling of conditions to be found elsewhere. John Brown's narrative deals with slavery in Georgia, William Wells Brown with Kentucky and Missouri, whereas Frederick Douglass and Samuel Ringgold Ward deal with conditions in Maryland. Each one gives the different shading to the subject and portrays with remarkable fidelity the naked truth.

Frederick Douglass of imperishable memory was the " cataract that roared." His imagery was fine, vivid. He told the story of his wrongs, so that they stood out in all their naked ugliness. And Samuel Ringgold Ward was the debater, the wit, always self-possessed and never disconcerted, always clear and forcible. He had the power not only to examine but to enable you to see the fairness of that examination and the justness of its conclusions. Such was the opinion of William J. Wilson, after having heard these two champions debate. The work carried on and done independently by Samuel R. Ward in England, in behalf of our cause, has not received the proper appreciation of our people. The *Narrative, My Bondage and my Freedom*, and others of Douglass' pamphlets, together with Ward's *Autobiography of a Run-away Slave*, are useful and inspiring models for our children to have before them.

Alexandre Pouschkin, a Negro descendant, has crowned himself with glory in Russia. Few of his works have been translated into English, except *Prose Tales* (Keane, ed.), *Marie, The Captain's Daughter*, and his narrative of his grandfather, an unfinished work. He was a prolific writer. Suffice it to say that he was a luminary in Russian literature and as a poet was called the " Black Byron."

The works of Alexandre Dumas are too well known for me to bring to your notice. He was the king of romance and historical novels.

Clothel, or the President's Daughter, by William Wells Brown, was one of the first anti-slavery novels written by our men. It was originally printed in London in 1853 and in America at the close of the same year. The London publication says that Thomas Jefferson was the father of two slave girls, Clothel and Althesa. But in the later, the American edition, no mention is made of the circumstance. Frank J. Webb published in London *The Garies and their Friends*, with an introduction by Mrs. Harriet B. Stowe and a prefatory letter from Lord Brougham. Dunbar's novels, his *Uncalled, Fanatics, The Heart of Happy Hollow*, and others, are sure indication of the usefulness of this kind of reading matter.

James Anthony Froude, the great English historian, the Herodotus of English polite letters, during the year 1888 took a trip to the West Indies and wrote a book entitled *The British in the West Indies*, which reflects on the Negroes of the several islands as well as on the ability of the islanders to measure up to any degree of representation. Up to this time Froude enjoyed the praises of the English-speaking critics. It was left for a Negro from Trinidad, who is noted for having given the Creole language the dignity of a grammar—the Hon. John Jacob Thomas—to come forward and answer the mighty Froude. Mr. C. Salmon, an Englishman, be it said, took Mr. Froude to task for some aspersions in a book called *West Indian Confederation*. Thence came Thomas, who not only set to rights the pages of Mr. Froude's book, but showed the English-speaking people the fallacy of this great man, his habit of misquoting history, how inaccurately he handled the king's English, how painful it was for him to set the book aright and correct sentence after sentence. This work of an obscure Negro opened the flood gates. And the English critics took notice and the downfall of the English Herodotus occurred with a dull sickening thud. Mr. Thomas' book is called *Froudacity*. It was coined from the words " Froude-Audacity " and was published in Philadelphia in 1890.

In 1892 Mr. F. A. Durham, an African, published the *Lone Star of Liberia* and took pains to express

Racial Integrity

his opinion of Froude and things English. Thence came Mr. Leger of the Haitian diplomatic service to add a little more castigation to Froude in his book *Haiti, her History and her Detractors*.

There have been written many histories of our people in slavery, peace and war, each one serving a purpose. From Alexander's history in 1888 to George W. Williams' *History of the Negro Race in America*, published in 1893, there is an improvement. The latter is not perfect, yet no other work has appeared to eclipse it. No books have been read with more zeal and interest than Wilson's *Black Phalanx*, William C. Nell's *The Negro Patriots of the Revolution*, and William Wells Brown's *The Black Man* and *Rising Sun*. These have been our landmarks, our rock of ages.

The Rev. Alexander Crummell, the English scholar, the author of the *Future of Africa*, *Africa and America*, and *The Greatness of Christ*, is the peer of any divine of excellence in his church. Archdeacon Phillips of Philadelphia has well said of Crummell, " as a thinker and writer he had no superior among the colored men of his country and not many among the whites. . . . Whoever studies his writings will drink deep from the well of English undefiled." (*In Memoriam*.)

Among our men who have attained distinction for having in any measure served in any exploration, mention must be made of Bishop Crowther's *Journal of an Expedition up the Niger and Tshadda Rivers*, published in London in 1855. The book telling of the work carried out by the members is in itself very illuminating. Years afterwards, another expedition was undertaken from the United States; Dr. Martin R. Delany and the scientist Robert Campbell, a former professor of the Institute for Colored Youth, were members of the expedition who have left tangible evidences of their ability and attainment, the former in his *Official Report of the Niger Valley Exploring Party*, and the latter in *A Pilgrimage to my Motherland*, both published during 1861.

Bannaker's Almanacs, Symonds' *Men of Mark*, Still's *Underground Railroad*, Africanus Horton's medical books on African fevers are notable works. John Mensah Sarbah, the distinguished lawyer who was knighted by Queen Victoria and made a Companion of the most distinguished order of the C.M.G. for having given the English nation *The Fanti Customary Laws*, must be mentioned also.

We must bear in mind that galaxy of Haitian writers and poets. Spencer St. John, who was so bitter in his book against the Haitians, devotes 17 pages to the serious consideration of its literature. He pays a high compliment to Madiou fils' *The History of Haiti* in 4 volumes, and Ardouin's *Etudes sur l'Histoire d'Haiti* in 11 octavo volumes.

This paper is devoted exclusively to Negro authors who have striven in life to help their fellow men; for that reason I have not mentioned our sincere and helpful white friends who fought and battled with us. Such as Blumenbach in his *Anthropological Treatises*; Abbé Grégoire in his *Littérature des Nègres*; Thomas Clarkson in his *Works and Essays*; Anthony Benezet in his Tracts; Granville Sharp in his many tomes; L. Maria Child in her *Appeal* and her *Freedom's Book*; Armistead in his *Tribute to the Negro*, and others.

We have reached the crucial period of our educational existence. I have shown by a few examples of the past available and useful material upon which we can base our future structure. We have chairs of almost everything, and believe we lack nothing, but we sadly need a chair of Negro history. The white institutions have their chair of history; it is the history of their people, and whenever the Negro is mentioned in the text-books it dwindles down to a footnote. The white scholar's mind and heart are fired because in the temple of learning he is told how on March 5, 1770, the Americans were able to beat the English; but to find Crispus Attucks it is necessary to go deep into special books. In the orations delivered at Bunker's Hill, Daniel Webster never mentioned the Negroes having done anything, and is silent about Peter Salem. In the account of the battle of Long Island City and around New York under Major-General Nathaniel Greene, no mention is made of the 800 Negro soldiers who imperilled their lives in the Revolutionary War. Cases can be shown right and left of such palpable omissions.

Where is our historian to give us our side view and our chair of Negro history, to teach our people our own history? We are at the mercy of the " flotsam and jetsam " of the white writers. The very learned Rev. Alexander Crummell, before the American Negro Academy, stated that he heard J. C. Calhoun say that the inferiority of the Negro was so self-evident that he would not believe him human unless he could conjugate Greek verbs; and yet it must have been evident to Calhoun that in North Carolina there were many Negroes held as slaves who could read and write Arabic (see Hodgson, W. B., *The Gospels in the Negro Patois*, etc., N.Y., 1857). In those days men like Juan Latino, Amo, Capitein, Francis Williams, Rev. J. Pennington and others could not only conjugate the Greek and Hebrew verbs,

but had shown unmistakable evidences of learning, for they had received degrees from the Universities of world-famed reputation. Yet in those days there were many whites unrestrained, enjoying the opportunities of education, who could not conjugate Greek roots nor verbs of the spoken language of the land. Yet this barrier was set up to persons restrained by force from the enjoyment of the most ordinary rights.

We need in the coming dawn the man who will give us the background for our future; it matters not whether he comes from the cloisters of the university or from the rank and file of the fields.

The Anglo-Saxon is effusive in his praises to the Saxon shepherds who lived on the banks of the river Elbe, to whom he pays blind allegiance. We need the historian and philosopher to give us with trenchant pen the story of our forefathers. When the fact has been put down in the scroll of time, that the Negroes of Africa smelted iron and tempered bronzes at the time Europe was wielding stone implements, that " the use of letters was introduced among the savages of Europe about 1500 B.C. and the European carried them to America about the 15th century after the Christian era," that " Phœnicia and Palestine will live forever in the memory of mankind since America as well as Europe has received letters from the one and religion from the other " (Gibbon, *Decline and Fall of the Roman Empire*), we will feel prouder of the achievements of our sires.

The Growth of Negro Literature

by V. F. CALVERTON

NEGRO art and literature are, in many ways, as rich in ancient tradition as in modern challenge. The discoveries of archæologists, dating from the explorations of over a century ago, have disclosed the remnants of an African culture that hitherto was almost completely unknown. Tennyson's youthful apostrophe to Timbuctoo has a deeper meaning and import today. Timbuctoo stands now as but a single reminder of an ancient civilisation that was, perhaps, as rare in diversity and as advanced in ways of life as any civilisation, however adjacent or remote, of its time. The products of this civilisation, or if we wish to include the civilisations of Ethiopia, Ghana, Melle, and the Songhay in separate categories, then of these civilisations, are an eloquent testimony of their progress.

In the Songhay empire, for example, education was advanced to such a point that people came from all over the Islamic world to teach in its schools; and the savants of the Songhay were active also in Mohammedan countries to the north and east. In fact, throughout the Sudan, university life was fairly extensive. Ahmed Baba, one of the strongly arresting figures of his period, stands out as a brilliant example of the sweep of Sudanese erudition. An author of more than forty books upon such diverse themes as theology, astronomy, ethnography and biography, Baba was a scholar of great depth and inspiration. With his expatriation from Timbuctoo—he was in the city at the time that it was invaded by the Moroccans in 1592 and protested against their occupation of it—he lost, in his collection of 1,600 books, one of the richest libraries of his day. Ahmed Baba, of course, although the most conspicuous, was only one scholar amongst many. All through West Africa the Negroes had established many centres of learning. In their schools and universities courses were given in rhetoric, logic, eloquence, diction, the principles of arithmetic, hygiene, medicine, prosody, philosophy, ethnography, music and astronomy.[1] The Negro scholars in many instances surpassed the Arabian. In Ethiopia their contributions to culture streamed far beyond the borders of their own nation in influence and power. Every exploration and excavation of African materials adds to this historical revelation. We see rising before us, in the form of obscure manuscript, relics of apparel and architectural remains, the lives of peoples and the movements of civilisations once buried in the sands of a dead world. In this Negro ancestry there were discovered rulers who expanded their kingdoms into empires, generals who advanced the technique of military science, and scholars who brought with their wisdom an advancing vision of life.

When we realise, then, that the Negro is not without a cultural past, we can readily understand his

[1] *Negro Culture in West Africa*, by G. W. Ellis.

achievements in American art and literature in terms of environmental evolution. Most Americans, unacquainted with this past, and unappreciative of the potentialities of the black peoples, interpret the developments in Negro literature in ways that are immediately stultifying and absurd. One way is tragically familiar. Negro advance, according to this way of interpretation, is the result of the white blood infused in the black personality. The advocates of this interpretation have gone to great pains in their endeavour to prove that every Negro genius is a product of white miscegenation. Their argument that it is only through the presence of white blood that black genius can derive, is no more logical than the contention that it was only through the presence of black blood that Pushkin could develop into a white genius. Nevertheless this method of interpretation still prevails, even in circles that often pretend to be scientific. But there are other ways of interpretation that are scarcely less unfortunate in their logic—or lack of it. Another is the one that tries to treat the growth of the new Negro literature as a fad, which, in its sudden flare, reflects nothing more than an interest in the curious. The Negro, in the eyes of the critics, is an oddity, and as an artist and an intellectual is stranger far than fiction. Their explanation of his recent success is based mainly upon what they consider an aspect of patronage on the part of the reading public and the publisher. His work is greeted from the point of view of race and not of art. He is pampered as a Negro, and his work is praised often when it ought to be attacked. As a consequence, they are convinced that in a few years, as this illusion in reference to his work has begun to vanish, the interest in Negro literature will cease, and the urge in favour of its creation will correspondingly disappear.

Upon close analysis, these interpretations are seen to be at once irrelevant and futile. In the first place the Negro did advance and achieve in Africa before white blood could make its intrusion, and many Negro geniuses in America show very little trace of white blood at all; and, in the second place, his contributions to American art and literature are far more free of white influence than American culture is of English. Indeed, we may say that the contributions of the Negro to American culture are as indigenous to our soil as the legendary cowboy or gold-seeking frontiersman. And, in addition, it is no exaggeration whatsoever to contend that they are more striking and singular in substance and structure than any contributions that have been made by the white man to American culture. In fact, they constitute America's chief claim to originality in its cultural history. In song, the Negro spirituals and to a less extent the Blues; in tradition, Negro folklore; and in music, Negro jazz—these three constitute the Negro contribution to American culture. In fact, it can be said that they constitute all that is unique in our cultural life. Since Indian remains have been very largely exterminated, Indian culture, with its native originality, has been mainly lost. At least, enough does not remain to challenge the contributions of the Negro. When Dvořák sought to find an inspiration in American environment for his New World Symphony, he inevitably turned to the Negro. After all, the Negro, in his simple, unsophisticated way, has developed out of the American *milieu* a form of expression, a mood, a literary *genre*, a folk-tradition, that are distinctly and undeniably American. This is more than the white man has done. The white man in America has continued, and in an inferior manner, a culture of European origin. He has not developed a culture that is definitely and unequivocally American. In respect of originality, then, the Negro is more important in the growth of an American culture than the white man. His art is richer, more spontaneous, and more captivating and convincing in its appeal.

The social background of Negro life in itself was sufficient to inspire an art of no ordinary character. Indeed, the very fact that the Negro, by the nature of his environment, was deprived of education, prevented his art from ever becoming purely imitative. Even where he adopted the white man's substance, as in the case of religion, he never adopted his forms. He gave to whatever he took a new style and a new interpretation. In truth, he made it practically into a new thing. There were no ancient conventions that he, in his untutored zeal, felt duty-bound to respect, and no age-old traditions that instructed him, perforce, as to what was art and what was not. He could express his soul, as it were, without concern for grammar or the eye of the carping critic. As a result, his art is, as is all art that springs from the people, an artless art, and in that sense is the most genuine art of the world. While the white man has gone to Europe for his models, and is seeking still an European approval of his artistic endeavours, the Negro in his art forms has never gone beyond America for his background and has never sought the acclaim of any culture other than his own. This is particularly true of those forms of Negro art that come directly from the people. It is, of course, not so true of a poet such as Phyllis Wheatley or of the numerous Negro poets and artists of today, who in more ways than one have followed the traditions of their white contemporaries rather than extended and perfected the original art forms of their race. Of course, in the eighteenth century when Phyllis Wheatley wrote, these Negro art forms were scarcely more than

The Growth of Negro Literature

embryonic. Today, on the other hand, their existence has become a commonplace to the white writer as well as the black.

In a subtle way, Negro art and literature in America have had an economic origin. All that is original in Negro folklore, or singular in Negro spirituals and Blues, can be traced to the economic institution of slavery and its influence upon the Negro soul. The Negro lived in America as a slave for over two hundred and forty years. He was forced by the system of slavery into habits of life and forms of behaviour that inevitably drove him in the direction of emotional escape and religious delirium. Existence offered him nothing to hope for but endless labour and pain. Life was a continuous crucifixion. The earth became a place of evil. As a downtrodden and suppressed race he had nothing to discover within himself that insured emancipation or escape. His revolts had all proved ineffectual. Inevitably he turned toward the white man for the materials of his " under-dog " logic. He accepted and absorbed the ideas of the ruling class, as do most subordinate groups and classes, until they became a part of his reaction. The white man's paradise suddenly became a consuming aspiration. He became enamoured of it as a holy vision. His belief in it became a ferocious faith. Its other-worldly aspect only lent it a richer enchantment. There were no realistic categories to thwart or limit its undimensioned beauty and magnificence. The scarcities of this world had no meaning in the infinite plenitude of the next. Gold could be had for the asking, and everything was as dream would have it if in a land beyond the sun.

It was as an expression of this consecrated other-worldly ardour that the Negro spirituals came into being and grew into form. There is more, far more, than the ordinary Christian zeal embodied in them. These spirituals are not mere religious hymns written or recited to sweeten the service or improve the ritual. They are the aching, poignant cry of an entire people. Jesus to the Negro is no simple religious saviour, worshipped on Sundays and forgotten during the week. He is the incarnation of the suffering soul of a race. In such a spiritual as *Crucifixion* one finds this spirit manifest. Or in such a spiritual as *Swing Low Sweet Chariot* we discover the other-worldly motif in fine, moving form.

When we turn to the Blues and Labor Songs, the economic connection is more obvious. Here we have folklore in poetic form, springing spontaneously from the simple everyday life of an oppressed people. The Blues have a primitive kinship with the old ballads that is strikingly curious upon close comparison. While the rhyme-scheme employed in the Blues is often less clever and arresting than that found in the ballads, the incremental repetitions are not less effective, and the simple, quick descriptions are often as fine in this form as the other. The labor songs, growing up as part of the workaday rhythms of daily toil, have a swing about them that is irresistibly infectious. The musical swing of the hammer, its sweeping rise and fall, is communicated, for instance, with rhythmic power in the song entitled *John Henry*. And in the familiar levée song we meet with another but not less enticing rhythm :

> Where wuz your sweet mamma
> When de boat went down?
> On de deck, Babe,
> Hollerin' Alabama Bound.

The Negro has retained unquestionably in his art a certain primitivism that is wonderfully refreshing in contrast to the stilted affectations of the more cultured styles and conceptions. We come closer to life with these primitivisms, feel beauty in its more genuine and intimate and less artificial and cerebral forms.

These primitivisms of the Negro are a singular evolution of our American environment. In describing them as primitive, we do not mean that they are savage in origin, or that the instincts of savagery linger in them, but that they are untutored in form and unsophisticated in content, and in these aspects are more primitive than civilised in character. The art of primitive peoples is often the very opposite in spirit to that of the African Negro. African art is rigid, economical of energy, and almost classic in its discipline. The exuberance of sentiment, the spirited denial of discipline, and the contempt for the conventional, that are so conspicuous in art of the American Negro, are direct outgrowths of the nature of his life in this country.

In jazz this vital and overwhelming exuberance of the American Negro reaches its apex in physical dynamics. If the origin of jazz is not entirely Negroid—that its fundamental form is derivative of Negro rhythms no longer can be disputed—its development of attitude and expression in America has certainly been chiefly advanced by the Negro. While the spirituals represent the religious escape of the Negro, the jazz rhythms vivify his mundane abandon. Today this mundane abandon has become a universal craving on the part of youth in Europe as well as in America. Since the war, the dance has become a

mania. It is the mad, delirious dance of men and women who have had to seize upon something as a vicarious outlet for their crazed emotions. They have not wanted old opiates that induced sleep and the delusion of a sweet stillness of things and silence. They have not sought the escape which an artificial lassitude brings to minds tormented with worry and pain. They have demanded an escape that is active, dynamic, electrical, an escape that exhilarates, and brings restfulness only from exhaustion. Jazz has provided that escape in increasing measure as its jubilant antics and rhythms have become madder and madder in their tumult of release. To the Negro the riotous rhythms that constitute jazz are but an active translation of the impulsive extravagance of his life. Whether a difference in the calcium factor in bone structure or conjunction, accounting for an exceptional muscular resiliency, or a difference in terms of an entirely environmental disparity, be used to explain the Negro's superior response to jazz, his supremacy in this departure in music remains uncontested. Jazz, Stokowski contends, " has effected a profound change in musical outlook." In this change, Stokowski adds:

> The Negro musicians of America are playing a great part. . . . They have an open mind, and unbiased outlook. They are causing new blood to flow in the veins of music. The jazz players make their instruments do entirely new things, things finished musicians are taught to avoid. They are path-finders into new realms.

Jazz reflects something of the essential irresponsibility, or rather the irresponsible enthusiasms and ecstasies that underlie Negro life here in America, and which give to Negro art such singular distinction in verse and spontaneity. While jazz in its inferior forms is a vulgar removal from the idea of the exquisite which prevailed in music before our day, it nevertheless has the virtue of great originality and the vigour of deep challenge. In a very significant sense, indeed, it remains as the only original contribution to music that has been made by America.

If the spirit of jazz is captured almost to a point of precision in these lines from *Runnin' Wild*:

> Runnin' wild, lost control,
> Runnin' wild, mighty bold,
> Feelin' gay and reckless too,
> Carefree all the time, never blue,
> Always goin' I don't know where,
> Always showin' that I don't care,
> Don' love nobody, it ain't worth while,
> All alone, runnin' wild.

it would be a serious and most reprehensible exaggeration to maintain that it is this mood which permeates all Negro art in America. In fact, much of contemporary Negro poetry is as far removed in spirit from the jazz motif as the poetry of John Milton is from that of T. S. Eliot. There is indeed an over-seriousness, even an affected dignity in the work of many Negro poets. This tendency to an artificial loftiness of utterance, verging often upon the pompous, is more marked in the work of the Negro writers of the 19th century than of the 20th. In many cases education removed the Negro writer further from his people, and inclined his work in the direction of imitating the artificial standards of other groups rather than of advancing and perfecting those of his own. As a result, a certain naturalness and fine vigour of style were lost. While this tendency has not disappeared, a reaction has already set in against it, and today Negro writers have begun to develop a more candid approach.

In the poetry of Langston Hughes, for instance, there is a freshness even in artifice that was absent in the poetry of the 19th-century Negro. Even Dunbar, who was the leading Negro poet prior to our own day, avoided the affectations and conceits of his contemporaries only in his poems of dialect. In the verse of such writers as Albert A. Whitman, Mrs. Harper, George Moses Horton, James Madison Bell, Joseph Seamon Cotter and James David Corrothers, this literary fallacy is unpleasantly conspicuous. They aspired at the stately, when they should have aimed at the simple. Their poetry, as a consequence, was hopelessly inept and sentimental. It is only with the present day, and the emergence of the contemporary school of Negro poets, led by such figures as Langston Hughes, Countee Cullen, Jean Toomer and Claude McKay, that this type of verse has been condemned with scorn.

If the recent developments in Negro literature cannot be characterised as a renaissance, they certainly must be noted as marking off a new stage in the literary history of a people. Without question the work of Jean Toomer, Rudolph Fisher, Burghardt DuBois and Walter White in fiction; Langston Hughes, Countee Cullen and Claude McKay in verse; and Alain Locke, Franklin Frazier, James Weldon Johnson, Charles S. Johnson, Abram L. Harris and George Schuyler in the essay, has been distinguished

The Growth of Negro Literature

by fine intelligence and advancing artistic vision. Surely at no other period, and certainly never in so short a time, have so many Negro writers of genuine talent appeared. If among these writers no great artist or great thinker has so far evolved, there is no reason for despair. The great achievement of Roland Hayes on the concert stage, and of Paul Robeson in the theatre, gives promise at least of similar success in the literary art in the future. The appearance of these numerous artists and the growth of this newer spirit on the part of the Negro, is really not so much a re-birth in the sense of a renaissance, as it is the hastening of an old birth which had formerly been retarded in its growth and evolution.

Steadily this trend in the New Negro literature has developed in favour of the vigorous instead of the exquisite. Challenge has become more significant than charm. The submissive acquiescences of the Booker T. Washington attitude and era have now become contemptuously anachronistic. The sentimental cry of a 19th-century poet such as Corrothers:

> To be a Negro in a day like this—
> Alas! Lord God, what ill have we done

has been superseded by the charging defiance of a 20th-century poet such as McKay:

> What though before us lies the open grave?
> Like men we'll face the murderous, cowardly pack,
> Pressed to the wall, dying, but—fighting back!

The admission of inferiority which was implicit in so much of the earlier verse, the supplicatory note which ran like a lugubrious echo through so many of its stanzas, has been supplanted by an attitude of superiority and independence on the part of such poets as Countee Cullen, Langston Hughes and Gwendolyn Bennett.

George Schuyler in prose has given this same attitude a sharp, ironic turn. His clean-cut, biting style, inevitably in keeping with his theme and purpose, is at times superb. He meets his materials with a directness that compels by its vigour. His writing is never sentimental; rather it has a hard, metallic brilliance that convinces without endeavouring to caress. In *Our Greatest Gift to America*, which deals in satiric form with the Negro's position in this country, Schuyler's criticism is acute and devastating.

As the racialism of the Negro has become more assertive and radical, a new attitude has begun to reveal itself in his fiction. There has been a marked tendency in the past, except in stories of dialect, for Negro writers to centre their attention upon the more enlightened and prosperous members of the race. In *The Fire in the Flint*, for instance, Walter White has chosen a doctor for his protagonist; in *There is Confusion* Jessie Fausset has featured a dancer as her star; in *Quicksand* Nella Larsen has selected a school teacher for her main character; and in *The Dark Princess* DuBois has made an aristocratic woman into his heroine. Today in the novels of Rudolph Fisher and Claude McKay the class of characters has shifted. In *The Walls of Jericho* and *Home to Harlem* the main characters are proletarian types, piano movers and stevedores, who are endowed with little education and less culture. The lives of these lower types are seen to be as fascinating and as dramatic as those of the upper. In fact, a certain native drama is revealed in the lives of these colored folk that is absent in the lives of most white people in the same class of society. This added drama flows from the freer and more irresponsibly spontaneous way in which these black men live. In time, no doubt, these proletarian types, since the Negro, dating from his vast migrations from southern to northern latitudes during and immediately following the war, is becoming rapidly proletarianised, will occupy an increasingly large part in the entire literary scene.

If this new literature of the Negro in America does not constitute a renaissance, it does signify rapid growth in racial art and culture. It is a growth that is as yet unfinished. Indeed, we may say it illustrates a growth that in a dynamic sense has just begun. It indicates more than the rise of a literature. It marks the rise of an entire people.*

* The editor is indebted to V. F. Calverton and The Modern Library publishers, N.Y., for permission to reprint this article, which forms the introduction of Mr. Calverton's excellent *Anthology of American Negro Literature* (Modern Library, New York, 1929). The original article is somewhat longer in that it contains spirituals and quotations from certain poems, George Schuyler and W. B. DuBois. For the approach to and first contact with the whole subject of American Negro literature no better book than this Anthology could possibly be recommended.

Some Aspects of the Negro
interpreted in Contemporary American
and European Literature

by JOHN FREDERICK MATHEUS

Professor of Romance Languages, West Virginia State College Institute, West Virginia, U.S.A.

John Frederick Matheus

"THE destiny of the Negroes is in some degree entwined with that of the Europeans. The two races are bound one to the other, without being blended thereby. It is as difficult to separate them completely as to bring them completely together.

"The most frightful of all the evils which threaten the future of the United States rises from the presence of Negroes on their soil."

This quotation from Tocqueville's famous *Démocratie en Amérique*, written a century ago during the turbulent generation of Andrew Jackson, is in turn taken from a study, made less than a decade ago by Professor Franck L. Schoell, of *The Color Question in the United States*.[1]

Both these Frenchmen, though a hundred years apart, have sought to interpret to France, and thus to Europe, the status and life of the black population of the American Republic. Both are impartial, logical. Professor Schoell thoroughly and justly has presented statistical externals and the application of reason and science to the delicate problem.

André Siegfried, four years later, in *America Comes of Age*, a book that has gone through many editions, devoted a chapter to "The Colour Problem," attempting also to interpret to his fellow countrymen and the continentals the acute position of the Negro in the United States.[2]

In 1930 Georges Duhamel assumed the rôle of seer and analyst of the American *mores*. Repercussions of the protests aroused in the United States reveal not so much hypersensitivity as chagrin over plausible half-truths that hurt. No one in colored America, however, will take the least exception to the author's observations and ratiocinations concerning the Negro. They are fair, incontrovertible, proof of the bloodless machine that makes, in Monsieur Duhamel's opinion, American civilisation so inferior to European.[3]

But if American citizens in general take with reservations this new Jeremiah from the Seine in his probings into the American psyche, the American Negro, if not concurring in the revolt against *Scenes of the Future Life*, will do his part in assailing the foreign writers of current fiction who, following the lead of the investigators of the social sciences, essay to give to the world exterior to the United States, and for that matter within its borders, the American Negro psyche.

In any indictment of present-day life in the United States of America the Negro cannot be ignored. The American of African origin composes a little over nine per cent. of the population, yet his influence reaches a proportion far in excess of his numerical ratio. Count Keyserling paid him the compliment of observing that the Negro has furnished the unique and distinctive note in the expression of an indigenous American art. He is the father of the Blues, creator of jazz, the determinant of characteristic American attitudes; he has reacted upon linguistic and social habits, is of tremendous economic importance, of potential political power and, finally, the background for a literary and dramatic vogue, for a renascence in the plastic arts.

Yet paradoxically the American colored group has never been adequately portrayed or understood by the whites. No white writer has fully sounded Black America, nor for that matter has any Negro author. Silhouettes have been made, minute studies of local centers in the *genre* style, but they err, or

[1] *La Question des Noirs aux États-Unis*, Schoell (Payot, Paris, 1923), chap. vii, p. 155.
[2] *America Comes of Age*. A French Analysis. André Siegfried. Translated by H. H. and Doris Hemming (1927).
[3] *Scènes de la Vie future*, Georges Duhamel, Mercure de France (Paris, 1930). Chap. xi, "La Séparation des Races."

perhaps, more correctly, those who read them go astray in concluding that these details are apposite to all American Negroes. This being true, how much less capable then must be the writer from foreign shores to present the true picture of the Negro in the New World.

The first European literary interest in the American English-speaking Negro dates from 1852, when Harriet Beecher Stowe published *Uncle Tom's Cabin*. Continental notice of the achievement of the Negroes of Haiti at the end of the eighteenth century had found expression in literature through Lamartine's *Toussaint L'Ouverture*, in Wordsworth's sonnet and Harriet Martineau's novel on that surprising black genius, in Hugo's *Bug Jargal*, and the writings of the English emancipators, Wilberforce and Clarkson and their followers. But it was left to Mrs. Stowe's masterpiece to give to Europe the most widely sold, translated and dramatised book of the nineteenth century.

The Irish playwright, Dion Boucicault, in *The Octoroon*, first played at the Winter Garden, New York City, 1859, won popularity in a London version. This play was based somewhat on a novel, *The Quadroon*, by Mayne Reid, published in New York in 1856, and recalls the Paris success of *L'Etrangère*, by Dumas *fils*, a study of the theme of the near-white in the toils of the American color system.

The interest aroused, however, in the Negro at this time was romantic and sentimental. The story which the abolitionist champion and intrepid colored leader, Frederick Douglass, tells in his autobiography, *Life and Times of Frederick Douglass*, illustrates this attitude. While visiting in England a certain sympathetic duchess was profoundly stirred by his recital of escape from slavery, but became coldly haughty when he related that he had served as his master's coachman.

European opinion of the United States during the Civil War days veered between the extremes of Thomas Carlyle, who growled that "the foulest chimney in Christendom was burning out," and Victor Hugo's acclaim of John Brown as a great martyr, comparing him with Christ in an unusual symbolic painting. (Hugo was master of the brush as well as of the pen.)

Three-quarters of a century later, the prolific American *littérateur* and connoisseur, Carl Van Vechten, struck another note that launched a new international interest in the extraordinary at home and oversea success of *Nigger Heaven*. Between Harriet Beecher Stowe and Carl Van Vechten one passes from romantic sentimentalism to objective realism, with streakings of Freudian analyses pornographically adorned. There is the inimitable beauty of the aëry prose of rare Lafcadio Hearn, whose supersensitive nature first capitulated to a mulatto girl of Cincinnati; the quaint cameos of Creole life in Louisiana drawn by George Washington Cable; the antebellum Negro types of Mark Twain of Missouri, of Joel Chandler Harris of Georgia and of Thomas Nelson Page of Virginia; the overdrawn pictures of Judge Albion Tourgée on the side of the Negro; and the silly propaganda of hate of Thomas Dixon, junior, on the side of the Ku Klux Klan and the poor white.

Then came the younger group of enlightened Southerners, as Clement Wood, T. S. Stribling, Dubose Heyward, Julia Peterkin, Paul Green, Roark Bradford, whose *This Side of Jordan* was inspiration for Marc Connelly's phenomenal play of Negro religious conceptions, *Green Pastures*. These writers have manifested a sympathetic interest in the Negro as a human being and within narrow circles have given artistic glimpses of his emotions and daily life.

It is significant, too, that Van Vechten's best-seller came on the wave of a recrudescence of Negro writers, sponsored by that astute critic, scholar and leading sociologist, Charles S. Johnson, then editor of the Negro magazine *Opportunity*. It followed a decade and a half of *The Crisis*, example and stimulant of artistic expression of Negro life under the fearless and militant leadership of William Burghardt DuBois, long the voice of the Negro intellectual.[1] It was contemporary with Alain Locke's *New Negro*, re-emphasised and launched the works of James Welden Johnson, Countee Cullen, Langston Hughes, Jessie Fausset, Claude McKay, Walter White, George Schuyler, Rudolph Fisher, Willis Richardson, and others less widely known.

Because of the popularity and wide acceptance of his thesis of American Negro life, Van Vechten marked a milestone of a new fashion. He presented Negro life as he saw it in Harlem, detached, without propaganda, ironically in some instances, but yielding to a philosophy of defeat as concerns the struggle of the Negro in the hostilities of environing white civilisation.

Unfortunately it seems this has been the philosophy that present-day Europe has accepted, as revealed in current literature treating of the Negro. In short, as regards the American Negro, the Van Vechten picture has been received as the *whole* picture, partly because it may fit in with colonial policy and partly because there has been no counter-pen to present the other side. In America this defeatist philosophy is

[1] The editor cannot do otherwise than state here the profoundest and uttermost disagreement with Professor Matheus' qualification of both Dr. DuBois as militant leader and *The Crisis* as intellectually of any importance whatsoever.

Some Aspects of the Negro in Contemporary Literature

one commonly taken by white writers of Negro life wherever an attempt is made to interpret Negro struggle. There is always frustration, a futile volting with moth's wings into the searing flame. It is found in Paul Green's plays, as *In Abraham's Bosom*; in Eugene O'Neil's *All God's Chillun Got Wings* and *Emperor Jones*. Negro writers even are not free from this pessimism, exhibited, for instance, in Claude McKay's *Home to Harlem*.

European ignorance of the African Negro is monumental, and misinformation concerning the American Negro ridiculous, but in most cases not a bigoted prejudice, but sheer lack of knowledge. For example, the writer may cite the surprise of that stolid Britisher who once blandly asked him after an afternoon's chat on the train between Venice and Rome concerning the Negro's status and achievement in America: " But—ah—really now, do you actually speak English among yourselves?"

The geography of America is as hazy in the minds of untravelled Europeans as is the location of the Russian provinces in the average American's store of facts. The presence, function and condition of the American Negro is a sealed mystery in most centers of Europe. The too gullible public credulously accepts the Van Vechten school as presenting the true analysis of the American Negro, a deduction whose premises may lead to the conclusion that the Negro is at best a veneered primitive and at worst a spoiled savage or degenerate.

The pioneer among French writers to give this picture of the American Negro and then to enlarge its scope so that it might include *the* Negro is Paul Morand, impressionistic, symbolistic specialist in the exotic.[1] Paul Morand has given his talents to the study of the Negro in the United States, Africa and the West Indies. What is the sum total of his impressions? That the Negro when " civilised " is a superficial emotionalist, ready to return to the practices, if not to the cult, of the Jungle Gods, that he is not far removed from the " raw " Negro nor advanced much above the level of his ancestors from the Congo or the West Coast. One drop of African blood is fatal, for M. Morand makes one of his characters, an octoroon, Mrs. Pamela Freedman, return to the jungle by an impossible atavism.

Mrs. Pamela Freedman of New York has engaged passage on a round-the-world cruise. She passes for a white woman. Accidentally her racial " taint " is discovered. When the boat stops off the coast of Africa to allow passengers to go ashore to sight-see, her written instructions from the ship official stated that the boat would remain from 8.00 A.M. until 10 P.M. It should have read from 8.00 A.M. until 10.00 A.M. (Typical Nordic trick.) She is therefore stranded in Africa. Does she cable home, seek redress? No. Journeying into the interior she reaches a native village, hears the beat of the tom-toms. Presto, change! What happened? Let us quote:

" Negresses are the queens of the black world. . . . She tore off her clothes, her necklace, threw to the ground her rifle, cartridges, tossed to the winds her money. . . . Mamadou (son of the chief) pressed her naked against his naked torso, rubbed her against his skin. . . . Farewell New York! Pamela Freedman had come to the womb of Africa. She was no longer worth a hundred million dollars, she was worth three beeves, as the other women. . . . She was seen to strike hands together . . . to bend at every cadence of the drum, like the other black women, for now she was one of them! "

What height of folly! Where, M. Morand, have you learned your psychology? Such conduct would be as repugnant to an American Negro woman as it would be to an American white woman.

The most disconcerting volume from the American Negro's point of view is one which appeared in 1930 under the name *Auprès de ma Noire*, by Jean Lasserre.[2] The author follows the rapid, cinematographic style of Morand, Giraudoux, Jean Cocteau. The story, centered in Harlem, can scarcely claim a plot, but does present rough sketches of the Harlem scene and flashes of the Negro in the South. The author lived for a time in Harlem, mingled intimately with a *certain* class. There lies the danger. The toughs with whom he associated are paraded before us as typical of the American Negro. The portraits are true, individually, but if incorporated into a picture of the American Negro the focus will give a blurred image.

The type of the colored woman shown is Mandy. Here are some sentences about her: " She has drunk too much whiskey. She has a slight headache. She must dash some cold water in her face and rinse out her mouth. . . . Her dress is green as an apple, with a big violet bow at the waist."

The male characters frequently shout, " How about a crap game?"

" Negroes always carry their razors in their pockets. They are not Gillette blades either, but veritable cutlasses that would cut the throat of an ox."

[1] *Magie Noire*, Paul Morand (Grasset, Paris, 1928). Translated into English by Hamish Miles, with drawings by Aaron Douglas (Viking Press, New York).
[2] *Auprès de ma Noire*, Jean Lasserre (Les Éditions de France, 20 Avenue Rapp. Paris).

Some Aspects of the Negro in Contemporary Literature

" The Rev. Buss Lincoln just back from a morning search for souls to save—whom a pious and energetic mother, who managed the kitchen for Rockefeller, Jr., had sent as far as theological school, only knew of the life he read about in the Bible."

The Rev. Lincoln is vamped by Mandy, lays his bible down and becomes a driveling, drunken sot when the wench deserts him. In brief the picture of the American Negro world of *Auprès de ma Noire* is a hell of opium venders, drug fiends, tipsy sports, puerile ninnies, whose alcohol costs " two dollars a glass and four days in bed," if not blindness. It is the world of Dance Dives, prostitutes, the "Di-ga-di-ga-do," of monkey shines and ceaseless pursuit of pleasure, sensual pleasure. It is as true as the picture of Thérèse Raquin by Zola, yet that adulteress and murderess is not the type of French womanhood.

The Negro in the Latin world is only dimly aware of his blackness. He feels no racial consciousness as he does in the Anglo-Saxon world. Paul Morand doubtless omitted Brazil from his itinerary with purpose. Thirty per cent. of Brazil's population is Negro, but there is no color problem. Consequently there has developed little racial gregariousness, other than that of Brazilian nationalism. Her writers in many notable instances have been of mixed blood. Machado de Assis, for example, poet, dramatist, novelist, critic, shows no African fire, but is always coldly restrained, writing as in his magnificent *A Mosca Azul* (" To the Blue Fly"), a chiseled Parnassian perfection. Castro Alves, who wrote in defense of the Negro during the days of the slave régime in *Vozes d' Africa* (" Voices from Africa ") and *Navio Negreiro* (" O Slave Ship "), championed more the cause of oppressed Brazilians rather than the cause of the black race. Coelho Netto, half Indian, half Portuguese, filled as a child by his Negro nurse with stories of African legend, has, as he himself has said, a triple imagination: Negro, Indian, white.[1] Aluizio Azevedo, in *O Mulato* (" The Mulatto ") (1881), is emphasising the Brazilian.

The mulatto poet of Cuba, Gabriel de la Concepción Valdés, better known as Plácido, wrote his immortal sonnet, *Despedida a Mi Madre* (" Farewell to My Mother ") and his impassioned *Plegaría a Diós* (" Prayer to God "), which Peninsular critics have pronounced the noblest in Castilian, as a Cuban. His lilting lyrics, his lofty outbursts against tyranny, inspired the cause of his country as much as the military genius of that other Cuban mulatto hero, Antonio Maceo. Gertrudis Gomez de Avellanida, in her early novel *Sab*, pictured the Cuban of mixed blood, but with no theme of hopelessness. In *María* Jorge Isaac paints Negro slaves in a rather patriarchal Columbian setting, in religion, manners, dark Spaniards rather than Negroes.

While the Haitian poets have written with more color awareness, their best expressions, crowned by the French Academy, as Etzer Vilaire's *Nouveaux Poèmes* (1912) and Georges Sylvain's *Morceaux choisis des auteurs Haïtiens*, an anthology (1905), they have followed in the main the traditions of French letters. Their works breathe more of the Seine than either the Congo or the Artibonite. Only today is the brilliant young editor and poet, Jacques Roumain, leading a movement that seeks its inspiration directly from Africa.

Quite generally, then, the writers of Negro birth who seek to express themselves in French, Spanish or Portuguese, are but dimly conscious of their color, that psychosis being absorbed in their various national psychologies. Writers without Negro blood who interpret the Negro in any of these same media, have thought of him and treated him, until recently, nationally, rather than racially, or at least as a human being first and a Negro after.

But in these later days, when the Anglo-Saxon's color phobia has followed the Panama Canal, interventions in the Caribbean and Central American Republics, there has crept into fiction written about Negroes a note of defeatism and patronising. *El Negro que tiene el alma blanca* [2] (" Black man with a white soul "), by Alberto Insua, Habana novelist, offers an illustration. The principal character, Pedro Valdés, born of slave parents in Cuba, is taken to Spain by his master's family and there grows up to become a dancer of fame, with the English name Peter Wald. His color weighs him down. He can find no solace, even though he wins millions, and in the end dies of grief for a white girl, his dancing partner, who from a dread aversion turns too late to offer herself as his wife.

Mulatto Johnny,[3] by Alin Laubreaux, inspired probably by the meteoric flash of Jack Johnson across the pugilistic heavens, makes the same moral, hopeless frustration. The hero is a half-breed of New Hebrides, who has to leave his island home because of killing a white man who cursed him. After many adventures among cannibals, on an Australian peonage farm, and an almost successful winning

[1] *Pequena Historia da Literatura Brasileira*, Ronald de Carvalho, 4a Ed. Revista e augmentada (F. Briguiet & Cia., Rio de Janeiro, 1929). *Brazilian Literature*, Dr. Isaac Goldberg.

[2] *El Negro que tiene el alma blanca*, Alberto Insua (Madrid).

[3] *Mulatto Johnny*, Alin Laubreaux, translated by Coley Taylor (E. P. Dutton & Co., New York).

Some Aspects of the Negro in Contemporary Literature

of the heavy-weight championship, he learns that the war has come, and with it brought him immunity from punishment. He returns home to find his white father dead, deserted by his black mother for a native man, his home of youthful memories destroyed. There is no hope. He renounces civilisation and returns to the bush, clad in a clout.

So the Latin writers are beginning to reflect the hopelessness taught by Nordic writers in depicting the Negro. The issue of miscegenation in South Africa, as treated by Sarah Millen in *God's Stepchildren*, is a beautiful, ironical, sympathetic but barren picture. Again in the *Coming of the Lord*, the problem of the Jew and the Negro are both dramatically treated, but the end is death. Let the truth be told by all means, but that diamond has more than one facet. Sacha Guitry, in *Blanc et Noir*, is not so sure as Mrs. Millen, and in Charbonneau's pathetic story of *Mambu et son amour* it is the white man who is defeated.

Claire Goll's *Der Neger Jupiter raubt Europa* ("Jupiter, the Negro, steals Europa") shows the operation of the defeatist influence in a Teutonic conception of the Negro. The author limns the same ultimate bafflement. There, as in Morand, is the fallacy that the Negro is ashamed of his color, plays the sedulous ape, would be a white man. Let us quote a bit:

"So now he had fulfilled that burning wish of every Negro, to marry a white woman and free his offspring from the stigma of being colored."

"As always when the problem of his color rolled back and forth in his mind, he groaned. He shoved his fingers into his kid gloves. How good was it to have white hands! Ah, his children would be a little bright colored, quince-yellow."

The German weekly, *Die Woche*, gives a more optimistic outlook in the November twenty-first issue, containing Friedrich Freksa's study of the Negro woman, in a series of studies of womankind, " Die Frau in fünf Erdteilen." It will be interesting to compare this statement of fact with Paul Morand's deplorable picture.

"The Negro woman of North America has obtained a success in a special art. The taste of the times for exotic song and dance has brought to her artistic recognition but no social admittance in America. . . . Beside the picture of the oldtime American Negress, the faithful nurse, appears to-day the new type of the discontented, ardent, belligerent colored woman."

The above statement is fit companion for the fate of a little frizzly haired colored girl told in an Italian version of Malot's *Pompon*,[1] a book picked up by chance in Milano for four lire. After many trials Pompon and her lover Casparis are happily united, although her rival is a white girl, an ending that might happen in Italy or in France and even in parts of the Nordic world.

René Maran, that amazing artist, who created *Batouala* and wrote *Djenn, petit chien de la Brousse*, lifts a bit the veil of mystery from the face of the Sphinx. So few have ever attempted to peer behind those unfathomed depths. René Maran is thus the antithesis of Paul Morand. When one has completed *Magie Noire*, if he be white he probably will say, " What a race of children! How inferior to us! So that is what is lurking behind the countenances of black faces I have seen."

"But no," says the Negro who *knows*, who lives the life. "This is no answer. It is caricature, satire, mockery, but not soul stuff."

When one lays aside René Maran's books he weeps.

"For the Negro, yesterday or two centuries are the same thing. What has he behind him? Nothing. His father was as ignorant as his remotest ancestor," comments the author of *Auprès de ma Noire*.

The Negro no past! It envelops him like Medea's poison robe, eating out his vitals. The old men of the tribes glory in the exploits of their fathers, Abyssinia has a great past, and Haiti. As the sound in Antonio Machado's poem of earth falling at an open grave on a wooden box, it is " a serious thing, unutterably serious."

And the future! Even though it be said in *Auprès de ma Noire* that there is no tomorrow for colored people, the Negro does stare ahead, he thinks, from the African chieftains lamenting that there is no " book " for the young men of the tribe so that they may learn from the white man, to the wild dreams of Marcus Garvey.

It is because of the future that the American Negro resents the caricature that masquerades as Negro personality. American Negro artists abroad have waged and are waging battle for its suppression. Florence Mills before her untimely death, Josephine Baker, Adelaide Hall, Ethel Waters, have established a new type of soubrette and danseuse. There have been the triumphs in song and acting of Roland Hayes, Paul Robeson, Madame Evanti, Jules Bledsoe and Florence Cole Talbert; the acclaim recently given in Paris to the musical compositions of Clarence Cameron White, the popularity of the Hampton

[1] *Pompon*, Ettore Malot (Collezione Sonzogno, Via Pasquirolo 14, Milano).

singers under Dett, and of that victorious team, Layton and Johnson; the scientific recognition accorded in Germany and Italy to Dr. Ernest Just, to Dr. Francis Sumner by the University of Vienna for his research in Freudian psychology, and to Percy Julian, awarded the doctorate in Chemistry by this seat of learning. International reference to the research of the *Journal of Negro History*, directed by Dr. Carter Godwin Woodson, the products of such educational institutions as Atlanta, Fisk and Howard Universities, West Virginia State College, Hampton, Tuskegee, united with the individual effort, bear increasingly powerful evidence, both of the falsity of the burlesque Harlem type as representing the Negro and of the crudity of the philosophy of hopelessness.

If it be true, as was said of Jupiter, that " für die Weissen war jeder Schwarze ein Kaffer" (" to the white man every Negro is a Kaffir "), then without disparaging the Kaffirs, the American Negro seeks to demonstrate its fallacy by revealing the differences and also the fundamental common human qualities in all peoples. That there is need for such concern is plain from the facts as narrated in current European fiction, following the lead of American progenitors.[1]

This was one of the strongest motives for American Negro initiative under the leadership of Dr. DuBois in the Pan-African Congresses. A new movement has been launched in Paris for the intellectual pooling of Negro talent to counteract the possible damage of the tendencies as manifested in present-day fiction so far as it concerns the Negro. Its official organ is *La Revue du Monde Noir*, published at 45 rue Jacob, Dr. Sajous editor, Mlle. Paulette Nardal secretary.[2]

So it is in spite of the insistence of the enemy, intentional or unwitting, the Negro looms a larger and larger figure in the white literary world, as did that weird West Indian Negro in Joseph Conrad's *Nigger of the Narcissus*, whose strange insinuation dominated finally hate, repugnance, intolerance, all that ship and crew from fore to aft, body and soul.

Sterling Brown: The New Negro

Folk-Poet

by ALAIN LOCKE

Alain Locke

MANY critics, writing in praise of Sterling Brown's first volume of verse, have seen fit to hail him as a significant new Negro poet. The discriminating few go further; they hail a new era in Negro poetry, for such is the deeper significance of this volume (*The Southern Road*, Sterling A. Brown, Harcourt Brace, New York, 1932). Gauging the main objective of Negro poetry as the poetic portrayal of Negro folk-life true in both letter and spirit to the idiom of the folk's own way of feeling and thinking, we may say that here for the first time is that much-desired and long-awaited acme attained or brought within actual reach.

Almost since the advent of the Negro poet public opinion has expected and demanded folk-poetry of him. And Negro poets have tried hard and voluminously to cater to this popular demand. But on the whole, for very understandable reasons, folk-poetry by Negroes, with notable flash exceptions, has been very unsatisfactory and weak, and despite the intimacy of the race poet's attachments, has been representative in only a limited, superficial sense. First of all, the demand has been too insistent. "They required of us a song in a strange land." "How could we sing of thee, O Zion?" There was the canker of theatricality and exhibitionism planted at the very heart of Negro poetry, unwittingly no doubt, but just as fatally. Other captive nations have suffered the

[1] This is not true of French travel and anthropological books, such as those by Delafosse, Blaise Cendrars, André Gide, etc.
[2] This review ran for about six numbers, but has now suspended publication. ED.

88

Sterling Brown : The New Negro Folk-Poet

same ordeal. But with the Negro another spiritual handicap was imposed. Robbed of his own tradition, there was no internal compensation to counter the external pressure. Consequently the Negro spirit had a triple plague on its heart and mind—morbid self-consciousness, self-pity and forced exhibitionism. Small wonder that so much poetry by Negroes exhibits in one degree or another the blights of bombast, bathos and artificiality. Much genuine poetic talent has thus been blighted either by these spiritual faults or their equally vicious over-compensations. And so it is epoch-making to have developed a poet whose work, to quote a recent criticism, " has no taint of music-hall convention, is neither arrogant nor servile "—and plays up to neither side of the racial dilemma. For it is as fatal to true poetry to cater to the self-pity or racial vanity of a persecuted group as to pander to the amusement complex of the overlords and masters.

I do not mean to imply that Sterling Brown's art is perfect, or even completely mature. It is all the more promising that this volume represents the work of a young man just in his early thirties. But a Negro poet with almost complete detachment, yet with a tone of persuasive sincerity, whose muse neither clowns nor shouts, is indeed a promising and a grateful phenomenon.

By some deft touch, independent of dialect, Mr. Brown is able to compose with the freshness and naturalness of folk balladry—*Maumee Ruth, Dark O' the Moon, Sam Smiley, Slim Green, Johnny Thomas,* and *Memphis Blues* will convince the most sceptical that modern Negro life can yield real balladry and a Negro poet achieve an authentic folk-touch.[1]

Or this from *Sam Smiley* :

> The mob was in fine fettle, yet
> The dogs were stupid-nosed, and day
> Was far spent when the men drew round
> The scrawny wood where Smiley lay.
>
> The oaken leaves drowsed prettily,
> The moon shone benignly there;
> And big Sam Smiley, King Buckdancer,
> Buckdanced on the midnight air.

This is even more dramatic and graphic than that fine but more melodramatic lyric of Langston Hughes :

> Way down South in Dixie
> (Break the heart of me!)
> They hung my black young lover
> To a cross-road's tree.

With Mr. Brown the racial touch is quite independent of dialect; it is because in his ballads and lyrics he has caught the deeper idiom of feeling or the peculiar paradox of the racial situation. That gives the genuine earthy folk-touch, and justifies a statement I ventured some years back : " the soul of the Negro will be discovered in a characteristic way of thinking and in a homely philosophy rather than in a jingling and juggling of broken English." As a matter of fact, Negro dialect is extremely local—it changes from place to place, as do white dialects. And what is more, the dialect of Dunbar and the other early Negro poets never was on land or sea as a living peasant speech ; but it has had such wide currency, especially on the stage, as to have successfully deceived half the world, including the many Negroes who for one reason or another imitate it.

Sterling Brown's dialect is also local, and frankly an adaptation, but he has localised it carefully, after close observation and study, and varies it according to the brogue of the locality or the characteristic jargon of the *milieu* of which he is writing. But his racial effects, as I have said, are not dependent on dialect. Consider *Maumee Ruth* :

> Might as well bury her
> And bury her deep,
> Might as well put her
> Where she can sleep. . . .
>
> Boy that she suckled
> How should he know,
> Hiding in city holes
> Sniffing the " snow " ?[2]

[1] This exquisite poem is in the Poetry section. [2] Cocaine.

Sterling Brown: The New Negro Folk-Poet

And how should the news
Pierce Harlem's din,
To reach her baby gal
Sodden with gin?

Might as well drop her
Deep in the ground,
Might as well pray for her,
That she sleep sound.

That is as uniquely racial as the straight dialect of *Southern Road*:

White man tells me—hunh—
Damn yo' soul;
White man tells me—hunh—
Damn yo' soul;
Got no need, bebby,
To be tole.

If we stop to inquire—as unfortunately the critic must—into the magic of these effects, we find the secret, I think, in this fact more than in any other: Sterling Brown has listened long and carefully to the folk in their intimate hours, when they were talking to themselves, not, so to speak, as in Dunbar, but actually as they do when the masks of protective mimicry fall. Not only has he dared to give quiet but bold expression to this private thought and speech, but he has dared to give the Negro peasant credit for thinking. In this way he has recaptured the shrewd Aesopian quality of the Negro folk-thought, which is more profoundly characteristic than their types of metaphors or their mannerisms of speech. They are, as he himself says,

Illiterate, and somehow very wise,

and it is this wisdom, bitter fruit of their suffering, combined with their characteristic fatalism and irony, which in this book gives a truer soul picture of the Negro than has ever yet been given poetically. The traditional Negro is a clown, a buffoon, an easy laugher, a shallow sobber and a credulous christian; the real Negro underneath is more often an all but cynical fatalist, a shrewd pretender, and a boldly whimsical pagan; or when not, a lusty, realistic religionist who tastes its nectars here and now.

Mammy
With deep religion defeating the grief
Life piled so closely about her

is the key picture to the Negro as christian; Mr. Brown's *When the Saints Come Marching Home* is worth half a dozen essays on the Negro's religion. But to return to the question of bold exposure of the intimacies of Negro thinking—read that priceless apologia of kitchen stealing in the *Ruminations of Luke Johnson*, reflective husband of Mandy Jane, tromping early to work with a great big basket, and tromping wearily back with it at night laden with the petty spoils of the day's picking:

Well, taint my business noway,
An' I ain' near fo'gotten
De lady what she wuks fo',
An' how she got her jack;
De money dat she live on
Come from niggers pickin' cotton,
Ebbery dollar dat she squander
Nearly bust a nigger's back.

So I'm glad dat in de evenins
Mandy Jane seems extra happy,
An' de lady at de big house
Got no kick at all I say—
Cause what huh " dear grandfawthaw "
Took from Mandy Jane's grandpappy—
Ain' no basket in de worl'
What kin tote all dat away. . . .

90

Sterling Brown : The New Negro Folk-Poet

Or again in that delicious epic of *Sporting Beasley* entering heaven :

> Lord help us, give a look at him,
> Don't make him dress up in no nightgown, Lord.
> Don't put no fuss and feathers on his shoulders, Lord.
> Let him know it's heaven,
> Let him keep his hat, his vest, his elkstooth, and everything.
> Let him have his spats and cane.

It is not enough to sprinkle " dis's and dat's " to be a Negro folk-poet, or to jingle rhymes and juggle popularised clichés traditional to sentimental minor poetry for generations. One must study the intimate thought of the people who can only state it in an ejaculation, or a metaphor, or at best a proverb, and translate that into an articulate attitude, or a folk philosophy or a daring fable, with Aesopian clarity and simplicity—and above all, with Aesopian candor.

The last is most important ; other Negro poets in many ways have been too tender with their own, even though they have learned with the increasing boldness of new Negro thought not to be too gingerly and conciliatory to and about the white man. The Negro muse weaned itself of that in McKay, Fenton Johnson, Toomer, Countee Cullen and Langston Hughes. But in Sterling Brown it has learned to laugh at itself and to chide itself with the same broomstick. I have space for only two examples : *Children's Children* :

> When they hear
> These songs, born of the travail of their sires,
> Diamonds of song, deep buried beneath the weight
> Of dark and heavy years;
> They laugh.
>
> They have forgotten, they have never known
> Long days beneath the torrid Dixie sun,
> In miasma'd rice swamps;
> The chopping of dried grass, on the third go round
> In strangling cotton;
> Wintry nights in mud-daubed makeshift huts,
> With these songs, sole comfort.
>
> They have forgotten
> What had to be endured—
> That they, babbling young ones,
> With their paled faces, coppered lips,
> And sleek hair cajoled to Caucasian straightness,
> Might drown the quiet voice of beauty
> With sensuous stridency;
>
> And might, on hearing these memories of their sires,
> Giggle,
> And nudge each other's satin-clad
> Sleek sides.

Anent the same broomstick, it is refreshing to read *Mr. Samuel and Sam*, from which we can only quote in part :

> Mister Samuel, he belong to Rotary,
> Sam, to de Sons of Rest;
> Both wear red hats like monkey men,
> An' you cain't say which is de best. . . .
>
> Mister Samuel die, an' de folks all know,
> Sam die widout no noise;
> De worl' go by in de same ol' way,
> And dey's both of 'em po' los' boys.

There is a world of psychological distance between this and the rhetorical defiance and the plaintive, furtive sarcasms of even some of our other contemporary poets—even as theirs, it must be said in all

Sterling Brown: The New Negro Folk-Poet

justice, was miles better and more representative than the sycophancies and platitudes of the older writers.

In closing it might be well to trace briefly the steps by which Negro poetry has scrambled up the sides of Parnassus from the ditches of minstrelsy and the trenches of race propaganda. In complaining against the narrow compass of dialect poetry (dialect is an organ with only two stops—pathos and humor), Weldon Johnson tried to break the Dunbar mould and shake free of the traditional stereotypes. But significant as it was, this was more a threat than an accomplishment; his own dialect poetry has all of the clichés of Dunbar without Dunbar's lilting lyric charm. Later in the *Negro Sermons* Weldon Johnson discovered a way out—in a rhapsodic form free from the verse shackles of classical minor poetry, and in the attempt to substitute an idiom of racial thought and imagery for a mere dialect of peasant speech. Claude McKay then broke with all the moods conventional in his day in Negro poetry, and presented a Negro who could challenge and hate, who knew resentment, brooded intellectual sarcasm, and felt contemplative irony. In this, so to speak, he pulled the psychological cloak off the Negro and revealed, even to the Negro himself, those facts disguised till then by his shrewd protective mimicry or pressed down under the dramatic mask of living up to what was expected of him. But though McKay sensed a truer Negro, he was at times too indignant at the older sham, and, too, lacked the requisite native touch—as of West Indian birth and training—with the local color of the American Negro. Jean Toomer went deeper still—I should say higher—and saw for the first time the glaring paradoxes and the deeper ironies of the situation, as they affected not only the Negro but the white man. He realised, too, that Negro idiom was anything but trite and derivative, and also that it was in emotional substance pagan—all of which he convincingly demonstrated, alas, all too fugitively, in *Cane*. But Toomer was not enough of a realist, or patient enough as an observer, to reproduce extensively a folk idiom.

Then Langston Hughes came with his revelation of the emotional color of Negro life, and his brilliant discovery of the flow and rhythm of the modern and especially the city Negro, substituting this jazz figure and personality for the older plantation stereotype. But it was essentially a jazz version of Negro life, and that is to say as much American, or more, as Negro; and though fascinating and true to an epoch this version was surface quality after all.

Sterling Brown, more reflective, a closer student of the folk-life, and above all a bolder and more detached observer, has gone deeper still, and has found certain basic, more sober and more persistent qualities of Negro thought and feeling; and so has reached a sort of common denominator between the old and the new Negro. Underneath the particularities of one generation are hidden universalities which only deeply penetrating genius can fathom and bring to the surface. Too many of the articulate intellects of the Negro group—including sadly enough the younger poets—themselves children of opportunity, have been unaware of these deep resources of the past. But here, if anywhere, in the ancient common wisdom of the folk, is the real treasure trove of the Negro poet; and Sterling Brown's poetic divining-rod has dipped significantly over this position. It is in this sense that I believe *Southern Road* ushers in a new era in Negro folk-expression and brings a new dimension in Negro folk-portraiture.

Education and the Negro

by MORRIS EDWARD ORGEL

THE question has often been asked, " What opportunity has the Negro in the professional world? " There is only one answer that is correct: the Negro never has had a fair opportunity in the pursuit of a profession, and it will be a long time before he may.

The barriers that the Negro has to overcome, at first, are usually typical of those of the white man. But the Negro, after having broken through all these barriers, soon finds that there exists one barrier which is more impenetrable than was the Great Wall of China or the Great Wall of ancient Babylon! That greatest of all barriers—that of race prejudice!

For who can deny that an education in this modern day doesn't help to place the Negro in a deeper state of misery? Especially, since he now is the more able to understand the futility of his position more fully. Had he not prepared himself in the field of Law, Medicine, Teaching, etc., he would not have met with this stern opposition, for, not having been trained for the professions, he would have made no attempt to enter them. Many Negroes perceive this fact far in advance, and it is for this, as well as for economic reasons, that you find so few Negroes preparing themselves for a professional career. What is the good of preparing for Law or Medicine when sooner or later you will only be pushed back into a position that necessitates neither skill nor education?

How frustrated and dejected a man must feel who has prepared himself for a medical career and finds himself a railroad porter or a laborer! Though he may have a job, does he not feel that he was the last to be hired and will be the first to be fired?

I have on hand quite a number of such cases. What impression can one possibly obtain from those cited below?

Case A received both the A.B. and M.A. degrees from Columbia. When he completed his studies he determined to settle down in Chicago and teach History. He soon found out, however, that his color made it impossible for him to procure a position. When the World War broke out the manual schools were greatly in need of men teachers. Case A applied to principal after principal for an appointment as a history teacher, but with no success.

One day one of the principals he was consulting took it upon himself to " enlighten " him.

" Why do you go around seeing principal after principal," he said, " when you know that no one will accept you because you are colored? What if you are just as capable as the white man? Should we allow you to teach white boys and girls, their parents would undoubtedly raise a cry of protest.

" I'll go a step further. The fact that you will have girls as well as boys in a history class will be very much against you. What if a girl, knowing that she has done rather poor work all term, starts to flirt with you and you lose your head? Even if you didn't lose your head and remained firm in failing her, she could say many untrue things about you for the sole purpose of securing revenge. A scandal would inevitably result, and whom would they believe? The papers would clamor about it! Nobody would believe your innocence! Why, man, can't you see you wouldn't have a chance? "

Case A felt so thwarted in his ambition, that after several years he came to New York, and I am pleased to say that he is now engaged in the teaching of History. He has since received the Doctor of Philosophy degree from one of the leading universities in New York and is now very prominent in his profession.

The following is an extraordinary case. It tends to illustrate a novel method a school conceived in ridding itself of an undesirable student who had been accepted by " mistake."

Case B filed an application to enter the —— School of Diplomacy. He sent them a letter, stating all of his qualifications and was accepted. He was notified on what day the course would begin, and on the specified day he made his appearance in the school.

" What do you want? " somebody asked him.

" Why, I'm Case B, whose application you accepted."

The man consulted the list of accepted students and was amazed to find that they had accepted a Negro by " mistake."

There was only one thing to do. They would have to get rid of him. If they refused him admission he might insist upon his rights, which might bring trouble. At last they resolved upon a plan. They led him into a room and gave him six months of the one-year course in about three hours. An hour off for luncheon, and he returned to receive the balance of the course in another three hours. It was near evening

of the same day when they graduated him and presented him his diploma. In less than ten days he was appointed to a post in the diplomatic service.

In practically all of the leading professions such as Law, Medicine, Dentistry, Nursing and Theology, the men and women engaged in them are confined within the limits of the colored area. Segregation plays the most important role in their lives. They dwell among and administer their services to the people of their own color in their small secluded area. It is only in the hospitals and clinics of Harlem, New York, that one can find so many Negro doctors, dentists and nurses. It is only in the Harlem district that one can find so many church officials. In other parts of the country, the moment some white people make their appearance in a bishopric, the bishopric will be relieved of its colored bishop and a white one will fill his place. Everyone knows, however, that this is not the case when the reverse occurs. A colored bishop is assigned a bishopric only when approximately 90 per cent. to 95 per cent. are colored constituents.

But how in the world can anyone expect the Negro to be given fair treatment when even the courts are wont to perform injustices of the gravest type, when the democracy of the nation is put to shame through unfair administration? And who can say that this is not the case? I believe that one example will suffice in illustrating this point.

Case C, by hard work and thrift, followed by wise investments, soon became a wealthy land-owner in the South. Being a man with a deep sense of respect, and very kind, he was held in high esteem by all.

There was a family that occupied one of his houses who hadn't paid him the rent that was due for a very long time. When the rent was several months due, the landlord began to ask for it, but was put off continually with all sorts of promises. When the family began to cause discontent among the other tenants, the landlord insisted upon his rent or that they vacate the premises. The lady of the house told him to come again the next day, when she would have it for him. When he appeared again the next day, the lady started a cry all over the town that he had attacked her.

In a very short time the man was brought into court, and despite the fact that there was not one fraction of evidence that could be used against him, he was sentenced to life-imprisonment.

It so happened that the lady who had been responsible for his being sentenced to jail was on her death-bed some fifteen years later and confessed the entire story. Because a court refused to reason fairly with the evidence presented, an innocent man had to languish in jail for fifteen long years!

Approximately three hundred years ago the white men invaded Africa, plundered her shores, and committed one of the greatest crimes in history by seizing a number of Negroes and carrying them to America, where they sold them as slaves. Soon after the introduction of the first shipload the demand

for Negroes became so great that the influx of their numbers assumed the greatest pro-portions. They were run down like animals by the bloodthirsty slave-catchers, torn away from their families, and herded like cattle on ships. They were torn away from their loved ones, their culture, their traditions and customs!

They learned the white man's language, learned the white man's customs, learned to think like the white man, and to want the same things the white man received. And now, those things that they very things that desire are the deny them! the white men a people that Why is it that pressed, will, have been op- their freedom, upon securing oppress others? be the first to

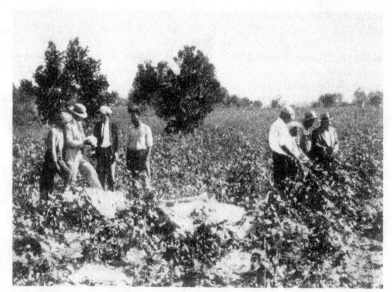

H Club boys inspecting one of their cotton demonstrations in Richland County, South Carolina

Photo by courtesy of J. B. Pierce, Hampton Institute, Virginia

Why is it that a people who have been denied certain rights, will, upon securing them, be the very ones to deny them to others? Why is it that a people will not look upon a state of affairs in the very same light in which they had wished their own, once, to have been looked upon by others?

It is all a very sorry plight. For anyone with the least degree of intelligence can perceive the fact that this is not only a fight solely for the Negro, but for mankind at large. This is a fight for every living individual. For it is only when every living individual can be assured of fair play and just treatment that this world can really be called civilised !

There is only one way that this can be brought about, and that is through education. Even though, as I stated before, it tends to give the Negro a deeper sense of misery, it is absolutely necessary for him to avoid the greater misery that is in store for him. For in education there is light and understanding. And it is only when light exists that man can see his way before him !

The Negro Student in the U.S.A.

by GABRIEL CARRITT

DURING the last months of 1931 and the first months of 1932 student groups from several of the Northern and Eastern States formed the basis for a National Student League.

The purpose of this league was to organise and lead the revolutionary student movement in the U.S.A.

During the spring of 1932 groups from many colleges joined the organisation, but until June no Negro college had been in touch with the league, though individual Negro students attending colleges in Northern States had become members. In July student delegates visited Negro universities in the Southern States.

This is probably the first time that any student movement in America has taken the revolutionary step of going out to break down the barrier between coloured and white students by uniting to fight for a common programme of student rights.

Because of the position of the Negro masses in America the Negro student has been inevitably out of contact with the student movement, both in America and abroad, and whenever there has been contact it has been of a consciously " inter-racial " character and falsified by philanthropic motives. The inter-racial conferences and Y.M.C.A. groups bring the Negro student in contact with sympathetic white people, who feel sorry for him, or else with those who are anxious to discover among the Negroes material for a novel. Their very purpose of getting together to discuss " how they can best get together " is a covert admission of racial prejudice.

The mass of Negro students has been isolated by segregation in their Southern schools. These are of various kinds. There are the industrial schools or technical institutes, some of which were founded by the Rosenwald-Rockefeller dollars, and because they exist on white generosity are controlled accordingly by the white ruling class. These institutes are founded on the principle that the Negro is incapable of the higher education and is best suited to a manual trade. With this equipment he will work as a faithful servant and never aspire to those occupations which are the prerogative of the white race. But even this much enlightenment was thought to be presumptuous, and for years at Tuskegee the windows along the highway were kept heavily curtained lest the sight of a Negro studying offend the less literate white passers-by.

At some of these institutes, by the rules of the founders, the students live under military discipline: room inspection, parading to meals, compulsory chapel and compulsory military training. Distinguished from the industrial schools are the Negro colleges of liberal arts. These began as theological seminaries when preaching was the only profession open to the Negro. The curriculum includes cultural courses, though theology predominates. Here the students are allowed a measure of self-government and freedom of expression, also debating and political discussion are countenanced. Those who are not preparing for the ministry mostly expect to teach ; a few will go North for post-graduate work, one or two will go through medical school.

One important Negro University, Howard, is maintained by the government, and is, like the rest, a jim-crow institution.

The Negro Student in the U.S.A.

Negro education is ultimately controlled by the white ruling class and is therefore controlled in the interest of that class; the control takes various forms. There are the preachers and ex-preachers, usually at the head of the institutions, who can be " depended upon " to be " loyal." They are reactionary. There are the younger instructors who come full of good intentions, but are soon shown that it is as much as their job is worth to participate in any unrecognised student activity. There are also a number of white instructors at some colleges, most of whom are not there because they believe in the political and social equality of Negroes, and their appointment by a white governing body to a segregated Negro college indicates the dependence of these colleges.

Besides this composition of the staff, the curriculum is controlled. Not only are many text-books out of date—for instance in one college the text-book in use proved the biological inferiority of Negroes—but also economics and history are taught with race and class prejudice.

The general standard is low, and when a Negro student goes from a Southern college to do graduate work in a Northern college he is often unable to take senior standing. But what the Negro student does not learn in college he has learned from experience. Over 90 per cent. of the students depend on employment during the summer in order to pay their next year's tuition. For the last two summers they have been unable to get jobs, and many of the jobs which used to be " reserved for niggers " have in the general unemployment been given to whites, when the prejudice against a Negro job gives way before economic necessity. The majority of Negro students are of working-class origin and hitherto many hoped that a college education would enable them to join the professional class. This illusion cannot survive any longer. Students work hard and their parents sacrifice for their education, but when they graduate they are forced to take any unskilled, low-paid job they can get; and today qualified medical students are porters at New York stations. If they enter one of the professions, they do so as ghetto professionals, limited in their practice to the segregated quarters. There, as lawyers, doctors, etc., they tend to form a Negro bourgeois class, and exploit, as ruthlessly as the white bourgeoisie, the mass of Negro workers from which they have emerged. But for several years now these professions have been overcrowded. As a result Negro students have become more class conscious, and faced with the problem of work and bread they see the problems of the working-class student are the same as those of the working man. Furthermore they begin to analyse the whole situation in which the Negro student finds himself today. They see that if the Negro of working-class origin accepts the present scheme of things and tries to make good in a profession, he will be climbing to position and wealth on the backs of the mass of his own people; that even if he controls a bank, is a doctor or a teacher, he will not be his own master, but will hold his position and wealth dependent on the interests of the white ruling class, and further that he himself will become a tool in keeping the Negroes oppressed and exploited. For the Negro business man and intellectuals trade with the masses in the segregated quarters of great cities, and since the Negro bourgeoisie could never compete with the white bourgeoisie it depends for existence upon the perpetuation of the segregated Negro masses. Finally, the Negro student looks critically at the personnel of that professional class which has emerged from the Negro masses, a class that has for its very existence aped the ideals and manners of the white ruling class; a class that has proved by its ruthless exploitation of the Negro working class that the race problem is above all a class problem.

The political awakening of Negro students has thus made them critical of the race leaders among the Negro bourgeoisie. Because their awakening threatens the existence of this bourgeoisie it has called forth renewed efforts from educators and Utopian idealists, advocates of the back-to-Africa movement, to side-track students again into the harmless paths of collaboration with the white philanthropists. The new radical talk of such Negro journals as *The Crisis*, the articles and speeches of Dr. DuBois, are evidence of how the old leadership is endeavouring to keep the control. The treachery of the old leadership is revealed in the part played by the National Association for the Advancement of Colored Peoples in the Scottsboro defence. The sabotage and recriminations of this organisation when it failed to take over this case revealed effectually to Negro students the nature of the policy behind it.

The programme of the National Student League was welcomed by many groups in the Negro colleges. They realise the necessity for students being their own leaders and fighting for a programme that recognises their interests as common with the interests of the working class. As members of an oppressed race they have felt the injustice of capitalist society. What the white student is just beginning to learn, the Negro has known all along. The white student, his mind befogged by the poison of race hatred, more slowly realises that while the Negro student is a slave the white student will never be free.

Today throughout the Southern States Negro students, intellectually alert, are repudiating the sham ideals and casuistry whereby a spurious educational system seeks to reconcile them to an inferior status.

A Letter to Ezra Pound

D<small>EAR</small> N.,—The enclosed letter has just come and there isn't time to get the writer's permission to print it. I mean before going to press. I think it is too valuable to be omitted and therefore send it without the author's signature.

D<small>EAR</small> E<small>ZRA</small> P<small>OUND</small>,

Do you know this about Negro schools? That most of them are missionary schools (or philanthropic institutions) still highly religious, highly imitative of the "best" white models, and mostly controlled by white gentlemen who live in Boston and New York and never heard of Benin.
The two best of the lot, Howard and Fisk, are trying desperately to become little Harvards. Fisk is becoming fashionable, and Howard is in Washington among the politicians who give it money, and the aristocratic Negro families who try to run it. And both have ministers for presidents. And both of them probably think Benin is somebody's back yard somewhere. Tuskegee is a huge trade school going dead . . . Of course, there ought to be a chair of Africanology in a Negro university. But one can't ought it into being without a sensible place for it to be in, and somebody who knows something about the subject and loves it, to head it. . . . Did I ever suggest that you write to Alain Locke about the matter? He's a professor at Howard, brought the Theatre Arts Exhibit of African Sculpture to America, and probably could exchange a much more informed opinion on the matter with you than I can. . . . Liked your letters and advice about my poems. . . . I've had a swell time in Middle Asia this winter: Samarkand, Bukhara, and the Turkmen desert, and a Beluchi kolkhoz. . . . Please send your books for me to my publishers (etc.)

If any of my hundred per cent. white, Celtic or Asian, correspondents have done better during the past few months their epistles have got lost in the post.

A Note on *Contempo* and

Langston Hughes

E<small>VERYONE</small> knows the further South you go the worse the prejudice (with a few exceptions here and there, such as the town of San Antonio, Texas, which was Mexican until a few decades ago—latin therefore, non-"nordic." A Texan Negro friend said the degree of prejudice and race hatred varied surprisingly in regions as close as thirty miles from each other). Sometimes the barriers get broken down, by determined people, as at Chapel Hill, in North Carolina, the seat of an important (white) University, where, amongst others, Paul Green, sympathetic author of several fine plays on Negro life, is professor. There used also to be there a lively, straight-speaking and active periodical, called *Contempo*.[1] In December 1931 Langston Hughes, the most famous of the younger Negro poets, was on a lecture tour through the States. The students of Chapel Hill invited him to speak, *Contempo* printed him. Langston Hughes denounced the *Scottsboro* case and flayed the Southern *crackers*.[2] The effect was of course like wildfire. The North Carolina crackers had never seen the like before. *The Southern Textile Bulletin*, Charlotte, N.C., December 3, 1931, wrote:

Langston Hughes, a Negro, while participating in the communist effort to create interest in nine Alabama negroes convicted of assaulting two white girls, wrote an article containing the following:
"For the sake of american justice (if there is any) and for the honor of southern gentlemen (if there ever were any) let the south rise up in press and pulpit, home and school, senate chambers and rotary clubs and petition the freedom of the dumb young blacks so indiscreet as to travel unwittingly on the same freight train with two white prostitutes. . . ."
In spite of the fact that this Negro deliberately and intentionally made the above and many more insulting remarks about the people of the south both his statement and his poetry were published with gusto and approval by Contempo, a publication issued by the students of the university of N.C., and that publication also said:
"Langston Hughes, prominent poet and novelist, is soon to be the guest of the editors of Contempo."
We had hoped the swallowing of the insults of this Negro was limited to the editors of Contempo, which is not

[1] At present published in Snow Building, Durham, North Carolina ; editor, Anthony Buttita, (author of *Negro Folklore in North Carolina*, see previously).
[2] The rabidly offensive Southerner crazed with race-prejudice.

A Note on *Contempo* and Langston Hughes

an official publication of either the students of N.C. university or the university itself, but we note the following editorial in the daily Tar Heel, the official student publication:

" Langston Hughes, prominent Negro poet and novelist, spoke before various groups of the student body during the latter part of last week. His poetry as well as his speaking is the expression of a clear and sincere spirit."

We have no doubt that Langston when he said that there were never

The editors of *Contempo* enter-them, Buttita, sent me this photo-" daily discrimination " (I had Chapel Hill):

Negroes are not allowed to eat in get any service at all in large places with a pale shame on their faces. they are quickly gotten rid of, and soda in the place, sandwiches can be and buses, the Negro always gets crowded, bus wont stop for Negro, that particular occasion we had snappiest cafeteria in town . . . surprise, and what was the idea and waitresses were particularly comment arose. We were going to this; some people even threatened cafeteria explain . . . of course, Langston to a white drug store for soda jerker took Hughes for a at that, but since he found out that had given him service the way he angry and attempted to catch us the jaw . . . told his friends about cheap vengeance for some days. in our bookshop for a day or so the University came around to talk color line, race question and other

Buttita and Abernethy, editors of Contempo, *standing on each side of Langston Hughes in front of the U.S. Post Office, main street, in Chapel Hill, North Carolina.*
On this occasion the breaking of the prejudice in this Southern State lies in the fact that black and white together could be seen by the townsfolk on an equal footing!

Hughes meant to be very clear any southern gentlemen. . . .

tained Langston Hughes—one of graph and wrote me this note on asked him what this was like in

same places as whites; they do not unless they wait around for a while In drug stores and soda fountains, do not get to eat cream or drink taken out . . . in cars and trains the lousiest back seat . . . and if but will for white man. . . . On Langston Hughes for dinner at the everyone looked and looked for of it all . . . the Negro waiters pleased in seeing the event. Much be boycotted for carrying on like to make the manager of the he didnt know . . . then we took a drink . . . the cheap, southern mexican or something and let it go Hughes was a " nigger " and he would have a white man, he got in a place or two and sock us in it and we were looked at with That is not all. We had Langston . . . ladies of the courtly order of and argue with Hughes on the such stuff . . . a certain wife of a

certain nephew of good old Woodrow Wilson—she can't have kids, by the way—thought Hughes was darling, cute, and wanted to have him out to dinner in her Dreamshop . . . her home in the Buttons, a section in Chapel Hill, . . . think she forgot it or changed her mind. . . .

Black America

by W. E. BURGHARDT DuBois

Editor of *The Crisis*.

W. E. Burghardt DuBois

THERE were perhaps five thousand Negroes in all the Americas in the 16th Century. They had come as body servants and laborers—a few being free, most of them being regarded as slaves. They took part in exploration : they were with Balboa and De Soto, and one of them, Estevanico, led the expedition from Mexico that discovered the south-western part of the United States in 1539.

Negroes were permanently landed in what is now the territory of the United States, in Virginia, in 1619. They were the answer to the problem of new free land which America had thrust upon Europe. This land called for labor, and the labor was supplied by stealing white men in Europe and black men in Africa. The supply of white men, however, was lessened by the needs and labor laws of Europe. The supply of black men was practically unlimited by the disintegration of African life, begun by the Mohammedan invasion and increased by the slave trade itself.

The result was that by the beginning of the 18th Century large numbers of Negroes had been brought to the West Indies and some fifty thousand to the United States. This importation of slaves became profitable in two ways : it furnished labor for a new and widely demanded set of crops ; and, on the other hand, the carrying trade was tremendously advantageous to the sea-faring nations.

Fierce rivalry began for the monopoly of this trade in black men. The Dutch secured it in the 17th Century, but in 1713, the crowning triumph of the war between England and Spain was the securing of the monopoly of the American slave trade by the English. The result was that by the middle of the 18th Century, the fifty thousand Negroes in the United States had increased to two hundred and twenty thousand, and the crops of tobacco, sugar and rice began to cross the seas and to appeal not simply to the rich and privileged, but to the mass of middle-class buyers. The demand for these crops and the extension of their culture, led to vigorous activity in the slave trade during the latter part of the 18th Century, so that by the beginning of the 19th Century there were 900,000 Negroes in America and a fourth crop had been added to the other three, destined to become the greatest crop of all, and the foundation-stone of a new modern economic kingdom. This crop was cotton. The United States raised eight thousand bales of cotton in 1790. By 1820, it was raising 650,000 bales, which began the economic foundation of a new American labor problem.

At the same time there were various indications that the slave system was not securely established. From the very beginning there had been serious slave revolts, like that of the Maroons in the West Indies, and early revolts in Mexico and Virginia. This culminated in the great revolt of Haiti, where after spasmodic fighting between mulattoes and white masters, suddenly, on August 22, 1791, the black slaves arose and eventually succeeded in driving out the whites and taking charge of the country.

In the United States, 5,000 black soldiers had been used in the Revolutionary War, and black soldiers and sailors were used in the war of 1812. These facts, coupled with the new humanitarianism of the 19th Century, brought efforts at slave revolts in South Carolina and Virginia, and the abolition movement in the North. The abolition movement began to be successful when it secured actual slaves, like Frederick Douglass, as personal exhibits of the injustice of slavery.

At the same time, the too rapid expansion of the cotton kingdom brought an economic crisis in the decade 1850–60, which led to a demand for more slaves and more slave territory, and met the opposition of Northern labor and Northern humane feeling.

By 1850 there were 3½ million Negroes in the United States, who had increased to over four million at the time of the Civil War. After the war, there came a reconstruction of Democracy in the United States, and in this the Negro played an important part. Through his vote it was possible to restore the South to the Union, to establish in the South a public school system, and to begin a new social legislation.

The Negro paid the penalty for helping the nation in this way during the post-war reaction when he

suffered disfranchisement and caste restrictions, so that by the beginning of the 20th Century he was restricted in his right to vote, to travel freely, to live where he would and to frequent public places like other American citizens. Today, in the second quarter of the 20th Century, there are between 12 and 13 million Americans of Negro descent, and we must regard them not simply as a class of Americans to a degree physically separate from the mass of Americans and forming a separate series of problems, but as persons who because of their long connection with American life are a part, and an important part, of American civilisation.

Democracy in America, for instance, has been developed because of the pressure of the slaves for freedom and recognition. The status of women has been changed greatly because the Negro woman was a working woman before she was a housewife, and her example and competition has spread among white working women. Education, particularly in the South, has become popular, and the public school is an accepted institution, primarily because of the insistence of Negroes on free education.

But above all, in two fields, the Negro has made his great contribution to American culture, and that is in art and in labor. We do not usually connect these two things. The more or less open ambition of every American is to become so rich that he will not have to work, and the only native American art is Negroid, and consequently has not been highly regarded by most Americans. But the hard manual toil of the American Negro has helped to develop America, and sometime when we have a greater respect for work, this will be recognised as a great contribution. Beyond this the Negro has helped in skilled work and invention.

On the other hand, we are already beginning to see the beauty of Negro Art in American literature, in music and dancing, and such social ideals as good will and sacrifice ; and we shall come to see beauty in other lines to which the American Negro has contributed. We can, therefore, well think of the Negro element in America as an integral part of American life and as having made a permanent contribution to American civilisation.

So much for formal history—the sort of thing an outsider might see looking in upon the United States. Now comes the much more interesting and fateful question : what effect has this contact of races had on the American soul and upon the souls of black folk in America? This is a matter of inner thought and character, of psychological reaction. First of all, the presence of the Negro has greatly changed the specific idea of American democracy. The 18th Century in many different ways dreamed of establishing on this continent a government of men and a social and industrial organisation which should be freer than that of Europe, more pliable, easily adjustable to human character. They foresaw a more equitable distribution of the work of the world and of its rewards in wealth, and they desired especially that the thought of human beings should be more untrammelled and unconventional—less cramped and predetermined. Something of this dream has been realised. There is in America a certain freedom of movement and action unknown and unpermitted in the older world. There is a wider distribution of wealth and a wider range of activity for workers and for those who guide them. There has also been considerable freedom of thought and expression.[1]

At the same time, all this has been undoubtedly limited by the fact that color caste has grown up in America and this has helped in the growth and development of other caste restrictions. Almost all liberal movements in the United States for two centuries have been limited and changed out of their natural course by the presence of the Negro. Exceptions had to be made in religion, in democracy, in social intercourse, in philosophy of life because of black folk. This color caste tended to become crystallised into social differences based on wealth. Negroes were poor and black and enslaved. They were disfranchised primarily on account of previous slavery. Because their color was so long an index of slavery, their poverty the result of slavery, inevitably poverty in any form shared the caste feeling against slaves.

Similarly all colored people, even those who had not been enslaved in America, came under the American color ban. Public opinion in free democratic America leaped to sympathise with imperialism, autocracy and race hate wherever it appeared in Europe, and particularly if colored peoples were involved. Thus, we joined Europe against the Chinese Boxers, we long excused and defended England in India, and we applauded all the exploiters of Africa.

If America then today is a land where wealth rules, Negro slavery has been an indirect cause of this, because slavery and poverty were so linked together. In a similar way, the disregard of law in America, which is so widespread and persistent as to be almost characteristic of the country, has in part arisen from the fact that there was no law that could protect the Negro in the past, and that laws for his protection today are often by common consent ignored. The slave codes were bad and harsh enough, but

[1] See in particular " ' Insurrection ' Farce in Georgia," in " From the American Press." ED.

Black America

even they were often ignored. A cruel, selfish master could practically do what he pleased with his slaves, even to the extent of life and death. He could force the black women to his will : he could sell fathers, mothers and children and separate families ; he could work his slaves to death ; he could beat them into submission. And, of course, on the other hand, he could be a most kindly and generous patriarch of a large family, allowing his black children wide freedom, even giving them education, treating them with consideration and affection. The point is that he could do as he pleased, and the white master class of the South grew up with this inborn idea of superiority to all law, whether it related to black or white. The mass of the poor whites imitated them as soon as they had the chance ; it was the sign of their social emancipation, and the lawlessness of the South spread over the country with its trail of lynching, mob law, and gang rule. There are, of course, many other contributing causes to American lawlessness, but the caste system against Negroes is one of the most potent.

The habit of public charitable giving in the United States, which is a singular return to the habits of the Middle Ages, has been encouraged by the presence of Negroes. It arises when the caste lines between groups of people are so strong that there is no hope or thought that this disadvantaged class is ever going to outgrow its disadvantages. The only thing that can be done is temporarily to ameliorate its condition by doles. Normally, in a rich country like the United States and in a country where the working class occupies so high a place, charity should have become the last method of social reform. But with a class of black folk who are not permitted by public opinion to receive higher wages, who are not expected to be fully educated and developed, the habit of alms-giving became in America much more widely spread than otherwise would have been probable or defensible.

America, then, because of the presence of slaves and freedmen has developed a caste system which has emphasised the rule of the rich, spread lawlessness and made alms-giving a main method of social reform.

Let us turn now to the American Negro himself. Usually his inner development and reactions have been neglected by students and observers. The reason, of course, is that the truth in these matters is much more difficult to attain. One has to bridge a wide social gulf and enter a land of natural distrust and suspicion. This shadow land is guarded by defensive mechanisms of thought and habit—a suave effort to agree with critics, appease the powerful and amuse a world accustomed to think of Negroes as primarily entertainers—bizarre clowns and genial minstrels ; and, too, there is, of course, the openly expressed or widely held assumption that there is no inner reaction among Negroes ; that you are dealing with a people who, while they are swayed by certain primitive feelings and instincts, are not thinking and planning or moving in any self-motivated ways.

All this is misleading and untrue. The Negro has from the beginning reacted and reacted sharply to his surroundings, until today the American Negro is one of those groups of thinkers in the world who must be reckoned with in any view of the world's future. They must be considered in any discussion of the future of Africa, in any forecast of the marvellous West Indies, in any view of the amalgamated blood of South America, and even in our plans for the relations of Asia to white Europe.

In the 17th Century, before American slavery was fully developed and systematised, there were many strong individual Negro thinkers who came to the fore in various places on the American continent. They did not represent a unified group, except possibly in the case of the Maroons of the West Indies, who transported to America and developed among the runaway slaves the ethos of tribal West and Central Africa. Directly out of this came the success of the Haitian revolt in the latter part of the 18th Century.

As slavery became a fixed system in the United States and the slaves were regimented under careful training and rule, their reaction came in two ways : through their religion and through their attempts at revolt. The list of slave revolts in the United States is long and impressive. One has only to read the legislation against them to realise the fear that they inspired. Leaders like Prosser, Denmark Vesey and Nat Turner are not to be forgotten in the development of America. But revolt was finally given up as a weapon because of a more effective method of attaining freedom, and that was the method of the runaway slaves. Organised running away of slaves took place in the far South, where it caused the so-called Seminole Wars and led to the eventual removal of the Indian tribes westward. Afterwards, running away, they took the paths that led to Canada, the Blue Ridge Mountains, the Mississippi Valley, the swamps of Virginia. Under leaders like Josiah Henson, Harriet Tubman and Sojourner Truth, aided by hundreds of white abolitionists, slaves disappeared by the thousands, and this became one of the great economic and political causes of Emancipation.

On the other hand, the emotional outlet of the slaves was through their churches. These churches had more or less internal autonomy ; they raised up a leadership of their own ; they devised their own music,

dancing and ceremonies. The result was nothing less than tremendous in the development of both black and white America. The slaves originated the curious and beautiful volume of song that has come down through centuries as a never-to-be-forgotten contribution to the world's music. From it has developed the " gospel " hymns of the whites, the syncopated rhythm and jazz of the world of art and a wealth of material for great composers like Gilbert and Dvořák.

In literature, articulate voices of Negroes appeared in early days—the poet, Wheatley ; the radical, Walker ; orators like Ward and Douglass. Then suddenly came political emancipation through war. When emancipation came, it was regarded as miraculous by the religionists among American Negroes and as the fulfilment of opportunity by the black philosophers. The gates were now opened, the barriers down ; the Negro was in law a full-fledged American citizen, and by the help of education and wealth, he was going forward to claim his heritage. The burning desire for education came first, as this seemed first the key to all. But it proved a difficult path. The State did not do its part ; philanthropy performed miracles, but after all was unequal to the thorough training of so many millions ; thus, after nearly seventy years of Negro education, the Negroes are still, as a mass, an ignorant people, whose illiteracy must be compared to that of Southern Europe.

Their attention next was drawn toward the accumulation of wealth, the American panacea for all ills. But here they were handicapped even more than in their search for education. They started with nothing, neither land nor capital. The skill which some of them had acquired was very soon displaced by new machines and new technique. In the new world-wide organisation of capitalistic enterprise they were given small place, so that despite their legal emancipation, economic emancipation lingered long and still lingers. All this was expressed by a flood of literature—biographies, complaints, appeals, fiction, history. All this was at first an inner stream, written by Negroes for Negroes and unheard of the world without. Thus wrote Whitfield, Wells Brown, Harper, Nell, Payne and Trotter. Then, in 1896, the racial river burst its banks and Williams, Dunbar and Chesnutt raised voices to which all the world listened. Negro literature became a recognised part of American literature.

The burden of this voice today among the 12 million or more American Negroes is marked by tremendous difficulties and heart-searchings and inner strivings on the matter of their relation to the modern world. There are those who, building on the older group philosophy which triumphed at the time of emancipation, declare that the object of this black group is solely to become American citizens without distinction or color. They do not mean that colored people as such are necessarily going to disappear, although most of them would probably admit that in three or four centuries they would probably be absorbed by the nation ; but their chief point today is that, despite color, Negroes must be treated in their political and civic rights as citizens, without color discrimination.

The difficulty in this philosophy comes up in the matter of " social " rights ; for what is the difference between admitting a man to the theater, where he sits beside you, and admitting him to a public luncheon, or admitting him as a guest to dinner in your own house ? If colored and white people become acquainted without artificial discrimination, social barriers are sure to grow less ; some inter-marriage will certainly follow, and, as some persons put it, the United States will tend to become octoroon.

As a rebound from this logical conclusion and because of the bitterness and insult which any possible legal mixture of races in America always engenders, many Negroes fly to the opposite extreme and declare that while they want legal rights, they desire no social contact nor social intermingling. They seek only the company of their own race ; they marry into their own group and disown those who do not ; they are not only willing but desirous of remaining radically distinct. The difficulty with this philosophy is that it leads logically to a further refinement. Why should a separate group live beside another group ? Why not follow social separation with physical segregation—in its own part of the city ; in a distinct part of the state ; even in states of its own in the United States ; or, finally, in a movement which would take it back to Africa ?

Here are three logical stopping-places of Negro thought. Each has its impasse. Prejudice today forbids racial contact in the United States ; that same prejudice makes segregation difficult and dangerous ; and where in Africa or the South Seas could a group of black freemen escape the tentacles of modern imperialism ?

Fortunately or unfortunately, logic has little to do with real situations. While the future of the Negro is being thought out within and without the race, actual things are happening. The Negroes are becoming curiously integrated into American civilisation. In the past, they have been servants and laborers. Today they are still servants and laborers, but more than this : they are artisans, merchants and professional men, appearing here and there in all walks of life. They help to support, transport, amuse and entertain the

nation ; they are a part of its literature, a part of its daily life. They have in reality no desire to leave America because America is their home. They are as strange to Africa as to China. They landed here before the Pilgrims. They are much nearer the soil and genius of the country than the majority of the

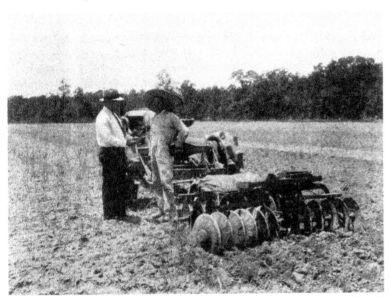

Negro farmer disking his land with his tractor outfit in Nausemond County, Virginia

Photo by courtesy of J. B. Pierce, Hampton Institute, Virginia

white inhabitants ; and in addition to all this, while the question as to whether white and black people are going to mingle their blood in this country or not is being bitterly argued, the striking fact stands out that these bloods have already been mingled to such an extent that it is impossible to separate white and black in the United States by physical characteristics. There are white people who call themselves Negroes because of an invisible drop of Negro blood. There are Negroes who call themselves white, ignoring or not knowing the fact that they had a great grandfather who was a black slave. So-called black America is of every conceivable hue and shade, and white America is by no means "lily-white." It is idle to ask whether this mixture is increasing

or not, the dominant fact is that the intermingling began two centuries ago and has not stopped, and will not stop. The unity, then, in the Negro-American group, while still predominantly a matter of blood, is by no means wholly so. It is increasingly a psychological unity—a matter of memories and hurts and ambitions. And out of these things are arising poignant problems ; questions of revolt and self-assertion ; questions of compromise and yielding to superior social force ; questions of ideal and racial development ; questions of narrow racial pre-occupation in the face of a broader national and humanitarian outlook. All these are manifest today in black America, and just what the end will be, who can say?

The Negro and the Supreme Court

by WALTER WHITE

FEW events of recent years have stirred public interest so deeply or caused wider and more acrimonious discussion than the rejection by the United States Senate on May 7, 1930, of the nomination of John J. Parker as an associate justice of the United States Supreme Court. The narrow margin of defeat—41 to 39 votes—and the circumstance that all of the remaining sixteen Senators were paired attest the tenseness of the struggle to choose a successor to the late Mr. Justice Sanford. Acute as was the feeling at that time, one runs little risk in prophesying that the rejection of the North Carolinian holds for the future immense political significance. For, to quote the Washington *Post*:

Negro political consciousness, until the last year or so rather vague, has been much stirred by the Senate's rejection of Judge John J. Parker. . . . The potentialities of the Negro vote in Northern States have been much enlarged by attributes of the recent struggle over the justiceship. At the same time the case may stimulate a revival in parts of the South of the race question as an acute political issue. . . .

There are in the effluvia of that result impressive evidences of a " come-back " by the Negroes as a minority voting power [the Washington newspaper adds] on a scale that may cause them to be reckoned with more seriously than at any time since Southern reconstruction days. For Negro voters now easily can decide contests between the big parties in a half dozen or more large Northern States. All they need are

103

The Negro and the Supreme Court

Walter White

political-mindedness, cohesion, and management. And in the result of the fight over Judge Parker there are makings for all those requirements.

It seems certain that all this and more is true. For the struggle against confirmation of the North Carolina jurist, so far as the Negro's part in that rejection is concerned, not only revealed in startling fashion the resentment of eleven million Negroes at a rapidly growing disregard of their political rights but showed as well that the Negro no longer intends supinely to permit the whittling down, little by little, of the constitutional rights which, theoretically, belong to him as an American citizen.

Because of the significance of that struggle, it will perhaps be worth while here to record something of the manner in which Negroes made themselves felt. When the late Justice Sanford died it was generally understood that a Southern jurist would be named as his successor. Negroes, and especially the National Association for the Advancement of Colored People, were naturally somewhat apprehensive as to *what* Southerner would be chosen. There was no feeling against the possible nominee simply because he might be from the South, but there was deep concern as to whether he represented the old or the newer South—whether he was of the school which still agreed in theory and practice with the Dred Scott decision that a Negro possessed no rights which a white man was bound to respect.

With particular apprehension Negroes read of the possible choice by President Hoover of either of two men—one of them a member of the United States Senate—who are notorious Negrophobes. Judge Parker's nomination came from a clear sky, as reports from Washington indicated that he stood little chance of having his name presented to the Senate. A hurry-up call for information from reputable North Carolina citizens, white and colored, revealed that in 1920 Judge Parker, as the Republican gubernatorial nominee of that year, had declared in his speech of acceptance of the nomination that " the Negro as a class does not desire to enter politics. The Republican party of North Carolina does not desire him to do so. We recognise the fact that he has not yet reached that stage in his development when he can share the burdens and responsibilities of Government. . . . I say it deliberately, there is no more dangerous or contemptible enemy of the State than men who for personal or political advantage will attempt to kindle the flame of racial prejudice or hatred . . . the participation of the Negro in politics is a source of evil and danger to both races and is not desired by the wise men in either race or by the Republican party of North Carolina."

The issue was clear-cut and unmistakable. Judge Parker seemed either unaware of or indifferent to the fact that the Federal Constitution forbade denial of the right to vote to any citizen on account of race, color, or previous condition of servitude. He made no distinctions between Negroes who possessed character, education, property, and intelligence and those who were without these attributes. Nevertheless, those colored people and whites who disagreed with him wanted to be free from any taint of unfairness towards Judge Parker. The National Association for the Advancement of Colored People telegraphed him to ask if he had been correctly quoted by the newspapers of his own state, or, had he been correctly quoted, if he held in 1930 the same views he had expressed a decade before. Inquiry of the telegraph company revealed that the telegram of inquiry had been delivered. When three days had passed and no reply was received, a formal protest against his confirmation by the Senate was filed with the Judiciary Committee.

No serious consideration was given at the time to the Negroes' protest. At the hearings of the sub-Committee of the Judiciary Committee, the committee and the press gave practically all their attention to the protests of organised labor who opposed confirmation on the basis of Judge Parker's decisions involving the so-called " yellow dog " labor contracts. The spokesman for the Negroes was heard only after all other protestants had been allowed to speak, and even then his statement aroused only mild interest.

Soon, however, the Negro protests began to pour into Washington in a steadily mounting volume. Telegrams, long-distance telephone calls, letters, petitions, and personal visits impressed upon various Senators, particularly from Northern and border states where the Negro vote is potent, that their Negro

constituents were very much in earnest in their opposition to confirmation of a judge who had brazenly repudiated the guarantees of the Fourteenth and Fifteenth Amendments to the Constitution in so far as Negroes were concerned. A few of the Senators were frankly skeptical of the protests, believing that they were ephemeral and would soon die down. Others resented the protests, being somewhat bewildered at the spectacle of the Negro stepping out of his traditional role of a meek, uncomplaining creature who submitted without question to whatever was put upon him. Others were alarmed at the extent of the movement and apprehensively thought of approaching elections. Soon they began beseeching the White House to withdraw the nomination of Judge Parker and save them from the dilemma of voting either against the Administration or against the wishes of their constituents. To such requests the White House turned a deaf ear.

The National Association for the Advancement of Colored People headed the movement, aided without reservation by the two hundred Negro newspapers of the country, by the National Association of Colored Women representing approximately two hundred and fifty thousand women, by fraternal organisations, churches, and individuals. On no issue have Negroes worked so unitedly since the Civil War. Faced with what at times seemed insuperable odds and confronted with all the influence in Parker's behalf which the Administration could muster, they grimly went on with the struggle.

They did not indulge in any buttonholing of Senators at Washington. Through friendly sources, including Washington newspaper correspondents, they maintained, however, constant contact with developments at the Capitol. They received exact information about certain attractive offers which were made to Senators if they would only agree to cast their vote for confirmation. Equally exact were the reports which they received of threats made against other members of the Senate if they did not stand by the nomination. Cajolery and blandishments were used on some of the newer Senators, and the Negro leaders learned about these and discovered what persuasive arguments were employed. Through this information the meager resources of the Negroes, who were desperately fighting to keep from the Supreme Court bench a man who was willing to disregard their rights as citizens, could be and were used with maximum effectiveness.

It was no easy task. Many of the newspapers were fair in both their editorial and news columns but many others were not. The editor of a North Carolina daily, in whose columns had appeared the quoted statement which Judge Parker was charged with making, sent a telegram which was read into the *Congressional Record* denying that his paper had ever published such an item. The question of veracity having thus been raised, within twelve hours photostatic copies of the yellowed, ten-year-old clipping were placed by the Advancement Association in the hands of the President, of members of the Senate, and of the press. Thereafter no further charges of inaccuracy by Negroes on this point were raised.

On another occasion, supporters of the nominee pointed to a decision he had rendered in a case involving residential segregation of Negroes in Virginia as proof of Judge Parker's lack of prejudice against colored people. Within a few hours after the statement had been made it was pointed out that in the case in question the Federal District Court had first declared the Richmond Segregation Ordinance invalid on the basis of two unanimous United States Supreme Court decisions, which held arbitrary residential segregation by city ordinance or state law on the basis of color unconstitutional. Judge Parker, as one of three justices sitting in the Appellate Division to which appeal had been taken, had merely concurred in a *per curiam* decision with the two other judges.

During a tense moment of the fight, when it seemed certain that confirmation or rejection would surely be by an uncomfortably narrow margin, it was learned that certain individuals were industriously working in behalf of Judge Parker by appealing to the sectional or racial prejudices of certain Southern Democratic Senators. Of them was being asked, " Are you going to let it be said that Negroes have beaten you, too, into line?" To appeal to certain of these Senators, who came from States where Negroes are not allowed to vote and who thus were peculiarly amenable to racial prejudices, would obviously have been unwise if not disastrous. Yet united support of Parker on a sectional basis would have insured his confirmation. Certain of these Senators, especially some who are notoriously addicted to Negro-baiting, were thereupon queried as to the truth of rumors that they intended " to vote for confirmation and thus help reward North Carolina for going Republican in 1928." When the issue was presented in this vivid fashion, these Senators remembered that the nominee's Republicanism had undoubtedly played a large part in gaining him the nomination and that his elevation to the Supreme Court bench would unquestionably play a material part in subsequent elections. As a result of these queries, there was little purely sectional support of Judge Parker.

Amusingly enough, strenuous efforts were made by flattery and other less pleasant means to induce

Negroes of prominence to endorse Judge Parker and thus offset the welling tide of Negro opposition. One of the most distinguished Negro educators of the country was thus approached. He not only flatly refused to endorse Judge Parker but registered effectively his strong opposition. Negro politicians, editors, business men, ministers, and others were sounded out with the same result. A few nonentities were cajoled into writing endorsements (or signing endorsements written for them) but to no avail. One of these endorsers in a North Carolina town was featured in the local white press as a man of influence among Negroes and a possible United States minister to the Republic of Haiti; on the same day appeared another news item telling of the same man's indictment by a Federal Grand Jury. Only one Negro of standing—an educator in North Carolina who is president of a school for Negroes supported almost in entirety by state funds—gave active support to Parker, and his action brought down upon his head unequivocal condemnation from Negroes of all classes. In contrast with this man's attitude, some 188 prominent Negroes of North Carolina signed affidavits which were sent to the Senate Judiciary Committee in which these men and women registered their strong opposition to confirmation and set forth the reasons for their disapproval of Judge Parker. When over-zealous friends of the jurist went so far as to make threats against Negroes who would not sign endorsements, even this intimidation proved unavailing. In New Jersey a prominent young Negro physician practically abandoned his practice, and almost literally lived for weeks in his motor car as he visited ministers, fraternal order leaders, officials of civic and welfare organisations, and other influential Negroes to stir them to action.

This man's zeal was typical of the attitude of Negroes all over the United States. In Chicago, Cleveland, Detroit, Kansas City, Los Angeles, Philadelphia, Baltimore, St. Louis, and other cities where large numbers of Negroes reside, mass meetings were held at which telegraph blanks were provided for the use of those who wished to write and pay for messages to their Senators. It was estimated that from Chicago alone on the Sunday before the vote on the nomination more than two thousand telegrams were sent to the Illinois Senators, many of these messages coming from churches, lodges, and other organised bodies. One message spoke for eighty-four thousand Negro Republican women.

> The result [wrote Dr. W. E. Burghardt DuBois, the distinguished Negro editor] was a campaign conducted with a snap, determination, and intelligence never surpassed in colored America and very seldom in white. It turned the languid, half-hearted protest of the American Federation of Labor into a formidable and triumphant protest. It fired the labored liberalism of the West into flame. It was ready to beat back the enemy at every turn. . . . So in every twist and turn of the enemy, the battle was pressed down to the last minute.

II

What does this demonstration, new in American political history, portend? Is it to be regarded merely as an ephemeral outbreak of resentment by Negroes which will soon be forgotten? Predictions are always precarious. But when one looks backward and realises that the unyielding opposition to the confirmation of a man holding views such as Judge Parker held has been in the making for more than forty years, one can realise that the recent event at Washington may be one of the most portentous happenings of our time.

The Negro did not beat Judge Parker singlehandedly, nor could he have done so. Some of the Senators who voted against confirmation did so because of their conviction that the Supreme Court was becoming far too conservative and was showing a tendency to lay greater emphasis on property than on human rights. Others were moved by the protests of organised labor speaking through the American Federation of Labor. Some of the Southern members of the Senate unquestionably were motivated in their opposition to Parker by the suspicion that choice of a North Carolina Republican was in a measure due to the desire to annex that Southern State permanently to the Republican column. Detached and non-partisan observers agree, however, that the determining factor in the rejection was the Negro, to whose influence they attribute no less than eleven adverse votes and perhaps more.

The seeds of that protest were sown four decades ago. Dissatisfaction with and rebellion against the treatment accorded the Negro have constantly though imperceptibly grown throughout the last forty years. To understand this one needs only to consider the story of his climb, often thwarted, toward recognition as an integral part of American political life.

At the close of the Civil War there were two distinct schools of Southern white thought concerning the Negro and concerning the most profitable course for the late Confederacy to pursue in re-entering the Union. One school, led by General Robert E. Lee, was convinced that the only wise course was to accept the verdict of armed conflict and, furthermore, to understand that fundamentally the Civil War had been a conflict between two diametrically opposed economic systems—between the agricultural, slave-holding South and the industrial North. The industrial revolution had outmoded the economy

on which the South had relied, and the only sensible thing to do, these leaders argued, was to forget the glories of the past, most of which had never existed in reality, and to build a new scheme of things based on the new conditions. Unhappily, such wise counsel was not followed. Instead the South as a whole turned to the program of the tragically ludicrous Ku Klux Klan, the White Camelias, and other such movements designed to re-enslave the freedman as far as was possible without bringing down again the armed forces of the North.

Beginning in the nineties, after federal troops had been removed from the South, various means were utilised to take the ballot away from the recently enfranchised freedmen. Among the first widely used efforts at disfranchisement were the so-called Grandfather Clauses. Various Southern States passed constitutional amendments imposing educational requirements upon all voters and providing that no person should be allowed to vote unless he were able to read or write any section of the state constitution. Exemptions, however, were specifically granted to all those who, or whose ancestors, had had the right to vote and had voted anywhere in the United States prior to January 1, 1866.

Among the States which passed such constitutional amendments was Oklahoma. A test case arose in that State which eventually reached the United States Supreme Court. The late distinguished authority on constitutional law, Moorfield Storey of Boston, submitted a brief in this case (*Guinn and Beall* v. *The United States*, 238 U. S. 347) on behalf of the National Association for the Advancement of Colored People, of which he was President. In this brief Mr. Storey clearly pointed out that the real purpose of the exemption, especially as signified by the choice of January 1, 1866, was to disfranchise Negroes. "The effect of the amendment," declared Mr. Storey, "is to allow almost *anybody* to vote, whatever his education or extraction, unless he happens to be a Negro, for it is well known to the Court as it was to the framers of the amendment that practically all residents of the United States, other than Negroes, enjoyed the right to vote in 1866." The Supreme Court in its decision declared such constitutional amendments unconstitutional.

Later there came into general practice the system of primary elections. This system offered another means of denying the ballot to Negroes in certain States. Various of these States passed laws prohibiting Negroes from voting in Democratic primaries. It is a well-known fact that in most of the States of the South, and especially of the lower South, the Democratic primary is *the* election. In the Texas Democratic primary in July, 1926, for example, the six candidates for Governor received a total vote of 735,186; in the subsequent general election Dan Moody, Democratic gubernatorial candidate, was elected by 89,263 votes over a Republican candidate who received 11,354. The United States Supreme Court was asked to pass upon the issue involved in the Texas law and similar laws in other Southern States. The case involved a qualified Negro Democrat of El Paso, Texas, Dr. L. A. Nixon by name. Dr. Nixon, a property holder, a man of education, and a citizen esteemed by both races, was refused under the terms of the law the right to vote in a Democratic primary. When the case reached the United States Supreme Court a unanimous decision ruled the Texas law unconstitutional, "because it seems to us hard to imagine a more direct and obvious infringement of the 14th Amendment."

Those who were determined that Negroes should not be allowed to vote in certain States were not, however, to be discouraged. The next step was the passage by various legislatures, among them Texas, Arkansas, Florida, and Virginia, of enabling acts giving to political parties the right to determine their own qualifications for membership. In other words these State legislatures said, in effect, that political parties should have the right and power to do that which the Supreme Court had said the States themselves could not do. Various test cases have arisen under these enabling acts. In the case arising in Virginia, that of *West* v. *Bliley*, Judge D. Lawrence Groner of the Federal District Court sitting at Richmond promptly declared this enabling act unconstitutional. Appeal was taken to the Appellate Division of the Federal Court, which affirmed Judge Groner's decision. Proponents of the measure did not take advantage of the right of further appeal, permitting the time granted for such appeal to pass.

This long-drawn-out, difficult, and expensive attempt to prevent violation of the Negro's constitutional rights has been carried on chiefly by Negroes and their friends as represented in the National Association for the Advancement of Colored People. Perhaps the chief value of this struggle has been in its educative effect upon Negroes themselves in causing them to realise the importance of the ballot. Colored Americans do not imagine the vote in itself to be a panacea for all the ills from which they and others suffer. They do realise, however, that a voteless people is a defenseless people. They know that when a man can be denied the right to say who shall govern him, who shall enforce the laws, and who shall have control over the expenditure of public funds, the man so denied may more easily be made the victim of lynching, segregation, and denial of industrial and educational opportunity, that he and his fellows may be kept in the position of a subject race.

The Negro and the Supreme Court

The full impact of this restlessness and of this dissatisfaction with his lot in American life gave Negro influence in the Parker case considerable weight. It marked, according to general opinion, the greatest political demonstration by the Negro since the Civil War. The influence of that demonstration did not end when the Senate voted on the Parker nomination. In Kansas, for example, when Senator Henry J. Allen ran in the Republican primaries for re-election during the summer of 1930 he polled in the Negro districts of Kansas City, Kansas, only 27 per cent. of the Negro vote where normally he would have received not less than 75 per cent. of that vote, and probably a good deal more. In Ohio, where Senator Roscoe C. McCulloch stood in 1930 for election to fill the unexpired term of the late Senator Theodore E. Burton, Negro voters of the state without regard to political affiliation or other circumstance united against Senator McCulloch because of his vote and speech for confirmation of Judge Parker. Ohio is normally a Republican state by a margin of 400,000 to 500,000 votes. Nomination by the Democrats of Robert Johns Bulkley, a distinguished lawyer, personally popular and a " wet," together with the inevitable reaction against the Administration because of unemployment, cut down the normal Republican majority to the point where the 170,000 Negro voters of Ohio practically held the balance of power.

Never before has Ohio seen such a campaign, nor has there been in the history of the State so astounding a turnover among Negro voters. In Cleveland in the election precincts predominantly peopled by Negroes, considerably more than half of the voters either supported McCulloch's Democratic opponent or refrained altogether from voting for a United States Senator. A well-informed lawyer declares that " there is no escaping the fact that in Cuyahoga County Negroes contributed substantially to McCulloch's defeat, for without their support Bulkley's majority would have been considerably less."

In Negro precincts of Toledo Bulkley polled slightly more than three times more votes than McCulloch. In Columbus the colored wards went to Bulkley by large majorities. In Akron two-thirds and more of the Negro voters supported McCulloch's opponent. In Canton 86 per cent. of the Negro vote went to the Democratic senatorial nominee, and only 14 per cent. to McCulloch, while large numbers of others abstained altogether from voting for a United States Senator. The same margins of Negro revolt obtained throughout the State. It can hardly be questioned that McCulloch's defeat was primarily due to economic depression and prohibition, but it is also equally true that the resentment of Negro voters against his support of Parker played a striking part in his rejection.

A similar revolt occurred in Kansas, a rock-ribbed Republican State. Negro voters supported, practically without exception, Senator Arthur Capper, Republican, who is a member of the Board of Directors of the National Association for the Advancement of Colored People. The same voters swung against Senator Capper's Republican colleague, Henry J. Allen, materially helping the wheat farmers and labor to defeat Allen. " Undoubtedly Allen would have won had he had every Negro vote as in previous years," is the verdict of a leading newspaper man of the State.

Though less successful, Negro voters in Rhode Island opposed Senator Jesse H. Metcalf, and in Delaware opposed Daniel H. Hastings, who had both voted to confirm Judge Parker. Though each of these Senators was re-elected by exceedingly narrow margins, the effect of the breaking away from the Republican party of the colored voters of these States cannot be ignored. In Providence, according to reliable observation, less than 50 per cent. of Negro voters cast their ballots for the Republican ticket. At least 30 per cent. voted the Republican ticket but scratched Metcalf, while more than 20 per cent. voted a straight Democratic or a split ticket. In Newport, Metcalf's Democratic opponent's plurality was increased 87 per cent. by the Negro vote.

Senators who voted against the confirmation of Judge Parker, such as Senators Capper of Kansas, Thomas J. Walsh of Montana, and Thomas D. Schall of Minnesota, were loyally supported for re-election by the Negro voters of their respective States. Party lines were cast aside. The psychology of victory replaced that of defeatism. It is well within the range of possibilities that the part played by Negro voters in carrying on a sustained campaign for a high principle, which resulted in the rejection of Parker, may mean the greatest step yet taken towards political emancipation of the Negro by the Negro himself.

III

Finally, one legitimately may ask, why should Negroes have been so stirred by a nomination to the Supreme Court bench? What though Parker held such views—if confirmed, would he not have been merely one of nine justices?

The answer lies in the fact that, whatever his fate in lower courts, the Negro has come to feel—especially within recent years—that in the Federal Supreme Court he stands his best chance of obtaining justice. In that court six notable decisions have been won within the last fifteen years, each of them of

The Negro and the Supreme Court

far-reaching effect on the Negro's constitutional rights. Three of those decisions outlawed the herding of Negroes in ghettos by means of city ordinances or state laws; another established the principle that trial of a person accused of crime in a court dominated by mob influence is not due process of law; while two others ended disfranchisement by means of Grandfather Clauses and of enactments preventing participation in Democratic primaries.

Negroes and their friends know, too, that within the next few years cases testing other forms of disfranchisement, cases challenging unequal apportionment—on a racial basis—of public funds, state and federal, for education, the issue of the " Jim Crow " car system and that of segregation by means of private property holders' covenants will be carried for decision to the Supreme Court. Negroes have noted the considerable number of five-to-four decisions by that court within recent years. And they know that one vote by a justice holding Parker's anti-Negro views might easily mean an appreciable increment to their already heavy load.

Emphasis has perhaps been laid too heavily upon the import of the Parker rejection to Negroes alone. Its possible effect upon the whole American scene may be as marked. The migration northward of a million and a half Negroes since 1916 has given the Negro the balance of political power in no less than eight states. Each of the last ten years has seen growth of emphasis by Negroes on men and issues and less on party. This rapidly increasing political independence and political-mindedness have within them potentialities which may conceivably play a role of vast importance in the political life of the United States within the next decade.

Immediately, Parker's rejection means a number of things. It has given hope to Negro voters in demonstrating that intelligent, sustained struggle for a principle can be successful. It has created a new and wholesome respect for the Negro among informed, fair-minded whites. It has forcibly reminded Americans that the 14th and 15th Amendments to the Federal Constitution are not yet wholly dead. And it has served notice convincingly upon politicians that it is no longer wise to attempt to climb to high office on the backs of helpless blacks through violent Negrophobe attacks.

Reverberations of the Parker rejection may be heard for some years to come.

Reprinted from *Harper's Magazine*, January 1931, by permission of the author.

Things I Remember

by W. S. CONNOLLY, B.A.

W. S. Connolly, B.A.

I REMEMBER, while a young man attending college at Howard University, Washington, D.C., right under the eye of Viscount Bryce, then Ambassador of Great Britain to the United States, how a young white car conductor of the Virginia Electric Railway forcibly pulled me from my seat in the coloured section (pity the American psychology) of a street car, pushing me back to the last seat with a blow from his fist, saying as he did so, " If you move from there again I'll nail you," simply because I did not get up from the coloured section where I had paid my fare to give my seat to a young white couple who entered the car, and who evidently did not care to sit, seeing there were two empty seats in the coloured section behind me. The young couple evidently preferred to stand holding the straps while they flirted.

I was then a minister, just returning with my bible in my hand from Alexandria, Va., where I had been invited that sabbath day to preach a sermon.

I replied to his challenge, " I shall not move, but when I get to Washington I'll find out if you are allowed to treat a law-abiding British subject in this way."

Strong representations were made to the Ambassador, who did not even condescend to see me, although I asked to have an audience with him. I was sent to the British Consul, who without inquiry, immediately upon my stating the case, declared, " You must have done something."

I reported the outrage to Mr. Ramsay MacDonald, the then leader of the Opposition in the House of Commons. Reply came that Mr. MacDonald was in India. Nothing more was heard of the matter.

I remember while in London in 1919 seeking employment after the war that was to make the world safe for democracy, that a responsible clerk in a Labour Exchange of whom I asked a job replied, " Do you think I would give you work when there are so many good white men around here looking for work ? " He, and the whole of the London Labour Exchange, kept his word.

I remember one night a few months after that experience in London I was standing on the streets of Edinburgh selling toys made by two enterprising Chinese who gave me that chance to earn an honest livelihood, that a Scotchman threatening violence drove me from Scotland, saying, " Go on back to your own country. We have no work here for you."

I remember leaving Scotland and England and going to France, to a people of another language, another race, and superior psychology, where I received employment five days after my arrival in Paris, and remained one year and ten months employed during the whole time of my sojourn among the noble French.

I remember approaching Rev. Herbert Hughes, the present Secretary of the Jamaica Board of Education, in August 1931, with an A.B. Degree from Howard University, Washington, D.C., seeking employment as Secondary or Elementary school-teacher in Jamaica. Rev. Hughes said he had nothing to do with supplying teachers for schools unless the school wanted a teacher from England. In that case he supplied the need. Each school of itself arranged for supplying its local teachers. Rev. Hughes also gave me the enlightening information that no teacher would come out from England for less than £400 a year and quarters. I asked, " Why not save travelling expenses and give me one of those jobs ? " Rev. Hughes replied, " But you are not in England."

During this same August 1931 there was an opening in my own island, Grand Cayman. The Commissioner of Grand Cayman, Mr. Frith, instructed me to register in Jamaica and return to Grand Cayman to be headmaster in a school. Rev. Hughes held me from the post because I had graduated in U.S.A. and had not had two years' teaching experience in Jamaica. I happen to know that His Excellency, Sir Edward Stubbs, the Governor of Jamaica, who, be it said to his credit, always evinced interest in my efforts to obtain employment, wrote to the Board of Education stating that he was not satisfied with their rulings in that case, and advised reconsideration. All to no avail.

Things I Remember

The Rev. H. Hughes had decided that I must starve. He wanted the school to send to him for an Englishman, I suppose.

I have a B.A. Cum Laude Degree from an American University. No thanks to Britain for it. For had it not been for my inborn desire to uplift myself, coupled with opportunity to do so in America, I should perhaps be numbered among the hundreds of illiterate and semi-schooled that now inhabit Grand Cayman. Britain neither has done, nor is doing anything to uplift the masses by education. They are too poor to furnish £400 a year and quarters.

I remember entering the employ of the Jamaica Public Service Co., Ltd., under appointment by Mr. Roy S. Nelson, the then Supt. of Light and Power Dept., as Statistics Clerk, November 10, 1927 (Armistice Eve), and serving with satisfaction for many months before it became known that I was married to a white woman—my wife being a Parisian lady. The moment that became known, Mr. Archie Young, a conceited Scotchman, then chief clerk under Mr. Nelson, undertook the task of getting rid of me.

His first act was to take me from Mr. Nelson's Dept. to be directly under him, he being appointed " distribution engineer," whatever that meant. Rumour among the native employees had it that the new name and new place was created simply to provide a post for a Scotchman, from which he might bound over the head of Harry Campbell, the greatest electrical engineer in the Company, or in Jamaica. And so it turned out. Today Mr. Archie is Supt. of Light and Power ; Mr. Nelson being promoted to a managerial post in America, while Harry still harps on his second fiddle.

On the very day of my transfer from Mr. Nelson's Dept. to be directly under him, Mr. Young said to me in an angry tone without any reason whatever for anger, seeing nothing had transpired between us, " You are working for me now, not for Mr. Nelson, and the less you have to say to Mr. Nelson the better it will be for you."

Men of honour could hardly conceive of such heartless conduct, but it is a fact that on the morning of April 12, 1930, Mr. Archie Young without any valid reason came in front of my office, called me out, and walking along by my side, for he couldn't face me, said, " Connolly " (Negroes must say " Mr." to white upstarts, while these reserve the right to address Negroes as it pleases them), " Connolly, we have been considering your case for some time, Mr. Nelson and I, and we have decided that we don't need your services any more after today ; so this evening when you are going home you can go to Mr. Newton (the cashier) and get paid."

Thus was an honour graduate of Howard University called out of his office and peremptorily dismissed from his post, after serving for nearly 3 years, simply because Mr. Archie Young had it in his power to do so.

Right here I give verbatim the letter of recommendation, dated April 25, 1930, given me by Mr. Roy S. Nelson a fortnight after my dismissal. Although Mr. Nelson is an American it was apparent that even he felt it was a dirty deal. " Owing to re-organisation I regret that it is necessary to dispense with your services. During the two and a half years you have been with us I have found you honest, industrious and attentive to your business. I am glad to recommend you to anyone in need of your services. (Signed) R. S. Nelson, Supt. Light and Power, Jamaica Public Service Co., Ltd., Kingston."

I was held in high esteem by all my fellow employees, and during my time of service in the Company there was nothing annoying besides the periodic prodding of Mr. Young.

On the morning of my dismissal Mr. Young had the impudence to advise me, when I informed him that I would see his superior officer and mine to find out why such drastic action was taken, " If I were in your place, I would bow gracefully and say as little as possible about it." Is that British fairplay or Scotch cowardice ? As direct result of that unwarranted dismissal, my wife and two innocent children from November 15, 1930, until the present time have had to drink to their bitterest dregs the cup of misery and semi-starvation. And the end is not yet.

When I pressed Mr. Young for reason for the act I was bluntly told, " We have got to make retrenchment, and you are *marked* for being put off."

Upon receipt of the above recommendation, I said to Mr. Nelson, " If you can say that during the two and a half years I have been with you, you have found me honest, industrious and attentive to my business, what more do you want ? This is not a church but a business concern, why should I lose my job ? " Mr. Nelson saw the force of my argument, and took me back, putting me in another Dept. where Mr. Young, now bestriding the Company like a colossus, could haggle me no more, reducing my pay by 10s. per week, to see if economic pressure would force me out. There Mr. Young permitted me to remain a brief 6 months, dismissing me again finally November 15, 1930.

111

Things I Remember

In working up his shameful case this flippant Scotchman studied at all times to treat me with insolence.

On one occasion, for simply asking for clarity on one of his orders that distinctly needed clearness, I was told that I had " a head like a sieve." On another, when it was clearly proven, and the books are there now to prove, that another employee who delivered the gas entered 9 gallons of gas to Mr. Nelson's car that should have been charged to the Manager's, simply because I added up without detecting it, Mr. Young said to me, in presence of Mr. R. W. Campbell, another but honest Scotchman, " If I had a dog, and he was as big a fool as you, I would shoot him," Mr. Campbell at once said to him, " No, no, Mr. Young, I wouldn't say that."

Then to add injury to insult he met me in the yard a few minutes afterwards and stopping me addressed these words to me : " I want to tell you something now that I want you to pay close attention to. You will do well to let it sink into your brain—get to the back of your head. You have a wife and children, haven't you ? " " Yes, sir," I replied. " Well, the very next mistake you make here you are going to be fired. The very next one, do you hear me ? "

It was that white wife I had married that caused the hellish hate. Negroes had just fought in a war to keep white scoundrels free to prostitute black women, but their struggle did not give sufficient liberty to permit a decent coloured man to marry a white lady and beget children by her.

As for me, I forgot to ask their permission.

The world is pregnant with panaceas proposed for the solution of the Colour Question. One, and only one, is effective. Its solution lies in its dissolution. I am doing my bit.

Negroes awake ! Hear you not the charges and counter charges of military men—the inevitable precursors of mailed fists, military marches and murderous onslaughts ? Have you forgotten 1914–1918 and your reward since ? On which side in the coming conflict think you to align yourself, or are you not thinking ? From time immemorial the Negro has been like the ostrich of the African desert—his ponderous, potential prototype. Like him when storm approaches he sticks his head in the sands and thinks that because he sees nobody, nobody sees him. But as in the past, men who think are preparing to snatch you by the rump from the sands of stagnation and send you to the forefront for cannon fodder.

Echo asks on which side think you to align yourself. On the side of America ?—Discrimination, race-riots, lynching. On the side of perfidious Albion ?—Supercilious subserviency, hollow hypocrisy. On the side of any white man ? With due reverence, you are a Christ beside a Judas. Beside Japan, undisputed leader of the Orientals ? Together they constitute the x, the unknown in the unsolved equation. By elimination where stand you ? Alone ! Neutrality not armed is negligible. Vide Africa everywhere ! The lesson ? Arm yourself. Either with the sword of the spirit, or the sword of Cæsar. Both are to be wielded in the coming conflict.

During the past war we heard much about " making the world safe for democracy." Bunkum ! What we need is not men who will make the world safe for democracy, but men who will make the world unsafe for autocracy.

As I review the revolting record of the dealing of democracy with the down-trodden Negro, since the dreadful day when in its defence the streets of bloody Boston ran red with the crimson gore of Crispus Attucks, since the day when at Sumpter, Gettysburg and Appomattox he strangled into submission the omniverous octopus as it crept to the cradle of crawling democracy, since the day when he climbed for the colonel the sanguinary slopes of San Juan and collared the Castillian in Cuba's liberation, since the day when with the pompous Pershing expedition he carried the colours to Carizal chasing Villa—the vanishing will-o'-the-wisp—since the day when he planted for Roberts the Union Jack upon the shattered ramparts of Pretoria—since the day when at the Marne, Verdun and at the Somme, great God ! on a hundred hell-swept battlefields he held back the " horrible Hun " . . . as I review the revolting record, I repeat, of undemocratic disfranchisement in our political life, of horrifying, inhuman humiliations in our domestic dealings, of " out-Hunning " outrages at the lynching pyre, I emphatically declare that democracy has *never* and *nowhere* given the Negro a square deal.

The Ku Klux Klan in Indiana

by Dr. SARAH FRANCES CHENAULT

Dr. Sarah Frances Chenault

To those who do not know, I will explain that the Ku Klux Klan is a secret organisation, a circle, or a society, now of national scope, which was formed in the Southern States of America back in the eighteen eighties, after the Civil War.

It was organised to check, by terrifying, barbaric methods, the seemingly threatening supremacy of my people, the freed Negroes.

The name was adapted from the Greek word "Kyklos," and the English word "Clan."

After Congress passed the Force Bill in 1871 it gradually died out, to be established again in 1915, having as its headquarters Atlanta, Georgia. In its infancy it achieved its purpose, and now in its adolescence, while not quite as barbaric, it remains still inhuman, powerful and absurd.

By the year 1927 I was old enough to realise among other things that this ugly octopus-like organisation had its slimy clutch on me as an individual. I began to feel intensely what it had really done, and what it was still doing to me and my race. For along about this time damaging evidence against the influential activity of this lawless clan was exposed to thousands of law-abiding citizens in the middle west. The evidence was against men of high offices, rotten politics, and included the rape of a white girl of good family.

David Curtis Stephenson, then a young man in his thirties, from somewhere in Texas, was a boss, or a leader in this mysterious organisation, which was against the Kikes, Koons, and Catholics (Jews, Negroes, and Catholics). He sold memberships at the cost of ten dollars per member to over four hundred thousand men and women. It was said that two dollars and fifty cents at least, or four dollars at the most, of each ten went as profit into his own pockets. This may not be true, but if it *is* true, he became rich.

He was a good salesman. But what he sold was not so much memberships as the idea of hate and intolerance; and in the end, what he gained was not so much wealth and popularity, as disgrace and life imprisonment.

He used some of the money he made to build himself a superb mansion in the suburbs of Indianapolis. He rode in high-powered automobiles and flew in expensive aeroplanes, dropping mysterious notes of propaganda into crowded out-door meetings of the Klan.

For a while he was influential in political elections. In every precinct in Indiana he had Klan workers; in every city and every city block. He could, on short notice, reach and put them to work in a political way, as he wished. Indeed, his political arm was long. It reached into cities, villages and country. It reached into business offices, into homes, and into the very heart of churches. Yes, it is true, there were thousands of "Kluxers" calling themselves Christians.

When the Republican National Convention met in Cleveland, Ohio, in June 1924, to sleep in the hot, sweltering rooms of hotels, he, with his evil influence, was busy entertaining his political friends from Indiana on his magnificent yacht (which was rumored to have cost one hundred thousand dollars), on the cool waters of Lake Erie.

Then one day, when he was too full of optimism and liquor, he with two other Kluxer men lured a nice white girl, Madge Oberholtzer, to a hotel in Hammond, Indiana, where they brutally raped her. She was brought back (her lovely body bitten, chewed, bruised and lacerated, her spirit soiled and crushed) and left on her front porch. After that she could not face the world, her good relations and herself, so she committed suicide by taking poison.

When the law came to arrest him he, the great leader of the Ku Klux Klan (whose object is to protect the honor of white womanhood), was found hiding, like a rat, in a closet.

The Ku Klux Klan in Indiana, at that time, seemed to be made up mostly of Republicans. After that my race, though not "one hundred percenters" but followers of that party, because of loyalty to Abe Lincoln, with a great many white Republicans, who were also not one hundred percenters, lost respect for the whole beloved party and became full-fledged Democrats.

D. C. Stephenson is now in a cell for his atrocious act. All the power of the Klan could not save him from that, but had he been a man of color, I shudder to think of what would have been his fate. I am sure

in stating that he would have been dead by now. Yes, dead! He would have been tarred, feathered, dragged through the woods, hung by the neck to a tree, riddled with bullets, his ears, fingers, toes and private parts cut off as souvenirs. His body then would have been burned and by now his ashes would have been well on the way to oblivion.

But he was not a man of color, he was white; so he sits in a murderer's cell, with hopes of getting out; and some day, some kind judge may pardon him.

Once the Ku Klux Klan had a convention here. They came in great numbers from all parts of America, and I found myself unable to keep from observing them. I found from their appearance and talk that they were not rich or highly educated. " They were just plain, unadulterated white trash." They were just ignorant people, who could not and did not think for themselves. I could understand, after seeing them, how a raper like Stephenson and a few other Imperial Wizards could lead them. And I will never forget how that affair, as a whole, fanned the flame of my resentment.

I looked down from the window of my office as they swarmed the streets, thinking of what they had done in the past to my people; and stood there in anger, wondering if civilisation really moved in circles. I think that every colored person, and every half-white person, who has had her race mothers and sisters, in Africa and America, raped, insulted and belittled by such " gentlemen " would have felt and thought the same. I looked down on them with contempt; for they, the brazen, ignorant, cheap " one hundred percenters " who had come to take their forefathers' place in protecting the purity of white womanhood against the contamination of color, when they themselves had already betrayed her, D. C. Stephenson, their leader, by his fiendish rape, had demonstrated what they thought of a white woman's honor.

Well! they had their hooded parade. I did not want to see it, but all the window shades in the Roosevelt Building (where I had my office at that time) were drawn full length, except those which would form an immense cross, when the lights were left on. That building is twelve stories high. You will believe me when I say that that cross was immense. I viewed it from the sidewalk with hot tears in my eyes, and boiling blood in my veins.

I hoped that Jesus (Jesus the Jew, whom the white race had taught me to know) was not looking down just then; for to me it was blasphemy. It was anathema. How dared those Kluxers hang out as an advertisement to their dirty rotten chicanery the sacred emblem of Christianity; the Christianity which is to remind us to give our lives that others might live. Burning there it showed just what they meant it to show: lawlessness, hate and murder.

George Jean Nathan, a prominent Jew and literary critic, states in his book, *The World in False Face*, that, " Whatever else may be charged against the South, it must be admitted, that that region has perfected the most engrossing form of sport yet devised by the nimble and ingenious American mind. I allude, obviously, to Ku Klux Klanning."

The old Negro Mammies, Aunt Jemimas and Uncle Toms are dead. The significance of the African forest and American plantation has faded; the horrific Mumbo-Jumbo and gris-gris are things of the past. The tom-toms and ivory trumpets are silent, only their echoes resound down the years. The story of black slavery is an old and sad story; for those who were not murdered, died of broken hearts. W. E. Burghardt DuBois, a prominent Negro, says, " The colored folk have much to remember, and they will not forget."

The new Negro offsprings of Mammies, Aunt Jemimas, Uncle Toms and slave masters, are *not* dead. They sing sad songs and laugh a little. Sherwood Anderson calls it in his book, " Dark Laughter." They laugh because they know we need not have an humble " Old Black Joe " or " Uncle Tom " feeling of gratitude to the white race for its gift of freedom. That debt, if it were a debt, has been paid with interest. It has been paid by warm red blood, salty sweat, tears of agony and hundreds of years of servitude.

We, the new Negro, have a right to be thoughtful, resentful and hypersensitive. If the Ku Klux Klan feeling of prejudice, discrimination, mob-violence and such evils remain, so must their sisters, unrest, protest and brooding. For the new Negro cannot feel at home in the America we have helped to build and would give our lives to protect.

We know that the colored individual has removed the taboo of inferiority from his race. We know that science, with all its research, has found no evidence whatsoever that one race is less or more intelligent than another.

We know that there is no specific importance in the color of a man's skin; and yet we cannot feel happy, for this thing of no importance, this thing called color, has become the most vital, indispensable thing in America, for that matter in the whole world. It has become also a nightmare, a mental complex, a chronic disease and a lingering menace.

Everywhere we turn, at all times we find it: in the housing districts, in the schools, in the streets, in

114

the stores, in the factories, in the street cars, in the shows and in the churches. Everywhere we turn we find it, disturbing the emotions and the welfare of people.

Arthur Brisbane, the white newspaper man, says : " Race prejudice is more powerful than any feeling except international hatred."

There is only one link between the slavery of yesterday and the freedom of tomorrow ; that link is to-day. There is only one bridge between world chaos and world utopia, and that bridge is intellectual improvement.

I am an American Negro woman who, in spite of all the Klannish feeling in the world, is grateful to the Creator, since it pleased Him to create me thus, and proudly I join with those who denounce hatred and advocate love. Proudly I join with those who, having lost their fear, their color-complex and inferiority-complex, face the future with unbowed heads and uncrushed spirits. Proudly I proclaim my faith in the black race.

.

Editor's note.—Concerning the *hypocrisy* of the white American towards Negroes this is how Evans P. Harris briefly puts it :

The " Ku-Kluxers " are a supposedly fraternal organization advocating what they call " patriotism " and " woman protection," originally organized in the Southern slave states for the practice of racial oppression. It is the most flagrant example of hypocrisy. For instance, they parade and sing " Onward Christian Soldiers " under a burning cross supposedly representing Jesus, openly advocating lynchings and other violence and mistreatment of Negroes. Devout secrecy in membership is of course a necessity—such secrecy as hides their real aims and practices. Many of their leading members are known to be the fathers of illegitimate Negro children. The writer, whose grandfather was a Southern white man who never married but was otherwise " kind to " the writer's Negro grandmother, can swear to having seen, though not daring to speak of later, many shameful incidents relative to enforced racial mixture.

So boldly evil has hypocrisy grown that it is dangerous to speak or publish the simple truth. Particularly in America, any plain fact concerning some minor ill-deed of the Negro is magnified by the press and movies to represent either a monstrous crime or a menace. While any fact of anything good, or any achievement on the Negro's part is always minimized or " soft-pedalled." In order to perpetuate the " keep the Negro down " policy the truth is forbidden or obscured by the Nordics. This evil is the great invisible force hindering also the unification of colored enterprises, and their support by friendly white people. The press and moving pictures are the greatest agencies to spread this evil.

Where Color Prejudice is not a Creed

by HENRY CROWDER

Henry Crowder

I N the past few years a great deal has been written *about* Negroes, and what is more important, *by* Negroes. Most of this literary output has its origin in the United States, where there is a large number of intelligent and progressive colored people. Each year, despite their severe handicaps and to the amazement of the world, they attain new heights in the sciences and arts. The American Negro is looked on as the real leader of the black race. To me, however, one of the most serious drawbacks to his growing culture is his inability to travel to a greater extent. This is due principally to the lack of money, but also to the lack of knowledge. Many more Negroes could travel in Europe for short periods if they understood how little money is necessary and realised the educational value of such a trip. This latter is well worth the price, to say nothing of the pleasure derived.

115

Where Color Prejudice is not a Creed

During my three and a half years' stay in Europe I was fortunate enough to see France, England, Belgium, Germany, Italy, Spain, Austria and Switzerland. At this writing, I have crossed the Atlantic five times and wish to set down some of my experiences in the countries I visited, especially as related to color prejudice and social contact with white people.

My first trip across the Atlantic was on an English boat in third class. I was a member of a Negro quartette of singing and playing musicians. All our expenses were paid by a wealthy New Yorker who was in love with a musical comedy star and wanted to place her, and us, in a night-club in Paris. Since he was footing all the bills we were naturally at his command, so although booked in third we spent nearly all our time in first entertaining him and his friends. When I left the U.S.A. I had not a dime, but on landing in France I was the richer by two thousand francs in tips. The English crew was very nice and courteous, the food excellent and everyone friendly. There was no special social contact on this voyage as we were sufficient unto ourselves. Arriving in France our " good angel " immediately abandoned us. His musical comedy protégée returned to America without singing a note and he, as a result, tried to see how much money he could lose in French casinos. Meantime our hotel bills were going unpaid. Finally, after a cheque for our expenses had been extracted from him, he left for America and his cheque could not be cashed.

Leaving trunks as security we went to work in Italy. In Venice conditions improved. Aside from being stared at by the populace as curiosities and almost devoured by mosquitoes, our stay here was very pleasant. I saw no sign of discrimination against us on account of color. I got to know some charming English people who to this day have remained my best friends. Through these I have met some of the most brilliant literary and artistic personalities in Europe, among them being Norman Douglas, Ezra Pound, Wyndham Lewis, Augustus John, Richard Aldington, Roy Campbell, David Garnett, Louis Aragon, James Joyce, George Antheil, Elliott Seabrooke, and many others.

From Italy, back to Paris, to work in a smart night-club. After three months I quit the band and started my travels, first visiting Brussels and the remarkably fine collection of Congo art in the Tervuyren museum. No trouble in securing the best hotel accommodations, nor in going to the élite night-clubs and gambling rooms.

In Paris I had often heard of the difficulty of American Negroes getting into England. This is actually true, not on account of color but because of working conditions. By this time I was without professional status and crossed freely into England. The English certainly *have* color prejudice and to a very marked degree. Most of the larger hotels do draw the line as to Negroes, but possibly not as to Orientals. There are hotels in London that accommodate Negroes, but the trouble is finding them. Also there are certain restaurants and even public-houses that refuse to serve black people. But the English people I met were as sensible about the question of color as I could want anyone to be. I was received as a guest at all sorts of parties, went about everywhere with my English friends, and in fact was dined and wined to the point of suffusion. The British colonial policy is despicable, but there are many in England who not only condemn Britain's exploitation of her colonies but are actively combating it by propaganda. I recall the amazement of some of my English and French friends when I described conditions as to the Negro in America. They could hardly believe what is commonly known to any fifteen-year-old Negro lad. In June 1931 I represented America at a large international friendship conference. Sixty people from eighteen different nations attended. A fine example of people of different races meeting on terms of absolute social equality.

France's attitude towards the color question is one that other countries might well emulate, though this statement does not excuse her colonial policy. I do whole-heartedly commend the attitude of the French as a nation towards black people in France. To be colored in France is never a mark of inferiority.

Two brief excursions into Spain hardly afforded me time to judge of the people, but my impression was that color prejudice as practised in the U.S.A. is unknown.

In Germany I found the people very courteous. I had motored from Paris to Frankfort to hear the first performance of George Antheil's opera, *Transatlantic*. After the performance I was invited to the civic banquet given in his honour at the leading hotel; none of the German or American guests seemed aware of the difference in our color—I was not assigned to a segregated table.

The Austrians and the Swiss seem to find life a pleasant enough occupation without bothering about the color of a person's skin.

As to Americans—those I have met and made friends with *in Europe* appear to find pleasure in knowing and associating with Negroes. This caused me great surprise at first. But it is striking what can happen

to American pride and prejudice on coming to Europe (though I must add that I have walked about pretty much as I chose in New York with a white woman without molestation).

My desire is that more Negroes travel and go as far as means will permit. The problem of the black man in the U.S.A. must, in my opinion, be settled there, but I strongly recommend travel in Europe for the experience and mental development that come only from personal contact with various peoples and conditions. In Europe the Negro will learn that color prejudice, though it exists in some places such as in England, is never, as in America, a religion or a creed.

Hitting Back

by HENRY CROWDER

I

BEEN on a two weeks' visit to Atlanta, Georgia, after having lived two years in Washington, D.C. Decided to get a box-lunch and went in men's café to procure same. White men sitting at tables eating and smoking. No women permitted in this room. I stood at bar counter just inside the entrance and asked the white clerk for a 25 cent. box-lunch to take away, knowing I could not eat in the place. He did not reply, but only stared at me. Thinking he misunderstood I repeated my request. Then he asked me what was the matter with me. I very innocently said, " Nothing," and only wanted the box-lunch. He then told me if I wanted to be served to take off my hat. I immediately left without the lunch.

II

In Washington just before the big riot just after the War. Leaving a restaurant on 14th St. near S about 12 o'clock at night I started peacefully toward my home. I happened to live at that time at 17th and R, which is an aristocratic section. At 14th and R I met a soldier and a civilian. Without any provocation whatever the civilian told me to get off the streets and get off damn quick. I immediately said I would do nothing of the sort. Then he said they would put me off. Seeing that I was outnumbered two to one I replied that they might possibly put me off, being two to one, but I would at least give them a battle. As the battle grew more imminent a large car drew up at the curb and a huge Negro friend of mine asked what was the matter. I said two ofays [1] intended beating me up for nothing. He got out of his car and said, " Choose the one you want to fight and I will take care of the other one." The soldier quickly stated that he had nothing to do with it, so I waded into the civilian. For about 5 or 10 minutes there were some fireworks. I tried to get hold of the guy, but he was very elusive. Finally he hit me a glancing blow on the head and smashed my straw hat. Then I succeeded in getting a hold on him. He kept his head ducked. Seeing I could not deliver an effective blow because of his dodging I took a chance and swung underhand, and caught him forcibly and cleanly somewhere on the face. He tore from my grasp and fled, leaving me with bleeding knuckles. A crowd began to gather and my friend and I boarded his car and left the scene.

III

During the Atlanta riots I was travelling with a quartette representing Fort Valley High and Industrial School, a Georgia institution. One week after the riots I arrived in Atlanta about midnight. Everything was deathly still. The man at the station advised me to take a cab home and not walk. Having been in New England during all the disturbance I did not realise its seriousness. However, I took a cab. Arriving at my home I rapped loudly on the door and in jest demanded that it be opened immediately. My old father, who was there and had been through all the hell of the riot, responded, " Who is there ? " " Never mind," said I, " open up." He replied, " Alright—whoever you are I am going to open and die along with you if it is necessary." I quickly said, " Daddy, it is me," and gave my name. He opened the door with a shot-gun fully loaded in his hands. I will never try that kind of joke again.

IV

Playing piano in a house in Washington, D.C., that kept colored girls exclusively for white men. Mahogany Hall was the name. The landlady had a beautiful small white poodle that she required

[1] Whites.

117

me to take out for an airing about midnight each night. One night after being on the street for about 5 minutes I met a trio of half-drunken white hoodlums. One gave the poor poodle a terrific kick straight off. Of course an argument immediately followed. We happened to be opposite a vacant lot piled with diverse pieces of timber. Sensing the superiority of my antagonists I surreptitiously picked up a scantling and dealt the dog-kicker a terrific blow on the head and dared any of the other trio to wade in. The noise attracted a number of Negro men from the nearby saloon and my attackers fled.

V

I had a small orchestra at Harvey's Café at 11th and Pennsylvania Ave., N.W., in Washington, D.C. It was Saturday night and the beginning of the Washington riot. The manager came to me and said that the dance session would be suspended because of the news of rioting which was going on about 4 blocks away. He warned us to go rapidly and direct to our homes. As we left the restaurant we noticed a lot of yelling and excitement 2 or 3 blocks away. We later knew that some Negroes were being beaten by a mob of whites at 11th and the Ave. One of the boys in my band was very fair, the violin player. He laughed at the idea of any danger and said it was all stuff. On our way up 11th St., which leads into the N.W. Negro section, we observed at New York Ave. a patrol of U.S. cavalry from Fort Meyer. My violin player, although more impressed, was still somewhat dubious as to the seriousness of the situation in spite of all we had said to him. He was from New York. We continued up-town. At Rhode Island Ave. and 11th St., which at that time was a sort of southern boundary of the Negro section, as we crossed the street a large touring car filled with Negroes suddenly swung into 11th from Rhode Island Ave. My violinist, who had been mistaken for white, was commanded to stop. A very gruff voice demanded to know if he was white or black. The dialogue was something like this: " Stop a minute, buddy! Who and what are you? White or black ? " I, sensing the situation and knowing the deadly peril that threatened my boastful violinist, quickly went to the auto and told the occupants that the boy was O.K., meaning that he was a Negro. The car quickly swerved and moved on toward the white section of the city. This roaming car made history during the Washington riot, and my violinist became meekly silent the rest of the way home.

VI

Leaving my job at Harvey's Café in Washington with my violinist and my banjo player we got into my automobile and proceeded up 9th St. towards home. Just after passing New York Ave. we heard yells of pain and noted a crowd of whites beating a lone Negro. I stopped the car and we three got out, and, grabbing what we could get hold of as weapons, we went to the rescue of the Negro. I had a quart bottle half filled with water. My violinist only had his violin and its case, and my banjo player very luckily was able to get his hands on an iron bar about a foot long that I kept in the car. This was a deadly weapon. Thus armed we descended on the gang. After a few well-delivered blows we rescued the terrified Negro and scattered those who were beating him. The poor Negro immediately fled. We were now a block from my car. We immediately resumed the attack on any white person near. I yelled at my banjo player just in time to stop him from murdering an innocent white onlooker. We were now chasing the only two whites who lingered. One outdistanced us, and the other, realising that he was sure to be caught, dashed into the door of a white residence. I, still holding my bottle, and my banjo player the iron bar, both hurled these at the fleeting white. He ducked both missiles and the front door of the house, which was of glass, was wrecked. We quickly motored away followed by the terrified screams of the landlady.

VII

A friend and I boarded a street-car one evening about 8 o'clock in Washington, bound for home. The car was of the kind where the seats run lengthwise on both sides and the passengers face each other. The car was nearly empty. For no reason I sat on one side of the car and my friend on the other. Soon I became aware of an altercation. My friend was having an argument with two white men. I immediately asked what was the trouble. My friend said one of the white men either kicked him or attempted to do so. One of the whites asked me what the hell I had to do with it. I said, " The hell of a lot." The white asked me if I wanted to fight. I replied, " Certainly." He said, " Alright, we will get off the car." I said, " No need to wait, let's fight now." However, we waited for my stop, glaring at each other. At 14th and Tea St. all four of us got off. At this point the street-car company was making repairs by putting stone blocks in the centre of their tracks. These blocks could be held comfortably in a man's hand. There were piles of them all along the sidewalk. My friend quickly picked up one and without a word

hurled it at one of the whites. He tried to dodge. It caught him on the back of his neck and he fled yelling in pain. My antagonist, bewildered by the sudden flight of his companion, received a stiff jab on the head from my fist, forcing him to follow his friend in flight. We mustered some of our Negro friends, expecting trouble, but the affair ended there.

VIII

A friend and I had just read the bulletins in a large Washington newspaper that Jack Johnson (Negro) had beaten Jim Jeffries (white) for the heavy-weight championship of the world. Great, of course, was our elation. Hats in hand and yelling like madmen we started home down Pennsylvania Ave. towards 6th St. We lived in that section at that time. Passing 13th St. we noted a terrific commotion in the doorway of a very noted Negro bar-room. I saw two or three men fall from blows delivered by one man in the doorway. The door was shut and with his back to the wall he was fighting a crowd of howling white men. The police charged and we continued our way home still throwing up our hats and howling with delight. We later learned that the man fighting the crowd in the doorway was a giant Negro armed with brass knuckles, and that several white people had received cracked skulls before the police subdued him. I think he got a considerable term in the penitentiary. That night the white people gathered in thousands and took possession of Pennsylvania Ave., and no Negro dared show his face on that street. One Negro was chased down our street by a mob of whites. The Negroes quickly ascended to the tops of buildings and hurled brickbats onto the throngs below, scattering them, and giving plenty of work for ambulances. About 2 A.M. on the same night as a group of about 10 of us were standing in a bar discussing the events a Negro suddenly dashed in and through the place, out the back and over the rear fence on to God knows where. Not a word was spoken. A few minutes later a mob of about 15 or 20 whites, led by two policemen and a white man covered with blood, suddenly crashed into the doorway. The police demanded to know if we had seen a fleeing Negro. Certainly we had not. After a cursory search and a surly command that all of us Negroes go home the entire bunch left. We Negroes remained where we were, drinking and laughing.

The scurrilous letters and news coverage that marred Nancy's second visit to Harlem in 1932 left a legacy of amusement and rage. One choice memento, which had withstood pillaging and constant travel, was a news photo showing Nancy standing alongside a Negro man. When we looked at it in 1963, she explained that another man, a white, had been standing next to her, too, but that he had been cut out of the photo when it was printed. A handful of letters had also survived, and as she read them to me again after many years, it was apparent their potency had not died. Some years earlier, while composing her book on Norman Douglas in the early fifties, Nancy had occasion to comment on this subject. "What would you [Douglas] have said to these crazy letters, these frantic eructations? And the Abbé Fénelon, on whose Telemachian island I now sat, he who

had officiated at the Prieuré de Carennac across the river—what would he
have thought of such outbursts of fury as lay beside me this August on his
willow-thick sand-stretch?... Many were sex-mad and scatological; all
were juicy. And none, judging by spelling, grammar or language, was
written by a literate being. I should have liked these anonymous clowns
and hoodlums lined up for our inspection! A few of the printable effusions
went into that book [*Negro*]—first-hand evidence of what happens in
the United States of America when it is suspected that the truth is going
to be set down in print about Coloured and White there!" (Nancy Cunard.
Grand Man, Memories of Norman Douglas, London, 1954), pp. 99-100.

<div align="right">H. F.</div>

The American Moron[1] and the
American of Sense—Letters on the Negro

<div align="center">by NANCY CUNARD</div>

HERE are examples of some of the wild letters received by me at the time I was in Harlem, New
York, collecting part of the material for this book. The American press, led by Hearst's *yellow
sheets*, had turned this simple enough fact into a veritable racket. Despite all the " liberal attitude
of progressive whites " and the recent " New Negro " movement whereby Americans learnt with incredu-
lous amazement that there is a distinct Negro literature, any interest manifested by a white person,
even a foreigner to America (such as myself), is immediately transformed into a sex " scandal." The
American press method (one of America's major scandals), led by the world-famous " yellow press " of
Hearst, is to invent as vulgar and " sexy " a story as possible, to which any official denial merely adds
another " special edition." The American public is intended to believe that no white person has ever
stayed in Harlem before. But everyone knows that many thousands of whites actually live in Harlem,
married to Negroes, or domiciled there.

No chance is ever missed by the American press, and the type of American that believes it (vastly
preponderant), to stir up as much fury as possible against Negroes and their white friends. To do this
the sex motive is always used. As in the South it is always the lie of the " rape " of white women by
black men, so in the North it is always the so-called " scandal " of inter-racial relations. The Hearst
publications *invent* black lovers for white women. A reporter goes round to try and bribe the hotel
people into saying that such and such a Negro is staying there—communicating rooms, etc. (This is
the case in *my own* experience.) As of course there is not such a good " story " in scandalising about
plain coloured X, some well-known coloured star or personality is always picked (one instance of this
was the late Booker T. Washington himself, at the age of 60 or so). In that way the Hearst press hopes
also to damage the star's professional reputation. If individuals persistently behaved in this manner
amongst themselves, they would be locked up as criminals or insane; but what is to be done when this
is one of the pillars of American society—the press? The equivalent to the jailing of individuals is of
course the total suppression of the American press. An illuminating comment by Americans themselves
on their newspapers is that journalists have got to write *something*—the papers have got to be filled every
day, you know . . .

[1] The American widely used term for idiotic, cretinous or degenerate.

The American Moron and the American of Sense—Letters on the Negro

It is necessary to explain to the English reader (I think?) that "caucasian" in the U.S. is used as a self-awarded title of white man's superiority. It has no more to do, geographically, with the Caucasus than "nordic" (same meaning) has to do with Scandinavia.

I should like to print all the raving, illiterate, anonymous letters—some are very funny indeed, mainly from sex-maniacs one might say—but what is to be done? They are obscene, so this portion of American culture cannot be made public.

Of course there were other letters as well—some 400 or 500—from Negroes and friendly whites, commending the stand I took and the making of this anthology. Of the anonymous threats, etc., some 30. Most of them came in a bunch, just after the press outcry, May 2, 1932.

Letters

Mrs. Nancy Cunard take this as a solemn warning, your number is up. You're going for a ride shortly. You are a disgrace to the white race. You can't carry on in this country. We will give you until May 15th. Either give up sleeping with a nigger or take the consequences. This is final. X 22. P.S.—We will not only take you but we'll take your nigger lover with you.

* * * * *

Miss Nancy Cunard repair to pay ransom 25,000 dollars will be demanding kidnaping H—B kidnaping inc.

* * * * *

Miss Cunard, this is one of the rare instances where we have found it necessary especially among intellectuals to deal drastically with those who would impair the fundamental principles of the Caucasian race of peoples. Since you have evidently found it expedient to disrespect your Aryan birthright and as we are conscious of that which might result from your present environment while in this country or your previous associations in Europe you will please be governed as below.
We shall call for you just as soon as the necessary plans have been completed for your reception.
The secretary of the second society of Caucasians of America.

* * * * *

Miss Nancy Cunard, you are insane or downright degenerate. Why do you come to America to seek cheap publicity? you have not gained any favor but a whole lot of hatred. If I saw one of your publications I would be the first to suppress it. Furthermore I and a committee are appealing to the U.S. department of labor to have you deported as a depraved miserable degenerated insane. Back to where you belong you bastard. If you dare to make any comparison you had better look out for your life wont be worth the price of your black hotel room. You for your nerve should be burned alive to a stake, you dirty low-down betraying piece of mucus. [Here follows a sentence which might be considered obscene and which is not, therefore, printed.] K.K.K. 58 W 58.

(I suppose this purports to come from the Ku Klux Klan, or possibly the writer only stole their "signature.")

* * * * *

Of the other side it is only fair to quote as well. There are *indeed* many white people who have a liking for Negroes; some are afraid to say so, others are not. (I must perforce exclude in this count entirely the followers of the Communist Party, with whom it is a *sine qua non* to stamp out all race "inferiority"; this has not exactly *come of itself* to some of those who have joined the Communists, and there have been cases of trial and exclusion of members who have been taken back into the Party after their admission of guilt in race-prejudice, and conditional on their eradication of it in themselves and in others.) This type of letter is from people who are presumably not yet aware that all race-prejudice has a distinctly economic basis, that the Negroes in America are looked down on primarily because they were once slaves; the more so in the South because these slaves were taken from them by the result of the Civil War in 1865. Though it is out of place nowhere when talking of the Negro and slavery to repeat that the vast bulk of Southern State Negroes are as enslaved as ever; the name only has gone, the condition is the same, and worse.

Letters

New York, *May 2.*

MY DEAR MISS CUNARD,—It's with a great deal of pleasure that I read about you in today's papers. I might say also that I am proud of you when you come out and defend the Negro race. It has been my good fortune to know some very fine people of the Negro race. I went to public school with Negroes, they were no different than any other children, perhaps better than some others. I'm staying in New York tonight, so after dinner I went up to the Public Library at 103 West 135th St. to read a book by a Negro. I could not find any fault with the people there. In fact I found it a very pleasant place to be. The book I wished to read was looked up

121

and obtained by a colored gentleman. When I left the library at closing time I walked around for perhaps a half hour. Life there is no different than any other place in New York. I can enjoy looking at a pretty Negro girl just as much as at any color. The so-called color line in this country is often a big noise by people not near as nice as a great many of the colored race. There is so much of good to say about the Negro race that it's useless for me to try and say anything. And I want to add that I am proud of you as a girl to come out and stand up for the Negroes, you certainly are a brave young lady. I surely would like to shake the hand of a real girl as you are a credit to your sex.

(This is a signed letter bearing an address.)

 * * * * *

DEAR MISS CUNARD,—It is very gratifying indeed to know that in these trying days someone deserts the great make-believe world and devotes her time to a real problem dealing with humans. Your determination to do your OWN work in so noble a cause has inspired all of us who devote our lives to the service of others and we most sincerely congratulate you.

Out here in the mountains of South California we operate a small boarding school for boys. Our place is very beautiful and the setting is most inspiring. We would be happy to have you avail yourself of our hospitality and to come out and visit us at any time. You will find this a wonderful place for rest, quiet and study.

May success crown your every effort and may the example you have given the world be the means of creating interest in the conditions of the Negro in this country. Being a Virginian, the writer fully appreciates the status of the American Negro.

Best wishes to you, cordially.

(This letter is from a California school, from the Headmaster.)

I reproduce the following letter here as an example of the totally shameless and stupendous form of LIE that Southerners still hope to put over. This one comes from Rome, Georgia, and is anonymous:

NANCY CUNARD, c/o Cooks, 587 5th Ave., New York, N.Y.

I would not worry too much about the Negro rapists in Alamaba [1]; it might spoil your complexion. Their "case" has now gone to the Supreme Court; and it is an internationally known fact that no judge is named for the federal courts—from the lowest federal court to the Supreme Court, the highest tribunal in America—*unless and until* he has proven his bias in favor of the Negro race, *and unless and until* the Negroes have approved of him for the post. The president now in office has established this predecent [1] as a permanent thing; it was never before the *only* requirement necessary—as is the case now. He dares not appoint a judge who does not fullfill this one requirement. So, don't worry: the Negro rapists will go free. In every known case where a guilty Negro's "case" has been carried to the federal courts he is *always* cleared and freed, because, by reason of the nature of his crime (if it is rape) he has become an *international* hero.

The grandson of a Negro rapist from Georgia (who, by the way, *was* lynched for his crime: white men were *men* in those days) has just been named vice-presidential candidate of the communist party subject to the November election. So, we are very apt to have a Negro vice-president *in fact*, in a few more months. The Negro politicians rule the present regime *now*. Why not have them in office and let them rule *in fact*?

At the present time, it is such a common occurrence for a Negro beast to rape a white woman and murder her or leave her for dead, in the south, that it is no longer news. Sometimes it may rate a one-inch space on an inner sheet of the newspapers, but nothing is ever done about it. They are afraid it might offend "THE RACE." The victim is ignored and forgotten, while the bestial offender automatically becomes an international hero to be publicly acclaimed and rewarded by public honors. When I refer to "THE RACE" I am referring to their own name for themselves (see copy of *The Race*, published in Chicago).

As for the "dark" part of America—the south—Negroes control the south politically and economically: the president of our nation takes orders from them. Every federal position is open to them for the asking. Atlanta is the Negro capital of the south. It stands next to head in the number of homicides to the population: Memphis, another southern "dark" town, stands head. There are about ten Negro colleges in Atlanta, supported by misguided white people from afar, like yourself.

[Two lines have had to be omitted here. They refer to two very well-known American official public figures whom the writer referred to as supporting "a Negro harem in Atlanta."]

So, I do not think you need lose any sleep, knowing that the little chocolate "brothers" in Alamaba [1] are all hunky-dory. Their "case" is with the Supreme Court, and all is well—for them. *They* have nothing to worry about: so, why should you?

A SOUTHERN WOMAN.

It is really too patently stupid to comment on. Suffice it to say that the "Negro rapists" are the 9 innocent framed-up Scottsboro boys—that Federal Court judges are in no way chosen for their lack of race prejudice and are as likely to be as determined "nigger-haters" as the rest of the general American population—that Negroes have no say whatever in their election to the Supreme Court (beyond their

[1] *Sic.*

122

comparatively small vote of 2,000,000—the white American vote being 72,000,000—inasmuch as 4,000,000 out of the 6,000,000 Negroes who should vote are disfranchised in 9 Southern States where two-thirds of the total Negro population of the U.S. live). " The president now in office " was Hoover, one of the worst presidents ever known where the Negro is concerned. " Vice-presidential candidate for Communist party " refers to James W. Ford, the first time a Negro has been chosen for such a position (thereby affirming the Communist theory of the abolition of all race " inferiorities ") with the exception of Frederick Douglass in 1872, in a very different kind of political campaign, however (see previously). White women are not " raped and murdered," but this happens to black women, and Negroes are terrorised and framed-up every day. As for the political and economic control of the U.S. by Negroes —it would be impossible for one even totally ignorant of the whole state of things there to see how this could tally with the complete disfranchisement of all the coloured voting citizens in the Southern States, and the economic slavery, bondage and peonage to which they have been subjected for a very great number of years. (See statistics of the Negro vote.)

In a word this letter is the best example possible of the threadbare and vicious lies of the classic American race-hate.

Let me give some examples of the kind of " political control " the Negro has in the South.

Intended to terrorise Negro citizens who might seek to vote in the primaries in Dennison, Texas, last week, handbills scattered thoughout the town read as follows :

NIGGERS!

The white people do not want you to vote Saturday. Do not make the Ku Klux Klan take a hand. Do you remember what happened two years ago, May 9th?

(George Hughes was burned to death, the county courthouse destroyed.)　　　(*The Crisis*, Sept. 1932.)

Albert White, editor of the Shreveport, Louisiana, *Afro-American*, was last week driven from Shreveport by enraged state and city police, forced to hide in outlying hills, because of his activity in organising a league of Negro voters. Unable to find White, the heavily armed constabulary stormed the large Lakeside Auditorium where a mass-meeting of the League of Negro Voters had been scheduled to be held, stood guard before all entrances, threatened with death any who dared enter. Shreveport's leading citizens declared that the streets of their fair city would be drenched with blood before Negroes would be allowed their right to vote.

(*The Crisis*, Sept. 1932.)

Concerning the Scottsboro boys (see further) this extract from a (white) Alabama newspaper simply regrets that a lynching did not take place. The expression " the shortest way out " signifies precisely this, it is the *phrase used* for lynching.

The ugly demands . . . from outsiders that Alabama reverse its jury decisions, and filthy insinuations that our people were murderers when they were sincerely being as fair as ever in the history of our country, is rather straining on our idea of fair play. It allows room for the growth of the thought that maybe after all " the shortest way out " in cases like these would have been the best method of disposing of them.

(*Jackson County Sentinel.*)

Cain 　　　 *and* 　　　 *Laura*
my two best friends in America

Nancy naturally wanted to see the South. Her Negro friends were right to dissuade her. Even in Harlem she was capable of straining the tolerance of those who knew and accepted her. Kenneth Macpherson, a contributor to *Negro*, who lived there for a year, recalled that Nancy's friends used to greet her return to Harlem by crying, "Nancy's back. We're in trouble!"

Nancy would have created a rumpus in the South, perhaps one that would have had serious consequences for her. She obviously enjoyed (one is tempted to say, relished) violating racial barriers. In Philadelphia, which except for a brief trip to Washington was as far south as she ever went, Nancy had her hair done by a colored hairdresser. Later she reported, she "could not think why all the attendants seemed so odd in behavior, as if rather flustered. At the end they confided with many smiles that I was the first white woman ever to enter that shop. And my being English did not appear to explain it all away! Oh, really, said I to myself." (Letter to Charles Burkhart, undated).

H. F.

Flashes from Georgia Chain Gangs

by JOHN L. SPIVAK

WE talked in low tones, sitting there on the two worn, wooden steps of the Seminole county convict camp stockade. The night was heavy, stifling.

The rasping sound of snores disturbed the hush over the wire-enclosed world. They came from a huge cage, like one in which a circus pens its most ferocious beasts. Two lanterns hanging on the outstretched arms of a cross driven deep in the soil threw a sickly, yellowish light over the stockade.

In a momentary lull in the chorus of snores the faint sound of rustling could be heard, a sound as of a wild beast creeping through a tangle of jungle brush.

" What is that? " I asked.

" Straw mattresses," the night guard replied. " When they turn in their sleep, you know."

" Yes," I said, " and that clinking sound of iron? "

" Their chains," said the guard.

A mosquito lit on my neck and I slapped at it. A fly droned about our heads.

I strolled over to the cage. A sickening stench rose from a zinc pan under it, used by the convicts at night. Through the screened bars I saw them stretched out on the iron bunks ranging the cage in three-decker tiers, the whites in a compartment near the door and the Negroes in the rear. They slept in their striped trousers, their chests bare, for few had underwear. In the faint light from the cross the sweat on their half-naked bodies glistened.

One scratched himself tiredly. Another slapped at one of the insects that hummed and buzzed in the cage, insects attracted by the pan under the cage. And one, who could not sleep, lay on an elbow looking at me through the bars with despair in his eyes.

" What did these men do to be chained and caged like this? " I asked.

" Anything from vagrancy to murder."

Thirty days and thirty years mingled indiscriminately. There, with his face pressed close to the bars for the cool feel of iron on his hot forehead was a boy who could not have been more than seventeen ; and in the bunk adjoining his was a thin, weazened man in his fifties, with a face marked by years of crime and dissipation.

" A killer," explained the guard.

The cook, sleeping in a sagging, dilapidated shack in a corner of the stockade, was awakened. He

124

came out scratching himself and pulling his jacket over his torn underwear. He stumbled to the kitchen. A lamp was lit and his shadow moved across the dirty window-panes like a weird, fantastic bat.

The smell of coffee filled the air.

Tin plates and cups clattered on the long, wooden mess hall tables, shining, under the lamp hanging from a beam in the ceiling, with the grease of countless meals.

With a harsh, grating sound the iron door of the cage swung open.

" Everybody out ! " the guard shouted. " Come an' get it ! "

Bare feet thudded to the floor. Twenty-inch chains riveted around their ankles rasped and clanged as they struck the rims of the iron bunks. The convicts straggled sleepily out of the two-foot aisle in the cage and down the wooden steps to the cool soil, a ragged crew, three white and eight colored.

I entered the cage while they were at their breakfast of grits, molasses and coffee. The stench from the pan mingled with the smell of the eleven unwashed bodies which had slept there. Flies and mosquitoes buzzed and droned angrily. The mattresses and blankets were filthy.

I remembered the neat little booklet of rules governing inmates of the Georgia penitentiary that was given me in Atlanta. I remembered it said : " Slips and sheets must be changed not less than once each week."

But if there are no slips and sheets?

A truck appeared at the stockade gate. Streaks of a drab dawn flecked the sky and Seminole county convicts were ready to be taken on the road for their day's work, for the State of Georgia requires that " the hours of labor shall be from sunrise to sunset. . . ."

They counted out as they passed through the gate, a straggling, weary crew, their chains dragging on the dark soil. A convict passed me, chuckling delightedly to himself, shaking his head and muttering under his breath.

" A little cracked," explained the guard.

So the convict crew went out to work, the young, the old and the mad.

Each of the county convict camps in Georgia are run by wardens appointed by the State Prison Commission. The Commission consists of three men elected by popular vote every two years for a term of six years. Their office is in the State Capitol in Atlanta and in a little room cluttered with letters and papers and desks sits Commissioner Vivian E. Stanley, in charge of the office routine.

" Chain gangs," he said, " we have them good and bad and we are trying to eliminate the bad as rapidly as we can."

" I hear convicts are killed and wardens are sometimes removed for inhuman cruelty," I said.

" You have no business knowing these things," he returned. " That's for the State of Georgia to handle, not you. The care of our convicts is our own business."

But their files are public property and I studied them, the pathetic letters from convicts complaining of cruelty and brutality, the doctors' reports on sickness and injuries and deaths, the punishment reports —those little slips of paper gathering dust that told the stories of hopeless lives.

" We have little money," the Commissioner explained. " The legislature grants us very little and we cannot investigate all the camps. We do the best we can. We have gotten complaints of flogging that we couldn't investigate ; and we haven't enough money for a general medical inspector to check on doctors' reports on food, sanitation and deaths."

" How do you rehabilitate your prisoners ? "

" Georgia," said the Commissioner firmly, " takes the attitude that these men committed a crime and consequently owe a debt to society. The State proposes to collect this debt."

" I should like to visit your camps," I said. " Will you give me a letter of introduction ? "

" If you will tell me what camps you want to visit, I'll write the wardens."

" No," I smiled, " I would rather have a general letter of introduction to all convict camp wardens so that I may drop in on any camp without the warden knowing of my coming."

The Commissioner gave me the letter.

" You will find no inhuman cruelty," he said in parting.

I went out on the road to watch the Seminole county convicts work.

I had seen men stripped to the waist before a roaring inferno stoking a ship ; I had seen men in steel mills working with molten iron ; I had seen men deep in the bowels of the earth cutting coal, but I had never seen a Georgia chain gang at work and I said to myself : " This cannot be so everywhere. I will go to a larger town. This county is lost in rural Georgia. It must be different in other places."

I stood with Warden C. H. Wheatley on a Sumter county road. Young, tall, a college man, he was

a new and rare type of Georgia warden. The road was torn up. Red clay was heaped high in irregular mounds to be shovelled into wagons and transported to level hollows. Convicts in stripes, with their feet shackled, ranged in a semi-circle, ankle deep in the soil, shovelling it into a mule wagon. A Negro set the lick, for a shovel crew must work in unison lest if one digs while another heaves, they slash each other's arms.

The lick leader was a hulking, two hundred black and he hummed a tune as he shovelled. The convicts bent and rose with him in perfect rhythm. The sun beat upon them with tropic fierceness. Their mouths were wide open, gasping for air. Little rivulets of sweat ran down their faces and their striped suits clung to their bodies. The soil dribbled into their shoes as they bent and rose, bent and rose, fourteen times to the minute, minute after minute, hour after hour—from sunrise to sunset under that burning sun.

Dust hung in the air like a cloud, dust that settled in their nostrils and mouths and ears and covered them with a fine, red film.

As I listened, he raised his voice in a plaintive work-song that held in it all the pathos of despair:

No—more,
No—more,
No—more,
O—Lord.

At each " No " the shovels scraped into the soil and at each " more " swished their load into the wagon.

There was something so poignant, so heart-wrenching in this song of men doomed to bend and rise, bend and rise until they were freed or—died.

O—Lord,
O—Lord,
O—Lord,
I'm tired.

O—Lord,
I'm goin',
I'm goin',
O—Lord.

So—tired,
O—Lord.
Oh, so tired,
O—Lord.

" Hey ! " the warden laughed. " Can't you sing a little faster? "

" Yes, suh, Boss," the leader grinned, " but singin' faster ain' gonter bring my time roun' no sooner ! " I left Sumter county wondering if men drop under that terrific strain.

There was that death report in the State Capitol in Atlanta, the one about Will Harris who died of apoplexy in the Clarke county convict camp stockade at five o'clock in the afternoon of June 13, 1931. Dr. H. M. Fullilove, the county physician, said Harris had been sick about four hours. I wondered if working from sunrise to sunset under a burning sun is conducive to apoplexy.

Or George Johnson, who was a strapping youth of 27, five feet ten and a half inches tall and weighing 161 pounds. He had coughed up his lungs on the Georgia highway. " Sick with T.B. for some time," Dr. Fullilove had reported when the boy died at 3 o'clock in the morning of February 23, 1931—of T.B. they said.

I wondered why this youth was kept in the Clarke county stockade until he died if he had T.B., for the Prison Commission rules say: " When a convict is found to be permanently impaired or diseased, so as to incapacitate him from labor, the physician shall certify the fact to the Prison Commission."

I wondered if Dr. Fullilove had certified the fact before George Johnson died, and if so, why the ailing convict was not transferred.

I wondered if men and boys go mad under that strain and prefer the silences of death to the agony of the chain gang. Like twenty-year-old George Neal who drank phosphorus, soap and turpentine rather than continue in the Chatham county chain gang. I remembered this boy's letter, a pitiful complaint mailed hopefully to the Prison Commission saying that he was suffering untold pain and couldn't

Flashes from Georgia Chain Gangs

get medicine, that he was swelled all over and that people in the camp laughed at him when he asked for medicine.

The Prison Commission wrote to Warden T. Newell West at Savannah on June 19, 1930, quoting the boy's complaint. Two days later, on June 21, Warden West replied with a letter from county physician J. C. O'Neill that " He has been so singularly free from anything pointing to such a condition that it must be self-induced by taking substances such as phosphorus, soap and turpentine. . . ."

There was nothing said about the boy's complaint that people laugh at him when he asks for medicine. There was nothing said, but two days later they mailed in George Neal's death certificate.

I remembered those death certificates, the neat little batches with rubber bands around them, each telling a story of one dead of apoplexy, tuberculosis, heart failure, sunstroke . . . little sheets of paper in the Prison Commission office, and somewhere under the Georgia sun, mothers and wives weeping on mounds.

On a wide stretch of highway in Decatur county with the sun shining clear I saw a creature working with a group of convicts and as he shovelled the sun caught the glint of bayonets on his feet.

" What are those? " I asked.

" Spikes," said the guard.

Spikes. Long, steel bayonets riveted around ankles, ten inches long in front of you and ten inches behind, so that when you walk you can scarcely keep from tripping.

" Why those instead of chains? " I asked.

" Reminds them when they wake up in their bunks that it doesn't pay to run away," said the guard. " Every time they turn in their sleep they have to wake and raise their legs."

I remembered Commissioner Stanley telling me : " We have no spikes in Georgia."

But now I know better.

A hundred convicts were relaxing in the Muscogee county camp stockade that Sunday morning. As I walked through the white-washed cages the sounds of a hymn reached my ears. Some preacher was leading them in song and while the preacher taught them to pray I found a convict lying on a bunk with an iron collar locked around his neck, like some ancient galley slave.

" He ran away," said the warden.

" I want to talk to him alone," I said, and the warden withdrew.

" Why did they do that to you? " I asked.

He looked sullenly on the ground.

" You may talk freely," I said. " There will be no harm come to you for it."

" Not while you are here," he said.

" What happens when no outsiders are here? " I persisted.

" We get hit over the head with sticks and pick handles," he said.

Prison Commission rules said : " Guard shall not be permitted to strike a convict except to prevent escape, in his own defense or in that of another, and in no case will be permitted to curse a convict." And I remembered prison inspector S. W. Thornton's letter on May 16, 1931, from Milledgeville to Miss Ida J. Henderson, the Commission's secretary :

> I expect that one of the commissioners did have an axe handle and did use it which in my opinion was the best way to get them out of the cage.

And I remembered the Prison Commission's letter to Mr. Thornton on July 30, 1931 :

> Many complaints of laxness in camps throughout the state and of abuses of prisoners, of improper feeding and of working prisoners in violation of the rules keep coming in; and, as you have seen, the papers are teeming with criticisms made by outsiders touching some of these matters.

And the pathetic letters convicts themselves scrawled laboriously in pencil, pleading letters like Eugene Brown's, sent from Gwinnett county on May 2, 1931 :

> Mr. E L Reany lissen here Mr Reiny This is Eugne Brown talking Mr Reincy I am begging you with tears in my eyies for a trancefor Becais I cannot make my time here Becais this worden and county C B M is beating us over the head with pick handle and they draw their guens on us and make us stand and let these trustes Beat us up and Let the hare gun to Mr Reiny I dont Belive that you know how they is treating us prizners you auto come and see Mr Reincy I want you to do all you can I am willing to go anywhere and make my Time Becais my hand is all messed up and every time I ask the doctor for anything they is ready to punish me my hand is so bad till I cant hardly hold a shurvle and I am asking you now for help I am looking for your awancer wright away Yors
>
> <div align="center">EUGNE BROWN</div>

<div align="center">127</div>

Flashes from Georgia Chain Gangs

And Willie Little's terrified scrawl from McDuffee county chain gang on Aug. 2, 1931:

Dear Mr. Ranie just a few lines to let you know of my Condition i have lost my health on the Public Work of the State of Georgia i have the Rheumatism also shots in my lungs and my arms torn all to pieces in the Elbow and i dont see a night Rest With it no Body knows what a Broken limb is But the one hafter carry it and i hafter to shovel and dump Wheelers with it Because i am not able i hafter Be punish and put in the stock and Being Beat on that account i am asking you please transfer me where i can Make my time i am Willing to make duble time any where Else But here judge you can find my Reckord aint give no trouble this Willie little this is the Meanest place i ever Ben in prisnon my crime Was committed here and i am treated Bad May the lord Reach your heart and come and transfer if good peoples like you dont take this in hands i dont know what Will Become of us please come or send a doctor i reports it to the inspector it sem to Make it Worse the inspector told me to see the Doctor But dont no doctor come here please have Mercy on me any Where you place Me i Believe i Will fair Better than i am Begging for Mercy just as We Would Be at the judg Mentn day please Rember me than you.

<div align="right">

WILLIE FRANK LITTLE,
McDuffia Chain gang
thomson Ga.

</div>

I remembered the many, many letters of abuse and torture of the helpless and hopeless who owed Georgia a debt.

I found myself within eight miles of the Seminole county camp and went there again.

A drowsy summer hush was over the stockade. In the glaring light of the day the clapboard shacks baked under the tropic sun. The kitchen with its torn screen, the mess hall with its grease and flies and mosquitoes, the rusty wire fence and the cross, now bare and bleak, throwing its shadow on the red soil swarming with ants.

A boy lay at the foot of the cross, bound hand and foot, with a pick thrust between the limbs. His eyes were closed and his head lay loose on the soil, as though the neck were broken. He could not move.

He opened his eyes when I walked over to him.

" Does it hurt, boy ? " I asked.

" Yes, suh. It sho does," he said weakly and closed his eyes again.

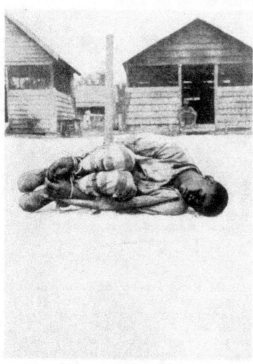

" Hog-tied "
A convict boy in the Seminole County stockade, Georgia

" What did this boy do ? " I asked.

" Talked back to guard," said the warden. " Sometimes they become unconscious and then we untie them," he added.

I examined the neat little booklet of prison rules. Each warden is instructed to " frame in a glass, and hang up in a conspicuous place in the building, a copy of these rules." I did not see them hanging anywhere, nor did the warden have a copy available. But my copy read :

> They (the wardens) shall safely keep all prisoners committed to their custody, rigidly enforce discipline by the use of such humane modes of punishment as will best enforce submission to authority. . . .

" Humane modes of punishment. . . ."

The Commission itself suggests as one humane method of punishing, " fastening them in stocks in such a way as will cause them to be restricted in their movements for not longer than one hour at one time, provided the prisoner is found to be physically sound upon examination by the camp physician."

" Stocks," I thought ; " this cannot mean the old Puritan stocks, for that is gone three hundred years. Even Webster's dictionary says : ' Stocks : a frame of timber, with holes in which formerly the feet and hands of offenders were confined . . . by way of punishment.' "

Flashes from Georgia Chain Gangs

In the Early county stockade I saw a convict in stocks. His hands and feet protruded through the holes made to hold them. I walked closer. I had seen pictures of Puritans in stocks. They sat them on boards in a public place, but here in Georgia, 300 years later, he did not sit on a board even in this wired world.

He hung.

He hung, a groaning, helpless, pain-wrenched thing crying weakly:

" O my Lawd, my Lawd, look what they is doin' to Yo' chillun."

He hung, for the board was pulled out from under him, hung three inches from the ground, with the wood encircling his wrists squeezing against his arteries and interfering with the circulation, while the weight of the body dragged him down, tearing at his shoulders and threatening to break his back.

The sweat broke out on his face and tears rolled from his eyes.

" How long do you keep him in stocks?" I asked.

" Not more than an hour at a time," said the warden, J. D. Williams. " If they lose consciousness we release them and when they are a little stronger we restrict them again."

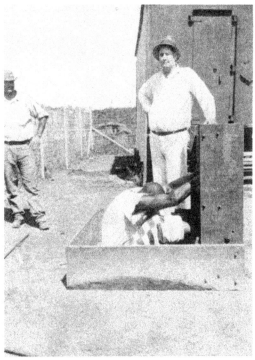

Stocks

Warden J. D. Williams of Early County, Georgia, watching convict hanging unconscious in stocks. The convict hangs by wrists and ankles two inches from the ground. He is left thus under the tropic sun. The position is an excruciating torture which quickly produces unconsciousness

Photo copyright by John Spivak. Reproduced by courtesy of John Spivak

" What did he do for this?"

" He's been fussin' about his meals," said the warden.

I remembered a Constitution somewhere that said:

" Excessive bail shall not be required, nor excessive fines imposed, nor cruel and inhuman punishment inflicted."

But that was in a land far away in this world drowsing under a Georgia sun.

" Isn't this worse than the lash the legislature abolished?"

" Oh, I don't know. I'd like to see the leather returned. The worst we can give them now is a little stretching."

" Stretching," I thought, " what can this stretching be that is worse than hanging helpless in stocks?"

When you work from sunrise to sunset under a Georgia sun you go mad sometimes and talk back to the guard, and a convict in Early county talked back.

They put handcuffs on him and tied a rope to the cuffs and led him to a little post to which they laced him tightly from ankles to hips. A white trustee took the rope attached to the handcuffs and swinging it around another post, yanked sharply at the warden's command.

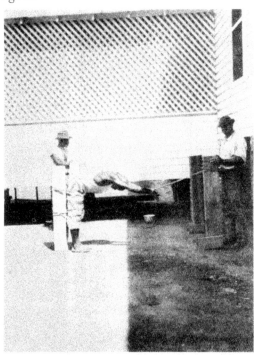

The Georgia Rack, Early County, Georgia

Known as " stretching" and " restricted movement." The convict is laced to a post and the rope tied to the handcuffs is pulled around the second post until the arms are almost torn from the sockets. The " stretched" convict is then left under the broiling sun. They frequently lose consciousness within an hour

Photo copyright by John Spivak. Reproduced by courtesy of John Spivak

Flashes from Georgia Chain Gangs

The convict's torso jerked forward, his hands outstretched.

" Pull ! " shouted the warden.

The trustee pulled until the rope was taut. He dug his heels into the red clay of the stockade.

The convict screamed in agony.

His head drooped between his outstretched arms.

And as the beads of sweat broke out on his arms and neck and face a cold sweat broke out on me. They were tearing his arms out !

" Oh, Jesus ! " the convict moaned.

The trustee quickly tied the rope around the post and left him stretched on the Georgia rack while the sun beat upon him and the sweat from his head dripped to the red soil.

I left with the convict's groans and prayers ringing in my ears.

Early on a Sunday morning I rode in the bus from Bainbridge to Blakely. The southern morning was fresh and clean. The car purred over the wide, level highway.

Beside me in the car was a kindly minister on his way to deliver his monthly sermon to a flock in their little town.

" Tell me, sir," I said, " I hear so much about Georgia chain gangs. What are they like ? "

He turned a surprised face in my direction.

" Why, I really don't know," he smiled apologetically. " I've been here only six years."

Nancy Cunard's contention that only Communism would destroy the "barriers of race" as it eradicated class distinctions should not be accepted as evidence of a rigid dogmatism. To begin, Nancy was never a Communist, although she once remarked to her friend Anthony Thorne, "I've sometimes wondered why I wasn't." She had neither the interest nor the temperament for it. Nancy was an idealist (some would say a romantic) who unabashedly embraced any program that agreed with her ideas. Concerning Communism, Charles Duff has perceived that her "ideas coincided with the party line of the Communists only when it coincided with her own humanitarian ideas."

When Nancy announced that one of her intentions in *Negro* was to attack racial prejudice, she naturally welcomed the support of as many individuals and organizations as possible, whether Communist or not. Then, in the United States, as she learned what the Communist Party had vowed to do to end discrimination, and as she witnessed the Party's involvement in the Scottsboro case, where the Communists, in her opinion, emerged as the only defenders of the accused, and as she saw the Party nominate James W. Ford, a Negro, for the vice presidency of the United States, she became firmly convinced that the Communists had the only viable program for the deliverance of American Negroes. She would say that one did not have to be a Communist to support this program. Besides

attracting her approval of their plan and organization, the Party appealed
to Nancy's insatiable demand for action. At one time she even believed that
the results of such action could already be seen in the "new expression in
some of the faces" she saw, an expression she described as a "look of
purpose and responsibility." And behind everything lay the belief that
race hatred had been artificially bred by whites to maintain and preserve
their power. The Party's conclusions that there was no color problem, only
the fact that a black race existed, and that white and black might join
together to end discrimination, harmonized with her own beliefs.

As several people have noted, to call Nancy Cunard a Communist reveals
an ignorance of Communism. Nancy herself did not understand what
Marxism was or is, and of course she really did not mind. She once asked
me if I understood the meaning of dialectical materialism, and then con-
fided she had never been able to comprehend it, and, in fact, had always
found systems of all kinds repugnant. Nancy was an individual whose ideas
of justice and truth and freedom seemed at times "like a mystical faith, a
faith so strong, so dedicated to the 'moral evolution of mankind,'" as
Solita Solano has written, that politics of any color could hardly be ex-
pected to influence it. "I am not a Communist," Nancy said more than
once. "I am an anarchist!" Besides helping to reduce the myth of her
being a Communist, the remark preserves a self-assessment that may be
less exaggerated than we suppose.

H. F.

Marxism and the American Negro

by WILL HERBERG

COMMUNISM, revolutionary Marxism, bases its program and conclusions not upon vague and
indefinable sentiment but upon a scientific analysis and an objective evaluation of social relations
and class forces. When Communism approaches the " Negro problem " in the U.S.A. the first
question it puts is : " What is the actual status of the Negro in American society, how did this status
arise and how is it maintained? "

THE AMERICAN NEGRO AS A SUBJECT CASTE

The American Negro is not free—even in the extremely limited sense in which freedom can be spoken
of at all in bourgeois society. In the South, the Negro peasant is practically a serf ; in fact his status is sub-
stantially no more than a modified form of the slavery of former days. In Northern industry, the hundreds

¹ Resolution of the Communist International on the *Negro Question in the United States*.

of thousands of Negro proletarians occupy a position of definite inferiority—they have no access to the more desirable situations, they are hindered in their approach to skilled or even semi-skilled jobs, they are forced into the least paid and most menial occupations, they are discriminated against in wages and in working conditions. The black man, concentrated in the South and in about a dozen Northern cities, is segregated by law and custom into veritable ghettos. In a large part of the country he cannot eat where the white man eats; he cannot attend the white man's places of amusement and recreation or else cannot frequent them on an equal basis; he cannot even travel as does the white man. In an even larger part of the country, Negro children cannot attend " white " schools, colleges or libraries and are forced to be content with the most shamefully inadequate facilities. Throughout the entire South the Negro is deprived of every civil and political right. And over all hovers the dark shadow of Judge Lynch. . . .

The Negro in the United States forms a well-defined subject caste, with a distinctly inferior economic, social and political status.

The Roots of the Subject Status of the Negro

Communism traces the roots of the present subject status of the Negro in America back to the days of slavery, nearly three-quarters of a century ago. Under slavery there was an immediate and obvious basis for the social subjection of the black men—their economically enslaved condition as a race. Had the American Civil War really effected the complete emancipation of the Negro slave, there would indeed have been no ground for the continued existence of the Negro as an inferior caste. But the victorious industrial bourgeoisie of the North adopted a course of action that led to quite other results. It rejected the " Radical " plan of Reconstruction, a plan that envisaged the complete destruction of the economic and political power of the slaveocracy and the real emancipation of the Negro slaves, *i.e.* their transformation into free peasant-proprietors and into free proletarians. On the contrary, the Northern bourgeoisie, after considerable hesitation, threw its support to the " moderate " plan of Reconstruction which aimed to conciliate the old slave-owners by abolishing chattel slavery in name but retaining it in somewhat modified form in fact. The bourgeois-democratic revolution—the historical essence of the Civil War—was thereby stifled and distorted; the emancipation of the Negro was rendered incomplete, even from the consistent bourgeois standpoint. Thus the present economic status of the Negro farmer (and at least 50 per cent. of the Negro people are still farmers) is essentially a survival of slavery. And when, in the course of time, the Negro farmer comes to enter industry, he naturally brings with him his caste status. The *specially depressed* economic position of the Negro is the basis upon which the whole system of social, political and cultural subjection is reared.

Modern Capitalism and the " Relics of Feudalism "

The caste status of the American Negro is a pre-capitalist survival, a " relic of feudalism." But such pre-capitalist survivals find a welcome place in the decaying structure of capitalism in its final, imperialist-monopolist epoch. The bourgeoisie is no longer, as it was in the great days of its youth, the ruthless destroyer of the reactionary and the obsolete. In its senility, " the decaying bourgeoisie . . . supports everything that is backward, dying and medieval . . ." (Lenin). The British Raj sustains the forces of feudalism and the dark powers of superstition in India; American imperialism carefully fosters everything that tends to keep the colored man in his semi-serf state.

The specially depressed economic status of the Negro peasant and proletarian serves as a valuable source of super-profit for monopoly capital—in a strictly analogous manner to colonial exploitation. At the same time it also serves as a point of support for the class domination of the bourgeoisie (" Divide and conquer ! "). For this reason the race oppression of the Negro has become an integral element of the bourgeois-imperialist system in this country.

The Roots of Race Prejudice

Class interests are directly transmuted into class ideology; this is a fundamental social mechanism. The caste status of the American Negro—so advantageous to the ruling class from the viewpoint of economic profit and class power—is transformed into the corresponding class ideology—the " theory " of the " inherent " racial inferiority of the Negro, race prejudice, etc. But " the ruling ideas of any age are the ideas of the ruling class " (Marx). Race prejudice develops into an element of the currently accepted social thought and is absorbed by the other classes of society to the degree that they are under the ideological influence of the ruling class. It is because the white American workers and farmers are so " backward," *i.e.* so much under the spiritual influence of the bourgeoisie, that they are so afflicted

Marxism and the American Negro

with anti-Negro race prejudice. Nor can we under-estimate the social significance of the feeling of racial superiority as a form of psychic compensation to the backward masses of the white toilers for the incredible miseries of their everyday existence.

Negro Emancipation and the Proletarian Revolution

The whole burden of the Communist analysis goes to prove that, altho the deliverance of the Negro people from their caste existence is in its content essentially a democratic task, in all respects similar to the liberation of subject nations or colonies, the " Negro question " today cannot be solved within the framework of the capitalist system and of bourgeois democracy. It is clear that only the elimination of the underlying economic conditions upon which the subjection of the American Negro is predicated,

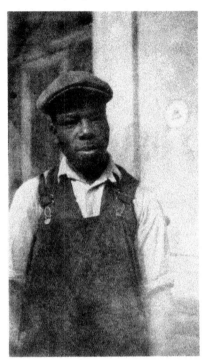

Porter, stevedore, train-attendant, etc., and all the forms of rough labour are what capitalist American " democracy " allots its so-called " liberated " Negroes, with a separate and inferior wage-scale established also to undercut that of the white workers
Karl Marx said : " Labour with a white skin cannot emancipate itself where labour with a black skin is branded "

can make possible any real emancipation. The radical eradication of tenancy, share-cropping, " furnishing," and all other forms of semi-slave exploitation, the shattering of the power of the Southern landlords through the nationalisation of the land and its distribution among the cultivators, the elimination of all elements of inferiority in the Negro's position in industry—these are the very basic pre-requisites. Obviously enough, these proposals represent merely the demands of consistent democracy; they are in all respects akin to the classical ideals of the bourgeois-democratic revolution, the great French Revolution, for example. Not a single one is a specifically Socialist demand—not one necessarily implies the socialisation of all the means of production, etc. Yet the opposition of capitalism today to such a program is not a whit less bitter for all that. So anti-democratic has the bourgeoisie become in its period of decay, so organically bound up with everything that is outlived, reactionary and decadent, that the realisation of these democratic demands in the present historical period is possible only through the over-throw of capitalist " democracy," through the concentration of political power in the hands of the proletariat. In such dialectical contradiction does history move that only the dictatorship of the proletariat can guarantee democracy to the masses and bring real democracy, for the first time, to the Negro people. Today only a proletarian revolution can accomplish what the American bourgeois revolution that was the Civil War failed to do !

The Negro Migrations, Class Alignments and the Struggle for Emancipation

The great Negro migrations during the last two decades, in the course of which scores of thousands of Negro farmers swarmed to the great Northern industrial centers and to the basic industries of the land, really introduced a new stage in the history of the American Negro. They effected a profound social fermentation and a basic re-alignment of class forces. They really created the modern Negro proletariat. They greatly stimulated the development of the Negro bourgeoisie and petty bourgeoisie and seriously transformed the relations between these classes. Above all they opened a new chapter in the long and painful story of a race striving for deliverance.

The *Negro bourgeoisie* is rather weak numerically, but through it, through the more pliant elements of the petty bourgeoisie, and through the professional " race leaders," the white bourgeoisie exerts tremendous influence over the Negro people. The fundamental standpoint of these conservatives was theoretically formulated by Booker T. Washington in the famous " Atlanta Compromise " : the Negro is to be content with the place in the American scheme of things so graciously vouchsafed him by the white man. He is to bend his energies towards becoming an efficient servant of the white master, a hard-working farmer, a skilled artisan, a small business man if possible. Any present aspiration for social and political rights—and above all, any yearning for social equality—is a vain and dangerous delusion. In the South the Negroes are to acquiesce in their complete political disfranchisement; in the North,

133

they are to serve as blind voting cattle for the Republican party. (Lately an infamous flirtation with the Democrats has even been initiated.) Clique squabbles, gross corruption and shameless patronage mark the " political " activities of these " race leaders "—all at the expense of the life interests of the Negro masses. Of the emancipation of their people they know nothing and care less !

The *Negro petty bourgeoisie*, especially the intellectuals and the professionals, are quite numerous and of considerable consequence. Like the bourgeoisie, this class found a firm basis of existence only with the great Negro migrations and the creation of huge Negro cities in the relatively free atmosphere of the North. In the post-war " renascence," a period of deep-going fermentation and great achievement, the Negro intellectual played a brilliant role, especially in literature and the fine arts. As a significant factor in the life and development of the race, the petty bourgeoisie is second only to the new proletariat.

The social outlook of the *Negro petty bourgeoisie* has always been marked—quite inevitably, as the Communist sees it—by its lack of consistency and resolution, by its grave inner contradictions, by its endless vagaries, by its extravagant oscillations from one extreme to another, by its fantastic utopianism combined with an equally fantastic " practicalism "—but all within the bounds of the basic bourgeois preconceptions. Especially characteristic is its touching faith in the belief that the " Negro question " can be solved within the framework of capitalism, perhaps even with the benevolent aid of the white capitalists themselves—a delusion that no amount of experience or thought, it seems, has as yet been able to dispell. At one time Garveyism, an essentially reactionary philosophy based on an inverted form of the " white supremacy " gospel of the white masters and shot through with the crassest demagogy and the grossest charlatanism, had considerable hold over the lower middle class elements in the large Negro cities. Now Garveyism is happily dead. Today the Negro intellectual and professional are lost in the absurd utopia of creating a self-contained Negro economy through utilising the " organised buying power " of the race, or through some equally efficacious means. The capricious and ever-changing vagaries that dominate the Negro petty bourgeoisie are a certain indication of the gulf that has arisen between it and the masses of the Negro people, the peasants and workers, whose interests are poles apart from the unreal fantasies of the small business man or professional. Their growing estrangement from their own people is unquestionably the greatest inner weakness of the Negro petty bourgeoisie.

Black and white workers are realising their solidarity more and more against their true enemy, American oppression of the toilers of both races

Photo by courtesy of Essman

Nevertheless, from a general historical viewpoint, this class still has progressive potentialities. Considerable sections of the Negro intellectuals are already definitely moving leftwards. But the actual realisation of its historical potentialities implies an end to reactionary and futile utopian dreaming, an organic approach to the masses, a participation in their interests and aspirations, a close alliance with the advanced sections of the proletariat, black and white.

The wave of Negro migrations and the experiences of the World War had an immense effect upon the great and basic mass of *Negro peasants* in the South. The bleak seclusion, the dreary isolation of decades was broken. A vigorous breath of fresh air swept through the poisonous atmosphere of the Old South. The vision of the Negro peasant was suddenly and immensely enlarged ; intimate contacts were established with migrated friends and relatives in the North ; an understanding that things must not be always—and are not everywhere—the same, began to dawn. The Negro peasant began to mature as a vital factor in the movement for freedom.

The rise of the *modern Negro proletariat* that came with the migrations drew scores of thousands of black men out of the narrow and stultifying conditions of Southern rural life and threw them into the very whirlpool of modern America—the great industrial centers of the North. The creation of an industrial proletariat on a large scale constituted a change of colossal historical importance, for it gave to the Negro people its natural leadership, a class thrust to the fore of modern society by the immanent processes of capitalist production themselves. The creation of the modern Negro proletariat was the most significant advance in the history of the Negro people since the days of Reconstruction.

Marxism and the American Negro

The sudden influx of tens of thousands of black workers into Northern industry inevitably aggravated the anti-Negro prejudice of the backward white workers—and the vast majority of the American workers are still backward. At the same time, the narrow and exclusive craft structure and the opportunist philosophy of American trade unionism served from the very beginning as a most serious obstacle in the way of the black workers in industry. The Negro is almost exclusively an unskilled laborer : why should the craft unions of skilled workers " bother " about him? The Negro is thrown into a despised position of caste inferiority by the capitalists : why should the opportunists, who slavishly anticipate the mere thoughts of their masters, whose very fibres are seeped through with the poison of race prejudice, " bother " about him? The conservative trade unions have practically closed their doors to the Negro workers and have all but invited them to throw in their lot with the white capitalists as scabs and strike-breakers—a course incessantly urged by the conservative Negro leaders as well. The darkest page in the history of the American organised labor movement is its shameful record of antipathy and discrimination against the black worker.

But the progress of the class struggle—Communism points out—promises to heal even this ominous breach in the ranks of the American proletariat. The white heat of class war will burn out the corruption of race prejudice. The fraternisation of white and colored workers in the South during recent strikes, however hesitating, uncertain and unstable, is a straw in the wind. The slow but inevitable deepening of the class consciousness of the white proletariat, *i.e.* its growing ideological liberation from the bourgeoisie, will certainly deliver the white workers from the thoroughly bourgeois nightmare of race prejudice.

THE COMMUNIST PROGRAM

The close organic link between the democratic emancipation of the Negro people and the Socialist revolution of the proletariat only emphasises the tremendous historical role the new Negro proletariat is bound to play as the chosen vanguard of the Negro people. The racial emancipation of the Negro cannot come as the result of a " purely racial " movement—of a movement deliberately aiming to subordinate, in the name of an unreal " racial unity," the masses of the Negro people to the narrow interests of the Negro bourgeoisie (who work hand in glove with their white paymasters), of a movement consciously striving to divorce the liberation struggle of the Negro people from the chief social movement of our times, the class war of labor against capital. The racial emancipation of the American Negro, in the present historical situation, is possible only as an integral aspect and an inevitable consequence of the revolutionary overthrow of the capitalist system, of the victory of the proletariat.

But the Communists well realise that this far-reaching perspective can today assume vitality and general significance only if it can be shown in life itself to emerge as a natural development of a program of immediate action intimately associated with every phase of Negro life. The Communist program represents the basic interests of the Negro workers, of the Negro peasants and also of the Negro petty bourgeoisie, to the degree that the latter constitutes a progressive historical force. The Communist program champions the abolition of peonage and the serf conditions of the Negro farmers in the South, the organisation of leagues of share-croppers and tenants, of unions of farm-laborers. It stands for the complete equality of the Negro in industry, the smashing of the barriers against the Negro workers in the trade unions, the organisation of the unorganised and the unskilled. It takes up the struggle against lynching and jim-crowism. It demands the complete social and political equality of the Negro race. It strives to break the hold of the capitalist political parties over the Negro masses and to win these masses to the cause of labor, which is their own cause as well. Such is the appeal Communism makes to the Negro people in the United States today.

A Word as to Uncle Tom

by MICHAEL GOLD

ONE of the midnight fears of the American Tory-Babbitt today is that the Negroes are becoming Communist-minded. The color of this Tory-Babbitt is white. It is also black, brown, yellow and gold. The bourgeoisie of both races is uniting on a singular program in which the proletariat of both races is kept under the iron heel.

135

A Word as to Uncle Tom

Three months ago the Communists organised a demonstration in the Negro South Side of Chicago. A poor Negro woman with a sick husband and children was to be evicted. Her furniture was on the street. She was in the street with her poverty. The Communists put her furniture back and defied the landlord. The police came and fired into the crowd, and killed three Negro Communists. Later, it was discovered that the police had been called into such evictions, and egged on to violent action by a committee of Negro landlords, the spokesman and strategist of which was a Negro attorney who is also the Chicago leader of the N.A.A.C.P.

Thus is the class war revealed in a flash of lightning and murder. It cuts across all the race lines. It is more important than the race conflict. It is the CAUSE of the race conflict. The mass of the Negro race in America is peasant and proletarian. Hitherto the small fringe of Negro artists, intellectuals and business men has been chiefly concerned with climbing into the white bourgeois world. Who of the Negro leaders has ever given thought to the life-problems of the Negro mass? Who of them has spoken for the rent-croppers, shoeblacks, waiters, Pullman porters, masseurs, ditch-diggers, steel workers, North and South, the eleven million black toilers who are the RACE?

The fate of a few artists or business men is not the fate of a race. I, as a Jew, know that. We have had centuries of Jewish millionaires, and poets like Heine, and thinkers like Einstein. But a Jew in Poland today is no better off than a Negro in Alabama. In the old Czarist Russia there were wealthy Jews, pious Jews, respectable, bourgeois Jews, but the Jewish mass was lynched, massacred, segregated, insulted like the American Negroes. The Czar's bloody government sustained its power by playing off the races against each other, exactly like the English in India today, who play Mohammedan against Hindu. When there was a famine, when taxes were high, when the peasants were ready to rise in revolt, the Czar's spies went whispering that the Jews were to blame, and Jewish blood was poured out in a pogrom.

In America, the chief cause of anti-Negro feeling is not skin, race, exotic strangeness, social prejudice, but these same economics of a master class. Read Civil War history. Andrew Johnson was a native of Tennessee, but fought on the Northern side of the Civil War. He came from poor farmer stock, and hated the rich slave-owning landlords, who despised the poor whites as much as they did the Negroes. After Andrew Johnson became President, this same early class hatred moved him against the feudalists. He said the " poor whites " had been forced into the war against their will; they did not want slavery, it degraded all labor, white and black. The Civil War freed the Negro from chattel slavery, and thrust him into wage slavery. The Negro's problem now is to free himself from this wage slavery, the same problem, exactly, as the white worker's, no different. But he can never be free until there is a social revolution. This is a hard saying, but let us not avoid reality.

The Negro business men and intellectuals have made their own revolution and won it. They have money and success, and they are willing to let the world remain as it is. When they say Freedom, they mean themselves. But the Negro MASS is still enchained in steel mills and on cotton plantations, and every move it makes towards freedom is met with guns, rope and faggot. But the white worker meets the same treatment. Negro landlords shoot down Negro tenants, with the aid of white police. White bosses shoot down white workers. Jewish bosses in the New York garment strike kill and maim Jewish workers by the aid of Italian gangsters and Irish cops. There is no RACE in the class war.

In the last three years a great drift among thoughtful Negro workers and farmers has set in towards the Communist theory. These Negroes understand there is no hope in the bourgeois Uncle Toms who want everything to stand still, or to be done by lawyer-like diplomacy. Into the Communist movement the Negro comes not as a suppliant, or a tolerated ally, but with demands. It is the one movement in the world where he can DEMAND social equality, economic equality, intermarriage, anything that is his. He can and does bring white Communists to trial in Communist tribunals if they show any race prejudice. There have been a number of such cases, and the criminals have been expelled from the Party.

In the South the bosses keep the races divided. In strikes Negroes have been used as scabs, with the approval of such leaders as Kelly Miller. No one ever dared to organise the Negroes for their rights in the South; no one ever dared to preach Negro equality to the white workers in the South, until the Communists penetrated there. The strike at Gastonia a few years ago was the first battle. The Communists went into a community of pure-bred mountain whites, and told them boldly they could not have a textile union without giving the Negroes full rights. I know some of the organisers who were first in this field. They knew they carried their lives in their hands; they knew they were risking everything, including the possibility that the white workers would hate Communism forever. But they preached the Communist

A Word as to Uncle Tom

doctrine that the workers of every race can only free themselves by uniting with the workers of every other race. And they won. The miracle happened. The white workers understood. The Negro was given his full standing in the union. The same thing has happened in fifty other places in the South since. It is becoming a national force.

The Communists are teaching that there cannot be a strong and successful labor movement in America unless the 11,000,000 Negro workers are included. Outside, they are a dangerous reservoir for scabs and lower wages. Inside, they are the last guaranty of final victory. And the white workers are beginning to understand this Communist doctrine. There is more being done in these past five years to break down anti-Negro prejudice in the South than has been done in fifty years of Uncle Tom cringing, concert hall singing of spirituals, literary articles, and other bourgeois methods. It is a bitter and bloody progress, of course. But when has a race gotten anywhere except by sacrifice? Yes, the Communists call the Negro forth to new sacrifices, but they can assure him of some great victories, and a great goal at the end. It is better to be a man and die for a great cause than to flee like a rabbit before the lynchers.

In Russia, the old Jews, and the bourgeois Jews, had an Uncle Tom policy also. It is amazing to see how the history of the two races parallels at so many points. These old, pious, legal, Jewish Uncle Toms would deliver young Jewish revolutionists to the Czar's police. Young Jewish revolutionists would be brought in chains by the police to a synagogue and the Rabbi would preach against them and warn all other youth. The same thing in America. The landlords, intellectuals and other bourgeois Negroes have commenced a fierce drive against the Communist influence. It does not make them indignant against the murderous bosses when Negro workers are shot down in a strike. They are indignant against the Communists who prevailed upon the Negroes to strike. These Judases run like stool-pigeons to the authorities and expose Negro Communists. In print and from the platform they preach the extermination of Communists, exactly like all the Czars and reactionaries.

A terrible scandal was created by them in the recent case of the Negro boys on trial for their lives in Alabama (Scottsboro). Because the Communists first took up the defence of these boys and, with passion and courage, made of it an international issue like the Sacco-Vanzetti case, these Uncle Toms were indignant. They wanted the case

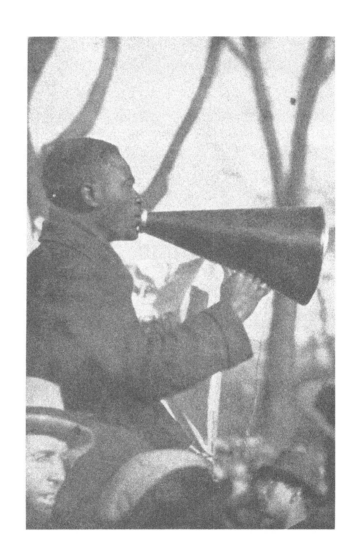

Poyndexter, Negro Communist, speaking opposite the White House, Washington
Photo by Workers' Film-Photo League, 16 W. 21st St., New York

137

Charles Alexander, Negro Communist speaker, U.S.A.
Photo by Workers' International Relief, New York

conducted quietly, respectably; they wanted a polite, well-mannered lynching. But the Communists believe in widespread publicity; they believe in accusing the upper-class criminals to the whole world. Can you have a fair trial for Negroes in Alabama? Especially when the defence was half-hearted and conceded guilt where there was no guilt? Can you have a fair trial for Dreyfus or Sacco-Vanzetti without a world-wide publicity?

The Uncle Toms have no program to offer the Negro masses. They are NOT organising the starving rent-croppers or steel workers. They are NOT going into the hell-holes of the South and preaching Negro equality to the white workers. Their platform is the bourgeois one of let the unemployed man starve quietly to death, let the Negro suffer quietly, begging only for a few crumbs of justice.

But the workers of the world are rising. We are living in the century of beginnings. No one can stop this flood. In China, in India, in Japan, yes, and in Africa, on the continent of Europe, in the Malay seas, in the Siberian tundras, in the Egyptian deltas, south to Cape Horn, north to Nome, Alaska, the movement spreads, and the American Negro worker has at last taken his proud and fearless place in the world ranks. And these Uncle Toms think they will stop it. They will do much damage; they will help betray many a strike, and help, by their frenzied denunciations, many a lynching and massacre, but they can never keep the Negro worker from his manhood.

Blacks turn Red

by EUGENE GORDON

Eugene Gordon

ENTRENCHED Negro leadership both secular and saintly is disturbed today as never before. Seeing prerogatives of generations slipping from its clasp, it is desperate. The leadership of Aframerica today is like a parent who awakes suddenly to the disturbing discovery that Percival has slipped the reins of parental restraint, defied parental authority, thumbed his nose at parental dogma, and shouted at parental dignity to chase itself down the alley. In its role of abused and outraged parenthood, entrenched Negro leadership is recounting reproachfully all the benefactions it has bestowed on, and all the suffering it has endured for, the ungrateful wretch, predicting calamitous mishaps to befall the miscreant unless he returns his footsteps to the gullied paths of tradition. The reason for Negro leadership's despair is that a shockingly large mass of patient, good-natured, long-suffering blacks have become surly towards the *status quo*. They disregard the counsel of their hoary prophets and flitter after base and clay-footed gods. In short, masses of blacks formerly extolled for their ass-like docility are lingering rather long before the soapbox of the Red agitator. In fact, thousands have themselves become Red agitators. For the first time in American history whole masses of Negroes are contradicting the stencil that although they are gratuitously and regularly persecuted, they stand by loyally, appealing dumbly for a chance to spill their last drops of blood for their beloved oppressors.

Blacks turn Red

And—most incomprehensible !—blacks who are guilty of this treason are not all " ignoramuses and illiterates," an influential metropolitan news-sheet to the contrary notwithstanding. Some of the best minds of Aframerica are among them. Yet he would have a ludicrous misconception of the Negro worker's changing psychology who supposed this turning of blacks to Reds to be a trick of colored intellectuals. For it is nothing less than mass metamorphosis springing from mass wretchedness and disillusionment.

Entrenched Negro leadership is that which presumes the right of paternalism over the black masses. It is both Caucasian and Negro. When the snobbish Boston *Transcript* and the supercilious New York *Herald-Tribune* assume an attitude of condescending paternalism towards the black worker, advising him for his soul's good to flee from Communism, the *Transcript* and the *Herald-Tribune* manifest traits of entrenched Negro leadership. These and other newspapers frequently do so. That it is wiser to examine the thing they are warned to stay away from than to heed the advice and flee, is already axiomatic among Negro workers. No other people in the world is quite so chary of the Greeks who come bearing gifts.

Entrenched Negro leadership came to flower in the church in slavery days, and until today it has felt secure behind the breastwork of traditional white ruling-class advantage. It has felt secure because it has seen the Negro perpetually in the role of a cringing, grateful dependent praying for white ruling-class benevolence. From the beginning white masters comprehended the value of Christianity as an opiate to induce sluggish content. So effectual was the narcotisation of the blacks that, with one or two exceptions, recorded instances of slave rebellion make wearisome reading. Why? Because such revolts were usually but half-formed, sissified gestures. Christianity's mollycoddling had rotted the very fabric of their stamina.

This early leadership of the black masses did its work well. Complaint today among sable Men of God against Communism is chiefly that " them Reds is atheists ; they don't b'lieve in no God." It is only now, after all these scores of years, that the black masses are struggling out from under the mountainous disabilities loaded upon their backs by the leadership of the pre-Lincoln era. It was a leadership that turned black feet into a maze of by-ways which until now have kept the Negro bewildered and uncertain. Having found his way out of the maze, the black worker's uncertainty gives way to a conviction and his bewilderment no longer exists.

Leadership following " emancipation " assumed a complexion slightly dark. Being the beginning of an era of struggle for an economic foothold, it was, dialectically, the beginning of Negro parasitism. This parasitical leadership was composed of two sections, the Negro ministry and the Negro editor-politician. Both ministers and editor-politicians dreamed of power and possessions ; but the ministry hoped that the Men of God would form the black aristocracy, while the editor-politician could conceive of no élite which excluded him. Both agreed that the black worker was to be kept in his place. Thus the preacher exhorted the worker to support the church and to scorn materialism. Supporting the church, the black millions remained in poverty, being degraded to the status of a new slave system, while the rising aristocracy of the church accumulated vast material possessions.

Editor-politicians were less individualistic. They worked for a class of wealthy landowners and professional men ; a class which, composed of editors, holders of political office, physicians, lawyers, and insurance heads, would be supported by the toiling masses. This was their dream of the black aristocracy. Both groups succeeded somewhat, but the aristocracy of the Holy Men apparently prospered beyond that of their materialistic brethren. Wealth tied up in Negro churches, from which the ministers derive direct benefit, greatly exceeds that owned by the professional aristocracy.

Off and on through this period of struggle for economic security the black masses sought a leadership which would be adequate in all ways. Now and then an individual leader arose, a Frederick Douglass or a Booker Washington ; but his vision was invariably clouded by the miasma of opportunism. A petty political office or the condescending patronage of the ruling class usually turned his head so far aside that he could not see the miserable degradation of the black masses who prayed he would deliver them. If either Douglass or Washington, in his later and affluent days, saw the true plight of his Negro kinsmen, he did not concern himself about it. Douglass, turned petty Republican politician, vegetated like a contented country cabbage on the outskirts of Washington, D.C., while millions of blacks all around him wallowed in ignorance and neglect. Booker T. Washington compromised readily with the vindictive white South, eschewing social and political equality for the masses while grabbing at even the shadow of it for himself.

Entrenched Negro leadership is today totally bankrupt, and the masses are hoarse with clamoring for a figure tall enough to be seen above their heads and a voice penetrating and steady enough to be

heard above their own cries of wretchedness. Having chafed for generations under burdens laid upon their backs by these misleaders, the masses of blacks feel that they have a right to choose their leadership of the future. They have chosen it.

II

Present Negro leadership is dominated by the press. The Negro church exerts the next greatest influence. Following the church strut the politicians. Individual newspaper writers like Kelly Miller, William E. B. DuBois, George S. Schuyler, Gordon Hancock, and William Pickens remain individual leaders. Each has a small following of thoughtless hero-worshippers. None of them could possibly rally an appreciable percentage of the workers, the reason being that none of them has anything basic to give. Kelly Miller is intellectually sterile because intellectually stranded; the swift current of events leaves him untouched. DuBois, who calls himself a socialist and tries valiantly to love the masses, is incurably snobbish. George S. Schuyler is an opportunist of a most odious sort. Gordon Hancock is Uncle Tom reincarnate. William Pickens is not dependable, having shown that he will retract if his owners order him to do so. Nor are the well-written and well-edited editorial pages of the Norfolk *Journal and Guide*, the Chicago *Defender*, the New York *Amsterdam News*, the Chicago *Whip*, and the Pittsburgh *Courier*, each constantly dominated by the influence of the Republican or Democratic party, nearly so powerful as they used to be. Having played for years on one tuneless string, their weary song of race-solidarity, loyalty to the Republican party, loyalty to the Democratic party, and unswerving patriotism to our great country, is no longer heard. The noise is there but it penetrates no one's consciousness.

The Negro church is still influential in places. The reason for this unfortunate condition is that millions of black workers are forced to continue in ignorance. But the power of the ministry is waning. Enlightened Negroes long since turned from the ministry as a field for leadership. If one now and then enters it today he does it for the same reason that a boy enters West Point or the Naval Academy. It will offer a soft job with a lot of graft. Church membership falls off gradually from year to year, as United States Census Bureau statistics show. In short, the Negro church, still influential to some degree among a few of the peasant blacks of the South, is a pitiable joke to most of the offspring even of these saintly souls. When young folks come to make ribald allusions to Yahveh it is time to junk him. The automobile, the newspaper, the radio, and the motion picture have carried knowledge to the backwoods, and the church, with its mumbo-jumbo superstitions, has retreated, mouthing curses.

As for the black politicians, they do not pretend more than a periodic and selfish interest in black voters. If the casual observer wonder perplexedly how year after year these sleek and engaging scoundrels control the Negro vote, the voter himself is completely befuddled. Steeped for generations in the nonsense of " race pride " and " race consciousness," he doubts whether to trust the suave Negro politician who " proves " that a colored gentleman in office reflects a golden glory upon the lowliest black worker, in whatever hovel he may sleep or from whatever garbage can he may filch his meal. The bewildered black voter tries to recall one instance of *his* wages being raised, or *his* rent being reduced, because he obeyed instructions of a colored political boss and voted the boss's boss into the mayor's seat. Yet, because he *has* had race pride and has been race conscious, he obeys orders. " We Negroes must stand together and put our own kind into office," the black worker is told. But once in office the Assistant United States District Attorney, or the Assistant Corporation Counsel, or the Assistant Clerk of the Juvenile Court, moves so far beyond smelling distance of the black workers' slums that he has to buy a powerful straight-eight to reach his office on time. The black worker is thinking about all these things now. He is thinking of them both as worker and as voter. One of the results of his thinking has been the swelling Communist vote in Negro neighborhoods. His thinking about these things has not led him to vote Communist in a vindictive or reformist spirit. He knows that a rotten vegetable cannot be reformed into a sound one, or that a decaying carcass cannot be rejuvenated into a frisky animal. He votes differently to indicate that he wants a radical change. Moreover, he feels sure that voting for this change is simply a gesture and that radical changes are not brought about simply by thumbing the nose.

I must make a parenthetical mention of organisational leadership here. This leadership has done its share of confusing the masses, but the majority of Negro workers are now aware that any organisation— such as the National Association for the Advancement of Colored People and the National Urban League, to name two—is impotent when it depends for its very existence upon the class which oppresses those it purports to lead. The workers see clearly that these organisations are tools manipulated by puppets at the hands of those who give the money.

The black masses today stand searching the horizon for leadership : one which will not exploit them ;

which will endeavor to keep its promises to them ; which will be of them ; which will so understand them and share their lives that, if called upon to do so, will either die with them or for them ; whose program, however, is for richer, happier living on earth, excluding all consideration of a hereafter. They have never found such a leadership in all the 300 years they have been here. They have doubted that such a leadership was to be found. And now the eye of the Negro worker has caught the eye of the Communist ; and the eyes of these two hold each other in mutual understanding.

III

Entrenched Negro leadership is naturally terrified at what it sees in the eyes of the black worker. His old worshipful attitude, that old look of awe, his respectful deference, his cringing self-effacement, his doglike loyalty to an indifferent master, his blind and dumb patriotism—these attributes of the old Negro are vanishing. There is a smirk of cynicism ; there is an arrogant self-assurance ; there is forceful assertiveness. These are characteristics of the transition period. Later there comes the self-assurance without arrogance ; there is no longer a cynical smirk, for the worker knows that a whole new world lies ahead of him. The roundly developed adult is too intelligent to be cynical. The white boss and the black errand boys are so many parasites ; he catalogues them as such and ignores them except as they get in his way. Entrenched Negro leadership thereupon decides frantically that this strange new creature will bear watching. Learned Negro editors discuss him weightily in *The Crisis*, using this alien word "communism" as if it were an obscenity or a sacrilege. It is evident that few of the discarded leaders know what to make of it. The editor of the Norfolk *Journal and Guide*, for instance, marvels that "The Communists in America have commendably contended for and have practised equality of all races " ; but he shakes his head doubtfully, muttering that the Communists have also " aroused such charged feelings in many sections " that it is " difficult for the best of both races to get together and study and correct problems in an orderly way." The kindly editor is perhaps too bewildered to recollect that " the best of both races " have been getting together for decades, that very fact being one of the reasons for the revolt of the masses today.

That there is still a strong inclination on the parts of " the best of both races to get together and study and correct problems in an orderly way " seems to be well established in the utterances of at least two men. One of them is Bruce Reynolds, white, compiler of a volume of anti-communist protestations ; the other is the Negro editor of the Atlanta *World*. The white man (who loves Negroes and wishes to see them kept in their place) and the black man (who loves Negroes and wishes to keep his place) arrive at some amazingly similar conclusions.

Reynolds says :

> The true American Negro is . . . perfectly satisfied with his present status in Society. . . . In fact, he has contempt for the white person who fawns upon him and offers him equality and intimacy. He knows that this is hypocrisy and deceit. But the Communist agitator from Moscow has figured out that there are enough of the bad, unintelligent element among the Negroes from which to draw adherents to Communism through picturing to them this " Heaven-on-Earth," when all barriers will be smashed and the Negro will be a first citizen, enjoying full and equal rank and privilege with the whites. . . . The day of race prejudice in America is past. . . . There is a place in American Society for every man, no matter what his color, creed, or religion.

The editor of the Negro Atlanta *World* avers that he knows personally of blacks who joined the Communist Party only so they could dance with white women. He is uncompromisingly opposed to social equality of this kind. Not only that, this editor says, but " Small groups of Negroes in the South going Red have harmed themselves and others in the community. Violence and bloodshed have resulted," he declares ; and he blames the militancy of the black share-croppers of Camp Hill, S.C., for the murder of some of their number when, in a meeting to form a union for common protection, they defended themselves with rifles against white landowners who militantly objected. Agreeing further with this representative of the master class, the Negro editor says :

> This race is slow to change. It would prefer keeping its present status, no matter how low, than fly to a system, no matter what its worth, that is constantly lambasted by press and radio.

But he is given the lie by one of his fellow craftsmen, the editor of the Philadelphia *Tribune*, remarking that although it is " paradoxical that Negroes must seek protection under some flag other than the Stars and Stripes, the flag for which they have fought to keep flying in the cause of justice and human liberty," nevertheless, " thousands of converts have sought solace and comfort within the folds of the deep-pink banner of the party of Lenin and Stalin." Why, he exclaims, " I am told that there are more dark-

141

Blacks turn Red

skinned than white Communists in Philadelphia "; and he adds : " If numbers mean success, then the drive for Negro members succeeded." It is unmistakably clear that the editor of a Negro paper in Philadelphia is more likely to be honest about these facts than his brethren in Atlanta. Therefore I think we may accept the *Tribune's* estimate as being more honest than that of the *World*.

There are various other discussions by gentlemen of the capitalist Negro press, most of them revealing that these men are forced to admit the sweeping spread of Communism among Negroes. They admit it grudgingly, as if to do so breaks their very hearts. Thus the Houston *Defender* laments that, " Being an exploited, maltreated and disadvantaged minority group, there is grave danger that Negroes will embrace any doctrine which offers them relief from certain oppressive, repressive, and depressive conditions under which they live and eke out an existence "; while the Houston *Informer* points out reproachfully that the whites may expect Negroes to go on " grabbing at straws," being " lured by Communism and every other name that holds out to them bright hopes of relief from their burdens." The New York *Amsterdam News* does not wonder that " the Negro is beginning, at least, to think along Communistic lines, but that he did not embrace the doctrine *en masse* long ago."

Most of these editors of the Negro press discuss the black Red weightily and fearfully, but it is patent that few of them have learned from an original source what Communism is. To one it is something to " sell," like a headache powder ; another refers to it mistily as being similar to Christianity. One scholarly scribe speaks of the radical changes in the Soviet Union as " reforms," and another, equally erudite, tells us that Communism is the big " plan " we have been hearing about. Only two of these learned gentlemen see what the masses of black workers saw long since : that Communism is no mere *promise* of better days and things, but a working program, in operation every day of the week, towards bringing about the changes promised. The most far-seeing of these men is the editor of the Baltimore *Afro-American*, who says briefly that the Communist appears to be the only party " going our way."

Thus entrenched Negro leadership, white and black, contemplates this new menace to its waning authority ; this new menace to a social system which has given it wealth and power. Indeed, the word " contemplates " is far too mild, for there is a definitive counter-struggle going on against this rising leadership of the Negro masses. The politicians, utilising Oscar DePriest as their spokesman, warn Congress that *they* will not be responsible if, through Congressional indifference and neglect, black voters turn Red. The preachers shout to the masses that Communism is an illegitimate child of Satan. The professional class begs the workers to realise that only through creating a strong middle class can the race " find " itself.

Meanwhile news dispatches tell of workers throughout the country who, imbued with what the capitalist detractors sneeringly refer to as " the Communist religion," evince such fortitude in the face of persecution as " the good old-time religion " has never inspired. Thus we see a black worker organising the unemployed in Wellsville, Ohio, while the police arrest and beat him again and again. Thus we read of the black miner in the Kentucky coal fields who ignored bribes to get out, and continued organising whites and blacks until beaten to a pulp and slammed into jail. Thus we hear of black men and women in Chicago, Camp Hill, Pittsburgh, Cleveland, Boston, and New York fighting with such zeal and suffering with such fortitude as the black worker has never before been known to possess. We shall continue to encounter such dispatches, for the Negro's recognition of his new inspiration is just beginning. While a discarded leadership fumes impotently at what it considers the " treachery " of the black worker, the Communist Party issues a release and the Negro masses read :

> With the demand for equal rights for the Negro people and self-determination for the Black Belt as one of its major political planks, the Communist Party of the United States has issued through its Central Committee a call for a nominating convention to be held in Chicago May 28 and 29 [1932].
> In this convention [announces the call] all workers and farmers, Negro and white, and their organizations, all persons and workers' organizations prepared to support a militant workers' platform and candidates, are invited to participate.
> The convention call lists six major points in the platform of the Party, on the basis of which it will ask support of the workers and poor farmers. These points are :
> 1. Unemployment and social insurance at the expense of the state and employers.
> 2. Against Hoover's wage-cutting policy.
> 3. Emergency relief, without restrictions by the government and banks, for the poor farmers; exemption of poor farmers from taxes, and from forced collection of debts.
> 4. Equal rights for the Negroes and self-determination for the Black Belt.
> 5. Against capitalist terror; against all forms of suppression of the political rights of the workers.
> 6. Against imperialist war; for the defence of the Chinese people and of the Soviet Union.

Blacks turn Red

Reading these six election planks, the black worker seizes upon those which most directly apply to him. He asks: "What is the exact meaning of the demand in your program of 'equal rights for Negroes'?"

Here is the answer he gets:

> By equal rights for Negroes we mean complete equality in every sphere of life. Political equality includes the right to vote, to hold office, to sit on juries, to enter into political and other organizations, to take part in the whole political life of the community. This demand includes those so-called democratic rights supposedly granted to everyone, but in reality denied workers and especially Negroes—certain court rights, for example, denied to Negroes, especially in the South.
>
> The Communist Party fights against jim-crow restriction in the daily life of the Negro workers—residential segregation, jim-crow in restaurants and theatres, transportation lines and schools. We demand the abolition of the anti-intermarriage laws which exist in 29 states at the present time.
>
> On the economic field we struggle against the special discrimination to which Negro workers are subject in their efforts to make a living. We are pledged to determined struggle for equal wages for Negro workers, for the right to work at every trade, against discrimination practised openly or in a hidden manner in the job agencies and relief stations.
>
> Our program holds good for every section of the country, including the South.

Having read this declaration, the Negro worker entertains no doubts of which party he will vote for hereafter. He realises clearly two facts. One is that campaign promises have been made by other parties in other days and forgotten. The other is that the Communist Party is the only one which works at its program day after day throughout the year:—directing the organisation of Negro share-croppers at Camp Hill; leading black workers in demonstrations against evictions in Chicago, Cleveland, New York, and scores of other cities; defending a homeless and friendless Negro worker in the courts of Maryland and preventing a legal lynching; forcing the courts of Alabama to delay execution of eight Negro youths whose guilt has been questioned the world over; forcing the management of an "exclusive" Brookline, Mass., hotel to admit Negro high-school graduates to a class dance with their white friends; punishing white Americans in the Soviet Union for assaulting a Negro worker; protesting against the massacre of black workers in the Belgian Congo who revolted against labor conditions in commercial enterprises; constantly fighting against capitalist imperialism; organising agricultural workers among black peoples of American, French, British, Belgian, Dutch, Portuguese, Spanish, and Italian imperialism. And the Negro ceases looking for that leadership he has sought for generations. He knows that he has found it and that it has found him, at last.

Having vainly entreated Yahveh to reveal the secret of changing Red blacks into the ordinary, simple-minded blacks they originally were, entrenched Negro leadership gloomily bows its head, mournfully rolls its eyes, and mutters resignedly: "Brethren, only one course is open to us, and that is the course this leadership has pursued since emancipation. We must continue to pursue it to the bitter end. Brethren, while there remains an opportunity for us to do so, let us *prey*."

James W. Ford Accepts

JAMES W. FORD, nominee for Vice-President on the Communist ticket, said in his acceptance speech: " Negroes exist as a nation of social outcasts in this country. This is their status after 70 years of so-called ' Emancipation.' And now the crisis has sharpened this and brought untold misery to the Negro masses. In city after city and in all parts of the country, one out of every three Negro workers is unemployed.

" The Negroes were jim-crowed in the army, they were discriminated against and lynched. Upon their return to this country many of them were lynched while wearing the uniform of the United States Army.

" The two capitalist parties, the Republican and the Democratic, help to carry out the attacks on the Negro masses. The Socialist Party, despite its pretence of friendliness to Negroes, follows basically the same line and policy of the American Federation of Labor and the ruling class towards the Negro masses.

" Life itself is proving that the Negro toilers are rallying to the struggle along with the white workers : struggles of Negro and white workers here in Chicago against evictions, struggle for unemployment relief in Cleveland, the struggles in the coal fields of West Virginia and Pennsylvania.

" The Negro toilers of the South too, at Camp Hill, have begun to struggle against domination of the white landlords.

" The enemies of the Negro toilers are not only confined to the white agents of the ruling class but found also among Negro politicians and reactionary organisations, notably the National Association for the Advancement of Colored People.

" The Communist Party fights for unconditional political, economic and social equality for the Negroes, for the smashing of all jim-crow barriers in whatever field. It fights and carries on the struggle for the right to self-determination of the Negroes in the Black Belt, where they constitute the majority of the population. All these demands can only be realised through the closest fighting unity of Negro workers with white toilers against capitalist oppression.

" In accepting the nomination for Vice-President, I will boldly and fearlessly put forward the election platform of the Communist Party and call upon the Negro masses to fight along with the white workers for these demands." (From the New York *Daily Worker*, May 31, 1932.)

Sketch of the Life of James W. Ford

NEGRO WORKER NOMINATED FOR VICE-PRESIDENT OF THE U.S.

MORE than 50 years ago, a Negro worker by the name of Forsch—his first name has not been recorded—was lynched in the small town of Gainesville, Georgia. The excuse given was the usual lying charge of " getting fresh with a white woman."

The grandson of this Negro worker was put forward by the Communist Party as its candidate for the vice-presidency, to serve with William Z. Foster, presidential nominee, as one of the two chief standard bearers of his Party in its election campaign at a monster convention of over 1200 delegates in Chicago on May 30, 1932. This is the first time in the history of America that a Negro has ever been nominated for vice-president.

The name under which the candidate for vice-presidency on the ticket of the Communist Party will be known to the voters is James W. Ford. How he got this name is a story in itself.

Lymon Forsch, son of the Forsch who was lynched in Georgia, began working for the Tennessee Coal, Iron and Railroad Company in Pratt City, Alabama. When he got his first pay-envelope he found that the name had been changed to " Ford." He appealed to the foreman. " Keep that name," said the white foreman, " it don't matter about a nigger's name nohow."

Today the grandson of a man who was lynched " to show niggers their place," the son of a laborer whose name was changed because " it don't matter about a nigger's name nohow," has been brought by a wave of working-class solidarity, or working-class resentment against jim-crow and lynching, to the position of candidate for vice-president of the United States.

James W. Ford was born at Pratt City, Alabama, near Birmingham, on Dec. 22, 1893. His father, Lymon Forsch, had been for years a farm hand at Gainesville, Georgia, a farming community about 50 miles from Atlanta. His mother had been Nancy Reynolds.

144

James W. Ford

Head of the League of Struggle for Negro Rights and Communist candidate for Vice-President of America in the elections of Nov. 1932

Photo by Workers' Film-Photo League, 16 W. 21st St., New York

The father of Lymon Forsch was a railroad track-walker. When the grandfather was lynched the family was driven out, and migrated to Pratt City, a mining town. Here Lymon Forsch worked as a coal miner and steel worker. Later the family moved to Ensley, Alabama.

There were three in the Forsch family—James, who was the oldest, and two sisters. Nancy Forsch worked as a washwoman and cleaning woman in order to keep her children in school. But at 14 years of age young James was forced to go to work. First he got a job as a water boy on the railroad tracks, earning 50 cents a day. Then he worked in a blacksmith's shop as helper, later as a steam hammer operator and machinist's helper. By saving his money he was able to finish high school, and complete three years at Fisk University, Nashville.

In 1917 James Ford left Fisk University to join the army. He entered the 325th signal corps, connected with the 92nd division. He became expert as a radio and telegraph operator. In France he was sent first to an American radio school, where he was jim-crowed and refused admission. Then he attempted a French radio school. As a sergeant he served at the front in the 86th brigade of the 92nd division. He organised a protest against captain Felsenheld for statements that the Negroes are inferior, brutish, etc. This protest resulted in the removal of Felsenheld. When one of the men in the outfit was framed on the charge of " raping " a Frenchwoman, Ford was instrumental in calling a meeting of protest which frightened the army authorities out of proceeding with the frame-up.

While in the army Ford took an active part in the fight against the jim-crowing and persecution of the Negro troops.

Ford first joined the Communist Party in 1926. His devotion to the working class, his tireless efforts in the organising of workers, Negro and white, his leadership in the struggle against segregation and jim-crow led to his early recognition as one of the most capable men in the Party. He rose rapidly to a position of leadership. In the spring of 1928 he was one of the delegates elected to attend the Fourth World Congress of the Red International of Labor Unions to which he was elected a member of the Executive.

He was the chief organiser of the First International Conference of Negro Workers, and former Secretary of the International Trade Union Committee.

James Ford is today a member of the Central Committee of the Communist Party. He is the director of the Negro Bureau of the Trade Union Unity League, a Federation of left-wing unions and groups composed of Negro and white workers. (From *The Negro Worker*, June 15, 1932.)

Communism and the Negro

by JAMES W. FORD

(VICE-PRESIDENTIAL CANDIDATE OF THE COMMUNIST PARTY OF THE UNITED STATES IN THE NATIONAL ELECTIONS OF 1932)

DURING recent years, especially since the economic crisis of capitalism, there has been a rapid growth of Communist influence among Negroes, and undisguised alarm and concern on the part of the capitalists and petty bourgeois Negro reformists over this undeniable fact.

The Negro petty bourgeois reformists all admit the oppressive nature of the capitalist system. They admit that the Negro people are brutally oppressed and robbed under the capitalist system. But, admitting all this, they openly expose their support of the very capitalist system whose oppressive nature they are forced to admit.

They are under the influence of the various imperialist theories, including that of the " inherent inferiority " of Negroes and the supposed " superiority " of the so-called white race. They all look upon capitalism, and especially jim-crowism under capitalism, as offering them a career, a chance to build personal fortunes at the expense of the Negro masses. These factors in a measure determine the objective role of the Negro bourgeoisie reformists.

The top leadership of the National Association for the Advancement of Colored People, a petty bourgeois reformist Negro organisation in America, is notoriously composed of bourgeois Negroes and white imperialists, like Major Spingarn and others. The National Association for the Advancement of Colored People leadership represents the highest expression of the united front of the Negro bourgeoisie

146

with the white imperialist enemies of the Negro masses. Its leaders have completely exposed themselves in the Scottsboro case.

The real issues that face the Negro masses in America today are the fight against starvation, for unemployment and social insurance, emergency relief for small farmers, exemption of poor farmers from taxes and forced collection of debts, *equal rights for the Negro masses, and the right of Self-Determination for the Black Belt of the Southern part of the United States.* In the fight for these working-class demands it is necessary to build a firm working-class unity in resistance against the capitalist hunger and war offensives, against the wage-slashing campaign, against terror, against all forms of suppression of the political rights of the workers, against imperialist war, and for the defense of the Chinese people and the Soviet Union.

COMMUNISM AND CHRISTIANITY

Christianity, almost from its inception, has been used as a weapon in the hands of the various ruling classes—the slave-owners, the feudal lords, and the capitalists—for the suppression of the masses. This fact was expressed by Karl Marx, in his classic statement: " Religion (of which Christianity is a form) is the opium of the people."

Two thousand years of Christianity have resulted in the poverty and misery of the masses, while on the other hand, Communism (the theory of the revolutionary working class in its struggle against the bourgeoisie, as expounded by Marx and Engels) has led to the establishment of the Soviet Union, the emancipation of the population of one-sixth of the globe from oppression, the liberation of one-fifth of the population of China from the yoke of imperialist slavery and the development of a Communist movement in every important country in the world as the only force fighting against oppression.

The theory of Communism " merely expresses in general terms actual relations springing from existing class struggles going on before our eyes." Karl Marx, the founder of scientific Communism, once wrote that " in actual history it is notorious that conquest, enslavement, robbery, murder, briefly—force, play the great part. In the tender annals of Political Economy the idyllic reigns from time immemorial." Marx shows how the " rosy dawn of the era of capitalist production " was signalised by the extirpation, enslavement and entombment in mines of the aboriginal natives of the American continents, by the beginning of the conquest and looting of the East Indies, and the turning of Africa into a warren for the commercial hunting of black skins. He quotes W. Howitt, an authority on the Christian colonial system, who says:

> The barbarities and desperate outrages of the so-called Christian races, throughout every region of the world, and upon every people they have been able to subdue, are not to be paralleled by those of any other race, however fierce, however untaught, and however reckless of mercy and of shame in any age of the earth.

And Marx summarises his conclusions in two short but brilliant sentences:

> Force is the midwife of every old society pregnant with a new one. It is itself an economic power.

We have here no horrified moralising and foolish preaching about the evils of violence. Marx does not merely judge and condemn but supplies us a scientific understanding of the historical and revolutionary role of force.

ROLE OF REVOLUTIONARY FORCE

Duehring, a reactionary leader in the German labor movement during the time of Marx, insisted that force is the highest evil and its use demoralises the user. Since Duehring was causing a lot of confusion among the German workers of that time, Frederich Engels, co-founder with Karl Marx of scientific Communism, found it necessary to show the utter hollowness of Duehring's position.

> According to Mr. Duehring [Engels wrote] force is the absolute evil. The first act of force is to him the first call into sin. His whole conception is a preachment over the infection of all history up to the present time with the original sin. He talks about the disgraceful falsifying of all natural and social laws by the invention of the devil. That force plays another role in history, a revolutionary role, that it is, in the words of Marx, the midwife of the old society pregnant with the new, that it is the tool by the means of which social progress is forwarded, and foolish dead political forms destroyed—of that Duehring has no word to say; only with sighs and groans does he admit the possibility that force may be necessary for the overthrow of a thievish economic system. He simply declares that every application of force demoralizes him who uses it, and this in spite of the moral and intellectual uplift which followed every revolution.

The question of force was raised in one of its many concrete phases following the Revolution of 1905 in Russia. The question then revolved around the question of partisan war as a form of struggle during

147

the period of revolution. With somewhat of the moral approach of Duehring, the argument was made that partisan warfare tends to demoralise the revolutionary proletariat by bringing it close to the drunkards and vagabonds. And Lenin replied, illuminating in one short paragraph the wretched poverty of a point of view which seizes only on one side of every question, and is incapable of viewing it in its totality. It is true, Lenin said, partisan war does bring the conscious proletariat close to the drunkards and vagabonds.

> But from this only one conclusion may be drawn, that the Party of the proletariat cannot consider partisan war as the only, nor even as the main form of struggle; that this form must be subordinated to other forms, must correspond to the main forms of struggle, must be ennobled by the enlightening and organizing influence of socialism. But in the absence of the last mentioned condition all, absolutely all, forms of struggle in bourgeois society bring the proletariat nearer to various non-proletarian strata above and below it, and, if left to themselves, to the spontaneous course of events, they are bound to get worn out, perverted, prostituted.

Lenin here showed the true meaning of revolutionary force and struggle. He shows that it is not a question of force in the abstract, but of a many-sided struggle animated and inspired by the fundamental aim of building a new socialist society. It is the existence and leadership of a disciplined Communist Party which stimulates and organises the revolutionary energy and initiative of the workers and oppressed masses and prevents them from degenerating and frittering away into fruitless struggle.

THE RIGHT TO REVOLUTION

The bourgeois mind cannot understand the tremendously progressive and ennobling role of revolution in the lives of millions of people, including millions of oppressed and degraded Negroes, who have been degraded, warped and shrivelled up with superstition and race prejudice. The revolutionary activity of the masses, inspired by a Communist goal, will not only change their conditions, but will also change their own natures as the gigantic achievements of the Soviet Union abundantly prove.

Precisely because of their revolutionary methods and revolutionary aims the Communists are feared and hated by the jim-crow rulers and exploiters of the United States.

Of course, it is true that the more the capitalists pile up their bloody instruments of mass destruction and intensify their brutal terror against the masses, the more their agents declaim about the " violence " of the revolutionary workers. The crimes of all the slave-owners from ancient Rome down to pre-Civil War days in our own South pale into insignificance beside the bloody violence of modern capitalism against the exploited and oppressed of all lands. Capitalist wealth began with the plunder, pillage and murder of colonial peoples, and it continues to drip with the life-blood of millions of toilers at home and in the colonies. American history might easily be described as a story of capitalist violence, directed at all times particularly against the Negroes.

One of America's most respected bourgeois historians of the 19th century, John L. Motley, has admitted this as far back as 1861.

> No man [Motley wrote] on either side of the Atlantic, with Anglo-Saxon blood in his veins, will dispute the right of a people, or of any portion of a people, to rise against oppression, to demand redress of grievances, and in case of denial of justice, to take up arms to vindicate the sacred principles of liberty. Few Englishmen or Americans will deny that the source of government is the consent of the governed, or that our nation has the right to govern itself, according to its own will. When the silent consent is changed to fierce remonstrance, the revolution is impending. The right of revolution is indisputable. It is written on the whole record of our race. British and American history is made up of rebellion and revolution. Many of the crowned kings were rebels or usurpers. Hampden, Pym and Oliver Cromwell; Washington, Adams and Jefferson, all were rebels. It is no word of reproach. But these men all knew the work they had set themselves to do. They never called their rebellion " peaceable secession." They were sustained by the consciousness of right when they overthrew established authority, but they meant to overthrow it. They meant rebellion, civil war, bloodshed, infinite suffering for themselves and their whole generation, for they accounted them welcome substitute for insulted liberty and violated right. There could be nothing plainer, then, than the American right of Revolution. [J. L. Motley, " The Causes of the American Civil War." A letter to the London *Times*, 1861, p. 15.]

HISTORY OF CAPITALISM A HISTORY OF VIOLENCE

Violence, the violent suppression of the exploited workers and poor farmers and of the Negro people, is of the very essence of capitalism. Over 4,000 Negro toilers have been lynched since the Civil War. Is not this the most dastardly act of violence against an oppressed people? Indeed, what else is it but violence when 50,000,000 people throughout the capitalist world are forced to starve amidst plenty?

The history of capitalism has been the history of violence against the working class, and it is only by the revolutionary struggle of the majority of the working class, supported by the oppressed Negro people

Communism and the Negro

and poor farmers, that the masses will finally be able to rid the country of the plague of capitalism. Not only has all history proved that this is the only way out for the oppressed and exploited majority, but the open cynical statements and deeds of the " 59 rulers " of the United States have made this perfectly clear.

ESSENCE OF THE REVOLUTIONARY METHOD

A ruling class that did not hesitate to murder thirteen million people in a war for profits will not peacefully relinquish its hold on the industries and the wealth of a nation produced by the toil of the workers and poor farmers. Wherein is the essence of the revolutionary period? It consists, first, in developing a real struggle against every form of oppression and exploitation, against every wrong and grievance of the workers and poor toilers, against every case of police persecution, against every assault on the lives of the working class, whether it be evictions or wage cuts or unemployment, etc. It consists of a thousand and one little daily struggles which are gathered up and accumulated and directed not only against one wrong or one grievance, but against the entire system of economic, political and national oppression and exploitation of the majority of the population by a small group of parasitic landlords, bankers, capitalists and speculators. The real essence of the revolutionary method consists in the fact that every action is inspired by a fundamental aim not merely to make the slavery of the masses a little more bearable under capitalism, but to destroy the entire system of slavery which breeds and exists only at the expense of the life-blood of all the toilers.

In the second place, the revolutionary method consists in rousing ever larger masses to economic and political struggle against the capitalist system and the capitalist government. It seeks to awaken all the masses to political consciousness and to draw them into the arena of the historical struggle for the establishment of a new social system. For only their struggle can achieve this. Precisely because it is not merely a question of correcting one wrong but of eliminating the very system that continually reproduces these wrongs, do the Communists seek to raise every struggle to a fundamental, revolutionary struggle aimed against the entire political and social system.

REVOLUTIONARY TRADITIONS OF NEGROES

This is a variation of the false bourgeois theory (and hope !) that slaves will never dare to strike for their own freedom, that liberation is something to be handed down, or denied, from above. This nonsensical theory completely ignores the heroic slave insurrections in the United States under the leadership of Nat Turner, Denmark Vesey, Gabriel Prosser and scores of other Negro revolutionary leaders. It ignores the revolution of the Haitian Negro slaves who not only dared to strike for their freedom but who overthrew the slave-holders and successively defeated the veteran troops of Napoleon's European campaigns and the best troops of England and Spain. These insurrectionary struggles of the Negro masses were also constantly lambasted in the press of the ruling class. This attitude represents the conscious policy of the Negro petty bourgeoisie of attempting to hide and destroy the revolutionary traditions of the Negro masses and to support the imperialist slander of the Negro people as servile and cowardly, as accepting any conditions imposed upon them by the master class. From this position, the Negro petty bourgeoisie quite naturally proceeds to the advocacy of a boot-licking diplomacy for the Negro people.

It is the boot-licking diplomacy of the Negro petty bourgeoisie and its traitorous betrayal of the struggle of the Negro masses which retards the Negro liberation struggle and prevents the winning of greater victories. The slave insurrections in the United States had a tremendous effect in exposing the horrible nature of chattel-slavery, in crystallizing abolitionist sentiment and in accelerating the armed conflict between feudal and capitalist economy for the domination of the country. The recent struggles of the Negro croppers at Camp Hill, Alabama, forced the rich landowners to abandon their threat to cut off the food supply of the croppers during certain seasons.

On one hand, the Negro bourgeoisie seek to block the growth of the revolutionary movement. On the other, they engage in an opportunist exploitation of the fact of the growing radicalisation of the Negro masses in order to wring petty concessions for themselves from the white ruling class. They use the radicalisation of the Negro masses to scare the white ruling class into conceding them a greater share in the bitter exploitation of the Negro masses. In other words, they offer themselves as betrayers of the struggles of the Negro masses, as hangmen of the Negro workers, FOR A PRICE !

This Judas-bid for a few additional crumbs from the white ruling class is accompanied by an intensive campaign directed at confusing the Negro masses. Illusions are shamelessly peddled such as the " possibility " of liberation without a struggle against imperialism, of real democracy under robber capitalism, of emancipation from the skies, *i.e.* by supernatural means, etc., etc.

Communism and the Negro

Communism Way Out for Oppressed Negro Masses

These developments among the Negro masses are being rapidly hastened at the present time by the sharpening crisis of dying world capitalism, the growth of terror against the Negro masses and the increase in lynchings.

The Negro workers suffer all the miseries of the working class as a whole. Their interests are, therefore, one with all the workers. But the Negro workers suffer special national oppression. Therefore, they have an important part in the leadership of the movement for the overthrow of American imperialism, and consequently, a leading role in the future dictatorship of the working class in this country.

Just as Communism is not the theory of the workers of any particular race or nation but is the theory of the international working class, so is the Communist Party not a party of the white workers alone. It is the party of the workers, Negro and white. It represents the interests of the entire working class independent of race or nationality.

Therefore, the Communist Party points out and raises to the front the necessity of international solidarity of the working class as the prime condition of a successful struggle against the common enemy—the capitalists. It is to the interests of the white workers to support the struggles of the Negro masses for freedom because the white workers cannot be successful even in their everyday struggles against capitalism without the fullest support of the struggles of the Negroes. Precisely in these places where one hundred per cent. white chauvinism (race hatred) reigns supreme, and where oppression of the Negroes is the sharpest (in the South), it is also found that the conditions of the white workers are the most degrading.

Only the Communist Party is leading the struggles of Negro and white workers. Only the Communist Party can lead such a struggle. The imperialists and their agents, black and white, therefore consider it necessary to intensify their offensive against the Communist Party.

The ruling class has by every means in its power instilled in the white working class the racial hatred which has operated to keep it apart from the Negro working class. The white bosses sow seeds of race hatred as a means of keeping Negro and white workers divided, by arousing suspicion and mistrust among the Negroes.

The trend of the present day, however, thanks to the leadership of the Communists, is the increasing emancipation of the white workers from the poison of boss-class racial prejudice. In recent months, hundreds of American white workers have braved the bosses' policy of terror to protest the frame-up and lynch verdicts handed out by the boss lynch courts to the innocent Scottsboro Negro boys. The Negro and white workers are being solidly welded together in the fires of the struggle for their common emancipation.

The growth of Communism, as the theory of the international working class, could only take place in proportion to the development of the working class. The Negro masses did not embrace Communism, say fifty years ago, for the simple reason that the American working class in general, and the Negro workers in particular, had not accumulated sufficient experience; had not at that time reached the stage of development in which it was able to throw up from its midst an advanced detachment, capable of understanding the aims of that struggle and leading the masses of toilers, Negro and white, in struggle against the ruling class oppressors.

The explanation, therefore, for the growth of Communism among Negroes today is to be found, on the one hand, in the growth of the revolutionary labor movement in the United States, and on the other hand in the maturing of a Negro working class as a component part of that movement. Precisely this growth of a Negro working class is a most important phenomenon of recent years. This working class, through the experiences of sharpening class struggles, is rapidly liberating itself from the reactionary influences of the Negro misleaders, and together with the white workers is embracing Communism as its weapon in the struggle against American imperialism. Thus, there has at last appeared among Negroes that class which, as an organic part of the whole working class, is the only force capable of rallying and leading the oppressed Negro masses in the struggle for national liberation—a struggle which, inspired largely by the example of the freedom won by the oppressed people in the Soviet Union, has gained a powerful impetus in recent years.

Historic Example of Soviet Russia

Soviet Russia's insistence upon absolute equality for all people is not a matter of " treatment " handed down as a favor from above, but of a fundamental policy of the Soviet Government and the Communist

Party on the national question. This policy has led to the freedom of the nationalities formerly oppressed by the Tsarist regime in the same way that the Negroes are oppressed in the United States, to the recognition of the right of self-determination and of equality of these peoples, resulting in the establishment of the Soviet Union as a voluntary union of all races, colors and nations on the basis of proletarian solidarity. This achievement was accomplished by the joint struggles of all oppressed classes and races. It is not a formal equality. The policy of the Soviet Union is directed to the rapid development of industry and culture in these backward nations, held for centuries in oppression by Tsarist capitalism.

The huge population of the Soviet Union includes 70 different nationalities, millions of whom are of non-white races. I will give a concrete example of how Communism has successfully solved both national and economic problems in the Soviet Union where the workers of the various races have overthrown capitalism and thereby abolished the roots of race hatred and of exploitation of man by man. And I will quote a respected liberal intellectual, J. Louis Fischer, who had an article in the May 25, 1932, issue of *The Nation*, entitled " The Jews and the Five-Year Plan." In that article Mr. Fischer wrote :

The Five-Year Plan is revolutionizing the character of Soviet Jewry. At the same time it promises to save the Jews of the Soviet Union from the economic eclipse which threatens the Jews of almost all other East European countries. The tragedy of European Jewry is its middle-class composition. In Poland, Rumania, the Baltics, and the Balkans a new national petite bourgeoisie is expelling the Jew from his chief profession—commerce. Using anti-Semitism as a crowbar, it is quickly loosening the Jewish hold on marts and rialtos. . . .

Czarism nourished the roots of anti-Semitism with gold and with rivers of blood; the revolution withdrew these foods. The Bolsheviks, indeed, tried to burn out some of the roots and to poison others. The roots, to be sure, are deep. Anti-Semitism is a hardy plant. Nevertheless, anti-Semitism in Russia is waning. The state, the Communist Party, and social institutions like schools, clubs and trade unions are making every effort to combat it. The Bolsheviks condemn anti-Semitism as reactionary and as a weapon used by capitalism to inflame racial animosity in order to obstruct class antagonism.

Active propaganda against anti-Semitism is conducted in Soviet schools, clubs, and newspapers. The struggle with it also takes the form of trials to demonstrate its evils. In a factory, for instance, a Russian worker has insulted a Jew. The incident is not very serious. It might have been overlooked. But the authorities seize the opportunity for educational purposes. The worker is tried in public. A prominent political figure is the prosecutor. He points out the anti-social and anti-Bolshevik character of anti-Semitism. Frequently the worker confesses and explains the reason of his guilt; that he has not yet shaken off the traditions of his pre-revolutionary past, that he went to church in his youth and imbibed the anti-Jewish spirit, that he has not attended Communist courses sufficiently and has not learned the Marxist approach to racial questions. In this manner such trials are exploited to expose the significance and purpose of anti-Semitism. It is a misdemeanor to make an anti-Semitic joke in a Soviet theater or vaudeville performance. Russians have been arrested for applying the uncomplimentary epithet of Zhid (Yid or Sheenie) to Jews. Jews are not caricatured or mimicked.

All revolutionary disabilities have, of course, been removed. . . . All restrictions have been lifted and no person would dare to impose his own without immediately inviting the wrath of the state. Soviet universities enroll thousands of Jewish students. Whereas Jewish young men and women in European universities are exposed to offensive discriminations and at times violent attacks, race is completely ignored in the matriculations in Soviet higher institutions of learning.

Of all the benefits conferred by Bolshevism on the Jews, the greatest is the abolition of pogroms. These massacres occurred frequently before the war, and when they did not occur, the fear of pogroms was ever present. Life was nerve-racking and precarious. But no pogroms have ever taken place in the Soviet Union. Experience in Czarist Russia, in post-war Poland and Rumania, and more recently in Palestine, has shown that a pogrom is, by definition, violence perpetrated with the active assistance, or at least the connivance of, the authorities. Pogroms are therefore impossible under the Soviet regime. And this security means more to Jewry than any hardships it must undergo during a transitional period of economic adjustment. Far from discriminating against Jews, the Soviet Government has been known to discriminate in favor of Jews. Agricultural colonization is the outstanding illustration. The Bolsheviks submit—and President Michael Kalinin once enunciated the policy in public—that more money and more attention should be given to the settlement of Jews on the land than to the settlement of non-Jews, because conditions before the revolution militated against the creation of a Jewish peasant class. The revolution must wipe out the handicaps imposed by the monarchy. This is one of the fundamentals of Bolshevik policy vis-a-vis nationalities.

Contrast this with the deliberate cultivation of race prejudice in America by the capitalist press, the theatre, the church, the schools, courts and all instruments of the capitalists ! Contrast it with the hullabaloo raised in the capitalist press when jurors in Hawaii dared to bring in a verdict of guilty against four self-confessed white lynchers of a dark-skinned native ! Contrast the Soviet policy of burning out

race prejudice with the reward given by the United States government to these four lynchers, the pressure brought to bear by the United States government and Congress to secure their immediate release, the enthusiastic welcome given them by the capitalist press and the American imperialists upon their arrival in this country, the present move in Congress for a full pardon to wipe out any disability imposed upon them by the verdict of guilty!

" Pogroms are therefore impossible under the Soviet regime." While lynchings of Negro workers are rapidly increasing during the capitalist crisis, with the courts increasingly used to carry out the lynch verdicts, as in the case of the Scottsboro boys, that is why Negroes in the United States are more and more embracing Communism. We admonish our brothers in Africa and the West Indies who are held in subjugation by British, French and Italian imperialism, to also embrace Communism and to unite with our brothers in China and India for national liberation, and with the revolutionary working class in the mother countries to overthrow world capitalist-imperialism and establish world-Communism.

SCOTTSBORO

The nine innocent Scottsboro boys

after their arrest on a false charge of assault on two white prostitutes in Alabama, March 25, 1931

Scottsboro—and other Scottsboros

by NANCY CUNARD

To bring out the absolute fiendishness of the treatment of Negro workers by the governing white class in America, more specifically, but by no means restrictedly, in the Southern States, I am going to start with what may seem a fantastic statement—I am going to say that the Scottsboro case is not such an astounding and unbelievable thing as it must, as it certainly does, appear to the public at large. What? 9 provenly innocent Negro boys, falsely accused of raping two white prostitutes, tried and re-tried, still held in death cells after 2½ years. . . . It is unparalleled. It is not *primarily* a case that can be called political, as is that of Tom Mooney, still held for 18 years in St. Quentin, a California jail, on an equally vicious frame-up because he was an active strike-leader; nor at first sight do the same elements predominate as in Meerut and the murder-by-law of Sacco and Vanzetti. But the same capitalist oppression and brutality are at the root—because every Negro worker is the potential victim of lynching, murder and legal lynching by the white ruling class, simply because he is a worker and black. No, this frame-up is not unparalleled, though the scale of it and its colossal development into what is now really a world-issue, are so. No previous Negro case has aroused such a universal outcry against the abomination of American " law."

Here are some other frame-ups, murders and lynchings of Negroes to compare it with, instances taken at random out of the huge record, quite recent cases only:

Here then is the story of the Scottsboro case, the main facts of which, at least, are known to the world at large.

On March 25, 1931, black and white hoboes were " riding the rails," hidden up and down the length of a freight train going from Chattanooga to Memphis, Tennessee. No money, no fares, setting out to look for work. Travelling in this manner is a frequent occurrence in America. But such is the race hatred that white tramps even will object to the presence of Negro hoboes in the same wagon. Not for nothing has the white ruling class for decades been teaching the " poor white " that he can always look down on the Negro worker, no matter how wretched his own economic condition may be. So the white boys started a row and tried to throw the " niggers " off. The Negroes resisted them, and the whites did not get the best of it. All but one jumped off and telephoned the station-master at Stephenson to arrest the niggers who'd dared to fight with them. The train had already gone through this station, so was stopped at Paint Rock. Here sheriffs and excited citizens took 9 Negro boys and 3 white boys out of separate parts of the train. At first all were charged with vagrancy and told to get out of that county as quick as possible. And then suddenly, while all were being searched, two of the white boys were discovered to be girls in men's overalls. So the sheriff got an idea; it wasn't possible for Negroes and white girls to be on the same train, in the same car maybe, without the question of rape coming in. The boys protested they had not even seen any girls; some of them had seen a fight, that was all. The girls denied that the boys had touched them. But some of the crowd were for an immediate lynching; authorities assured them the " niggers " would be properly dealt with and should not escape " justice." All were promptly locked up, the Negroes to be brutally beaten, the girls to be put through the third degree and forced into saying they had been raped. Both girls were known to be prostitutes; Victoria Price had a prison record, and impressed on Ruby Bates the utter necessity, now, of falling in with the authorities' views, so that they might themselves escape the law's punishment. The trial date was first of all fixed for April 1, but postponed till April 6, a fair-day in Scottsboro, one which would assure the largest crowd possible and enable the mob to witness the condemnation of what the local papers called " the Negro fiends."

Scottsboro is described as a sleepy little town of some 10,000 inhabitants in the northern part of Alabama, but on the trial day the presence of the military who had been called in to make a show of quelling the lynch spirit made it look like an armed camp. The authorities had deemed it necessary to send 118 soldiers to bring the nine boys into the town from Gadsden jail, where they had been held since arrest. Armed soldiers were on guard inside and outside the court house, to which only persons holding special permits were allowed entry after having been searched. Already by 8 a.m. thousands had gathered from all over the neighbourhood, and by 10 o'clock the crowd was estimated at 10,000. The lynch

spirit had been whipped up to such a point by the authorities that statements were going around saying that the " horrible black brutes had chewed off one of the girl's breasts." The doctor's evidence on his examination of the girls immediately they were taken from the train, showing they were unscathed, and which was public knowledge, meant nothing to the people of Scottsboro. The local newspapers tried to whitewash the presence of the agitated mob by saying that the crowd was " curious, not furious," and maintained it had gathered out of mere curiosity. The trial began on the 6th and was all over on the 9th of April—three days to convict and sentence to death 9 Negro boys all under 20 years old, two of them 13 and 14 respectively. It is not difficult to see that the jury had made up their minds long before hearing any evidence, even before coming into court—verdicts on Negroes are automatic, it is always: guilty. There were no workers on this jury, nor white nor black. It was composed of local business men and neighbouring well-to-do farmers. Just before the proceedings began, Wembley, the legal adviser to the Scottsboro Electric Company, which controls the town, had walked through the mob and told them that " everything would be alright in a few days," and that his company had enough power to " burn up the niggers."

In court, the boys—with only a lawyer to represent them who had not, on his own statement, studied nor prepared the case (Stephen Roddy, member of the Ku Klux Klan, who told them to plead guilty), and another appointed by the court itself (Milo Moody), a member of the Scottsboro bar—without having been allowed to communicate with parents, relatives or friends (none of whom even knew, at this time, what had happened to them), yet maintained their innocence and told a straight story : they had not even seen any white girls on the train, they were riding the rails, some of them alone and in different cars, all had left home to go and look for work. During the proceedings the following evidence was heard :

POSITION OF THE BOYS ON THE TRAIN

Willie Roberson, aged 17, hidden in one of the first empty box cars, where he stayed by himself, not seeing any of the white boys, or the girls who accused him.

Clarence Norris and *Charlie Weems*, aged 19 and 20 respectively, both workers from Atlanta, who had got into a car together towards the end of the 49 trucks that made up the train.

Olin Montgomery, aged 14, who had got into an oil tanker by himself, going to Memphis to consult a free clinic for his bad eyes.

Ozie Powell, aged 14, also travelling alone in an empty freight car.

Roy and *Andy Wright*, brothers, 13 and 18 respectively, with *Heywood Patterson*, 16, and *Eugene Williams*, 14, childhood friends, all from Chattanooga, going to look for work on the river boats in Memphis.

Andy Wright testified that he had not seen any of the other defendants, save those he travelled with, or any white girls, until taken off the train at Paint Rock. He had seen a fight of some kind between white and Negro boys in another car and 5 Negro boys jump off ; he had heard a white boy hollering and had gone to see what was the matter, and had prevented him from jumping off as the train was going fast. The testimony of all the boys was to the effect that some saw a fight and others did not, but that none of them saw or even knew of the presence of white girls on the train.

TESTIMONY OF THE TWO GIRLS

Victoria Price, who was the main State witness and the chief plaintiff of the two because of the visible confusion and unwillingness of Ruby Bates in giving false evidence, stated that both of them had left their home in Huntsville together because there was no work for them in the cotton mills. They had hoboed their way to Chattanooga, but there had been no work there either, so they were coming back to Huntsville in the same manner the next day, March 25. They had been wearing men's overalls because it was easier to travel that way. First they had climbed into an oil tanker and then into a gravel car in which were 7 white boys. They hadn't spoken to any of these. Then 12 Negroes had climbed into this from other cars and had begun to fight the white boys, " telling them we was their women," and holding them off with knives. (Anyone who knows anything about the terrorisation of Negroes throughout the South, and the whole of America for that matter, will see how unlikely it must be for any Negro to go deliberately and provoke a white man. His daily and constant preoccupation is to steer as clear of white people as possible.) Victoria Price continued, that having thrown the white boys off, 12 Negroes then proceeded to rape her and Ruby Bates (6 each), that three of Ruby's customers had jumped off the train before it was stopped. Other evidence showed that Orvil Gilley had remained on it, the local papers claiming he had been forced to remain on it out of the viciousness of the Negroes,

that he should witness the assault. The distance covered by the fast-moving train while these 12 attacks were alleged to have been going on was 38 miles. The last boy, said Victoria Price, was in process of assaulting her when the train was stopped. She was positive that all 9 of the Negroes in court had had sexual intercourse with her and Ruby. They had held knives at their throats, some of the boys had held her and her companion down while others ravished them ; they had shot off guns five times. (No guns or knives were found on any of the defendants, save a small pocket knife on Eugene Williams.) She pointed out those who ravished her ; she had to designate the attackers of Ruby Bates as well, for the latter could not and did not identify them.

Is it not astounding that there were no signs of struggle, no disarranged clothing, no hysteria on the girls' part, no guns or knives found when all this had supposedly been going on over that short distance of 38 miles? And that Gilley was not bursting with indignation and desire to testify about his having been forced to witness it all? And that, for the first time in legal procedure, the victims of rape should have been locked up in the same jail as their attackers for 10 days pending trial, whereas their homes were only a few miles away? And that if the Negroes had had any reason whatever to fear arrest they should not have jumped off the train? But most significant in this frame-up is the fact that on their arrest and questioning by the sheriffs both girls brought no charge whatsoever against any Negroes, and indeed refused to agree to the suggestion made to them that they had been attacked. This point, needless to say, was never brought up at the trial. The girls were not individuals with alleged wrongs, but had been transformed into part of the lynch machinery which " keeps niggers in their place " by such frame-ups, so that other " niggers " shall not dare to ask for their rights.

Evidence given by the two doctors who had examined the girls immediately they had been taken from the train should have been sufficient to clear the prisoners entirely. Doctor Bridges' testimony was that both girls had had sexual intercourse, he could not say exactly when. Its evidence suggested that it was several hours previous to his examination, perhaps as much as 20 hours or so. He had seen them as soon as the train was stopped (within a few moments, consequently, of the alleged rape). There were no lacerations or signs of force, etc. (such as might be expected if the rape story were true). They were not in the least hysterical, though they were extremely hysterical and crying when he saw them next day, after a night in jail. He had also examined Willie Roberson, who was suffering so acutely from a venereal disease that physical relationship would hardly have been possible.

(After later investigations made by the International Labor Defense lawyers it was shown that the girls had both spent the previous night with two white boys in the " Chattanooga Jungle," in the woods, and that it was nowise strange that Mrs. Callie Broochie (name of the woman with whom Victoria Price said they had stayed the night in Chattanooga) could not be traced, as no such person existed ; " Callie Broochie " being the name of a character in a popular magazine and used by Victoria Price on the spur of the moment.)

There were no witnesses called for the defendants, nor did the prosecution put any of the white boys who had been on the train in the witness box, although all of these were under lock and key at the time of the trial, nor was Orvil Gilley, stated to have been an eye-witness, allowed to testify freely. The doctor's evidence was set aside, the prisoners had not been allowed to get into touch with parents or seek aid. The prosecution was content with the words it had put itself, under threat, into the mouth of a lying prostitute who proved herself smart enough in sensing what was wanted of her at the trial to earn public commendation as a good witness from the judge. Uncertain and confused Ruby Bates, who by the discrepancies of her evidence might have given the whole show away, was quickly silenced, while Victoria answered for her. So it was on the statements of this girl alone, that nine Negro boys and children, whose ages ranged from 13 to 20, were convicted and eight of them given the death penalty, the jury disagreeing over Roy Wright's case.

It took the jury less than two hours to return their verdict on the first accused, Clarence Norris and Charlie Weems. Spectators in court and mob outside as soon as this was known broke into frantic applause. The next day, Heywood Patterson was tried alone. After three hours the jury found him guilty. In the third case five of the remaining boys were tried : Olin Montgomery, Andy Wright, Eugene Williams, Willie Roberson, Ozie Powell. In the case of Roy Wright, aged 13, the jury did not agree, eleven being for death penalty, one for life imprisonment. This was an attempt at putting up some semblance of " fairness " in the sentencing of these Negro children. Several of the trial officials said later that he was " the worst of the lot." As a sop to outside public opinion the judge declared a mis-trial in this case ; Roy Wright was sent to prison with the other boys, to await a further ordeal. The date set for the execution was July 10, the very first day possible after conviction, the law requiring 90 days interim

for the filing of an appeal. The boys were then taken to Birmingham jail so that the mob in Scottsboro might not have the chance, even after the announcement of the verdicts, of trying to rob the State of its victims by an actual lynching.

SOME POINTS IN THE APPEAL

Up to the trial the victimisation of these innocent boys had been quite a local matter only, seemingly destined to increase the number of barely reported cases, amongst so many others, of death sentences passed on framed-up Negroes. But an investigator of the International Labor Defense had read of it—just the few lines there were—in a local paper, and had got in touch with the head office in New York. The I.L.D. took up the case immediately, one of its lawyers, Alan Taub, going to see the boys the day after the trial, on April 10. Notice of appeal was directly made, and all the false evidence and illegal procedure sorted out and studied.

Some of the main points in the Appeal to the Supreme Court of Alabama are as follows :

Defendants were prevented from having and did not have a fair trial.

The denial of the motion for change of venue was a reversible error.

The court overrode and disregarded the fundamental legal rights of defendants.

Mob spirit and hysteria dominated the trial, terrorised judge, jury and counsel, and denied to the defendants " due process of law."

The verdict of the jury was not sustained by the great preponderance of the evidence, and the guilt of the defendants was not proved beyond a reasonable doubt.

Material evidence newly discovered, which the defendants could not have procured and presented at the trial, should move the Supreme Court to grant a new trial.

Exclusion of Negroes from the juries denied to the defendants " equal protection of the law."

The circuit court of Jackson county (Scottsboro) had no jurisdiction to try and sentence the defendant Eugene Williams, a juvenile alleged delinquent.

Other points presented were that :

All of the defendants were without funds with which to pay for legal advice. They had not been allowed to communicate with parents or friends. A Chattanooga attorney, Stephen Roddy, had appeared at the trial stating that he was not retained, had not studied the case, had merely come " to investigate " the situation and was unprepared to appear for the boys, adding finally that he thought it would be better for them if he stepped out of the case entirely. As a purely official gesture, the court had appointed a member of the Scottsboro bar, Milo Moody, to represent the defendants. The trial had begun and Roddy had filed a petition for change of venue, but this had been overruled by the judge.

Not one of the white boys on the train had been called as witness for the State prosecution, although all of them were in custody at the time of the trial, except Orvil Gilley, who had been in the truck with the girls. He had given no testimony corroborative of their story and so had been dismissed, remarks being circulated about him such as that he was soft-headed, and " well, everyone knows what sort of woman his mother is."

On page 6 of the *Brief for Appellants* :

> When the court opened on April 6, 1931, a tremendous crowd, estimated at about 5,000, had gathered around the court house and were kept from entrance by the military force. At the end of the first trial, State *v.* Norris and Weems, when the jury announced the verdict of guilty, the spectators in the court room burst into applause, which outburst was taken up by the throngs outside and climaxed by a brass band bursting into such strains as " There'll be a hot time in the old town tonight." No safeguards were placed around the jury, who were allowed to mingle freely with the hostile populace, to read the hostile newspapers, and to witness the demonstrations.

Investigations made by Hollace Ransdell, of the American Civil Liberties Union (*Report on the Scottsboro Case*) in May, 1931, took her to see the girls in their home in Huntsville. She found that both were cotton mill workers getting an average of about $1.20 a day, that is, the days there was work for them, for in the increasing trade depression many of the mills were laying off employees every other week. Small wonder, as many other workers did to eke out this miserable wage, that the girls had taken to prostitution. Both had bad reputations, especially Victoria Price. The Huntsville sheriff knew her trade but didn't bother her, because, he said, " she was a prostitute who took men quiet-like." But neighbours emphasised her drunkenness, the " violent and vulgar language " and the frequent association with Negro boys. They said she boasted about having " Niggers' day "; they signed affidavits for the I.L.D. attorney giving her a thoroughly bad and undependable character. Yet these things and many more of the sort

were ruled out as non-pertinent by the trial judge—although Orvil Gilley's character was pronounced against because his mother had the same reputation. Ruby Bates and her family lived in the coloured section of Huntsville in a house that Negroes had inhabited; the social worker who led Hollace Ransdell to see them complained of "that nigger smell you never get rid of," while Mrs. Bates, who is described as a modest and rather orderly woman, murmured about "having well cleaned and washed out the place." Talking to both girls and their families made it very clear to Hollace Ransdell that the experiences they alleged to have been through had not struck them as particularly out of the ordinary. The publicity had impressed them very much; that was all.

Other points made by the defence lawyers in the appeal were the need for military protection on the trial days, testified to by Major Starnes and the county sheriff, which gave proof of the danger of lynching the defendants had been in. The jury had not been, as they should have been, questioned as to whether or no they bore any race prejudice. (This technical point strikes one as bitterly ironic.) The local press had increased public hostility by violent and inflammatory articles. An example of this, some time after the case had begun to attract public attention and protest:

> The ugly demands of threats (sic) from outsiders that Alabama reverse its jury decisions, and filthy insinuations that our people were murderers when they were sincerely being as fair as ever in the history of our country, is rather straining on our idea of fair play. It allows room for the growth of the thought that maybe after all "the shortest way out" in cases like these would have been the best method of disposing of them. (From an editorial in the *Jackson County Sentinel*.)

It need not be explained that "the shortest way out" signifies lynching. The brazenness of the lies and the hypocrisy of the Southern white ruling class is without parallel. One is particularly struck by this. For instance, State prosecutor Knight says there is no race prejudice in Alabama. . . . Press and legal authorities are always claiming that a fair, unbiassed trial has been held. . . . The only thing that the Southerners fear, as State law gives them full power over practically every conceivable legal matter without there being the possibility of recourse to the Federal Government of the U.S., which in the case of Negroes is hardly less prejudiced, is—exposure.

Entry of the International Labor Defense into the Case
Exposure of the Behaviour of the National Association for the Advancement of Colored People

> On the day after the trial, April 10, an International Labor Defense attorney, together with the Southern representative of the I.L.D., interviewed the boys in jail, and after being retained as legal defense, at once issued notice that he would appeal for a new trial, as the boys were clearly innocent. On May 5th motions for a new trial were heard and denied by Judge Hawkins. At this hearing George Chamlee (former attorney general of Tennessee), I.L.D. lawyer, was present to plead for the boys. Roddy was not present. May 20th was set as the day for further hearing. On that day Hawkins phoned George Chamlee informing him that the hearing was postponed and set for June 5th. On June 5th the I.L.D. attorneys, Chamlee and Brodsky, argued motions for a new trial. Roddy and Moody were also present at this hearing. The question of the right of defendants to select counsel was raised by the I.L.D. attorneys and by Claude Patterson, father of Heywood, who was present to demand sole recognition for the I.L.D. attorneys, but judge Hawkins refused to make any decision on the point at that time. (From *Some Facts on the Scottsboro Case*, by Milton Howard, Labor Research Association, Jan. 15, 1932.)

After having been definitely retained by Claude Patterson to defend his son, George Chamlee examined the court record and discovered that judge Hawkins had neglected to sign the order denying a new trial to Heywood Patterson. This technical point was seized on by Chamlee to demand a reopening of the case; out of fairness to the other defendants the same to apply to their cases. Motions for new trial were then granted and investigations that had meanwhile been made concerning the character of the girls, and actual facts in the frame-up, were now entered into the record of the appeal.

International Labor Defense representatives had seen all the boys on April 10, the day after their conviction, and had received from them authorisation as defence counsel. In the next few days the same was received from the boys' parents and relatives, first orally, then in writing, and on April 14 the announcement of an appeal was first made by these attorneys. Yet immediately after these documents had been signed, Roddy, and two ministers of Chattanooga, asserted they had repudiations of the I.L.D. from certain of the defendants. It was shown that two of the boys had been coerced into signing these when told that I.L.D. lawyers were not fitted to defend them. This was the first attempt of the National Association for the Advancement of Colored People to bring as much disruption and confusion as possible

into the case. These repudiations were, however, immediately revoked by the boys. Because of the constant repetition of the mis-statement that the I.L.D. was not the sole organisation in charge of the defence, the boys and their relatives had to issue as many as 6 statements from May 1931 to Jan. 1932 making the position clear. These were published in the press. Yet, persistently for many months, the N.A.A.C.P. continued to issue press releases and make publicity to the effect that it had control of the defence, despite the fact that the statements of boys and relatives were filed with the Alabama Supreme Court. The N.A.A.C.P. secretary, Walter White, and sundry organs of the Negro press, at that time almost daily attacked the I.L.D., and in exact opposition to all facts continued to maintain that the boys had repudiated I.L.D. lawyers and were being defended by those of its own choosing. Thousands of dollars were meanwhile being collected by it for the defence on the basis of these statements. A very large retainer was paid to Clarence Darrow (whom the I.L.D. had invited to help them immediately after the convictions but who had declined on grounds of advanced age). Darrow, "engaged" by the N.A.A.C.P., "retired" at the end of 1931 from the case, which, as the N.A.A.C.P. itself had no connection with it, he could on no account have been considered to be in.[1] Confusion upon confusion was added by Walter White's diverse statements to press and public that his organisation had been represented at the trial by the same Roddy who had said himself at that moment that he was neither engaged nor ready to undertake the defence. And the climax in the scandal of

Claude Patterson (father of Heywood Patterson, again condemned to death in the Decatur re-trial, April 1933)

Photo taken at the Chicago Conference, May 1932, by Workers'
International Relief

the N.A.A.C.P.'s manœuvres and squandering of funds came when its Chattanooga branch telegraphed headquarters, "Roddy has betrayed us," in May, a month after the trial, but Roddy continued to be retained.

The boys had been sentenced to die on July 10. Protests were pouring in from all over the world. Workers' organisations had signed by tens of thousands. The first mass manifestations to take place in Europe were outside the American consulate in Berlin; the militancy and anger of the German workers was supreme. Soon there were demonstrations in front of the American consulates in other countries; the legations were wiring to America for orders as to what attitude to take as these manifestations had great effect. Einstein, Thomas Mann, Wells, Shaw, Dreiser, Gorki and thousands of other celebrated and lesser known intellectuals had protested. In America the I.L.D. called for the utmost co-operation in a Scottsboro United Front. It roused the entire country by countless meetings, gatherings and speeches showing up this attempt at legal lynching. Negro and white churches, clubs, societies, business concerns, etc., individuals of every shade of political opinion gave their support. But the N.A.A.C.P. ignored all invitations of co-operation while all the time proclaiming its desire for unity! This " unity " it demanded in the same breath as it denounced the I.L.D. on the allegation that the latter's only interest in the case was to make Communist propaganda!!

The I.L.D. is *a non-partisan organisation* which defends the cases of black and white workers alike; yet its slogan of " Legal Defense supported by Mass Protest " was distorted into " No Legal Defense— only Mass Action." A " red scare." The boys' parents were not spared this. They were told that the I.L.D. (solely identified with Communists) would lose the boys their lives. The legal capacity of the defending lawyers was also attacked by Walter White, although recognised from the start by Alabama courts. The public was also told that the I.L.D. were terrorists sending threats of death to the Governor of Alabama, to the judge, etc. These, and the countless cables and messages from all over the world, were protests against the frame-up and legal mis-procedure in the lynch atmosphere of the courts, as

[1] April 1932, Darrow defended, successfully, the two rich American murderers of the Hawaian native, Kahahawaī, in Honolulu.

Comrade Jim Headley speaking at a Scottsboro protest meeting at Stepney, London, June 1932

much prevalent later at the Decatur re-trial as at Scottsboro. They are protests such as: "This organisation of 10,000 members demands that you stop this legal lynching and holds you responsible to stay the hands of the lynch mob." (Executive Committee, League of Struggle for Negro Rights.) Yes, the "red scare" was what this disgrace to the Negro people, this insult to the Negro masses of America, the N.A.A.C.P., put forward as its own conception of United Front to Save the Scottsboro Boys.

Throughout that year and subsequently, pursuing its double-faced policy of trying to get the boys and their relatives to entrust the defence to its lawyers while completely ignoring the nation-wide demand for its collaboration, the N.A.A.C.P. actually refused to allow the Scottsboro parents to make appeals and to speak at its public meetings and in churches, etc., where it had influence. But the most vicious of its counter-moves to all the efforts made to gain public support is to be found in a statement by Walter White (published by several Negro papers) to the effect that *mothers were invented* at Scottsboro meetings: "When the supply of mothers was inadequate to cover such meetings, substitutes were found." (Walter White, *Harper's*, Dec. 1931.)

The astoundingly hypocritical and treacherous bearing of the N.A.A.C.P. throughout the whole case, and up to the very present, when it is being called upon by the I.L.D., sole defence for 2½ years, to hand over all funds collected, which it has delayed again and again in doing, needs a word of explanation. It is a body financed largely by white "liberal" money; it is capable of raising large sums; it has branches all over America; it has existed since 1912; it is supposedly the representative body of the whole coloured race, pledged to its interests. Because of these very attributes and what it supposedly (but supposedly only) stands for, it could not afford to be out of the Scottsboro case, yet it has been sufficiently seen that it is virtually at one with the Southern lynch-courts by its assertions that the world-protests are only "a red scare," by its advocacy of letting the law take its course (lynch law), by its engaging of Stephen Roddy (lynch advocate), by its lies and frauds, insults and inventions against the actual defence. Here are just a few of the members on its executive committee or branches: Frank Murphy, ex-mayor of Detroit, a party to police murders and attacks on the starving white and black workers outside Henry Ford's factory in April 1931. Arthur Capper, Senator from Kansas, who made no sign of protest against the continuation of the jim-crowing (segregation) of Negro Gold Star mothers on their journey to French battlefields, nor over the shooting down of black and white bonus-army marchers in Washington. Major J. Spingarn, who advised the Negro soldiers to meekly accept the jim-crowing in their regiments and forget about the lynchings of their people when the American imperialists needed their blood and bodies for the war, insulting them further with the lie that "full democracy" for the Negroes would come out of this very war. Walter White, promulgator of the monstrous lie that the Scottsboro parents were impostors. Miss Nannie Burroughes, educationist, who in print advised Eddie Tolan, Negro, the world's

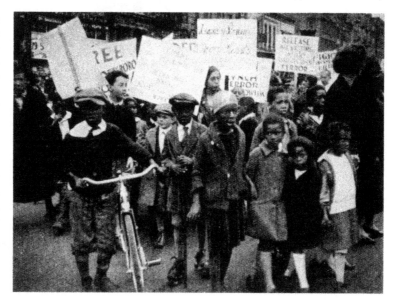

" Down with lynching and Jim-Crow ! Free the Scottsboro Boys ! "
A procession in New York, 1932

Photo by Workers' Film-Photo League, 16 W. 21st St., New York

quickest runner and American Olympic Games winner, 1932, to be content with his record and forget all about his " race-inferiority." The N.A.A.C.P. seeks to justify itself at the expense of the really militant and functioning organisations (such as the League of Struggle for Negro Rights and the I.L.D.), in the eyes of the whole Negro population, by which, however, it is becoming more and more openly discredited, as it becomes, itself, more morally and politically discredited.

AFTER THE SCOTTSBORO TRIAL

" Our legal procedure is a kind of map of our ruling-class mind. In the South, in a case where Negroes are involved, every white man is given the luxury of being part of the ruling class. You have to realise how physically and emotionally undernourished and starved the small tenant farmers, the small store-keepers, the jelly-beans and the drug-store loafers who make up the lynching mobs are, to understand the orgy of righteousness and of unconscious sex and cruelty impulses that a lynching lets loose. The feeling of superiority to the Negro is the only thing the poor whites of the South have got. A lynching is a kind of carnival to them.

" Reading the testimony of the Scottsboro case, you feel all that—the band outside the courthouse, the mob starved for joy and sex and power hanging around, passing from mouth to mouth all the juicy details of the raping. You feel that filthy prurient joy in the court room, the stench of it is in the badly typewritten transcript of the court procedure, in the senseless ritual, the half illiterate, poorly phrased speeches of the judge and the solicitor, the scared answers of the two tough girls, evidently schooled for days in their story, sometimes seeming to enjoy the exhibitionism of it. Evidently the court stenographer didn't take the trouble to put down what the colored boys said in their own words; what they said didn't matter, they were going to burn anyway."

Thus wrote John Dos Passos.[1] From this, from the investigations after the trial, from I.L.D. press releases you get a characterisation of the Southern whites. There is not much in the whole case written down about the Negroes. The eight families of the boys are typical, most exactly so, of the oppressed black toilers on the Southern land. Ada Wright, Roy

[1] In Contempo.

Ada Wright, mother of Roy and Andy Wright, two of the 9 innocent Scottsboro boys, walking down Fleet St. to interview newspaper editors in her campaign for the liberation of her sons and the 7 other lads. London, July 1932.

Scottsboro—and other Scottsboros

and Andy Wright's mother, is the granddaughter of a slave who in her time was sold for 300 dollars. Black children were taken away from their parents then too, not by frame-ups and murders and the fact of being forced out by starvation at home to go hiking and bumming for work all over America in thousands as now, but by being sold on the auction block when who jumped highest under the lash fetched the most. The slave-driver has merely changed in name; nowadays he is any one of the bosses, landowners, authorities, sheriffs, etc. Some work is needed by the State—" niggers " are arrested " for loitering "; black man power, treated as that in African colonies, used the same way. " Niggers " have no rights. Andy and Roy's mother started working at 12 years old for a white family for her food and clothing, no wages. At 17 she was earning 75 cents a week. Her husband was put in jail on a ninety days sentence, " forgotten " there for eight days longer by the warden. Andy began to earn a few

Lucille Wright, 11-year-old sister of two of the Scottsboro boys. This child has learnt to address huge meetings for these innocent victims of American frame-up and attempt at " legal lynching."

Photo by Workers' Film-Photo League, New York

cents as a rag-picker; job. At the time her boys was cook to a white family. they gave her 5 dollars. But other whites said they money in the river because could never have a chance But she managed to col- it in a lawyer's hand. told her to " keep away was after the I.L.D. had she saw " the Reds look help us."

Such is the law's fiend- months before the I.L.D. sion out of it for any of children, under death the defence attorneys, in New York the long trains that some of these be allowed finally to see in the presence of in- for exactly 2 minutes be- the jail again. An electric prison wall as extra pre- there were bayonets, exe- demned Negroes the boys constant threats and vio- to little Roy Wright, aged " promise " of 500 dollars would turn state evidence committed the rape. knocked out some of his

then he had a lorry driving were arrested Ada Wright When they heard the news " You must get a lawyer." would sooner throw Negroes arrested for that anywhere in the South. lect 50 dollars and put Neighbours came and from the Reds "—that taken up the case—but like the only ones want to

ishness that it was several was able to force permis- the parents to see their sentence. I heard one of Joseph Brodsky, describe dragging journeys in rural parents had to make to and speak to their children sulting, infuriated guards fore being driven out of current was on top of that vention of escape. Inside cutions of other con- were made to witness, lence. What did they do 13? They offered him a and his freedom if he and say the other boys had When he refused they front teeth. Andy Wright

was molested by the guards. Even when they should have been in other cells, during the different stages of the trials and appeals, they were, they are now, in death row. Most brutal of all, the wardens on one occasion at least withheld from them the news of the stay of their execution.

Here is a letter from Andy Wright to his mother:

Kilby Prison, Montgomery, Alabama, *April* 14, 1932.

Hello Mother Dear, how are you today. This leaves your son not feeling so well. Mother I am trying hard not to worry but I really can't help but worry because I have got tired of laying in this little tight place. I wish they could have us moved back to Birmingham county jail so we will have room to walk around some, and maybe I wouldn't worry so much. I know for sure I wouldn't, but in this little tight place with nothing to keep my mind together, no enjoyment here at all to keep a person from worrying you can imagine how it goes with me. So Mother dear I will close now. Read and remember your son for ever.—A. Wright.

The series of execution dates and stays of execution has been going on now for two and a half years, and down this vista of torment is the threat of one of the most torturing deaths ever devised, electrocution.

Scottsboro—and other Scottsboros

How did Beatrice Hastings (one of the many writers who has protested against this monstrous case) word it? "A human being boiled in his own blood, burned and scorched until death comes in from 5 to 15 minutes." [1]

PROTESTS AND DEMONSTRATIONS

The capitalist press has, of course, been silent on as many of these as possible. The first exposé of the frame-up appeared in the New York *Daily Worker* on April 2, 1931, the week before the trial. On April 24 the first protest cable from Europe arrived from the Berlin Transport Workers Union, and the first large Harlem Scottsboro Protest Parade was held and broken up by the police. Throughout the summer, the execution date having been set for July 10, there were meetings and manifestations not only all over America but in European countries outside the American Embassies and legations. On May 1, 1931, the I.L.D. had organised over 300,000 Negro and white workers in 110 American cities. In Detroit alone there was a manifestation of 10,000. In Cuba a militant meeting took place outside the American-owned *Havana Post*. Several deaths, smashed windows in the American Embassy and police fights marked the breaking up of a huge manifestation in Berlin. Protests poured in from the workers of the Soviet Union, of China, of Mexico. *L'Humanité*, in Paris, lists in one day, just before the execution was postponed by the appeal, the following protests:

40,000 Parisian workers. The Fédération Unitaire des Métaux.
Jeunesses Communistes. Italian Section of the Red Aid.
15,000 members of the Paris Municipal Workers.
The Ligue de la Défense de la Race Nègre.

On receiving these protests the American legations cabled to the U.S. for instructions; the organisation of the International Labour Defense of each different country has mobilised more and more protests and manifestations with each successive move in the case.

In the Soviet Union the vice-president of the Academy of Science wrote, " that such things can come to pass is unbelievable and incompatible with the mind of a normal being. Of course anything can be expected from the U.S. where proceedings have been brought against Darwinians. But I do not understand how American science can remain mute on such scandalous sentences."

Later, in July 1932, when Mrs. Wright had come to England, amongst other public protests sent to the American Ambassador for transmission to Hoover was one from the London School of Economics. Another from the University of London, signed by 274 of the students and teachers, by Professors Ginsberg, Martin, White, Hogben, Laski, Tawney and Eileen Power: " We, the undersigned, emphatically join in the world-wide protest against the legalised murder of the Scottsboro Negro boys. We regard this travesty of justice, the result of the gravest race prejudice, as an intolerable abuse of the basic principles of civilisation, and demand immediate repeal of the sentence."

Some of the members of the Church to protest were: the Bishops of Durham, Worcester, Bradford, Rochester, Wakefield, Chichester, Southwell, Pella, Galloway, Dunkeld, Hexham, Newcastle, the Chief Rabbi, Dr. Hertz. Amongst writers, poets, artists and intellectuals: Dreiser, Sherwood Anderson, Sinclair Lewis, Professor Frank Boas, Ezra Pound, John Dos Passos, Edna St. Vincent Millay, Malcolm Cowley, Heywood Broun, Waldo Frank, Floyd Dell, Eugene Gordon, Lincoln Steffens, Langston Hughes, Mary Heaton Vorse, Mike Gold, and all the American John Reed (literary) Clubs.
Outside America: Wells, Bertrand Russell, Middleton Murry, Aldous Huxley, Julian Huxley, Arthur Symons, Augustus John, Rebecca West, Virginia Woolf, Professor Malinowski, Priestley, Storm Jameson, Naomi Mitchison, David Garnett, C. R. Nevinson, Laurence Housman, Norman Douglas. Outside England: Einstein, Gorki, Leo Tolstoi, Barbusse, Gide, Leon Pierre-Quint, the French Surréalist (writers) Group, and tens of thousands of others in every land.

The total number of protests from all over the world is listed at some 10,000,000.

In the face of all this (which is noted here as an indication only of part of the volume of mass indignation) what is the reaction of the U.S. authorities? Both the President, at that time Hoover and now Roosevelt, and Governor Miller of Alabama have had it in their power all along to grant pardon or to order that the boys be freed. The attitude of American authorities is of course classic. They decline to comment, " know very little about the case," etc. Governor Miller, however, was surprised and disquieted by the number and militant tone of the cables and messages received. Voices from the entire world denouncing the condemnation of nine mere Negro working lads in Alabama, a thing of purely local issue, the sort of thing that had happened all the time " without any fuss " . . . But no, it was no concern of Governor Miller. He saw then, he sees no reason now, to exert his powers.

[1] In *The Straight-Thinker*, Sept. 1932.

164

Scottsboro—and other Scottsboros

A sidelight on the official American mentality, regarding the intellectual status of the Negro, is given by Comrade Garan Kouyaté (a Bambara African) after going with a delegation to the American Embassy in Paris at the time of the U.S. Supreme Court Appeal in November 1932 : " When we got there we were told the ambassador was out. The chargé d'affaires who received us admitted that deputations had been coming all day with the same object. His whole manner showed the utmost surprise at Negroes talking correct French. His astonishment turned to anger and mortification when we told him in plain terms that we held Miller and the President of America responsible for the lives and fate of the boys."

ADA WRIGHT AND J. LOUIS ENGDAHL IN EUROPE

America brings pressure on all European countries to keep these agitations and mass protests out of the press. How much more so did this pressure operate, with the fullest concord of all the capitalist governments, in attempting to debar Mrs. Wright and J. Louis Engdahl, national secretary of the American I.L.D., when they came over in the summer of 1932 to tell the European workers of the Scottsboro frame-up and exploitation of the Negro masses. This tour comprised 13 countries. In Hamburg and Berlin Mrs. Wright was forbidden to speak. Denied entry into Belgium, but smuggled across the frontier. Imprisoned, as was Engdahl, for several days in Czecho-Slovakia and Bulgaria, then deported. Acclaimed everywhere by huge crowds and manifestations they were constantly harried and held up by various national authorities. Denied entry into England. After a long delay, Engdahl being still debarred, Mrs. Wright was given just ten days here, during which she appeared and spoke at no less than seven meetings in London, and in Manchester, Dundee, Kirkcaldy, Glasgow, Bristol, with I.L.D. organisers. Ireland refused her

Ada Wright and Louis Engdahl (then secretary of the American International Labor Defense) leaving New York for a tour of protestation in 13 European countries against the Scottsboro frame-up and lynch verdict, April 1932

Photo by Workers' International Relief, 16 W. 21st St., New York

entry. Engdahl and Mrs. Wright were later at the Amsterdam Anti-War Congress, all members of which signed a mass protest. Their European tour culminated in Russia at the moment of the celebrations of the Soviet Régime's 15th anniversary. It was here that Engdahl died, weakened and worn out by the incessant fight and organisation of the whole Scottsboro campaign. And meanwhile a child of 11 was speaking to huge audiences throughout the middle western states in America. This was Lucille Wright, sister of the boys.

ALABAMA AND WASHINGTON SUPREME COURT APPEALS

On Jan. 21, 1932, the Alabama Supreme Court heard the Appeal. The case was argued by I.L.D. lawyers in presence of the biggest assembly ever held in the Montgomery court. Although justice John Anderson disagreed with the other judges, holding that the accused " did not get the fair and impartial trial required by the Constitution," the Appeal was dismissed and the death verdicts maintained on 7 of the boys. Eugene Williams, second youngest, was granted a new trial on the grounds that, as a juvenile like Roy Wright, his case had been tried in the wrong court at Scottsboro. But neither of these boys' cases have been re-heard.

The defence had already announced that if the Appeal failed it would take all the cases to the Washington Supreme Court, the highest in the land. Appeal to this court was heard by 9 judges, some of whom were said to be known " liberals." This took place on Oct. 10, 1932, while a large demonstration and picketing was going on outside, attacked by police with tear-gas bombs and clubs, 16 being

arrested and many clubbed. The judges deliberated, but their decision was reserved for one month till after the presidential elections. On Nov. 7 it was known that the Appeal had been granted. That this came in no way from the abundant evidence of the boys' innocence and frame-up, nor from the numerous other factors of injustice during trial, is shown most clearly by the one ground on which the Appeal was allowed. As *The Liberator* wrote: " Only the fact that the boys *had not been properly represented by counsel* entitled them to a new trial. The crying evidence that the trial was held in an atmosphere of lynch law, that threatening crowds milled about the streets, the fact that Negroes were barred from the juries that tried the boys—all these facts the judges of the Supreme Court set aside as ' immaterial.' Such is the impartial justice of the highest court in the land."

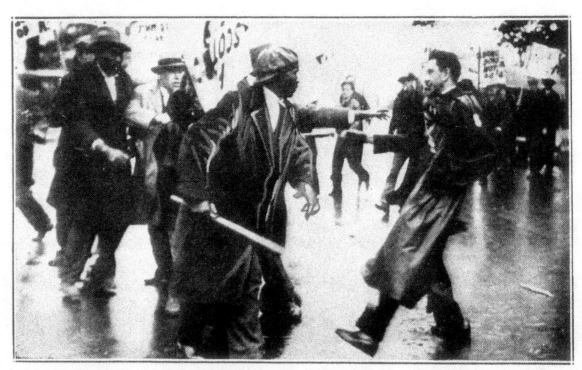

The manifestation in Washington, U.S.A., Nov. 8, 1932, on the day that the U.S. Supreme Court reviewed the Scottsboro case and granted the appeal for re-trial. Black and white formed an orderly procession, but this photo shows the moment when a policeman is about to throw a gas bomb onto the manifestants

Photo by courtesy of L'Humanité, Paris

RUBY BATES REPUDIATES THE RAPE LIE

About two or three months after this, while the I.L.D. was preparing the whole of the case anew for re-hearing, it became public that a letter written by Ruby Bates to a boy friend, in which she stated that she had lied about the " rape," had been seized and kept by the police. The defence forced this to be handed over to the court as evidence. Ruby Bates had written :

Jan. 5, 1932, Huntsville, Alabama.

dearest Earl, I want too make a statement too you. Mary Sanders is a god-damn lie about those Negroes, those policemen made me tell a lie. that is my stement because i want too clear myself that is all too if you want too belive me ok. if not that is ok. you will be sorry some day. if you had too stay in jail with 8 Negroes you would tell a lie two. those Negroes did not touch me or those white boys. i hope you will belive me the law dont. i love you better than Mary does ore any body else in the world that is why i am telling you of this thing. i was drunk at the time and did not know what i was doing. i know it was wrong to let those Negroes die on account of me. i hope you will believe my statement because it is the god's truth, i wish those Negroes are not Burnt on account of me. it is these white boys fault. that is my statement and that is all i know. i hope you tell the law; hope you will answer. Ruby Bates. P.S. this is one time that i might tell a lie but it is the truth so god help me.

Scottsboro—and other Scottsboros

THE DECATUR RE-TRIAL

March 27 had been set for the re-trial in Decatur, Alabama, although the defence had asked for change of venue to the large town of Birmingham as less likely to contain the lynch spirit so dominant in Scottsboro. Decatur is under 40 miles from Scottsboro and as frantically, bitterly prejudiced. But change of venue had been denied. At this time prosecuting attorney Knight made statements to the press that the boys had had a fair trial and would have a fair re-trial. It has been seen how fair the first trial was. At this time also Knight opposed the defence lawyers when they asked that action be taken against the militiaman who had stuck a bayonet into Roy Wright's face in addition to the beating and torturing that he had undergone in the attempt to make him testify against the other boys. Knight said a Negro's accusation was of no value, and covertly opposed demands from the defence for private interviews with the boys prior to the trial; the presence of guards of course preventing prisoners from speaking openly.

On March 27 the trial opened. The chief figures in it are:

Samuel Leibowitz, defence counsel, a celebrated criminal lawyer from the North, who had never yet lost one of his very numerous cases.

Joseph Brodsky, chief lawyer of the International Labor Defense.

General George Chamlee, of Chattanooga.

State Attorney Prosecutor Knight, who had prosecuted the cases at Scottsboro, a Southerner of the rankest cracker type.

Judge Horton, the same who was later to hear the 2nd Alabama Supreme Court Appeal.

Ruby Bates, one of the two white girls, who had repudiated her false testimony and whose letter to a white boy friend confessing she had lied had been stolen and kept for months by the police.

Lester Carter, one of the white boys on the train, who now came forward to testify to the Negroes' innocence and to denounce the frame-up.

Although all the boys were brought to Decatur only *Heywood Patterson* was tried.

As at Scottsboro the crowd began to collect early; the court-room was jammed. There were soldiers everywhere, by the judge's desk, and outside, hedging in the court-house with drawn bayonets. About 400 people inside the court, of whom a third were Negroes. These last were of course in the separate jim-crow pen, including the two Negro reporters from the *Afro-American* and the *Norfolk Journal and Guide*. To leave at the end of each session the Negroes had to wait seated until the whites had gone out first. Meanwhile the Southerners were proclaiming *there is no discrimination*. In the same breath they would say that men of dark skins are not " of sound mind." This idiocy was thrown into sharp relief by the courageous and intelligent testimony of a Negro plasterer from Scottsboro put on the stand by the defence the first day. At two o'clock a van rolled up with the boys from Birmingham jail, preceded and followed by squads with riot guns and tear gas. Olin Montgomery is nearly blind. He stumbled as he got out. A wave went through the crowd. They thought he'd been shot; they thought the shootings were beginning. That was the state of tension the townsfolk were in. As Roy Wright entered the court Leibowitz came and shook him by the hand, to the angry stupor of court officials. By now the audience had increased to about 600, and half of these were Negro.

A Southerner, Mary Heaton Vorse, a white author, who was present throughout the entire trial, told me that the Negroes and whites were " perfectly friendly, fraternising even " everywhere except in court, where the tension was bitter, violent, at times positively frantic, so that you didn't know what mightn't happen. I find this " friendliness " too difficult to believe; one cannot see how this could happen, with the daily insults flung by Knight at the Negroes, with his appeals based on race difference and prejudice made continuously to the only-too-appreciative jury. I think her desire that it should be so made it seem so to her—as also her statement that judge Horton was just and well-disposed . . . a fact that I will come to presently proved it otherwise. We know there are degrees in the visibility of prejudice.

All through the day small organised bands of whites from surrounding communities such as Scottsboro, Huntsville and Athens kept filtering into the town, adding to the danger of " extra-legal " action, a danger to the boys, to witnesses called for the defence, to the defence itself. " There is no danger whatever to the prisoners," proclaimed the authorities. The jail the boys were kept in during the two weeks of the trial was so rotten and old it had been abandoned for white prisoners. " Why, you could break out of it with a spoon," said a sheriff—indicating unwittingly it could be broken into as easily.

The first proceedings were statements by defending counsel Leibowitz that *no Negroes had been employed on juries for 40 years. This is illegal*; this is in exact opposition to the 13th, 14th and 15th amendments to the U.S. Constitution, which guarantee that Negroes shall serve. These amendments had to

be made in 1865, for until Abolition no Negroes had any rights, civic, legal or political. These amendments are systematically, unfailingly disregarded in all the Southern States, as Leibowitz proceeded to show when he called for the jury roll. There was not a name on it of any Negro citizen qualified to serve; not one had served within living memory. Knight refused to answer on this point. "Prove it," was his retort. And Leibowitz proved it.

An arc light was thrown on the cracker mentality when Benson, of the Scottsboro *Progressive Age*, was called in. Leibowitz asked him if he had ever known a Negro to be placed on the jury roll. "Never heard of one, never noticed one," answered Benson with apologetic glances at prosecutor Knight. "There are 666 Negroes of serving age in Jackson county [where Scottsboro is situated], were none of these qualified to serve as jurors?" continued Leibowitz. "Some of them are good Negroes as far as Negroes go," said Benson, "but they couldn't be said to possess sound judgment, they couldn't get round that clause, and they all steal; they haven't been trained for jury duty" (!) "I might say the same thing about women—the Negroes haven't been trained, not made a study of justice and law, and such." The defence collected evidence showing that there were 26 Negroes at least who could have served in the Scottsboro trial.

No, it was not the trial of the nine boys, particularly during the whole first week in Decatur; it was the trying and proving guilty of the entire Southern manner of denying to the Negro his constitutional rights.

Meanwhile, and throughout the trial, and ever since, and without doubt in the future too, the Southern authorities, press, etc., proclaim that there is neither discrimination nor prejudice; and that these fiendish and scandalous trials were "fair." William Patterson, national secretary of the American I.L.D., himself a Negro, and a lawyer, analysing, commenting on the whole matter wrote: "If the authorities of Alabama had been or were in any way sincere in their claim to a desire to give the boys a fair trial and to prevent them being lynched, they themselves, through their organ the capitalist press, would issue a call for full social, political and economic equalities for the Negro, and expose the real reason why the Negro people are now in such a state of oppression, and why the Scottsboro boys are framed on faked charges. But this they cannot do, for capitalism would then no longer be capitalism."

The sheriff of Morgan county, in which Decatur is situated, needed 30 national guardsmen to "prevent the boys escaping"; the same troops which had beaten and mistreated them previously and were soon to do so again. It is a recognised provocation to lynch mobs to call in the aid of the National Guard; double provocation to call in, as was suggested, the Federal troops.

On this first trial day, the judge, Horton, overrules the defence's demand that all the indictments be quashed on the ground of the absence of Negro jurors. Knight's cracker spirit begins to rise. He addresses the witness Tom Sanford, Negro plasterer, as "John," bullies and browbeats him. Leibowitz remarks sharply, "Call witness Mr. Sanford." "Not doing that," answers Knight. Then a lynch-inciting pamphlet is discovered. It is being hawked about in the crowd. A battle opens between defence and prosecution; Leibowitz demands its suppression, Knight defends its right to be circulated. Finally the judge has it confiscated.

A day or two later Knight jumps to his feet clapping his hands during the declaration of a prosecution witness that the boys took a penknife from Victoria Price. Constantly there are little incidents of this sort, rabid pin-pricks of hatred studding the whole of the trial. The testimonies of state (prosecution) witnesses form an indescribable jumble of lies and contradictions, each more stupefying than the last. They are contrasted against each other by Leibowitz. For example: Price said she fainted after the "rape" in the train; but a state witness affirmed he saw her walking and talking. Another had seen a Negro prevent a white girl from jumping off the train—but the photograph taken subsequently from the spot where he stood showed that he could have seen nothing at all. Price's overalls, she said, were torn and stained; yet they were neither when produced in court. "And why were they not introduced into the first trial?" asked Leibowitz. Knight and the judge made objection to this query. Throughout, Price spoke mechanically, maintaining the whole of the rape story with its knives and guns, but only answered questions at the direct prompting of Knight. And the two doctors, Bridges and Lynch, called by the State, branded as false the story she told of being battered and bleeding. She was without any marks or wounds, save a few scratches which would be likely to come from clambering about on the train and from the gravel in the freight-car she'd travelled in. While she was being cross-examined a man got up in court. "Let's get Leibowitz now," he muttered. The soldiers seized and searched him for arms and put him out. Also were put out two others who had begun a struggle.

Scottsboro—and other Scottsboros

The lives of Leibowitz, Brodsky, Ruby Bates, Lester Carter and the boys were in constant danger from mobs or gangs forming daily, broadcasting their intention of lynching them. Well, it would have been too much even for the State of Alabama if four white people, the four chief protagonists in this case angrily watched by a universe, had been murdered. So all the time a handful of soldiers was set around lawyers and witnesses. They didn't know it perhaps, but at the time that Ruby Bates and Lester Carter were giving evidence two lynch-mobs had already started out from Huntsville and Scottsboro to get them. The militia posted along and across the roads outside Decatur turned them back. In keeping with the reiterated lie that nothing at all was going on, given out by the authorities, the press were asked not to mention this. But the press said they had come to send news and to take photos. " Send it only if something happens." Terrorisation or interference with the press was a strong feature throughout. Photographers were threatened at Paint Rock while taking pictures of the scene of arrest. A group of black and white people were arrested because found together in a Negro neighbourhood; charged with contempt of court (!) they were then brought before judge Horton. A white journalist, Fuller, had already been run out of the town because he was reporting for a Negro daily, the *Atlanta World*. As to Leibowitz, they called him " a Russian Jew Nigger who ought to be hung." But the attitude and spirit of the Negro population were stirringly militant. " If a mob comes we're not running," they said. They were told, of course, that the Communists were only making propaganda and that they did not care about the issue of the trials. " If the reds are responsible for all this," said the Negro workers, " then we are with them."

And the boys in the rotten jail you could break out of with a spoon. . . . A special correspondent went to see them. Thirteen iron steps and the shadow of the hangman's noose. So, for 2 years they'd been face to face with the electric chair across the passage in front of their cells and now they had the gallows to stare at in the electric light. On the last step was the trap-door to eternity—a painting of Christ at Gethsemane, done by some dead convict, above it. The correspondent looked at the gallows and the Christ. Then he saw the eyes—the Scottsboro boys were looking at him. It was full of shadows in that place—jailors and guards moving about, the shadow of the actual noose, shadows of themselves shuffling round, straining ears for the rumble of mobs. They couldn't sleep ; they were wondering all the time if they would die in Decatur, lynched, or be convicted again. Did they dare even to think of the possibility of acquittal? Vermin was on them, the cockroaches crept over the filthy cell floor ; the bed bugs lived in their clothes, they couldn't get them out ; jail gives no change of clothes. " What'll you do when you are freed?" asked the journalist. " Olin Montgomery seized one of the greasy bars and leaned against it, peering intently with his one near-sighted eye, ' Go home,' he said simply. ' Oh boss, I wants to go home. I been here 2 years and 9 days, 2 years and 9 days.' "

Between the scenes in court, the gallows and the mob threats, the blood-lust outside and the agony, terror and despair within, the brutalities of the jailors and the thought of death that must never leave them, how is it that these boys did not go insane?

The Scottsboro boys in Birmingham Jail just before the Decatur re-trial. Left to right (standing) : Clarence Norris, Ozie Powell, Heywood Patterson, Roy Wright, Charlie Weems, Eugene Williams. (Sitting) : Andy Wright, Olin Montgomery, Willie Roberson

In court the " lantern-jowled morons," as Leibowitz ended by calling them, are sitting and smoking, very informal. Plenty of them out of work in this impoverished rotting South always 50 years behind the times in everything. Hard eyes staring at judge and counsel. Only a whetting of the appetite so far to be sure, the death hunger will be sated alright, for haven't they been assured again and again that the boys won't get out of Decatur alive if the jury does acquit them? The Negroes sit apart, straining to hear and see, grim and silent. Other Negroes outside, trying to see into the court. Leibowitz and Chamlee keep Heywood Patterson between them. There's a photo in a French paper, Heywood Patterson is holding a horseshoe. . . . "Were you tried at Scottsboro?" " I was *framed* in Scottsboro."

They try to force him to admit he pronounced a phrase they have invented themselves: " I told you if we had killed those girls we wouldn't be here." Knight has announced that he will simply *ignore* Ruby Bates' repudiation of her Scottsboro testimony, her admittance of perjury. A little later Knight says he'll have her arrested for perjury. Leibowitz tells the world that the Negroes are being framed up—he says he will fight like hell to save them.

" THE NEGROES NEVER TOUCHED ME, AS THEY NEVER TOUCHED VICTORIA PRICE "

This is what Ruby Bates told the court. Though they had heard she was coming now to be a witness for the boys, and that she had publicly repudiated the rape lie, to hear this Southern white girl, one of themselves, utter this statement, made them aghast and convulsed them with fury. It is the first great crack in the old Southern structure of white supremacy. It will never be forgotten, it is a very high and splendid point in the history of black and white. Realise too that it needed very great courage, physical and moral, in these two young white Southerners, Ruby Bates and Lester Carter. With their testimony they were piercing the whole of the rotten Southern fabric of lies and race hatred, holding it up to the entire world, tearing it inside out.

Knight and other court authorities said Lester Carter and Ruby Bates had been " bought " by the Communists, pointed at the different clothes the latter was now wearing (most ordinary city girl's clothes). " We didn't dress Victoria Price up like a lily of the valley," vociferated the state prosecutor. Until her appearance in court Knight had been angrily shouting : " Produce Ruby Bates ! " and saying it could not be done. She came in with Brodsky and Mrs. Jones, a social worker. " You have been asking for Ruby," said Leibowitz quietly, " here she is. I ask that she be sworn." An electric shock went through the court. An I.L.D. Scottsboro release says : " Knight, who had been in the witness room preparing rebuttal witnesses, rushed back into the courtroom. Judge Horton called for order ; an extra cordon of soldiers was thrown round the courthouse. Victoria Price was called in and stood staring at Ruby as she was asked to identify her as her companion on the trip."

Cross-examined by Knight with all the rancour and viciousness that one can visualise, she made a flat denial of the rape, could not identify Heywood Patterson, explained that she had lied out of excitement, ignorance, terrorisation by the police and at Victoria's prompting to escape jail. " The whole thing was a frame-up," she said. And it had troubled her so long that finally she had left her home in Huntsville in February 1933 and gone to New York, and seen Rev. Dr. Fosdyck, and he had told her to go back South and tell the truth at Decatur. She had not even known the meaning of the word " rape "; she had had to ask her mother what it meant ; that was after the Scottsboro trial. No, the boys had certainly not touched her or Victoria.

Lester Carter, a tall blond Southern boy, gave evidence too. His conscience had been at him for two years, since the frame-up. Now, here, it was " like getting well from being dead." His story tallied with Ruby's ; he had been on the train with the girls—he was very detailed. He'd met them both in Huntsville jail in 1931 ; he was then doing 50 days on a chain gang. Victoria was under sentence too. And Ruby had come to see her. After they'd got out they had met again and planned the trip. They'd spent that night in the Chattanooga jungle. The other boy who was along was married, so he hadn't accompanied them on the journey ; he was going to follow later. On the train, he (Lester) had seen some white boys throwing stones at some Negroes ; they'd shouted to him to come and join them, so he'd gone along. Then he jumped off the train when one of the Negroes took a swing at him. They did not have either knives or guns. He had been one of those who had notified the authorities about the fight. At Paint Rock, later, he'd overheard Victoria ask Orvil Gilley to pass as her brother, so that she would not be arrested for hoboing. And in Scottsboro jail, where they had all been locked up without knowing on what charge, he heard those two having a quarrel, Victoria telling Gilley he must keep to her story, and what did niggers matter anyway? let 'em all go to jail. But Gilley had said she was mad, and that " some time a nigger may have to testify to save *your* life." Of course the State interjected here that Carter had been coached to say all this. So Carter told how he had been in the Scottsboro prison for 16 days and barred from testifying because they saw he wouldn't lie. After that he'd been so uneasy in his mind he had bummed his way to Albany in New York State to see Governor Roosevelt, who refused to see him. And finally he had heard that the I.L.D. in New York was defending the boys and had gone to them.

What did Knight do in the face of this testimony?

He asked Lester Carter if he had syphilis !

Scottsboro—and other Scottsboros

This attempt to damage his character drew an immediate protest from Leibowitz indicating that this astounding question was sufficient for a mis-trial to be declared. The judge overruled this, and Knight said, " I am not ashamed of the way I am treating this witness."

A gynecologist from Chattanooga, Dr. Reisman, had proved with charts and diagrams of feminine anatomy that it was not possible the alleged rape could have occurred at the time stated, backing up the declaration of the other two doctors. (It goes without saying that these doctors were also threatened by lynchers.)

Knight is now again browbeating Heywood Patterson. " Did you pick up Victoria Price and hold her over the side of the train? Who did you see raping the girls? " Patterson repeats he'd seen no girls at any time, admits freely to the fight when the white boys had attacked him and the others. And he tells his mother—she is sitting beside him, she hasn't seen him for over a year (they allow her to see him sentenced to death again), " I'm afraid of what'll happen if they free me."

Another mob formed; led by Ku Klux Klan men, 200 of them were coming to the court house for Leibowitz. Sheriff Davis argued with and " cajoled " them (yes, that is the word used), but they wouldn't go away till they saw the soldiers were at the point of firing. This is when most of the press agreed to withhold news. The Klansmen however boasted of it, and the I.L.D. forced the truth of this and of many other incidents into the open.

As the trial went on 5 of the Negro boys were put on the stand by the defence. And then the very initial start of the whole thing came out. It was Eugene Williams who told how the white boys were climbing from one car to another and one of them had walked on Heywood Patterson's hand, and Heywood had asked him couldn't he be more careful . . . and so the fight had begun. And then Heywood had pulled back Orvil Gilley as he was about to jump off. Why would he save a white boy's life to let him see a white girl raped afterwards? asked Heywood Patterson.

Victoria Price had said she'd never seen Carter or Gilley, but Dallas Ramsay, a Negro witness, had seen them all together on the morning of the freight-ride, when she had asked him when there was a train to Memphis. Both General Chamlee and a sister of the Wright boys, who live in Chattanooga, said how they had searched it for the Callie Broochie and her house where Price said they had spent the night, but in two years' investigation had never found either. Further " character testimony " was ruled out by the judge, who had allowed Knight to insult and attack defence witnesses as much as he pleased.

" That Black Thing "

Knight is shaking his fist at Heywood Patterson and calling him " that black thing over there." Leibowitz has made a four-hour summing up. Insults to Ruby Bates, Lester Carter, Leibowitz and Brodsky have been spat out by Knight and other prosecuting counsel. Leibowitz and Brodsky are " New York jews, but jew money can't buy Alabama justice "; all four have received many death threats. And another of the prosecuting attorneys has made a lynch-inciting speech which has increased the number of fiery crosses (Ku Klux manifestations) that have burned nightly for over a week in all the surrounding villages. The ammunition stores report they are sold out, " but no cartridges sold to niggers."

The jury deliberates all night. Then they actually ask if they can give their decision based on the Scottsboro trial !! They don't want to take into account any of the Decatur hearing. Next morning the jury file in, many of them with broad grins. Horton reads out their verdict: " Guilty. We ask for the death penalty." The court empties in a flash; the news is shouted all over the town. The first case is settled, and now they can get on with that of Charlie Weems. . . .

One would like to engrave the entire report, the whole detail of these trial testimonies of both sides, the false along with the real, on some matter that would last as long as humanity; to record for ever also the moment of this cutting open of the plague of hatred, the exposure of Southern courts' " justice." The whole of the American Negroes' misery tightens into one phrase, into two lines written by one of their own poets :

> Oughta had mo' sense
> Dan to evah git born

That is by Sterling Brown. And if it rings agonisingly defeatist so often it rings as bitterly true. But it is going to change. Five years ago the Scottsboro boys would have been just another locally heard-of case of 9 more dead victims.

Scottsboro—and other Scottsboros

AFTERMATH OF RACE HATRED

It was only two hours after this monstrous renewed death verdict was known that the *Amsterdam News* (Harlem's largest Negro paper) issued a proclamation asking for 500,000 protest signatures to be collected and sent to Roosevelt. In a few hours some 50,000 had come in. And the I.L.D. immediately announced the " Free the Scottsboro Boys March " on Washington, which thousands volunteered for. Floods of protest telegrams came to Miller, governor of Alabama, Horton, Knight. The *Huntsville Times*, not content with the verdict alone, asked for the arrest of Ruby Bates. When Leibowitz, who had given his services in the case, arrived back in New York a crowd of some 5,000 workers, mostly Negro, met him at the station and manifested their gratitude for the heroic fight he and the other defence lawyers had made.

A new development, the postponement of Charlie Weems' trial, came as a surprise to the defence, and was announced at the same time as the date of execution of Heywood Patterson was set for June 16. The notice of appeal already filed by Brodsky automatically suspends this.

Throughout the whole case there have been numerous acts of terrorisation in Alabama, opposition of all kinds in diverse parts of America. Here are just a few : General Chamlee's house broken into by a gang who tried to rifle a safe containing legal documents. L. Harper, Negro teacher, sacked from Birmingham for having given his pupils Scottsboro protests to distribute. Ted Richards, a Negro boy of 19, jailed for 2 years for speaking on Scottsboro, asking freedom for the boys, for organised action against evictions. Herman Carter, author of " Scottsboro Blues," held up and threatened by white hooligan motorists in Nashville, Tennessee. Two Negroes shot at and wounded in a Decatur street by " unknown " whites. The house of a Negro witness who was to testify in Charlie Weems' case burned to the ground, in Decatur. In other parts of America : June 1933, in Mount Vernon, New York State, the Ku Klux Klan covered the walls of an auditorium, where a black and white workers' meeting was being held to protest Scottsboro and Negro terrorisation, with messages, " The Ku Klux Klan has its eye on you " ; the word " eye " being represented by the large and evil photograph of one. Leaflets frantically attacking black and white solidarity filled the hall. At the time of the Decatur trial the I.L.D. had issued a Scottsboro penny stamp to aid in raising funds. Although the Red Cross and other stamps go regularly through the mail the U.S. post office in New York attempted, but failed, to bar this stamp. A play given by the John Reed literary club in Los Angeles was broken up by a fascist police squad, books, paintings, documents destroyed, because they protested against Scottsboro and Negro oppression.

Today as I write this comes fresh news from Birmingham, Ala., that another Negro has been shot dead in the street by a gang at that moment making its third attempt to lynch yet another Negro.

There have been statements that the Scottsboro boys were fighting each other in their cells, fighting the wardens. Attempts to show them up as callous criminals. Heywood Patterson was reported stabbed to death by Andy Wright. But an investigation by Brodsky showed that, as usual, it was the wardens who were mistreating the boys. One reads of the boys beating each other with leaden piping torn from the walls. Jailors struck the boys and forced some 20 other prisoners to start an attack on them ; when they showed they would defend themselves they were starved. Brodsky, after seeing them, said their spirit was high, that they believed in their ultimate freeing by the weight of the mass protests.

THE MARCH ON WASHINGTON

It took place from Harlem on May 6, when some 5,000, mostly Negroes, left in vans, lorries and trucks, some starting on foot. Rain drenched them. Police that accompanied them in heavy numbers had taken the precaution to mix

Outside a meeting when Mrs. Wright spoke to protest against the Scottsboro mis-trial. Shoreditch Town Hall, London, July 6, 1932

Photo by courtesy of London I.L.D.

oil with the gasolene of their motor-cycles; the workers marched in an atmosphere of burning, acrid smoke. On their way through Baltimore new contingents joined them. At the same time a different group, some of the black bourgeoisie, also left New York for Washington, to tell President Roosevelt how fair judge Horton had been despite the death verdict, and to assure him that they continued to have faith in the justice of Southern courts. This was an attempt at disrupting the Scottsboro United Front, their objective being of course to discredit as much as possible the I.L.D. and the defence. In this a large amount of funds collected for the defence was wasted by the N.A.A.C.P. and other reactionaries.

A Scottsboro Press Release says: " Ruby Bates marching at the head of the Scottsboro parade in Washington, May 8th, by herself gives the parade more significance than any other single unit. When she told Mr. Howe, secretary to the President, and Mr. Rainey, speaker to the House, that the Scottsboro boys are innocent, she exposed the frame-up at the doors of the highest authority in the land." At the Capitol, William Patterson and a delegation of the marchers asked to see Roosevelt. Sec. Howe said it was quite impossible, the President was seeing no-one but foreign representatives and bankers. Patterson insisted that Roosevelt be informed of their presence and demands. Down the telephone then came Roosevelt's emphatic *No*, heard by all in that room. The marchers' objectives were to demand immediate freeing and safe conduct of the innocent boys, to protest against the death sentence, to leave with Roosevelt and Congress the " Bill of Civil Rights for the Negro People " prepared by the League of Struggle for Negro Rights. This Bill states that the 13th, 14th and 15th amendments must be made to function (right of Negroes to vote and sit on juries) and contains a clause demanding the death penalty for lynchers. A copy of this Bill was taken by James W. Ford (Negro Communist leader and Communist candidate for vice-presidency in 1932) to speaker Rainey, who pretended he knew almost nothing about the Scottsboro case, but who gave himself away by trying to browbeat Ruby Bates on her change of attitude. The Negro Congressman, Oscar de Priest, a millionaire landlord who is responsible for some of the bloodiest evictions of black and white workers, when confronted by William Patterson's demand that he present the Bill to Congress, cut short the interview, replying that if anything needed to be said he would say it himself, no-one could tell him what to say.

The effect of the march was to greatly increase the adherence to the defence. The number of meetings has multiplied itself as time draws nearer for the October re-trial. Mother Wright, Ruby Bates and I.L.D. speakers are at this moment on a three-month tour; Mother Patterson, Lester Carter and Richard B. Moore, a dynamic Negro Communist orator, are speaking in some hundred different places in the West and Middle West.

ALABAMA SUPREME COURT APPEAL, 1933

A lot has been said and written about judge Horton's " fairness." Yet the evidence presented him in the Appeal was precisely the same as that used in Decatur, and on which the jury had convicted Heywood Patterson. Nothing new had been added. Judge Horton had not set aside the jury's verdict; he had confirmed it. On June 22 Horton granted the appeal. If he was " fair " in granting it now in the Alabama Supreme Court, he had not been so in condemning Heywood Patterson in Decatur. The judge's decision now, that the evidence greatly preponderated in favour of the accused, sums itself up in his own words: " The natural inclination of the mind is to doubt and to seek further."

This decision has had the immediate effect of producing a new lynch figure: ex-senator Heflin, a leading member of the Ku Klux Klan, who has wired his " services " free of charge to prosecutor Knight. This is one more indication of the

Comrade Chris Jones speaking at a Scottsboro protest meeting in Trafalgar Square, London, Oct. 1932

Southern ruling class determination to have the boys killed. A move to get the coming re-trial in October transferred out of Horton's court into that of judge Callaghan, another well-known Ku Kluxer, has also been spoken of. Applications for bail for the boys were refused; the two youngest are still illegally held since the beginning, never having been tried in the juvenile court where their cases belong. Knight has made it clear throughout that he will do his utmost against these now 15-year-old boys, whom he calls "incorrigibles."

* * * * * *

That, at present writing, is the state of the case. That the verdicts on all the boys will most probably be the same as that on Heywood Patterson is likely. This is one of those long periods, of which there have been many in the two and a half years since the frame-up was enacted, during which no fresh move takes place, no word about the boys comes out of America. Remember the apprehension that lives with you as your daily companion in a cell—the boys face this third trial in October, next month. Yes, the legal position is better for them now, two Appeals having been granted; but the lynching spirit was even fiercer at Decatur than at Scottsboro, prosecutor and jury as determined to convict. As the world's anger, the world's protests augment, so do the fury and mortification of Alabama mobs and "justice." The outcome of the third trial is by no means certain. One thing we know there will be, and that is a yet greater increase of hysteria, an increase of the danger of actual lynching. Despite State law it is *not* an impossibility, constitutionally, for the case to be tried out of Alabama, right out of the South. A word from President Roosevelt would be sufficient influence to bring this about. But the boys can rely only on the International Labor Defense. The I.L.D. has proved by its colossal legal fight and organisation since the beginning that world protests backing up the struggle to establish Negroes' legal rights can stay the hand of lynch law, can and do expose the criminal mistreatment of Negroes in America.

It is only by fighting that anything of major issue is obtained. In the way of justice, of aid and of good the black man in America until now has received from the white only what must be classed as the comparative crumbs of humanitarianism and philanthropy. We do not ask for our Negro comrades these tokens of guilty conscience, these palliative gestures. *We demand recognition and enforcement of the Negro's full rights, as an equal, as a brother, and an end to the oppression of coloured peoples the world over.*

Sept. 16, 1933.

Lynching in the Quiet Manner

by JOSEPHINE HERBST

THE new trial for the eight Negro boys at Scottsboro, Alabama, condemned to die on July 10 [1931] has at this writing been denied. It has now been appealed to the state supreme court. The Jackson County papers are upset at the publicity thrown on this case. They would like everything to run in a nice, quiet, gentlemanly way. Those well-meaning people who wish to depend on "legality" to save these boys, are, whether they are aware of it or not, hand and glove with Jackson County. The South has always been strong for lynching in the quiet manner, without even the confusion of the law. Now that the law is brought in, they would like to see it oiled so that the boys could be shot through to the chair without disturbing anyone's feelings. If you read the transcript of the first trial and particularly the judge's admonition that there is to be no demonstration, you will be impressed with the legality. It was, from Jackson County's point of view, perfectly legal. Quiet in the courtroom, and outside a brass band playing "Dixie" to the cheers of thousands in celebration of the verdict of guilty. The trouble with legality is that it has a thousand different interpretations. Legality alone has never been known to accomplish much. Without social pressure it can run in grooves hundreds of years old. Law is supposed to represent the *mores* of a group and it lags behind several hundred years and is never brought out of its rut without social pressure. The particular handling of the Scottsboro case is a remnant of legal slavery. The Negro has never really emerged from slavery. Conditions of tenant farming, vagrancy laws, chain gangs, have conspired to keep him in his place. If legality is going to be his last appeal, he might as well give up.

Legally, the Negro is penalised all over this country, North and South. He can't beat the law game when it is interpreted by white men still dominated by a slave-owner's code. The Negro may run a

Lynching in the Quiet Manner

better chance in the North, but only because the North never depended on the Negro for its big labor supply. The Negro wasn't as necessary in the North, where there was a steady stream from Europe of Wops, Bohunks, Micks and Polacks.[1] The South has never got over the Civil War. Down there you may still hear youngsters talk about the war and wonder what war. Why, the Civil War. They are still fighting it. In the mind of the South, the Negro has never got past his Civil War status. The first laws concerning the Negro were made when slavery was introduced in this country, and those laws, in different forms, still exist. They are still there to guarantee Negro labor in the South.

Jackson County is stepping lightly in this case. They expect, if given time, things will quiet down. Then the legal machinery can roll on quietly to their satisfaction. But they are fooled. The longer it is postponed the louder will be the protest.

Left to legality, the superstition of rape would finish off these boys in the chair. The testimony of the alleged victim, Victoria Price, conflicts with itself. Her version of the affair is a gaudy one. A knife was at her throat and twelve Negroes all brandishing knives and guns leaped over the side of the gondola at her. Although her mouth is smothered by a hand or arm and she is almost beside herself she manages to keep track of the boys and to identify them in the order they vanquished her. Out of the corner of an eye she also takes in the customers of Ruby Bates, her fellow traveller. Such an all-seeing eye dumbfounds one. It isn't to be believed. And it confutes itself the next day when she admits she cannot identify the boys in the order of their attack. She isn't even sure of Ruby's customers. Her ears have sharpened, however, because on the first trial she hears one shot; on the second, seven. She betrays herself with slips of the tongue. Denying that she ever saw the white boys in the gondola before, and ever spoke to them, she yet calls one of them by name. "Thurman," she says, "saw the Negro grab me as he went over the side of the car." It is for these women, established as prostitutes, who were not overpowered or hysterical, according to the doctor's report, but merely talkative, that eight Negro boys were legally condemned to die.

The Nation comes more or less half-heartedly to the defense of the case. It wants a gentlemanly defense. If this were a "just" world there would be a good deal to say for that. Depending on legal machinery is continuing to trust where trust is no longer justified. It was all very legal in the Sacco and Vanzetti case. Whatever reprieves Mooney has won were got by working-class protest and a wave of public sentiment that started in time to save him at least from the chair. It is too late to be polite in cases of this kind. The law is not abstract, impartially arbitrating between conflicting social classes; it is a tool in the hands of those who govern.

The N.A.A.C.P. (National Association for the Advancement of Colored People) have complicated matters by refusing to co-operate in the defense. Because they are largely subsidised by upper class money they pretend to smell a rat in the I.L.D. defense. They claim that the case is only being made into Communist material; and rather than pollute themselves they confuse the boys on trial and reduce the issue to one of petty squabbles. Eugene Gordon, Negro writer, comes out with a strong statement against this process. "The N.A.A.C.P. no longer exists for the advancement or the advantage of the lowly Negro."

Some say this is not a labor case, but these boys were on the move because their families were poor and they had no work. The whole race problem in the South is first of all economic. It is his position as a laborer that forces him back into the legal status of a slave. The ignorance and poverty which *The Nation* so deplores is an economic problem. It isn't a mystical one. The Negro worker is ignorant and poor because it has seemed to be an economic advantage to keep him that way.

Mrs. Wright, mother of two of the boys, may be poor, and she may even be ignorant, but character and fortitude she certainly has. Her husband has been dead for seven years. She leaves the house every morning at quarter-past five and gets home at half-past seven. For this, she gets six dollars a week. It was lately raised from five dollars. She is very tired when she gets home and doesn't cook much, just opens a can of something. It isn't so healthy, but there is very little money. Car-fare costs so much. This winter things were pretty bad. The boys couldn't get a thing to do. Then her daughter came home. They were on a farm and it was closed out on them. She and her husband came to live in their house. Of course, she brought along a lot of canned stuff, and that was as good as money, and she brought along her own meat. Yes, she brought a pig weighing 135 pounds and that was fine alright. But they soon ate that and he couldn't find work. Her six dollars, five at first, didn't go far. Her boy, that's Andy, he said he just wished he'd get work so she could sit her down. He says, "I just wish you could sit you down." But there weren't no work and so him and Roy said they would go to Memphis and maybe find some.

That's the way the two boys left home. Then one day she was on her way to the five-fifteen car, and her sister that lives near the car-line came out with the paper. "'Where's your boys, Ada?'

[1] Italians, Central Europeans, Irish and Poles—derogatory.

" ' Why, my boys are in Memphis,' I says.

" ' No, Ada, your boys ain't in Memphis,' and she hands me the paper. I read it and I just says, " Well, well, well." I couldn't think of another word.' "

Of course these boys didn't get much schooling. One went to the third grade, the other got as far as the sixth. The other eight boys have similar stories. They are, as *The Nation* says, poor and ignorant.

The Wright boys sometimes teased to go to a movie, and then their mother says to them, " Well, if you boys want to go without your supper, you can go, I can't afford supper and movies," and then the boys would go without their supper. It was either supper or movies, and they didn't get to the movies often, because they were always hungry.

The legal machinery is very rusty in the South with its traditions of slavery, its superstitions and its fears. It will take more than that to save these boys. It will take what Jackson County is afraid of : working-class protest, the pitiless eye of publicity that will expose, evidence for evidence, the flimsiness of the case against them, that will not only show up the evidence but the mob psychology aroused, stimulated and constantly exploited by the governing classes of this country.

Reproduced by courtesy of the author and of *The New Masses*, New York, July 1931.

Speech on the Scottsboro Case

June 5, 1931

by THEODORE DREISER

(Theodore Dreiser is chairman of the National Committee for the Defense of Political Prisoners, working in conjunction with the International Labor Defense on the Scottsboro Case.)

I BELIEVE that light may come upon this Scottsboro case only by considering it from the point of view of the Negro question in the large. The Negroes, whom I believe to be a promising race with a future, were viciously enslaved through outside instigation during the early days of this country. The United States as a whole, particularly the North, felt that holding and driving these humans was not in keeping with advanced standards of freedom, opportunity, and decent living. A tremendous sympathy and humanity welled up to the American Negro ! Later, and as a result of the Civil War, the country tried to force this attitude upon the South. Unfortunately, attitudes not in accord with custom or mood are forced upon any people with difficulty. For that reason the South changed little from the pre-Civil War slave standards under which they were brought up and to which they were accustomed. The drastic old slave codes of the 1830's were, after emancipation, remodelled in only a minor way. Though the Constitution gave Negroes the right to vote, this was early evaded by clauses denying this privilege to all except those whose grandfathers had voted before the Civil War. Since illiteracy has always been great, if not complete, among dominated Negroes, the voting requirement that persons must read and write has deprived hundreds of thousands. Private coercion as well put down almost every small privilege permitted at law.

These harsh statutes, and the vicious subjection of the Negro who has always been inhumanly exploited in the South, endure until this hour. And yet, I wonder if today it is not more a matter of custom rather than of real angry thought or feeling, and that this custom is being utilised for ulterior purposes. We are all so prone to continue a custom or habit long after the reason for it has been forgotten. At present, Negro tenants are held to the land by scores of brutal laws, and law enforcement tactics furthering forced labor and peonage. Even the industrial Negro, at his first concern for his own welfare, is treated with violence. Because of its common training, the mass, united and strong, as well as the intellectuals who sit above and direct it, hold to the conviction that the Negro race is intended by Nature or God to be an under-privileged one.

Yet these enormous class gulfs provoke a psychology terrific in its possibilities for cruelty and evil, and in its turn this becomes the very rock-bed of mob-rule and mob-horror. But why ? Our Negro Americans did not come here. They were forced here. And since coming, have worked and worked well and peaceably. As I see them, they are the least destructive and actually the most law-abiding of all our mixed peoples.

Speech on the Scottsboro Case

And yet, the entire sociological background of the South today remains against them, and has a direct bearing on this Scottsboro case. The severe law, for instance, inflicting the death penalty for rape is, in itself, a commentary on what I mean. It is so definitely aimed at the Negro male, and so very lenient to his white equivalent, who miscegenates without opposition. But mixing the blood of a white man with that of a Negro woman is certainly the same as mixing the blood of a black man with that of a white woman. The difference is that of tweedledee and tweedledum. But is the white man hanged for rape? Or do white mobs gather to see that he is hanged? Yet this latest alleged black outrage has excited the minds of the people of the whole region adjacent to Scottsboro. The psychology of the South concerning white girls reported alone with colored men, as they were in this case, leaves no doubt of rape to those who see the imminence of rape in the mere proximity of the two races.

Black is black and white is white, and the one shall be the slave of the other. During the trials of these nine Negro boys in Scottsboro, for instance, people so fiercely believed rape had been committed, and so wanted this vicious so-called justice, founded on their prejudice, that hooting and yelling and rejoicing and applauding not only followed the verdict of death, but this outcome of one trial was being uproariously cheered while the jury for another of these boys was behind closed doors deciding as to their verdict. But is it not obvious that these 10,000 people in the yard outside the courthouse, tumultuous in their mob-unity, and with a band of music blaring forth their conception of what was fair and necessary, made the trials of the remaining Negro defendants only slightly above a lynching in the ordinary sense of the word?

The entire trial, as I see it, its brevity and fierceness, showed all too plainly the underlying class viciousness of the South. I now consider that these Negro lads were convicted more on prejudice than on the evidence brought against them by the State. For one thing, a number of points was made as to who was colored and who was not. Instead of trying them as human beings, they were tried as black men. The testimony which caused eight of them to receive the death sentence was that of Ruby Bates and Victoria Price, whom they were supposed to have raped. Neither of these girls made any charges until confronted by the excited townspeople—and apparently forced by officials. A doctor testified that although on the night of the alleged rape at the first examination they were calm, at the second one, and by the time they had been pumped and cross-questioned insistently, they were greatly unnerved. I believe that this came from being forced to say what was not so, or what the two girls could not agree upon. The evidence of intercourse was of such nature that it could have occurred two or three days prior to the alleged crime; besides, there was almost no evidence even of this nature regarding Victoria Price, who testified that she didn't scream, and that she delayed getting off the train until she wanted to.

Furthermore, these two girls, from affidavits gathered by the new defense, are lacking in moral discretion. From reading their testimony I know that they are ignorant, and the older one hard-boiled and racy. The fact that these girls were in overalls and alone on a freight train made the very nature of the situation provocative. Ruby Bates testified that white boys were on the train to Chattanooga the day before the alleged crime, and also when she and Victoria returned the next afternoon, white fellows hopped a car in the same city. Victoria Price, one of the girls alleged to have been raped, said on the witness stand that she had seen two of the Negroes previously in the home town of Huntsville.

The only evidence of the force necessary to make intercourse actual rape was that of the two girls for the State, and denied by the defense for the boys, a gun or two which were supposed to be in the Negro crowd, but had not been fired, also so-called and supposedly drawn knives, although apparently no more than jack knives. Yet Victoria was likewise carrying a knife!

With evidence so sketchy and contradictory, and with the whole case so hastily prepared and presented, and, above all, with the rule of the mob over the jury, I believe that a change of venue should now be granted; the trial moved entirely away from this frantic spirit of opposition by the people.

Further, though, my interest is not only in a more sound-minded trial for these boys, but more particularly for the general broadening and humanising of the universal treatment and condition of the Negroes, especially in the South. For up to now, this general attitude continues to practically encourage and achieve an indirect form of enslavement, and because of the ruthlessness of this class difference, incites prejudice to the point where scores of cases, like this Scottsboro affair, happen, and hundreds of actual lynchings result. Yet such violent exploitation and hatred and prejudice can only provoke, not lessen, crime on both sides. Besides, by now this Negro-lynching has become not only an age-old national menace, but almost a legitimate practice in the South which must be averted and stopped.

But at present, understanding and even humaneness? No, mob and judicial murder!

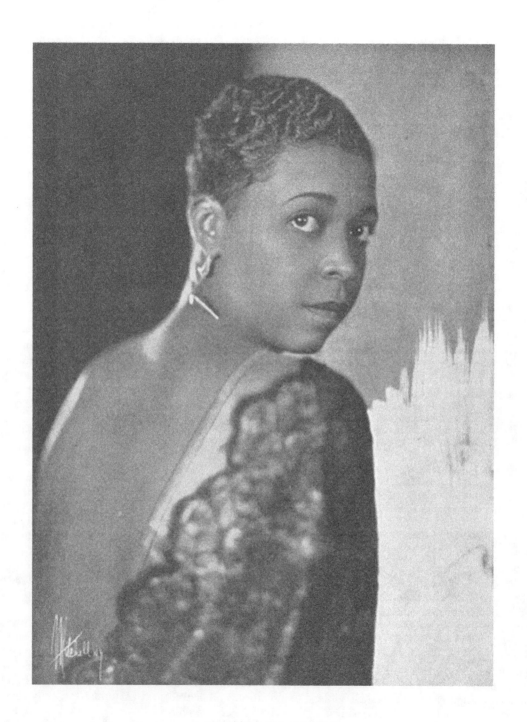

ETHEL WATERS
Great vaudeville star and singer

NEGRO STARS

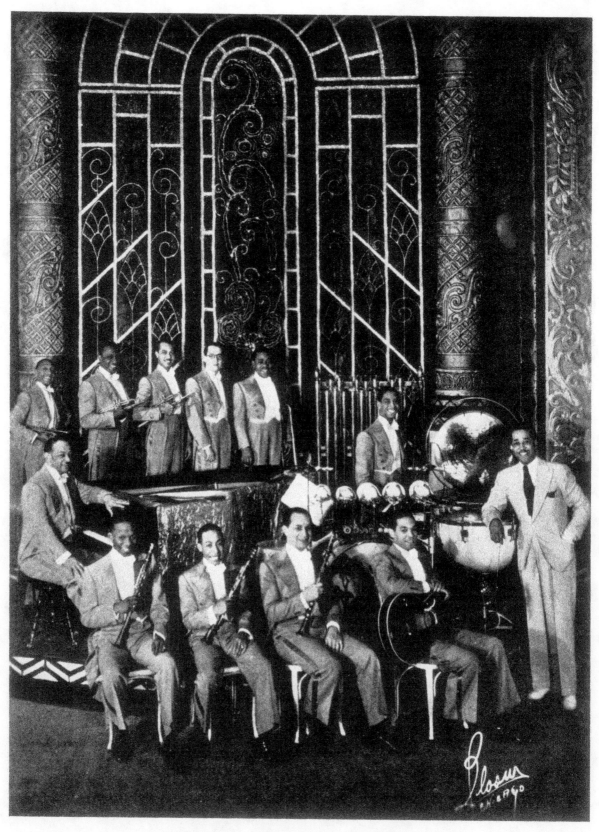

The great DUKE ELLINGTON
and his famous orchestra; " The Duke " standing on extreme right

The Best Negro Jazz Orchestras

by ROBERT GOFFIN

(Translated from the French by SAMUEL BECKETT.)

FROM the Atlantic to the Pacific, from Harlem to 'Frisco, the fertile musical territories of the States are studded with the tumultuous capitals of fashionable jazz. There are certainly more good orchestras than there are states, which means that it is very difficult to be familiar with them all, at least as far as I am concerned, who have never been able to identify all the stars of the American flag.

The conscientious explorer must arrange to spend some time in the provincial towns and small villages if he wants to make himself acquainted with genuine local flavours and with the strange and passionate quality of the numerous orchestras whose function is to maintain the fever of their patrons at high pitch.

It is the Negroes, children of the sun, who have restored to America something of her old radiance, pouring forth a music whose charm is never wasted on the people that matter, and which has done more to further friendly relations between blacks and whites than all the laws and edicts ever issued.

Jazz is the supreme link between this lovable people and its ideal. At the present time black and coloured musicians participate on equal terms, like chess-men, in a disinterested collaboration. The Negroes, with their syncopated music, stimulating art and sensitive spontaneity in whatever they do, are founding a great cultural tradition in America.

In Europe too there are some vigilant spirits susceptible to the syncopated magic of the new Negro music and anxious to lose no syllable of the oracle as evoked at will from the spinning and flashing of the discs beneath the needle.

Oh you musicians of my life, prophets of my youth, splendid Negroes informed with fire, how shall I ever express my love for your saxophones writhing like orchids, your blazing trombones with their hairpin vents, your voices fragrant with all the breezes of home remembered and the breath of the bayous, your rhythm as inexorable as tom-toms beating in an African nostalgia!

The first ambassador of syncopated music to visit Europe was Louis Armstrong.

I went to London to hear this colossus of jazz. His name is up everywhere in enormous letters, all the local musicians are in a ferment, the demented scales of his nostalgia are evoked in every conversation.

I hurried off to Victoria Station on the chance of seeing him. I waited for half-an-hour in a tumult of home-comings, screaming porters, rainbow-labelled luggage and the terrifying gravity of Cook's undertakers.

I see a man laden with flowers—but I've wasted my breath, they are not for Armstrong. Then a Schubert-skulled tourist, but he is only a clerk and thinks that Armstrong is a celebrated lawyer; then an inexcusably beautiful woman looking boomerangs for all she is worth, and assimilating me to a universe of adorers; then a gentleman in a blue suit, flowing blue tie and beaver; his equatorial complexion and wet eyes decide me:

" Are you waiting for Armstrong? "

" Yessir, that's me."

Immediately he starts clapping me on the shoulder, calls me dipper and sacker-mouth, his rough voice crackles with petulance, his eyes go on fire with laughter like a child's, his mouth opens on the whitest of teeth.

He does not know who I am, but that does not matter. He assumes I am some sort of musician or manager or pugilist, a good pal anyhow whoever I am. When I give him my book he dances with pleasure, takes me in his arms, overwhelms me with cigarettes, threatens to have a shave in my honour. We fly about London in a taxi. Beside the driver there is a kind of metal drum beating the rhythm of the shillings—and what a rhythm!

We arrive at a restaurant; I look at him beside me, he is simple, naive, jovial, sly, malicious, his mouth is a maw of laughter. His rosy-palmed hand beats a tattoo on the table or seizes me by the arm or plays on the imaginary pistons of a fork.

He is firmly established before his sugared baked beans and he is happy because his thoughts are of New Orleans, of Charlie Alexander his pianist, and the Southern cooking whose praises he sings in *When It's Sleepy Time Down South*; and perhaps also of me whom he is beginning to like.

There is a first rehearsal at six o'clock at the Studio in Poland Street, where the ten coloured musicians recruited in Paris are ready and waiting. I scrutinise him more closely: he is smaller than he appears in his photographs but his trumpet is bigger; he talks and gags with the ten musicians; continual use of

The Best Negro Jazz Orchestras

the mouth-piece has put a tuck in his lips; he produces a few vertiginous notes, sees that his players are where he wants them, executes a pirouette, snatches off his coat and opens a huge trunk packed with bundles of music labelled: " Louis Armstrong and his Victor Recording Orchestra."

The tempest of *Rocking Chair* breaks loose and Louis plays, conducting with his eyes, sudden jerks of his hands, capers and contortions of his whole body, as though he wanted to terrify the three saxophonists who find themselves called on for a " hot " ensemble. Then he sings softly, facing his public, his eyes lowered, his hands behind him splayed like a valve before the impact of the rhythm; he twists his mouth, mumbles his words, interpellates the pianist, lifts his leg and rocks with laughter.

After *Rocking Chair* he gives us *Sunny Side of the Street, Confessing, You Rascal You, When It's Sleepy Time Down South, Them There Eyes,* and finally *Chinatown,* which explodes like a bomb.

In action Armstrong is like a boxer, the bell goes and he attacks at once. His face drips like a heavyweight's, steam rises from his lips; he holds his trumpet in a handkerchief, passes into a kind of excruciating catalepsy and emerges Armstrong the sky-scraper, rockets aloft into the stratosphere, blows like one possessed and foams at the mouth; the notes rise in a wauling and the whole right side of his neck swells as though it must burst; then, summoning up all the air in his body for another effect, he inflates his throat till it looks like a goitre.

Soon he is lost in the rhythm, he is master of the rhythm, he is the rhythm, the force and energy of the music, so that the audience rises to its feet, sways and dances and laughs with Armstrong and tries to embrace him.

The players themselves seem electrified before their stands; they gesticulate and play as functions of Armstrong; a gesture of his hand and they stop—another, and they resume.

I was present at the first performance, in a tense and overheated hall. Armstrong was laughing, sure of his triumph. The vast hall of the Palladium was too small for his thunderbolts, the trumpeters broke their instruments on their way out.

I dedicated my book *On the Frontiers of Jazz* to Louis Armstrong because he is the king of rhythm. Apropos of this dedication, Henry Prunières, the French musical critic, expressed himself in the following terms: " Robert Goffin thinks that Armstrong is the greatest of them all; I myself admire him profoundly, but I consider him very inferior to Duke Ellington."

I do not think it is possible to compare an individual with an orchestra. Armstrong is the quintessential expression of " hot," the genius of improvisation; Duke Ellington represents the phenomenal achievement of the man-orchestra, he is the genius of cohesion, the leader of the finest ensemble in the world.

What words can express the sublime accomplishment of Duke Ellington? For years, with incomparable courage and temerity, he strove to enrich his race with a truly personal music. Now little more remains for him to do. Before we can realise the full extent of this amazing performance we must go back to his early records and listen to the quality of balance, attack and cohesive power peculiar to his unparalleled production.

I consider Duke Ellington as the most extraordinary phenomenon in the whole development of jazz. He took wing in a first period of enthusiasm, in common with other executants, for the undiluted spirits of " hot "; these early performers played in a kind of inspired trance, they were accumulators of musical energy and transmitted the flow of syncopation without comment. This technique of production has been rationalised by Ellington, who has never ceased to cultivate, along with the essential " hot," the problems of arrangement and presentation. He realised that most of the best Negro orchestras had sublime flights of individual improvisation above the inferior level of a too much improvised ensemble, and it was this disproportion that he proposed to remedy.

The music of Duke Ellington tends away from the instinctive " hot " towards a style whose organisation is miraculous. This unique conductor has gradually placed intuitive music under control. Never doubting the importance of his undertaking he has realised, in his glorification of jazz, the greatest achievement of his time.

Reference to his less recent records leaves us with no doubts regarding the quality of jazz as presented by Duke Ellington—brilliant, carefully gradated and proportioned, its rhythmic element scrupulously cultivated, the ensembles of brass full of original initiative, the arrangements fresh and stimulating. Such is the personal achievement of Duke Ellington, to which must be added an extraordinary gift for exploiting the " hot " personality of his players. Thus the greater part of his magnificent *Tiger Rag* is devoted to a clarinet explosion from Barney Bigard, and a long passage in *Don't Mean a Thing* to a vertiginous solo by Johnny Hodge.

Duke Ellington strengthens his position daily. I have heard his latest records: *Sheik of Araby, Moon*

182

The Best Negro Jazz Orchestras

Over Dixie, Jazz Cocktail and *Stars*, and there is no doubt that this great conductor is pursuing his work in accordance with its initial conception. His realisations are emancipating themselves more and more from dance music and undiluted " hot " and tending to become concert music of the most definite description, full of a rare creative sense, a fertile initiative and an incomparable originality, analogous to that of the *Rhapsody in Blue*, but more complete, because it is only under Duke Ellington that composition and execution coincide.

Ladies and gentlemen—the orchestra of Duke Ellington. It will bring jazz and Negro music to all those who are in love with the classical tradition, it will satisfy the cultivated aspirations of all those who up till now have been disappointed.

Not far below these peaks of Negro jazz we find others whose achievements are beyond all praise ; I refer to the orchestras of Fletcher Henderson, Don Redman and Baron Lee ; nor should we forget the celebrated Cotton Pickers, Luis Russell, Cab Calloway, Chick Webb, King Oliver, Bennie Carter, Noble Sissle, Sam Wooding, Earl Hines, Jimmie Noe, whose vitality makes the petulance of white orchestras sound a very poor thing indeed, with the sole exceptions of the Casa-Loma and Red MacKenzie bands.

It is impossible to consider in detail these orchestras and many others. They have all a well-developed personality, a sure sense of " hot," an originally organised rhythmic structure and executants of the first order.

Worthy of special recommendation, however, are the achievements of Fletcher Henderson, whose *Radio Rhythm* and *House of David Blues* are on a very high level indeed. Their imaginative organisation is extremely powerful and bound together with the musical inspirations of such virtuosi as Hawkins, who is the greatest saxophonist in the world today.

Then there is the orchestra of Don Redman, who for so long was leader of the Cotton Pickers. His records are remarkable for their precision of gradation, inexorable rhythm and that instinctive propriety of atmosphere which imparts to such numbers as *Shacking the Africa* and *Chant of Weeds* an indescribable quality of beauty and nostalgia. Nor can I refrain from mentioning Baron Lee and his Mills Blue Rhythm Boys, whose highly personal performances are notable for the exquisite excursions of the pianist Edgar Hayes, the tenor Cass MacCord, and the trumpeter Anderson.

Some critic whose name I forget, speaking of the above-mentioned orchestras, described them as the " Big Five " and asserted their unquestionable superiority over all their rivals.

Space will not allow of my dealing with the endless cohort of satellites that attends these major planets, but I cannot conclude this study without naming the four musicians who have left an indelible mark on jazz, so much so that jazz would not be what it is but for the inspired contributions of these creators. First and foremost we have Louis Armstrong and Bix Beiderbecke (the latter a white man of Jewish extraction), whose powerful and original treatment of passages for trumpet have revolutionised the entire technique and theory of that instrument ; then Hawkins, who more than any other has influenced saxophone playing, and it may be asserted that but for him even the finest exponents of that instrument would be incapable of evoking that atmosphere of instinctive power which is his alone and which we recognise in them as coming direct from him. And the fourth is of course Earl Hines, who a few years ago was an archangel of the pianoforte, astonishing all those who heard his records, and whose influence on pianoforte technique has been widespread and profound.

That is an approximate balance-sheet whose assets are sadly understated but which, I trust, is sufficiently informative to encourage all those who take an interest in the subject to explore for themselves and in greater detail this magnificent Negro music.

Jazz is abundantly and gloriously alive. All honour to those who, with nothing but their instinct to serve them, gave America this music of which she will one day be proud. And may these few lines be the first act of homage from a son of Europe to a race whose prodigies, north and south of the Line, are without number.

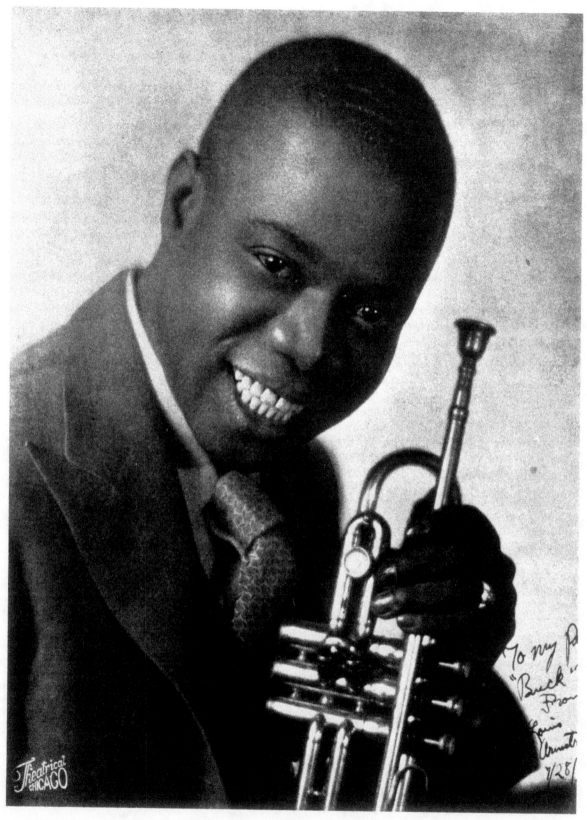

LOUIS ARMSTRONG

The world's greatest trumpeter and a superb musician; the
orchestra leader whose renderings of jazz are unique

Photo by courtesy of Floyd Snelson

184

Louis Armstrong

by ERNST MOERMAN

(Translated from the French by SAMUEL BECKETT.)

suddenly in the midst of a game of lotto with his sisters
Armstrong let a roar out of him that he had the raw meat
red wet flesh for Louis
and he up and he sliced him two rumplips
since when his trumpet bubbles
their fust buss

poppies burn on the black earth
he weds the flood he lulls her

some of these days muffled in ooze
down down down down
pang of white in my hair

after you're gone
Narcissus lean and slippered

you're driving me crazy and the trumpet
is Ole Bull it chassés aghast
out of the throes of morning
down the giddy catgut
and *confessing* and my woe slavers
the black music it can't be easy
it threshes the old heart into a spin
into a blaze

Louis lil' ole fader Mississippi
his voice gushes into the lake
the rain spouts back into heaven
his arrows from afar they fizz through the wild horses
they fang you and me
then they fly home

flurry of lightning in the earth
sockets for his rootbound song
nights of Harlem scored with his nails
snow black slush when his heart rises

his she-notes they have more tentacles than the sea
they woo me they close my eyes
they suck me out of the world

CAB CALLOWAY
The brilliant orchestra leader, composer, singer

Photo by courtesy of Floyd Snelson

186

Some Notes on the
Musical and Theatrical Negro Stars
of America

by FLOYD SNELSON

Floyd Snelson

THE MILLS BROTHERS, in my estimation, have made the greatest achievement on the stage and in the radio world that could possibly be made by any group of individuals. These boys have startled the entire country with their unusual ability and unique talents. They have astounded the nation with the most original technique, diversified entertainment, and vehement versatility of epochal significance ever before displayed, regardless of race or color. They were crowned the "Kings of Radio and Stage" by popular and public opinion last year, without competition or restraint.

DUKE ELLINGTON, whose orchestra, the "Aristocrats of Jazz," is proclaimed the most popular combination, was crowned "The King of Jazz" last season. It has achieved greater laurels than any other Negro band in the United States. Mr. Ellington, himself a royal gentleman, a master musician, a dapper maestro, and a perfect leader, is perhaps the best in his line.

BILL (BOJANGLES) ROBINSON, noted tap dancer and idol of the stage, is America's best entertainer at this particular time, especially where box office receipts are concerned. Bill is yet to be excelled when toeing the mark of the boards, and his unique stage presence is yet to be equalled. He's a wise-cracker unbeatable, and maintains a perfect reputation.

RICHARD B. HARRISON, "de Lawd" in the Pulitzer prize play *The Green Pastures*, is the marvel of the stage and theatrical world. Mr. Harrison has headed the cast of this remarkable play with great distinction, and his splendid artistry has made him an outstanding disciple of drama in the United States. The play may go to Europe, it is stated.

PAUL ROBESON, who is the star singer in Florenz Ziegfeld's late revival of *Show Boat*, is a performer who is admired on both continents. Before he went to Europe he made a name for himself in several casts as an inimitable actor. In his London performance of "Othello" his distinction was greatly manifested; and since his return to America his fame has doubled.

Bands, orchestras and music provide the greatest pastimes in these American states. CAB CALLOWAY has been the idol of the radio and dance fans for the past decade. The Columbia Broadcasting System has glorified the talents of this clever young maestro from the Cotton Club in New York City. His "hey de hey, hi de ho" rabble and his own composition, *Minnie the Moocher*, have met with the general approval of the younger group, and one much enjoyed by those who like the original Negro jazz tempo. Cab Calloway is perhaps one of the most sensational miracles of the orchestra world. He is an affable and debonair youth who rose from obscurity to the heights of fame and glory in the short space of about two years. His unusual stage presence and personality "plus" has amazed his elders. His voluptuous suavity in mastering the eccentricities of jazz-mania has created a furore on the great white way of Broadway. His appearances in the largest and finest Paramount-Publix and Warner Brothers' houses and on the R.K.O. circuit have been marked by gigantic successes.

MISS ETHEL WATERS, the sepia queen of syncopation, demands recognition because of the fact that she has added a new note to the Negro blues singing, and has caused many people to be cognisant of the fact that Negro jazz is a human instinct which they cannot avoid, if they are of true-blooded Yankee stock. Her singing has been a sensation from Broadway to Hollywood, and she has no rival in her particular line as yet.

187

Musical and Theatrical Negro Stars

At this particular time NOBLE SISSLE and his orchestra are thrilling the dance visitors at the Park Central roof garden, on the brink of New York's aristocracy. It is the highest class Negro band in the profession, according to the management of that notable hostelry. The élite of society is well pleased with Noble Sissle; he is a maestro who caters to its wants and desires. He satisfies it, and the result is that Noble Sissle holds a place no other can maintain.

VALAIDA SNOW is a wonderful character. World-wide fame rests upon the art and versatility of this little lady, and Lew Leslie's *Rhapsody in Black* is her greatest vehicle.

LOUIS ARMSTRONG, the greatest trumpet player the world has produced, is an outstanding figure indeed. His illustrious playing of the cornet and unusual display of artistry has won enviable plaudits for him. He's designated as the "King of the Trumpet," and he is.

ADELAIDE HALL is a most charming young lady of great finesse, with one of the most winning personalities to be found on the stage. She has had great success in Europe with the Louis Douglas troupe, and also in *Blackbirds*.

ROLAND HAYES, the Negro world's greatest tenor, a lad who went from Georgia to Boston, is a great artist whose dexterity is not the pride of his race or people, for he has set himself apart. He is a great man and his deeds are well known, but we are not so proud of him as a fellow Afro-American. He might just as well have been a Senegalese or a West Indian; but he's from Georgia. We hope he gets citizenship somewhere, but it won't be in the "cracker" state of Georgia.

GEORGE DEWEY WASHINGTON is an ace of voluptuous song, with a voice of vast magnitude and resonance. He has repeatedly captivated the patrons of the Radio-Keith-Orpheum, the Paramount-Publix and other picture and variety houses from coast to coast, and is very much appreciated in London and Paris also.

ADA WARD, the mellow-voiced radio star of the Cotton Club in New York City, often referred to as the successor of the late Florence Mills, is a prima-donna of excellence, possessing a surprising eloquence and poise. She has appeared on Broadway on numerous occasions, the most recent appearance being in *The Brown Buddies*. She was also in Lew Leslie's *Blackbirds* both here and abroad.

STEPIN FETCHITT is possibly the greatest Negro screen star in America. He is known throughout the world in his pictures for his comical drollery. His motion picture work in Hollywood has been very creditable in such films as *Hearts in Dixie* and *Salute*.

DANIEL HAYNES also is an actor and singer of great renown. His marvellous voice in the all-Negro talking picture *Hallelujah* was highly praised. On the dramatic stage he has starred during the past two years in *The Green Pastures*, the Pulitzer prize play of 1931.

ADA BROWN, known over the Radio-Keith-Orpheum circuit as the "Queen of the Blues," is also an outstanding artist. She was featured in *The Brown Buddies*, singing a number of popular hits, among which was *When a Black Man's Blue*.

JULES BLEDSOE, international singer, of *Old Man River* fame, who startled Broadway with his masterful eloquence in Ziegfeld's *Show Boat*, and has thrilled many distinguished audiences in America and abroad, has made a great hit in recent years. Bledsoe was a poor farm boy from a rural district of Texas who rose to lofty heights in spite of adverse circumstances.

WILL VODERY, master musical arranger, director and orchestra leader, who has been closely connected with Florenz Ziegfeld for a number of years, is one of the best musical authorities on Broadway. His advice and criticism are highly respected by the greatest producers of musical comedies in New York, as well as in the picture colony of Hollywood. His special arrangements have been highly appreciated in the musical world, especially in the Ziegfeld Follies and as theme songs of noted talking pictures. He is a native of Philadelphia, Pa., and began his career as an associate of Bert Williams, one of America's most famous actors.

FRANK WILSON is an accomplished dramatic actor who won his first laurels as the star of the Theatre Guild's greatest all-Negro production *Porgy*, which played a lengthy engagement at the Republic Theatre in New York, and later in London, England. The play returned to America and toured the leading cities. Mr. Wilson was a post-office clerk in the New York office, but he devoted his spare time to study,

and this enabled him to reach his great success. He has since been seen in leading roles in *Singin' the Blues* and *Abraham's Bosom*.

NINA MAE McKINNEY, the first Negro girl to pass the "film test" in the Metro-Goldwyn-Mayer Picture Studio in Hollywood, was starred in the great all-Negro talking picture *Hallelujah*, heading a cast of several hundred artists. This picture was produced at a cost of over a million dollars and shown in the leading theatres of America and Europe. Miss McKinney appeared along with the picture in Paris, Berlin and Monte Carlo. She began her career as a chorus girl in Lew Leslie's *Blackbirds*, and was chosen for the part by the producer, King Vidor, from a selection of hundreds of other girls of her race. Since that time she has been in Vaudeville. She also played opposite Dorothy Mackaill in *Safe in Hell*, a Warner Brothers' presentation.

LOUIS DOUGLAS, noted musical comedy producer, has produced shows in Paris for a number of years which have toured all the countries of Europe. He merits the name of a globe-trotter in every sense, being the best-known artist in Europe. His "Black Flowers" Co. is now on tour.

MME. NORA HOLT, the sweetheart of Monte Carlo, is a charming figure who has entertained extensively in the swank casinos of the Riviera, in Paris, Spain and Italy. Her wonderful artistry has been applauded by the aristocracy of Europe. She is a popular favorite in America and her entertainment in the most fastidious clubs and cafés in New York, Chicago and other cities has been highly appreciated.

EARL (SNAKE-HIPS) TUCKER, one of the most unique dancers of the profession, has been a sensational attraction in New York for several seasons. His style and clever acrobatic antics have stood out most conspicuously in the night clubs and Broadway shows. He was featured in *Hot Chocolates*, Lew Leslie's *Blackbirds*, which played at the Liberty Theatre in New York, and the Folies Bergères in Paris. Night-club patrons at Connie's Inn, one of New York's brightest spots, have been fascinated many seasons by his clever artistry.

MILLER and LYLES, often referred to as "America's greatest Negro Comedians," have long been Broadway's most popular funsters. They gained fame ten years ago in *Shuffle Along*, conceded to be the best all-Negro play ever staged by and for Negroes. Later they appeared in *Runnin' Wild, Rang Tang*, and *Sugar Hill*, and they are always headliners in Vaudeville.

GLADYS BENTLEY, comedienne of the bright-light spots of Harlem, is a very skilful pianist and singer. Her bizarre manner and surprising ability as an artistic entertainer have been the greatest attractions in the after-hour "speaks" of what is internationally known as "Hot Harlem," the black-belt of uptown New York. She is especially gifted in composing parodies upon the latest popular jazz hits.

OPAL COOPER, an international entertainer, better known perhaps in Montmartre, Paris, has had a more intimate acquaintance with contemporary celebrities, regardless of nationality, than any other entertainers of his race. He is a member of a world-renowned combination of stars that include (the late) Florence Jones, of Chez Florence, Sammy Richardson, Kid "Sneeze" Williams, and Elizabeth Welch, who entertained during the winter seasons in New York and during the summer tourist seasons in Montmartre.

EDDIE RECTOR, a dapper, nimble-footed artist whose skilful dancing is considered by many the best of his race. His neat-stepping, soft-shoe technique and pleasing personality have won him a place in theatrical entertainment that is hard to equal. He was seen in *Hot Chocolates, Blackbirds, Plantation Revue, Dixie to Broadway, Hot Rhythm*, and other Broadway musicales. He is much in demand in the night clubs of Hollywood as well as at Connie's Inn and Cotton Club in New York.

EDITH WILSON, internationally-known blues singer, is best known in New York, Paris, London and Chicago. Her rendition of the song hit *He may be your man but he comes to see me sometimes* made her famous in the revue with the late Florence Mills. She created a sensation in *Hot Chocolates*, singing *When a Black Man's Blue*, and was featured in *Hot Rhythm* and other attractions.

SAM WOODING and his European Orchestra, who recently returned to America after seven years of touring the Continent, are one of Europe's favorite Negro bands. He first gained recognition in Berlin in *The Chocolate Kiddies*, an all-Negro musical comedy that was imported to Germany. He remained abroad and thereafter toured the variety houses.

Musical and Theatrical Negro Stars

FLETCHER HENDERSON and his Victor Recording Orchestra have the distinction of being the first to be featured on the radio, and he is given the credit of having blazed the trail for the scores of Negro bands who are now featured over the ether. Henderson also has recorded more phonograph records than any other aggregation of color. He is one of the best known musicians in America.

CLARENCE MUSE, noted cinema actor of Hollywood, in recent years has been starred in more pictures in the leading studios than possibly any other member of the race. His parts have been mostly in all-white casts. At present he is the most active Negro in that profession.

McKINNEY'S COTTON-PICKERS, owned by William McKinney, is one of the best musical attractions in the mid-west. It has remarkable versatility in transmitting popular hits of the jazz market synchronised into melodious rhythm and tricky tonal mass. Intensifying his numbers in the old and new jackets, effectively arrayed, musical critics rate him as an ace. It is known as America's Collegiate Orchestra, having played for the leading colleges and universities for their annual fraternity and commencement promenades.

BUCK and BUBBLES are a pair of the cleverest performers on the stage today. They were the only members of their race featured in the Ziegfeld Follies last season, where they were proclaimed a riotous success. They began as ball-players in a baseball team in Louisville, Kentucky, and later had jobs in the jim-crow gallery as ushers in a cheap theatre. There they developed the idea of the stage. They have been box office sensations in all of the leading motion picture and vaudeville houses of the country. They also played several weeks at the Palladium in London and also in Paris.

CORA GREEN is Harlem's most popular torch singer, one of the highest salaried artists of the R.K.O. circuit. She has been the leading singer at Connie's Inn in New York for the past year. Has appeared in Vincent Youman's *Great Day*, co-starring with Miller and Lyles. Featured in Lew Leslie's *Blackbirds* along with Hamtree Harrington, having been called to London, England, to replace the late Florence Mills when she was taken ill. She is an accomplished artist and was well received in many Broadway productions.

JAMES CARL (HAMTREE) HARRINGTON is one of America's best Negro comics. Clever comedians must be amusing, funny, witty, comical, humorous, queer, strange, odd, original and laughable to be successful, and Hamtree Harrington knows how to fill the order. He usually works with a lady, having teamed with Maude Mills and Cora Green. Played in Leslie's *Plantation Revue, Dixie to Broadway, Blackbirds* of 1929, and has recently made a number of talking pictures. He is small in stature and is often called the vest-pocket edition of Bert Williams.

The incomparable LAYTON and JOHNSTONE have long been the idols of Europe. This internationally famous team, which has been a standard headliner in London, Paris and other capitals, has performed before the crowned heads of the land on numerous occasions. Their services have been in constant demand for many seasons at the Café de Paris, Kit-Kat Club, and other distinguished hostelries, by the Prince of Wales, the Royal Family and other notables. Their unique art is the summit of entertainment. They touch nothing they do not adorn. Even the most commonplace tunes become something like music in their hands, but when they get hold of a good tune they make you happy indeed.

JOHNNY HUDGINS is the original " Wah Wah " comedian. He sings, dances and acts, and never says a word. Some years ago, when he was playing in *Broadway Scandals*, he was feeling rather fatigued at one of the performances and it was quite a task to go on that evening ; so, when he did decide, he went on as a deaf-mute and put over his act, which was an instantaneous hit, and from then until now he has been a great attraction. Travelled all over Europe for three and a half years, and then went to South America. His performances are comparable to the antics of Bert Williams, Eddie Cantor or Al Jolson.

HALL JOHNSON is musical director of the choir of *The Green Pastures*. He is a native of Athens, Georgia, and received his musical education at the University of Pennsylvania, Hahn School of Music in Philadelphia, and the Institute of Musical Art in New York City. He was the winner of the Harmon Foundation award, having achieved the greatest laurels of his race, because of his wonderful arrangements of Negro spirituals and his original compositions. In his musical interpretations of these old themes he has followed the theory that they must reproduce the spirit and fervor of the old camp meetings which gave them birth in the Southland.

Musical and Theatrical Negro Stars

ALBERTA HUNTER, noted singer of Chicago, New York and London, made quite a name for herself in England when playing in the European edition of Ziegfeld's *Show Boat*. Miss Hunter has sung in Vaudeville and night clubs all over Europe, where she was greatly admired.

BILLY PIERCE is the director of a dancing school bearing his name on Broadway, which has been the place of instruction for the Negro dances. He has had the privilege of tutoring some of the biggest stage celebrities of Broadway in such dance routines as the " Charleston," " Black Bottom," " Buck and Wing," and all types and styles of tap and soft-shoe dances. Last year Billy Pierce was called to London by Charles B. Cochran to produce the dance routines for his musical success *Evergreen*, which had a successful run in Piccadilly. He has trained at his dancing school such stars as the Astaires (Adele and Fred), Irene Delroy, Frances Williams, Helen Morgan, Libby Holman, Lily Demetre, Marilyn Miller, Zelma O'Neil, Constance Bennett, Jack Buchanan, and scores of others.

THOMAS (FATS) WALLER, noted song writer of Negro jazz tunes, is accredited along with Berlin, Gershwin and Donaldson as the purveyor of sensational rhythm in scorching, wild-fire song hits. Just scan a few of his popular hits: *Ain't Misbehavin'*, *I'm Crazy about my Baby*, *Why am I so Black and Blue ?*, *Honeysuckle Rose*, *Rollin' Down the River*, *My Fate is in Your Hands*, *More than Satisfied*, *How Jazz was Born*, *Squeeze Me*, *Keep a Song in Your Soul*, *Concentratin' on You*, *Keepin' out of Mischief*, and many others. Waller wrote the music for many Broadway shows, including *Hot Chocolates*, *Keep Shufflin'*, *Tan Town Topics*, and floor revues at Connie's Inn, Everglades, Silver Slipper, and others.

MAMIE SMITH is the original phonograph recording blues singer. A healthy, clean-cut woman with a deep, wide voice who puts over blues numbers with all perfection and ease. Hers was the first Negro woman's voice to be synchronised on the disc. She has sung all over the country from coast to coast, and her type of artistry is especially in demand in the Southland, where it is as equally popular as the Negro spiritual.

DON REDMAN'S CONNIE'S INN ORCHESTRA is one of the best musical aggregations in America. He and his band of 14 musicians are heard regularly over the Columbia radio network from Connie's Inn in Harlem, and they are conceded to be one of the best on the air. His arrangements are in great demand with the orchestra world, and he has won great distinction with especially hot numbers for such famous bands as Paul Whiteman, Vincent Lopez, Ben Pollack and Nat Shilkret. He literally plays every instrument in his band. He began with a drum in his hometown, Piedmont, West Virginia, and later mastered the alto-horn, piano, violin, trombone, and finally the saxophone.

WILLIAM C. HANDY, the founder and originator of the blues, is the most noted song composer of the Negro race. He wrote the *St. Louis Blues*, which added a new note to the jazz interpretations of the Negro. *St. Louis Blues* is played and sung the world over, and is one of America's greatest popular favorites. Handy, the son of slave parents, was raised in the rural districts of Memphis, Tenn., and moved to New York City over twenty years ago, where he now makes his home. He maintains offices on Broadway, where he is known as the " Father of the Blues."

CLAYTON (PEG-LEG) BATES, noted comedian and dancer, is possibly the only man on the stage who has scaled the heights of fame and fortune with only one leg. He made his first Broadway appearance with Lew Leslie's *Blackbirds* in 1928, and went to Paris with the company, along with Adelaide Hall, Ada Ward and Snake Hips. He has toured the R.K.O. and Loews Vaudeville circuits, and is a great attraction from New York to Hollywood. He began the show business in O'Brien's *Minstrels*, and later in the *Dashin' Dinah from Carolina* Company. This cyclonic monopede has gained national fame on the stage.

CLAUDE HOPKINS and his ROSELAND BALLROOM ORCHESTRA have played on Broadway over 150 weeks at the ace of beautiful dance halls. He hails from Washington, D.C., and is a graduate of Howard University, holding the A.B. degree, and Mus.B. His first orchestra played at various New Jersey summer resorts, and in 1926 he sailed for Europe with Caroline Regan, a French playwright, who also took over the now famous Josephine Baker. While abroad he played engagements at the Champs Elysées Theatre in Paris, the Cirque Royal in Brussels, the Scala in Berlin, the Savoy Grill in Bremen, the Palace Theatre in Barcelona, Spain, the Royal Theatre in Budapest, and many other variety houses.

191

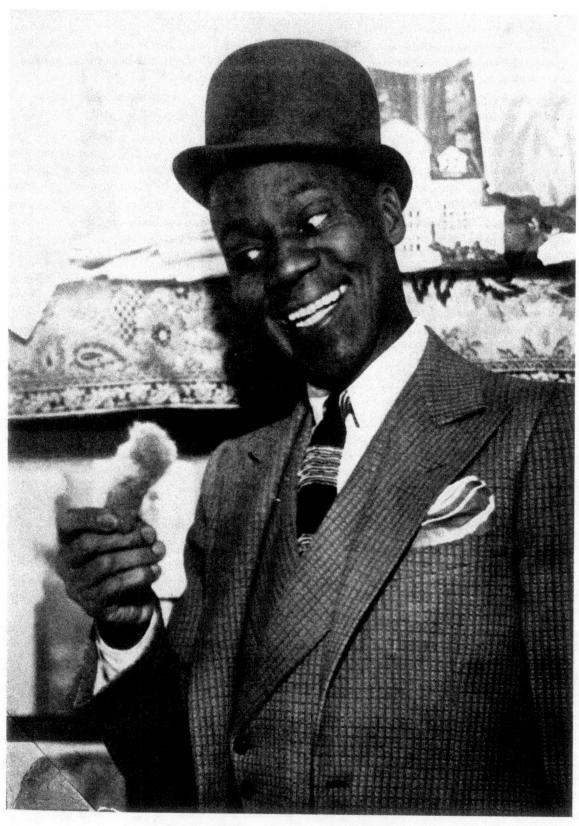

BILL (BOJANGLES) ROBINSON
Star of the tap-dancers

Photo by courtesy of Floyd Snelson

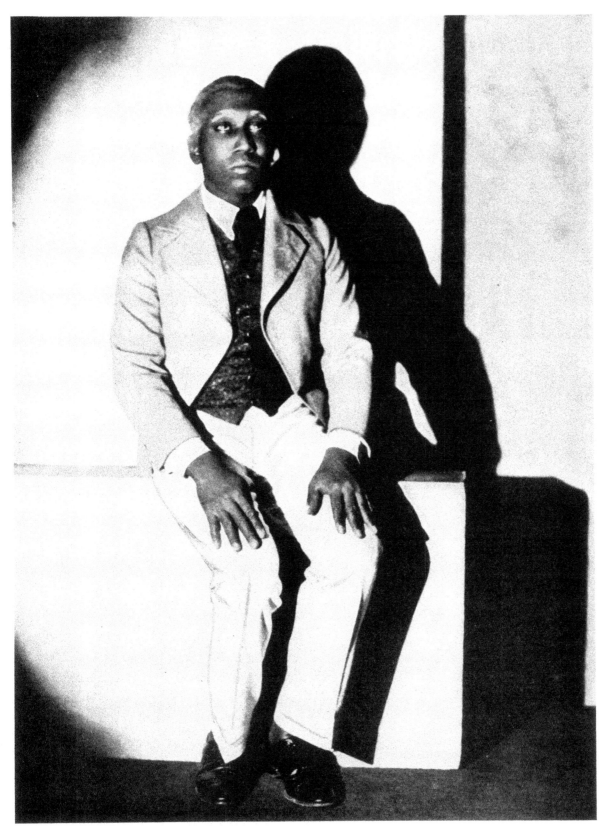

JULES BLEDSOE
A great singer and dramatic actor
in *Ole Man River—Show Boat*, 1930

193

The Negro Theatre—A Dodo Bird

by RALPH MATTHEWS

Theatrical Editor of the *Afro-American*

Ralph Matthews

A FAMOUS explorer returning from Africa once had much to tell about the Dodo Bird, an extinct fowl which, it was later revealed, did not exist at all. When one sets out to write about the Negro Theatre, he feels almost as guilty as the hapless explorer after the exposé. The Negro Theatre, as such, is a Dodo Bird.

By this I do not intimate that there are not certain cardinal Negroid elements, certain contributions of an unmistakable Afric origin, certain psychological situations that could be born only in the mind of a transplanted race, that distinguish the productions in which black folk appear from those of any other group ; but my main premise stands.

Because the American theatre is a commercialised industry instead of a medium merely for the expression of art for art's sake, the Negroes who have entered this field since emancipation have not been so much concerned with developing a vital, moving force depicting the soul of an oppressed people as they were with merely eking out an existence. Their paramount concern was, what side of the Negro can we sell?

No less an individual than the eminent psycho-analyst, Dr. A. A. Brill, answered this unconscious question most effectively when he said, " Everybody likes to laugh at a black man." Thus for the edification of the dominant race there grew up in the Negro theatre a type of entertainment from which they cannot break away. The black performer was looked upon only as a buffoon and a clown.

The early minstrels were predominantly " Rufus and Rastus " ignominiousness ; and the later musical comedies which appeared in the gay nineties bore such titles as *Mr. Lode of Cole*, *A Trip to Coontown*, *Darktown Follies*, and other such names that must have cut deep into the very hearts of the producers and actors themselves.

After more than 30 years there seems to have taken place but slight departure from this same discriminating procedure, as the titles of *Blackbirds* and *Hot Chocolates* all carry the same contemptuous implications.

The work of the pioneer sepia showman was pretty well circumscribed. America accepted him only in the form that exploited his inherent abilities. Thus the musical comedy field, that gave him opportunity for singing and dancing, talents that are attributed to the black man as a racial heritage, flourished ; while the drama, which required application, study and artificial development, could not get a foothold until after the late war. Even this, when presented in its most pretentious forms, could not conscientiously be classed as Negro theatre, because the productions for the most part are from the pens of white playwrights. Through their productions seeps an unconscious strain of Ofay psychology that presents the Negro not as he sees himself, but as he is seen through the condescending eyes of the detached observer. Thus only the extremities of Negro life have been brought on to the stage. *Porgy*, *In Abraham's Bosom*, *Emperor Jones* and *The Green Pastures*, all by white authors, fell into this category.

We find towering high above the names of our best dramatic stars the names of Dorothy and Dubose Heywood, Paul Green, Marc Connelly and Eugene O'Neil. In musical comedies this same situation pertains. White song-writers have been employed on innumerable occasions to be the tunesmiths for sepia revues. It is not my intention to give the impression that Negroes cannot create material for their own offerings, but to show that the American scheme of things does not always allow them this opportunity. In short, the two races have been so indistinguishably associated in the theatre that any attempt to find the line of demarcation would be the problem of a Diogenes.

That the Negro has made a very definite contribution to the American theatre is an irrefutable fact. His humor can be classified in three divisions. There is the droll, " po' me " type, created by Bert Williams, in which the poor black-faced comedian becomes the butt of adversity. His hard-luck situations appeal to the sympathies of his audience whose own sense of defeatism is minimised, and they find mental escape in his misfortunes.

This brand of fun-making also carries with it the Negro's supposed irresponsible and happy-go-lucky

nature exemplified in the classic observation, " Hard times don't worry me because I didn't have nothing when times was good."

Contrasted with this we find the slicker type of character brought to the fore by S. H. Dudley, in which one Negro is able to take advantage of his more ignorant brethren.

The third classification finds its humor built on suggestiveness that is quite frankly termed smut. This depends for its appeal on the ease with which the spoken word can be twisted to a base and vulgar interpretation. The latter type of humor flourished most in the houses catering exclusively to a colored clientèle prior to, and for the period immediately following, the war, when colored actors in Metropolitan houses were few.

It was also upon this same type of suggestiveness that the phonograph-record era, which gave rise to an army of blues singers and coon shouters who yodeled their way along the trail blazed by Mamie Smith, was built. Therefore, we found among the best-selling titles such songs as *My Handy Man*, who, the song says, " beats my biscuits and churns my cream," and constant references to the unfortunate gentlemen who " can't climb a hill without shifting gears."

This same type of humor, which the Negro seems unusually prolific in creating, also accounts for the popularity of Harlem night clubs where Park Rowers seek a rendezvous from the politeness of their own circles. Little of the piquant witticisms of the polished Broadway commentators, that depend on their timeliness for their laugh-provoking effects, are found in Negro revues.

Since *Shuffle Along* brought about a renaissance in Negro theatricals, so far as its relation to Broadway was concerned, there came about a gradual change in the attitude toward Negro artists. The years saw them accepted, not as monstrosities or curiosities, but as people capable of giving entertainment value for money received. At that, however, the all-colored show during the decade that followed the memorable revival remained in the experimental stage with few exceptions, of which the *Blackbirds* productions of Lew Leslie were perhaps the most outstanding.

The success of *Shuffle Along* was no accident. During the years that intervened between the balmy days of Williams and Walker, Cole and Johnson and C. Aubrey Hill's productions, and the time that Miller and Lyles and Sissle and Blake brought *Shuffle Along* to Mazda Lane, there had been developing almost unnoticed a wealth of talent in the colored theatres held together by a makeshift circuit throughout the Southland and a few acts in the white houses. It was not until they were assembled under one huge banner and given sure-fire material that their capabilities became apparent.

At first the idea of sepia choruses, garbed or ungarbed in the fashions of Follies or Vanities blondes, was frowned upon, and many predicted that Broadway would not accept them. The fact that, unlike their fairer sisters, the former supplemented their ability to wear clothes with an ability to dance with a feverish abandon that the latter could not or did not acquire, made them instant hits.

During the time that colored shows had absented themselves from Broadway the race had improved in appearance, thanks to amalgamation and the good offices of such kink destroyers as the late Mme. C. J. Walker. Broadway was, therefore, pleasantly surprised at its first baptism of high yaller femininity.

The sepia torso tossers were literal bundles of energy, and their vivaciousness gave birth to the speed-show idea with its accompanying " Charlestons," " Blackbottoms " and other dances reminiscent of the levee and the plantation, all of which had a particular appeal to the group they sought to please.

Many will contend that the Negro theatre has found its own level in the past decade and that it has taken on a definite form that has buried the stigma of the past, which once left it standing like a dingy jim-crow car on the sideline as the palace coaches of the American theatre rumbled on their way. My contention is that it has merely undergone a transition and that the basic principles upon which America has always accepted the Negro still remain.

The old musical comedy scenes which showed him in overalls against a background depicting a Mississippi levee have given way to a night club panorama, and Harlem has supplanted Dixie as the name synonymous with Negro.

The plunking banjo and the cotton-field chant have been supplanted by the moaning saxophone and the rent-party wail. The melancholy spirituals have been replaced by the equally melancholy but less reverent blues, and the rhythm of the old plantation has vanished in the path of the weird and sensuous tempo of the jungle and the transplanted beat of the tom-tom.

The " Virginia " and " Chicken wheel " of the early minstrels, and the " Cakewalk " of the pioneer musical comedies have given way to the carefree abandonment of the devil dance. The brass band in its flaming red coats has been displaced by the jazz orchestra with its dancing baton-wielders and " skat " singers. The busy interlocutor is now called a master of ceremonies.

The Negro Theatre—A Dodo Bird

The big names among Negro performers are only those who have appealed to the whimsicalities of the white race and conformed to their idea of what a Negro should be.

Those who have confined their activities exclusively to what we might term the Negro theatre, have either vanished completely from the arena or are wallowing in mediocracy. The American black man honors only those whom the gods have chosen.

Let me not detract one iota from the glory that belongs to these hearty pioneers who braved the tempest in those early days when their profession was looked down upon not only by the opposite group, but by their own race as well. I have nothing but praise for these gladiators who invaded the benighted Southland, playing in stuffy theatres, travelling in discomfort, sleeping and eating in places unfit for decent habitation. Snubbed and ignored by the better citizenry, they carried on, lifting their calling by their own bootstraps until the proper recognition could be attained.

This was the hothouse of Negro theatricals, but in the path of the vitaphone, the radio and other mechanised forms of entertainment, it has almost mouldered into decay with a few outposts still remaining. Harlem is now the mecca of the Negro theatre and Broadway is its goal. This means assimilation. A merger of talents has taken and continues to take place with the increasing years. Both groups have profited by the pooling of their respective interests and contributions. The American theatre moves on to a finer, more cosmopolitan and higher pinnacle by virtue of these changes. The Negro theatre is a Dodo Bird.

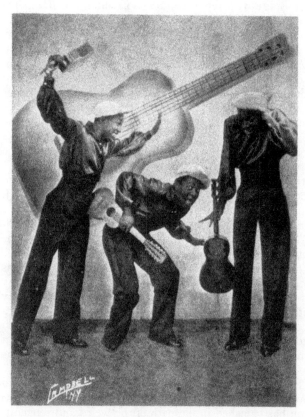

THE THREE INK-SPOTS

J. Sterling Russell, Hamilton Stewart jun.,
P. Clifton Armstrong

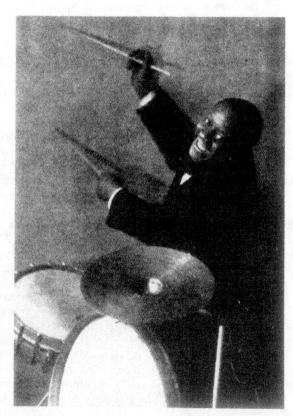

BUDDY GILMORE

Photo by Berenice Abbott

RICHARD B. HARRISON and SALEM TUTT WHITNEY
as De Lawd and Noah in *The Green Pastures*, the Pulitzer Prize
Play at the Mansfield Theatre, New York, 1931

Of Richard B. Harrison it was said by Paul Lawrence Dunbar, the famous Negro classical poet, " he has no
equal as a reader of my verse." Frederick Douglass said : " I am willing to leave the dramatic future of my race to
Richard B. Harrison."

Photo by courtesy of " The Green Pastures " Company

197

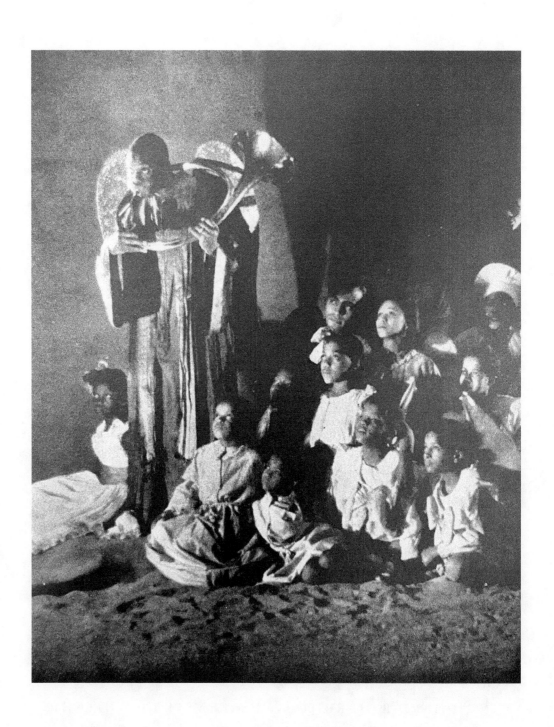

" Gabriel's desire to blow the fateful horn is one of the many bits of by-play that lend humor to *The Green Pastures*, without being sufficiently obtrusive to register specifically in the mind of the spectator—just part of the atmosphere."

Photo by courtesy of " The Green Pastures " Company

Rose McClendon

by ROBERT LEWIS

Rose McClendon got her first impulse to study the art of acting by watching various performances of children's plays in churches. She decided that children needed much more imaginative leadership in their efforts than they had. Desirous of helping them, she enrolled at J. Franklin Sargeant's American Academy of Dramatic Art. Her progress there was so phenomenal, and her personal ability and charm so much admired that she was persuaded to remain for three years.

In 1919, Butler Davenport, seeking colored actors to play in *Justice*, came upon Rose McClendon; and so, quite accidentally she found herself embarking upon a stage career. The next important step was *Roseanne*, in 1924, with the late Charles Gilpin, whose part in this play was later taken over by Paul Robeson. But it was in Arthur Hopkins' production of *Deep River*, in 1926, that Miss McClendon first achieved notable recognition. Speaking of her appearance in this "native opera," Mr. John Anderson, of the *New York Evening Post*, said : " An unforgettable picture of a proudly withered madam in the house of the quadroon woman." The deluge of laudatory reviews which followed the opening night of *Deep River* were enough to cause serious damage to a less sincere artist. To mention another critic's praise, Mr. Alexander Woolcott, of the *New York World*, described her as " the lost loveliness that was Duse."

Deep River also recalls to mind the now classic anecdote of how Arthur Hopkins, noticing Miss Ethel Barrymore in the rear of the theatre, in Philadelphia, where *Deep River* was trying out, said : " Miss Barrymore, stay until the last act if you can, and watch Rose McClendon come down those stairs, she can teach some of our most hoity-toity actresses distinction." At the end of the play, Miss Barrymore sought out Mr. Hopkins and told him, " She can teach them *all* distinction."

The next year, 1927, found Rose McClendon playing the leading female role in Paul Green's play, *In Abraham's Bosom*, which later received the Pulitzer Prize. For

ROSE McCLENDON

Rose McClendon

her work in this play she was given the *Morning Telegraph's* Acting Award, along with Ethel Barrymore, Alice Brady, Jane Cowl and Lynn Fontaine.

While still playing in *In Abraham's Bosom* she was summoned to the Theatre Guild to rehearse, under Reuben Mamoulian, the part of "Serena" in Dubose and Dorothy Heyward's play, *Porgy*. For three years *Porgy* delighted audiences here and in London. Which brings us to the present time and the rehearsals of Paul Green's *The House of Connelly*, which will soon open in New York.

As much as she is a consummate artist in the theatre, Rose McClendon is a perfect culinary artist in her home. Her house in Harlem is a meeting place for the most prominent as well as most promising artists of the day. They all consider her—as did the Negro journalist, who only last month eulogised her in an article—"the first lady of our stage."

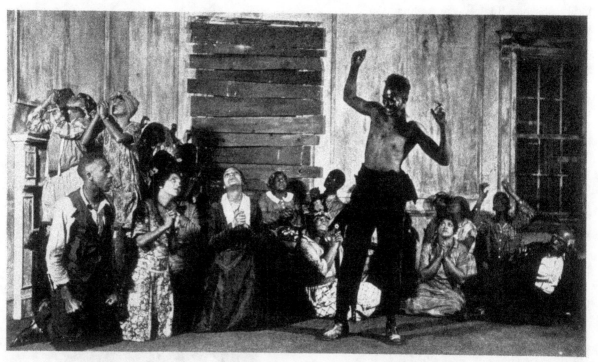

A scene from *PORGY*, with Frank Wilson, and Rose McClendon (third from left)

Photo by courtesy of C. B. Cochran

Florence Mills

by her husband, U. S. THOMPSON

FLORENCE MILLS was born Jan. 25, 1895, at Washington, D.C., made her first appearance on the stage of the Bijou Theatre in that city at the age of four years. She travelled with an act called Bonita and Herren, her mother being with her. She later appeared with a musical comedy, *Trip to Coontown*, as a special feature. Her mother had some trouble with the law in Philadelphia, and Florence was forced to leave the stage and go to school. A few years later she arranged an act with her sisters called " The Mills Sisters." She also played alone, in and around New York. Her success brought her many times to the old Lincoln Theatre, 135th St., near Lenox Avenue. In 1914 she teamed with one of Buddy

Gilmore's protégés known as success and their engagements as far as Chicago, where her came an entertainer at the South Side. It was here she " The Panama Trio," con-Smith (Bricktop) and Cora Williams. This trio was one kind, playing the better cir-quite hard for colored girls to Finishing this act after a suc-the Tennessee Ten, a Standard Act. It was with this act she later became her husband. He and dancer. In this they played musical show *Shuffle Along.* cess from her first performance. she accepted a three years' and later signed for three more. with her, the first high-class The same season she was en-Greenwich Village Follies. great that the white cast Mr. Leslie produced *Dixie to* playing a season. She then ville with a big act, and was headline at Keith's Palace.

In the spring of 1923 Mr. *Dixie* to London, playing at

FLORENCE MILLS

" Kinky." They had great carried them south and west partner married. Florence be-famous night club on the worked with an act known as sisting of Florence Mills, Ada Green, and later Carolyn of the outstanding acts of its cuits, as in those days it was secure recognised booking. cessful tour west she joined Keith and Orpheum Circuit met U. S. Thompson, who was the featured comedian together until she joined the She was an instantaneous suc-Having many flattering offers contract with Mr. Lew Leslie He opened the Plantation colored cabaret on Broadway. gaged as added attraction in Her advance publicity was so threatened to walk out. Then *Broadway* at the Broadhurst, played the high-class Vaude-the first colored woman to

Leslie brought *Dover St. to* the Pavilion Theatre for Mr.

C. B. Cochran for a successful run. Returning to America in the fall she again went into the Plantation. In 1926 Lew Leslie produced his first *Blackbirds*, which after a run in America he brought to Paris for a four weeks' engagement, which was extended to sixteen weeks; they then went back to London for Mr. Cochran and remained there a year.

Florence Mills became the toast of London and played before many royal personages. It was said the Prince of Wales saw the revue no less than twenty times, which was something unheard of.

When the *Blackbirds* went on tour, after playing in the principal cities she had to give up and go to Germany for a rest. She had been playing steadily for more than five years, never missed a performance and never had an understudy. She returned to America and decided to have an operation, which proved fatal. She passed on Nov. 1, 1927. It was a shock to both continents. After lying in state for five days, when rich and poor paid her homage, she was buried in Woodlawn Cemetery, where a flock of blackbirds flew over her grave.

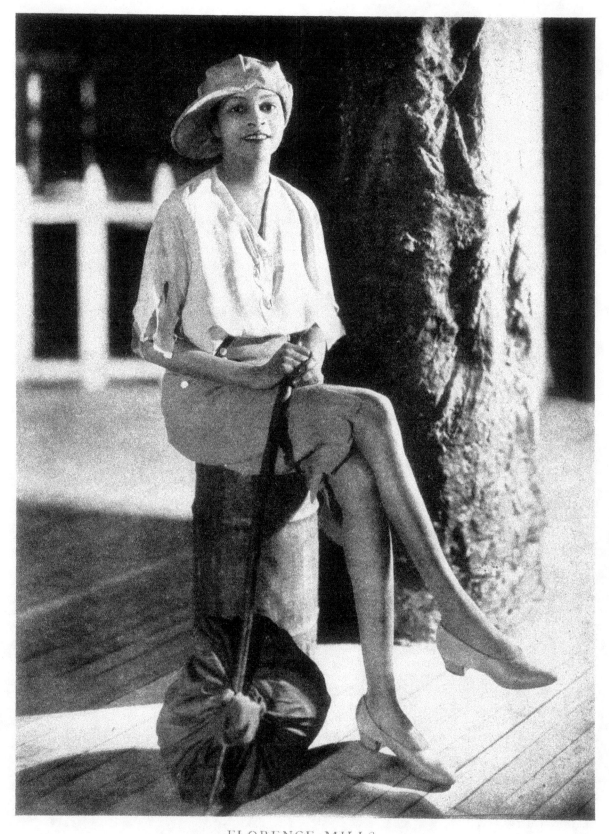

FLORENCE MILLS

in *From Dover St. to Dixie*—described by C. B. Cochran as one of the
greatest artists he has ever known

Photo by kind permission of C. B. Cochran

The Dancing of Harlem

by JOHN BANTING

So much has been written about Harlem that it might seem superfluous to write more. It has been exploited brazenly enough and, of course, with much inaccuracy, representing it as an entirely " night-life " quarter—every other house being a " speak," a cabaret, or a " buffet flat," and entirely missing the normal business and family life, and the different struggles of both " bourgeoisie " and workers. The " best-seller " novelists have even missed the dancing, maybe because they half-consciously realised the impossibility of doing it justice. Fortunately it also escaped Diaghileff and chi-chi.

The excellent American jazz, though derived as closely as possible from Negro dancing, is still a very different affair to this art from the older continent of Africa. In many travel films the ritualistic dances performed by natives have the identical rhythms and steps of the " Charleston," " Shimmy," " Black-Bottom " and " Lindy Hop," done to-day on Harlem stages and dance floors and in the more enthusiastic evangelical churches.

We have seen some of the finest coloured dancers in Europe, but dancing is an art needing congenial conditions more than any other. A complete and " hot " orchestra (not yet *blasé* with fame) and a sympathetic audience to appreciate all the detailed *finesse* of technique, rather than one ready for a delightful novelty; these two things will make such a difference that the amateur will perform almost as well as a practised professional. Therefore one cannot fully appreciate Negro dancing from what we have seen in Europe. It is a case of " wine being best in its own country."

The vaudeville talent in Harlem is brilliant and is now being sought after more and more " down-town," where, although audiences much appreciate it, the press often ignores it and the management bills coloured stars in small print.

Six years ago, the New York revue producer George White introduced the " Charleston " to Broadway, the chorus being taught by children from Harlem. He claims the honour of being its inventor. The dance is named from the town in South Carolina and its fast rhythm and flashing steps are the same as those performed in many parts of Africa.

Eight years ago a similar " steal " was made by Gilda Grey, who popularised the " Shimmy "; but only " seeing is believing " when Earl (" Snakehips ") Tucker and his partner, Bessie Dudley, quiver from top to toe or make a circular hip movement (rather similar to a *danse du ventre*) called " barrel-housing." *For, no matter how agile, it is folly for a white dancer to try to recapture the inherent rhythm of the Negro race.*

Bill (" Bojangles ") Robinson is the originator of present-day tap dancing (or, as it was called in the South, " jigging "). Standing almost motionless, his feet send forth a rapid fire of complicated rhythms such as are generally only possible on the drums. He is now over fifty and still gives his wonderful foot music. His " nerve-tapping " is the gentlest foot vibration, sounding like pattering rain. He now has many talented followers, and no band is complete without a group of three or four whirlwind boy dancers forming part of its programme.

One Harlem dance floor is well filled every night with young couples dancing with a rhythm and grace that make the beholder gasp. The improvised steps done at breakneck speed are of a complication generally only seen on the stage. These sober and athletic girls and boys work in offices and shops in the daytime and at night get drunk on nothing more than the music—" music hot and strong enough to make a tadpole whip a whale." There the expression " getting off " does not mean flirting, but " getting going," or inspired, and the dancing is earnest and Platonic.

A wildly jigging couple will suddenly shoot apart, the girl pirouetting away from the man until their two arms' length is reached. Taps, kicks, prancing and shimmying will then be done separately until, in a manner somehow reminiscent of some courtly round dance, they will rejoin each other and whirl onwards with preoccupied expressions. Five hundred people fitting beat to beat and pause to pause, keeping immaculate time, is a fine sight.

The slender girls have " chic " whether they are expensively dressed or not, and present-day fashions seem made for them and their own special movements. Their different complexions definitely give an added glowing richness to whatever colour they are wearing. The men also are very neat and dapper. Their skill is the more amazing in being possessed by such numbers, and with something more than skill collisions are completely avoided.

This dance hall is the home of the " Lindy Hop," as it has been named since the transatlantic flight.

The Dancing of Harlem

It is a synthesis of all the other dances, but done in Charleston time and with a slight hop on every fourth beat and open to many elaborations. One of them is the Geetchie Walk (also from South Carolina), consisting of strutting proudly alone and slightly wriggling from head to feet—the head shaking rather like a musical "timer." The "Lindy Hop" probably originated in Philadelphia, and in New York became largely popularised by "Twist-Mouth George" and "Shorty," who performed it on the stage with great success.

I do not give the name of this dance hall or the "ofays" will start flocking in, the prices go up, and the dancing down, and an Italian gangster take it over as a "speak" and a show place.

The older generation also manifests a similar spirit in the more enthusiastic Baptist churches. One evangelist, who preaches with fire every night for over three hours, says, "The devil keeps you quiet in church." His congregation of about a thousand goes to hear his worldly wisdom and wisecracks, or to enjoy the music (which is excellent—Bach and Beethoven, old and little-known spirituals and syncopated hymns, played by an organ, violins, saxophone and piano), or to enjoy themselves by catching his fervour.

These last are the older "sisters." During the reiterated hymns they will raise their arms up straight, and, flinging them apart, jig to the Charleston rhythm, with heels together. Sometimes a forest of arms will sway to cries of "Hallelujah," "All right," "Amen," and "Thank God for Jesus." Surely, if you have "got religion," this is the best kind to have!

An authentic history of Negro dancing would be a large volume, for it consists of so much more than a diversion as to embrace almost all aspects of existence itself and to form a highly important part of it. We largely owe the universal jazz of to-day to Jim Europe (coloured), who was the first to bring his band to Europe in 1910. Ethel Levey (white) and *Hullo Ragtime* came in 1911. But W. C. Handy (coloured), "Father of the Blues" and writer of the classic *St. Louis Blues,* was "doin' that thing" first in Tennessee and then Harlem years before. . . . How many centuries old these movements are it would be impossible to discover, for they are as old as Africa.

Reprinted by courtesy of *Everyman*, London.

An Example of Success in Harlem

SAVOY BALLROOM, HOME OF HAPPY FEET

Harold Parker

DID you know there is a business in Harlem run by Negroes doing a million dollars gross per year, and paying $200,000 per year back to the race in salaries? This business within six years has spent $500,000 in advertising, a big share of which went to the local Harlem Negro newspapers. Now I'll wager many people who live in sight of the place are eager to know what business is this?

It is the Savoy Ballroom, 598–612 Lenox Avenue, from 140th to 141st streets, known far and wide as "the world's finest ballroom in America, white or colored." It was opened in March 1926, after an outlay of more than $100,000 in cash, and its instantaneous success has caused a second Savoy, in Chicago, to be built. This $100,000 cash capital which was invested in the Savoy was purely a gamble by the others (white) on the Negro, and it proved a success. The new Savoy in Chicago is for Negroes too. These two instances ought to prove the Negro to be a real economic factor in American life.

But any book on economics will tell you capital is helpless without management. And what will probably surprise some of the old-timers is that the gigantic aggregation of white capital in the Savoy in New York pinned its faith in Negro management. A staff of one hundred people is employed, headed by a Negro Managing Director. And this Managing Director is a young man, in his early thirties, clean-cut, wide awake, efficient and dependable. A white man in a similar job in another business could not be more broad yet concise, big yet not big-headed, jovial yet not negligent nor slack. This man is Harold M. Parker.

204

An Example of Success in Harlem

The Savoy has a capacity of 4,000. There were dance palaces in Harlem before it opened, but since its opening it is known as *the* dance palace. It offers twelve hours of continuous dancing, with two bands in normal times, and three and even four bands on Saturdays, Sundays and holidays. The music never stops ; the dancing never stops until the place closes. When one set of dancers become tired they simply step aside and lounge on the luxurious divans and easy chairs and watch others. Young men who don't dance are provided with hostesses to teach them, so that a man can come without a lady and enjoy himself. A new rug has just been laid in the Savoy at a cost of $7,000.

This place can't be beaten for an evening of enjoyment, no matter where one goes. The strict discipline of our employees, the very charm of our interior, the good music, the spacious dance floor, the courtesy of the hostesses, all contribute to make one relax and enjoy oneself. We also vary our programs with novelties which are big attractions.

The novelties mentioned are a Chinese Mandarin Ball, a South Sea Isle Ball, when all the employees are dressed in costumes. Prizes of various kinds are awarded to the winners.

There is also a club called the Savoy 400 Club. This club is made up of the best Lindy Hop dancers. They meet every Tuesday night at the Savoy Ballroom, where they try to out-dance each other. All of Broadway may be seen sitting around the ringside watching them dance. Very often celebrities such as Lilyan Tashman, Libby Holman, Clifton Webb, Edmund Lowe, John D. Rockefeller 3rd, Johnny Weismuller, Carl Van Vechten, Ted Lewis, Paul Whiteman, and various others come in and offer cash prizes for a Lindy Hop contest.

A Negro Film Union—Why Not ?

by KENNETH MACPHERSON

Editor of *Close-Up* [1]

THE Negro as his own film-chronicler, his own film-voice, the Negro expressing himself integrally, as have the Russians ; historically and socially conscious, and equipped ; set free to say what he wished. One wonders.

And wondering, is suffused by what lies latent, the veritable fury of richness in his material with which to disembowel, flagellate and recreate a world around him stupefied to new comprehensions.

This is what one sees, what seems possible, what, indeed, seems shameful if not done !

On the other hand, is film a concept foreign to the Negro himself, would he see things in this light, is the cinema not his medium? Apart from the fact that such a condition does not appear possible at the present moment (that is to say, a condition by which the Negro could be consolidated in an organised union sufficiently resilient to withstand the attacks which would come raining upon it), there has to be taken into account, and accepted or rejected equally as fact, the certainty that before long some such union cannot be withheld or resisted.

The Negro in this rapidly changing world will come into his own, maybe even dictate to all of us— a possibility which it would be foolish to pretend to deplore, and might, indeed, prove beneficial all ways round !

For the moment this is not the point. I must limit my survey more or less strictly to those aspects and conditions which would directly involve or be involved by—what shall we call it ?—a " Confederated Negro Socialist Cinema."

What an idea !

And what a good idea, and what an important one !

Let us look into it.

[1] *Close-Up*, 26 Lichfield St., Charing Cross Rd., London.

A Negro Film Union—Why Not?

In the first place, it would be useless to the cinema in any of its significant or potentially significant aspects, that films as they are today should include films made by Negroes with Negro casts. They would remain at the deprecatory stage (the white man and his burden would see to that) with which we are familiar enough already in American (registered-as-second-class-matter) magazines. Deprecatory, falsifying and base in their concealment of truth. Incidental charm, talent and a great deal of virility might find their way in, could hardly fail to do so, but real issues would be evaded.

I once wrote of a Negro actor that he gave " more than a promise, though the trouble is he isn't meant to do as much." Flirting through the film as a dusky playboy, he alone lived, and here is what I went on to say of him: " There is more than promise in the jungle, lissom lankness that slams down something unanswerable in front of what we let go past as ' beauty.' This splendour of being is one good key to open a good many doors, all the way to our goal simply, . . . he waves loose, racial hands, and they, like life, touch everything that the world contains. They are startling with what nobody meant to put into them, but which is all too there. . . . Making this greatness articulate for the cinema is the fascinating pioneer work of somebody."

In this instance I had seen, perhaps I should say I had been haunted by, a sense of *virility or solidarity of being* which was at once discernible as imperatively Negroid.

And the mind bounced down a long corridor of deduction, rather like an old tennis-ball, making swift if somewhat intangible links of recognition and discovery through old jungle civilisations to the present centralisation of progress in New York's Harlem. It was an odd sensation, fugitive enough but exciting; like a new hope, discerned but not described.

Paul Robeson, who later made a film with me, and at that time was discussing a theme, said firmly, " Nothing in the nature of cotton-picking! " And I was—rather sorry! For Robeson was seeing something like a darky version of Metro-Goldwyn-Mayer glee-singing " shorts," (how could he help it?), while I was visioning the captivating ways of lynch-mad farmers and their victims, who—although you did not see it in *Hallelujah*—are worse off now than in the days of slavery. Slaves were valuable, black life just simply is not—as *Georgia Nigger*, which had not then been written, admirably shows, and would have done to illustrate concisely what, tentatively, I had in mind.

However, there it was! I thought it would be a good starting-off place, a film of primitive impact, physical and cruel and unanswerable except in immediate alleviation. But what would have happened? It would have been banned and its maker declared insane or " a dangerous, subversive Bolshevist! " That is the way these fatheads talk—the white man " confronted with an instability—his own—which he calls a race-problem! "

Shown on the quiet, undoubtedly it would have put international diplomatic relations in ferment and diplomats in a blue funk, and kept Geneva in clover for many a month!

That too had its appeal. But it was not a film for me. My knowledge and means were insufficient, for one thing, and my idea was and is—the Negro as his own film-chronicler.

Which brings me back to the question, is cinema a concept foreign to the Negro himself, is the film not his medium?

One cannot know if he would lose inherent power working with a material which might tend, unless finely sensed, to flatten drama into melodrama and fact into tract. Too much grinding of an axe gives a blunt yield! A self-conscious attitude would cause a tentative, even apologetic presentation. Such are the tricks of the camera! Feeling is one thing, expression another. It has to be admitted that Negro literature (such of it as the publishers allow us to see) is often disappointing, lacking colour, incentive and drive—" genteel " in a word. In this respect, allowance must be made for the uniform and *levelling* effect of the printed word. That would be sufficient to comb out what is lithe and opulent in Negro music, in the way it is sung and played, in Negro dancing, with its atavistic " pull "—in Negro *nuance* generally. But would not excuse content. Not a bit of it. But undoubtedly the publishing houses are our censors in this instance. Yet a white man gets past with *Georgia Nigger*! These politics are very complicated.

Clearly, what would be necessary in the first place would be an Inter-State Academy of Cinema, run on exactly the same principles as the State School of Cinema in Moscow. Here teachers and pupils would work in vibrant, conscious *rapport* with the exact ethics of social renewal. From this core the ideology and methodology of a truly forensic race polity would be discerned.

How to start such an organisation, apart from instantly perceptible difficulties, remains a leading question, and, in the beginning, Negro students probably would have to study under the few really great—men like Eisenstein, Pudovkin—or, preferably, sit down together, as did the Russians in the

A Negro Film Union—Why Not?

beginning with Kuleshov, and work out their own specific formulæ on paper, or, if obtainable, on film.

In this way would develop the quintessential Negro Cinema, saturated with the unique recognisable and inimitable characteristics of its creators—for apart from what is " lithe and opulent," as I have called it, and apart from power grown and sustained darkly, inherent in root stock, and apart from that gift which Robert Herring ironically called " freedom," here historically, socially, humanly, is the deep heart's core of drama.

My hope is that the Negro might bring that quality which I found symbolised in the hands of a casual, nondescript player of a white-man's-nigger role to the construction and composition of his work, that he would use it freely, consciously and unconsciously, and with the same certainty and power as, in consciously controlled work, he alone is capable of manipulating in rhythm, movement, histrionics, music—the dynamic arts, in short, and cinema is nothing if not dynamic. To go further—in his skill as a hunter, courage as a warrior, his magic as a witch-doctor, his genius as a sculptor or his prowess as a lover !

Finally, the idea of the Negro and the film, viewed in this or any other light, is no mental fun-fair for the epigrammatic and perverse. And cannot be countenanced because of slack enthusiasms and unfounded wishes. Either the Negro is or is not capable of taking into his hands and using well and thoroughly for his own good and the good of all civilisations a weapon of which Lenin said : " For us the cinema is the most important of the arts ! "—or he despises it and is not equipped to take control. It will rest almost entirely with him, and what it would lead to nobody can foretell. But that is relatively unimportant today when nobody can foretell anything. Ultimately it could not but mark a big step forward in the humanising of the human race.

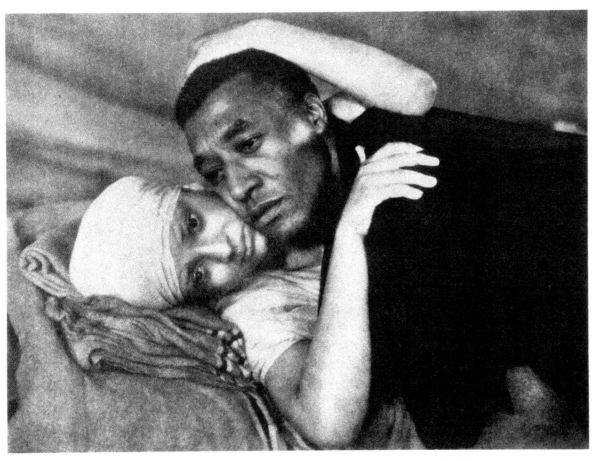

NINA MAE McKINNEY and DANIEL HAYNES
in *Hallelujah* (Metro-Goldwyn-Mayer film, directed by King Vidor)

Photo by courtesy of " Close-Up "

207

The Record of a Negro Boxer

AS WRITTEN, TO PUT IN THIS BOOK,

by BOB SCANLON

ONE OF THE BEST MIDDLE-WEIGHTS OF HIS TIME

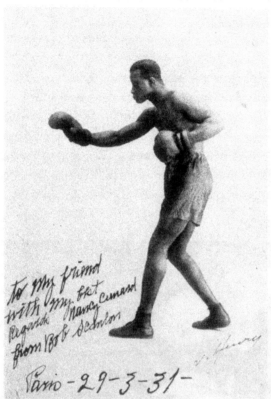

I AM sending you some of my record as near as I can recollect—

Benjamin Lewis born the 7th February 1886 at Mobile, Alabama, U.S.A. At the age of 16 went to Mexico, worked on a ranch as a cow-boy for 1 year and came to Vera Cruz. Joined a ship as second cook and sailed for England. Discharged on January 2nd, 1903, at Renfrew, Scotland. Came to London, engaged a porter carry my kit bag as being a kid and did not drink I gave the porter 10 shillings to get a drink on our way to a boarding-house so he gave me the slip by another door with my kit and all that I possessed in the world except a few pounds in my pocket. So I went to a boarding-house in Limehouse E.C. until all my money had gone. So I fell sick and they sent me to Doctor Barnardo's Home in Commercial Rd. E.C. and when I was well again they sent me to Cardiff to join a ship as I really wanted to be sent to Canada but only British subjects has that right as I am an American born subject, so in Cardiff I went to a branch of Dr. Barnardo's and an old sea captain named Cpt Church signed me on a ship named the *Florence Pile* of Dublin.

So I went abroad again for 2 years and came back to Middlesbrough, was paid off, came back to Cardiff, hung around for a few weeks and couldn't get a ship. I went to Pontypridd and tried to get a job in the coal mines but had no experiences of underground work so I had no luck. So I went in search of something else. So I found a boxing booth owned by a man named Tom Taylor at Pontypridd and he saw me knocking around the show and called out to me: I say black fellow can you fight? I said: let someone jump on me and they will see. So as it happened it was Peter Brown the middle-weight champion of England who was to meet a coloured boy by the name of Frank Craig the coffee cooler and he did not turn up so I took his place and Brown quit in the 5th round, so I was signed on and hailed as a champion. So I met Dai Peters the Welsh champion and stopped him in the 5th round. Then I met Larry Cronnin, beat him in 6th round— Harry Jones in the 10th round. And in 1905 I met Australian Billy Edwards, beat him in 9 rounds at Northampton. In the same year I beat Harry Alridge the champion of the Midlands, K.O. 7 rounds. So I

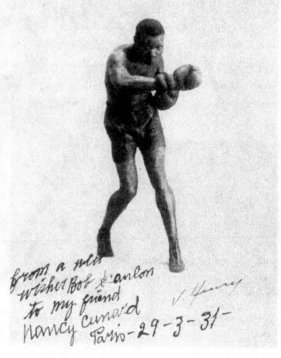

The Record of a Negro Boxer

stopped boxing and went to Coventry and worked at Camel and Lairds as a gun painter and in 1907 came to London again at the invitation of the National Sporting Club to take part in a middle-weight competition which I won. And then Harry Jacobs of the Wonderland sent for me. He gave me a contract for 1 year. My first fight there was with Jack Andrews. So I beat him twice in 6 rnds. And afterwards Bob Russel, and I stopped him in 8 rnds. Arthur Harman beat me in 6 rnds on points and gave me my cauliflower ear and I asked for a return match and stopped him in 1 rnd. Then I went to Wales again and beat Ginger Osborne in 3 rnds. Then I came to France and during my tour I discovered a little blond boy named Georges Carpentier in Lens with Francois Descamps. That was in 1908, so I could see that he was the makings of a champion, so I got them to come to Paris. At that time Carpentier was only 14½ years old and I, 21 years old. So his first fight was with Georges Salmon at the Café de Paris, Maison Laffitte, and he was making good until the 11th round and then he blew up. That was really because he was inexperienced on the square circle. He was to box at 9 o'clock; at 7 o'clock he ate at dinner an hors d'œuvre très copieuse, a litre de vin rouge, a big beef steak saignant and chips, tart and coffee—but again he was knocked down several times after the 10th round, so I said to Descamps to stop it. He said No. So I jumped into the ring and stopped it, picking little Georges up in my arms and took him to his corner amidst the cheers of the crowd. He was always game to the toes. So that was the début of the famous Georges and that's true. Then I went to America and whiles there I took part in 5 matches. My first was Al Palzer a white hope who was masked and called the Masked Marvel, the man to beat Jack Johnson. So I put pay to his bill in 3 rnds by K.O. The next was Bill Brown. I beat him in 6 rnds at the Sharkey A.C. New York. And then I met Jeff Clark who beat me at the Sharkey A.C. on points in 10 rnds. So I sailed for France and they matched me with Blink MacKloskey for a 25 rnd fight, so I knocked him out in the 7th, being the 1st and only man to do that, including the famous Jack Johnson, Harry Lewis, Sam MacVea and others too numerous to mention.

So when the war was declared I joined the foreign legion on the 22nd of August 1914 and went to the front and took part in the battle of the Marne and Aisne and the Argonne, and when the battle of Verdun a commencé I was at Givry in the Argonne and should have gone on leave. After the offensive in Champagne as we came from Alsace and went to Champagne for the 25th of Sept. 1915 we attacked at 9 oclock in the morning and by 11 oclock we had advanced 11 kilometres, really too fast—we run into our own barrage. As it started to rain after the tropical heat and the ground was covered with a mist and the ballon captif could not see us although we had large banners rouge and blanc to signal to lengthen the fire we suffered mostly from our own fire. When night fell we took the Bois de Navarin. On the next day went to join the 170e Infanterie in a wood near by and there I met my old pal Georges Carpentier. He was in the aviation. He was very pleased to see me, and I, him; he invited me to come over to the aerodrome to have a bottle of champagne. So we left for Givry-en-Argonne the next day and whiles there I was to have my leave but on the 21st of Feb. 1916 the bataille de Verdun started. All leave stopped. The next morning we boarded the camions for Verdun and after 8 days continuous fighting we went down to rest and réformer the regiment at Vaucouleurs, Meuse, and on the 25th au soir we went back to the enfer and attacked entre Vaux and Mort Homme the Bois de la Caillette and I got wounded, and after 14 months hospital I was discharged from the army with pension. Right during my convalescence I boxed with very varied success. In London in Jan. 1918 I boxed Sergeant Palmer at the Ring, Blackfriars, to a draw, 15 rnds. I K.O. Bill Bristowe in 9 rnds at the same place. I lost to Sergeant Couzon in 9 rnds, abandon. Came back to France to get invalided out of the army and three days afterwards went to Bordeaux and fought Albert Lurie then the heavy-weight champion of France, 15 rnds to a draw. Then came to Paris and fought Marcel Nielles to a draw at the Cercle Hoche, 10 rnds. Went to Deauville and fought Billy Balzac to a draw, 10 rnds.

Went to Belgium and boxé Jeff de Paus. Lost on points, 12 rnds. Went to Rotterdam and boxé Piet van de Vere, the giant Dutchman and abandonné in the 9th rnd. Came back to Paris and boxed the giant american Bob Martin and lost on abandon 11th round. Lost by abandon to Harry Lewis at Salle Wagram in 2 rounds. Lost to Marcel Nielles 2 rnds by arrêt combat by the referee. And then I decided to lay the gloves aside as I was no more good to continue after 3 years at the front suffering hardships, severely wounded, and as the men I met was much younger men and had never been to the front. And everyone can say Bravo Bob, a real game boy in every term of the noble art who has done his bit on this planet and may his name rest in peace until the end etc.

About Battling Siki, when I was with him, and left him to go with Carpentier as his chief trainer and adviser. I met Siki at a gymnasium which existed at that time in 1922 at the corner of the Faubourg Montmartre and the Rue Bergère owned by André et Felloneau, and Siki was a big hearty boy, strong

and very quick, but did not know very much about the noble art, so I said to him, Come on, let's have a round or two and I'll show you how to hit straight; but after a few days it got to be very uncomfortable for me as he was very young and strong and very brutal so I suffered a great deal from his onslaughts. So we changed quarters and went to Luna Park to train. Then the match was made with Georges Carpentier. Siki had for manager Charles Hellers, a frenchman, and he agreed to pay me one hundred francs a day but he afterwards saw that Siki couldn't land on me at will so he cut our bout to only three rounds instead of 4 rnds and afterwards to 2 rnds, then he cut my wages to 75 francs and I was not satisfied so I decided to quit. So that night I went to Montmartre and whiles there in a night cabaret I met Gus Wilson, Carpentier's chief trainer, and he said to me, Say Bob, are you still with Siki? so I said No. So he said, Well if you want to go down in the country to La Guerche to train Georges Carpentier here's the fare so take the train at the Gare d'Orsay in the morning about 9 o'clock and you will arrive about 5 o'clock in the evening and in the meantime I will send a telegram so that they will meet you at the station. So I arrived at the camp and never saw Georges until 3 days after my arrival. So he came up in his car with some friends. He said, Hello Bob, I am starting in the morning to do some road work; so we went out for 3 days in succession and boxed 9 rounds ever day for 3 days. This was 3 weeks before the fight, and after those days of work I never saw Georges, only rarely; after all my pleading to him to train he took no notice. He said, I'll beat him, I'll knock his black head off. So I said, No Georges, he's very strong and has plenty of speed and wind and can hit, and tough, so what more does a man need? But all that was to no avail, he would not train, he preferred his car and fishing and hunting to the gymnasium. So I tried to scare him by telling him of Siki's measurements, his big arms, and that he never gets tired, but the brave Georges said that he cared nothing for those big arms and speed as his right to the jaw would put a stop to all that nonsense. So the day of the fight we came up to Paris and that afternoon we went to Buffalo Stadium. So when the fighters was going to the ring a feather-weight by the name of Georges Gayer ask me if Carpentier was in good shape, and I not knowing, thinking him a friend of Carpentier's, I said naturally, No, he has not trained. So he said, Thanks, I'll get my revenge because I have a grievance against Descamps since my match with Paul Fritsch so I am going in Siki's corner. So he did, and he told Siki: now is your chance to become champion of the world as this guy you are meeting is the light heavy-weight champion of the world—just look at the money you will make and the cars you will own and all the houses you can buy with the money you will make, everybody will be crying Siki, the President will invite you to dinner. . . . So Siki seen nothing but dough. So the fight started and Descamps told me not to get into Carpentier's corner as it might have an influence on Siki so I sat by a neutral corner. Well, the first round Carpentier clipped Siki with a right. Siki went down for a count of 6, so after all feeling run high so I signalled to Siki to get up; being a colored man myself I didnt want to see him beaten in a way like that, so he got up to continue until the end of the round. The second round Carpentier sent Siki to the floor again for 9 seconds. After that Georges got careless and thought he had a cake-walk, to his sad mistake, as when the 3rd round started he began to play with Siki, pulling faces at him. So all of a sudden Siki caught Carpentier with a terrible left hook and poor Georges went to the boards for 9 seconds, and at that moment Siki saw his chance and he never left Georges. He fought him all over the ring and finally in the 6th round came the K.O. It was a left hook that done it, and as it was done in close quarters they tried to claim a foul by saying that Siki tripped Carpentier. So the referee gave the decision to Carpentier on a foul but the great crowd protested so strongly that the President of the Boxing Federation, Mr. Victor Bryer, got into the ring and at that moment you could hear a pin fall. So he said, Me as President of the Boxing Federation I will not allow this injustice, Siki has won fair and square, so therefore I reverse the decision, therefore I give the verdict to Siki. So the applause of the crowd was like a dozen machine-guns rattling, so they carried Siki on their shoulders all around the ring; so he was a real champion but would not listen to me any more. So a few days after the fight I was going to the gymnasium in the Faubourg St. Denis; at the corner of the Boulevard St. Denis I saw a great crowd of people assembled so a policeman called me and asked me if I knew Siki. So I said, Yes. Well, he said, we dont want to arrest him so go and take him away. There he was with two big Great Danes and a revolver firing it in the air and trying to make the dogs do tricks, so I hailed a taxi and bundled Siki and the dogs in and myself. So he said, Lets go to the Chope du Nègre, a Café in the Faubourg Montmartre. After having drinks there I tried to get him to go home but he wanted to go to Luna Park, so we stopped on the way and we bought 2 new hats and he would not ride inside, he wanted to sit next to the chauffeur and me inside with the two dogs. So he fell asleep and his hat fell off, so I knocked on the window for the taxi to stop but Siki said, No, I have plenty of money and can buy another hat. So when we arrived at the Porte Maillot the

The Record of a Negro Boxer

police held up the traffic to let the pedestrians pass as it was 6.30 and all the people going home from work. One little man spied Siki on the front of the taxi so he exclaimed in a loud voice, Look at that drunkard Battling Siki who beat Carpentier, drunk as a lord. . . . So Siki did not like that insult so he drew his revolver from his pocket and said, Repeat that and I'll blow your head off. So that was the end of our day. The police surrounded the taxi and made us pull into the side and asked Siki to give them the gun but he wouldnt, so they looked inside the car where I was with the dogs and asked me to come out and disarm Siki, so I did. And now come on to the Station-House. Siki would not get down so again I had to render my services. So once on the ground they marched him off to the Police Commissioner. So he said, What, a man like you with a revolver, and you who beat Carpentier want to kill a poor work-man? Siki said, No, I was only kidding him. But lucky for him it was a very small revolver and he only had blanks in it. The Police Chief said, I am going to send you to jail, and winked at me and told the policemen to search him. Siki said, Oh Monsieur, dont do that as I have a rendez-vous with my wife to go to the cinéma. So they searched him and took all the money out of his pocket and counted it. He had 18,000 francs on him. So Siki said to the workman, Here, pal, and handed him 400 francs. So he put it in his pocket and flew down the stairs crying out, I am finished with the affair, bon soir Siki camarade, tomorrow I hope . . . So the station sergeant told me to take Siki and his dogs home so he can go to the movies with his wife.

Poor old Siki, a real good sort, and may his soul rest in peace.

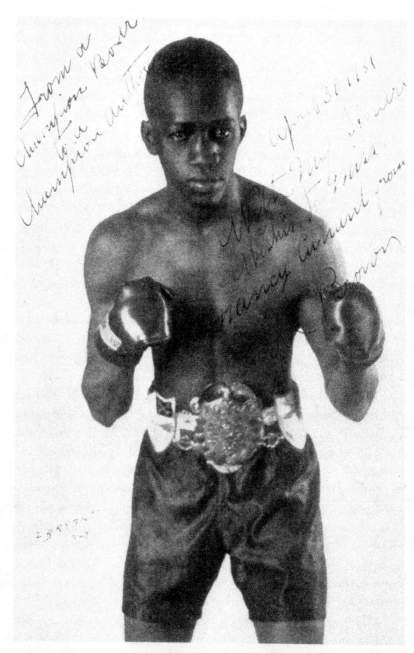

AL BROWN
World's Bantam-weight Champion

MUSIC

The Negro on the Spiral

or

A Method of Negro Music

by GEORGE ANTHEIL

SINCE Wagner, music has had two gigantic blood infusions: first the Slavic, and, in recent times, the Negroid. The Russian Five, leading gradually into young Debussy, and eventually into young Strawinsky, seemed to pass naturally into the present Negroidian epoch, especially after the great and world-shaking events of the *Sacre du Printemps* and *Noces*. It is not difficult to understand the transition when one examines these two last-named works and realises how completely they exhausted Slavic music, and how the Negroidian music, already used to existence under the most terrible heat when all other life and musics must perish, was the predestined influence to carry music through the difficult after-war period until the present time. The Negro music, like the Negro, has been living for a number of million years under terrible heat; Negro music has, in consequence, been baked as hard and as beautiful as a diamond; it was the only thinkable influence after the *Sacre* and *Noces* had exhausted once and for all every last drop of blood that the primitive Slavic music had in it. The first Negro jazz band arriving in Paris during the last year of the great war was as prophetic of the after-war period immediately to come as the *Sacre* was prophetic of this selfsame war, declared only a year after the stormy scenes at the Champs Elysées Theatre in 1913. And this was the war which exhausted the world and left it without a grain of its former " spirituality." Likewise the *Sacre* left music sunbaked, parched, without a drop of water, and without a blade of green grass; the famine was here; there was no hope; a cataclysm; a great work marking a finality. Nothing could survive underneath this dense heat and smoke except Negro music. It absorbed this period so naturally that in 1919 we find the greatest Slavic composer living writing " Piano-rag-music " and " Ragtime " almost without knowing it, and a whole school of young composers springing up in Paris deeply influenced by American Negro music. By 1920 the gigantic Slavic influence of the past 40 years ended; not even the long-delayed performance of *Noces* could call it back; in 1923, with this première of *Noces* we realised that *Noces* was written in 1914, and that *something* had happened in between time, and that *we were no longer the same*. Strawinsky himself began to forsake Slavic music. Then, frightened at the gigantic black apparition, each European people scurried hurriedly towards their own racial music; the Latins became more Latin, and the Germans more German (and the Britons and white Americans of that time, having mixed French impressionism with Russian and German avant-gardism, became absolutely incomprehensible). From 1920 to 1925 we see one definite trend . . . no matter how absolutely Latin the Latins might become . . . or how Germanic the Germanics might become . . . deep down (or perhaps not even concealed at all) . . . is *ever* present the new *note* of the Congo. This *note* has erroneously been called " American," but this note belongs no more specifically to the North American Negro than to those of the West Indies or South America. It is *black* . . . not white, nor yellow. It is strongly marked and recognisable, never to be mistaken, even by the musical illiterate. Rhythmically it comes from the groins, the hips, and the sexual organs, and not from the belly, the interior organs, the arms and legs, as in the Hindu, Javanese, and Chinese musics, or from the breast, the brain, the ears and eyes of the white races. It is angular and elliptical like the lines of a Brancusi sculpture . . . or better . . . like the sculptures of the African Negroes themselves. In its original state in Africa, this music first impresses us as hard, wooden, incredibly complicated rhythmically, so that even the most involved Arabic music must seem tame in comparison. To a white European musician, hearing for the first time choruses from the Congo (even though it be upon gramophone records) . . . he is invariably stunned by the machine-precision of the black choirs in rhythms and counter-rhythms even more difficult than the last cataclysm of the *Sacre*, which demands for its performance musicians of the highest order and many painstaking rehearsals. The idea of correctly presenting these choruses with such vital and direct rhythmic accuracy *is unthinkable with even the best-disciplined white chorus in the world*. One thing is certain, the Negro has a rhythmic sense second to none in the world; one can scarcely believe that one has not to do with a highly civilised race, masters of steel, mathematics, and engineering, in hearing these choruses from the Congo . . . so intricate in rhythmic

The Negro on the Spiral

pattern, so delicately balanced in contra-rhythms and proportions, and so breath-taking in unisons and choral *impact* are these extraordinary performances. One is reminded of a colossal *Noces* fabricated by a *single* people for ages . . . broader . . . wider . . . infinitely more intricate and at the same time more epic; not accompanied by four pianos in a Parisian ballet, but by the gigantic xylophones of a thousand wooden drums fashioned from the hollow trunks of trees; the sound of the tragxylophone, iron bells, the rattle of baskets of stone, primitive but sonorous harps fashioned from a memory of thousands of years back which long ago came down the Nile, one-stringed zithers on long narrow poles, harps with gourds attached to their middles, violins with zebra-hair strings played by a zebra-hair bow with several gourds attached and sounding like clarinets of the richest quality, palm flutes, *wooden* trumpets, great horns made of elephant tusk, the twisted horns of antelopes, each one with a stranger sound (a sound which no European orchestra could possibly duplicate). Imagine added to this the great Negro choirs themselves, and the strange high vibrant treble of the Negro women, and the special Negro throats of the men, and . . . incredible co-ordination.

It is inevitable that this tremendous musical impetus originating in the heat of Central Africa was carried over through the slave deportations to North and South America and the West Indies, and that each one of these black populations overflowed with its own separate music in an infinite number of new designs and phenomena, due to the new musical absorptions and influences the original African impetus underwent. But it is important to notice that these influences, whether they be of Yankee hymn tunes, or the Habaneras of the Portuguese or Spanish, or other points further southward in the New World, were always completely absorbed, and did not conceal or hinder the original pure Africanism underlying every measure of this music. This exact quality is hard to define technically, as it has an infinite amount of variants, but in general one might say that the African " sound " in music is usually a tightening-up of the musical force, an intensive concentration and compactness, and thinning-out of line, and brilliant and sudden rhythmical decisions more daring than those of any other people or race, a marked tendency towards the "black" on the pianoforte, and the inevitable eighth-note on the strong beats throwing into an immediate quarter-note following, the latter with an accent (almost the Negro signature, for go where one will in Negro music, these two notes occur like the signature of Alexander the Great in the ancient world). The least common denominator of the Negro music has not changed; one still finds it in an almost pure state upon the islands off the coast of the American southern states where the fire-ritual dances are still played and sung after two hundred years and three thousand miles distant from the Congo. In the interior of the United States the work-songs and the children's songs and occasionally the well-known and often overestimated "spirituals" attest to this. The *Rumba* of Cuba and the *Biguine* of Martinique, although Spanish in dress, have Negro hearts and certainly nothing but Negro bodies. The peculiar rhythm of the present popular West Indian music still escapes everyone but the actual native orchestras; daily it becomes more and more astounding that a white orchestra cannot catch the exact click of the two wooden sticks, or the momentum of the rattles, or, indeed, anything but the most simple outward characteristics of the rumba. If this does not attest to the individuality and enormous skill of even popular Negro musicians, then nothing else ever will. As for South America, Darius Milhaud, who spent a number of his years there connected with the French Embassy, brought back a collection of half Spanish-Portuguese and Negro music. These formed the basis of his well-known ballet, *Bœuf-sur-le-Toit*, and his equally well-known collection of South American dances. This music is some of the very best that Milhaud has written, and stands in the front rank of to-day's creative music. All in all, the Americas have done well by Negro music, for they have furnished a musical détour to Europe, which liaison would otherwise have been made impossible by the Arabs. For although the Iberian peninsula and Africa almost touch one another, it has been evident that the shortest way from the Congo to Paris and Berlin musically is via America, North and South, where for several hundred years African music has come into contact with the European and become organically comprehensible and even popular with the white race. The mixture has not especially harmed Negro music, but it has furnished it with a hundred new combinations and an infinite vista and a definite influence. Negro music has never become Spanish, Portuguese, or Yankee, but the latter have actually become Negroid. Who can deny that the popular music of the United States has become definitely mulatto, even if only partially so; the union between a Negro and a white invariably produces a Negro and not a white. The Negro music, like the Negro, absorbs, but does not become. It is a definite compactness, and an invulnerable, indestructible quality. It has existed under the broiling sun for thousands of years . . . the sun which blinded in the day and left the night full of jungle steam, terrors, and sounds. Being in the midst of Nature at her cruellest, it is not pastoral. It has survived and built up an incredible musical machinery.

215

The Negro on the Spiral

And in 1919 it made its official appearance in Europe.

The fact that Europe was ready for it can only be accredited to the Russian Five, Tschaikowsky, Strawinsky, and the great Frenchman, Debussy, who had spent his early life in Russia as a tutor, and came back to Paris filled full of *Boris Godounov*. Debussy came back to a French Capital that was somewhat surfeited with Wagner, at least in intellectual circles. It is France that we have to thank for the western European support of the revolution against the ponderous scores from Germany, growing ever more bulky and pseudo-Olympian. Borodin, Moussorgsky, Tschaikowsky (and eventually, when everything was ready for his entrance, Strawinsky) turned the desert cyclones of the Gobi and Mongolia loose upon this German music and swept it away for the time being, to the new adventures and progress of music. These musical Marco Polos came back to Europe with marvellous languages and symphonies. Rimsky-Korsakow, formerly an officer in the Russian Imperial Navy, introduced to Paris *Sheherazade* ... some time afterwards the Russian Ballet was formed and Diaghileff discovered the young Strawinsky and gave him his first chance; the new Slavic Barbarism was under way, and the air was completely clean-blown of German learning and Wagnerian cadences; in 1911 the Italian Futurists gave out their first manifestos, and Picasso became well known; in 1912 Diaghileff and Strawinsky conceived the idea of the *Sacre du Printemps*, which was produced the following year in the Champs Élysées Theatre with historical results. Paris was buzzing with new ideas, and had turned her back upon Wotan; in the circles where ideas and tastes count, a gradual tension was being felt; a grim, inevitable drifting towards a great catastrophe was evidenced in the tremendous artistic revolutions of that time; the *Sacre du Printemps* alone was enough to herald it if nothing else. Then came the war, one single terrible flattening blast; indeed what could survive after this whirlpool of ideas and events? The American Negroes advanced upon musical Paris, took command, reigned for a time, and then disappeared, leaving everywhere gigantic mulatto patches; musicians particularly seemed to have turned at least to octoroons. Like wildfire the *Negro patch* spread everywhere in Europe except, perhaps, in Hungary, to whose Mongolian ancestry this music is entirely foreign. Counting out Kodaly and Bartok, every other European composer pretending to being even partially alive at that time became mulatto. Waking up one morning somewhere around 1925, the musical world of Europe became alarmed at its racial problem, even as once long ago North America woke up after the Civil War of 1865 frightened to death with the spectre of a mulatto or an octoroon population. Thereupon came the reaction. Every time a white composer was caught consorting with Negro music he was promptly run off and musically lynched; after a vigorous year of campaigning Europe sat back and told itself that Negro music was no more.

Still, papal decrees continued to be issued against jazz; dancing approximated more and more to the St. Vitus sickness; people went back to the old music and found out they could not even listen to it.

They treated the situation as a sickness; special cliniques were founded; still people recommended writing music as if nothing had happened. Strawinsky, great genius that he is, had already commenced writing a music for this difficult time; one heard in his new music the classic sound and intention, but tightened as hard and fast as a piece of Negro sculpture. Strawinsky abandoned the " development " section which for a hundred years had been the pet insanity of the Germans, and what sound he did take from the classic music he absorbed completely into himself; these sounds became *him* . . . he did not *become like* Bach; thus like the Negro music he remained the original unit; he did not give but he took; he absorbed but was not absorbed. In this torrid after-war period he alone persisted; he did not become white, but all else became mulatto after his fashion. Even when he touched these strange old *sounds* which had lain dusty in the opera libraries or in the sounds of several decrepit Parisian orchestras, he gave them a simple and barbaric intensity; the extra and unnecessary notes were all left out; classic sound took on, for the first time, an extraordinary rhythmic tightness not belonging to the old European culture in any way. The classic sound, however, exploded the brains of a number of his whoopee followers, harebrained people who judge everything by externals, and who had been until now fascinated by the steely and barbaric Slavic sound of his former music. They thought Strawinsky had abandoned their sacred " Modern Music," as they called it, naively unaware of anything comic in their appellation. As a consequence Strawinsky's way has not been too easy since. However, his music has been the only music which has not melted down in the electric furnace of post-war Europe.

Excepting, of course, the Negro influence which is accustomed to such heat.

For look where we may today beneath this classical music of Strawinsky, or beneath the cheap but infinitely touching " Berlinese " of Weill, or beneath the beery but interesting and strong (in a Breughel-like way) fabrications of Krenek, or for that matter the last creations of Schönberg, Milhaud, Auric . . . we find the note . . . the technic . . . the *aesthetic* of the Congo . . . all the more important and

216

The Negro on the Spiral

insidious in its influence because now it is more deeply hidden but now *everywhere* present. It would seem outwardly as if this tremendous mulattoism has become absorbed and taken into our European music for whatever it is worth. The French have become more Latin, and the Germans more German. Strawinsky, Milhaud, and one or two young Italians belong even to a now definitely recognisable " Mediterraneanism " ; Weill, Krenek, Weinberger, and a number of other Germans have become the journalists of their separate cities, times, and politics . . . a thing Georg Grosz did with real success a decade ago. Still, how superficial any viewpoint would be which contends that Negro music has been absorbed can be proven by looking into almost any modern score. The violin concerto of Strawinsky is full of recognisable jazz (the first outright jazz Strawinsky has allowed himself in some time) ; the last opera of Schönberg concerns itself with the present day and contains some of the very worst jazz that white man has ever written ; I could go on easily filling up this page. The Negro is *not* absorbed, but absorbs. Even though a white might lay with an octoroon of the whitest color, still after one or two white children a child absolutely black might be born. Europe has been impregnated, and impregnated deeply. We need no longer be surprised by our dark children. Music will no longer be all the white keys of the piano, but will have keys of ebony as well.

The tremendous détour that Negro music has taken to reach the European continent at its most torrid, barren, smoking, and psychological moment has been via the Americas, because this music could never have adequately pierced the Arabian veil thrown over the top of the African continent like magic, or as an iron lid to keep this boiling and seething musical ferment in the jug of Africa. For the Arabs, like the Phœnician Semites before them, are an eastern people, and their music an oriental one coming via the Arabian desert from the Gobi and the Himalayas. The Arab music is in itself a strong music, and the combination of Mongol and Mussulman roaming for a thousand years up and down Russia brought about a strange mixture of blood, so that we are not at all surprised when Borodin writes *Prince Igor* . . . he was himself directly descended from a Tartar chieftain. We scarcely realise today exactly how near to the soil was the whole Russian movement. Strawinsky has a partially Asiatic cast of countenance ; he comes naturally to the barbaric heritage he has so adequately expressed. But we cannot try to part Russian music and Mongolian and Arabic music. The three have a blood kinship, even though today the Arab might be far removed from the north Russian ; the Arabic music in a far-flung western and African branch was sufficiently strange and strong to keep any Negroid inflections from crossing the Mediterranean to the new music cultures of 16th to 19th century Europe. This European music culture drifted in one way or another from the earliest church composers, through Mozart and Beethoven (both of whom wrote " Turkish " music) to Wagner, who (as might suit your own taste) was either Viking or pseudo-Viking . . . from the viewpoint of tendency it does not much matter which. It is interesting to note that this culture passes to culture, and influence to influence, like a gigantic spiral starting from a central point and throwing out its long spiral line like those peculiar revolving optical illusions which we spun upon a pinwheel as children. It is like a gigantic radio station. For if we start with Bach we go immediately afterwards to Vienna (still remaining purists and classicists) with Mozart and Beethoven ; and then clockwise (in ever larger circles) to Paris (and southern Germany) with Schumann, Chopin, Berlioz, and early Wagner ; then in still larger expanding spiral to northern Germany and Scandinavia, with later Wagner and Grieg ; then to Petrograd with Tschaikowsky in ever larger spiral (still clockwise) to Moussorgsky, Borodin, Rimsky-Korsakow and Strawinsky through eastern Russia, western Asia, and downward to Arabia ; then the line passes invisibly through the very centre of Africa (although no one knew it at that exact moment !). I called the Americas an enormous détour, but perhaps indeed they were no détour at all, but absolutely upon the path of this gigantic spiral now throwing out its enormous circle over the South Atlantic, taking in South America, the West Indies, and North America in one gigantic swing. Then in 1919, the line, still swinging clockwise, comes back over the North Atlantic and hits Europe. Wagner at the very height of his northern music culture succeeds to Strawinsky who, at the very height of his eastern Tartar culture, succeeds to the Congo. Clockwise the Viking passes on to the Slav, and again the Slav passes on to the African. It is twelve o'clock with Wagner ; three o'clock with Strawinsky ; and when the height of African influence and culture is reached, it will be six o'clock. But the point I wish to make clear by the example of this gigantic spiral going clockwise throughout the centuries is this : music progresses logically ; even geographically it is possible to trace its course ; can one with some optimism be clairvoyant? Certainly it is not impossible to see immediately the kinship between Slav and African, and how one must inevitably pass to the other ; and how the utmost end of one development is not unsympathetic to the other. The great Russian poet Pushkin was a mulatto ;

217

it was he, Pushkin, a mulatto, who wrote the text for the greatest *Russian* opera of all time . . . *Boris Godounov*! In regard to the relationship with New York (and referring obviously to Irving Berlin) Jean Cocteau writes (1932), "*Les premiers grands rag-times* (1918) *furent l'œuvre de musiciens russes chez les Nègres de Harlem, à New-York. Le Rythme intraduisible de Pouchkine ne viendrait-il pas du sang noir?*" . . . Negro music appeared suddenly (after a gigantic preparation) after the greatest war of all time . . . it came upon a bankrupt spirituality; to have continued within Slavic mysticism would have induced us all, in 1918, to commit suicide; Negro music made us to remember at least that we still had bodies which had not been exploded by shrapnel and that the cool 4 o'clock morning sunshine still coming over the hot veldt of yesterday was this morning very, very sweet. We needed at this time the licorice smell of Africa and of camel dung . . . the roar of the lion to remind us that life had been going on a long while and would probably go on a while longer. Weak, miserable, and anaemic, we needed the stalwart shoulders of a younger race to hold the cart awhile till we had gotten the wheel back on. But first acquaintance with this charming and beautiful creature, the Negro, made us love him at first sight; we could not resist him.

Then the panic seized us . . . a usual first reaction of love!

Perhaps it was also self-preservation. In 1919 nothing else could have borne the strain, the terrible strain. Nothing else was strong enough, hard enough, new enough. This music came with absolute sympathy and a complete collateral aesthetic in the other arts. Modigliani had already devoted his life to painting marvellous elliptical heads; Gaudier-Breszka and Brancusi had sculpted them; Chirico painted rooms full of Roman ruins with egg-heads; the Dadaists collected every bit of Negro sculpture they could lay their hands upon; the Surrealists in 1924 exhibited the best of it with their own painters. Without knowing it we were learning to live again in the bright torrid sunshine of reasonable animals without mystical northern lights, without any spiritual food except that which we lay in wait for or *trapped* by ourselves. Everywhere the traps were laid; everywhere the lions roared menacingly; at every moment we remembered the years of famine which were directly behind us. The Germans sat down in their methodical way and tried to build up another world-supremacy in music, as they once had done, but they built with counterpoint and scholastic "durchkomponiertes Musik" . . . these were the only principles they knew, and these principles had worked for a long time before and they thought they would work again now. But in Paris everyone was like a hunter of wild beasts; we found ourselves suddenly in a dangerous epoch like a wilderness without end, without food, and without life. The Negro taught us to throw away our useless folding baths, our hot-water bottles, our travelling frigidaires . . . to put our noses to the ground, to follow the scent, to come back to the most elementary principles of self-preservation. We found ourselves in the Parisian veldt; Chirico, Picasso, Strawinsky, Cocteau, and many others were hunters who roamed the wild jungles and trapped every day, every month, without fail, our existence. No longer could we arrive at the water-well with an automatic graph or synthetic compass. The Viennese meanwhile, full of automatic-synthesis, invented a system whereby they could reproduce genius upon purely mechanical principles; they thought their science would outdo itself in reproducing life; but so far it has produced nothing but a breath-taking and awesome system. The twelve-tone system is such that each and every melody to attain pure atonal balance must sound at some point within itself, *the whole chromatic scale . . . no more, no less. In consequence, the soul of music has passed out of the hands of the old Germans* (Schönberg and followers) into the hands of the young Germans. And the young Germans embraced mulattoism after their fashion. It is true that they are often as much Negroid as a German performance of *Green Pastures* with native Berlinese in blackface might be, but at least they black their faces unabashedly; *Jonny Spielt Auf* did a considerable lot of good in opening up the new operatic movement in Germany. And their new operatic movement in Germany is the first step they have made towards the recovery of any of their lost musical supremacy. The hero of this last-named opera is a Negro called "Jonny" (!), albeit a beery and Viennese Negro who achieves his highest moment by breaking into "Swanee River." But in Paris it was different. The water-holes were watched and set with traps; Bunuel caught enormous alligators in grand pianos with their life-blood dripping down upon the white keys. Houses were no longer made in Wotan-like architecture, or pseudo-baroc, or what-not; men began building houses, white, like tents, and filled them with camp-stools made of nickel stretched with canvas. Everywhere we looked we saw the long straight lines of the whitewashed houses of North Africa; we began to realise that home is but a camping ground which we can make simple and beautiful with modern engineering and glass and steel. Still all of these houses carry the feeling of clean straw thatch and mud, as if built for torrid climates. Europe became dotted with white simple architecture as if we hourly expected the gulf-stream to change its course and the temperature of Europe to reach again the torrid temperatures of the pre-ice ages and the sabre-toothed tiger. One came to many streets where by looking

The Negro on the Spiral

at the houses in brilliant white, steel, and glass, one felt as if one should approach and enter them only in a sun helmet and white duck pants. Europe began in the early twenties to assume the aesthetic of the desert camp; subconsciously it came within the plan of things to live upon the veldt. The great war had come and gone, we had been robbed and ransacked of everything; *and we were on the march again.* Therefore we welcomed this sunburnt and primitive feeling, we laid our blankets in the sun and it killed all of our civilised microbes. The Negro came naturally into this blazing light, and has remained there. The black man (the exact opposite color of ourselves!) has appeared to us suddenly like a true phenomenon. Like a photograph of ourselves he is the sole negative *from which a positive may be drawn*! Holding this negative up to the sun we see in essence that which so many eyes and ears have been trying to demonstrate on canvas, paper, and stone . . . the other side of that which we cannot see, but which we can put our arms around; the hard indestructible object with air around it, a world transferred over into the opposite world, a new start, the black man.

But very little has been written about Negro music technically and that which has been written is mostly tripe. These writings attempt, in effect, to prove that the music of each separate country has been benefited greatly *by the absorbtion* (!) of Negro music, and trace down, more or less, these "absorbtions," usually presenting in the latter part of the book the result of this mélange, to the honor and glory and complete victory of the white race. This being exactly the reverse of the necessary process, I cannot presume to occupy myself here with any of these books, and in consequence with any long list of references. Neither can I in so short a space adequately give any idea of Negro music whatsoever; but I can sketch a method. This method would be to start upon the spiral at the Congo, and go clockwise to South America, the West Indies, North America, and then cut the spiral downwards sharply to Europe. I have attempted to give the main principles of this aesthetic earlier in this article; its connection with each and every phase of the art and music it has either influenced, absorbed, or is about to absorb. To go over each and every step of this pathway is the work of future musical scientists; I can at this moment give a number of the best examples of Central African music, or the centre point; I should like at this moment to go into a lengthy song of praise of Louis Moreau Gottschalk, the first American composer to become known in Europe, whose work Chopin himself praised, and who had a considerable furore in his day, but who, because of our American habit of discounting and discrediting our great men, has fallen into the limbo of forgotten genius.

Louis Moreau Gottschalk was a mulatto. In looking over his work recently I was astonished to find a *Cubana* which was, without a shadow of a doubt, the celebrated "Peanut-Vendor" rumba, note for note!! But it was written over three-quarters of a century ago, and with what astonishing ingenuity and pianistic brilliance! Truly Europe must have been astonished, and the salons through which Chopin walked electrified by this dark and slender American who left his white gloves intentionally upon the piano (for the ladies afterwards to tear apart!). Indeed, to trace this spiral so rich in all of these things should be a great sport for someone. A greater duty would be to trace, scientifically and carefully, the development of the Great Spiral, the victory of the Slav over the German, and the victory of the Negro over the Slav.

Negro Creative Musicians

by EDWARD G. PERRY

Mr. Perry is a well-known young coloured musical critic on several of the Harlem papers

Mᴏsᴛ Americans, and perhaps a majority of the people in many other parts of the world, are of the opinion that the spirituals are the Negro's only worthy contribution to the creative music of the world. Many of these people also believe that the spirituals, in their musical origin or inspiration, are based upon or derived from African rhythms or tribal songs. This, of course, is quite erroneous, since these folk-songs of the black man's early days of plantation slavery in America contain almost nothing that is African in their origin. Therefore, they are as much the creation of a group of people—now long removed from the native land of their black ancestors—as the folk-songs of the Russian peasants. And because these songs were born of the souls of men and women, who, through the hardships of slavery, fertilised a great portion of the soil of America, they are as much a part of the native music of this continent as that of any other group. They are, in the simplicity of their rhythmical beauty and fervor, not only a noble tribute to the creative genius of the black man but they are the supreme offering of America to the music of the world.

Therefore, if the modern Negro has not demonstrated any great ability as a creative musician, or has failed to contribute any outstanding and impressible compositions to the music of America and the world, it has not been because he has not thought of or attempted to do more serious work than his well-known arrangements of the spirituals and his later popular ballads, "rag-time," and jazz compositions, but only because he is living in a highly mechanised and material civilisation—a civilisation that is in every way inconsistent to the cultural and artistic advancement of its people—that he has turned, like other present-day creative artists, to work that is much more remunerative. That is, if the younger Negro musician has not developed his talent as a creator of the higher forms of music, he has certainly contributed much to the present popularity of American jazz. Therefore, considering these things, it is no discredit to the black people of America, or the world, that their musicians have not wrought any music of divine greatness, since it is almost too much of a fact that the so-called native music of other American composers has been, and apparently continues to be, somewhat muddled and sentimental carbon copies of the music of the old European masters.

Concerning the creative ability of the Negro musician, as long ago as the early part of the nineteenth century there were many well-educated colored people in New Orleans, a number of whom were talented musicians who also gained some distinction as composers; while in Philadelphia there were several colored men who not only wrote music but were publishers of it as well. In this latter group— from 1829 to 1880—were James Hemmenway, publisher of a musical journal known as *Atkinson's Casket*, and whose better-known compositions are *That Rest so Sweet like Bliss Above, The Philadelphia Grand Entrée March,* and *Hunter and Hope Waltzes*; Edwin Hill, the first Negro admitted to the Philadelphia Academy of Fine Arts, and A. J. Conner, whose compositions were published by reputable music houses in Boston and Philadelphia. Other composers of this period were Justin Holland, who wrote a number of compositions for the guitar, and Samuel Milady, known as *Sam Lucas*, who was the first Negro to write popular ballads; while two of the outstanding songs of the nineteenth century were written by colored men: James Bland composed *Carry me Back to Old Virginia*, and Septimus Winner, under the *nom de plume* of Alice Hawthorne, wrote and published *Listen to the Mockin' Bird*. The former song or ballad, *Carry me Back to Old Virginia*, has become almost a classic in its sentimental appeal and popularity among the American people.

But the most distinguished of all Negro composers, Samuel Coleridge-Taylor, was an Englishman of African descent. He was born in London during the first year of the last quarter of the nineteenth century. His father, a native of Sierra Leone, was a doctor of medicine in London. Having started to study music at the age of six, Coleridge-Taylor entered the Royal Academy of Music, London, when he was only sixteen. Later he was a pupil of Villera Stanford.

Although he composed many opus numbers, including a symphony, a sonata and other compositions of chamber music, Coleridge-Taylor's best-known works are his choral music, of which *Hiawatha*, a cantata in trilogy form, is outstanding, as it has been sung at various times in almost every modern country. He also composed three oratorios—*Herod, Nero,* and *Ulysses*; while *A Tale of Old Japan*, his last choral work, was an unprecedented success when it was first performed. Coleridge-Taylor, because he was endowed with a supreme knowledge of the pianoforte, composed music that is intelligently original in form, and even though it is sometimes astoundingly vigorous, it is written with such clarity and imagination that it is not only sensitive and beautiful but highly impressive.

Negro Creative Musicians

While Coleridge-Taylor was creating his great choral works and other compositions in London, the musicians of his race on this side of the Atlantic were by no means idle. They were working with the lighter forms of music and writing arrangements of the spirituals. This, of course, was at the turn of the century, when most of the musicians who had any creative ability were devoting their time and efforts to the popular ballads of the period. Foremost among these composers was Will Marion Cook, who not only wrote music but was, at different times, leader of two well-trained musical organisations—the Clef Club Orchestra and the New York Syncopated Orchestra—both of which attained much prominence during the early 1900's. And it was during these days that Cook wrote such popular ballads as *The Casino Girl*, *Bandanna Land*, and *Cruel Popupa*. But the two compositions of his which have been kept alive because they reveal something of his creative genius, are *Swing Along* and *Exhortation*. Although Will Marion Cook is still living, he has written very little during the past few years. But because he so greatly influenced the younger generation of Negro musicians and other artists he is still considered with much favor.

Perhaps no Negro musician has done as much for the musical advancement of his people as J. Rosamond Johnson, who was born in Jacksonville, Florida, and received his higher musical training at the New England Conservatory of Music in Boston. At the beginning of the twentieth century he was writing the music for the light operas and operettas presented by Klaw and Erlanger, two of the most famous producers of that day. He was also responsible for the musical scores of the extravaganzas produced by Klaw and Erlanger, and therefore wrote a number of songs for the stars of their shows, who were such eminent music-hall artists as Lillian Russell, Anna Held and May Irvin. Among the popular songs he composed at this time were *Under the Bamboo Tree*, *The Congo Love Song*, *My Castle on the Nile*, and *Lazy Moon*. In 1913 Johnson became the director of Hammerstein's Opera House, London, but soon resigned and returned to New York, where he became the guiding spirit of one of the first musical institutions for Negroes in this city—the Music School Settlement. Later he turned seriously to composition and wrote some distinctive arrangements of a large number of spirituals; his later work includes a choral development of *Nobody Knows the Trouble I See* and several art songs, among them *Since You Went Away*, *The Awakening*, and *A Song of the Heart*. The latter songs are music of the finest quality, written in an original musical manner. The music for *Lift Every Voice and Sing*, a stirring song, magnificent in its emotional appeal, was written by Johnson, with lyrics by his brother, James Weldon Johnson, the eminent literary scholar, poet, author and diplomat. *Lift Every Voice and Sing* is popularly known as the Negro national anthem. So perhaps those people who call J. Rosamond Johnson " the apostle of Negro music taken seriously " are right.

The spirituals have played an important part in the recent cultural and artistic development of the Negro. That is, during the so-called *New Negro Renaissance*, hardly any Negro singer attempted a program without including a group of spirituals. Most of them felt that their programs would have been a failure without several of the folk-songs of their race included; while one or two singers even went so far as to offer entire programs of spirituals, which, it must be admitted, were highly successful financially.

Foremost among the arrangers of the spirituals is Henry Thackeray Burleigh, a native of Erie, Pennsylvania, who studied at the National Conservatory of Music and was a pupil of the great Anton Dvorák. Burleigh is a notable personage not only among Negro musicians but among the musicians of America. For many years his name has been, and continues to be, constantly before the public as an arranger of the spirituals and the composer of many " semi-classical " or art songs. He is also baritone soloist in one of the oldest and wealthiest Episcopal parishes in New York—St. George's Church, and is a member of the editorial staff of G. Ricordi and Co., one of the largest music publishing houses in America.

While Henry T. Burleigh is often considered the creator of the American art song, he has done more to bring about the high appreciation of the spirituals than any other Negro musician, unless it be Hall Johnson, whose work will be mentioned later. Those songs of his which are sung most, apart from his distinctive arrangements of the spirituals, are *Jean*, *In the Woods of Finvara*, *Were I a Star*, *The Grey Wolf*, *Three Shadows*, *The Saracen Song*, and *Passionale*.

While a large number of spirituals have been adapted in a singularly interesting manner by older Negro musicians, Hall Johnson, a native of Pennsylvania, and a young musician of rare genius, has written some arrangements that are so harmonic and rhythmic that they surpass in musical brilliance most of the efforts of his predecessors. But Johnson has not only given us some highly original adaptations of the spirituals but has turned his attention, with much success, to other Negro folk music—work songs, secular songs and native " blues." And while he has developed much of this folk music in a rather elaborate manner, he has done so without spoiling its sensitive, earthy quality.

And when this purely racial music is sung by the Hall Johnson Negro Choir—a group of singers whose training under the direction of Johnson has brought them notable success—it is given the greatest

expression. This chorus alone, if nothing else, would give Johnson an outstanding place in any future musical history of America. For the genius of his fine musicianship is so skilfully displayed by the Hall Johnson Negro Choir, whose diction, harmonic wizardry and startling variation of rhythms are musical perfection. And because he has refused to compromise with those inhibited and too self-conscious members of his race, who would destroy in their arrangements the beauty and simplicity of the Negro folk-songs, by offering them without the dialect and inspirational fervor of their native creators, his contribution to our musical culture is a significant one. Of course, Hall Johnson has also composed a number of songs, all of which reveal his exceptional musical ability.

Few Negro composers have written compositions solely for the piano or other string and wind instruments. That is, most of them have been interested in music for the voice. But R. Nathaniel Dett, who is still a rather young man, has devoted much of his time to the creation of music for the pianoforte, even though he was for a number of years director of one of the finest choirs in the country—the Hampton Choir, at Hampton Institute, in Virginia. This musical organisation is now famous internationally, as a result of their excellent training under Dett. Unlike many other musicians of his race, Dett has found much that is beautiful in African rhythms, and many of his compositions for the pianoforte have sonorous, yet weird, exotic qualities, while certain portions of his *Magnolia Suite* and *Barcarolle* have the delicate brilliancy of the music of Debussy. Dett, of course, has written some fine arrangements of the spirituals, and among his other important compositions are *In the Bottoms*, *Juba Dance*, *Marche Nègre*, and a number of songs and oratorios.

Another musician whose compositions are known for their African themes is Ira Amanda Aldridge, daughter of the famous nineteenth-century Negro actor, Ira Aldridge. Miss Aldridge, who now writes under the *nom de plume* of Montague Ring, was born in London, where she still lives. She has written a number of songs, pianoforte compositions and ballet music, and conducted a performance of one of the latter compositions at Buckingham Palace.

Returning to America, one can find in the group of finer musicians here such men as Melville Charlton, distinguished organist, who once conducted grand opera performances in the famous ballroom of the old Waldorf Astoria Hotel, New York, served as organist for the largest and wealthiest Jewish congregation in New York, and is at present holding the same position at Union Theological Seminary, New York. Charlton has written an outstanding composition for the pianoforte in *Poème Erotique*. Others in this group are Carl Diton, organist, pianist and singer, whose compositions are an organ fantasie on *Swing Low Sweet Chariot*, and a choral arrangement of *Deep River*; Clarence Cameron White, concert violinist, composer of *Bandanna Sketches*, and Hugo Bornn, composer of two piano compositions of merit—*Song of the Siren* and *Moon Revel*. And there are a few younger musicians whose names should also be mentioned here for their distinctive arrangements of the spirituals: Eva Jessye, whose volume, *My Spirituals*, contains some adaptations that are rich with rhythm and melody; Lawrence Brown, Edward Boatner, Percival Parham, William Dawson and Edward Mathews.

In the field of musical drama the Negro musician's contribution has been almost negligible. Neither as a composer or a singer has he been successful. And while there are a few men and women with fine voices who are well prepared to sing on the operatic stage, there have been few if any worthy opportunities offered for them to do so; and the Negro composer has not given enough time to the building-up of a significant background to enter the field as a composer of significance.

But only recently a young woman, whose name is Shirley Graham, completed an opera in four acts called *Tom-Tom*, which was produced during the summer of 1932 by the Cleveland Summer Grand Opera with notable success. The opera has for its dramatic theme the transition of the Negro from Africa to America; and the composer in developing the music has attempted to synchronise it with the action of the story. That is, throughout the first scene of the opera only the percussion instruments are heard beating the rhythm of the tom-toms, while the spirituals are used to develop the dramatic interest during the days of slavery, and the final scenes have a musical theme of counterpoint that reaches into the field of modern jazz. Miss Graham, like most modern composers, has apparently had some difficulty in avoiding the music of some of her European predecessors, but her score contains enough exceptional music to make it more than interesting. Therefore, while *Tom-Tom* certainly has its faults, it is up to the present time the Negro musician's most significant venture in the field of grand opera.

Of course, one cannot afford to overlook Lawrence Freeman, who has devoted almost all of his musical talent to the opera, but his compositions, even though they are often interesting, lack the skilful requirements of the musical drama; while two other musicians—Clarence Cameron White and William Grant Still—show promise of better things.

While the Negro has been able to keep the spirituals as his own native creation and contribution to the music of the world—even though other musicians and composers have interwoven them into the themes of their compositions—he has been fast losing ground as the original creator of jazz. This music, which is an outgrowth of Southern " rag-time," is now universal in its appeal, and was first introduced abroad by James Reese Europe, noted Negro band leader. While the " blues," like the spirituals, are still purely racial, they are in the same field as the old " rag-time " tunes, and many jazz compositions are therefore by-products of these strange and colorful songs.

Outstanding among the composers and arrangers of the " blues " is W. C. Handy, whose *St. Louis Blues* is almost a classic in its popular appeal. There is no doubt that this composition is the work of a first-rate musician; not only has it been heard over and over again in the dance casinos of America and Europe, but it has been sung in concert halls, and symphonic arrangements of it have been performed with much success. While there are other composers of the " blues," none of them have been able to achieve the success of W. C. Handy, whose compositions deserve serious consideration wherever they are heard. Three other composers who should and must be mentioned here are James Johnson for his *Yamacraw*; Duke Ellington for the exotic *Mood Indigo*, and Porter Grainger for his sincerely original Negro music. That is, if music can be called Negroid, then the music of Porter Grainger is just that. While among the better-known composers of jazz are Noble Sissle, Eubie Blake and Thomas Waller.

In conclusion, it might be mentioned here that Pitts Sanborn, eminent American music critic, writing in a recently-published volume, *America as Americans See It*, considers jazz " America's outstanding contribution, so far, to world music." Furthermore, Mr. Sanborn says that " Jazz jumped up, full fledged, of exotic origin, born of yearning for orgiastic display, supposedly among the roustabouts on the levees at New Orleans; but we hear of it very early indeed among the shrewd tone-merchants of Tin-Pan-Alley."

All of which deserves some consideration, of course, for the above-mentioned distinguished music critic not only overlooked the spirituals, as a part of the Negro's contribution to the music of America, but he failed to give them any credit for their exceptional ability as creators and musicians of jazz. Whether this was intentionally done or an oversight it is now difficult to say, but it is hardly possible that such an erudite musical personage as Mr. Sanborn could have overlooked the black man's contribution to the music of America or of the world.

Therefore, as in many other things, it is left to the Negro writer and pulpiteer to call to the attention of the world the Negro's gifts to its cultural and artistic advancement. Perhaps the Negro's contribution has not been of any supremely great and fundamental importance in recent years, but it has surely been significant enough to be recorded in any history of American music, since the impression he has made has been, and continues to be, so definite that it is impossible for any intelligent person to overlook its worth. Musically, the Negro is growing and there is no doubt that he will rise proportionately with other creative artists of the present day.

Spirituals and Neo-Spirituals

by ZORA NEALE HURSTON

THE real spirituals are not really just songs. They are unceasing variations around a theme.

Contrary to popular belief their creation is not confined to the slavery period. Like the folk-tales, the spirituals are being made and forgotten everyday. There is this difference : the makers of the songs of the present go about from town to town and church to church singing their songs. Some are printed and called ballads, and offered for sale after the services at ten and fifteen cents each. Others just go about singing them in competition with other religious minstrels. The lifting of the collection is the time for the song battles. Quite a bit of rivalry develops.

These songs, even the printed ones, do not remain long in their original form. Every congregation that takes it up alters it considerably. For instance, *The Dying Bed Maker*, which is easily the most popular of the recent compositions, has been changed to *He's a Mind Regulator* by a Baptist church in New Orleans.

The idea that the whole body of spirituals are " sorrow songs " is ridiculous. They cover a wide range of subjects from a peeve at gossipers to Death and Judgment.

The nearest thing to a description one can reach is that they are Negro religious songs, sung by a group, and a group bent on expression of feelings and not on sound effects.

Spirituals and Neo-Spirituals

There never has been a presentation of genuine Negro spirituals to any audience anywhere. What is being sung by the concert artists and glee clubs are the works of Negro composers or adaptors *based* on the spirituals. Under this head come the works of Harry T. Burleigh, Rosamond Johnson, Lawrence Brown, Nathaniel Dett, Hall Johnson and Work. All good work and beautiful, but *not* the spirituals. These neo-spirituals are the outgrowth of the glee clubs. Fisk University boasts perhaps the oldest and certainly the most famous of these. They have spread their interpretation over America and Europe. Hampton and Tuskegee have not been unheard. But with all the glee clubs and soloists, there has not been one genuine spiritual presented.

To begin with, Negro spirituals are not solo or quartette material. The jagged harmony is what makes it, and it ceases to be what it was when this is absent. Neither can any group be trained to reproduce it. Its truth dies under training like flowers under hot water. The harmony of the true spiritual is not regular. The dissonances are important and not to be ironed out by the trained musician. The various parts break in at any old time. Falsetto often takes the place of regular voices for short periods. Keys change. Moreover, each singing of the piece is a new creation. The congregation is bound by no rules. No two times singing is alike, so that we must consider the rendition of a song not as a final thing, but as a mood. It won't be the same thing next Sunday.

Negro songs to be heard truly must be sung by a group, and a group bent on expression of feelings and not on sound effects.

Glee clubs and concert singers put on their tuxedoes,[1] bow prettily to the audience, get the pitch and burst into magnificent song—but not *Negro* song. The real Negro singer cares nothing about pitch. The first notes just burst out and the rest of the church join in—fired by the same inner urge. Every man trying to express himself through song. Every man for himself. Hence the harmony and disharmony, the shifting keys and broken time that make up the spiritual.

I have noticed that whenever an untampered-with congregation attempts the renovated spirituals, the people grow self-conscious. They sing sheepishly in unison. None of the glorious individualistic flights that make up their own songs. Perhaps they feel on strange ground. Like the unlettered parent before his child just home from college. At any rate they are not very popular.

This is no condemnation of the neo-spirituals. They are a valuable contribution to the music and literature of the world. But let no one imagine that they are the songs of the people, as sung by them.

The lack of dialect in the religious expression—particularly in the prayers—will seem irregular.

The truth is, that the religious service is a conscious art expression. The artist is consciously creating—carefully choosing every syllable and every breath. The dialect breaks through only when the speaker has reached the emotional pitch where he loses self-consciousness.

In the mouth of the Negro the English language loses its stiffness, yet conveys its meaning accurately. "The booming bounderries of this whirling world" conveys just as accurate a picture as mere "boundaries," and a little music is gained besides. "The rim bones of nothing" is just as truthful as "limitless space."

Negro singing and formal speech are breathy. The audible breathing is part of the performance and various devices are resorted to to adorn the breath taking. Even the lack of breath is embellished with syllables. This is, of course, the very antithesis of white vocal art. European singing is considered good when each syllable floats out on a column of air, seeming not to have any mechanics at all. Breathing must be hidden. Negro song ornaments both the song and the mechanics. It is said of a popular preacher, "He's got a good straining voice." I will make a parable to illustrate the difference between Negro and European.

A white man built a house. So he got it built and he told the man: "Plaster it good so that nobody can see the beams and uprights." So he did. Then he had it papered with beautiful paper, and painted the outside. And a Negro built him a house. So when he got the beams and all in, he carved beautiful grotesques over all the sills and stanchions, and beams and rafters. So both went to live in their houses and were happy.

The well-known "ha!" of the Negro preacher is a breathing device. It is the tail end of the expulsion just before inhalation. Instead of permitting the breath to drain out, when the wind gets too low for words, the remnant is expelled violently. Example: (inhalation) "And oh!"; (full breath) "my Father and my wonder-working God"; (explosive exhalation) "ha!"

Chants and hums are not used indiscriminately as it would appear to a casual listener. They have

[1] Evening dress.

a definite place and time. They are used to " bear up " the speaker. As Mama Jane of Second Zion Baptist Church, New Orleans, explained to me : " What point they come out on, you bear 'em up."

For instance, if the preacher should say : " Jesus will lead us," the congregation would bear him up with : " I'm got my ha-hands in my Jesus' hands." If in prayer or sermon, the mention is made of nailing Christ to the cross : " Didn't Calvary tremble when they nailed Him down."

There is no definite post-prayer chant. One may follow, however, because of intense emotion. A song immediately follows prayer. There is a pre-prayer hum which depends for its material upon the song just sung. It is usually a pianissimo continuation of the song without words. If some of the people use the words it is done so indistinctly that they would be hard to catch by a person unfamiliar with the song.

As indefinite as hums sound, they also are formal and can be found unchanged all over the South. The Negroised white hymns are not exactly sung. They are converted into a barbaric chant that is not a chant. It is a sort of liquefying of words. These songs are always used at funerals and on any solemn occasion. The Negro has created no songs for death and burials, in spite of the sombre subject matter contained in some of the spirituals. Negro songs are one and all based on a dance-possible rhythm. The heavy interpretations have been added by the more cultured singers. So for funerals fitting white hymns are used.

Beneath the seeming informality of religious worship there is a set formality. Sermons, prayers, moans and testimonies have their definite forms. The individual may hang as many new ornaments upon the traditional form as he likes, but the audience would be disagreeably surprised if the form were abandoned. Any new and original elaboration is welcomed, however, and this brings out the fact that all religious expression among Negroes is regarded as art, and ability is recognised as definitely as in any other art. The beautiful prayer receives the accolade as well as the beautiful song. It is merely a form of expression which people generally are not accustomed to think of as art. Nothing outside of the Old Testament is as rich in figure as a Negro prayer. Some instances are unsurpassed anywhere in literature.[1]

There is a lively rivalry in the technical artistry of all of these fields. It is a special honor to be called upon to pray over the covered communion table, for the greatest prayer-artist present is chosen by the pastor for this, a lively something spreads over the church as he kneels, and the " bearing up " hum precedes him. It continues sometimes through the introduction, but ceases as he makes the complimentary salutation to the deity. This consists in giving to God all the titles that form allows.

The introduction to the prayer usually consists of one or two verses of some well-known hymn. " O, that I knew a secret place " seems to be the favorite. There is a definite pause after this, then follows an elaboration of all or parts of the Lord's Prayer. Follows after that what I call the setting, that is, the artist calling attention to the physical situation of himself and the church. After the dramatic setting, the action begins.

There are certain rhythmic breaks throughout the prayer, and the church " bears him up " at every one of these. There is in the body of the prayer an accelerando passage where the audience takes no part. It would be like applauding in the middle of a solo at the Metropolitan. It is here that the artist comes forth. He adorns the prayer with every sparkle of earth, water and sky, and nobody wants to miss a syllable. He comes down from this height to a slower tempo and is borne up again. The last few sentences are unaccompanied, for here again one listens to the individual's closing peroration. Several may join in the final amen. The best figure that I can think of is that the prayer is an obligato over and above the harmony of the assembly.

[1] See *The Sermon* in the American section of this book.

Negro Songs of Protest[1]

NORTH AND SOUTH CAROLINA AND GEORGIA
by LAWRENCE GELLERT

THE music for most of the lines that follow is simple, spiritual, poetic and elusive. A New York musician is arranging them, together with some fifty others I've gathered in the Carolinas and Georgia, for early publication.

A plantation chant of other days. Simple and archaic. One of the very few slavery songs I came across. Strangely enough the score looks for all the world like one of the early Semitic wails. Old Ben who sang it served slavery eighteen years. He still lives within a mile of the place he was born in. He explained, after he finished the song in a quavery cracked voice typical of ancient Negroes, that if a fellow on a plantation saw a girl he wanted, he'd have to see her master. He'd feel his muscles. If they were powerful and stout the master would be pleased. Yes, he'd like to have some of his stock. Come over next Friday for an hour or so. Tell your master I'll pay him for your time.

Belinda she love li'l Joe
Belinda she itch fo' li'l Joe
Belinda she wan' jump broom with li'l Joe
But Marse he say no

Marse he raise bes' horse an' cow
Marse he raise bes' nigger an' sow
Marse he sho' know jes' how
An' Belinda she cain' has Joe

Big black nigger Marse gwine buy
Big black nigger wit' Belinda lie
Big strong nigger'll open her eye
An' she forgit 'bout Joe

The Negro's joy and exultation in the new-found freedom was short-lived. He could leave the old plantation if he wanted to. But where was he to go? And how? His worldly possessions wouldn't fill his ragged bandana. And starving Negroes were already drifting about in thousands. An old Negro in the Greenville, S.C., poor-house sang this song for me. The tune is lugubrious, dirge-like, replete with pathos, grief and despair.

When Marse he gi' me freedom
F'om de plantation—f'om slabery
When Marse he gi' me freedom
Ah wants to go free
But ah ain' got no ready-made money
So ah cain' go free—Lawd ah cain' go free

Nigger got no places to go where
Nigger got no shoes to go wit' dere
Nigger got no corn to eat when he git dere
Poor nigger he stay

Ain' it a shame, shame, shame,
Nigger slabe fo' forty year—ain' got penny to his name

This one I heard a group sing on a plantation near Hamburg, S.C. The tune is *Mulatto*—traces of the English ballad very much evident in the score. Yet the variations of pitch, glides, curlicues, flourishes and intentional striking of notes off key by the singers marked it for their very own.

Went to Atlanta
Neber been dere afo'
White folks eat de apple
Nigger wait fo' core

Went to Charleston
Neber been dere afo'
White folks sleep on feather bed
Nigger on de flo'

Went to Raleigh
Neber been dere afo'
White folks wear de fancy suit
Nigger de over-o

Went to Heben
Neber been dere afo'
White folks sit in Lawd's place
Chase nigger down below

[1] Printed by courtesy of the author and of the *New Masses*, 31 East 27th St., New York City, from the Nos. of Nov. 1930, Jan. 1931, and May 1932.

Negro Songs of Protest

In Georgia as well as elsewhere in the South the white courts are open for Negroes as well as the rest of the population. But should a Negro lose his case and be unable to pay costs, the chain-gang for him. Consequently, in a District Court near Oglethorpe to the records of which I had access, I found that less than $\frac{1}{2}$ % of the civil actions were brought by Negroes. (They comprise about 60 % of the entire population.) Thus he is cheated with comparative impunity. They withhold wages. Turn back clocks to get more work into a day. One, a barber, told me he deposited 50 dollars at the local bank and it was entered by the cashier as so many cents. They kicked him and his account out when he protested. The song following is a lament in this vein:

Nigger go to white man
Ask him fo' work
White man say to nigger
Get out o' yo' shirt

Nigger threw off his coat
Went to work pickin' cotton
When time come to git pay
White folks give him nothin'

Li'l bees suck de blossoms
Big bees eat de honey
Nigger raise the cotton an' corn
White folks gits de money

Here sit de woodpecker
Learnin' how to figure
All fo' de white man
Nothin' fo' de nigger

Slabery an' freedom
Dey's mos' de same
No difference hahdly
Cep' in de name

I heard a Georgia chain-gang near Augusta sing this one. It's very popular—or would be, because of the exceedingly slow tempo affording more rest than usual between strokes of the pickaxe or shovel. But, complained one of the convicts, " Guard, he don' 'low us sing it much. He say it damn lull'by and put us all to sleep on dis heah job. Wants we should sing songs dat go faster. But ah tells him if ah work fas'er dat don' make mah t'ree year sentence up no sooner, an' he done got mad."

U-h, uh Lawsy
I wonder why
I got to live
Fo de bye an' bye
De sweet bye an' bye

U-h, uh Lawsy
Don' you bother me
A'se neber happy
Cep' ah's on a spree
Cain' you see

U-h, u-h Lawsy
U-h, u-h Lawsy
U-h, u-h Lawsy
U-h, u-h Lawsy
Pore me

Here's a chain-gang number I heard on the highway near Spartanburg, S.C. A lugubrious chant— the rhythmic phrases punctuated by the steady thwack, thwack, thwack of half-a-hundred pickaxes creates the cheerful atmosphere of a grave-digging party.

Clothes all tore
Toes on de groun'
Got no job
None to be foun'

Ah'm hungry an' col'
Got nowhere to go
In mah face
Folks slam de do'

Poor man sho'
Am hahd 'nuff
Poor man an' nigger
Law' dat's tough

Mammy been taken
Frien's gone too
Law' ah'm lonely
Don' know what to do

Hear me Law'
Let me be gone
How soon oh Law'
Oh Law' how long

There are thousands of drifting Negroes. Homeless, half-starved. Some with wives and children. They rove about the South seeking work—a day here, a day there—wherever they can find it. The song

227

is about them. A young Negro chopper in a lumber camp near Anderson, S.C., sang it for me. A wistful, haunting little lay.

> *Diamond Joe wants sack o' flour*
> *Diamond Joe wants sack o' flour*
> *Diamond Joe wants sack o' flour*
> *Diamond Joe he don' work by de hour*
> *Drive on Diamond Joe*
>
> *Sometime he work in de country*
> *Sometime he work in de town*
> *Sometime he take a good notion*
> *To jump in de ribber an' drown*
> *Drive on Diamond Joe*

Here's an ode to Christianity. I first heard it in Charlotte, N.C., from a young Negress school teacher. She got it from her father. It was he who enabled me to get the musical score. The tune is wistful and charming.

> *White folks use whip*
> *White folks use trigger*
> *Eart' fo' de white folks*
> *Sky fo' de nigger*
>
> *White folks apointin'*
> *Jes' up high anywhere*
> *Fool nigger he stretchin'*
> *His neck fo' what's dere*

> *While nigger he busy*
> *Wit' Bible an' pray*
> *White folks dey's stealin'*
> *De whole eart' 'way*
>
> *White folks use whip*
> *White folks use trigger*
> *But 'twere Bible an' Jesus*
> *Made slave of de nigger*

A veteran of the World War and former Pullman porter, now a tenant farmer in North Carolina, near Hendersonville, wrote this down for me. The militant chord in these lines is rather unusual for that section of the country. He may have picked it up elsewhere. He didn't remember. The tune is martial, guttural and snarlish.

> *Stan' boys stan'*
> *No use arunnin'*
> *Look up yonder hill*
> *White trash acomin'*
> *Is acomin'*

> *He got knife in one han'*
> *Pistol in de odder*
> *Stan' boys stan'*
> *Brother stan' by brother*
> *Stan' by brother*

> *Nigger don' you run 'way*
> *White trash acomin'*
> *Is acomin'*
> *Get dat whackin' stick in yo' han'*
> *Ruckus boun' to happen*
> *Boun' to happen*

A lullaby I heard near Tyron, N.C.:

> *Sh-hhhhhh baby*
> *Hushabye*
> *Sleep soun' li'l baby*
> *Make yo' big an' strong*
> *Maybe so strong*
> *You have same's white folks*
> *All nice things*
> *Sh-hhhhhh baby*
> *Hushabye*
> *Sleep soun' li'l baby*

I heard a washerwoman, striding along the road with a bundle of laundry balanced on her head, sing this. The tune was in quick-march tempo—loud and free. She sang it with an abandon of exultation and joy difficult to describe.

Negro Songs of Protest

Shout Oh chillun
Shout yo' free
Now you has yo' liberty
Yo' no mo' slabe
Y' free, free, free

We gwine own de hoe
An' own de plow
An own de han' dat hol'
We sell de pig, de horse, de cow
But neber mo' chile be sol'

Here's one from Greenville, S.C. The five-tone scale through which the Negro expresses himself almost as easily as we do in speech is used in the melody. The listener unconsciously humps his shoulders under the impact of a pressing object of great weight, so remarkable is the Negro's skill in creating and imparting his moods in song. The mournful atmosphere in the opening lines is carried throughout. The apparently hopeful note in the chorus lines is not borne out in the tune. More derisive and ironic than anything else.

Nigger he jes' patch black dirt
Raisin' part de white man's Eart'
Lawd cain' you hear him groan an' weep
White man's aplowin' his'n soul down deep

Nigger shall be free, yes
Nigger shall be free, yes
Nigger shall be free, yes
When de good Lawd set him free

A tray boy in an Ashville, N.C., sanatorium sang this one. The tune is light, lively—flippant even. Not at all in keeping with the lament and plaintiveness with which the lines are burdened. It may be that the words are a parody on others—more cheerful—about love perhaps or whiskey.

White man go to college
Nigger to the fiel'
White man learn to read an' write
Nigger axe to wiel'
Well it makes no dif'rence how you make out yo' time
White folks sure to bring de nigger out behin'

Ain' it hahd, ain' it hahd
Ain' it hahd to be a nigger, nigger, nigger,
Ain' it hahd, ain' it hahd
Cause you neber get yo' money when it due

If a nigger get 'rested an' cain' has his fine
Dey sen' him out to work on de county line
Nigger an' white man playin' seben up
Nigger win de money, fraid to pick it up
He work all de week, he work all de time
White folks sure to bring de nigger out behin'

Ain' it hahd (etc.).

When a local administrative body contemplates re-election—and when do they not?—maintenance of good roads is an excellent asset. These roads are kept in repair by chain-gangs. Work on them, of course, is in proportion to the number of convicts available. Hence no crime goes long unpunished. Not if there can be found a stray Negro within a hundred-mile radius.

The convict at work wears the usual chain and ball. In special cases, where he is able to raise shackle bond—at the rate of some 25 dollar per month sentence—the shackle is removed. He works without it. They hope he runs away. Certainly he has every opportunity. The bond is forfeited. Clear profit. They can always get another to fill his place. The sheriff takes a walk and jostles a Negro—preferably an out-of-town one (no white friends to butt in). An arrest is made. Disorderly conduct. That's good for at least 90 days.

As a Spartanburg County, S.C., warden expressed it, " I'm willing to give the nigger the benefit of the ' knout' every time." He wasn't joking. Merely stating a fact. And the sentiment is usual with Southern petty officialdom everywhere.

The song following is in that vein.

> Standin' on de corner, wan' doin' no hahm
> Up come a 'liceman grab me by de ahm
> Blow a li'l whistle, ring a li'l bell
> Here come de 'rol wagon runnin' lak Hell
>
> Jedge he call me up an' axe mah name
> Ah tol' him fo' sho' ah wan' to blame
> He wink at de 'liceman, 'liceman wink too
> Jedge he say ah git some work to do
>
> Workin' on de road gang shackle boun'
> Lon' lon' time fo' six mont' roll roun'
> Miserin' fo' mah honey, she miserin' fo' me
> But Lawd white folks won' let go o' me

A workday song. A new verse crops up every time it's sung. There must be hundreds of them. This version I heard in Mills Springs, N.C.

> He work so hahd
> Jes' fo' gettin' 'head
> But he were cross-eyed
> An' fill white folks' pocket 'stead
> Ain' dat de truff
>
> Ef nigger work hahd
> He worked out fo' long
> An' white folks only wan' him
> When he stay strong
> Ain' dat de truff

> Pickin' off de cotton
> Hoein' up de cawn
> Ah neber does mo'
> Den ah's paid fo' doin'
> Ain' dat de truff
>
> De hahdes' workin' nigger
> Ah eber done saw
> Now goin' 'roun' beggin'
> He cain' work no mo'
> Ain' dat de truff

> Pickin' off de cotton
> Hoein' up de cawn
> Ah's de lazies' nigger
> Sho' 's yo' bawn
> Ain' dat de truff

I heard fragments of the next one in both Carolinas. It's a good lively work song. Whenever whites happen to be about other lines are conveniently substituted.

> Ah tol' mah Cap'n mah han' was col'
> Goddamn yo' han' let de wheelin roll
>
> Ah tol' mah Cap'n mah feet was col'
> Goddamn yo' feet let de wheelin roll
>
> Cap'n, Cap'n, you must be blin'
> Look at yo' watch, it pas' quittin' time
>
> Capn', Cap'n, how can it be
> Whistle done blow an' you still workin' me
>
> If ah was de Cap'n an' he was me
> I'd let him knock off an' go on a sleep
>
> Cap'n, Cap'n, didn't you all say
> You wouldn't keep aworkin' me in de rain all day
>
> If Ah haid mah weight in lime
> I'd whip mah Cap'n till he went stone blin'
>
> Pay day come an' we all git nuthin'
> Cap'n he tryin to cheat me fo' suttin
>
> My Cap'n he so damn mean
> Ah think he come f'om New Orleans
>
> I'm gonna spit in his coffee
> An' spit in his tea
> De Lawd help dis nigger if he cotch me

Negro Songs of Protest

A Negro boy " maid of all work " in the little hotel in Columbus, N.C., sang this. He must be the exception to the widely accepted rule that all Negroes are good singers. They generally have an excellent ear for music, true. Pick up four Negroes anywhere at all and the chances are that you have an excellent quartet. But screechy, unmusical, blatant voices amongst the Negroes are just as common as with us. The time isn't anything to get excited about either.

White man go to ribber
Couldn't get 'cross
Jump on top de nigger's back
Thought he was a horse

Nigger say to white man
Ah has o'ny two legs jes' lak you
An' fo' ah lets you ride me
Ah has to grow de odder two

White man go to mountain
Couldn' climb de top
Grab hol' de nigger's coat
Tell nigger to pull him up

Nigger say to white man
Ah has on'y two legs jes' lak you
An' fo' ah pull you up dere
Ah has to grow de odder two

In my opinion innumerably more instances of lynching occur than find their way into the records. Word of them is withheld at the discretion of local authorities. In many cases if a report is made at all, " Death from natural causes " suffices. As a matter of fact statistics of any sort regarding the Southern Negro are necessarily sketchy affairs. Legal documents cost money. The Negro can't afford them. Thus he's often born, wed and dies—all without official knowledge or sanction. This song I picked up in Traveller's Rest, S.C. The melody alternates in mood between that of a spiritual and Scottish War Chant—the emasculating Christian influence is dominated by the impassioned call to arms.

Sistern an' Brethern
Stop foolin' wit' pray
When black face is lifted
Lawd turnin' 'way

Heart filled wit' sadness
Head bowed down wit' woe
In the hour of trouble
Where's a black man to go

We're buryin' a brother
They kill for the crime
Tryin' to keep
What was his all the time

When we's tucked him on under
What you goin' to do
Wait till it come
They arousin fo' you too

Your head tain' no apple
For danglin' f'om a tree
Your body no carcass
For barbecuein' on a spree

Stand on your feet
Club gripped 'tween your hands
Spill their blood too
Show 'em yours is a man's

This song is of Civil War origin, undoubtedly. But it has a new significance now with the younger Negro. They all know and sing it—a martial air of excellent merit.

Oh brethren rise, give praise to glory
For the year of the Jubilee
Do you want to be a soldier
For the year of the Jubilee

Oh what you say brother
Oh what you say brother
Oh what you say brother
About dis wahr

I will die in the field
Stay in the field
Stay in the field brother
Stay in the field
Until the victory
March on and you shall gain the victory
March on and you shall gain the day

We want no cowards in our band
We call for only the strongest men

I intend to fight and never stop
Until I reach mountain top

Negro Songs of Protest

Chain-gangs get no compensation. They're what you might call "free" labor. One day I encountered a ragged, hungry Negro plodding along the highway. He had been released from jail that morning. Served eighteen months. And didn't even have the price of a railroad ticket back to his home.

The song below I heard a gang sing on a county road outside Greenville, S.C. The tune is simple enough though varying in pitch with a range through an entire interval at times. But thirty or more voices spinning and weaving filigrees of tone into intricate variations of the simple theme created a symphony miserere. And a more interesting one was never heard on any concert stage in New York.

> *Lay down late, getting up soon*
> *Twelve o'clock an' has no noon*
> *All ah wan's dese col' iron shackles off mah leg*
>
> *Diggin' in de road bank, diggin' in de ditch*
> *Chain gang got me boss got de switch*
> *All ah wan's dese col' iron shackles off mah leg*
>
> *Golly jedge you done me wrong*
> *ninety-nine years in jail's too long*
> *All ah wan's dese col' iron shackles off mah leg*
>
> *Freedom far, Lawd guard so near*
> *Don' know ef ah cain eber get clear*
> *All ah wan's dese col' iron shackles off mah leg*
>
> *Mah gal's sweetie hangin' roun'*
> *'nother gwine git her while ahm gone*
> *All ah wan's dese col' iron shackles off mah leg*

The Negro preacher differs little from the white one. He is a pompous, fat-headed, blow-hard parasite, prating meaningless platitudes about "de Lawd an' his By an' By Kingdom." But for himself on earth in the meanwhile he reserves the best house in the community. In addition to as much salary as he can bamboozle out of the meagre, hard-earned funds of his flock, the best chicken, pig or other choice delicacy gleaned on his rounds in the "interest" of "de Lawd."

One preacher in Gaffney, S.C., deemed slavery and the Negroes' present status, but little better, a fine thing. "De Lawd's trial by ordeal." Everything would be made right in the hereafter. But there was something more urgent he wanted rectified right here on earth. The white folks weren't showing him the respect his title and calling entitled him to. They treated him just as if he were an ordinary, ignorant "nigger." "When I send a notice of affairs to the local newspaper they never refer to me as 'Reverend.' Just 'Negro preacher.'"

The lines below are sung to what may have been an early spiritual. Anyway here's the Negro's version of Joe Hill's *Pie in the Sky*.

> *Religion is somethin'*
> *Fo' yo' soul*
> *But de preacher's belly*
> *Done git it all*
> *I know*
>
> *Trust de Lawd*
> *Go de Bible way*
> *You git yo' due*
> *On jedgemen' day*
> *I heard*
>
> *De Lawd make preacher*
> *big an' fat*
> *Sleek an' shiny*
> *Lak a beaver hat*
> *dat's so*

> *He eats yo' dinner*
> *An' take yo' lam'*
> *Gwine give you pay*
> *In de promise lan'*
> *Oh yes*
>
> *Two prayin' niggers*
> *ninety-nine years in jail*
> *Waitin' fo' Jesus*
> *To pay dere bail*
> *Dat's a fac'*
>
> *De Lawd make yo'*
> *Pore an' lean*
> *de sorries' sight*
> *Ah eber seen*
> *fo' sho'*

This comes from Bethune, S.C. But a thousand other places about the South may well have furnished one just like it. A Negro, asked the best town for Negroes in the South, answered, "Dey ain' none ob

Negro Songs of Protest

'em." The tune is lively—probably taken from some old English jig or reel perpetuated by the mountaineers.

Goin' to mah boss
To draw mah pay-roll
Don' wan' moah his mud
On mah feet 'tall
Oh mah Kitty, co co

Goin' fin' me a place
It cuts no figger
You git yo' due
Eben if yo' a nigger
Oh mah Kitty, co co

Goin' fin' me a place
White folks ain' inchin
An' nigger's belly
Ain' always pinchin'
Oh mah Kitty, co co

Goin' far 'way
Be mah own Master
Feet yo' too slow
Train take me faster
Oh mah Kitty, co co

Goin' somewhere
Dey knows nothin' 'bout Jim Crow
An ah cain walk
Right through de front do'
Oh mah Kitty, co co

Goin' to set right down
At de welcome table
Some o' dese days
I'll sho' be able
Oh mah Kitty, co co.

Always the Negro has been the first fired and the last hired. This is particularly true now. The whites compete now for the most menial jobs previously only " a nigger " would take. If South Carolina may be taken as fair indication of the general trend fully 75 % of all Southern Negro workers are unemployed.

The Negro is clannish. Like all suppressed minorities in history, they cling together for mutual protection. The last nickel is divided into five parts if necessary.

The singer of the following song dissects a chicken in verse to broadcast to his friends his hunger. I heard it in Charlotte, N.C.

If you kill a chicken, save me de head
Seem lak money sho' thinkin' ahm dead

If you kill a chicken, save me de breast
Lawd body so pore, fallin' right through mah vest

If you kill a chicken, save me de breast
When you think ahm workin', ain' doin' a thing

If you kill a chicken, save me de feet
When you think ahm earnin', jes' walkin' de street

If you kill a chicken, save me de feather
Git suckin' dat, if ah fin' nothin' better

If you kill a chicken, save me de heart
Lawd belly so empty, ain' got 'nuf fo' faht

Western Southern Pines is an all-Negro community. It had for years its own town officials—Mayor, Judge, Policemen—a Negro staff from top to bottom. The only one in North Carolina. They got along nicely. Practically self-supporting. Didn't need to hire out to white bosses. " A dangerous precedent." The idea might spread and then who would do the white man's dirty work?

Last month the State Legislative Body unanimously voted to abolish the township. Revoked the charter. And incorporated it with a near-by white one. Of course the Negro officials were retired to " private citizenships."

This song comes from there. The sulky, defiant manner in which the boy sang it convinced me his verses were not just " talkin' big." Not that it mattered. " Sassin' white folks " is as big a crime as killing one in a fight. " An' ah hauls in whackin' all ah cain, 'cause ah knows in de en' ahs gwine git de worse of it anyhow."

Ah's lookin' fo' no trouble, let me be
Set down white folks, stop aworryin' me
Set down white folks
Set down white folks
White folks you set down

Ah wants no ruckus, but ah ain' dat kin'
What lets you all shoe-shine on mah behin'
Set down (etc.)

233

Negro Songs of Protest

Ah tells you once ah tells you 'nuf
De nex' time ah tells you ahm gwine git rough
 Set down (etc.)

Come 'way f'om Georgia to git on a hog
But ah didn't come to be nobody's dog
 Set down (etc.)

Cat got nine lives, use 'em all fo' he go
Nigger die on'y one time, he cain' die no mo'
 Set down (etc.)

Peonage is still practised in the South. There are various legal methods. Whites and Negroes suffer alike. The boss encourages his workers to draw "advance money." Or run into debt at the company's store. A shrewd boss can juggle the account of an illiterate worker to keep him behind. A law makes it a criminal offence to draw advance money under false pretences. Thus if a worker quits a job before completion and the boss claims but refuses to accept whatever balance is still owing, the worker can be arrested for stealing money. If found guilty—and he usually is—a fine and suspended sentence is imposed. The general procedure is for the boss to pay the fine and have the court parole the worker in his custody to work out the fine money. Backed by authority of State a man can be compelled to work for a boss indefinitely.

Another way is via the vagrancy laws. If a worker cannot prove he is already employed, he can be picked up on the street and compelled to accept a job at whatever wages the boss is willing to pay.

But a variety of illegal methods are for the enslavement of the Negro alone. I've heard numerous complaints from them of threats with "running into the river" if they refused to postpone planting or harvesting on their own tenant farms and go to work on white plantations. A particularly vicious boss runs the McCawley farm near Sumpter, S.C. He has a widespread reputation as a "nigger killer." The neighbouring Negroes are terrorised by him. But his plantation is never short-handed. Several workers' deaths on the place have been "investigated" in recent years. But Mr. McCawley is a brother-in-law of a former Governor of South Carolina. And practically runs local politics. Inspection is not invited. I naturally couldn't get in. A Negro working about the entrance to the vast estate wouldn't tell me "nothin' 'bout nothin'." He probably knew about the Negro who had filed complaint with the town sheriff for being detained a week on the place and was whipped by Baron McCawley in sight of the convening court during the proceedings and driven out of town. But the Negro did sing:

Mammy dead, and pappy gone
Dey lef' me 'lone in dis Worl'
Nothin' but a slave
Mammy tol' me, mammy tol' me
When she were on her bed adyin'
De hahd luck Debil driver
Will sho'lly keep you down
Well, ahm leavin' town one mawnin'
Whackin stick won' make me stay
De mo' he agougin' an' squatch me
De further he drive me 'way

Here's another chain-gang number. Plaintive, mournful—in theme similar to the one from which the *St. Louis Blues* was evidently evolved.

Cawn pone, fat meat
All ah eber git to eat
Better'n ah gits at home
Better'n ah gits at home

Cotton socks, striped clo's
No Sunday rags at all
Better'n ah gits at home
Better'n ah gits at home

Bunk fo' mah head
Straw under mah head
Better'n ah gits at home
Better'n ah gits at home

Ring on mah ahm
Bracelets on mah feet
Better'n ah gits at home
Better'n ah gits at home

Baby baby let me be
Chain-gang's good 'nuf fo' me
Better'n ah gits at home
Better'n ah gits at home

The company store again. Generally on railroad jobs an extra inducement to stick till the end is the return ticket back to the point where the worker was hired. But below is the mournful picture of a worker compelled to walk home. An extreme case, no doubt. But that he's kept constantly broke on the job—paying 30 cents for a 10 cents can of tobacco and other items priced proportionately at camp stores—is a well-known fact attested to by workers everywhere. " Keep 'em broke all the time, that's my motto," said a gang foreman, " I never have a nigger quit me, 'cause he hasn't the money."

The song I heard in a mountain camp near Melrose, N.C., an exceptionally lugubrious lament even as Negro songs go.

> *Trouble neber lyin' dead on de bottom, dis heah Worl'*
> *Ev'ythin' you cain see shinin' ain' no gol'*
> *Workin' on de railroad, dollar dime a day*
> *Boss at de camp store, signin' all ah makes 'way*
> *Mammy write sho porely, please sen' some money son*
> *But ah ain' got no ready-made money, Lawd ah cain sen' her none*
> *Well, railroad is completed, cars arunnin' on de track*
> *No moah work heah 'bouts time fo' gettin' out de ol grip sack*
> *Help to buil' dat railroad, cain' 'ford ridin' tag*
> *Money talks but mah bits ain' bits 'nuf to brag*
> *Walkin' 'longside de track, hungry an' wantin' to eat*
> *Dog dead tired, shoes wore out, burnin' blisters on mah feet*
> *Don' care when tomorrow come, won' has a lovin' dime*
> *Feet fin' me a place to grub, an' sof' bed jes' one moah time*

Another lonesome-road song. Homeless, hungry, the singer's recital is replete with the injustices of a hostile world. I've heard the same last verse on numerous songs—the bard identifying himself with his signature portrait.

> *Forty-leben days gone by*
> *Sence last time ah slept in bed*
> *Ah ain' had three squares sence ah was bawn*
> *Money thinks ahm dead*
> *Money thinks ahm dead*
>
> *Chain gang link is waitin'*
> *Ah ain' done nothin' 'tall*
> *A place to sleep, somethin' to eat*
> *An don' ast fo' chain an' ball*
> *Ah don' ast fo' chain an' ball*
>
> *Clothes am torn to pieces*
> *Shoes am all worn out*
> *Ahm rollin' through an unfrien'ly Worl'*
> *Alway wanderin' 'bout*
> *Lawd always wanderin' 'bout*
>
> *Ain' got no one to lub me*
> *'Jes' stone slab fo' mah head*
> *A po' nigger's life is mis'ry*
> *Lawd ah wish ah were dead*
> *Yes Lawd ah wish ah were dead*
>
> *An ef anyone come ast you*
> *Who were it wrote dis heah song*
> *Ah's a pore nigger in worn-out duckins*
> *Alookin' fo' a home*
> *'Jes' alookin' fo' a home*

Beaufort is an American " Rotten Borough," if ever there was one. About 80 % of the population are Negroes. Some 800 white votes do the legislating for a population in excess of 25,000.

It seems the greater the proportion of Negro population the more check to their individual rights. Of course " a nigger is a nigger " from one end of Dixie to the other. Just an element of production—like the mule or rain. If he's lucky he'll have a house to live in almost as good as the one that houses the

other stock. Enough rest and food to keep going on the job. Beyond that he expects little. Gets less. And he changes his job just as often as opportunity presents itself. Even though he's learned that one place is about as bad as another.

This Beaufort singer, however, is not thinking of another " slavin' " job when he sings :

> *Ef you don' lak de way ah works*
> *Jes pay me off*
> *Ah ain' had three squares sence ah was bawn*
> *Befo' ah go*
> *Ah knows ahs pow'fully easy*
> *But ah ain' sof'*
> *Ah cain git another job*
> *An' be mah own boss*
>
> *Fo' dey ain' gwine be no rine*
> *Ah explains to you what ah mean*
> *Some other time*
> *Watermelon is good an' sweet*
> *Seeds 'bout de only thing*
> *Dat ah cain' eat*
> *Dere ain' gwine to be no rine.*

Near Augusta, Georgia, I hung around a chain-gang for days. One of the Negro convicts somehow aroused the wrath of the guards. Two of them went for him, pummelled and kicked him until he lay still and bleeding on the ground. " Isn't there a law of some kind against a guard beating a prisoner? " I asked a third guard lolling on the grass beside me, watching the proceedings. " Hell," he answered, " there ain' no laws for niggers. We has to use our own good judgement." And he showed me the horrible abrasions and ring sores brass knuckles had caused in the exercise of his "good judgement." " We ain' 'lowed to use no whips no more," he explained.

Among others the gang sang was this lugubrious chant. Joe Brown's coal mine, I learned, uses mostly convict labor leased from the State. Could learn nothing about it beyond that it was notorious for the ill-treatment of workers. And was located somewhere in Virginia.

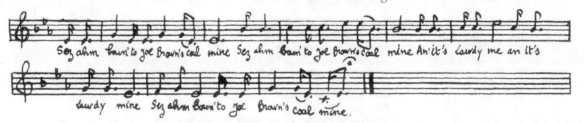

> *Sez ahm boun' to Joe Brown's coal mine*
> *Sez ahm boun' to Joe Brown's coal mine*
> *An' it's Lawdy me an' it's Lawdy mine*
> *Sez ahm boun' to Joe Brown's coal mine*
>
> *Sez ahm goin' ef ah don' stay long*
> *Sez ahm goin' ef ah don' stay long*
> *An' it's oh me, an' it's oh mine*
> *Sez ahm goin' ef ah don' stay long*
>
> *Dat's the train dat ah leave heah on*
> *Dat's the train dat ah leave heah on*
> *An' it's ho ho me, an' it's ho ho mine*
> *Dat's the train dat ah leave heah on*
>
> *Sez ahm boun' to dat sundown job*
> *Sez ahm boun' to dat sundown job*
> *Sez ahm boun' to dat sundown job*
> *Ah rob no train an' ah kill no man*

A county jail in South Carolina. Obliging warden : " Sure you can visit the niggers. Stay as long as you can stand it. Me? I never go there unless I can't help myself." No wonder. 102 in the shade out-

side. Yet the windows are jammed shut. And so filthy you can't see through them. Corridors strewn with filth of weeks' accumulation. Mingled heat, urine, body sweat and garbage—stench of the lion house at the zoo. Only more so. Five convicts to a cell 6 × 6. They're stripped naked. Stretched listlessly on tiered iron bunks. Or dirty pallets on the floor. Tongues loll out of their mouths. Like dogs panting.

I did stay as long as I could stand it. A half-hour later my visit ended in a wild rush for open spaces. Just too late. I puked all over the stairs on the way out. This is one of the songs I brought away with me.

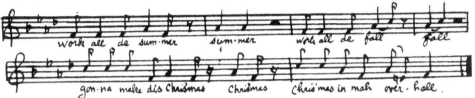

Work all de summer
Work all de fall
Gonna make dis Chris'mas
In mah overhall

Got any cawn bread
Cawn bread save me some
Got any cawn bread
Buddy won' you save me some

Don' min' de weather
So de win' don' blow
Don' min' dese chains
So de ball don' grow

Way far f'om home
Wit hammer in mah han'
Ahm so tire' hammerin'
Ah cain' stan'

Don' let dat gator[1]
Gator beat you to de pon'
Jes' be moah trouble
An' de day be long

Ah feels mah hell arisin'
Six feet a day
Lawd ef it keep arisin'
Gwine wash dis damn lan' away

Hot Jazz

by ROBERT GOFFIN

(Translated from the French by SAMUEL BECKETT.)

NOT so long ago André Cœuroy wrote: " improvised jazz is the most potent force in music at the present time; long may it remain so."

What then exactly is this force that has received the sanction of some of our greatest modern musicians and yet is so little known to others, such as Henry Malherbe, the critic of the *Temps*, that they cannot distinguish it from a counterpoint out of the *Tales of Hoffmann*, and assume in their simplicity that Maurice Yvain, Yves Alix and Christine are the masters of jazz in France? And how is it possible to associate the discernment of the one with the flounderings of the other?

It is scarcely necessary to repeat that jazz is Afro-American music, developed in the U.S.A. during the war, and attaining its maximum of expression during the period 1920–1930. In my book *On the Frontiers of Jazz* I have dealt at sufficient length with the various musical, technical and sentimental elements of jazz to make any recapitulation of them here unnecessary. They are common knowledge by now.

Let us therefore confine ourselves to hot jazz, otherwise known as improvised jazz, a type of music that was in existence long before it was formally tabulated. The epithet " hot " is applied to any passage " in which the executant or executants abandon the melodic theme and develop an imaginative structure on the basis of that theme and incorporated with it."

To write the history of this " hot " it would be necessary to trace the whole evolution of jazz in general. For we find its formulæ, common enough to-day, present at every stage of the development of syncopated music. It may be said that jazz would have died a natural death long ago but for this " hot " which has always been its unfailing stimulation, its purest mode of utterance, and to all intents and purposes its *raison d'être*.

The Negro slaves, transplanted from their scorching Africa to the marvellous but inhospitable countries of North America, treasured as their last possession that prodigious sense of rhythm which their traditional dances and their tom-toms beating in the equatorial night had made so ineradicably part of them.

Instinctive and unhappy, highly endowed with the most complete, because the most simple, poetical faculties, they soon began to express their emotions in song; labourers in the cotton plantations, dockers slaving in New Orleans, young Negresses herded together in the markets, fugitives hounded down by mastiffs, they all sang their abominable captivity and the brutal domination of their masters.

The African rhythm had not been lost; they clothed it with simple sentiment, moving expressions of love, biblical cries of celestial yearning, pastoral laments; and thus the Negroes came quite naturally to improvise upon a given rhythmic theme with changes of tone, combinations of voices and unexpected counterpoints—an improvisation that was to culminate in the incomparable harmonies that have bewitched the whole of Europe.

Little by little this habit of improvisation was extended to the brasses and it became customary for groups of musicians to meet and improvise on the themes of spirituals or simply on a given rhythm, each performer weaving his own melody.

Through the cake-walk, rag-time and blues Negro music proceeded towards that jazz which was soon to assume such important dimensions and absorb the forms which had gone before it.

" At this time jazz still belonged to the black musicians with their ancient traditions of invention and their unique faculty for improvisation and embellishment according to the dictates of their ingenuous hearts. They were the first teachers of the genuine lovers of jazz, while others in whom the commercial instinct was more highly developed ignored this necessary contact and transposed jazz airs in a way quite foreign to the Negro tradition."

This explains the upgrowth of a school of melodic jazz, exploited for a time with great success by Paul Whiteman, Jack Hylton and other famous leaders, who industrialised jazz to such an extent that nothing remained but a weak dilution devoid of all real musical character.

Melodic jazz has contributed nothing to music and will only be remembered for its unspeakable insipidness; whereas hot jazz is a creative principle which can scarcely fail to affect the music of the future in the most original and unexpected directions.

Hot jazz has already exploded the automatism of musical composition as practised before the war, when the composer wrote a melody, or a score, on the understanding that its realisation should only vary in accordance with the interpretative ability of successive executants, who generally showed but little

initiative in their reading of the work and could only express their own personality in their treatment of detail. It is obvious that the music of Beethoven and Debussy is played to-day exactly as it was when composed, and as it still will be a century hence.

The most extraordinary achievement of hot jazz has been the dissociation of interpretation from the " stenographical " execution of the work, resulting in a finished musical creation which is as much the work of the performer as of the composer. Up to the time of jazz it is safe to say that the performer was no more than the faithful representative of the composer, an actor whose function was to transmit the least phrase and stimulus of his text. But hot jazz has no patience with stimuli by proxy and requires more of its executants, insisting that each should have ample scope for independence and spontaneity of expression. The task of the performer is to realise, in whatever terms he sees fit, the possibilities of syncopation latent in the generally simple theme written by the composer. He is no longer a conscientious actor reciting his part, but one improvising on the idea or impression of the moment in the Italian *Comedia dell' Arte* tradition.

The admirable achievement of the first orchestras was an unconscious one, ignored at the time and not fully appreciated till twenty years later. We must turn back to these primitive orchestras and listen humbly to the musical inventions of these untrained Negroes before we can realise the brilliant audacity of these musicians who devoted themselves with enthusiasm and in the face of the most fatuous opposition to this new field, later to become the monopoly of the intelligent and cultivated section of the new generation. From this moment every black orchestra played " hot," with occasional discordant abuse of wawas, washboards and drums, which soon calmed down.

At that time only very few whites were able to appreciate the sublime grandeur of this music of the heart. We must not forget the first white orchestras to play " hot " in an America rotten with colour prejudice ; they laid the foundations of a solidarity and a mutual esteem whose benefits came too late for the majority of those most apt to enjoy them. The *Cotton Pickers, New Orleans Rhythm Kings, California Ramblers* and *Original Dixieland* will all have an honoured place in the eventual Pantheon of syncopated music.

Already a definite tradition is taking form in the domain of hot jazz and a codification is being gradually developed ; such discerning critics as Panassié, Prunières, Cœuroy and Sordet concern themselves with the manifestations of hot jazz and keep its development under the strictest observation and control. We are now so familiar with hot jazz, thanks to the countless records made of different orchestras, that we can distinguish the unmistakable note of its lyricism even in the most florid of its vulgarisations.

The talent and genius of certain composers and performers have received their proper recognition. A number of jazz orchestras have conquered the unanimous approval of the public. Finally certain individuals have enriched jazz with contributions of so personal a nature as cannot fail to delight all those who take an interest in the subject, and it is to them that we owe all that is best in modern jazz.

There are many orchestras in both Europe and America whose musical perfection has elicited the admiration of such competent judges as Ravel, Darius Milhaud and Stravinsky, and in these orchestras some exponents of " hot " whose style, to my mind, has had an enormous influence on the development of jazz in general. Special reference must be made to Louis Armstrong, whom I consider as the supreme genius of jazz. This extraordinary man has not only revolutionised the treatment of brass instruments but also modified almost every branch of musical technique as practised to-day. Nor should we forget that colossus of jazz, the late Bix Beiderbecke, the pianist Earl Haines and the tenor saxophonist Hawkins. There are hundreds of others hardly less important than these four and no less deserving of honour for not being mentioned by name.

Before I conclude this essay I would like to draw attention to the analogy between the acceptance of " hot " and the favour enjoyed throughout Europe by the *Surréaliste* movement. Is it not remarkable that new modes both of sentiment and its exteriorisation should have been discovered independently? What Breton and Aragon did for poetry in 1920, Chirico and Ernst for painting, had been instinctively accomplished as early as 1910 by humble Negro musicians, unaided by the control of that critical intelligence that was to prove such an asset to the later initiators.

Finally, it may be mentioned that hot jazz is regarded to-day by all the intelligent and cultivated youth of Europe as its staple musical nourishment. As Dominique Sordet says, many young men have derived an almost religious enthusiasm from the contact of this superabundant source of lyricism. For them hot jazz is almost the only form of music that has any meaning for their disrupted generation, and it is my fervent hope that America will not disregard this extraordinary element in its sentimental life and one which is surely of more importance than sky-scrapers and Fordism.

Creed

(To the Memory of SACCO and VANZETTI)

Music by HENRY CROWDER Poem by WALTER LOWENFELS

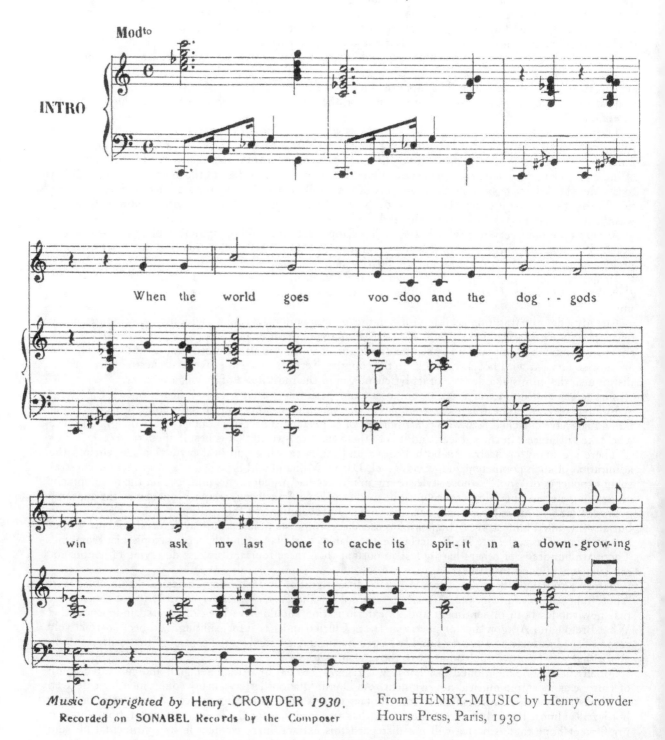

When the world goes voo-doo and the dog - - gods win I ask my last bone to cache its spir-it in a down-grow-ing

Music Copyrighted by Henry CROWDER 1930.
Recorded on SONABEL Records by the Composer

From HENRY-MUSIC by Henry Crowder
Hours Press, Paris, 1930

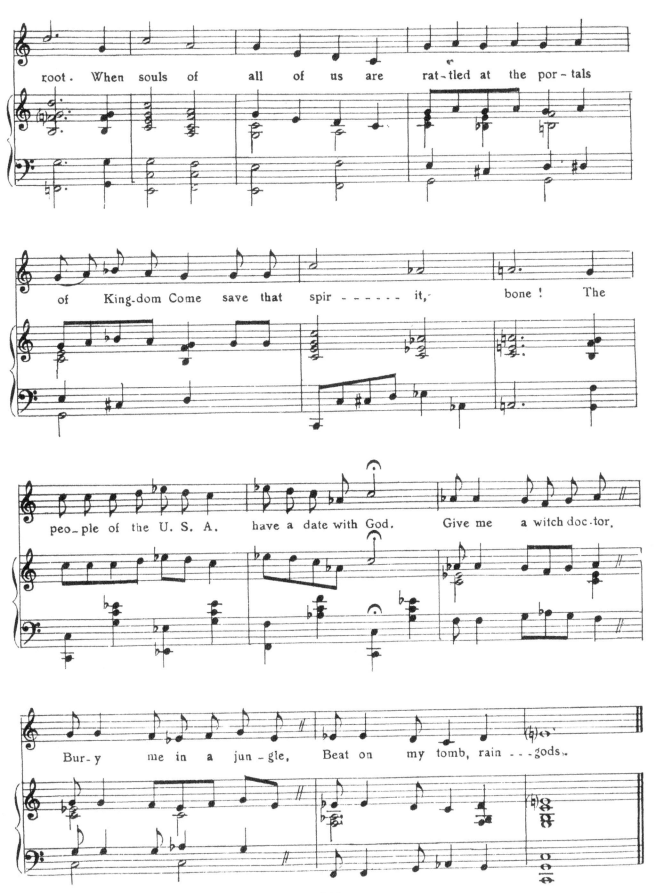

Folk Music of the Creoles

DISCUSSION ABOUT THE SPIRIT AND SONG OF A CREATED RACE

by MAUD CUNEY HARE

THE song of a certain people or folk can be best appreciated when both the physical and spiritual conditions under which a race labors and lives are known and rightly understood, for folk-song has its fount in a world of realism rather than of imagery. Song from the consciousness of a folk who know the long sun-days of the near-tropics, the blue waters of the Gulf of Mexico, with the boom of its lapping surf, the moss-hung live-oaks with the blue lubens of the prairie and the jasmine and pomegranate of the town gardens, must needs be greatly contrasted in mood with the song of a mountain hidden people or those of the cold snow-covered hills of New Hampshire. Far in the Southwest of the U.S. peopled by the emotional Spanish and French settler together with the African, sprang into being the melodious expression of a created race.

HISTORY AND RACE

The history of the Creole folk-song of America is interwoven with the history of the Southwest section of the country and particularly that of the State of Louisiana.

In August 1779, in the war of American Independence, a little army of 1,430 men composed of Creoles, two companies of which were free men of color, and 160 Indians, marched under Galvez to defend themselves against the British. For 16 years Louisiana, which had been founded by French immigrants under Iberville, had been a Spanish possession—a gift of King Louis XV to his Spanish cousin, Charles III of Spain.

There had been a revolution by the French colonists, but for twenty-two years longer Spanish rule prevailed until Napoleon took back the colony only to sell it to the United States. This was in 1803. The French with their usual indomitable spirit clung to the land of their nativity and throughout the chequered period of Spanish and French rule they continued to sing *La Marseillaise* and to hold high courage.

Spanish Ursulines had been sent from Havana to teach Spanish, but they were forced to teach French instead. French and Spanish intermarried, but the French Creoles remained French, the Spanish-speaking members of a family accepting the French language often in preference to their own. A few years prior to this, the old St. Louis Cathedral was begun, while as early as 1727 the Ursulines from Paris established a monastery that accommodated both boarding and day pupils among whom were Negroes and Indian women.[1]

In 1791, Negroes of Santo Domingo rose in rebellion and a few refugees found their way to Louisiana. Skilled in sugar-making, they revived this prosperous industry which had long remained dormant, although sugar-cane had been introduced 40 years previous by the Jesuits of St. Domingo.

Eight years later (a period to which the folk-songs often refer), Napoleon's soldiers threatened the West Indies. A large number of whites and mulatto refugees with their slaves had escaped in the St. Domingan insurrection and fled to Cuba. They were now by the war between France and Spain again forced to become exiles, and within three summer months of 1809, over five thousand persons, white, free mulattoes, and black slaves, came to New Orleans from Cuba. They continued to emigrate from Cuba, Guadeloupe and other French West Indies, until about ten thousand persons, two thousand of whom were free people of color, took refuge in New Orleans.[2] They soon proved their loyalty as citizens of their newly-chosen home—in the battle of New Orleans; a battalion of colored men, 44th Regulars, joined a battalion of St. Domingan mulattoes, on their march into town to help protect the city. Peoples of all nationalities continued to migrate to the new province.

"Little colonies from Spain or the Spanish islands on the coast of Africa were scattered in different parts. Such were New Iberia, Valenzuela in Lafourche, and Galveztown. For long they retained their languages and manners and pursuits,"[3] wrote H. A. Bullard in *De Bow's Review*.

The Acadians from Nova Scotia, who had come to Louisiana in 1754 and founded a French Acadian

[1] Alcee Fortier, *Louisiana Studies*, p. 246. [2] Gayarre, III, p. 595.
[3] H. A. Bullard, *De Bow's Review*, vol. 3, p. 23.

Folk Music of the Creoles

settlement, were a new contribution. Added to these were the descendants of the Canary Islanders known as " Les Islingues," speaking both the Spanish language and the French *patois*.[1]

Here began a mingling of races and languages, French intermarried with the Spanish and with the native women of the land, while there was the intermixture as well of those of African and Indian descent. Each locality had its particular *patois*. There was the Acadian dialect and the Spanish and Creole *patois*.

By 1788 the Louisiana province contained 1,701 free men and 21,465 slaves amidst the French and Spanish settlers. The Carmelite Convent played its part in these early days, as an educational centre. Here attended both white and free colored children ; many of the latter class had wealthy parents who paid a high price for their tuition—children of the wealthy were sent to Paris to complete their education. In fact, says an old Creole neighbor and friend of my grandmother, Mons. Victor, who came to New Orleans from Martinique in 1847, " Many of the women and children did not know whether they were Creoles or whites, nor could the whites themselves tell who was white and who was Creole, so generally was the population mixed, while the city was largely French in manners and life."

The town of St. Martinsville, on the Bayou Teche, was nicknamed " Le petit Paris," and here it was that King Louis Philippe (when Duke of Orleans) was entertained. " The streets, banquets, we should say, were bright with color, the nights filled with song and laughter. Through the scene the people of color add the spice of color in the life ; they add the zest of romance." [2] With the French spirit greatly predominating, from this mingling of races sprang the Creole, and in this environment, the Creole song.

Who are the Creoles? The word itself is used in Europe as well as in the French West Indies and in the Southwest section of this country. " Creole " as used to denote race is a term that is continually being misunderstood and warmly argued. The word " Creole " is from the Spanish " Crillo " and the French verb " créer," to create—a created race.

Of the Spanish Creoles, Calderon in *Latin America* says the three races, Iberian, Indian and African, united by blood from the population of Spanish America, while Arthur R. Gray in *The New World* says the European established in America, becomes a Creole ; his is a new race, the final product of secular unions. If all the races of the new world were finally to unite, the Creole would be the real " American."

Gayarre ventures the information that the term originally meant children of Europeans born in a French or Spanish-speaking colony, but this is not quite so pointed as the explanation by Friedenthal, who discusses the question in his book *Musik, Tanz and Dichtung bei den Kreolen Amerikas*. The French Creole of North America is not included in this work ; however, he states that a Creole is the descendant of Spanish or French settlers and the women of the land of whatever blood.

In South America the progenitors of Spanish-American Creoles are Spaniards from every district of the motherland and the Indians from different tribes. Friedenthal discusses the Creoles irrespective of their color or origin and adds that the Spanish call all Creoles whose forbears are from Africa or from foreign parts.

In the Southwest of North America, Louisiana and Texas in particular, Creoles are descendants of the original French or Spanish settlers and the women of the land of whatever blood, white or colored ; or those who came to Louisiana after the San Domingo massacre and their brothers of mixed blood whom they never deny.

In Louisiana the term *Creole* belonged at first only to descendants of French settlers, but daily it came to include any descendants of French and Spanish parentage and is still so used, all absurd statements to the contrary notwithstanding. The progeny, whether Spanish or French, are of the ruling class.

The terms *mestizos*, descendants of white and Indian ; *mulattoes* (Spanish and African), and *zambos* (Indian and African) are known in the West Indies, but in the Southwest of the United States a *mulatto* is one who is part white and part Negro ; a *quadroon*, one who has more than three-quarter Caucasian blood; and an *octoroon*, the possessor of only an eighth of African blood.

These sub-divisions according to " mathematics " and the number of white foreparents were strictly followed until recent years. According to the files of the *Boston Transcript*, in 1685, in the French West Indies, Louis XIV, because of his interest in Madame de Maintenon, a Creole, settled the status of these people of mixed blood, while up to 1803 in Louisiana the Creoles of whatever admixture with the Spanish or French forefather had the status of the white race.

Napoleon specifically stipulated that this should be retained after the cession of French territory. Josephine, we remember, was a lovely Creole from the French West Indies.

In 1908, Louisiana, with the unbridled increase of racial hatred and prejudice, under " Act 87," gave the Creole element of so-called "white admixture only " a classification with the whites, thus

[1] Alcee Fortier, *Louisiana Studies*, p. 200. [2] King, *New Orleans : The Place and its People*.

Folk Music of the Creoles

at the same time distinctly classifying the mulatto and octoroon, as the Supreme Court of the State of Louisiana correctly states that a person of mixed blood is not a Negro.[1] But even the passing of laws cannot obliterate history woven in song.

According to Lafcadio Hearn, there are three distinct Creole populations in the Antilles—English, Spanish and French—with their special element of mixed blood corresponding to each Creole race, speaking the language of each.

The term *Creole*, as commonly used, brings to mind that distinct type which is so beautifully described in *A Mid-Summer Trip in the Tropics*, and in which Hearn likens the colors of the flesh to the colors of the fruit.

" There are banana-tints, lemon tones, orange-hues, with sometimes such mingling of ruddiness as in the pink ripening of the mango.

" There is one rare race-type, totally unlike the rest ; the skin has a perfectly golden tone and exquisite metallic yellow ; the eyes are long and have long silky lashes ; the hair is a mass of rich, glossy curls that show blue lights in the sun. What mingling of races produced this beautiful type ? "

Léon Laviaux, the young poet of the Antilles, whose tragic death by accidental drowning occurred but one year after his *Ebon Muse and Other Poems* had been englished by James Myers O'Hara, glorifies the *fille de couleur* in his book.[2]

Laviaux was the son of Paul Gauguin, a famous painter of France and Tahiti, and Laure Laviaux, a beautiful Creole of Martinique. Enchantingly he sings of the loveliness and charm of the maiden of the tropics :

> Of my loves there are four
> That my song would endear;
> Golden Luore!
> Ebon Zaire!
>
> And with lyric caress
> Laurel each, as a queen;
> Bronze-hued Tanesse!
> Amber Fafine!

CREOLE MUSIC

There is a distinct Creole Music of the New World. According to Lafcadio Hearn, who though not musically educated, was intensely interested in Creoles and their music, Creole music was brought over from Africa to South American countries and to the West Indies, thence to Louisiana and its bordering territory, shaped by French and Spanish influences, after which it became a distinctive folk-song inheritance of America. Mr. H. E. Krehbiel, to whom we are indebted for much of our knowledge of Afro-American and Creole folk-song, says that Creole music is French melody founded on African rhythm.

It cannot be denied that the many refugees that continued to emigrate from Cuba, Guadeloupe and other French West Indies influenced the folk-song of the people of Louisiana. An example of Creole song which evidently sprang from this source is *Lisette*, known in the mother country of France as *Lisetto*, and sung in Martinique, San Domingo, Haiti and New Orleans in but slightly varied form. The last two verses, that are the same in the French West Indies and the New Orleans version, are not found in the old French song. The dances, *Calinda* and *Bamboula* which are mentioned, were performed alike in the Antilles and in Louisiana.

Creole song was wed to the dance. The dances are no longer generally practised, but the folk-songs remain. They bear the same characteristic rhythms as the more familiar Aframerican melodies and odd scale progressions and structural form of Latin folk-song. A number exhibit slight Spanish influences. The themes are but few and those are of the primal emotions. There are far more love songs than are to be found in any other section of the South. The work songs and those of wood and water are easily traceable to Negro influences and customs. The usual manner of travelling by boat brought forth many boat songs, and as in West Africa, the rowers were particularly fond of singing in the moonlight as they rowed in time to their song.

In Louisiana, owing to the many bayous, the plantations were on *chênières*—islands, and in oak

[1] D. D. Murray, Congressional Library, Washington, and in *Boston Transcript*.
[2] L. Laviaux, *Ebon Muse and Other Poems*, Smith and Sale, Portland, Me.

Folk Music of the Creoles

groves. Travel, therefore, was almost wholly by water, and the result was the rowing song with love as its theme. Heard also was the hunting song, the words of which were improvised for the occasion. There are songs of satire and sarcasm, ridicule and mockery, the text of which depicted an event or an unfortunate individual. Many of the satirical songs were linked to the dance, the *Counjai*. Such a one was the amusing *Musieu Bainjo*, first noted in *Slave Songs of the United States*, and said to have been heard on a plantation in St. Charles Parish, Louisiana. It was one of the Creole songs which I chose to harmonise for concert use:

> " Voyez ce mulet là, Musieu Bainjo,
> Comme il est insolent."

The outdoor dance hall of the slave, where many dances of African origin were performed, was known as " Place Congo." It was also used for ball games played by the Creoles and was in great contrast with the nearby plaza, Jackson Square, the rendezvous of the aristocrats—the master class. George W. Cable, the writer, vividly described the participants of the dance in Place Congo, and the audience. Here was danced the *Bamboula*, the *Calinda*, and the *Counjai* and other dances from African sources. Mons. Victor has told me of the dance in the old plaza, now known as Beauregard Square, as he remembered it in his early days. From two until nine o'clock Sunday afternoons men and women used to dance and sing in the square on a platform about thirty by forty feet. The place was thronged with whites on the fences and every other conceivable place. At later times no slaves were allowed in the park—only free colored persons and whites.

The instruments that furnished the accompaniment to the song and dance were drums made out of nail-kegs or butter-kegs, both heads removed and a sheep-skin nailed tightly on one end. The performer sat on the keg and tapped the drum-head with his open hand. Another instrument was a rattle ingeniously made out of the lower jaw-bone of a horse.

We find few religious songs such as the Negro spirituals of other sections. Those that are now sung in Louisiana parishes are chiefly paraphrases of melodies caught from the Catholic service, or those transplanted in variant form from Georgia and the Carolinas.

The Creole was wont to link his song to current happenings, and a situation which has been immortalised by extemporaneous song has been frankly discussed by the white historian, Grace King, of New Orleans. She tells of the ambition of the unmarried quadroon mothers of the *ancien régime* to have their children pass for white and thus become one of the privileged class—that of their fathers. To prevent this practice, public officers, when officially writing down the name of any free colored person, were required by law to add the qualification *homme* or *femme de couleur libre*. But in many instances bribery was used and the officers conveniently forgot their duty. Even baptism papers were thus recorded by those who possessed sufficient influence and wealth, and many families of colored blood were ever after placed in the files of " pure " white.

To the whites, all Africans who were not of white admixture were known as Negroes, while the remainder were called *gens de couleur*, and a distinct caste system existed. This condition of affairs, brought about by the irregularities of the social life, gave birth to the folk-song *Tou-cou-tou*, or *To le paces po blanc*. It has been incorrectly published in a folk-song collection as a song dealing with plantation hands and overseers.

However, *Tou-cou-tou* is based on an incident which took place before the Civil War. Two well-known free families became involved in a quarrel which became so intense that epithets were passed and one was accused of having Negro blood. Since it was customary to have judicial decision as to whether persons belonged in the white or colored ranks, a lawsuit was undertaken and the court decided that the family which had appealed was of African descent. Now this was the time of lampoons and satires. As early as 1763 they were written and posted on corner posts and in other public places, and sung by the populace. Joe Beaumont (1820–1872), called the " Béranger of the Creoles," himself a quadroon, did not approve of the denial of African blood in one's racial admixture. Satirising the family who had lost their case in court and consequently their social position, he wrote an ironic ballad with numerous verses. The original copy, which I saw in New Orleans (a memento treasured by a Creole family), contains the following lines:

> Mo sorti la cour Suprême
> Pou voir ca ye ta pré fait,
> Mo tandé juges loyés même
> Dit nous perdi non procés.

245

Following Beaumont's lampoon came the folk-song, *Tou-cou-tou*. There is more than one version of this song—the one in my possession was taken down from Mme. Erado (an aunt of the Creole composer, Dédé), an elderly Creole neighbor of my childhood days in Texas.

> Aurelia, mo connai toi,
> Toi cés tin Morico—
> Na pa savan qui tacé blanc
> Pou blanchi vous lapo.

The humiliation is patent—the morico (maid of dark skin) could not find soap white enough to bleach the skin that she might be eligible to the pleasures of the Creole (the noted octoroon) balls. The Creole or octoroon balls were a familiar institution until 1861. All the women were colored Creoles or of the class *femme de couleur libre*, and as the balls were organised by the master class—men of Caucasian blood—no outside persons were admitted. Men of color could only attend as members of the dance orchestra.

Creole folk-song is delightful in its sincerity and naïveté. No song is more closely woven with the intricate intimacies of the people or the traditions of the times. Incidentally one finds an heroic song such as *En avan Grénadié* (Go forward, Grenadiers) that was used in battle. Some of the dirges and chants are not unlike the Sicilian songs still chanted by the peasants of Greece and Italy.

The Creoles have added a new note in their gift to the folk-song of America. On the shores of southern seas and in the land of the nightingale, burdened souls lost their sorrows of mid-noon in the holiday song of twilight. The reverberating drum is no longer heard; the lay of the reeds and the quills is silent, but the breath of the songs of yesterday and the fleer of the jesters remain as our heritage in a melodious wealth of minstrelsy.

Negro Music in Porto Rico

by MAUD CUNEY HARE

I T is to be expected that the African influence should be strongly felt in this island of the West Indies. Both the aboriginal Carib and the African suffered the cruelties of slavery, but while the Indian perished the Negro survived. The Carib blood, however, remains in a fusion of blood of Spanish fathers and Negro and Carib mothers, and a later amalgamation of all. This union of races gives to this section a folklore of Spain, native Carib and African Negro. Very few pure Negroes are to be found in Porto Rico. Those mainly on the eastern end of the island are black people who come from the Virgin Islands and the British West Indies.

Negro musical influences are found in the dance. Fernando Callejo speaks of the annual celebrations held during the slavery régime by Negroes of different tribes in the old market place of San Juan, when the only instruments used to mark the rhythm of the dance-songs were the *Bombas* and the *Maracas*. The *Bombas* (dances) take their name from the Bomba, the Negro drum which accompanies the dance. The Bamboula, the Creole and Negro dance of the French West Indies and Louisiana (U.S.), likewise takes its name from African terms which describe the dominating drum.

Strange to say the vanished Carib owes to the Negro the survival and the memory of his prehistoric music. The earliest of the dance-songs (areitos) were war dances used for marriage, birth and death ceremonies. The music is strangely akin to that of Haiti. An interesting legend exists in this connection. When the Cacique Guarrionex was asked what would be the fate of the natives of the West Indies, he consulted the gods, who replied that clothed men would come to Haiti to make the people captive and that the natives would be destroyed. One of the oldest dance-songs used in the festivals bears this story.

The *Bomba* is known in Haiti. There is the stanza:

> Aya bomba ya bombai
> La massana Aanacaona
> Aya bomba ya bombai
> La massana aanacaona.

A refrain, *Igi aya bomba*, found in fragmentary form in an old areito which is known in Porto Rico, has left its trace in the national hymn of Borinquen—*Fatherland of powerful men*.

The spirit of the areitos survives in the modern dances. In the primitive danzon there was a simple combination of notes—a triplet of three-quarter notes in 2/4 time called " tresillo ne negras," and named after the Negro. The danzon remains the most popular dance form of Porto Rico. While in search of native music there, I found the danzon played everywhere as a salon piece. It is to Porto Rico what the Habanera is to Cuba.

In the dance form of the jivaros (the peasant class, the peon of the mountains), the simple *Seis* (the name of the dance) is interrupted to recite a copla of humor called *Bombai*, which is a short melodic part of eight measures with interminable variations on one theme. The rhythm is a combination like that of the Habanera. In the modern *Vals Jibaros* of the country frequent syncopation is employed by leaving out the first beat of each measure and substituting a stroke by the hand on the box of the crude instrument.

While there are many queer guitars and string instruments made of hollowed wood and gourds found on the island of Porto Rico, three popular ones are said to be of unmistakable Negro origin. They are : the Bomba ; the Maraca ; the Guiro (juiro or guicharo). The maraca is always used with the " Aguinaldos," a type of song that is sung at the New Year's celebration of the Three Kings. This occurs a week after Christmas when gifts are received. The singing of the aguinaldos on the streets may be likened to the carolling of Christmas songs by other nations. This celebration of the Three Kings is a Portuguese custom, and I found in Porto Rico an identical song which is among those that I collected from the Portuguese of Provincetown, Massachusetts.

As a Portuguese practice, it is not surprising to find that the singing of the aguinaldos takes place in Brazil to celebrate the New Year. Here the Negro celebrates with street dances and pays homage to an elected king and royal court as in a New Orleans Mardi Gras. The Congo slaves brought to Brazil absorbed the Portuguese custom and called this celebration the *Congada*. At the Emancipation in 1888 the *Congada* was held all over Brazil by the thousands of freedmen.

The most popular of all instruments in Porto Rico is the *Guiro* (pronounced wee-ro). As in the neighboring Virgin Islands, it is to be seen everywhere and is the main instrument in the percussion section of the orchestras and bands. I have listened with amazement to the extraordinary playing of a Negro guiro player in the Porto Rican Municipal Band at San Juan. The many and varied rhythmic effects and the rapidity with which he produces syncopated notes makes him the centre of attention to tourists who listen to the outdoor concerts given in the plaza.

The guiro, or juiro, is made of a hollowed gourd, cut with many small grooves, decorated with simple motives and two or three cut-outs. The medium-sized one in my possession, by a few designs, is made to resemble a fish. The instrument is stroked by means of a steel wire or even a hairpin. There are many excellent colored musicians in Porto Rico, both in the orchestras and in the municipal band.

The Biguine of the French Antilles

by MADIANA

MARTINIQUE, Guadeloupe and French Guiana all have a folklore which is closely akin, and also closely linked with dancing.

The main character of the popular tunes lies in their rhythm, the form mostly used being that of syncopation.

The *Biguine* is the best known of the dances. The *Bel-air* and *Calypso* are sung in dialect, as are all Creole tunes. Here the drum plays the role of accompaniment. There must be three drums, the one to " damme " (to announce), the other to " refoule " (to send the rhythm back), the third to " coupe " (or cut) ; between them the musical phrase will be richly scanned. Of the Antillese tunes the *Laggia* is the most characteristic. Its music is improvised, its recitatives full of humour. Danced and sung as it is in the glow of torches out in the country by workers and labourers who have bared themselves to the waist it is extremely picturesque.

Amongst these it is the *Biguine*, known as the *Biguine d'exportation*, which has become the most popular.

The Biguine of the French Antilles

It is to be deplored that the *Biguine* should be presented to Parisians only in an obscene interpretation when it can express both a languorous grace and an extreme liveliness according to the changes in its tempo. Two short gliding steps resulting in a supple swaying of the hips form its essential principle. The *Biguine* differs from the " blues," characterised by a swaying of the whole body, and from the " Charleston," which is nothing more than a rhythmic exercise.

In the real *Biguine*, as it is danced by the Creoles themselves, the performers do not embrace; they mimic the everlasting pursuit of woman by man. The former advances and withdraws to the accompaniment of a thousand enticing gestures, while her partner artfully approaches or feigns a haughty indifference which he drops quickly in order to catch up with his flippant companion who is running away, borne along by her swishing skirts. Whether they dance in couple or in square formation, both the steps and the gestures accurately interpret the theme suggested by the music.

The melody, usually written in a major key, is very simple, without any embellishment at all. Modulations are much more unusual than in the other songs of the locality, such as the old lullabies common to the French West Indies, to Louisiana and to St. Maurice Island, the seventeenth century ballads in a colourful *patois* taken from old French, and finally the laguias and bel-airs. If it were not for the rhythm, the melody, which is played in aftertime, would be quite monotonous. From this point of view, the *Biguine* is closely related to the " Rumba," of recent fame. Syncopation is the reigning feature of both these dances; although perhaps it appears less studied here than in the bel-air and the calypso, where, by the intricacy of its blending, it registers almost imperceptible values, jumbling the time-divisions in a most unexpected way. Because of the irregularity of the accented beats, transcription is very difficult, but fortunately the phonograph is capable of a faithful reproduction. Aside from a few incomplete versions for the piano, no attempts at orchestration have been made.

Instinctively, the Antillian musicians harmonise the melody so that there is no need of the score. The accompaniment is extremely colourful. Indeed, the musical pattern would seem monotonous without the clarinet which embroiders it with variations cut by unexpected pauses. Either in solo or playing with the other instruments, the clarinet becomes by turns the interpreter of a lively spasmodic rhythm, which sometimes takes on a mocking sensuousness and a surprising buoyancy. To a stranger's ear certain records might seem confused. I am speaking particularly of the first attempts, which, moreover, were somewhat out of tune. But listening more closely, one is struck by the marvellous wealth of rhythm in these short themes and by the actual feats which the different parts perform in order to adjust themselves into the disjointed measure. Even the words contribute to the creation of this atmosphere. Written to comment upon a political or sentimental adventure, these songs are satirical, or of a certain wistfulness, always relieved by a shade of humour. In their dialect, the crudeness of the words often offends decency. These folk-songs used to remain popular only during the Carnival time in the Antilles, that is, from January to March. Then they were rapidly forgotten, but thanks to the phonograph, nowadays certain ones are being revived, such as the *Biguines* formerly played during the delirious Carnival of St. Pierre, the city swallowed up by the volcano of Mont Pelée. The romance of the guitars and mandolins, the garrulous " shashas," the tinkling triangles, the simple accordeon of the countryside, the wailing clarinet, the blaring trombone, the staccato of the strings, the muffled beats of the bass-drum, transform the dreariest winter day into a dazzling tropical sunshine flooding the palms.

All the proof Nancy needed of the Afro-American's musical ability resided in Henry Crowder. She was amazed to learn he had had no musical training. Everything had just "come natural," he told her. Still more remarkable was Henry's ability to read the most difficult scores and improvise original harmonies. Determined to publicize Henry's talents, Nancy proposed that The Hours Press publish a music book which would contain poetry and original music by Henry. Together they found six poems they liked by Samuel Beckett, Walter Lowenfels, Richard Aldington, Harold Acton, and Nancy, and then vanished to the tiny village of Creysse, on the Dordogne, where Henry, inspired by the river which evoked the "times of primitive man," composed the scores for *Henry-Music*.

<div align="right">H. F.</div>

Is the African Musical?

by OLUWOLE AYODELE ALAKIJA, B.A., B.C.L. Hons. (Oxon)

THROUGHOUT the world there is a general conception of what music is or what it should be. The same applies to other arts which are practised in various forms in all parts of the world. Were this not so, Epstein's modern sculptures would be less cruelly criticised by those who fail to see art from his point of view. Therefore the question as to what music should be only arises in countries which fail to understand what is meant by music in Africa.

Barbaric rites and rituals (and here " barbaric " means " foreign to the non-understanding individual "), beliefs and practices, if isolated from their context and viewed from the other barbaric standpoint of the average European culture, appear to be irrational if not immoral. They are judged from the European standards, and being out of harmony with these standards they are condemned as savage. Studied, however, in relation to the motives which inspire them, a careful examination will bring to light the hidden mystery.

Of course a great deal of this misunderstanding of the African mind arises from the accounts of explorers, sailors, traders and missionaries often unlettered, untutored, and in the last case prone to exaggeration of the barbarity they had to face, who would go out of their way into details of the most sensational type and of what was the most bizarre. We cannot stress too much that these accounts, especially the more recent ones, present the most biassed pictures of African life. This atmosphere of exaggeration can only be dispelled by a general uplift of the Aryan intelligentsia, whose present ignorance lies at the bottom of its most serious misconceptions.

Having explained the general viewpoint on matters exclusively African, we may include among such matters African music; but does it exist? If it does, then the African is musical. On the other hand, we are told that he is not, and that if even some apology for music exists in Africa, it is uncouth and barbaric. But this only proves that the height of education has not yet been reached among the Aryan races; they should keep silent on matters which are beyond their comprehension. However, I will attempt to prove that not only is there music in Africa but also that it is the home of modern music which has become the world's rage at the present time.

First of all, what do we understand by m u s i c ? It is a succession of sounds so modulated as to please the ear—that is, melody or harmony, and the science of producing them. Now, does it matter whose ear the sound pleases ? If they are pleasing to the African, then he is the sole judge of what his music should be, and is not responsible to interlopers. The African is a born musician, and from childhood he becomes familiar with his national songs so that when he grows older he has a ready repertoire of well-known African ditties.

I have often watched African children at play, and I have discovered that each and every one of them has the gifted capacity of becoming a good composer. The leading light among them quickly improvises

<div align="center">249</div>

a little something in the nature of community-singing in which every child joins. When the African child gets knocked about, as is usual with children of all nationalities, he must cry his heart out. If no one takes any notice of him, his cry is changed into a series of sounds not unlike musical notes. Other children sometimes join in this new outburst, which is definitely an improvement on his wailings.

Turning to language (and this applies to all African languages) we find that no compound syllables can be correctly pronounced without striking on a musical note. This, in particular, is where the European fails to understand, or to be able himself to teach any African languages effectively. He may live all his life in Africa but he is ever baffled by those mysterious musical notes which add *tone* to the African languages. Intonation is the gist of African languages, and were I a language tutor I would teach my European pupils the rudiments of music before embarking on a hazardous attempt to impart the language to them.

No African ceremony is complete without its musical background, and you may surprise the African in any form of occupation, he enjoys his labour best when he sings. Whether it be a wedding, a dance, a religious ceremony, or even a funeral, there is music to suit every mood.

I have never witnessed a silent funeral procession in West Africa. The foreigner need only go there to find that it is indeed the home of Negro spirituals. One feels that the beloved one whose death is being mourned has really gone to heaven. Here we must distinguish between youth departed and the dead great-grandmother. The ceremony for the former is mournful enough, but because that for the older generation is celebrated with dancing and feasting, etc., the foreigner takes offence and of course the missionary condemns it as barbaric and crude. Here they fail to understand why such music should be evident at the death of any human being. I am sorry for their ignorance, but the reason for such a ceremony is simple. No one is ever pleased to lose his beloved one. If so, then why the dancing and hilarious excitement at the death of an old person? This is the expression of joy at the fact that one of them had been spared to reach such a ripe age. Of course this has nothing to do with the saying that " he whom the gods love dies young." It may mean that even an old man may still die with his young spirit of innocence—but here I am digressing.

It is only the African love for music that has made the task (if such it be) of the missionaries less laborious. The African had, and to a certain extent does still preserve, his own form of religion and religious beliefs. He has always had a word in his language for the Almighty. In Yoruba it is literally " the Lord of the heavens." Hence the missionaries found it difficult to get their converts, and not until the African reverend gentlemen began their own campaign did the ranks of the converts swell. This was done by the adaptation of some African songs into religious services ; and having evolved a dance tempo to these songs the African just danced his way into christianity. I am appending a few bars of one of these songs. In passing, we mention the name of the late Rev. Canon J. J. Ransome Kuti, who was so instrumental in swelling the ranks of the converts.

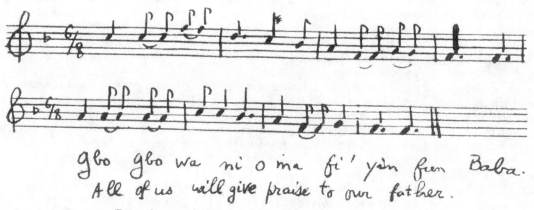

gbo gbo wa ni o ma fi' yin fun Baba.
All of us will give praise to our father.

(Extract from one of the many tunes that need no counterpoint or harmony.)

The African works best when he sings. He has his own sea shanties, town sing-songs and farm carouses. He will do anything in less time if he finds it possible to sing at the same time. A canoe moves at a remarkable speed when manned by real he-men singers, and a forest area is cleared as soon as the workers begin to exercise their vocal chords.

I cannot repeat too often that in every sphere of occupation the African is at his best if he finds it con-

Is the African Musical?

venient to indulge in some musical air. Hence we find that the more musical the foreman the more efficient are his men. Indeed Africa has always been the home of community-singing. It was only recently inaugurated in Europe, and even then it is very much restricted to special occasions, and everybody sings not because he feels like it but because everyone else has joined in the singing.

In Africa we sing not for the sake of singing but because we feel that on occasion certain forms of expression of the soul must be manifested, and these manifestations vary with the circumstances which have occasioned them. Again I say that Africa is the home of community-singing. On the slightest pretext crowds gather and give vent to their feelings in music, whether peaceful or riotous. Throw money out to a crowd of dancers and immediately they sing your praise in verses which can only occur to them on the spot. Fling a pail of water on them and you cannot damp the ardour with which they will make their vituperative verses reverberate throughout all the neighbouring surroundings. To listen to an African poet-singer improvising verses to impromptu tunes and leading his chorus of female voices is indeed something never to be forgotten and highly valuable to a student of music.

In Africa we sing what we like, and according to individual taste. The human voice can produce more notes than any existing musical instrument, and the African has realised this. Hence he has less to do with artificial musical instruments, but he preserves his drums for rhythm; I think that, for drums, no other continent can boast of a larger collection than Africa. We have still to invent a special piano for African tunes. The eight-notes-to-the-octave is far from being the genuine article. In fact very few African tunes can be played with any effect on the piano.

That the drum is the most important in musical rhythm is a fact which has enabled the African to realise great possibilities with this instrument. We have dance drums of all shapes and sizes, " speaking " drums, and drums for sending telegraphic codes over incredible distances. The speaking drums do speak, and are so played that the sounds are almost indistinguishable from human voices. This is a most baffling research to the European musical research students.

In fact the African can play any trick with his drums, but the rhythmic effects of the drums in certain dance movements have given birth to modern ballroom dances, especially the foxtrot, blues, a form of rumba, and even the waltz, and, to a certain extent, the $\frac{6}{8}$ rhythm. The Africans having done their share with the drums have left any necessary adaptation of ballroom rhythms to their brothers across the seas. The Charleston is reminiscent of an African war-dance, but I cannot quite place the Black Bottom. However, this originated in Africa.

As for the efficiency with which our African brothers across the seas have carried out the adaptations for ballroom dancing, this is common knowledge and there is no lack of laudatory remarks in American, English and other European musical publications. It is a well-known fact that the first 10 bands in the world are all Negro bands, and the band contest was adjudged by white Americans, who have not been slow to acknowledge the superiority of their black masters.

Europe's best tenor saxophonist writes in a recent number of the *Melody Maker*: " I cannot claim to have heard in the flesh any of the famous recording coloured bands such as Fletcher Henderson, Don Redman or Duke Ellington (these by the way are the world's leading dance bands); it is one of my greatest ambitions, which I hope will not be long in realisation, to do so. Nevertheless, I have heard one or two other coloured bands which have made me anxious to sample more."

He states further that the superiority of Negro orchestras when it comes to sheer rhythm is all the harder to explain when we consider the individual players! This is a pretty astounding remark (to say the very least of it), the more so as he is bold enough in stating that when it comes to individual comparison, generally speaking, there is no such inferiority of the white musician apparent! Little wonder that a coloured band has named itself " The O.K. Rhythm Kings." In fact they will give the K.O. to any white band.

In contrast to the above is the following statement by R. C. F. Maugham, C.B.E., in the current number (Jan. 1933) of *The West African Review*: " The African's appreciation of European music is, on the whole, slightly less, perhaps, than is ours of his—songs sung in unison being invariably preferred to vocal harmonies, counterpoint being considered positively ugly." Here the writer forgets that European music is stereotyped, whereas African music has more soul and cannot be constrained into a box of black and white keys which cannot give effect to, or render sufficiently, any expression of the musical soul. Therefore European music seeks the aid of counterpoint to embellish its emptiness. The African can produce fine music at will according to the dictates of his soul, and when he confines his vocal music to themes interpreted by as few notes as possible the explanation is that what comes from the soul is responsible to the soul alone, for the very nature and being of the African are intensely musical.

One of the elements that help to explain Nancy's defense of the black man is her appreciation and understanding of his musical accomplishments. Although it was American jazz played by black musicians in Paris clubs that attracted her so strongly, she had always had a scholarly interest in its African origins, and some years before the publication of *Negro*—in 1928—she had proposed to Henry Crowder that they travel to French Gaboon to record the native music. Plans to go to Gaboon finally had to be abandoned, but Nancy, determined to show Henry the land of his ancestors, tried again in 1930 to interest him and Norman Douglas in an African trip. "What of [African] music?" she reminded them when she sensed some hesitancy about going. "As a pianist and composer, Henry could do good work in that field and bring back something as yet unknown, which later might be published by the Hours." Nancy clearly conceived of the trip as a "mission" to collect data and music, but again the proposal was gradually forgotten, as both Norman and Henry cited one difficulty after another that would make the trip impossible.

Nancy did eventually travel to Africa with Douglas, but then only for a month in 1938 and only to Tunisia. Her account of the trip does not mention music.

H. F.

West and East African Songs

Transcription by E. KOHN

1. SORIOH (BUNDU SONG) Susu. French Guinea

Tigidenkey with chorus, xylophone and drums

(Reproduced by courtesy of Carl Lindström, A. G. Parlophon, Plate Serial B45063.)

2. BAMBA BOA Konno. Sierra Leone

With chorus and calabash rattles

(Reproduced by courtesy of Carl Lindström, A. G. Parlophon, Plate Serial B45038.)

West and East African Songs

3. Shegbura Mawale Mende. Sierra Leone

With chorus and calabash rattles

(Reproduced by courtesy of Carl Lindström, A. G. Parlophon, Plate Serial B45050.)

4. Accra Body In Gâ. Gold Coast

Sung by SQUIRE ADDO ACCRA TRIO (Squire Addo, Douglas Papafio, Harry Quashie)

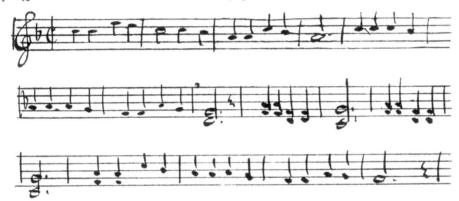

5. Hwe Mbre Mina In Fanti. Gold Coast

Sung by DANIEL ACQUUAH with chorus and tambourine

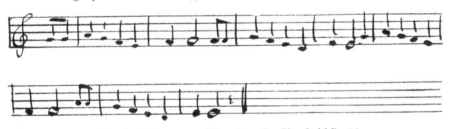

(Reproduced by courtesy of Zonophone Co., Plate Serial E2.78.)

6. Accra Dwom Ashanti. Gold Coast

Sung by K. FREMAN BAND

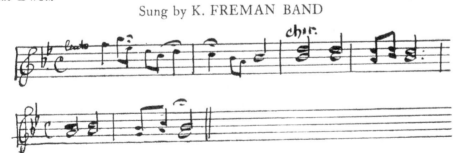

(Reproduced by courtesy of Carl Lindström, A. G. Parlophon, Plate Serial B43018.)

253

West and East African Songs

7. KOFIA NYEKUNDU In Swahili. Tanganyka, East Africa

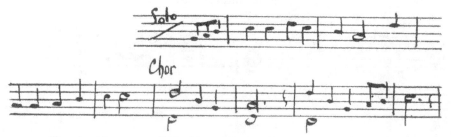

(Reproduced by courtesy of Columbia Gramophone Co., London, Plate Serial WE10.)

8. MWAKAM BEYA Wimbo-Kingoni. Tanganyka, East Africa

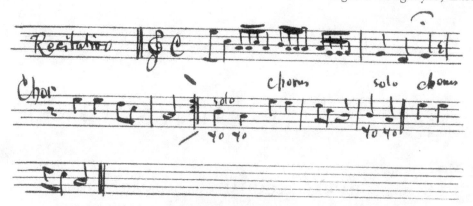

(Reproduced by courtesy of Columbia Gramophone Co., London, Plate Serial WE34.)

9. NATUPIGE HODI Wimbo-Kingoni. Tanganyka, East Africa

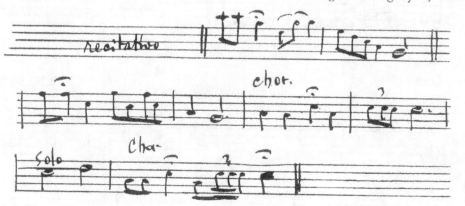

(Reproduced by courtesy of Columbia Gramophone Co., London, Plate Serial WE34.)

254

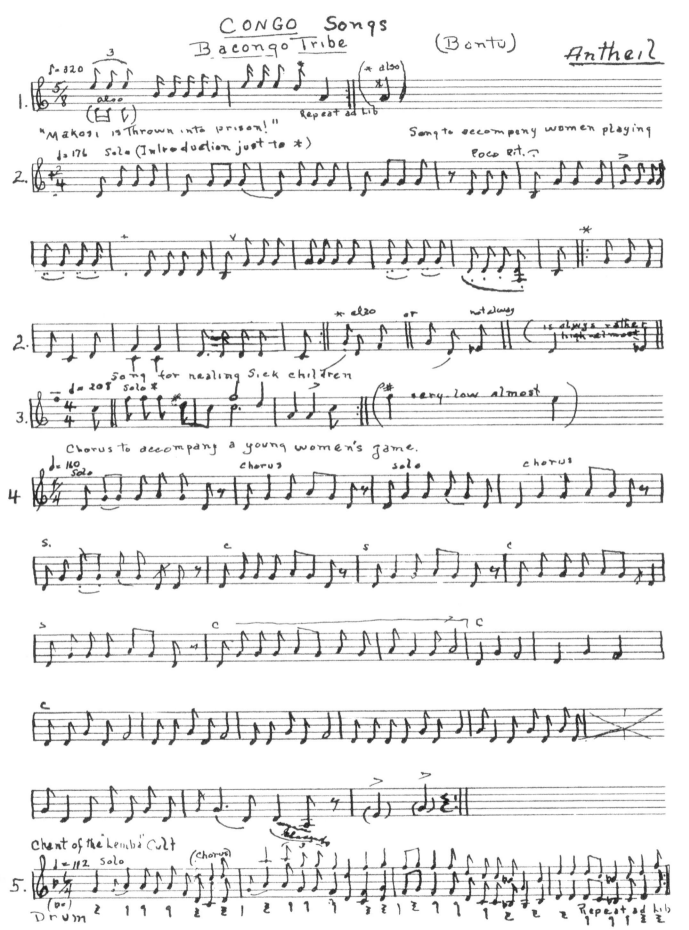

255

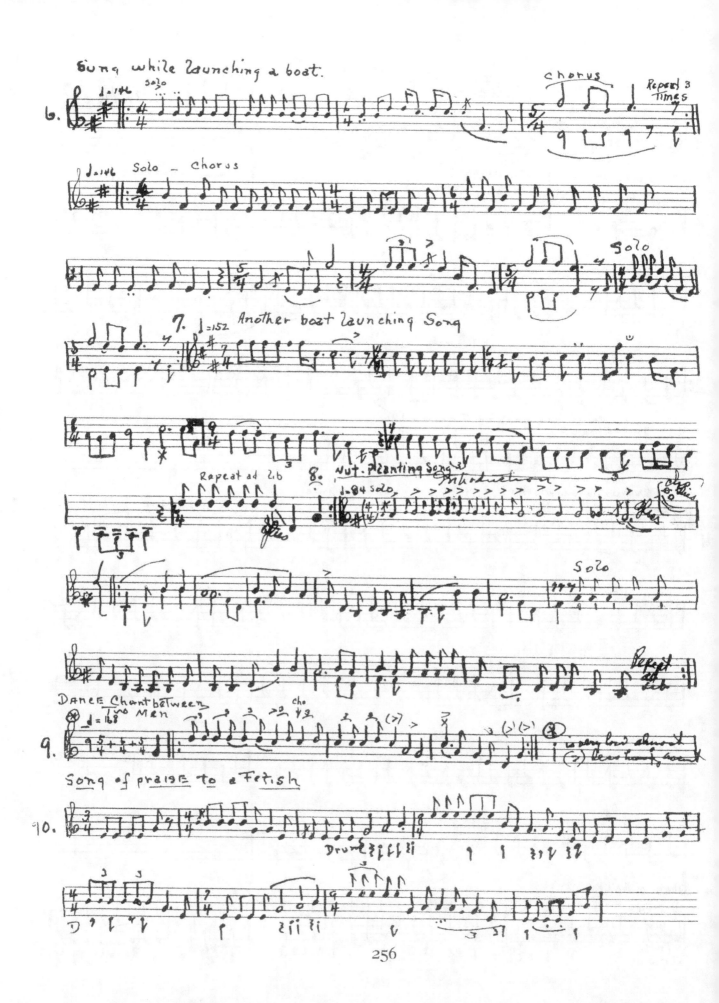

POETRY

Sterling Brown

Arna Bontemps

Thomas Fortune Fletcher

Georgia Douglas Johnson

Nicolás Guillén

Donald Jeffrey Hayes

Carrie Williams Clifford

Jonathan Brooks

Langston Hughes

Countee Cullen

Walter Everett Hawkins

NEGRO POETS

POETRY

CLOSE YOUR EYES!
Arna Bontemps

Go through the gates with closed eyes,
 Stand erect and let your black face front the west,
Drop the ax and leave the timber where it lies ;
 A woodman on the hill must have his rest.

Go where leaves are lying brown and wet,
 Forget her brown arms and her breast who mothered you,
And every face you ever loved forget,
 Close your eyes ; walk bravely through.

DEPRESSION
Jonathan H. Brooks

With his panama, the style ere the days got cool,
All flopped like an ear of a lazy mule ;

The worn, fur collar of his overcoat,
A mangy hound's scratched, rusty throat,

And his rough shoes curved like last-quarter moons
Attached to the cuffs of his white pantaloons—

He goes to church, a wrinkled necktie
On a blue work shirt, to learn how to die.

THE POET
Jonathan Brooks

He probed life's surface for the core,
And polished phrases till they bore
The tears of women paid to moan,
The feel of coolest marble stone.

Song shivered through his chilly soul
Like winds across the icy pole,
And the cool truth was ecstasy,
But fancy was as leprosy.

The love of truth froze up his heart ;
A cold, bare fact to him was art.
He made both soul and body ache
To know how hard are hearts that break ;
How high the morning sun must rise
Before the dew on roses dries ;
And was so painfully precise,
He often doubted his own eyes.
His song was merely fact and tone,
With neither soul nor flesh—just bone.

STRONG MEN
Sterling Brown
" The strong men keep coming on."—Sandburg

They dragged you from homeland,
They chained you in coffles,
They huddled you spoon-fashion in filthy hatches,
They sold you to give a few gentlemen ease.

They broke you in like oxen,
They scourged you,
They branded you,
They made your women breeders,
They swelled your numbers with bastards . . .
They taught you the religion they disgraced.

You sang :
 Keep a inchin' along
 Lak a po' inch worm. . . .

You sang :
 Bye and bye
 I'm gonna lay down this heavy load. . . .

You sang :
 Walk togedder, chillen,
 Dontcha git weary. . . .
 The strong men keep a-comin' on,
 The strong men git stronger.

They point with pride to the roads you built for them,
They ride in comfort over the rails you laid for them,
They put hammers in your hands
And said—Drive so much before sundown.

You sang :
 Ain't no hammah
 In dis lan',
 Strikes lak mine, bebby,
 Strikes lak mine.

They cooped you in their kitchens,
They penned you in their factories,

They gave you the jobs that they were too good for,
They tried to guarantee happiness to themselves
By shunting dirt and misery on to you.

You sang :
 Me an' muh baby gonna shine, shine,
 Me an' muh baby gonna shine.
 The strong men keep a-comin' on,
 The strong men git stronger. . . .

They bought off some of your leaders,
You stumbled, as blind men will . . .
They coaxed you, unwontedly soft-voiced . . .
You followed a way,
Then laughed as usual.
They heard the laugh and wondered,
Uncomfortable,
Unadmitting a deeper terror. . . .
 The strong men keep a-comin' on,
 Gittin' stronger. . . .

What, from the slums
Where they have hemmed you,
What, from the tiny huts
They could not keep from you—
What reaches them
Making them ill at ease, fearful ?
Today they shout prohibitions at you :
" 'Thou shalt not this,"
" 'Thou shalt not that,"
" Reserved for whites only "—
You laugh.

One thing they cannot prohibit—
 The strong men . . . comin' on,
 The strong men gittin' stronger.
 Strong men . . .
 Stronger. . . .

Strong Men and *Memphis Blues* by Sterling Brown have appeared in his first published volume of poems, *Southern Road*, Harcourt Brace, New York, 1932. *Children of the Mississippi* is here reprinted by courtesy of the editor of *Opportunity*, 1133 Broadway, New York.

259

MEMPHIS BLUES

Sterling Brown

Nineveh, Tyre,
Babylon,
Not much lef'
Of either one.
All dese cities
Ashes and rust,
De win' sing sperrichals
Through deir dus' . . .
Was another Memphis
Mongst de olden days,
Done been destroyed
In many ways . . .
Dis here Memphis
It may go
Floods may drown it,
Tornado blow,
Mississippi wash it
Down to sea—
Like de other Memphis in
History.

Watcha gonna do when Memphis on fire,
 Memphis on fire, Mistah Preachin' Man?
Gonna pray to Jesus and nebber tire,
 Gonna pray to Jesus, loud as I can,
 Gonna pray to my Jesus, oh, my Lawd!

Watcha gonna do when de tall flames roar,
 Tall flames roar, Mistah Lovin' Man?
Gonna love my brownskin better'n before—
 Gonna love my baby lak a do-right man,
 Gonna love my brown baby, oh, my Lawd!

Watcha gonna do when Memphis falls down,
 Memphis falls down, Mistah Music Man?
Gonna plunk on dat box as long as it soun',
 Gonna plunk dat box fo' to beat de ban',
 Gonna tickle dem ivories, oh, my Lawd!

Watcha gonna do in de hurricane,
 In de hurricane, Mistah Workin' Man?
Gonna put dem buildings up again,
 Gonna put em up dis time to stan',
 Gonna push a wicked wheelbarrow, oh, my Lawd!

Watcha gonna do when Memphis near gone,
 Memphis near gone, Mistah Drinkin' Man?
Gonna grab a pint bottle of Mountain Corn,
 Gonna keep de stopper in my han',
 Gonna get a mean jag on, oh, my Lawd!

Watcha gonna do when de flood roll fas',
 Flood roll fas', Mistah Gamblin' Man?
Gonna pick up my dice fo' one las' pass—
 Gonna fade my way to de lucky lan',
 Gonna throw my las' seven—oh, my Lawd!

 Memphis go
 By Flood or Flame;
 Nigger won't worry
 All de same—
 Memphis go,
 Memphis come back,
 Ain' no skin
 Off de nigger's back.
 All dese cities
 Ashes, rust . . .
 De win' sing sperrichals
 Through deir dus'.

CHILDREN OF THE MISSISSIPPI

Sterling Brown

These know fear; for all their singing
As the moon thrust her tip above dark woods,
Tuning their voices to the summer night
These folk knew even then, the hints of fear.
For all their loafing on the levee,
Unperturbedly spendthrift of time,
Greeting the big boat swinging the curve
" Do it, Mister Pilot! Do it, Big Boy!"
Beneath their dark laughter
Roaring like a flood roars, swung into a spillway,
There rolled even then a strong undertow
Of fear.
Now, intimately
These folk know fear.
They have seen
Black water creeping, slowfooted Fate,
Implacably, unceasingly
Over their bottomlands, over their cornshocks,
Past highwater marks, past wildest conjecture
Black water creeping before their eyes,
Rolling while they toss in startled half sleep.
 De Lord tole Norah
 Dat de flood was due,
 Norah listened to de Lord,
 An' got his stock on board,
 Wish dat de Lord
 Had tole us too.
These folk know grief.
They have seen
Black water gurgling, lapping, roaring,
Take their lives' earnings, roll off their paltry
Fixtures of homes, things as dear as old hearthgods.
These have known death
Surprising, rapacious of cattle, of children,
Creeping with the black water
Secretly, unceasingly.
 Death pick out new ways
 Now fo' to come to us
 Black water creepin'
 While folks is sleepin'
 Death on de black water
 Ugly an' treacherous.
These, for all their vaunted faith, know doubt.
These know no Ararat;
No arc of promise bedecking blue skies;
No dove, betokening calm;
No fondled favor toward new beginnings.
These know
Promise of baked lands, burnt as in brickkilns,
Cracked uglily, crinkled crust at the seedtime,
Rotten with stench, watched over by vultures.
Promise of winter, bleak and unpitying,
No buoyant hoping now, only dank memories
Bitter as the waters, bracken as the waters,
Black and unceasing as hostile waters.
 Winter acomin'
 Leaner dan ever,
 What we done done to you,
 Makes you do lak you do?
 How we done harmed you,
 Blackhearted river?
These folk know fear, now, as a bosom crony :
Children, stepchildren
Of the Mississippi. . . .

THE BLACK DRAFTEE FROM DIXIE

Carrie Williams Clifford

(Twelve Negro soldiers who had served overseas were lynched upon their
return to their homes in the South)

Upon his dull ear fell the stern command;
And though scarce knowing why or whither, he
Went forth prepared to battle loyally,
And questioned not your faith, O Dixie-land!

And though the task assigned were small or grand,
If toiling at mean tasks ingloriously,
Or in fierce combat fighting valiantly,
With poise magnificent he took his stand!

What though the hero-warrior was black?
His heart was white and loyal to the core;
And when to his loved Dixie he came back,
Maimed, in the duty done on foreign shore,
Where from the hell of war he never flinched,
Because he cried, " Democracy," was lynched.

From *The Widening Light,* published by Walter Reid Co., Boston,
1922.

FROM THE DARK TOWER

Countee Cullen

We shall not always plant while others reap
The golden increment of bursting fruit,
Not always countenance, abject and mute,
That lesser men should hold their brothers cheap;
Not everlastingly while others sleep
Shall we beguile their limbs with mellow flute,
Not always bend to some more subtle brute;
We were not made eternally to weep.

The night whose sable breast relieves the stark
White stars is no less lovely, being dark;
And there are buds that cannot bloom at all
In light, but crumple, piteous, and fall;
So in the dark we hide the heart that bleeds,
And wait, and tend our agonizing seeds.

FOR A LADY I KNOW

Countee Cullen

She even thinks that up in heaven
 Her class lies late and snores,
While poor black cherubs rise at seven
 To do celestial chores.

INCIDENT

Countee Cullen

Once riding in old Baltimore
 Heart-filled, head-filled with glee,
I saw a Baltimorean
 Keep looking straight at me.

Now I was eight and very small,
 And he was no whit bigger,
And so I smiled, but he poked out
 His tongue and called me " Nigger."

I saw the whole of Baltimore
 From May until December:
Of all the things that happened there
 That's all that I remember.

These three poems of Countee Cullen are from *Carolling Dusk,*
Anthology of Verse by Negro Poets, edited by Countee Cullen,
Harper, New York, 1927.

THAT OTHER GOLGOTHA

T. Thomas Fortune Fletcher

Yes, Jesus,
I know how you felt
On Golgotha
That night.
They lynched me, Jesus,
Just like they lynched you,
But you didn't care,
Old Death couldn't hold you.

They put cruel spikes
In your hands,
But with those hands
You rolled away the stone.
Yes, you did, Jesus,
I know that even
If they do say
The angel done it.

No sir! No lady angel
Could'a moved that rock,
'Twas your precious blood
Done that, Jesus.

Was you scared, Lord,
When the mob come for you?
Well, I was, Jesus.
They took me before
I could say,
" Lord, help."

What'd I done, Lord?
What did you do?
They strung me up
On a tree, Jesus,
Just like them Jews
Put you on the cross.

Only I wasn't brave like you,
Lord, I cried and begged,
Damning them to the Hell
I feared.
I thought of you then, Jesus,
With the spear in your side
And it didn't hurt so bad.

I cursed 'em, Jesus,
But you don't hold that
Against me,
Do you, Lord?
They didn't know what
They was doing and
I didn't know what I was saying,
'Cause I wasn't brave like you, Lord,
I was scared.

Yes, Jesus, I know
How you felt
On Golgotha
That night.

FOR A CERTAIN PH.D. I KNOW

T. Thomas Fortune Fletcher

If you could forget
Those years at Harvard or
Those Tourist-Third Summers in Europe
Or the fact that you " discovered " Harlem
Then perhaps my nose would not quiver
When your silly name was mentioned and
I might not think you such a damned fool!

THUS SPEAKS AFRICA

Walter E. Hawkins

I am Africa:

Dark is the wraith of my travail,
Deep as the wealth of my coal mines.
Mid the hot breath of Harmattan,
And the dread scourge of the forests
In the full flush of the morning,
When time was young at the dawning,
On the wild plains and dark rivers,
I built Timbuctoo and Karnak,
Luxor and Memnon and Memphis,
I sang in the temples of Isis,
I sang to the stars and Osiris.

I am Africa:

I am the Sphinx and the Pyramids,
The rub and riddle of the universe
Defying time and the elements.
From the pinnacles of my Pyramids
I laughed at the legions of Caesar.
Upon the bosom of my prairies
I shelter the caravan of nations,
I lull them to sleep in my midnight,
I bury them in my Saharas.
Out of the might of my midnight
Arose the hut of the Zulu,
The wigwam and kraal of the Bushmen,
The dynasties of Rameses and the Pharaohs,
The palaces and temples of the Ptolemies.
My daughters were queens in old Sheba,
My sons were the kings of old Egypt;
On the banks of the Nile I have reared them,
In immortal art I embalmed them.

I am Africa:

Deep is the wealth of my coal mines,
Dark is the wraith of my travail.
Prometheus on the rock of adversity,
The nations I feed on vitals.
Food for the tables of monarchs,
Coal for the palaces of princes,
Diamonds for the bosoms of queens,
The queens in the palaces of London,
The salons of Brussels and of Paris,
The salons of Berlin and New York.

I am Africa:

On the fertile banks of the Congo
My sorrow in song I have lifted;
In the canebrakes and cornfields of Texas
My sorrow songs still I am singing.
I sleep 'neath the stars in the jungle,
Brother to the beasts of the forest,
The lion's strength moves in my sinews,
In my bones is the iron of my Africa.
I worship the life-giving sunlight,
Oblations I give to the moon;
My gods are of stone and of iron,
No greater than these have I found.
I build temples which I may not enter.
I garner the harvest but eat not;
I gather the cotton in the Southland,
Give grist to the mills in the Northland,
Give gristle and grist to America.

I am Africa:

Wild is the wail of my waters,
Deep is the cry of my Congo.
I laid down my life at Fort Pillow,
My blood's on the Commons of Boston,
I died on the flag at Fort Wagner,
My bones lie bleaching in Flanders.
I was burned at the stake down in Georgia,
I was fuel for the mob in Texas.
And then like the Phoenix of Egypt,
I rose from the ashes immortal,
And sat in the sun at noon-day
And laughed at the wraith of my travail.
I am the Sphinx and the Pyramids,
The rub and riddle of the universe,
Defying time and the elements,
I am the nimbus of nations,

I am Africa.

TO PROMETHEUS

Walter E. Hawkins

Hail, Prometheus, glad to meet you,
Fellow radical, I greet you;
We are comrades bound together
In the rain, and storm and weather.
I who wooed a woman's heart
Won a hatpin for a dart,
And a dress and feather.
You who stole the heavenly fire
Thought to teach men to aspire
To the portals—
You are chained unto a rock,
While the greedy vultures flock
To pick your vitals.
'Tis my knowledge and belief,
Men don't set a petty thief
Up for worship;
Had you stole a Tea-Pot Dome
You'd be wined and dined in Rome,
And New York, and Washington;
You would be a favorite son
To be a bishop.

APPOGGIATURA

Donald Jeffrey Hayes

It was water I was trying to think of all the time
Seeing the way you moved about the house. . . .
It was water, still and grey—or dusty blue
Where late at night the wind and a half grown moon
Could make a crazy quilt of silver ripples

And it little mattered what you were about;
Whether painting in your rainbow soiled smock
Or sitting by the window with the sunlight in your hair
That boiled like a golden cloud about your head
Or whether you sat in the shadows
Absorbed in the serious business
Of making strange white patterns with your fingers—
Whether it was any of these things
The emotion was always the same with me
And all the time it was water I was trying to recall,
Water, silent, breathless, restless,
Slowly rising, slowly falling, imperceptibly. . . .

262

It was the memory of water and the scent of air
Blown from the sea
That bothered me!

When you laughed, and that was so rare a festival,
I wanted to think of gulls dipping—
Grey wings, white-faced, into a rising wind
Dipping. . . .

Do you remember the day
You held a pale white flower to the sun
That I might see how the yellow rays
Played through the petals?
As I remember now
The flower was beautiful—
And the sunrays playing through—
And your slim fingers
And your tilting chin
But then:
There was only the indistinguishable sound of water silence;
The inaudible swish of one wave breaking. . . .

And now that you have moved on into the past;
You and your slim fingers
And your boiling hair,
Now that you have moved on into the past,
And I have time to stroll back through the corridors of memory,
It is like meeting an old friend at dawn
To find carved here deep in my mellowing mind
These words:
 " Sea-Woman—slim-fingered-water-thing. . ."

FLORIDA ROAD WORKERS

Langston Hughes

I'm makin' a road
For the cars
To fly by on.
Makin' a road
Through the palmetto thicket
For light and civilization
To travel on.
Makin' a road
For the rich old white men
To sweep over in their big cars
And leave me standin' here.

Sure,
A road helps all of us!
White folks ride—
And I get to see 'em ride.
I ain't never seen nobody
Ride so fine before.

Hey, buddy!
Look at me!
I'm makin' a road!

HOUSE IN THE WORLD

Langston Hughes

I'm looking for a house
In the world
Where the white shadows
Will not fall.

There is no such house,
Dark brother,
No such house
At all.

TO CERTAIN NEGRO LEADERS

Langston Hughes

Voices crying in the wilderness
At so much per word
From the white folks:

" Be meek and humble,
All you niggers,
And do not cry
Too loud."

ALWAYS THE SAME

It is the same everywhere for me:
On the docks at Sierra Leone,
In the cotton fields of Alabama,
In the diamond mines of Kimberley,
On the coffee hills of Hayti,
The banana lands of Central America,
The streets of Harlem,
And the cities of Morocco and Tripoli.

Black:
Exploited, beaten and robbed,
Shot and killed.
Blood running into

 Dollars
 Pounds
 Francs
 Pesetas
 Lire

For the wealth of the exploiters—
Blood that never comes back to me again.
Better that my blood
Runs into the deep channels of Revolution,
Runs into the strong hands of Revolution,
Stains all flags red,
Drives me away from

 Sierra Leone
 Kimberley
 Alabama
 Hayti
 Central America
 Harlem
 Morocco
 Tripoli

And all the black lands everywhere.
The force that kills,
The power that robs,
And the greed that does not care.

Better that my blood makes one with the blood
Of all the struggling workers in the world—
Till every land is free of

 Dollar robbers
 Pound robbers
 Franc robbers
 Peseta robbers
 Lire robbers
 Life robbers—

Until the Red Armies of the International Proletariat
Their faces, black, white, olive, yellow, brown,
Unite to raise the blood-red flag that
Never will come down!

From *The Liberator*, Nov. 4, 1932

263

GOODBYE, CHRIST
Langston Hughes

Listen, Christ,
You did alright in your day, I reckon—
But that day's gone now.
They ghosted you up a swell story, too,
Called it Bible—
But it's dead now.
The popes and the preachers've
Made too much money from it.
They've sold you to too many

Kings, generals, robbers, and killers—
Even to the Tzar and the Cossacks,
Even to Rockefeller's Church,
Even to THE SATURDAY EVENING POST.
You ain't no good no more.
They've pawned you
Till you've done wore out.

Goodbye,
Christ Jesus Lord God Jehova,

Beat it on away from here now.
Make way for a new guy with no religion at all—
A real guy named
Marx Communist Lenin Peasant Stalin Worker ME—

I said, ME!

Go ahead on now,
You're getting in the way of things, Lord.
And please take Saint Ghandi with you when you go,
And Saint Pope Pius,
And Saint Aimee McPherson,
And big black Saint Becton
Of the Consecrated Dime.
Move!

Don't be so slow about movin'!
The world is mine from now on—
And nobody's gonna sell ME
To a king, or a general,
Or a millionaire.

From *The Negro Worker*, Nov.-Dec. 1932.

West Indian Poetry

" Poetry in the West Indies has been too often only an imitation of European models in form and content. The young Negro poets presented here, however, are doing much to free the poetry of their islands from out-worn foreign patterns. *Nicolás Guillén* has written with great success in the dialect of the Cuban Negro, using the rhythms of Caribbean folk-music. *Regino Pedroso* has put into verse his background as a factory worker in Havana, and as a child of Chinese and Negro blood. In Hayti, *Jacques Roumain* writes of the black peasants and the African strain in the New World. And all three of these poets are vastly concerned with the problems of the darker peoples." These translations from the Spanish and the French are by Langston Hughes.

CANE
Nicolás Guillén

Negro
in the cane fields.

White man
above the cane fields.

Earth
beneath the cane fields.

Blood
That flows from us.

BLACK WOMAN
Nicolás Guillén

With the circle of the equator
Girdled about her waist
As though about a little world,
The black woman,
The new woman,
Comes forward
In her thin robes
Light as a serpent's skin.

Crowned with palms,
Like a newly arrived goddess,
She brings the unpublished word,
The unknown gesture,
The strong haunches, voice, teeth,
The morning and the change.

Flood of young blood
Beneath fresh skin!
Never wearying feet
For the deep music
Of the bongo.[1]

THE CONQUERORS
Regino Pedroso

They passed this way. Avaricious epics flamed
in their eyes from the Atlantic
to the Pacific. They came in iron boots,
long guns on their shoulders,
and the land wild.

What truth did they preach to men?
What gospel of joy to suffering humanity?
What psalm of Justice over the immense lands
did their iron cannons raise toward the skies?

In the name of law and peace they came . . .
Came toward the people calling them brothers:
And as in Holy Writ, America was the Christ
who saw them rend the earth like garments,
and fight over the free tunic of their destiny!

They passed this way.
They came in the name of a new democracy:
even on the highest peaks of the Andes
they slept the deep and brutal sleep of bayonets.

They passed this way.
With new postulates of liberty they came:
reaching as far as the old land of Li Tai Pe
on the floating skyscrapers of their battleships,
amidst the clamor of weak and torn nations.

They crossed here.
Now toward their barracks in Wall Street they go,
sacks of dollars on their shoulders,
and the land wild.

[1] Bongo : Afro-Cuban drum.

264

UNTIL YESTERDAY
(A Chinese Mood)
Regino Pedroso

Until yesterday I was polite and peaceful. . . .
Last year I drank tea from the yellow leaves of the *yunnen*
in fine cups of porcelain,
and deciphered the sacred texts of Lao-Tseu, of Meng-seu,
and of the wisest of the wise, Kung-fu-Yseu.
Deep in the shade of the pagodas
my life ran on harmoniously and serene,
white as the lilies in the pools,
gentle as a poem by Li-tai-Pe
picturing the rise and fall
of white storks at eve
against an alabaster sky.
But I have been awakened
by the echo of foreign voices booming from the mouths of
 strange machines—
metal dragons setting on fire with spittle of grape-shot—
O, horror of my brothers killed in the night—
our houses of bamboo and our ancient pagodas.

Now from the watch tower of my new consciousness
I look upon the green fields of Europe
and her magnificent cities
blossoming in iron and stone.
Before my eyes the western world is naked.

With the long pipe of the centuries in my pale hands,
I am no longer enticed by the opium of yesterday.
I march toward the progress of the people,
training my fingers on the trigger of a mauser.

Over the flame of today
impatiently I cook the drug of tomorrow.
In my great pipe of jade
I inhale deeply the new era.
A strange restlessness has taken all sleep from my eyes.
To observe more closely the far horizon
I leap up on the old wall of the past. . . .

Until yesterday I was polite and peaceful.

WHEN THE TOM-TOM BEATS
Jacques Roumain

Your heart trembles in the shadows
like a face reflected in troubled water.
The old mirage rises from the pit of the night.
You know the sweet sorcery of the past:
A river carries you far away from the banks,
carries you toward the ancestral landscape.
Listen to those voices: they sing the sadness of love.
In the mountain, hear that tom-tom
panting like the breast of a young black girl.

Your soul is a reflection in the whispering water
where your forefathers bent their obscure faces.
Its secret movement takes you into the darkness.
And the white that made you mulatto
is only a bit of foam thrown away,
like spit, on the face of the river.

OLD BLACK MEN
Georgia Douglas Johnson

They have dreamed as all men dream
Of glory, love and power,
They have hoped as youth will hope
For life's sunminted hour.

They have seen as others saw
Their visions fade in air,
They have learned to live it down
As tho' they did not care.

CELIBACY
Georgia Douglas Johnson

Where is the love that might have been
Flung to the four far ends of earth?
In my body, stamping round,
In my body, like a hound leashed and restless
Biding time!

by WHITE POETS
SOUTHERN SHERIFF
Nancy Cunard

White folks don't kill each other in the South
Ho no, not with so many niggers around.
It's the wrong end of the stick you got, englishman.
You say: " here's a murder, find the criminal "
We say: " too many niggers around with uppity ideas "
So we jus' take one or two along for murder,
Oh we ain' p'tickler, don't have to be no corpse
Found, we arrest 'em " for vagrancy," on suspicion-like,
We *frame* 'em, yah. Say, didn' Governor Sterling of Texas say
Sometimes you gotta burn a house to save a village?
That's when that nigger was framed
(Governor said mighta been innocent,
But a white woman cain't lie, see?)
Rape? sure they rape white women,
Leas'ways they'd like to—that's good enough.
We know how to handle our niggers,
You-all's plumb crazy over there
Why, you might even let a nigger sit down with you,
Where'd we be if that happened?
Sure, that story of the gang to kill the firemen's true,
$25 a head we got for each dead nigger,

Killed 30 in Mississippi in a year,
Niggers gotta be kept in their place.
Tell you what's worse—that's them Northern whites
They just turn the niggers crazy, " equality,"
" Organise for better wages," " black and white together fight "
Yah, we framed up
Angelo Herndon, gave him 20 years on the Georgia chain-gang
 for that
Under pre-Abolition law, " Incitement to slaves," not bad huh?
We hoped the " Atlanta 6 " bunch
Of whites and niggers with the same racket
Would get the death penalty. Sure, we always let the
Mobs take the prisoners *unless we*
Shoot 'em ourselves; that was the Tuscaloosa lot,
Weren't no gang of masked men at all,
Did it ourselves, yah, quick and neat
Save the third boy didn't die—oh that's alright
Daren't testify 'gainst no-one, we beat 'em in jail
Beat their families too, make 'em sign
" Under duress " we calls it. They sign, don't ask no help
From outside, perfec'ly content with lawyers court gives 'em.

265

We run them International Labor Defense attorneys out the town,
They nigh got lynched on the train, huh.
Know what them agitators for " Equal Rights " is askin'?
" Self-determination for the Black Belt."
Well, farmer over there'll show you an old lynched nigger's tooth,
Kinda lucky he thinks, on his fob,
Holds it up when a cropper hands him sauce
Askin' fer wages. . . .
That's the kind o' " Self-determination " *we* got,
Don't need no interference,
That's why we're shooting so many niggers jes' now,
Ain't we gotta protec' our white women?
Naw, ain't no rape, why, a nigger wouldn't dare. . . .
Jes' our word, sorta slogan.
Old nigger in Maryland, Euel Lee, in jail 3 years now
Fer nuthin—farmer and fam'ly found murdered,
Course he didn' do it, that nigger asked for his wages
See? cain't have that; other niggers would too.
Them Scottsboro boys is innocent, we all knows that—
But hell, looka what'd happen if they free 'em. . . .
Other niggers 'd be askin' for their rights,
Showin' how we keep 'em on chain-gangs till they die,
Share-croppers goin' to planters for pay,
Askin' for unemployment insurance;
Might git together with the poor-whites
More'n they do—yah, we been breakin' up those meetings—
Askin' fer " probes an' enquiries,"
An', well, tryin' to stop all we do,
Because we gotta protec' our bosses ain't we?
Why, it'd upset the whole South.
Now the Ku Klux Klan
Weren't made fer nuthin' I suppose?
And if we don't get lynch *law* we have plain lynchin'.
We got ex-Senator Heflin
Knows how to talk:
" If Alabama courts can't
Stop nigger rapists white men can and will."
Whole case been goin' on too long,
Whole world protestin,'
Oughta had " the quickest way out," courts is too slow.
Reckon *we* can account fer about 80 niggers we killed this year,
Right here in Birmingham, Alabama—year ain't over yet:
Tisn't everyone knows that,
We got our records, from Jan. to Aug., 'bout 80 niggers.
An' we'd like to shoot every son of a bitch that comes down here
Talkin' " equal rights "—them white agitators
And niggers from the North.
Maybe we'll get to doin' it.
Only thing is
Looks to me they're gettin' more and more determined,
Those that calls themselves " comrades,"
Gettin' an' stickin' together,
Jes' won't do if it goes on. . . .
That is the Southern justice,
Not lynch-mobs, but part of the Law speaking.

CREDIC
Jean de Journette

Boy, it sho is funny
How you thinkin' all de time—
Wheh do it git you?
You think tell yo' fo' head
Is all wrinkles,
Frownin' like a ol' conjur 'oman's:
Thinkin' 'bout religion;
Thinkin' how de law ain't made fer you;
Thinkin' 'bout yo' self,

An' how yu gunna be more'n a ordinary nigger.
Boy, yu gotta be lucky if you thinks!
Yu gotta think in yo' style—
An' they's jus' one style
'Cordin' to de ones 'at make 'em.

Bes' don't do no thinkin'!
Jes' be smart enough
To make a little money
To sta't some credic;
Then git a month's rations,
Take it easy a spell.
When yo' credic ain't good no moh
Git a brand new name
An' use it somewheh else.

Yes, yu treat 'em dirty sometimes—
Hit de grit owin' 'em money;
But it's better'n mixin' in de cleanest way.
Best don't do no thinkin'!
'Cause, " A nigger's a nigger," they say,
Jes' de same if you beat 'em,
Jes' de same if you don't;
So g'wan git yo' credic an' beat 'em.
When yu go way they jes' say,
" That triflin' no count nigger!
Might a known he wa'n't no good—
It's de way wid 'em all,
Jes' de way they's made,
An' yu can't blame 'em much fer bein' niggers."

HITTIN' DE GRIT
Jean de Journette

I dream las' night
O' my childhood days:
Shirt tail draggin',
Breeches-leg down,
Climbin' them rails fer de brindle cow;
Tore my pants,
Scratch my hind,
Maumee say, " Boy,
You sho' is gittn triflin'.
Whut yu gunna do
When yu git to be a man?
Is yu gunna dabble
Wid de cotton in de spring,
An' den sta't loungin'
Lak Sam an' Ben,
Layin' on de sto' steps
Rain er shine? "
I say, " I don't know."
She say, " I know!
You better wake up, boy!
De time is comin'
When yu gunna make a better man
'An mah other triflin' young uns,
Else I'm gunna turn
An' make yu hit de grit
Foh yo' self alone."

I still say, Maumee's
A good ol' Maumee.
She kep' her word
'Cause I wouldn' wake up.

Now I'se woke,
Done hit de grit
For myself alone
An' I knows whut she knows.

MISS SAL'S MONOLOGUE

(To Mr. Bert Williams,[1] the Mastersinger of Vaudeville)

Alfred Kreymborg

Come, get up, Sal,
 peel off another,
 peel still another day
 off the calendar—
come, get along,
 peel them for noon-time—
 potatoes—
 peel them for night-time—
 potatoes—
 some folk like them for breakfast,
 peel some for breakfast—
 potatoes—
 slip your knife between their
 skin and flesh
 and mind, don't go slipping it
 between your own—
 potatoes.

If Mr. Columbus hadn't been what he was,
 had he been what you are, Sal,
 he'd never have felt the world round,
 he'd have felt it a
 potato—
 crooked and wrinkled,
 never the same shape twice,
 no shape at all,
 full of bumps and crevices,
 warts like mountain peaks—
 no place for a man in his senses
 to go crawling, exploring—
 he'd have seen it what it is, a
 potato,
 and another,
 and then another,
 and then still another—
 and he'd have stayed at home like you,
 peeling,
 peeling potatoes,
 a potato peeling potatoes.

Go, peel them off your back,
 off your arms,
 off your hips,
 off your legs,
 off your feet—
 clothes—
 clothes—
when you call me in the morning, Mr. Rooster,
 don't call me Sal any more,
 I don't know that name any more,
 I don't answer to it any more,
 somebody else whose name is Sal,
 let her answer to it, mine isn't Sal—
 if you've got to get me up again, you call out,
 Potato!
Go, peel them off the bed,
 quilt,
 counterpane,
 sheet,
 and get under and dream—
 yes, be fooled a little more—
 yes, I know you, Mr. Bed—
 you're a nice soft fellow to lie with—
 you and your spooky talk,
 telling me your yarns
 fit to turn a nigger white—

 about potato goblins
 coming and going on match-sticks for legs,
 they doing the cake-walk,
 me playing the tune—
 " Peel, Honey, I'm peeling off my heart for you,
 so peel away your heart for me, do!"

I told you, Mr. Rooster, never to call me again—
 told you my name is Potato—
 told you not to call out Sal any more—
 told you to get up someone else by that name—
come, get up, Potato—
 yes, that's me—
 peel open your eyes—
 yes, I'll peel—
 come, peel off another,
 still another today—
 Mr. Today, yes, I know—
 don't have to tell me about you,
 I know you, Man—
 and yesterday,
 and day before yesterday,
 and day before day before yesterday,
 and tomorrow,
 and day after tomorrow,
 and day after day after tomorrow—
 your whole family, Mr. Man,
 the whole of old Noah's ark of you
 todays—
and day after day after day after tomorrow,
 when I die—
 I know that too—
 laid out, a skinned potato in a tub—
 it being my today—
 I know they'll peel off some earth,
 and stick me under,
 and that'll be an end of peeling—
 I know that too—
 yes—
 no—no—
not if the wind use the rain,
 Mr. Wind use Mr. Rain
 for still another knife
 to come peeling some more!

Oh Mr. Lord—
 oh good Mr. Lord—
 peel open your eye—
 peel Mr. Cloud off Mr. Sun
 before Mr. Wind bring Mr. Rain
 to come peeling me from under
 the skin of Mr. Sod—
 oh dear Mr. Lord—
 if they do, Mr. Lord—
 if they've got to, Mr. Lord—
 if they've got to get me up,
 it being my today—
 and you've got to call me,
 me that's used to being called—
 don't call out, Sal,
 just call out, Potato—
 whisper Mr. Gabriel to whisper,
 Potato—
or I simply can't promise
 nobody,
 no-day,
 no-how—
 to peel the worms off my body,
 and the body off my soul!

[1] Bert Williams was a very famous and superb Negro comedian in America.

NIGHT OUT OF HARLEM

Norman MacLeod

(for Henry Crowder)

It is a dark country in which we live
Or there would be less need of electrification
Certifying the hour; it is black in our heart
And we are desperate with defense mechanism.
As we walk down Lenox Avenue
The pale brunettes are a warm dusk
In the streets of the city. Your large shoulders
Are bunched with easy power and your face
Is quick with no necessity for sadness.
In speakeasies over bars (and the glass
Curtailed reflection and bottles there

In a frame of grandeur) we lean
Like denizens of night
Over communication of impulsive hearts
And thoughts are tentatives of value.
By taxis to hotels and restaurants
Where wine and West Indian foods are served
We are tense with expectancy.
Can I ask you all that is in your travel
(Your courage there and distinction?)
You sing like a chorus of warriors
With black blood in your jaws.

THE SCORPION

William Plomer

Limpopo and Tugela churned
In flood for brown and angry miles
Melons, maize, domestic thatch,
The trunks of trees and crocodiles;

The swollen estuaries were thick
With flotsam, in the sun one saw
The corpse of a young Negro bruised
By rocks, and rolling on the shore,

Pushed by the waves of morning, rolled
Impersonally among shells,
With broken lips and bleeding eyes,
And round his neck were beads and bells.

That was the Africa we knew,
Where, wandering alone,
We saw, heraldic in the heat,
A scorpion on a stone.

THE BLACK CROW

Carl Rakosi

One must have sullen wits
to foot the jungle
like another darkness
because of heimweh
and an air spiced
with big fruit. Four
spooky winds tackle
one's knees like a swoon.
The bamboos shiver
and the tattooed bird caws
to the rose-chafer in the moon.
Now though one's black feet
straggle in the thrum
of oil palms, mumbo-jumbo
bangs a tom-tom.

The continent is waterbound
and one outside the singer
in the shack. And Sambo,
fat cigar in heaven,
chucks the white dice
gravely with a black crow.

ELEVATOR MEN

Florence Ungar

Up—down, up—down,
Up they go,
Down they come,
Up again
" First floor—
Anyone out ? "
Gloved hand shoots out
Wearily
For the hundredth time
That day,
Shoves the door to.
Whirr—whirr,
Up to the third,
In they pile
The motley crowd
Pushing
Jostling
Elbowing,
Gloved hand shoots out,
Presses lever,
Starts it going
Clear now up to the twelfth,
Down again
Stops at eighth
Fourth
Main
Down to the basement.
So the age-long day
They run the elevators
Skilfully
Without a hitch
Without a slip—
Tall brown men
Long and splendid-limbed
Made for running
Madly
In wild country,
Say—Africa!
Back to earth.
Stand up straight
In grim elevators
All day long
Tending levers, switches,
Pushing buttons,
Letting in
And letting out.

Strong brown bodies
Straitlaced
Into thick, blue uniforms
Stifling
Itching
Choking out
The running blood of them.
Faces squeezed
Of all expression
Like dry pulp.
Liquid eyes that strain
For sunlight
Lose themselves
In perpetual gloom.
Rich lips formed
For song
Frozen terror-stricken
Into silence.
Gleaming smiles
Come out all too seldom
When in off-times
They can widen out their mouths
And let them have their way.
Rippling bodies that would sway
Lazily in rhythm
Made to stand at stiff attention
All day long,
Opening, shutting elevators
A hundred times a day,
A thousand times a week,
God!
And then the months
And years!
Glorious age of machines
Indeed!
But is it?
When dark mass of humans
Run
Close-built coops of steel
That should run themselves
Mechanically
Like all else
In this splendid machinistic age!
Let those tall brown Negroes
Play!
Let them run and shout
And sing their crooning
Spirituals!
Let them dance
Joyously
Not
Desperately
Holding back the morrow
With feverish hands,
Eyes that gleam
And are pleasure-mad
And long, brown bodies
Running wet
With desire.
Terrible
For them the dawning—
Terrible to see
Their eyes go dead,
Their feet grow heavy as lead
As wearily they drag along
To serve another day of their life-term
In the murky prison-walls of elevators.

SONG OF THE WASHBOARD
Ildefonso Pereda Valdes
(A rendering from the Spanish)

Voice of the waters, river song
Above this row of clothes we hang;
Our chorused hands are beating free
In spume of soap frothed like a sea—
The Negresses sing ' Everyday.' [1]

Day after day, every day
Washing these clothes on ground we lay;
The wind is kind, knows how to dry,
And yet we know how come we cry,
Day after day, every day.

Oh! ancient river, river slow,
Along the singing current go
Our spume and soap within thy keep;
Us niggers sing so's not to weep,
Day after day, every day.

Oh dog of a life, oh nigger's life . . .
Plantation memory sharp as knife;
But drunken nigger gets to sing,
Gets gay, so long can get him gin!
Day after day, every day.

See the old Negress scrubbing white
These clothes, and never paid aright.
Her drunken husband beats her, chás!
Chás! chás!—the blows come thick, alas . . .
Day after day, every day.

[1] ' Everyday,' the refrain of an American Negro song sung by the washer-women.

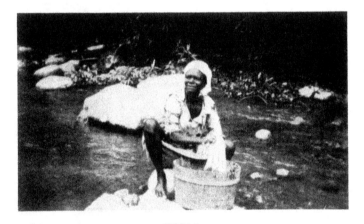

POEM
Louis Zukofsky

How many
Times round
Deck, ladies?
What says
The black man?
" Fi' minutes
After a
Man's breath
Leaves
His body
He knows
Much 'bout

Hisself's
Ten years
Before 'e
Was born—"
What you
Say to
That, ladies?
The Statue
Of Liberty's
Drunk?
French!

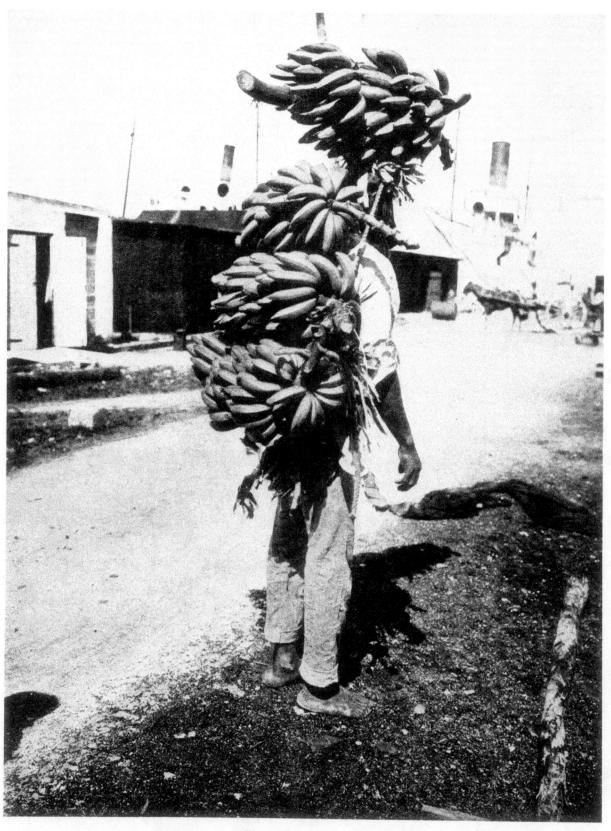

Banana Carrier

A weight of four full bunches on the head and back, paid about 2/10 a day for loading the ships, 10 to 12 hours' work.
In England the same work is paid 11/2 and done by the aid of machinery
Jamaica

270

WEST INDIES
AND
SOUTH AMERICA

Jamaica—The Negro Island

by NANCY CUNARD

I⸺T was in 1494 that Columbus first saw the lofty outline of a new land and set foot on it in the name of Spain. The native fisherman with him said they called it " Xaymaca " in their language, a word signifying " a land of springs." " The well-wooded and well-watered," added Columbus, describing it on his return to the Spanish court as he crumpled up a sheet of paper in comparison of its mountainous, tumbled surface.

As in other countries of the Western Hemisphere the Spaniards were unable to force the natives, the Indians as they called them, to work; this new concept of life, enslaved suddenly to the brutal white interlopers, making the Indians prefer death. White colonists were insufficient; the tropical climate opposed and frustrated their efforts. But the land was obviously rich and full of promise. The importation of the " ebony cargo " began.

In the time of Cromwell the English also discovered the wealth and advantages that would accrue from their possession of the island, and after numerous struggles with the Spaniards became virtually masters of it, although it was not until 1671 that by treaty Spain finally renounced all her claims. In 1656 the Spaniards, retreating before English attack, had liberated many of their Negro slaves. Sedgewicke, the English governor of that time, is eloquent on the absolute need of destroying them all or of coming to terms with them at once if the colony were to continue. More especially in the wild northern parts were these freed slaves unvanquishable. The *Maroons* (named thus from *cimarron* in Spanish, fierce, wild) were constantly reinforced by runaways from the plantations. They lived in the forests and rocky fastnesses as free as in Africa. The climate was their friend. When raids were sent against them no white man ever came back. The Maroons knew every detail of the impenetrable mountainous region where they had established themselves, from which they came forth to harry, plunder and defeat any invading whites. The whole history of Jamaica is bound up with the heroic stand made by them against the colonisers' attempts to bring them into slavery; they have been conquered by treachery alone, by perfidy, and finally by the white man's breaking of his own treaties. In Dutch Guiana, the only place in the world where this is still so, the white man pays a yearly tribute in money to the black and observes his compact made with the *Djukas*, who are the descendants of the fierce escaped slaves of the 16th and 17th centuries. The Djukas in the tropical forests of Guiana were of the same spirit and valour as the Maroons and have fared better than these.

Jamaica was in need of colonists. The mortality amongst English labourers was high, and small increases of souls, such as the 1,600 men, women, children and Negro slaves that arrived from the small island of Nevis in 1656, could not suffice. Permission to import Africans was granted by Cromwell. The Jamaican governor thought it useful to point out to Cromwell " that as their masters would have to pay for them they would feel a greater interest in the preservation of their lives than in that of mere labourers, and therefore be more careful only to work them with moderation." (Gardner's *History of Jamaica.*) This did not preclude the influx of white bond-servants. The colony now began to prosper. Tobacco, sugar-cane and flocks gladdened the hearts of the white masters; the fertile soil and its exploitation to Negroes and white bond-servants insured an augmentation of toil.

The Spaniards now attempted but failed to recapture the island. One of their slaves, St. Juan de Bolas, whose name lives yet as a hero, and various Spanish and Negro guerilla bands continued to harry the north, and when Charles II became king it was thought by many that Jamaica would be returned to Spain; but English domination had been well established; the king had no intention of giving back the island. From the sea buccaneers were bringing in rich prizes;

This is near the Maroon country, in St. James' Parish, not far from Accompong, and Accompong is a name from Ashantiland in Africa

272

Jamaica—The Negro Island

it was seen that the land would flourish. Only, there were the Maroons. No new plantations could be started anywhere near them, it was considered folly. They were in most of the interior of the island and killed any white who tried to settle there. Conciliation was suggested ; an offer was made to them of something which they had already in superabundance: land ! 20 acres and freedom was promised to each one who would *surrender*. Needless to say the Maroons refused this empty and treacherous offer.

It was during Modyford's administration that the slave trade became one of the chief issues in Jamaican life. More and more slaves were now needed to tend the newly-planted cocoa groves, the increasing number of sugar-cane plantations. In 1673 there were 9,504 slaves. Cargoes coming from Africa had consisted heretofore mainly of young people, but now were added to these many warriors who had been taken in battle, whose spirit was harder to crush. An uprising of some 300 to 400 slaves in 1690 terrified the white masters ; they had set fire to the canefields and killed some of the planters ; after the soldiery had defeated them many of the survivors fled to the ever-welcoming Maroons.

The Declaration of Rights in William and Mary's reign had sanctioned slave-trading by private companies, who, of course, vied with each other in hot competition. As sugar cultivation increased so did the number of Negroes imported. At one time a surfeit of these turned Jamaica into a depot from which slaves were sold out to other islands and to America. Rebellious ones were added to this number and shipped off mainly to Spanish colonies. And by no means at this time were Negroes the only slaves. This is how it operated for the white man. By all sorts of promises young men and boys from England were induced to come for a number of years as indentured labour ; others arrived who had been deported for vagrancy, for political offenses. Of the first, Esquimelling in his *History of the Buccaneers of America,* 1695, and himself at one time bond-servant to a French master, wrote :

> Having once allured and conveyed them into the islands they were forced to work like horses, the toil they impose upon them being much harder than what they usually enjoin upon the Negroes, their slaves. For these they endeavour in some measure to preserve, as being their perpetual bondmen; but as for their white servants they care not whether they live or die, seeing they are to continue no longer than 3 years in their service.

If for the white it was an intensity of suffering, for the black it was an eternity of anguish lasting as long as life itself.

Sloane, says Gardner, is the only writer who has fully described slave life on the estates. Sir Hans Sloane, founder of the British Museum, published his big work on Jamaica in 1725. Of the punishments inflicted by overseers he says, " For negligence, whipping with lancewood switches till they be bloody and several of the switches broken." After the whippings " some put on their skins pepper and salt to make them smart ; at other times their masters will drop melted wax on their skins." For running away " iron rings of great weight on their ankles, or pot-hooks about their necks . . . or a spur in their mouth." Rebellion meant death by burning ; half the foot might be cut off for attempting to escape. Branding and mutilating were tempered only by the fear that the Spaniards would refuse to buy the exported slaves marked in such manner indicative of their spirit. In the 1792 *Abstract of the Evidence presented to the British Parliament* by the abolitionists is the case of the pregnant woman who was made to lay her belly in a specially dug hole in the ground so that she might be whipped without danger of killing the child. Another witness speaks of the girl he saw hung by her wrists to a tree over a fire and set swinging so that the master had the added pleasure of cutting her flanks with a switch each time she came within his range. . . .

As on the " Middle Passage," the name given to the agonising voyage from Africa to the New World, death had less terrors than slavery. There were many who killed themselves. Death was a return to their own land. More particularly the natives of Angola thought this. And the African belief that the *duppy*, or spirit, must be cared for until its departure for Africa was carried on in Jamaica. Food and rum were placed on the graves, amid lamentations, for several days.

" From Can to Can "

The routine on the plantations was to start work at daybreak and end only with darkness. " From Can to Can " this was called—" from can see light to can see dark." A blast on a conch shell or a bell woke the slaves. In the busiest seasons they would begin work an hour or two before dawn and sometimes labour on by the moon of the following night. They were worked in three gangs in the fields. The first or strongest lot cleared the land, dug and planted cane holes, cut cane, tended the mill house. The second

273

lot, boys and pregnant women, weeded and did lighter jobs. The children weeded the gardens, collected food for the pigs, carried the smaller bundles and loads, and were always under the direction of an old woman with a switch. Infants were strapped on their mothers' backs as they bowed over the field. (Sloane even went so far as to attribute the flatness of the Negro's nose to this.) At midday one hour was given for eating. Those considered the more intelligent were trained as smiths, carpenters, masons. Parents were anxious for their children to get away from the rough field work where they might receive a slightly better treatment. The house-servants, often mulattoes, were better off. In all cases it was always on plantations from which the master was absent and the slaves under the sole control of the overseer that conditions were the worst. Considered purely as beasts of burden, worked as such and with more cruelty, all and any form of punishment was sanctioned. The slaves could also be seized for the master's debts; this was the outcome of a law made by George II to facilitate the collecting of debts in the colonies. There were more male than female slaves and they lived in a state of polygamy; the women who were the hardest worked had the least children. Slaves that suffered from ulcers or sore legs were quickly put into stocks so that they might not delay healing by moving about. Yaws and smallpox were prevalent. Some of the Negroes, as occurs in certain parts of Africa, would eat earth; whether this was a disease or a cure for one is not quite clear, but they were punished when found so doing, for this practice had sometimes led to the death of large numbers. Gardner adds that " dissatisfaction or the fear of Obeah seems to have induced it in many cases."

Mary
from Balaclava, near Accompong, Maroon
country

The habitations were run up round a few posts in the ground, the space between filled in with wattle and mud and thatched above with palm or banana leaves. The floor was of beaten earth. A rough mat and some calabashes were the sole furniture and utensils. They cooked out of doors in a rude shed. And only on Sundays and half of Saturdays could they work for themselves. It was obligatory too, for they must raise all the food they required in the small grounds allotted them some way from the plantations. The only holidays in the year were Christmas and Easter, spent by them mainly in dancing. In speaking of these dances as "licentious" it is clear that Gardner is describing the African rhythms and gestures transplanted along with the traditional drums made anew in Jamaica. One of these drums caused the masters such uneasiness that it was long prohibited—a war drum.

Now given as explanation for the maintained power and independence of the Maroons was the increase, always welcomed by them, of slaves escaped from the plantations of absentee landlords. All the records agree that overseers were more brutal than most masters and many were killed in the slave-risings that added to the number of the Maroons. Mosquito Indians were now imported to hunt them, barracks erected in the mountains. The Journals of Assembly of the early 18th century are filled with plans to capture and subdue for ever this relatively small number of 500 or so free black men who kept the interior in perpetual alarm. At this time there were 80,000 Negroes on the island. Of the 8,000 whites only some 1,000 are described as " really reliable people," or masters. The greater part of the rest were indentured servants who had no desire to fight those who had escaped from slavery. " The black shot " was next devised against them—Negroes impressed into military service. The Maroon leaders were again promised their freedom if they would pledge themselves and their followers to recapture and deliver up escaped slaves; moreover their settlements were recognised as such by the whites. But had they not their freedom and as much land as they needed already?

Records of that time speak much of the " fierce and war-like Coromantyns," who were, however, appreciated for their superior strength. Some slaves were from Madagascar, less valuable because not so strong and " choice about their food." Best the colonists liked those born on the island; they were more tractable. Those with slight admixture of white blood were often employed as domestic servants or assistants to tradesmen. Hardly more than 40 years after British conquest Sloane noted the great

variety of colouring amongst the Negroes—mulattoes, quadroons and mustees (the last being the offspring of white and quadroon). The number of slaves imported varied from year to year ; moreover many were exported to other colonies. An estimate for 1732 gives the figure as 13,000 ; in 1767 only a quarter of that number. In 1775 the total of Negroes in the colony was 200,000, and 12,737 whites. The colonists now began to protest against the influx, but from England Lord Dartmouth, president of the Board of Trade, Bristol and Liverpool, slave-ports, declared they could not " allow the colonies to check or discourage in any degree a traffic so beneficial to the nation." A conflicting sentiment in that very year, from Kingston, Jamaica's capital, voiced by several slave-holders, declared that the trade was " neither consistent with sound policy, the laws of nature nor morality." That was a Jamaican opinion on the *trade*, lightly veiling to those easily taken in the economic fear of a surplus of the black beasts of burden. When it came to the abolition of slavery itself, to the freeing of all those already in captivity, the Jamaican masters were as frantically opposed as may be imagined.

The reason is clear. Sir John Costello of Kingston was a veritable merchant prince in this traffic. Another planter sent home £50,000 in 1771 from the slaves he had sold. A good sugar estate was valued at some £30,000 to £40,000, rum and slaves counted in. One of the large properties, that of the father of William Beckford the writer, comprised 22 plantations and a number of slaves varying between 3,500 and 4,000. Apart from the value of each he estimated his yearly profits at about £10 per head on every one of them.

The Coromantyns were from the Gold Coast, composed of the Akim, the Ashantee and the Fanti peoples, and the whites seem to have been divided between the appreciation of their strength and activity and the apprehension of their fierceness, for in every rebellion would be found Coromantyns as leaders. An attempt to stop their importation failed. Other slaves were Eboes from the Bight of Benin, Mandingoes from the north coast of Sierra Leone ; some of these latter being Mahommedans could read and write ; the Papaws from Whiddah, " remarkable for their docility " ; others from the Congo and Angola. In the course of time these tribes mingled and their different characteristics were lost. Always, encouraged to it by the old-established British policy of " divide to rule," the mulattoes considered themselves better than the pure blacks ; likewise were they sustained in this by the better treatment they received ; they would refer to the Africans as " Guinea birds " and " salt water Nagurs."

If the white masters could break their bodies and spirits they could not obliterate the only things the slaves had been able to bring with them from Africa—their customs, language and love of music. Certain African customs persisted for centuries, would in fact be kept alive by the constant new arrivals from Africa. It was thus that the powers of Obeah (*fetish*) were seen to be most active and widespread soon after the coming of new African slaves. Around Christmas the Negroes would be seen wearing masks, boars' tusks and cows' horns ; a sort of carnival would take place at which John Connu, a noted figure on the Guinea Coast, whose meaning is now a mystery, would be invoked by the brightly costumed crowds. The great being in the Coromantyn belief—and it was Coromantyn influence which came to dominate the Negroes of other origins—was Accompong, god and maker of humanity. Obboney was the symbol of evil, Ipboa, the sea-god, to Assaici were offered all first-fruits. Fetish, or Obeah, until the priests and missionaries were allowed to christianise them, was their law, and the Obeah man was supreme.

A few kindly white figures emerge from the hideous record of slavery. William Beckford, who had inherited his father's vast plantations, was much concerned with the lot of his slaves on his visit to the island (for unluckily for them he was one of the absentee landlords), and tells somewhat naively of how when he had given them many small privileges and in general ameliorated their condition that they were always coming to him asking for more, that he could not understand what were their demands. . . . Through the activities of Jamaica's famous historian in the 18th century, Bryan Edwards, the custom

They begin " this picturesque custom " at the age of 3 or 4. More exactly they begin to work for the white imperialists as soon as they can stand up. Near Frankfield, Clarendon Parish

of not separating families who were on the same ship coming from Africa, and who would be sold on arrival, became law. At that time the slaves were allowed none of the white customs, marriage, religion, instruction. The testimony of any number of slaves was not accepted against a white man, though one slave alone could bring about the conviction of any number of blacks. The union of a couple was marked by some ceremony of their own making. As symbol of separation the *cotta*, or pad on which to this day Negroes carry immense loads on their heads, would be cut in two, each one keeping half.

In 1765 the Coromantyns took the fetish oath and met in council for rebellion. As with other revolts this was also put down with excessive brutality. If the Africans drank the blood of their vanquished enemies, as happened to the horror of the whites, this was done in exact following of African ritual which holds that the qualities of a dead warrior may thus be added to the valour of his conqueror, and not through any sort of cannibalistic or vague or empty ferocity. But, as in a previous rising when some 60 whites had been killed, the prisoners taken had been burned alive, hung up in iron frames for 9 or 10 days till they died from starvation. Often the heads of insurgents would be stuck on poles on the Kingston Parade. In that particular rebellion the colony had lost £100,000 in damaged property, and in the costs of its suppression. But instead of bettering the conditions of the slaves and thereby removing the main cause of revolt all laws were tightened up, and the black traitors who had informed against the insurgents were emancipated and pensioned. The history of so many of the risings is bitterly the same. The Negroes could not get together sufficiently, they were too quick to assume thay had the victory after a first success, they were betrayed by other slaves who from fear or other causes remained faithful to the masters, and lastly the white man had at times been able to induce the Maroons to take sides against them.

By the middle of the 18th century there were a number of free persons of colour and of pure blacks who had been manumitted. Of these certain favoured ones were sent to England to be educated, generally the illegitimate children of planters. A pure Negro, Francis Williams, protégé of the Duke of Montagu, returned from Cambridge as a man of letters and opened a school in Spanish Town. His patron hoped for a seat in the council for him, where his talents might best be displayed, but the governor opposed this, saying that slaves would refuse to obey any longer if one of their race were thus exalted. Williams owned slaves himself, as might all free persons irrespective of race, and is described as being of the utmost severity with them, and as one more anxious to stand in well with the white ruling class than to take up the burdens of his own people. Other free people were the Maroons, by reason only of their unfailing and never relinquished resistance to all attempts at subjugation or useless treaties ; they remained aloof and a menace, untouched by the white civilisation of succeeding decades.

Free-born and manumitted had different rights. The free-born were tried as white people, the ex-slaves were still judged as slaves, had neither civil nor political rights. When in 1763 an enquiry into the amount of property left to coloured beneficiaries showed this to be very considerable a law was quickly passed rendering void any amount exceeding £1,200 left by a white to a black or mulatto. Towards the end of the 18th century the missionaries, particularly the Moravian Brethren, were allowed to approach the slaves, it now being judged that they were " advanced enough " to be christianised and in some sort educated. The missionaries found that some of the Mandingoes, being Mahommedan, already prayed in Arabic ; the rest had no religion, nor had any time ever been given for it. In some cases it is true that the priests tried to better the slaves' lot but came up against either ferocious opposition or utter heedlessness from the overseers. Later, certain missionaries were even accused of urging slaves to revolt. Until abolition the owners' interests in getting as much work out of their slaves as possible, maintaining that neither religion nor instruction was necessary, proved strong barriers against the proselytising attempts of christianity. Also when the clergy were given full rein it was a good number of years before the cult and belief of Obeah were set aside. Obeah remained firm in many baptised Negroes, certain characteristics being amalgamated or brought into the christian faith. In present times there are still Obeah drums in the remoter hills. The Rev. Bedward (dead not long ago) was quite obviously the direct descendant, at least spiritually, of the Obeah man and had an immense following much decried by the orthodox church. The great belief had been that buckra (white man) cannot kill Obeah man. But this too came to fail.

ANTI-SLAVERY STRUGGLE

The legality of the right to own slaves had first come up in England in William and Mary's reign, when Justice Holt had decided that once a Negro arrived in England he was free, for " one may be a villeyn in England but not a slave." Yet this decision had been discounted entirely. Some 40 years later the question was revived and other justices pronounced now for, now against it. The public showed

no interest. The ports and London, due to constant new arrivals from Africa, often contained as many slaves as did the lesser West Indian islands. Advertisements such as this were frequent in English papers : " By sale, a chestnut gelding and a well-made, good tempered black boy."

In 1765 Granville Sharp started his campaign against slavery. He had befriended an ill-treated slave called Strong who had escaped but who had been found after two years and reclaimed by his former master and sold to a Jamaican for £30. Granville Sharp took the matter to court. For preventing Strong from being carried onto the ship he was sued by the original owner, but the case was dropped. Other such incidents arose. In 1772 the matter of whether or no slavery was legal in England was settled. The words that record this are, " as soon as any slave sets foot on English ground he becomes free." Motions for abolition were now put forward in Parliament, America sent petitions, the public interest became aroused. One scandalous case of brutality brought out the full horrors of the slave trade. In 1781 the *Zong* had left Africa with a cargo of 440 slaves for Jamaica. 60 had died on the way, many more were so sick they might not recover. The captain argued that the losses incurred by these deaths on board would fall on the owners, but that the underwriters would have to pay if they were cast into the sea. He argued that lack of water and the extremes they were in would be reason enough for putting them out of their misery. Despite sufficient provision of water and the fact that Jamaica had already been sighted (the captain later affirming he had thought it was Hayti), 54 of the slaves were thrown overboard at first, then 42 more, then 26 when Jamaica was but 3 or 4 miles off. From despair 10 others leapt in of their own accord ; thus 132 of the slave cargo were drowned. Probably the Jamaicans thought little enough of this, as some 5 per cent. of the Negroes usually died between landing and distribution in the island. After a trial to settle the dispute between owners and underwriters, the owners claiming £30 for each dead slave, the verdict was given to the latter. Granville Sharp was for bringing forward a prosecution for murder ; he was told this was madness ; " the blacks were property."

This event did much to create public indignation and was followed by a book full of revelations on the slave traffic and the treatment of slaves in the colonies by one Ramsay, for some time a resident in the West Indian island of St. Kitts, who had observed his facts at close hand. Clarkson's *Essay on the Slavery of the Human Species*, prior to his *History of the Slave Trade*, appeared ; the Society for the Abolition of the Slave Trade was formed in 1787. Pitt, himself expressing no definite opinion for or against, instituted a parliamentary enquiry into the traffic. Slight ameliorations, such as less overcrowding of the slave ships, the minute and hesitant moves that were to culminate finally in abolition, were now made.

But the opposition from the colonists and many of those who had Jamaican or other colonial interest was extreme ; the slaves represented some £50 apiece ; there were 450,000 in the West Indies. Wilberforce, seconded by Fox and Pitt, brought in a bill against further importations, but this was thrown out. William IV, then Duke of Clarence, was a strong upholder of the trade ; he had been in Jamaica and his opinion carried much weight. The French revolution and its effect on the Haytian self-liberation of the slaves greatly alarmed colonial slave-owners and at the same time found echo in the feeling of 300,000 people in England who refused to buy slave-grown sugar and sent in one year 517 petitions for abolition to Parliament.

The movement was successful in 1808, when the last act of Fox and Grenville's ministry was to obtain the king's consent to the outlawing of the slave trade, no vessels being allowed henceforth to fetch slaves, or to land any in the English colonies.

During the agitation in England a few reforms had been passed in Jamaica. It was forbidden to flog, to mutilate ; but as still a Negro's word could not be taken against a white man the flogging and mutilating could, and did, continue.

The Exiling of the Maroons

In 1795 came the breaking up of the Maroons as a free and separate people. They had complained that a well-liked white overseer had been taken from them, that two of their number had been flogged amidst the jeering of the slaves, that their lands were worn out and that no notice had been taken of their demand for new ones. Balcarres, then governor, took this as the occasion to pen them up in an unproductive district where they could live only by robbery and plunder. Wild tales were circulated that they intended to follow the example of Hayti, that they were about to rouse all the slaves. But the Maroons were tractable and had formulated their demands clearly. Balcarres however seized 6 of their leaders he had sent for and who were coming to him and put them in chains. Grandiloquent proclamations were issued and a large number of troops sent for ; the Maroons were told they and their people were surrounded, that they must surrender unconditionally under pain of death and were given 4 days to do so. The older

ones were for surrender; the younger protested that from all time they had been a free people by treaty made with the whites. The old chief, Montague, went down to the English with about 40 men and the same number of women and children. Their reception was watched by the others from heights over the British camp. As soon as they arrived Balcarres had them put in chains and taken to prison. This decided the rest to resist to the utmost. And now some 5,000 soldiers were sent against 300 Maroons, who defied and harassed them for many months. The forests were even more impenetrable owing to the heavy rains; they roamed the wild lands, leading the soldiers into ambuscades in the desolate cockpits full of chasms and precipices that they alone knew. Chasseurs with bloodhounds trained to hunt fugitives in Cuba were imported; the alarm of the whites increased, for by now the canefields were dry again and might be burnt wholesale; the French on the island were expelled from fear that they would encourage and aid the Maroons in their revolt to follow the example of the Haytian Negroes; the dread of the rousing of all the slaves was increased. Fearing no man, news of the bloodhounds, however, was a consternation to them. Walpole, the English general, had himself encountered their ferocity, they had nearly pulled him from his horse; he was ready to treat with the Maroons. The terms they themselves proposed were to kneel and ask pardon of his majesty, to agree to go to Old Town or such place as should be appointed them with new lands, and to deliver all runaways. In exchange Walpole gave them his oath that they should not be deported. But Balcarres intervening demanded immediate surrender, giving them no time to inform their people of the terms. As the liberated Maroons went back to the hills to convey their message they were fired on by white troops despite the pass which Walpole had given them and which was being held high in a cleft stick. The hostilities therefore started anew. The treachery of the English had once again proved itself, and they were more loath than ever to surrender their liberty. By persuasion, by diplomacy, by more promises but never by fighting were the Maroons finally vanquished, when Walpole at length succeeded in getting them once again into his camp. And now the governor Balcarres reversed Walpole's solemn promise and made it known to them that they would be deported from Jamaica. Walpole protested in vain. Later he went to England and in parliament showed how basely the Maroons had been treated. Yet there is here too an astounding revelation of the truth of this man's seeming partisanry. His concern was that his word had been set at nought by Balcarres, and, said he, he had " suggested that the Maroons should be settled near Spanish Town, or some other large town in the lowlands, where they would have access to spirits, the use of which would decrease their numbers, and destroy the hardy constitution gained in the mountains." (Gardner.) This general likewise stated that had it not been for the " treaty " they could never have been conquered, their surrender alone had saved the island.

In this way a whole tribe was deported; known as the Trelawney Maroons they were sent to Nova Scotia in 1796. Balcarres was highly honoured and rewarded for his subjugation of this free people by treachery in a war which had cost a mere £372,000!

By the efforts of Granville Sharp, and along with some slaves whom he had succeeded in getting freed and with some of the black soldiers who had fought in the American War of Independence and who at that time were in Nova Scotia, these unhappy people were not long after sent to the colony for the repatriated black slaves which had been founded in Sierra Leone.

EMANCIPATION

In 1808, at the time of the cessation of the slave trade, there were 323,827 Negroes in Jamaica, bond and free, and over a million had been imported into the island since its colonisation by the English in 1656. In 1822 there was much excitement on account of many proposals to abolish slavery itself. This had already been suspected and opposed by planters and slave-holders. Wilberforce had maintained that emancipation must follow. Fowell Buxton had moved certain resolutions in parliament. They were only gradual " reforms." Nor himself nor Canning would ask for immediate and total abolition. They held that the slaves would not be " prepared " for this, civil rights and privileges should be granted slowly. They proposed that only children born after a certain date to be agreed on should be free, that women should be exempt of corporal punishment. The Jamaican House of Assembly and the entire master class were incensed: what pledges would be given them in compensation of the losses they would incur from the freeing of the slaves? An address was sent to the king stating that it was false that the slaves were ill-treated or discontented with their lot, protesting against this interference in their affairs and going so far as to say that if England would buy their land for the philanthropic experiment it proposed they would then themselves leave the island.

The slaves had heard these rumours of approaching freedom and in 1831 rose again in rebellion as

their condition had not been improved. The immediate reply to this was that no date had been set for abolition; the slaves were likewise thought to have decided not to work any longer after Jan. 1, 1832, without their freedom. Excitement in the island was extreme. The insurgents burned and destroyed much property, the whites fled before them. Death and merciless floggings came as retribution. And the planters proclaimed that it was not in the power of the king to make any slaves free. But the English held that the slaves were the king's property and must therefore be under his control. In 1833 further measures were proposed. That a £15,000,000 loan should be offered the planters in compensation; that children born after the Act became law and those then under 6 years old should be free; that older ones should work for their former masters as apprentices for 12 years in the fields, for 7 if employed in the house. The outcome was a gift of £20,000,000 to the West Indian colonies, of which over 6 million went to Jamaica, and on August 1, 1834, emancipation was finally proclaimed. Yet as this was a gradual abolition that immediately concerned the children only, as seen, and a promise of four years to wait for the grown slaves, it was acclaimed without any outburst or demonstration; the black people had yet to wait these four years to become " full free."

Emancipation meant anything but security to the slaves. The masters could turn them off their estates if they considered them in any sense " unruly." This term of course covered all legitimate demands on their part, such as proper wages. No scale of wages whatever had been fixed. A shilling a day seemed to be the general idea; out of this house and ground rent had to be paid. And the small proprietors in particular had threatened to evict the black labourers in the hope of getting them to work for even less. Rent was now charged by the planters on each member of the ex-slaves' family. The extent to which this abuse was practised is seen by this one example on a certain property where the total asked of the black dependants amounted to £1,300 a year ! a sum that the property itself had scarcely ever been known to yield under slavery. Work could be exacted from each member of the family. The ex-slaves were not granted leases, rents could be raised by the proprietors on any pretext. To be really free the black people must go out and buy land on which to build their own villages. And what, in almost every case, were they to buy it with? So came freedom in Jamaica without any equality; economic and labour tyranny merely replaced corporal slavery.

In 1844 the census put the number of whites on the island at 15,776, coloured at 68,529, black at 293,128—a total of 377,433, or 361,657 black and coloured to 15,776 white. What is the comment on these and preceding figures? That the island was, and had been practically since importation of Africans began, increasingly a country of Negro and mulatto people. Black and coloured labour had built it up; but those of the white minority remained the same hard and grasping exploiters they had ever been. In one parish, in St. Thomas in the East, in 1861, we find 282 white and 23,230 black ! Four years later in that same parish a rising took place under the leadership of the mulatto Gordon and the Negro Bogle, who told the black people they must fight for their rights. The English, as before, crushed this revolt against over-taxation, underpayment, starvation and denial of political and judicial rights, with excessive cruelty. Of the 608 deaths which occurred it has now been shown by Lord Olivier in his latest book, *The Myth of Governor Eyre*, that 21 white and coloured men and 7 rioters were killed in the 30-hour disturbances. The rest were black men and women put to death subsequently, as reprisals, Gordon, after an illegal trial, himself being hung. There were also some 600 floggings, to say nothing of the 1,000 houses that were burnt. This attempt to obtain at least some of their rights was put down to the black peasantry as "the great rebellion." Lord Olivier has shown this to be, as known also at the time, a local revolt which was repressed with utmost brutality by the Negro-hating governor, Eyre.

Railway Lane, Spanish Town, Permanent Dwelling

The increase in population, and in proportion, of black and coloured to white after 1844 is shown in 1871 as : total population, 506,154—13,101 white, 493,053 black and coloured. *A proportion of 38 Negro and mulatto to 1 white.* From then until now the

same increase of black and coloured inhabitants to the extremely small number of whites has continued.

And the Jamaica of today? Evidently and most essentially a land of black people. It is ridiculous and bound to strike any traveller there overpoweringly that this island should be anything but a black man's territory. Africa is peopled by Negroes. So is Jamaica. As clearly and categorically as that. Of Kingston, the capital, I cannot say otherwise than that I found it a very ugly town, contrived by that singular British spirit which is quite desperately without any concept of even the existence of plan, architecture or form. Yes, totally in keeping with the administrative and official atmosphere, which in other words signifies no geographic or human atmosphere of any kind. Spanish Town is different; the latins made it, and though frequent earthquakes have shaken half of it down the sort of warm yellow sunset colouring on the lovely 18th century buildings gives an idea of what the white man's past must have looked like.

Of the black man's past . . . observe his present. Those wattled huts the slaves lived in, doing their cooking in still rougher shanties, or outside . . . all this is swept away? Indeed no. In the north, at least in such parts as I saw, the description of the 17th and 18th century writers is exactly appropriate still. I went through the island in the hot July days. There are few inns for the tourist save along the sea-coast. In Mandeville, a large country town inland, there are one or two " white " hotels, and banks. The feeling of the rather tentative " luxuries " you visualise the white man in general, the British in particular, hasarding in lands wrested from the natives. But no white people visible. Not one. It was market day, a sea of black people, a most vivacious crowd. What are they selling? The fruits of the earth; akees, yams, plantains and various delicious exotic half-fruits, half-nuts. Twists of rough tobacco. And those superb " Jamaica cloths," at 1s. 6d. a square yard, which are made at Manchester in England. All the women wear them turbaned about their heads. You begin to wonder what these blue, red and yellow striped squares cost to produce in Manchester, begin to suspect the profit made out of these rough cottons, but of course you will never see one in England; they are reserved for export to the West Indian colonies. They are not just kerchiefs, they have the standing of a dress, 1s. 6d. being a sum to the black worker. I looked for the indigenous goods that black Jamaicans might, in their turn, make a profit on in white markets. Sugar? No, she would not sell me less than that keg for 1d.; you could hardly carry 1d.'s worth of the rich brown melting cane sugar that has to be searched for as a delicacy in England. 5 or 6 bananas cost 1d.; we know what we pay for them here. Who gets the profits on that? Never the Jamaican peasant grower! Fruits and plantations are largely in the name of the United Fruit Co. The posters of the United Fruit Co. are enthroned throughout Jamaica; they sit on the eminent hills, and facing them on other feathery luxuriant heights are other inventions of white civilisation: tin or brick chapels. These and fine, not much travelled motor roads are the modernities of Jamaica inland. And in the valleys and gorges of Crooked River down comes the daily cloudburst in that season as the old washerwoman slams hurriedly together the dispersed items she has been trying to get clean " in all dese stones." Along the road there would suddenly be an expanse of English park land, not a palm or banana tree in sight. And then the rain made it all go black and dark green, as if one were looking up from under deep water at the low knotted hills of the old Maroon country. It is not possible to describe the rapid changes of this beautiful land; only a film will be able to give any sense of it. Black River, banana, plantain and palm fronds fiercely tossing in the rain, deserted roads on completely empty mountains, and then the region where the huts are so frail you wonder if people can live in these. They do. They live life out in them, things a man would run up in a day or two, with the smoke coming out through the old pressed-down palm thatch at one corner. Maroon Town, St. James— it was some trouble to find it, for several of the roads that seemed to go there ended after a time in a flank of forest. There were cows' horns on one or two of the houses in that place, perhaps as Obeah signs still, and the sense of the utter remoteness of a barely inhabited region, whose people though pay homage to christian Sunday with tightly clasped bibles, very much " dressed up " and with black buttoned shoes. The " progress " lies in the shoes; the wistful longing for shoes you meet with is a class distinction, to possess them constitutes a " rise " in the black labouring class. After Maroon Town there were no more huts even; the forests closed in the steep roads with immense trailing and dripping lianas.

Montego Bay is a sharp contrast. You come down on to a flat sand-stretch. A white man's resort, a bathing beach and accessory hotels, at 25s. a day. But there were no white men. Again, that night, there was the dense, moving, vivacious black crowd, round a preacher in the open square. The whites have planted christianity in Jamaica in such a way that it is as much *there* as the native vegetation. In Kingston the raucous crashing of the Salvation Army is as inescapable as it is insufferable. Imagine a

landscape of gravel, of glaring and flower-beds round an im-humanity-scarred tree, with a good Queen in whitest marble wedding cake—that is the centre A vast number of tropical plants, sible to portray otherwise than into a special garden nearby. For working on it the descendant 2s. a day. And it comes to about carries those full banana bunches must have between 150 and " we bruise them " (destroy worker who was coming down Day in Frankfield.

The English want this colony years before the banana agent, was able to get permission to miles from its previous terminus the bi-weekly consignments. He One day an official came from leading citizen of the place. My Negro. The Englishman, said finding a Negro with education tion with detail and authority— to have our railway. Is the really as simple as all that? ignorance is fully made up in

To one coming direct from a coloured people are, govern- " niggers," Jamaica may at first dementia. The colour question the English. It has the atmo- British. Authority respected— sively so. But soon enough you mum of really black people " in the shops, all kinds of trading middle-class independent life. the land, an agricultural peasan- maids of the inn at which I

Crooked River

The mode of washing clothes inland in Jamaica. When I had photographed her she asked me for 3d., " the day's meal." Five minutes later a tropical deluge came down lasting three hours. This happens for several months daily, every year. The black peasantry live in wattle huts that let in the rain at every pore, and go shoeless, forever carrying huge loads on their heads, to sell for a few pence the products that we pay ten times as much for in Europe. That is what you see for yourself in this so-called most pro- gressive and best-organised of all the British West Indies

white concrete posts, railings mense, exotic, though somewhat small arrogant statue of the like the apex of the victorian of Kingston under a flaming sun. and again they would be impos- by the film, has been gathered This too is a pineapple farm. of the slave told me he got about the same for the man who onto the boats. A full bunch 200 bananas. If there are less them), said the young black barefoot from the hills to Banana

to progress, they say. Yet it was an ex-justice and schoolmaster, have the railway brought some 11 to the banana centre, to transport had applied again and again. England. Asked to see the friend the banana agent is a pure he, seemed very surprised at and who could explain the situa- very soon after we were allowed ignorance of the white man However, what is lacking in prejudice. distorted America where all mentally and socially, labelled seem without any of this social is more " subtly " handled by sphere of an orderly place. an old-fashioned tempo, exces- notice there is a positive mini- office." By " in office " I mean establishments and all *milieus* of The pure black people are on try. Or in menial employ. The stayed are black—and shoeless.

The harbour workers, the market sellers are so. But in the newspaper offices, the shipping companies, banks, etc., and nearly all upper or middle class strata they are mulatto. This is indeed the white man's doing. As there are so few whites they have established on the rock foundation of British empire custom the " mulatto superiority " to fill the place of the " white superiority " which, from their very lack of numbers, they cannot operate with the same prestige here. From all times this has been used to divide the peoples of African and semi-African descent. White at the top, mulatto in the centre and black at the bottom of the economic and social scale.

There is one figure that British rule has not been able to keep out of sight in the background of the black peasantry, Marcus Garvey.

As Eric Walrond, a well-known West Indian Negro novelist and journalist, who at one time worked on Garvey's paper, wrote :

Garvey is of unmixed Negro blood. On its surface this may not appear significant, but it is indispensable to any consideration of the man. Goaded on by the memory that the first slaves stolen from Africa were full-blooded Negroes, Garvey and the gospel he preaches appeal particularly and not unexpectedly to the very black Negro

element. In the island of his birth, Jamaica, a land with as many color distinctions as there are eggs in a shad's roe, and all through his life, the fact that he was black was unerringly borne in upon him. Wherever he went, whether to Wolmer's, the college patronised by the upper class mulattoes in Jamaica, or to Europe or Central America as a student and journalist, he was continuously reminded that he was black and that it was futile for him to rise above the " hewer of wood and drawer of water."

In Jamaica, as elsewhere in the United Kingdom, England differentiates between the full bloods and the half bloods. In Garvey's Jamaica the mulattoes are next in power to the whites. *The blacks, who outnumber them 3 to 1, have actually no voice politically or economically.* (Italics mine. ED.) (From *The Independent*, Jan. 3, 1925.)

Garvey founded *The Negro World*, a violently racial weekly. It was, at that time, published in English, French and Spanish, and often suppressed in African colonies because of its message of race-consciousness and race-determination to the black peoples. This paper is still alive in New York, although in the hands of Garvey's enemies, a split from the original association, who, however, still call themselves " Garveyites."

In 1916 New York saw the arrival of Marcus Garvey and the founding of the Universal Negro Improvement Association with a nucleus of 13 only. The movement rapidly grew and attained immense proportions. The Negroes flocked to hear Garvey speak. " Africa for the Africans " was the slogan ; a sort of Zionism. But while making the Negroes conscious of themselves as a racial and separate entity, while attacking and exposing the white nations for their centuries-old pillage and exploitation of Africa and black peoples, his solution of these evils was simply to be the repatriation to Africa of all such American Negroes as desired, and would pay, to go there, and the demand of a Negro Free State in Africa itself. These two projects were to have Garvey himself as leader and figure-head. He constituted around himself a court of nobles, royal surroundings with court titles and offices, ceremonies, uniforms. Himself, once the projected plan had been carried out, was to be " Provisional Emperor of Africa." A fleet was brought into being to transport American and West Indian Negroes ; it consisted of some 5 or 6 steamers, the " Black Star Line." The contributions of the American coloured people—and the idea had so caught on that between 2 and 3 million dollars poured in—paid for all of this. By which capitalist white power the land for this African Empire would be granted was not revealed. Liberia seemed his choice. But Liberia is virtually an American colony, by reason of the huge loans forced upon it by the U.S., and by the Firestone rubber interests that control the country. Surrounded by charlatans and crooks of all sorts who dilapidated the monies that flowed into this fantastic scheme, his fleet actually unseaworthy and in the hands of adventurers, opposed by American officialdom and even by many American Negroes, the stupendous project, the dream of the black empire, blew up. And Garvey, target by then of many personal as well as public enemies, was eventually brought to trial before the New York courts, and, on a charge of " using the mails to defraud," sentenced to four years in the Atlanta penitentiary. Never had such a racial dream been put forth. While Garvey has done great good in arousing the race consciousness of the Negro his scheme stopped short at the purely racial. It simply ignored the far deeper and only solid basis of any reform—revolution is the correct word—in the condition of the black races of the world, their economic, their class status. A people of between 13 and 14 million, almost $\frac{3}{4}$ of whom are literally tied to the soil or economically enslaved by industry, cannot and

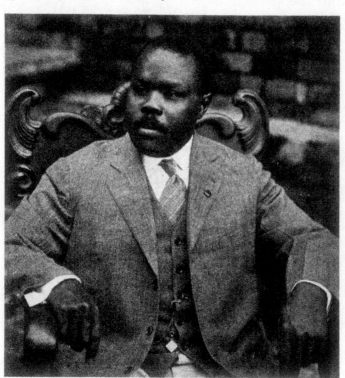

Marcus Garvey

Jamaica—The Negro Island

will not transport itself to the unknown. And the Negroes in the U.S. are such a people, and nothing had been said of the conditions in Africa they would be going to.

Garvey's " torrential eloquence," as it has been rightly called, and his theme of the necessary revolt of the black oppressed against the white oppressor, sufficed amply to rouse millions of partisans to his scheme. But Garvey's desire was to accomplish this alone. He failed, he fails now to see that only by the combined and organised struggle of the white as much as the black oppressed classes of the world will the coloured races of the world be, in that same day, free. Free of the diverse yet precisely similar rule of the white capitalist and imperialist powers. His " all-black " policy for the Negro race was to place them on an equal footing with the white races. This, Communists also desire and intend. But it is not by the empty parades of court figures and ceremonies, in short, by the totally impracticable approach to this major issue in world history, that such a vital revolution is accomplished.

In this sense Garvey is a demagogue. In the sense of the awakening of race-consciousness in the Negroes of the western hemisphere Garvey stands as a fixed point in Negro history.

At the League of Nations in Geneva in 1928, Garvey exposed his demands of " Africa for the Africans," and repeated this later the same year at a meeting in the Albert Hall. From the printed report of his speech he exposed ably and passionately enough the monstrous ills and wrongs to which the African populations are subjected, the whole scale of economic and social oppression, the penning up of natives on reserves where the land is of the worst quality, the infamous code of South African Pass Laws, the equally infamous wage contracts, the disfranchisement of black voters. Garvey's wife is also a fine speaker, and one who attended the meeting at which she spoke tells of the visible shame apparent in the audience who heard her describe their arrival in London, the £4 spent in taxis in the hunt for rooms from place to place which refused accommodation " to coloured," the disgrace of the British colour bar which can never be sufficiently denounced.

The two chief points in Garvey's dynamic personality are his energy and his eloquence. He has protested very outspokenly against the maintenance in various forms of slavery of the black races. Yet this conclusion is inevitable : his conception of the breaking down of this slavery is in no way linked up with the struggle to abolish the exploitation of the toiling masses of other races. The one will never be accomplished without the other, and this Garvey does not see. He does not see that the white imperialists will never *give*, but that they must be *forced*, and for this that the actual condition, the system itself, must be revolutionarily changed.

We have noted already the tremendously dominant number of black and coloured over whites in Jamaica, and of pure Negro over coloured. There is hardly any middle class in the island. It is essentially, as are other West Indian islands, a place of black peasantry. One is apt to think of " slavery " as the name for the most frightful condition that can befall mankind. Yet the economic state of the mass of black Jamaicans is not far removed therefrom. 1s. a day for 10 hours' work in a rope factory is one example of wages. The fruit packers of the United Fruit Co. are almost as badly off. There is no other work to go to outside of the other equally ill-paid forms of labour in an island which, though ample in proportion to population, cannot employ all its natives as it is. So that large numbers have been emigrating to America to settle, have been going to Cuba for plantation work and have been repatriated therefrom soon after, the conditions in Cuba being even worse. Of natural resources Jamaica has plenty, but insufficient capital to develop these. And it is logical that enterprise and effort will decline when constantly thwarted. Yet the Jamaican Negro peasant is particularly energetic ; this comes out most visibly in any chance conversation, for instance, along the roads. In no sense ever an *abruti* by the encompassment of the economic horizon. Jamaicans are as full of curiosity concerning the rest of the world as they are of talk, mother-wit and logic. A most lovable and interesting people. They give you a great sense of the *justice* in them. They are subtle, their minds work at such a slant angle (and how apparent this is in the very shortest exchange of words, and in their famous proverbs) that you have the impression no other people in the least like them exist in the world. Probably this is true. And they are a beautiful race, or rather, blend of black races. The women's hair is done in a wealth of twists and knobs and knots and curls—a perfect series in which no two seem alike in style but all suggest direct parentage to Africa. Their manners are exquisite ; a lusty, strong and dignified people, without the least trace of any of the surface " inferiority " or exterior hesitancy that has been beaten and pumped into some of the American Negroes by the bestiality of the American whites.

. . . I am walking along those blue winding macadam roads after rain, when the steam rises through the indescribably lovely trees, through the whole outpouring of these tender and dark green tropics that were so fluid after the dry and tawny Cuba. The black women come out of their houses laughing.

283

"Take us to Eng-land with
want to go a-way from here"
England, "mother country"
peoples, to the brutality of
the "not wanting the damned
about these things. "Oh we
much." These are the loyallest
pass on wondering *how much*
and domination of the whites

In a street near the harbour
black cripple hobbles over to
lish missie going away again,
very *very* poor—don't forget
Have I not indeed seen it. . . .
seer), the only mulatto I met
10 days: "The poor people
and they have a shackle round
off." And the black boys in
money thrown from gaping
ming miraculously right under
cheeks bulging with coins,
the dockers and ship loaders
steamers do come in. . . .

That is the Jamaica I saw.
that comes like a voice out of
the place of black peasantry, it
It belongs undividedly and by
the land."

The man with the bread-fruit
Picked from the tree, baked in hot stones
on the roadside, his only food for the day—
and he gave me half. Parish of Clarendon

you" (in a rich sing-song), "we
(scanning it, unforgettably). To
of so many plundered black
colour bar and all the talk about
niggers"? They know nothing
would like to see Eng-land so
subjects of Great Britain. I
longer the roguery, insolence
must last.

in Kingston an old majestic
me, peers into my face. "Eng-
we people here are very poor,
that." That was all he said.
And the *busher* (property over-
with in that inland region in
are the backbone of this country,
their necks they cannot shake
the harbour waters diving for
passengers on shipboard, swim-
the keel from side to side,
making a bit more maybe than
on such days as passenger

It culminates into a certainty
the soil itself. "This island is
must be unconditionally theirs.
right to the black Jamaican on

West Indian Negro Proverbs

by FRANK CUNDALL

P ROVERBS are the literature of the unlettered. They belong to the soil and its labours, but in the case of Africans in the West Indies they were influenced by the state of servitude—a means of expressing their feelings in their condition of dependence.

The proverbs of a people show the nature of the people almost as much by what they do not express as by what they do. Amongst the African proverbs there is little or no reference to honesty and thrift. Circumstances were against them. But in the use of applying proverbs to different occasions the Negro is without equal.

Though claimed as their particular property by individual countries, and even districts, proverbs are in great measure the common inheritance of the sentient human race ; and, all the world over, are substantially the same in sentiment, only changing the method of their expression with their locality. It is from them that the character and philosophy, and indeed, as several writers on the subject point out, the soul of a people, can be gauged.

The Negro proverbs of Jamaica are no exception to this rule. They are noticeable for the economical use which they make of the English language, especially by their omission of the article. But, as exceptions to the rule, we may note that the Jamaica " Him sa a no him a him, him say a him a no him," ill compares for brevity with " Qui s'excuse s'accuse " ; and " Too much-hurry get dey to-morrow ; tek-time get dey to-day " with " Much haste, worse speed."

The Negro proverbs of the West Indies are divided into four classes : those that have their origin in West Africa—which is the country roughly speaking from Cape Verde to the Cameroons facing for the most part due south ; those originating in the West Indies ; those adapted from European proverbs; and those that are frankly European proverbs expressed in Negro language. These proverbs, like the folk-lore, are traceable for the most part to Ashanti and the West Coast generally, whence came Annancy, while the Brer Rabbit of the Southern States of America came with the Negro from Lower Guinea. In essentially British colonies, such as Jamaica, Barbados and Antigua, many of the proverbs are based on those of the United Kingdom. In the French colonies, and in the colonies that were at one time in French possession, the proverb of the land of the original settlers has had its influence, and the same may be said of those colonies that once belonged to Spain.

Benjamin A. Morton, in *The Veiled Empress*, writes :

> The life of the Negroes on the plantations in Martinique is reflected in their proverbs. They are the naive expression of a simple mind, close to nature. The proverbs are part and parcel of every-day conversation. They have a piquancy of phrase analogous to the tang of the music and the vividness of the costume. . . .
> Some of the proverbs spring clearly from the mind of the slave, they speak of class distinction, resentment, poverty, fear, resignation, despair. Others, of bad luck, rascality, superstition. Some are merely vivid phrases and idioms. Most of them express in natural mnemonics the homely philosophy of every-day life. They strike, some of them, universal chords of human nature.

A comparison shows that several of the proverbs most often heard in Jamaica—*e.g.* " Greedy choke puppy " ; " Rocktone a riber bottom neber know sun hot " ; " When black man tief, him tief half a bit, when bockra tief him tief whole estate " ; " Ebery John Crow tink him picknie white "—are common to both British and French colonies. The last named in the French colonies is rendered in patois : " Macaque pas jamais ka die iche li lai " (Monkey never says its young is ugly).

As they improvise some verses to their songs as they sing, so the Negroes improvise proverbs and proverbial sayings. For this reason one meets with two or three renderings of the same saying, and very often the same idea, clothed in different words. Sometimes they are in direct opposition, as " Man mus' die, but wud neber die," and " Wud mus' die, but man mus' lib." The Jamaica proverb " Blacbud have fe him ticks fe pick, and pick fe cow own " was obviously improvised in the island.

In the West Indies, proverbs are turned into meanings more readily understood of the people—*e.g.* " A cat may look at a king " becomes " Darg hab liberty fe watch gubnor." Similarly, " Hard words break no bones " becomes " Cuss-cuss neber bore hole a me 'kin " and " Les absents ont toujours tort " becomes " Behind darg it is ' Darg '; before darg it is ' Mr. Darg ' " ; or, in the patois of the French islands : " Deier chien ce ' chien,' douvant chien ce ' Missier Chien.' "

West Indian Negro Proverbs

" Familiarity breeds contempt " (which the Italian expresses by " Don't play with the bear if you don't want to be bitten ") becomes in Jamaica, " If you play wid puppy, puppy lick you mout' " ; and " Honesty among thieves " is rendered by " Darg no nyam (eat) darg." " Ebery man know wha' him own house a leak " obviously is a rendering of the English proverb dating from the time when Negroes wore no shoes to pinch their feet. " He laughs loudest who laughs last " becomes " Fus laugh a no de ending." " All is not gold that glitters " becomes " No ebery ting wha got sugar a sweet," which is especially applicable in the land of the sugar-cane.

In the study of West India proverbs, the most interesting feature is their origin from West Africa, where proverbs are highly valued. In Yoruba they say, " A Councillor who understands proverbs sets matters to rights," and " A proverb is the horse of conversation ; when the conversation flags, a proverb revives." In Ashanti they say, " When a fool is told a proverb, the meaning of it has to be explained to him."

In Jamaica they say, " New broom sweep clean, but de ole broom know de carner." At Accra they say, " An old broom is better than a new one." In Jamaica they say, " Two bull can' tan a one pen." At Accra they say, " Two rams cannot drink out the same calabash." In Jamaica they say, " When bull foot bruk him nyam wid monkey." In Liberia they say, " Though the lion be humbled yet will he not eat with the frog." In Jamaica they say, " Bush hab yeye [eye] " ; the Ashantis say, " A path has ears." In Jamaica they say, " When cockroach gib party him no aix fowl " ; the Ewe-speaking people say, " The goat does not pass the leopard's door ; " and, " If the mouse be ever so drunk he does not go to sleep in the cat's bed." In Jamaica they say, " Lilly finger say ' look yere,' big tumb say ' look yonder.' " In Yoruba they say, " The thumb cannot point straight forward."

The Jamaica proverb " Hen nebber mash him chicken too hot " becomes among the Ibo-speaking people, " The foot of a fowl treads on a chicken but never kills it."

In Jamaica they say, " When fowl drink water him say ' tank God,' when man drink water him say nuttin." The Turks have a similar saying.

In Jamaica they say, " Nebber mek goat trustee fe bread-nut tree." At Accra they say, " No one gives a pig to a hyena to keep."

In Jamaica they say, " Cuss John Crow (a vulture) ' peel-head ' turkey pee-pee bex (vex)." In Yoruba they say, " If you abuse the ettu (a kind of guinea fowl) you make the head of the awo (a bird of the same genus) ache." The same idea occurs in the Spanish proverb, " Offend one monk, and the lappets of all cowls will flutter as far as Rome."

In Jamaica they say, " One man beat the bush and de oder ketch de bud [bird]." The Yorubas say, " One man makes bill-hooks to put into the hands of others." Virgil says, " Sic vos non vobis." " Too much si' down bruk breeches " is a witty satire on idleness. The Ashantis say, " ' Good-morning good-morning ' kills an old woman."

Miss Alice Werner, in her introduction to Jekyll's *Jamaican Song and Story*, says :

> But we look in vain for the tortoise in these stories of Mr. Jekyll's. Even in the race-story, as we have seen, the part which in Africa is so peculiarly his own, is taken by the toad. Probably this is because the land-tortoise is not found in Jamaica, and the great turtle of the seas is not a creature whose ways would come under the daily observation of the peasantry.

" When turtle come out o' pond an tell you alligator hab feber, belieb him," is a very common Jamaica proverb, and land turtles are met with commonly in the island, and both green and hawks-bill turtles are well known to the peasantry.

In Jamaica they say, " When fish come o' sea an' tell you alligator hab feber belieb him." The West African saying is " if an apopekiki from the bottom of the river says the crocodile is sick, it will not be doubted."

In Jamaica they say, " No cuss alligator long mout' till you cross riber." The Ashanti proverb runs, " When you have quite crossed the river you say that crocodile has a bump on its snout." In Jamaica they say, " Alligator lay egg but him no fowl." In Ashanti they say, " A crab does not give birth to a bird."

In Jamaica they say, " One daddy fe twenty picknie, but twenty picknie no fe one daddy." The West African version is, " I have not begotten all that call me sire " ; to which one may compare Launcelot Gobbo's " It is a wise father that knows his own child."

In Jamaica they say, " One finger can't catch louse " ; in West Africa, " A man does not take one

finger and take out an arrow." The Jamaica proverb, " One fool no fool, but two fool a fool," at Accra is rendered, " Nobody is twice a fool "; the same idea is to be found in the Greek, " It is shameful to trip twice over the same stone."

In Jamaica they say, " John Crow ben wan' go a leeward befo' wha' you tink when hurricane blow." The Yoruba version is, " The crow was going to Ibara; a breeze sprang up behind; ' That will help me on famously,' quoth the crow." In Jamaica the old Hebrew proverb, " He that has been bitten by a serpent dreads a rope," becomes, " If snake bite you, you see lizard you run." The Oji version is, " He whom a serpent has bitten dreads a glow-worm."

In Demerara, though not in Jamaica, the Negroes have proverbs telling of elephants. These are obviously of African origin. In Jamaica there are no monkeys, but monkeys figure in many of their sayings; the explanation being no doubt the same. Tigers are also sometimes mentioned in their proverbs, as they frequently are in their Annancy stories.

Those proverbs that have frankly been taken from the English are of interest in showing the class of thought that appeals to the Negro mind. In the same way some Annancy stories of European origin have an interest second only to those of undoubted African source. In England one says, " Shot at the pigeon and killed the crow." In Jamaica, " Play 'tone kill bud." " He that fights and runs away may live to fight another day " becomes " Coward man keep soun' bone."

Scotch proverbs are noticed in " De bridge between laughin' and cryin' no long," which is the Jamaica rendering, " Laugh at leisure you may greet ere nicht "; and " Braggin riber neber drown s'mody " is a neat rendering of the thought in—

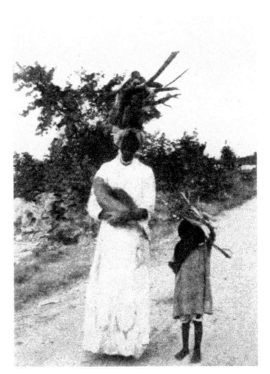

The native way of carrying loads in Jamaica, with a pad (cotta) *to balance them on the head*

> Says Till to Tweed:
> Tho' ye rin wi' speed and I rin slaw,
> For ilka man that you droon I droon twa.

Some proverbs have one or two different renderings. Some say, " Big words break nobody's skin "; others say, " Big words neber break man jaw-bone." Many phrases, it may be noticed, are more or less biblical in character: such as " Cashew neber bear guava," a Jamaica rendering of " Do men gather figs of thorns ? "

In so far as they touch upon morals and manners, the proverbs of a race seldom display its good points. They are practically the race's criticism of its own salient defects. If taken seriously, therefore, the proverbs of a race are apt to give an impression of its faults rather than its virtues. In the case of the West India Negroes, these defects on which stress is laid are hasty conclusions, improvidence, insincerity, greediness, want of foresight, interference, ingratitude, insolence, vanity and presumption.

With the spread of education the use of proverbs has a tendency to lessen; and the members of each succeeding generation, both in Africa and in Jamaica, know fewer proverbs than their fathers. Now the Negroes display a certain amount of diffidence in using them—at all events, before " buckra." [1] If asked the meaning of a somewhat obscure one, they will not infrequently plead ignorance: " Me no know," " Dat's only a saying." Some of them affect surprise or even indignation when a proverb is quoted against them, and will say, " Hi ! Wha dis buckra get all dem old time sayings ! "

Finally, on being asked to contribute this article, the writer thought, " A de willin' harse dem saddle mos'."

[1] The white man.

Hayti

by GRACE HUTCHINS

of the Labor Research Association

AMERICAN officials on the island of Hayti want Franklin D. Roosevelt to be elected President of the United States. Why? Because they know he will work to continue American occupation of Hayti and further the interests of American bankers and industrialists against the interest of Negro workers and peasants, who have repeatedly revolted against the bloody rule of Wall Street. These white overlords know that Roosevelt is their man because of his record as Assistant Secretary of the Navy, and often Acting Secretary from 1913 to 1920, when the U.S. succeeded in extending its colonial empire in the West Indies.

Roosevelt pulled the strings for Wall St. during the war period and the U.S. marines danced like puppets on the stage. He boasted in 1920:

"The facts are that I wrote Hayti's constitution myself, and if I do say it, I think it a pretty good constitution." (*New York Times*, Aug. 19, 1920.)

By the terms of this constitution written in 1917 by Roosevelt, then Assistant Secretary of the Navy, the Haytian people were made subject to the United States; martial law under marine rule was placed above the Haytian courts; and foreigners, meaning Wall Street, were given the right to own land, contrary to the provisions of Hayti's own constitution. All laws must be submitted to the United States before passage.

. . . The story of Wall Street's occupation of Hayti is one of the bloodiest chapters in the history of American imperialism. This Negro republic was seized by the U.S. for two reasons: first, in order to extend its naval base in the West Indies; and second, in order to gain control over the rich resources of the country. The National City bank secured ownership of the Haytian national bank and of the national railroad, and these investments of Wall St. have been protected by the U.S. navy.

. . . Forced work on the highways, called the *corvée*, had been abandoned in this Negro republic but was revived by the marines. "Unwilling workers were impressed. . . . They were sometimes manacled like slaves, compelled to work for weeks with little or no pay and inadequate food, and shot down if they attempted to escape." (G. G. Balch, *Occupied Haiti*.)

Official reports put the number of Haytians killed by marines and marine-officered gendarmerie at 3,250 in the first five years. Those killed included women and children.

. . . With the full approval of Roosevelt as Acting Secretary of the Navy, jim-crowism against Negro workers was practised in the U.S. navy, as in the army. Negro gunners' mates were not promoted. Negro workers enlisted in the navy were forced to do the dirtiest, hardest jobs. They were separated from the white men and herded into special groups similar to the labor battalions in the army. Negro enlisted men were used by the navy as longshoremen, loading and unloading boats and handling coal.

(From the *Afro-American*, Aug. 20, 1932.)

People without Shoes:

The Haytian Masses

by LANGSTON HUGHES

HAYTI is a land of people without shoes—black people, whose bare feet tread the dusty roads to market in the early morning, or pad softly on the bare floors of hotels, serving foreign guests. These bare-footed ones care for the rice and cane fields under the hot sun. They climb high mountains picking coffee beans, and wade through surf to fishing boats in the blue sea. All of the work that keeps Hayti alive, pays for the American occupation, and enriches foreign traders—that vast and basic work—is done by Negroes without shoes.

People without Shoes

Yet shoes are things of great importance in Hayti. Everyone of any social or business position must wear them. To be seen in the streets barefooted marks one as a low-caste person of no standing in the community. Coats, too, are of an importance equal to footwear. In a country where the climate would permit everyone to go naked with ease, officials, professional men, clerks, and teachers swelter in dignity with coats buttoned about their bellies on the hottest days.

Strange, bourgeois, and a little pathetic this accent on clothes and shoes in an undeveloped land where the average wage is thirty cents a day, and where the sun blazes like fury. It is something carried over, perhaps, from the white masters who wore coats and shoes long ago, and then had force and power ; or something remembered, maybe, as infinitely desirable—like leisure and rest and freedom. But articles of clothing for the black masses in Hayti are not cheap. Cloth is imported, as are most of the shoes. Taxes are high, jobs are scarce, wages are low, so the doubtful step upward to the dignity of leather between one's feet and the earth, and a coat between one's body and the sun, is a step not easily to be achieved in this island of the Caribbean.

Practically all business there is in the hands of white foreigners, so one must buy one's shoes from a Frenchman or a Syrian who pays as little money as possible back into Haytian hands. Imports and exports are in charge of foreigners too, German often, or American, or Italian. Hayti has no foreign credit, no steamships, few commercial representatives abroad. And the government, occupation-controlled, puts a tax on almost everything. There are no factories of any consequence in the land, and what few there are are largely under non-Haytian control. Every ship brings loads of imported goods from the white countries. Even Haytian postage stamps are made abroad. The laws are dictated from Washington. American controllers count the money. And the military occupation extracts fat salaries for its own civilian experts and officials.

What then, pray, have the dignified native citizens with shoes been doing all the while—these Haytians, mulattoes largely, who have dominated the politics of the country for decades, and who have drawn almost as sharp a class line between themselves and their shoeless black brothers as have the Americans with their imported color line dividing the occupation from *all* Haytians? How have these upper-class citizens of this once-Republic been occupying themselves? Living for years on underpaid peasant labor and lazy government jobs, is one answer. Writing flowery poetry in the manner of the French academicians, is another. Creating bloody civil wars and wasteful political-party revolutions, and making lovely speeches on holidays. Borrowing government money abroad to spend on themselves—and doing nothing for the people without shoes ; building no schools, no factories, creating no advancements for the masses, no new agricultural developments, no opportunities—too busy feeding their own pride and their own acquisitiveness. The result : a country poor, ignorant, and hungry at the bottom, corrupt and greedy at the top—a wide open way for the equally greedy Yankees of the North to step in, with a corruption more powerful than Paris-cultured mulattoes had the gall to muster.

Hayti today : a fruit tree for Wall Street, a mango for the occupation, coffee for foreign cups, and poverty for its own black workers and peasants. The recently elected Chamber of Deputies (the Haytian Senate) has just voted to increase its salaries to $250.00 a month. The workers on the public roads receive 30 cents a day, and the members of the gendarmerie $2.50 a week. A great difference in income. But then—the deputies must wear shoes. They have dignity to maintain. They govern.

As to the occupation, after fifteen years, about all for which one can give the Marines credit are a few decent hospitals and a rural health service. The roads of the country are still impassable, and schools continue to be lacking. The need for economic reform is greater than ever.

The people without shoes cannot read or write. Most of them have never seen a movie, have never seen a train. They live in thatched huts or rickety houses ; rise with the sun ; sleep with the dark. They wash their clothes in running streams with lathery weeds—too poor to buy soap. They move slowly, appear lazy because of generations of under-nourishment and constant lack of incentive to ambition. On holidays they dance to the Saints and the Voodoo gods, all mixed. They grow old and die, and are buried the following day, after an all-night wake where their friends drink, sing, and play games, like at a party. The rulers of the land never miss them. More black infants are born to grow up and work. Foreign ships continue to come into Haytian harbors, dump goods, and sail away with the products of black labor—cocoa beans, coffee, sugar, dye-woods, fruits, and rice. The mulatto upper classes continue to send their children to Europe for an education. The American occupation lives in the best houses. The officials of the National City Bank, New York, keep their heavy-jawed portraits in the offices of the Banque d'Haiti. And because black hands have touched the earth, gathered in the fruits, and loaded ships, somebody—across the class and color lines—many somebodies become richer and wiser, educate

289

their children to read and write, to travel, to be ambitious, to be superior, to create armies, to build banks, to wear coats and shoes.

On Sunday evening in the Champs de Mars, before the Capitol at Port-au-Prince, the palace band plays immortally outworn music while genteel people stroll round and round the brilliance of the lighted bandstand. Lovely brown and yellow girls in cool dresses, and dark men in white suits, pass and repass.

I asked a friend of mine, my first night there, " Where are all the people without shoes ? I don't see any."

" They can't walk here," he said, " the police would drive them away."

A Note on Haytian Culture

by LUDOVIC MORIN LACOMBE

(Translated from the French by SAMUEL BECKETT.)

Ludovic Morin Lacombe

HAYTI has no civilisation of its own. At the time of its discovery in 1492, it was inhabited by the Caribs, who were exterminated by the Spaniards and replaced by Negroes imported from Africa.

After becoming a French colony in 1666, the island of Hayti severed itself from the mother country in 1804.

The middle class, called free, consisting of freed Negroes and mulattoes—which came into power after the tragic death of Jean Jacques Dessalines and the expulsion of the white element—had received, from father to son, a purely French education.

So that we are in the presence of a select class, with the skins of Africans and the brains of Europeans. This class hopes to lead the country more rapidly towards progress and civilisation by banning all that recalls the African civilisation. It sees nothing capable of raising the Haytian people morally, except europeanisation and christianisation. And so it exalts nationalism and the sentiment of the liberty of the Haytian people to impress them the more with a sense of their superiority over the other Negroes.

This ruling Haytian class, by this clumsy assimilation of European culture, ends by ignoring everything that concerns that Africa from which it is not always proud to be descended, and does this through its constant, servile imitation of Europeans, losing all originality of thought, of conception and of execution.

A few Haytian writers strove to act differently from the Europeans, although formed by them. They introduced into their writings a critical sense, an originality which proved that their minds were emancipated.

Louis Joseph Janvier has the best trained mind in Hayti. He is the author of *Vieux Piquet, Les Détracteurs de la Race Noire, La République d'Haïti, Haïti aux Haïtiens*, etc.

Oswald Durand is a Haytian national poet, the author of *Choucoune*, the Haytian poem in *Creole* vernacular which savours most truly of the country.

Dr. Arthur Holly makes a constant study of the manifestations of Voodoo and the treatment of supernatural afflictions.

Candio is a Haytian singer in the *Creole* dialect.

Dr. Price Mars is the author of *Ainsi parla l'Oncle*.

These are men whose minds discard everything which departs from sound reason, drawing only on European culture for that which can be useful to their country and their race on practical grounds.

How many educated Haytians think as they do ?

The younger generation of Haytians which received its baptism of fire during the North American intervention in 1915 is always protesting against this crass ignorance of matters African. It is represented by Jean Barau, Daniel Heurtelou, Jacques Roumain, Carl Brouard, Julio Jean-Pierre, who have no intention of allowing themselves to be stupefied by religion and integral civilisation.

The ex-slave class, consisting equally of blacks and mulattoes, has been less favoured as regards

education. Having received nothing from the European, it is ready to retain implicitly the customs, morals and traditions of Africa. In it the recently landed African can find that African courtesy which astonishes the European colonial.

Let us conclude by stating baldly that Hayti is divided into two civilisations.

On the one hand, the African civilisation to which the Haytian peasants, the slaves of yesterday, remain faithful.

On the other, the European civilisation to which the Haytian *élite*, recently called the emancipated class, has adapted itself with much effort and with very little success.

The King of Gonaives

by JACQUES BOULENGER

(Translated from the French by SAMUEL BECKETT.)

IN 1915 the Republic of Hayti was presided over by one William Sam, who was so little appreciated as an administrator that steps were being taken to have him removed. Now it appears that William Sam, being alive to this, saw fit to execute no fewer than 200 hostages drawn from the most distinguished families throughout the country. He may have counted on the radical nature of this proceeding to reinstate him in the good graces of his fellow citizens, but the contrary was the case, and William Sam referred himself with all speed to the sanctuary of the French Legation. Here in due course there arrived some members of his flock to pay their addresses. Having saluted him with such heartiness as to break his two arms they threw him out of the window to the waiting populace, and William Sam terminated his career as mincemeat.

At this time France had such a full programme, what with fighting the good fight and one thing or another, that she simply could not spare the time to protest against the violation of her Legation; but the U.S.A., always on the spot and ready to oblige, intervened in her stead. It is common knowledge that the imperial spirit is altogether foreign to the U.S.A. They are merely impelled by a sense of duty and in the interests of liberty and law and order to add every now and then to their list of annexations. Being now constrained to take the view that law and order of the highly cultivated William Sam variety had been intolerably jeopardised by his assassins, they dispatched shiploads of marines to Hayti. They even entertained an anxiety to favour the adjoining state, the Republic of San Domingo, with a similar attention, and were only finally dissuaded by a storm of indignant opposition. It is to be borne in mind that all this happened seventeen years ago, and the Americans, notwithstanding the protests of the Haytians, are still in Hayti. The liberties of law and order are enforced by a dictator of their nomination and no measure is too coercive when it comes to imposing their language on the natives, who refuse to speak " English " and persist, in an extremity of pigheadedness, in preferring their own to American culture.

Among those marines who landed at Port-au-Prince in August 1915 was a certain Faustin Wirkus, a man whose integrity and natural curiosity distinguished him from his compatriots, and substituted for the fatuous arrogance of their dealings with the natives a real anxiety to understand their position. He soon got to know and esteem them. He has related his experiences in *The White King of Gonaives*, a unique book of its kind in the sense that it constitutes what, to the best of my knowledge, is the first authentic account of this black peasantry as distinct from the native life in Port-au-Prince so frequently described. I hope to convince you that such an account has been long overdue.

I think I am correct in saying that Faustin Wirkus first stayed in Hayti from 1915 to 1917. During this period he, in common with his fellow marines, was chiefly engaged in dealing with the *cacos*, a name given to the nationalists who had risen against the U.S.A. and the administration of their catspaw, President Dartiguenave. Wirkus is not deterred by the official description of these " rebels " as cut-throats and desperadoes from asserting that their only crime was to have resisted a form of government imposed by foreigners. For this good soldier, who would never question an order, has no patience with diplomatic hush-hush: he puts down his facts as they appeared to him, and it is precisely this outspokenness that gives such pungency to his memoirs. An example of this is his account of how the gallant Codio, chief and moving spirit of the cacos, met his end. The collapse of the rising in Port-au-Prince had forced Codio to fly for his life. " A Haytian scout lured him to the marines' camp," no doubt on the strength

of false promises, a manœuvre formerly brought to a high pitch of perfection at the expense of the Red-skins. " And that," concludes Wirkus, " was the end of him. His obituary notice was to the effect that : *General Codio has met his death in an attempt to escape from the custody of a marine*. Indeed, saving the respect of the professional pacifists, it was the only efficacious mode of procedure." Efficacious ? Highly so.

Wirkus returned to Hayti at the end of April 1919 as a lieutenant in the native constabulary newly founded by the U.S.A. His instructions were to hound down the numerous bands of cacos who, not at all daunted by the summary execution of General Codio, had established themselves in the outlying country. These " rebels " were extremely courageous and had nothing to learn from the white men on this score, but were very poorly armed ; moreover, their habit of closing their eyes and averting their heads every time they discharged their blunderbusses caused their fire to be very much less deadly than the pacific gestures of the Americans. Lieutenant Wirkus, after a little more than a year of this life, was so exhausted that he applied to be transferred, and was; in January 1920 he was appointed commanding officer of the sub-province of Arcahaie.

Here his main responsibility was the population of Carzal, where blue eyes and fair curly hair are by no means uncommon, and freckles actually flourish, and he avows frankly that he was all but brought to his knees by the charms of a blonde Negress. But his virtue pulled him through. He now decided to recruit his spirits with a visit to a remote corner of his jurisdiction, the island of Gonaives, 40 miles distant from Hayti. The crossing, effected in decrepit sailing vessels, was the reverse of agreeable, and Wirkus calmly expresses the opinion that not one of the white officials sent to take up residence in the island had ever succeeded in penetrating " more than five miles into the interior." As for " sanitary inspection," he describes its results without indulgence. . . . To make a long story short, he found himself a stranger in an unfamiliar world.

He paid an official visit to the gaol. Among the prisoners was a woman accused of having been " want-ing in respect towards the Republic of Hayti and the tribunals of Gonaives." She was a Negress, short, squat and muscular, with the eyes of a hawk. She wore a spotlessly clean white gown, a madras about her shoulders, another round her head, and on her feet that ultimate luxury, a pair of shoes, " dazzling, black, patent-leather shoes "! She was engaged in enlightening the warders, in unequivocal terms, as to their mothers and grandmothers, and hence, by devolution, as to themselves, stamping furiously up and down before the other prisoners, who seemed dreadfully intimidated. She turned on the American officer : " She looked like a general's wife who had just been reprimanded by a member of the FORCE." And behold, it was the Queen Ti Memenne.

Some time later he went to pay her a visit. He found her in her village, supervising the baking of a cake of cassava. She came to meet him with outstretched hand ; the Haytian of breeding shakes your hand on all occasions. " It is the queen," said a voice in his ear. " What queen ? " " The queen of all the Congo societies." She apologised for her *négligé*, and hastened away to make herself decent. Mean-while a maiden showed Wirkus to a hut where his camp-bed had already been installed and a wooden basin and jugs of water got ready. Scarcely had he completed his toilet when Ti Memenne appeared, now arrayed in a white gown and white cotton stockings, a red madras about her head, and on her feet a pair of sparkling shoes, with silver buckles. In the evening a great dance was held in his honour, to the sound of Haytian drums ; the queen set him on a raised seat by her side.

He found all this very interesting and pleasant. But when he told his comrades about the queen of Gonaives they laughed and supposed him to be pulling their leg ; their interests, according to Wirkus, not extending further than whisky and *clairin*, the local sack ; and when he realised that the Haytians themselves were equally indifferent and uninformed his only thought was how he could get himself appointed to Gonaives. But he had to wait until April 1925 for his transfer. Shortly afterwards he was crowned king of the island with all prescribed rites and formalities. And here a word of explanation becomes necessary.

Gonaives contained about 12,000 inhabitants, all farmers, and not a single landed-proprietor among them ; the entire island belonged to the government, who leased it to a group of concessionaires and they in their turn subleased it to the peasants. These last, in pursuance of an ancient tradition, were grouped together in what were known as " Congo societies." These societies operated in the following way :

Each member of the society was entitled to receive a day's work from all his fellow-members. When each one had received his due the cycle recurred. Each society had its queen, and all the queens were subject to the supreme queen, Ti Memenne. Wirkus gives a truly charming picture of the respect with which this queen of queens was surrounded and of her patriarchal authority ; reading, we seem to be back in the Homeric period. Every morning, at least during seed-time and harvest, the society met

The King of Gonaives

with drums and flags at the house of its queen. And all day long, to the sound of the drums as they marked the rhythm, the men laboured at tilling and building, the women cooked, the children ran on messages. In the evening there was a dance at the host's expense, this time with the " majors," professional musicians maintained by the society, beating the drums with palms and fingers in the complicated measures of their race.

On the Saturday evening there was a meeting at the queen's house for more dancing and the dispensing of justice. The names of all latecomers, defaulters and shirkers were communicated by the chairman of committee ; the charge then went before the president of the society, who reported it in due course to the queen. The sentence rested with her. All the week, until the Saturday, the accused had to wear a red armlet. All fines were lodged in the common fund, and if the offender could not pay in cash, his poultry, pigs or goats were confiscated to the requisite amount ; but the services of the society were at his disposal for the following Monday, by way of compensation for his fine. Such was this black socialism, invented in all probability by some remote ancestry that had never heard of syndicalism and did not even know how often the Republic of Hayti might change hands.

They were bled white by the tax-collectors, who duly pocketed nine-tenths of their collections. Wirkus succeeded in remedying this lamentable state of affairs, and it was partly in grateful token of his good administration, partly by virtue of his christian name Faustin, which was that of a former king of Hayti, that Ti Memenne and her heiress apparent, Queen Julia, declared and crowned him king with all the picturesque ceremony of voodoo ritual, voodoo being the only form of religion practised on the island.

Faustin reigned until 1928. On the sixth of March of that year His Excellency the General Borno, together with General Russell, paid a visit to the island of Gonaives, and all the Congo societies, complete with sacred voodoo flags and drums, turned out to do honour to these illustrious personages. It appears that the president found this attention in the highest degree embarrassing, or so at least we are given to understand by the American lieutenant whose statements have been closely adhered to in this synopsis. As a consequence, strict injunctions were issued, on the occasion of a second visit some months later, to eschew all ceremony, and above all abstain from taking photographs without the express sanction of His Excellency or one of his aides-de-camp. " The official attitude of the president towards the cult of voodoo," adds Wirkus, " could never be reconciled with his personal behaviour nor with that of his familiars," and he quotes various incidents to justify the supposition that " the majority of responsible white officials in Hayti were humble and fervent adherents of voodoo."

In January 1929 Lieutenant Wirkus was transferred to the constabulary in Port-au-Prince, assuredly a very poor return for the services of a man who had greatly augmented the revenue from taxation in his island, organised a number of reforms in the interests of the community that did not cost the state a penny, and developed the cultivation of the soil and the breeding of stock. But he does not despair of returning to his kingdom one of these days : his subjects are waiting for him.

In July, 1941, following a period of detention on Ellis Island, Nancy made an unplanned visit to Cuba, where she hoped to secure passage to England. As the days passed she busied herself, as usual, writing articles and poems, several of which were inspired by the black population of Cuba toward whom she was naturally drawn. Shortly before she sailed for England, she found she had written enough poems to fill a small volume and decided

to issue it from Havana under the title *Psalm of the Palms and Sonnets*. She addressed one sonnet to the West Indian poet Alfred Cruikshank, who had once asked her why she had taken up the fight for the black man's freedom:

> What was it moved you to enlist
> In our sad cause your all of heart and soul?

Nancy answered his query in her sonnet.

TO ALFRED CRUIKSHANK

My friend, ship rocks, and seas come great and small
Over the gunwale, but the captain reads
On despite this. On land the teeming seeds
Breed without fear, and after the gusty fall
Of rain comes, ready are they, present, erect,
Grown. Do you sense the symbol in it all?
The man outlives the storm, the tribunal
Of nature judges, tempering the elect.
Our lives are wars—You ask: "Why love the slave,
The 'noble savage' in the planter's grave,
And us, descendants in a hostile clime?"
Cell of the conscious sphere, I, nature and men,
Answer you: "Brother . . . instinct, knowledge . . . and then,
Maybe I was an African one time."

<div align="right">H. F.</div>

The Situation of the Negro in Cuba

by M. A. PÉREZ-MEDINA

(Translated from the Spanish by V. Latorre Bara.)

WITHOUT burdening our readers with historical details, let us recall the successive waves of Negro immigration to Cuba, answering the demand of the Spanish conquerors who wished to replace the Indians, first in the mines, and later on in the sugar-works. The Negroes were sold like beasts of burden by the slave-traders of civilised Europe, especially of France, England and Holland. Everyone knows of this former Negro trade, very similar in some respects to that at present carried on by the Yankee companies in the Caribbees who transport Negroes from Hayti, San Domingo, Barbados, Curaçao, etc., to the sugar-cane plantations of Cuba and the banana concerns of the United Fruit Co. in Colombia and Central America, in order for them to take the place of natives who are on strike.

As the price of every slave was relatively high, the masters and foremen took upon themselves to produce half-castes by rendering fruitful their female slaves. The half-caste could be considered as a free man (though not always), and this "freedom" enabled him to gain the position of a wage-slave. He worked "freely" and paid his masters either in labour or in kind, as the land which he cultivated did not belong to him, but was the property of his landlord. However, a few faithful half-castes (probably sons of the masters) inherited lands which were taken from them, later on, in the days of the "independent" republic, and of Yankee agricultural and industrial colonisation. It is for this reason that the Negro in Cuba has not yet acquired any love of private property. He has had no status other than that of a workman or an artisan, and his economic situation has been that of a half-paid worker. Many have

<div align="center">294</div>

The Situation of the Negro in Cuba

been able to enter the liberal professions ; not a few are concerned with the fine arts (especially music), and some, especially among half-castes, have devoted themselves to literature. But the great majority of those who have escaped from the peasant and working-class masses have taken refuge in politics, in the teaching profession, and in public positions that they have gained after several years of struggle in the Republic, serving and helping their white " friends " and " co-religionaries " in electoral contentions. This we shall discuss later.

In the struggle against Spain the Negroes were a factor of supreme importance—the veritable cannon fodder made use of by the nascent bourgeoisie that gave promises of " liberty," " equality " and " fraternity." The Negro soldier nearly always fought as a common private in the vanguard. Stripes adorned the shoulders of the whites. His bravery, his valour, his power and resistance, are the greatest monument of the Cuban Revolution. He was armed against Spain by the rising bourgeoisie and the " petit bourgeois," but he entertained the hope of participating in the spoliation of feudalism and of the clergy. He accepted the theoretical declaration of liberty together with the white master's gun, in order to make war against Spain, but he looked forward to the division of the land between members of his race—the race which has always formed the greater part of the population of Cuba.

The Negro was (and still is) an agrarian and an advocate of equality. These are exactly the principles of the programme advocated by the man who in that historical moment represented his aspirations for social betterment—the agrarian leader Antonio Maceo. The masses followed this half-caste reformer in his military campaigns and achievements, and they were faithful to him. It is certain that in the struggle against Spain, the different factions, with opposing interests, could not, without difficulty, realise a united front, and if this was realised at times, the result was not permanent, as it was not possible to reconcile the conflicting interests of the agrarian " petite bourgeoisie," whose aim was a bourgeois democratic revolution. It was they who, with the Negro masses, constituted the real motive force of the struggle of the nascent industrial bourgeoisie (Cespedes, Aguilera, Cisneros, etc.), who, being unable to combat this agrarian tendency, sought support in Yankee imperialism. Henceforth the Cuban bourgeoisie is allied with Yankee imperialism to forestall the division of lands, and wrest political power from the hands of Spain.

The United States always desired to annex Cuba, and this was the object of the protection afforded to the expedition of Narcizo López, the Venezuelan adventurer allied with the Negro slave-traders of the south of the United States. The aim was to maintain the Cuban Negroes in the same condition as the 12,000,000 Negroes of U.S.A. And we all know of the Monroe doctrine and its effects. The notion of maintaining and sustaining Cuban " independence " was the outcome of this doctrine. On this occasion imperialism wore silk gloves, as Al Capone is also capable of doing. Cuba is, according to Jenks (the author of *Our Colony: Cuba*), " the Yankee geographical indigestion." Its position, as a land or naval base in case of an imperialist war (against England, France, Japan, etc.), makes it indispensable.

The war against Spain was provoked by the Yankees themselves, the pretext being the sinking of the American cruiser *Maine* in Cuban waters. Spain lost all that remained of her great empire in America and Asia (Cuba, Puerto Rico and the Philippines), and the young Yankee imperialism secured an easy and bombastic triumph, having succeeded in ousting Spain and gaining new markets for U.S.A. products, and sources of material for industrial manufacture.

The Treaty of Paris (1898) resulted in a declaration of " independence " and the providing of a new proprietor for Cubans. From this moment Yankee products flowed into Cuba, and there began the war without armaments : imperialist economic penetration, and this was accomplished after preparing the way during *two years* of armed intervention, as Japan is doing today in Manchuria.

The first President of " Independent Cuba " was Tomas Estrada Palma, a gentleman *à l'américaine*, who has done much in serving Yankee interests as the governor of Puerto Rico or the Philippines. Without having had any contact with the people he took office under the sanction of the United States. Such was the first President, and the others have also followed the imperialist tradition.

One result of the Spanish-American War was the utilisation of the Negroes of the south as fodder for cannon. The Yankee racists had to find some use for the 12,000,000 Negroes whom it had not yet been possible to exterminate, either by bad living and labour conditions, or by such bands of Fascist assassins as the secret societies typified by the Ku-Klux-Klan. And yet the great " democratic " republic had made use of the experience of English and French imperialism in her colonies and semi-colonies.

In Cuba, the Negro masses had gained their " liberty " according to bourgeois history. But the promises were only on paper. The past of Spanish capitalism had brought no more benefit to Yankee imperialism than to the colonial bourgeoisie, its ally. The Negroes remained without lands and in the

condition of wage-workers who had to construct with their own hands the plan of Cuban agricultural industrialisation directed by Yankee technicians. Now they could make use of their only property, their labour-power, in order to put it out on hire for their white masters, nationals or foreigners, miserably expecting some measure of freedom, although their living conditions have not improved with the rationalising and brutalising rhythm of work, but remain the same as during the colonial period. And the land, trade and industry, as well as industrialised agriculture, are still in the hands of rich whites.

And within the " independent " republic, *by all and for all*, the Negro is excluded from public posts. In the teaching profession the number of Negroes is arbitrarily limited, or the lighter-skinned people are chosen, giving rise to the sentiments of the " half-caste élites." This explains the existence of societies composed exclusively of light-skinned half-castes, or of pure Negroes, among the elements belonging to the liberal professions, to the artisan class or the upper political bourgeoisie. They are in some ways similar to the " élites " of Hayti. Workmen and peasants are not admitted freely into these cultural and recreative societies, which seem at present to be the supreme aspiration of the Negro " petite bourgeoisie " and militant political bourgeoisie.

The refuge of Negroes who have escaped from the working class and peasant masses is, as we have already said, politics. They are utilised by bourgeois politicians as electoral agents, as seekers of votes

Negro children in San José, Cuba

among the Negro working class and peasant masses. And it is always for the promise of a place worth about $83. For a Negro, accord-ing to the bourgeois politician, it is amply sufficient, and he takes care to reserve the best posts for his white friends and relatives. It is only in this way that coloured people man-age to obtain public posts, and certainly, by their proven faithfulness to their white chiefs, some of them come, later on, to occupy higher posts in politics, be-cause the Cuban bourgeois are obliged to make concessions to their Negro and half-caste followers, in order to deceive the masses with this demagogy à la fran-çaise, maintaining an occasional Negro traitor or puppet, both in the ministerial team and in the upper or lower houses of parliament. Everything has its just reason, and produces marvellous effects on the masses whose class consciousness is dormant. This deceptive tendency to promote their Negro and half-caste servants to high posts is a trick from which the Cuban bourgeoisie has been able to profit abundantly. Otherwise there is no way of explaining how, although they form the greater part of the population, the Negroes are excluded, as it has sometimes happened, from the bakery trade (the case of Sandalio Junco in Havana), and how it is that " blue blooded " Cubans are unwilling to allow Central American Negro players to tread the soil of one of the bourgeois athletic clubs of Havana, or that in Santa Clara and Camaguey they are not allowed to be present in the park together with whites, and that it is permitted, with no serious consequences, to encourage a stupid racism imported by our brilliant youth from the United States.

As we shall see, the Negro Cuban proletariat has also its history of class struggles, although several quack politicians and theoretical reformers of the " petite bourgeoisie " pretend to deny this, or explain such things as the aftermath of slavery, indolence and fatalism. All these bourgeois stories and calumnies we must reject as false and motivated by self-interest.

The Negroes have not accepted the exclusions, eliminations, racial prejudices and the whole series of social injustices of which they have been victims, with a demoralising conformity, as some would have us believe. The facts prove the reverse to be the case, and although we reject and condemn Negro racism as a means of struggling against white racism, still its position of inferiority has made it follow this path and group itself under the racial banner the " Independent Colour Party "—a name which will suffice to remind Cuban Negroes of the period of terror through which they lived in May and June 1911. It was founded as an illegal party, as the law of Morúa (a Negro senator) prohibited such racial parties. This one fact shows us the degree of discontent existing amongst the Negroes, who considered that they

had as much right to participate in public life as the whites, and even more, without being the object of arbitrary restrictions and obvious slights simply on account of a question of skin colour.

In May 1911 there broke out in Cuba, and more especially in the province of Oriente, a badly-prepared " revolt," embracing several thousands of Negroes belonging to the " Independent Colour Party " deceived by the racist leaders, Estenoz, Ivonet, etc., and serving as instruments in the hands of the then President, General José Miguel Gomez, who wished by means of this stratagem to get himself re-elected to his position of power, and at the same time ingratiate himself with the United States, of whose support he was not certain. Thus the collapse of the movement brought about the collapse of the plans of the Negro leaders whose war-cry had been " Down with the Morúa law, and long live José Miguel ! " The discontent of the Negroes which had served the ends of General Gomez could not lead to an armed revolt prepared by a white leader, but still the opportunity of making an example of these Negroes was not to be lost. The Cuban bourgeoisie and Yankee imperialists were both determined to " teach the Negroes a lesson " ; armed forces, the police and militia of the whites commenced the massacre of the defenceless population. The newspapers of the time testify to the " heroic deeds " of the whites during this shameful chapter of the history of the republic. Repression went beyond all bounds, and there are no words to describe the savagery and cruelty which took place. The bourgeois and " petite bourgeoisie " youth wore black shirts, anticipating Mussolini, in order to combat the " revolt." As the cities were attacked, men were obliged to flee to the mountains, were decimated, sabred and hung. The Negroes, being entirely unarmed, were unable to fight, but were assassinated, shot and strangled. The bodies of defenceless Negroes were to be seen hanging from the trees. The most cowardly and bestial white could condemn and " do justice upon " his most humble Negro enemy. The vilest forms of revenge were indulged in with absolute impunity. The United States had allowed 48 hours for the suppression of the " revolt." General Menocal, who was to take office after General Gomez, organised militias in order to gain the favour of his masters the Yankees, and to make sure of his future re-election.

After the Negroes had been hunted like diseased rats in the country and in the cities, where they were not made prisoners but struck down like pest-ridden dogs, matters quietened down. Now this bloodiest of stories serves as a terrible accusation. Cruelty had beaten the record. Negro quack politicians, wishing to serve their own personal interests, or those of their white allies in the government, delivered up their friends to the executioner. All this was, later on, used between bourgeois parties and factions as a means of accusing each other during political and electoral campaigns. Today, Negro politicians in the service of the bourgeoisie and of imperialists, present themselves as Negro candidates where their race predominates. They try to awaken racial sentiment, to persuade people to vote in the elections for Negro candidates, and to maintain their aspirations within the existing bourgeois parties. By voting for " liberal," " conservative," " popularist " or " nationalist " Negroes or half-castes, they pretend that the Negro is fighting to vindicate his race, but it is certain that contributing towards the election of these obscure servants of the colonial bourgeoisie means diverting the attention of Negro workmen and peasants from the real struggle. Such people are the best agents and instruments of capitalism who strive to hide the unquestionable existence of racial oppression and the exclusion of Negroes from many circles. The colonial bourgeois try hard to deny that there is a Negro problem, and that Negroes are despised, but their own acts are contradictory. Negroes are excluded from commerce, industry, the university, the magistracy, diplomacy, etc The arbitrary procedure followed in order to accomplish this may be easily imagined. Negro students are examined with extreme severity, and this arbitrary method often forces them to abandon their studies. Admission to hospitals is nearly always a question of colour. As for private clinics, it is useless to raise the question. The Negro professional is boycotted by his white " colleagues " and eliminated from the management of professional organisations. The Negro poet finds his verses thrown into the waste-paper basket. The coloured journalist has thousands of obstacles. A reporter is not allowed to enter anywhere, except in certain specified places. The student generally finds his studies complicated by unjust disapproval, or he is charged an exorbitant matriculation fee in the university or in institutes, which he, as a poor student, is unable to pay. The Negro who perseveres and manages to enter a profession has cruel sacrifices to make, and he has to endure the vexations and provocations consequent upon a host of racial prejudices. If he devotes himself to the arts, it costs him many struggles, and if he triumphs it is because of the superiority of his talent. From theatrical life he is totally excluded, and " Negro " parts are always played by whites who black their faces.

It is necessary to say that in 1912, after the " war of May 1911," a law was passed by congress, preventing any Negro from becoming President of the Republic. In 1926 a proposed law establishing the employment in commerce and industry of 75 per cent. of native hands was rejected, because it would

have meant employing Negroes in these posts. This is a most obvious proof that the racial problem in Cuba is not a fiction.

In Cuba, as in the other Latin-American countries, this problem exists, as does that of the Indian in Peru, Mexico, Bolivia, Venezuela, Colombia, Ecuador, Paraguay, Brazil, Central America, etc., and that of the Negro in the United States. In Cuba, nearly 80 per cent. of the industrial proletariat consists of Negroes (or half-castes, but this is the same thing in such a case), and if there are few native Negroes among the peasantry, it is because they have been obliged to take refuge in the cities on account of the competition in cheap labour and resistance to poor living conditions, established by the traffic in Negroes from the Antilles.

This traffic in Negroes has been carried on in the 20th century by capitalist companies who transport and sell them like beasts, using them as armed forces in the sugar works and the banana works, and sometimes as blacklegs (in Colombia and Central America) against workmen engaged in an organised struggle for an increase in wages, or against a decrease. In this way they contribute towards the vanquishing of the natives by poverty and the awakening of a " nationalist " hatred against their class-brothers who are as yet not conscious of the manœuvres of the imperialists. As soon as the harvesting is finished they are declared indesirable and shipped back to their respective countries just as hungry and miserable as before —even more so now, when a bankrupt capitalism is incapable of finding work for millions of workmen and peasants, who are condemned by the system to forced idleness, hunger and misery.

This misery becomes more terrible every day among Cuban workmen (white and black), and according to the most recent figures (1931) the number of unemployed may be taken as 1,500,000, which for a population of 3,713,000 constitutes a genuine world record !!

Imperialism and its ally, the colonial bourgeoisie, have prevented for a long time the possibility of the Negro workman's uniting with his class-brother, the white workman, in revolutionary organisations to struggle in direct opposition to his class-enemy, Yankee imperialism together with its national allies. The Negro is now overcoming all his mistrust, and today he is like the Negroes of the United States, developing his class consciousness. Little by little, he goes on to occupy his place in the vanguard of the proletariat—the Communist Party.

And we must note the formation of the " League of the Rights of the Negro Race," the Cuban section of the " International Syndical Committee of Negro Workmen " in the worker's field, and of the " Negro Students' Committee," under the direction of the Cuban " Students' Left Wing." This promises to give good results in the class struggle of our country.

CONCLUSIONS

(1) That the racial problem exists and is clearly demonstrated by the series of facts and details which show the inferior position of Negroes.

(2) That there exist certain elements in the Negro race (either pure-bred or half-bred) who exploit this racial sentiment in the ranks of the bourgeois parties, and that these individuals are the worst enemies of the Negro proletariat.

(3) That revolutionary Negro students, workmen and peasants must oppose all those of their race who, in the ranks of the bourgeoisie, wish to " vindicate " the race and " represent " it in Congress.

(4) That it is an error of the Negro proletariat to contrast Negro racial sentiment with that of the white man, as the struggle is *not one of races but of classes*.

(5) That his class-brothers are the white workmen and peasants *who are exploited as much as the blacks*.

(6) That his vindication will be found with those of his white class-brothers, and in a Soviet régime where equality of race, sex, education, feeding and well-being will be possible.

(7) That, this very day, his duty is to struggle, shoulder to shoulder with his class-brothers, and inside the Cuban revolutionary organisations, working towards the Agrarian and Anti-imperialist Revolution, and a peasant and working class government, against the exploiting class and in favour of the exploited class.

(8) The struggle must be one of CLASS against CLASS, the PROLETARIAT against the BOURGEOISIE, the EXPLOITED against the EXPLOITERS.

(9) Our motto must be : against IMPERIALISM and its NATIONAL PUPPETS.

(10) For the admission of all Negroes and whites to our syndical revolutionary organisation, the WORKERS' CONFEDERATION OF CUBA.

(11) And to support and reinforce our Revolutionary Vanguard, the Communist Party, and impose on the bourgeoisie and the imperialists their legitimate place.

The Negro in Barbados

by GORDON O. BELL

Gordon O. Bell

IT is necessary at the outset to observe that there is a definite dissimilarity between the American and the West Indian interpretation of the term "Negro." In America the definition is universally applied to those persons who are not 100 per cent. white; in the West Indies it is apparently reserved for those who are 100 per cent. black. Indeed it is noticeable that in the society of people of Negro descent the word seems taboo, and is religiously eschewed, the term "colored" being used to classify the multiplicity of shades existing between the pure white and the pure black. To call the average colored West Indian a Negro is to affront him, and one such Barbadian minister, making a general reference to West Indians in a recent article, asserted: "In the proper sense of the word, we are not Negroes . . . we are hybrids."

To appreciate the true position which the Negro occupies in the life of Barbados today, it is necessary to know something about the environment to which he has been subjected during and since the days of slavery. A comparison of the history of Barbados with that of any other West Indian island makes it abundantly clear that the conditions which have always governed the lives of Negroes in Barbados have been largely peculiar to that British West Indian island. Many factors have contributed to this: chief among them may be mentioned the alarming density of the Negro population, and its extreme poverty. Cheap and abundant labour, and the truth of the axiom that "possession is nine-tenths of the law" have always combined to give the white oligarchy and plantocracy a firm strangle-hold upon the mass of struggling inhabitants. As a consequence, the Negro in Barbados today is in much the same position as he was in those not so far off days when, "crowded, terrified and cowed in the pestilential atmosphere of a dark cabin, stagnating between the decks of a Guinea ship, debarred the free use of his limbs . . . sometimes stinted with provisions and poisoned with corrupted water," he was taken from his native Africa to work upon the plantations of Barbados.

The date of the introduction of the Negro into Barbados is not correctly known—for the purpose of this essay it is comparatively immaterial. It is sufficient to know that slaves were brought to Barbados in such large numbers, that at no subsequent period of her history has the island suffered from a dearth of labour; indeed, such has always been the density of the slave population that at one time Louisiana could draw on Barbados for supplies.

The first country in the British Empire in which the sugar cane was ever planted, Barbados still depends upon it as its chief source of revenue, and that this supremacy of sugar has largely determined the status of the Barbadian Negro is beyond the limit of debate. In the first place, there were no Crown lands in Barbados when slavery was abolished, and consequently no grants of land could be made to the manumitted slaves, as was the case in many other islands. This small island, with an area of only 166 square miles, and with a population of 180,000, is owned for the most part by wealthy planters and land-owners who enjoy all the amenities of medieval barons and who are singularly destitute of any sense of their moral obligations.

It seems hardly credible that slavery yet exists in a British colony—yet such is the case in Barbados today. Sturge and Hardy in their admirable book, *The West Indies in 1837*, state: "The Barbados Legislature was the latest to pass an Act for the Abolition of slavery as required by the Imperial Government, and the planters have since succeeded in moulding the apprenticeship into an almost perfect likeness of the system they so unwillingly relinquished." The truth of this is evident from the presence on the Barbados statute book of an Act known as the Located Labourers' Act, which works on the following principle. A labourer is allowed to rent a house-spot on condition that he works on the plantation for five days of the week. There is usually a cottage too, for which the labourer agrees to pay partly with money and partly by service. The contract places him under an obligation which prevents him from working on any other plantation, even though a higher offer of wages might be held out to him. Should he absent himself from work, he is liable to a fine with the alternative of imprisonment if the fine is not forthcoming.

As late as June 1931 a located labourer was charged before a magistrate with "absenting himself from work without lawful excuse." In his defence, he stated that he had previously been struck by a

windlass while working on the plantation, and that he suffered from pains in his back; he also produced a medical certificate to show that during his absence from work he had been receiving treatment at the General Hospital. In spite of all this, he was ordered to pay a fine or to undergo imprisonment. The irony of it is that the Legislators are in no hurry to repeal such an obnoxious Act, and the reason is plain, for more than half of them are planters or have interests in plantations.

A word about the administration of government in Barbados will not be out of place. Like the Bahamas, Barbados enjoys a system of Representative Government; that is to say, the laws which are passed by its Constitution are not subject to approval by the Home Government, as is the case in those colonies where Crown Colony Government is in force. There are many who think this freedom a misfortune to Barbados, and with reason. The government is administered by two Chambers. These are known as the House of Assembly and the Legislative Council, and operate on a principle similar to that of the British House of Commons and House of Lords. No Bill passed by the House of Assembly can become law until it receives the sanction of the Legislative Council.

Ten years ago there was only one member of Negro descent in the House of Assembly. Today there are a good many more. Thus, nominally at least, the black man takes a share in the government of his country. His political position, however, is rather anomalous, for as I have already observed, the Legislative Council have the final word, and this body is composed of nine members who are nominees of the Governor, and who are all, not surprisingly, white. It frequently happens that when the Negro voters succeed in ejecting an obstructionist from the House of Assembly, he is given a berth in the Legislative Council, where he can continue to be just as harmful as he was before, or more so.

The results of such an iniquitous system of administration may best be described in the words of a distinguished visitor to Barbados who once said: " You have in Barbados the best—or worst—example of a real oligarchy to be found anywhere within the Empire. Nowhere is political power so completely in the hands of a single class. Opposition from a so-called representative Chamber makes it impossible for a Governor to carry out reforms in Barbados, whether administrative or social."

The term "so-called" is well chosen, for with a population of 180,000, only 18 per cent. of the male adult population enjoy the right to vote; and Barbados sends only twenty-four members to its House of Assembly. Contrast this with Bermuda, which, with a population of 20,000, sends thirty-six members to its House.

The representative nature of the Barbadian legislators can be gauged from the fact that they have sturdily opposed Franchise Reform, Compulsory Education, Luxury Tax, Death Duties, Workmen's Compensation Act, and the introduction of any Bills which might have had as their end the amelioration of the terrible economic and social conditions of the struggling mass of people.

As a writer accurately observed in a recent article:

> It is a remarkable fact, familiar to all who have given any attention to the political and social history of Barbados, that there is not a single beneficial reform of any kind, there is not a single salutary legislative enactment affecting the life of the masses, there is not a single public or private beneficent institution which owes its origin to any member of the Legislature of this country at any period of its history. For any little improvement in their intellectual, moral and material condition, their thanks and their gratitude are due to the Colonial Office in London and to the English officials, State or Ecclesiastical, which it has sent here from time to time. Throughout the entire history of the Colony the attitude of both Chambers of the Legislature has been invariably antagonistic to all public reforms or enlightened legislation.

Despite all this, despite the fact that the colour line is still observed in Barbados, despite the strong tide of bigotry and racial intolerance against which he has had to battle, the Negro of Barbados has yet made noteworthy progress since he was emancipated nearly a century ago.

This progress is chiefly noticeable in the realms of sport and music. In the former he naturally excels, and always figures prominently in any representative cricket or football team, and in athletics. In the sphere of music he is showing a development which, though slow, is full of promise. Negro artistes predominate at concerts and recitals, and at present can be said to furnish the musical life of the colony.

The present prospect of the Barbadian Negro is not a very bright one, and it would seem that his salvation must come through his attainment of greater economic and political power. The lowering of the franchise is one of the first steps towards the attainment of the latter objective, and it is pleasant to see that the feelings of the people in favour of such a reform are strong. There is, too, an awakening for the spirit of racial consciousness, which, if it lasts, may indeed signify the dawn of a new era in the life of the Barbadian Negro. No one knows what the future holds . . . no one knows what lies beyond . . . but the Barbadian Negro hitherto asleep and passive is stirring in his sleep at last, and the sound of his awakening is making itself heard throughout the land.

Folklore in Trinidad

by OLGA COMMA

Olga Comma

Trinidad's folklore, like its population, may well be termed cosmopolitan, for although most of the inhabitants are Negroes, our folklore, because of different influences brought to bear at different periods on the minds of the people, is gleaned from the French, the English, Spanish and Carib beliefs, each in turn very much seasoned with African ideas handed down to succeeding generations of the Negro population.

In recent years, however, some few writers, among them Mr. A. D. Russell, LL.D., Mr. W. D. Inniss and Mr. C. L. R. James, have given to the world a few of our folk tales, but, generally speaking, our folklore is still unwritten. Nevertheless it works its mystic influence not only on the Negroes but also on the descendants of the European settlers.

In nearly every case of superstition (belief if you will) and custom it is always difficult to trace the direct origin. But this does not take away from the strength of the conviction that the particular belief or custom conveys. The preface " they say," which conveys practically the same meaning as the French *on dit*, being sufficiently convincing. Whether this particular plural pronoun refers to the aborigines, or to the wiser heads of the present population, or to the naturally superstitious, one is not aware, but it is certain that no custom or superstition is ever valid unless it is sealed with that motto of force and truth " they say."

To educated minds superstitions ought to be distasteful, but neither education nor religion has yet succeeded in eradicating belief in or adherence to certain superstitions and customs of our island.

In the case of customs, a fair majority seems to have arisen from a misconception or misinterpretation of religious forms and ceremonies, when our ancestors in their uneducated simplicity were eager to grasp all that religion brought in its train. Some customs like the bush bath, frequently resorted to in this island, not only as a cure for bodily ailments but for social and financial ills, can be traced either from South America or Africa. Our ancestors were forced by circumstances to learn the value of each forest herb. No one can deny the value of the bush bath, but the fantastic beliefs associated with the bath place it among those customs which come under the head of folklore. Frequently the bath must be made of a certain number of herbs, any greater or lesser number tending to lessen its efficacy. On no account must the herbs be plucked after sunset, unless one—the spirit's share—be thrown behind the back of the picker. Sometimes, after the bath, the leaves are thrown on to the open road, so that some innocent passer-by may pick up the disease. When the herbs are made into a draught " some say " that nine leaves, and nine leaves only, must be used. Even persons with a family doctor are very careful about these little customs surrounding a bush bath. In every country a good thing is apt to be abused, and the bush bath is no exception. The *Obeahman*, the person who professes to know the cause and remedy for every conceivable human distress, finds material in this custom for his practices.

African ritual, too, has contributed a share to that department of our antiquities known as folklore. Some persons are inclined to gaze upon customs based upon African ritual as witchcraft, or Black Art, but this is hardly fair. Africa's children were considered heathen, but there did exist some kind of faith, some conviction, which must have left some traces down the years in spite of the fact that Afric's children have long ago in these parts embraced the Christ. It is the case in big countries that old customs and practices, or traces of these, in spite of new ideas and advanced theories, remain. In this island the " Shango," an African dance accompanied by a feast, is still practised to some extent. This dance must have been originally a midnight orgy when the centre of attraction was the fetish, and the dance was resorted to in times of stress or trouble, and Africans were convinced that it either allayed the trouble or dissolved it entirely. Nowadays no Trinidadian worships an idol, not even those who try to make fancy religions of their own, but the Shango remains though the fetish is gone. Choruses in African dialect are actually sung by the dancers, even though the meanings of the words have been forgotten.

There is another African custom which adorns our little store of folklore—the custom of wearing jet

301

or black beads. These beads are supposed to possess a certain charm which protects the wearer from any prevalent disease, and which keeps all spirits away. Infants in the island are commonly seen wearing bracelets of these little black beads. Doctors and nurses, however, have a special aversion to the sight of these charms, as invariably they are a sign that the parents are anxious to keep away a dreaded imaginary disease known as Maljoe.

"Maljoe," a name which is really a contortion of "Mal de Ojo," Spanish for evil eye, is a belief which holds sway over the minds of Trinidadians and which comes from the South American Indian. This disease is supposed to be caused by the eye of an envious individual, and even plants are not immune to the disease. In hundreds of cases where babies consistently lose flesh and droop, the simple-minded mother, seeing no cause for a malady, attributes the trouble to maljoe. The Carib's antidote for the trouble is indigo blue, applied to the child's back or foot-sole in the form of a cross.

Most countries can boast of ghost stories of their own, and the "soucouyan" or "la diablesse" is supposed to be a special ghost of Trinidad. The soucouyan, always considered a woman, is a nocturnal traveller whose presence is revealed by a ball of fire, and whose movements are provoked simply by a desire to frighten or annoy those whom she considers her enemies. "They say" that these creatures have a great dislike for salt, or for persons who use a great deal of the condiment. In recent years our folk have been very much inclined to believe that they may be the creations of the highly nervous minds of timid night travellers, but the likeness of one man's creation to that of another's prevents a total disbelief in this nocturnal apparition and soucouyans still exist in our midst.

The masseurs of our island deserve some attention. A common practice of theirs is the knocking of their hands against the posts of the bed after massaging a patient so that in their own hands will not remain the disease of the sufferer, even though the complaint be neither infectious nor contagious. Our masseurs find plenty of work to do as the Negro has a love of being massaged.

This love calls to mind the following ditty:

> De po' ole man is sick in bed
> And he wants somebody fo' to 'noint his head,
> Johnny come down from the high-low,
> De po' ole man.

The 'noint is short for anoint or massage. "High-low" one presumes must mean an upper storey.

Trinidadians place upon the sill of their front door a loaf of bread, which "they say" keeps the wolf from the door as long as it rests there.

Some of our island customs and beliefs, however, can be traced to English settlers, for example the ill-luck attached to the number 13 and walking under a ladder.

The folk-tales that have been handed down from one Trinidad generation to another are perhaps, though, the greatest adornments of our little store of folklore. They are all Negro stories that seem to have had their origin in the days of slavery in these West Indian islands. Unlike Grimm's tales, goblins and fairies do not play an important part, our Negro authors have instead taken for their heroes and heroines the familiar animals, rabbit, fox, cow, squirrel, etc., and some of these clever tales have set forth good morals. They are really for the most part bedtime stories told to the children, who nickname them "nancy stories."[1] It seems that the old Negroes tried to coin these tales with which to soothe and entertain the minds of the piccaninnies in the evening hours, and they continue to be told to West Indian children. Inborn in every Negro is a love of music, and some of the nancy stories are interlaced with music, the bright or wailing tunes adding a picturesque touch to some of the anecdotes.

Below is a familiar story.

Once upon a time there lived a couple who had an only daughter, a very beautiful girl. Their home was near the edge of a forest, and the girl was never allowed to go far alone. She was warned more of the men in her district than of the beasts that emerged from the forest, but the young lady knew no fear. At a certain season a very handsome man would pass the lady's door in an elegant carriage. He would smile neatly to the girl at her window, and she felt very proud at being the recipient of this handsome rich-looking man's smile. But her parents, with their eyes of wisdom, could see further than the maiden, and tried to make her think less of the passer-by. But the day came when she invited him into her house, and he duly proposed. So great was her joy that she turned a deaf ear to the pleadings of both her parents against one whom they knew to be a deceiver. Without consulting them she arranged to marry him,

[1] In Jamaica is the Annancy tales.

and the aristocratic bridegroom came one bright afternoon to claim his innocent bride. With little ceremony, the girl stepped into the beautiful carriage and the bridegroom drove off. But hardly had they entered the forest when she saw that her husband was in reality a huge snake who had played the role of the handsome gentleman. The maiden in utter dismay cried:

> Ma-mmy oh, Pappy oh,
> If a bin a hear wa' me ma-mie say
> Dongoya (Don't go here)
> If a bin a hear wa' me pa-pie say
> Dongoya.

He in ridicule replied:

> De young gal, De young gal say
> Don go ya.

These few lines are set to a wailing tune, and make very attractive music to the piccaninny's ears.

The tale, as one readily sees, has really no effect on the child's mind except the feeling of horror at the snake's appearance, but when the years of discretion come, the question of obedience is made clear.

The Uncle Remus tales, well known to English readers, have been probably gathered from such similar sources as our Trinidad folk-tales. In the waters around or 'neath the immortelle shades there are rocks and trees with fantastic tales woven around them, and many of our glens breathe mystery. Some think the mailed fish or " cascaradura," the flesh of which when eaten by the stranger forces him to remain within our gates, has some secret reason for donning a coat of mail down in his muddy home in the river bed. Our world-renowned Pitch Lake is also the home of many a supernatural story.

While we may not be able to boast of much folklore, life in our island is gilded here and there by fanciful or gruesome tales or beliefs handed down from this or that uncertain source. There is quite a lot in the region of these Carib Seas that is mystical, and our own Trinidad, like nearly all the other West Indian islands, possesses some of that mystical charm which adds considerably to the beauty of this island.

"White Trash" in the Antilles

by H. GORDON ANDREWS

H. Gordon Andrews

THE Antilles, or West Indies, are perhaps the oldest of the British colonies, and were the scene of an almost incessant warfare for over a hundred years between England, France and Spain, each struggling for possession. The blood of these three countries, shed on the battlefields during war, was in peace-time mingled with the blood of native Carib and African slave mothers.

I shall speak only of Grenada, the land of my birth, and trace the origin of its white inhabitants, the poorer classes of whom are known there as " White Trash."

The island of Grenada was discovered by Columbus on August 5, 1498. It is situated about 90 miles to the north of Trinidad and is about 21 miles long and 12 miles at its greatest breadth, with a total area of about 120 square miles. For over a hundred years after the island's discovery the natives were allowed to remain in undisturbed possession, apparently because the then great powers, England, France and Spain, were concentrating their attention on more important fields on the American Continent and on the much larger islands.

According to documents left by Major John Scott, written in the reign of Charles II, the first attempt to colonise Grenada was made by a company of London merchants who were equipped with three ships loaded with the necessary stores. They arrived there in 1609, and landed 208 colonists, but were so

persistently harried by the natives, the Caribs, that they were compelled to abandon the settlement and return to England, arriving in London on December 15 of the same year.

Although theoretically both England and France laid claim to it, yet it was not until the year 1638 that a Frenchman named Poincy attempted to effect a landing. He was driven off by the Caribs, who were not again troubled by invaders for a period of twelve years. Then in the year 1650, MM. Houel and du Parquet, shareholders of the French company of the Islands of America, landed on this island with 200 invaders. Whether overawed by their numbers or bribed by the gifts of beads, trinkets, knives, hatchets and two bottles of brandy, the purchase-price alleged to have been paid by du Parquet and his friends, it is not known. In the year 1651 du Parquet, having established himself, left a relative of his, Le Compte, as Governor. The natives, who hitherto had shown no signs of hostility, now sensed the dangers to which they had laid themselves open, and started a revolt to oust the invader from their shores; but being very feebly equipped with fighting weapons, they were overpowered and almost exterminated by Le Compte and his men—300 strong—freshly reinforced by du Parquet.

For forty-eight years afterwards the French held the colony, and, notwithstanding many small wars and rumours of war, enjoyed some amount of peace and prosperity.

1756-1763.—War was declared between England and France. Admiral Rodney arrived in the West Indies at the close of the year 1761 with a fleet of 18 ships of the line, and land forces, under the command of General Monckton, of 10,000 men. Upon the surrender of Martinique to him on February 4, 1762, he dispatched a squadron to Grenada under Commodore Swanton, whereupon the French surrendered to that officer, and the island passed under British dominion.

The Treaty of Paris was signed on February 10, 1763, conceding Grenada and the Grenadines to England. On October 7, by Royal Proclamation of George III, it was announced that letters patent had been issued creating the Government of Grenada, " comprehending the island of that name, together with the Grenadines, and the islands of Dominica, St. Vincent and Tobago," and providing for Councils and Assemblies of the representatives of the people therein.

It should here be noted that at the time of the cession the French were allowed to remove all public documents to Martinique, so that there are no records in the colony dating prior to 1763. This proceeding appears to have been provided for by the 22nd article of the Treaty of Paris.

In the year 1700 a census was taken and the following were enumerated: 257 whites, 53 free coloured persons, and 525 slaves who were employed on the plantations. Fifty-three years afterwards, in 1753, another census was taken and reported as follows: 1,263 whites, 175 free coloured persons and 11,991 slaves. This is the method introduced by the French into the island for classifying its inhabitants.

A brief reference might be made here to the activities of Sir Francis Drake who, history records, did a flourishing business in the year 1600 by plundering Spanish settlements in the West Indies and America and Spanish galleons at sea. His highly respectable friend and colleague, Sir John Hawkins, became immensely rich as a slave trader, which honourable profession he began to practise during the reign of Queen Elizabeth. His speciality was kidnapping Negroes along the West Coast of Africa, in particular Guinea, and selling them to the Spanish West Indies and America. His ship was called the *Jesus*.

So noble was that occupation considered in those days that the English Government became green with envy, coveting the spoils of the iniquitous traffic in human flesh. Their ambition was realised when the French, after their defeat by the English in an alliance with the Dutch, were forced to sign the Treaty of Utrecht. By a clause in that treaty the French, who then had control of that traffic, were forced to concede to the English that right, namely, that England was to have the exclusive right for thirty-three years to supply the Spanish-American colonists with Negro slaves. According to the Rt. Hon. Winston Churchill, writing on January 8 of this year in a London weekly newspaper, the *News of the World* (which claims the largest circulation in the world), " Over 660,000 slaves were held by ministers of the gospel of the different Protestant Churches in the United States of America during the period of slavery; 5,000 Methodist ministers owned 219,000 slaves; 6,500 Baptists owned 125,000; 1,400 Episcopalians (this corresponds there to the Church of England) held 88,000." But even that was not enough to satisfy the rapacity of these kind " white brethren." They probably also sought to hold their souls.

" White Trash," or " Yellow Legs," as they are called in the West Indies, is a derogatory appellation implying inferiority and contempt. It is a phrase coined in the United States of America to castigate and ostracise a section of a white community, and place them in a state of conscious inferiority.

" White Trash " in the Antilles

The " White Trash " colony in Grenada is located about 3 miles inland from the capital of St. George, in a district called Mt. Moritz. So far as the historical printed records of the island are concerned no information whatever is given on this subject. Whatever statement is made here on this matter is done in good faith and based on personal knowledge. The population of this group of poor whites is swiftly being absorbed by amalgamation with some of the lower classes of Africans. No mulatto or black who may consider himself of good class would inter-marry with one of these whites, so great is the contempt in which these poor unfortunates are held.

There are no official records as to the exact population of this poor white colony.

It is notorious that whenever these poor whites are on their way to market in the capital, street-urchins shout such epithets of abuse as " Poor Backra," " Backra Johnny," etc., and a short tune to local words is sung. I append it here. This tune is well known also in Barbados, where the population of poor whites is much larger, and, I believe, originated from the same source as that of Grenada.

Cricket Gills and Dried Barnabis

GLOSSARY

Cricket Gills = Crickets' wings.	*Bakra* or *Baccra* = Poor white.
Barnabis = A sort of home-made biscuit.	" *Bukra* " in Hindustani, I am told, means " goat."

Now go back with me to the England of the year 1649 and onwards, and you will see into perhaps the most barbaric and iniquitous period of English cruelty in her misgovernment of that unfortunate country Ireland—all done in the name of christianity. The fruits of this prejudice and hatred are being reaped today. You will see how the great " Land question " originated in the years 1649–51, the question in burning dispute between the two countries today—land annuities.

The Royalist party in Ireland proclaimed Prince Charles, son of Charles I, King. An attempt on the part of the English Puritans to root out Catholicism in Ireland (1641) had caused a terrible insurrection there. Parliament deputed Cromwell to reduce that country to order and to destroy the Royalists. Nothing could be more congenial to his " Ironsides " than such a crusade. They descended upon the unhappy island (1649) and wiped out the rebellion in such a whirlwind of fire and slaughter that the horror of the visitation has never been forgotten. To this day the direst imprecation a Southern Irishman can utter is : " The curse of Cromwell on ye ! "

Several years later (1653–54) Cromwell determined to put into practice a still more drastic policy. He resolved to re-people a very large section of Southern Ireland by driving out the Roman Catholic inhabitants and giving their lands to English and Scotch Protestants. It seemed to him the only effectual way to overcome the resistance which that island made to English rule. By the use of military power, backed by an Act of Parliament, his generals forced the people to leave their houses and emigrate to the provinces of Connaught on the west coast of Ireland, part of which district was so barren and desolate that it was said " it had not water enough to drown a man, trees enough to hang him, or earth enough to bury him." Thousands were compelled to go into that dreary exile, and *hundreds of families who refused to do so were shipped to the West Indies and sold to the planters for a term of years*, a thing often done in those days with prisoners of war. They sold them for a period of ten years to be worked to death or flogged to death on West Indian plantations.

After the abortive insurrection of the English Jacobites under the leadership of the Earl of

Mar, all the leaders (excepting himself, who escaped to the continent) were beheaded, and about 1,000 of the rank and file were sold as slaves to the West Indies and the plantations of Virginia in America.

The South-Sea Bubble, so called, came into being, embodying as it did that gigantic enterprise undertaken by the South-Sea Company to pay off the English National Debt, mainly, it was said, from the profits made in the slave trade between Africa and Brazil. The Mississippi Company also proposed to do the same from the profits of the slave trade between the West Indies and the countries bordering on the Mississippi.

The curse of Cromwell's puritanical hypocrisy still plagues us to this day in the form of a kill-joy spirit so prominent in our laws. He treated the most innocent customs, if they were in any way associated with Catholicism, as serious offences. He closed all places of amusement, and condemned mirth as ungodly. He made it a sin to dance around the Maypole or to eat mince-pies and Christmas pudding; fox-hunting and horse-racing were forbidden, and bear-baiting prohibited, not because it gave pain to the bear, but because it gave pleasure to the spectators. So much for christianity in Ireland.

In Ireland today, as a direct result of six hundred years' growth of the seeds of religious and political persecutions, Great Britain is reaping the fruits of hatred, war and civil strife. So intensely have these unfortunate people suffered, and for so many centuries, from the sword of tyranny and despotism, that it would be unnatural to find a genuine Irishman, woman or child who does not cherish some form of hatred for England.

By the foregoing historic facts a direct connection has been established between the unfortunate political and religious exiles deported from Ireland for the most part, and in a lesser proportion from Britain, to the West Indies, practically bereft of every vestige of economic value save their labour, there to be reduced to a condition of deterioration; their descendants are those who form the dejected colony of " Poor Whites " found in Grenada. *This stands as a permanent evidence of the relic of Cromwellian barbarity and oppression.*

A new race of coloured people born of African and native Caribbean mothers, and whose white paternal ancestors claim lineage from some of the best and noblest families of France and England, came into being.

The greatest of these coloured citizens in Grenada was the celebrated Fédon, who carried on against the English a war of extermination. It was his loyalty and that of his fellow-mulattoes that constituted the greatest menace to the English occupation of this island.

The year 1794 was one of stirring events not only in Grenada but in the other West Indian islands. The vibrations of the mighty wave of the French Revolution of 1789 were still in the air, and in the island of Hayti (or San Domingo) had borne fruit, in 1791, in an uprising of the coloured people and Negro slaves, who after a war of extermination directed against the whites, were by the year 1793 in practical possession of the French section of the island. A British expedition was sent from Jamaica to capture part of the island, but after varying success the attempt, which spread over several years, was abandoned. To the black and other coloured populations of the other settlements in the West Indies the success of their congeners had, however, sounded a note of awakening. Crushed by slavery, and even such of them as were free labouring under political and social disabilities, it is not to be wondered at that the prospect of freedom by similar means became the dominant idea in their minds. While all these elements of discord were fermenting in Grenada, and rebellion only required a leader, the emissaries of Victor Hugues arrived upon the scene. As leader of the insurrection, this coloured planter, Julien Fédon, who owned the Belvidere Estate on the heights of St. John's Parish, was selected and a commission given him as General Commandant under the French Republic. Other commissions as officers of the French Army were also given to other coloured men, namely, Stanislas Besson, Charles Nogues and Jean Pierre La Valette.

At midnight on March 2, 1795, the storm broke; a body of insurgents under Fédon surrounded the town of Grenville, and a horrible massacre of the British subjects ensued. Neither age nor sex proved a bar to the ferocity of the rebels, and by morning the town was a reeking shambles from which the rebels retreated to the mountains, laden with spoil. Simultaneously there was an outbreak at Gouyave on the opposite side of the island, but here the rebels contented themselves with seizing the British inhabitants, and haling them bound and half-naked to Fédon's Estate, Belvidere, where they proceeded to fortify the estate works, and finally to entrench themselves behind rude earthworks on the summit of an adjacent mountain, now known as Morne Fédon, or Fédon's Camp. Here they were joined by nearly all of the French colonists, the more respectable of whom were, no doubt, driven to this step by the fear of Victor

Hugues, whose proclamation, threatening terrible retribution on all who failed to join the movement, had been well circulated among them.

Lieutenant-Governor Home, at this time deputising for the Governor, instead of being at St. Georges, the headquarters, at such a time of danger, was spending some days with a party of friends on his estate at Paraclete, about 14 miles from the capital north-west of Grenville.

On hearing of the success of the rebellion, he despatched a native messenger over the mountains while he himself took the sea route, after a short land journey from Paraclete to the harbour, naturally considering this the safest way to the capital.

Embarking at Sauteurs on a small sloop, he attempted to get down to St. Georges in the South, but was intercepted at Gouyave, which, unknown to him, was also in rebellion and actually in the hands of the rebels.

Here panic seems to have seized him, and instead of continuing on his way by sea, he made for the harbour of Gouyave, where he walked, all unsuspecting, right into the enemy's camp. A battery opening fire on him and his party gave him the first intimation of danger. It was too late to retreat and he soon found himself and his party of 50 men taken captive. From Gouyave they were removed to Fédon's Camp and held for some time as hostages, in the meantime being treated with great indignity. Fédon thereupon informed Governor Home and his fellow-prisoners that if any attempt were made to rescue them or attack his camp he would slaughter them without mercy.

While an attack on the Morne Fédon was taking place, a horrible tragedy was being enacted within the camp on the top of the mountain. As has been stated, there were 51 British subjects in the power of the rebels, among them being Mr. Home, the Lt.-Governor; Mr. Farquhar, his A.D.C., and the Honorable Alexander Campbell, a member of the Council, and several leading men of the community. These unfortunate people had undergone much suffering since their capture, and had been repeatedly warned by Fédon that upon his camp being attacked they would be killed, and he had compelled them to write and say as much to the President and Council. This threat was now carried into execution, and during the assault just mentioned, they were, with the exception of three, done to death. These three happened to be: Rev. Francis McMahon, the clergyman, and Dr. John Hay, the medical officer, both belonging to Fédon's district, and Mr. William Kerr. As to the rest, with one or two exceptions whose protracted sufferings had affected their minds, they met their fate as became their race and station. It is indeed a tragic pity that no serious heed was taken of Fédon's threat, which seems to have been entirely ignored if not treated with contempt. This tragedy otherwise might easily have been averted.

Vanity and bombast seem to have dulled the senses of the English, so much so that they underestimated the valour, courage and fighting strategy of Fédon and his rebels, whom they assumed would turn and fly at the mere sight of the whites. The Englishmen evidently lost sight of the fact that Fédon was not the gullible and easy-going African, but that being a mulatto, he had inherited the cunning and craftiness of his white forebears while he retained the courage and nobility of his black ancestors !

In conclusion, I find from my researches that these unfortunate white people deported to the West Indies during the periods heretofore mentioned were merely victims of various forms of oppression, either religious, racial or political. I find also that the basis of all social distinctions or prejudices is economic. I hope that I have shown in my brief article that practically the entire community of " White Trash " or poor whites in America, in Grenada and elsewhere in the West Indies, came practically from the same source, and because of the same circumstances. The racial, religious and political hatred and passions of the 16th, 17th and 18th centuries were simply conveniently converted by heartless speculators into hard cash or its equivalent. It is for money, or social or political advantage, that men have sold their own flesh and blood.

The " Po' white trash " of the West Indies and America call for as much sympathy as the wretched Negroes of Africa who were enslaved and exploited for the same reasons, and against whom is felt that self-same prejudice that the lowliest Grenadian feels against poor " Backra Johnny," who to him is nothing more than " White Trash."

The Negro and his Descendants in
British Guiana

by A. A. THORNE, M.A.

THE POLITICAL AND ECONOMIC CONDITIONS IN BRITISH GUIANA, AND THEIR EFFECT UPON
THE NEGRO AND HIS DESCENDANTS

Transition from Dutch to British Rule

A. A. Thorne, M.A.

I T must be borne in mind that, prior to 1802 and to 1814, when this
South American colony came into the possession of Great Britain by
conquest and by treaty, that it was a Dutch colony with Roman-Dutch
laws, and that by the terms of the treaty in 1814 it was agreed that the laws
and constitution of the colony could only be changed with the consent of
its inhabitants.

Roman-Dutch law was more humane and more suited to a new colony
with an existing slave trade, to be abolished subsequently, than British law.
Under the Roman-Dutch law no woman is the mother of an illegitimate
child, and all children born of a couple before marriage are made legitimate
by the subsequent marriage of the couple. Furthermore, illegitimate
children of fathers who recognise them are heirs to their fathers after their
legitimate offspring, when there is no will, while fathers can bequeath
estate to them in wills not to be disputed unless by a wife who is heiress to
half of the deceased husband's estate, her estate not being hers to dispose
of at her sweet will after marriage, but being in community of possession
with her husband, without whose consent she can make no disposal in her
lifetime, for whose debts her estate is liable, and to whom half belongs on
her pre-deceasing him.

Dutch Paternal Affection for Coloured Children

Now many slave owners were infatuated with love for women-slaves, whom they regarded as their
mistresses, and by whom they had children. These children's freedom they purchased shortly after
their birth, so that there were very many " Free Mulattoes," as they were termed, before the abolition
of slavery in 1838. Many of these free mulattoes inherited estates from their fathers, and were educated
in Europe, having nothing in common with the Negro race from which their mother was drawn aside.

Segregation of Coloured from Black

There has consequently been a gulf separating the coloured and the full-blooded Negro, and it has
been chiefly by marriage between black men and mulatto women that this gulf has been narrowed, not
bridged. There is a great lack of unity among the descendants of the Negroes on this account, the
coloured section considering itself stigmatised if regarded as part of the Negro population of the colony.
The taint of slavery is held to have affected adversely for all time the full-blooded Negro, and to be
minimised and disappear in proportion to the fairness of complexion in those of mixed origin. A very
different idea to that obtaining in the United States of America, and very injurious to the morals of the
people, since illegitimate half-castes are regarded as superior to legitimate Negroes, and get more con-
sideration for employment in public services and in prosperous commercial undertakings than do the full-
blooded Negroes. This induces coloured women to have relationships with white men, who in British
Guiana are not generally a credit to the European set standard of morality, and have not the honesty of
the Dutch whites towards their coloured children.

Evil Effects of Absentee Proprietorship

British Guiana had after the abolition of slavery rapidly become a country of absentee proprietors
with no long-established families of gentility. Portuguese, Chinese, and East Indian immigrants were
introduced to supply the labour market on terms of indenture for a number of years, and from such
immigrants have sprung up the leading members of the community. The standard for priority of rank
has been fixed by money and not by culture. There is therefore not the greatest honour among the

308

merchants and professionals who occupy the leading positions in its colonial life, and shiftiness, un-reliability, and distrustfulness among the inhabitants are prevalent characteristics. The character of the Negro has deteriorated, and he lacks the honour, the honesty, and the spirit of co-operation with which he emerged from slavery in 1838.

Legislation Moulds the Negro

Legislation gave the Negro his freedom from slavery. Legislation supplanted him on the sugar estates with indentured immigrants. Legislation took the control of his villages out of his hands and placed them in the hands of the Public Works Department of the Government. Legislation subsequently, in 1892, gave him village councils, through which he took part in the administration of village affairs. Therefore the Negro has been compelled to take a keen interest in politics, and has suffered greater hardships through politics than any of the other races competing with him in the colony. Torn away from his native home in Africa generations ago, cut off from all intercourse with his forefathers and kin in Africa, stripped and denuded of all of his ancestral customs, good and bad alike, in an alien civilisation that denied him humanity until the abolition of slavery in 1838, the Negro has had a sharp struggle for existence, and in British Guiana he must have been effaced had it not been for the steady influx of West Indian Negroes, chiefly Barbadians, to replenish his lessened ranks, restore much of his lost courage, and infuse into him much of the ambition responsible for his progress along various lines. Becoming alive to this rejuvenation of Negro stock in the colony, the Negro of Guiana, incited to it by European residents who fear Barbadian competition, possesses an unreasonable prejudice against his Barbadian brother Negro, and practises much deceit against him.

Pernicious Effects of Colony's Isolated Position

British Guiana, through the physical features of its coastland and its small development, which is more or less confined to sugar in the hands of capitalists, is not on ocean routes, but is the terminus of vessels specially despatched to it. Its isolation impedes the progress of its peoples, but especially of the Negroes, who have not the means to travel frequently to and extensively in the Big World. There is therefore much narrowness of spirit, an excessive amount of petty jealousy instead of keen emulation or ambitious rivalry, and, among the Negroes, a parochialism which prevents sister-villages from linking together for their common welfare, and destroys all chances of successful leadership amongst them. To such an extent has this unfortunate tendency developed that, in this year of grace 1932, the Colonial Government has inaugurated a system of District Commissionership to terminate the constant bickerings in village councils and to supplant the little village administrations in the hands of villagers. This has been a disgrace to the efforts and valuable work done by the late William Harold Hinds (editor of the defunct *Echo*), first chairman of Plaisance Village Council, after the Village Councils' Ordinance was enacted in 1892; the late J. Macfarlane Corry, J.P., Chairman of Fellowship Den Amstel Council from 1892 to his death, and founder of the Village Chairmen's Conference, which was a power in his hands and commanded the respect of the Colonial Government; the late Rev. Fitzgerald C. Glasgow, Chairman of Bagotville Village Council, and a most respected member of the Local Government Board of the colony up to his death. This serious retrogression follows the loss of the Constitution of the colony in 1927.

The Negro in Politics

From 1838 to 1890 the Negroes, though constituting more than half of the colonial population, and being the principal contributors to the colonial revenues, had no direct voice in the administration of its affairs, while the plantocracy controlled the Government, having the 14 elective seats against the Government 8 in the Combined Court, which held the purse strings of the colony. The riots of 1889 caused by a Portuguese kicking a black boy in the Stabroek Market, Georgetown, brought home to the Negroes the need of a change in the Constitution. Many circumstances were favourable for a Reform Movement. Viscount Gormanston, the Governor, was an Irish Liberal. The Attorney-General, Dr. (afterwards Sir) John Carrington, was a Barbadian accustomed to and enamoured of electoral rights. The other Europeans disapproved of the Portuguese bearing towards the Negroes, and regarded the Portuguese *nouveaux riches* rivals in trade as upstarts. The Negroes had produced a goodly number of distinguished inhabitants, had graced the learned professions, and had entered the newspaper world effectively. Accordingly, in 1890, the Reform Movement, launched principally by D. T. Straughn, editor-proprietor of *The Liberal*, and William Harold Hinds, editor-proprietor of the *Echo*, received strong and enthusiastic support from European merchants and planters and the masses of Negroes. The other large portion of the inhabitants was composed of East Indian immigrants, indentured, and subsequently entitled to repatriation to India, mostly illiterate, and without any interest in politics.

The Negro and his Descendants in British Guiana

Jubilee Emancipation Celebration, 1888

It was most fortunate that the Negroes had, only a couple of years before the 1889 riots, celebrated the Jubilee of Emancipation fittingly and gained the admiration of the Government and of the resident Europeans. A galaxy of talent had been displayed, and there was no doubt as to the fitness of the Negro for the franchise. The distinguished Mayor and Mayoress of the city of Georgetown were coloured, Mr. and Mrs. George Anderson Forshaw. Mr. Forshaw was the leading solicitor in the colony, and to his residence the Governor of the colony was a frequent visitor. The music for the Jubilee was composed by local talent and rendered effectively by cultured Negro vocalists and instrumentalists. The Industrial Exhibition of the Celebration displayed a wealth of talent in art—paintings, drawing, modelling, embroidery, knitting and other fancy work—in handicrafts and trades, in horticulture and peasant farming. The scholarly sermon preached in St. George's Cathedral on the occasion was by a well-educated Negro clergyman, Rev. J. R. Moore, trained at St. Bee's, and C.Th. Cambridge University. The reporters and compositors of the two daily newspapers were coloured and black, the editors of the tri-weekly *Liberal* and weekly *Echo* were Negroes. The school teachers in the primary schools of the colony were all of the Negro race at that date.

Queen Victoria granted Change of Constitution

A thorough and extensive campaign over the whole inhabited area of the colony by the leaders of the Reform Movement brought it universal support and a huge number of signatures to the Petition to be transmitted to Queen Victoria praying for the Change of Constitution. Presented to Lord Gormanston, the Governor, in 1890, and favourably recommended by him in his despatches forwarding the Petition, Queen Victoria, whose reign was ushered in with the Abolition of Slavery throughout the British Colonies, was pleased to accede to the prayer of the Petition, and, in accordance with the Treaty of 1814, to change the Constitution at the request of the inhabitants of British Guiana.

1891 Constitution

Eight of the sixteen members of the Court of Policy were under this change of Constitution directly elected by the people on a fairly liberal franchise, and all six Financial Representatives to sit with the members of the Court of Policy to constitute the Combined Court, which held the purse strings of the colony. It was the most liberal and effective Constitution for the Negroes throughout the colonies of the West Indies and British Guiana.

Open Voting

At first all voters had to record their votes openly for candidates nominated for election. This meant that employers controlled the situation. The *Echo* fought hard for the Ballot, and persuaded an Etonian planter-proprietor, Edward Chauncey Luard, of La Bonne Intention, East Coast, Demerara, to take the initiative in his seat as Member of the Court of Policy for East Demerara, and use his great influence and eloquence to get the needed change to the Ballot, and successfully introduce the Ballot in the Constitution in 1895.

At the General Elections which followed in 1896, the people gained the majority of the seats in both branches of the Legislature. Duncan Macrae Hutson was elected Senior Representative for the city of Georgetown, and a little more than a year after was given a seat in the Executive Council of the colony, to continue in that seat until his death in 1915. He was the first coloured member of the Executive Council. In those elections also Patrick Dargan gained the seat for South East Essequebo to begin his remarkable career as a fearless champion of the cause of the people. Andrew Benjamin Brown also succeeded over a very influential planter-proprietor, Benjamin Howell Jones, in West Demerara, which he represented for twenty-five successive years, forfeiting the confidence of his constituents and the Negroes of the colony in 1919, when at the instance of the planters and Attorney-General Nunan he moved for the revival of East Indian immigration, under the guise of colonisation, to supply the estates with cheap labour in competition with local free labour.

This has been the turning point in the Negroes' march under the Constitution. Confidence shaken and hopes ruthlessly shattered by the Colonisation Movement, supported by the majority of his own electives, the Negroes have used their votes as a weapon of attack upon each other, having been misled by parasites and self-seekers of the worst type, have sold their votes to apparent friends, but in reality enemies, and have, through their representatives in a single term, 1921–6, made such a mess of public administration and financing that the Constitution has been altered on the report of the Wilson-Snell Commission, and the colony made a complete Crown colony with a single legislative chamber, the Legislative Council, composed of twenty-nine members, fifteen of whom are Government officials and

nominated. The misfortunes of the people are not to be wondered at, when the electors could be gulled into electing the Secretary of the Colonisation Delegation to London in 1919 one of their champion leaders and representatives. He was editor of a popular daily, and he used it for his own ends, and to sow the seeds of discord which hurt the colony irreparably up to the present time.

Governor Sir Gordon Guggisberg was the first administrator under the new Crown Colony Constitution. His change of attitude towards the Negro has been hard to understand. In his retrenchment policy in the public service of the colony in 1930 he hit the Negro hardest, and, to crown it all, he inaugurated a Land Settlement Scheme of some magnitude out of colony funds for East Indian families *exclusively*! The Negro has been a traitor to himself, and he has been made to taste the gall of treachery.

ECONOMIC CONDITIONS

Unskilled Labour

Though the area of the colony, roughly 90,000 square miles, is equal to that of Great Britain, and though its extensive coastlands can easily be made to produce 1,000,000 tons of cane sugar according to the reports of experts, the colony is for the most part covered with virgin forests containing valuable timber and gums, and gold, diamonds, and bauxite have been found in it on an extensive scale, yet the economic conditions existing in British Guiana have never been satisfactory because of the influence of the sugar-planters who dominate the Government. Sugar has been the first care and almost the only care of the Government under British rule. Sugar is an industry of the big capitalist, who has always willed that the cane cultivation be carried on by his slaves and his serfs, indentured immigrants. The land not under cultivation is either inaccessible from the coastlands, or is unsuitable for successful peasant farming through lack of drainage and irrigation. The hinterland has not been accessible for trade with the outer world in its timbers and minerals on an extensive scale. Consequently the Negro unskilled labourer has had to eke out a precarious existence as a general rule, the statutory low day's wage of the indentured East Indian immigrant, up to 1916, determining more or less the wage the Negro labourer could earn. The average daily wage of the unskilled labouring man is two shillings, that of the woman varying from sixpence to tenpence.

The recent census returns show 130,540 East Indians, 124,203 Blacks (Negroes), and 33,800 mixed. The mixed are chiefly, at least 80 per cent., of Negro origin. But the separation of the lighter-coloured Negro offspring from the full-blooded Negro has the effect of making the East Indian element of the population the greater. A very large percentage of those returned as Europeans, white, would not be so considered in U.S.A.

The East Indian has, from the abolition of slavery up to the present time, lowered the standard of wages and of living throughout the colony, and the meagre wages and returns from rice cultivation on which the East Indian exists would kill out the Negro labouring population very rapidly. The East Indian wears very scant clothing, lives on rice and dholl chiefly, and contributes very little per head to the customs revenues of the colony. The Negro and his descendants, on the other hand, live like the British people, feed themselves well, and too often over-dress.

Skilled Labour

The mechanics and artisans in the colony are for the most part Negro and Negroid. Owing to the undeveloped condition of the colony, the supply exceeds the demand, and so these workers are not steadily employed the year round. The average wage of a man thus trained varies from 3s. 4d. per day to 5s. Women, as dressmakers, milliners, and pastry-makers, fare even worse, and seldom earn more than £25 for a whole year.

Clerks

The natural tendency of the middle classes is to seek employment as clerks and salesmen, the spirit of initiative having been sapped by the hard experiences of their predecessors over a series of years. The wages of selling clerks—male and female—are not satisfactory when compared with the high cost of living created by abnormally high customs duties and excise licences. These wages usually vary from £2 10s. to £10 per month, the women seldom reaching £4 per month. The standard of morality is consequently very low, because the earnings cannot meet the ordinary requirements of life for them.

The clerks—male and female—in offices, public and private, earn salaries ranging from £4 to £20 per month as an average, and a fair number succeed in filtering through to the top as accountants, despite racial discrimination. These, however, do not receive the same salaries as Europeans in the same position,

but are paid at least 25 per cent. less. There are a few notable exceptions to this, chiefly in the Civil Service of the colony.

Professions

In the learned professions—law, medicine, the ministry, and secondary teaching—the Negroes and their offspring are well represented, quite a few of them standing in the front ranks. While there are no fortunes to be made in these callings under the existing economic conditions of the colony, yet it is very satisfactory that the Negroes and coloured members of the professions enumerated march *pari passu* with the European.

Merchant Traders

The Negroes and the coloured people are almost at a discount in this direction, so few of them being found among the successful business people. Their greatest progress in business has been in the drug trade and in jewellery. They have had excellent opportunities in the goldfields and in the diamond fields of the colony, but, unfortunately, the class of them operating there was of the unskilled labourer as a rule, and easily blown from the dizzy heights of success. Up to a decade or two ago the Negro and the coloured cattle farmers held the lead in this class of business, but today the East Indian has surpassed them.

Domestic Service and Laundry

This field was also the Negroes', until in the former the East Indians supplanted them at a cheaper wage on the sugar estates first, and later divided the supply of the waiting service with them in the towns and other parts of the colony. In the latter, the Chinese have gained the ascendancy, making the profits from this work, and leaving the Negresses to carry on the large unremunerative portion of it.

Social Conditions

There is no definite line of demarcation between the Negro race and the European socially, although there are a few clubs and business places in which dark-skinned descendants of Negroes are not to be found, while fair-skinned ones are. Yet the chief of these, the Georgetown Club, had as one of its founders the dark proprietor of a sugar estate, William Smith.

The change of the Constitution in 1891, with the Ballot provision added in 1895, resulted in many Negroes and coloured representatives in the local legislature from 1896 up to the present time. A goodly number of these having proved themselves worthy of that trust immediately, higher education was brought within the reach of Negroes without discrimination, and the Civil Service of the colony thrown open to all by Governor Swettenham in 1903. Consequently there has been continuously increasing cosmopolitan association in school life, in the professions, and in the Civil Service.

Race distinction had nearly disappeared in the colony ten years ago, but has reared its ugly head again, since some American-trained professional men returned to the colony and unwisely started a glamorous Negro Progress Convention which suited American conditions, but not British Guianese-West Indian. The Europeans have naturally countenanced this movement and its leaders in the following manner : they have taken the opportunity to form themselves into water-tight racial camps. Much ground has been already lost by the Negro and coloured people, and they experience great difficulty in getting fair play in the matter of employment as educated people. Two of the leaders of the Negro Progress Convention sit on the small Education Committee to advise the Director of Education, and have been powerless to prevent the Ursuline Convent refusing admission to girls of dark colour three years ago. Teachers of elementary schools, trained at training institutions in the West Indies to which they had been sent by the Government of the colony, prior to the establishment of a local training centre four years ago, have been unfairly treated and robbed of their rights as trained teachers. And, last year, we saw the sudden lowering of the standard of the Guiana Scholarship and higher education in the colony, and drastic restrictions in the competitions for preliminary scholarships at the Queen's College and high schools. A Special Committee has just been appointed to investigate and report upon the last of these because of the opposition aroused and the widespread dissatisfaction throughout the colony. The Negro who plays to the gallery and sells his race is preferred by the majority of the resident Europeans. Only time will put an end to such practices, after Negroes and their descendants have learnt that it is folly and self-destruction to allow themselves to be divided up by hardly distinguishable shades of complexion.

For articles about Negroes in South America, Nancy relied on the few connections she was able to make, or friends were able to make for her, with people living on the continent. Of considerable assistance in organizing this section of *Negro* and locating some contributors was Nancy's friend Bob Brown, the American writer who, in 1931, lived not far from her at Cagnes-sur-Mer. Brown, an inveterate traveler, had left Brazil after a long stay only a few years before Nancy met him in Southern France, and it was probably he who put her in touch with Ildefonso Pereda Valdés, a Uruguayan poet, editor, and critic, whose *Cinq Poèmes Nègres* and *Anthologia de la Moderna Poesia Uruguaya* had appeared in 1927. Following a journey through Equatorial Africa, Pereda Valdés began writing extensively about Negroes in South America, and in 1953 he edited a second collection of poetry, this one composed entirely of Negro authors, in which he claimed that only Nicolás Guillén of Cuba and Cruz e Souza of Brazil could compare with North American Negro poets like Langston Hughes, Sterling Brown, and Countee Cullen. Pereda Valdés's "Song of the Washboard," (p. 269) reveals his deep interest in Negro song and music.

H. F.

The Negroes in Brazil

by ILDEFONSO PEREDA VALDÉS

(Translated from the Spanish by V. LATORRE-BARA.)

NEGRO slavery begins in Brazil with the earliest settlements, as an accompanying part of colonial enterprise. Brazil was immense and Portugal was thinly populated. Workmen were required for the cultivation of this rich and extensive territory. The Indians were of no use as slaves, they were too rebellious, they died too easily under the burden of work in the open fields as agriculturists, and consequently they were not so profitable as the Negroes. The Indians found their defenders in America ; their masters who brought them civilisation were Jesuits. Brother Bartolomé de Las Casas appears as the apostle of the Indians, although other brother missionaries worked more than he. But this priest, who pleaded for the Indians in the Spanish courts, considered Negro slavery as quite natural and humane. The Church kept aloof from the infamous Negro slave trade ; not one voice was raised in protest. The churches did not admit Negroes into their improvised cemeteries. Despite the enormous influence which the Church had in those days, the Catholic priests did nothing to modify the decrees dictated by the Portuguese governors against the Negroes, one of which, by way of example, we reproduce herewith :

All Negroes found voluntarily meeting in " quilombos " (Negro assemblies) are to be branded on the shoulder with a letter F, which will be kept for this purpose in the rooms, and if this penalty has already been inflicted, an ear will be cut off, all simply at the command of the usual judge of the country or the magistrate of the province, with no trial whatever, and only as an example showing where the quilombo took place, and this will be prior to imprisonment.

While it is true that there were certain saints devoted to the Negroes—Saint Benedict and Our Lady of the Rosary—this protection was reserved for the other world, and in any case simply meant that the Negroes formed congregations. In Brazil, as in the Rio de la Plata, they tried to follow their own religion, forming secret societies, grouping themselves according to tribal affinities, so that African customs were revived, and thus they followed in their own way a religion which was a mixture of ancestral African rites and capricious interpretations of christian rites, a mixture of totemism and christianity giving rise to mysterious taboos which demonstrated the Negro sentiment of mysticism and superstition. Thus we find in Brazil, as in the Rio de la Plata, Negroes divided into many sects, sometimes at enmity with each other, like the Quiloas, the Benguelas, the Cabindas, the Manjolos, the Vatuas, the Luandas, the Molembos and the Mozambiques. Some of these sects corresponded to tribes of the same race, such as the

Congos, who all worshipped the same god, representing him under most varied forms. This adoration of Negro saints was nothing more than a concession which the Negroes made to the religion of their masters. Thus when their masters celebrated the advent of the three kings, Melchior, Gaspar and Baltasar, the last of whom was a Negro, they, by way of imitation, had their king Congo—a distinct festivity and a different king, for in the Negro we do not find servile imitation, but the assimilation of foreign elements which he makes his own.

Vallongo was the slave market. Here in the most beautiful Bay of Rio de Janeiro—amongst valleys covered with exuberant vegetation—here, with bitter irony, amongst the smiling placid beauty of this garden, came a sound of weeping and wailing, as that most infamous of all trades was established—that of the men suffering from the curse of Ham. Boats from the African coasts arrived, loaded with human merchandise, all huddled together in filthy holds. Here these ebony fruits were left without hope. They were bought on the coast for a few " missangas " or glass beads, and branded with the " carimbo," the indelible seal of slavery. There they were in the Negro ship, ready to be made into living corpses. Diseases, unhygienic conditions, the absence of light, the heavy chain or " limbabo," and, what is still worse, the " banzo " or longing for the land that had been abandoned, the " saudade " or home-sickness for the joyous liberty of nature, all combined to decimate the convoys. In one instance, of the three hundred Negroes who set out, only one hundred and twenty arrived at their destination in these " tumbeiros," as they were called by the exploiters—the name implying that they carried corpses rather than living men. The Negroes disembarked and passed through the customs house, like any other merchandise, to be sealed. They were nothing but skin and bones, and could hardly stand on their feet. This merchandise, ulcerated and vile-smelling, would be marched off to the market-places and put at the disposal of the buyers. There was a poster which said, " Fine Negroes, young and strong. Just arrived. Reasonable prices."

There they lay, on mats or on the hard ground, waiting for a buyer who would take them off to the " fazenda," or to the master who would make the lash resound over their shining skins. And now comes the worst of all tortures—the fattening. Just as a turkey is fattened for Christmas, the Negroes would be given plenty to eat so that they might get fat quickly. Each had to gain seven kilos in a few days. The greater part of them died of indigestion. Finally, the buyer would arrive and bargain for the goods and take them off to the fazenda. There the Negro would work all day without a rest.

> El dia es para gemir
> La noche para batucar.

> (The day is for groaning,
> The night is for dancing the " batuque ".)

says a Brazilian Negro song. At night in the " terreiro " with a guitar or a kettle-drum he would strike up some plaintive melody reminiscent of the long-lost far-away land, representing it as a miraculous continent which he would never see again. This would not be a noisy song, or a frantic dance like the " batuque " or the " cateret." It would be a melancholy air, a monologue which ever remained an authentic and soulful expression of African home-sickness.

When the Negro was old and no longer of any use, he would be thrown out to tramp the streets. He would become a professional beggar. And when he died, there was no burial ground for him. The Church rejected him, not wishing to have Negroes in her tombs.

The Negro, in the midst of his sorrow, does not lose his gaiety. But what a noisy gaiety! He makes as much noise as possible, in order to forget his trouble, wishes to deafen himself, wishes to forget, and dances until he is exhausted, because this intoxication does him good. Baudelaire says, in a beautiful prose poem, that we should get intoxicated either with wine or with virtue. The Negro becomes drunk with dancing and with pain. And at this point, we may picture to ourselves the Negroes in their noisy march in procession towards the palace to salute the Viceroy.

The Negro king wears a painted crown on his head. He is dressed in a brown watered-silk coat, breeches and stockings and, over his shoulders, a velvet cape. The heat parches him, so that he seems to melt, being lost in his royal pomp and splendour. But his appearance is none the less dignified and majestic on this account, for he has taken his kingly part in the farce seriously, and he plays it with dignity. The queen comes behind him, wearing a painted paper crown and a crinoline like a captive balloon. The procession stops in front of the palace. The king and queen are accompanied by a howling mob, beating kettle-drums with a deafening rat-tat-tat, occasionally dying down, only to return with a crescendo loud enough to burst the ears of all those in the city; and then it dies away once more in a prolonged diminuendo, being drowned by the shouting of the Negroes.

The Negroes in Brazil

The black servants come down from the alley-ways towards the king and queen, and the leader of the company beats time to the music with his big bell, saying, " It is going to begin, it is going to begin." The king descends from his throne, and begins a noisy dance, moving the silvery decorations of his cape, adorned with tin moons and stars :

So rei do Congo	(I am the king of Congo
Quero brincá	I want to dance the brinca
Cheguei agora	Now I am approaching
De Portugá.	Portugal.)

And the choir replies :

E sambangalá	(Sambangalá
Chegando agora	Is now approaching
De Portugá.	Portugal.)

The queen follows the king dancing and shaking her " tundá." And they both come back to their places under the canopy. One hears the deepening roaring and screeching of the Negro instruments, filling the city with African clamours :

Quemguré aoia congo do ma
Gira calunga
Manú que vem lá.

The " mameto," the king's son, a little black " molecote " dressed in silk like his parents, comes out and dances. He looks like an insect hypnotised and lulled to sleep by the sound of the kettle-drums. His arms rise up slowly and he starts to dance, singing in a falsetto voice :

Mameto do Congo	(The little prince of Congo
Quero brincá	Wants to dance
Cheguei agora	Now he is approaching
De Portugá	Portugal)

A " caboclo " (Indian), dressed like a chieftain, comes out from the ranks and brandishes the " tacape " (club) over the head of the mameto with a swift and sure movement. The mameto falls in a dead faint. And the caboclo, waving his plumage like a bird proud of its victory, sings triumphantly. A lament is heard :

Mala quilombé, quilombé	(The wicked black fugitive)

The leader takes the news to the king, and the king dances a tragic dance and calls for the magician (" quimboto "), whom he orders to bring the mameto back to life without delay. A magnificent Negro with a shining skin dances around the motionless mameto, singing :

E mamao. E mamao.
Ganga rumbá. Seisese iaco
E mamao. E mamao
Zumbi, zumbi, oia zumbi.

And then the choir joins in :

Quambato, quambato.
Savotá o lingua.
Quem pede mais ?
Eó só. E a lua.
Santa Maria.
E. Sao Benedicto.

The mameto shows no sign of life, but the quimboto, rising up from the ground, says slowly :

Tatarana, ai oue
Tatarana, tuca, tuca.
Tuca pue.

Then comes the resurrection. The mameto opens his eyelids and returns to life. And he dances. The caboclo, on seeing the mameto alive once more, again raises the tacape, but the magician steps forward outraged, and annihilates him with a look. The caboclo falls down vanquished. The quimboto triumphs, and they bring him a princess to be his bride.

315

Another celebration is that of the Congo Negroes in the procession of Our Lady of the Rosary and Saint Benedict.

Sao Benedicto	(Saint Benedict
E Sante de prete	Is a black saint,
Elle bebe garapa	He drinks lemonade,
Elle ronca, no peite.	He snores. Do not pray.)

Three black queens go along, protected by Negroes armed with swords, who form their guard of honour. Groups of others try to take away the crowns from the queens, but against this outrage the Negroes protect them. This pantomime is perhaps reminiscent of the struggles between Negroes and Indians, during which the latter tried to enslave the Negro fugitives in the forests.

The Negro Race in Uruguay

by ELEMO CABRAL

(Translated from the Spanish by V. LATORRE-BARA.)

Elemo Cabral

NEGRO slavery in America was an infamous régime of distinctly Spanish origin, imposed for the purpose of improving the low condition into which the natives (Indians) of the Spanish colonies had fallen after repeated protests had, through the mediation of the missionary fathers, reached the ears of the King.

Father Las Casas was the most decided defender of the Indians, wishing to substitute Negroes as rough workmen, in lieu of his protégés whose race was threatened by extinction, owing to continual wars and the refined cruelty of the conqueror. It was he who suggested the idea, and once this Jesuit solution was accepted, there appeared, with the official seal of Spain, the stain which was certainly a negation of the " civilising spirit " of the lords of the continent.

Thus it was to make of them a piece of merchandise, to be sold publicly, and to transform them into a servile element and a source of revenue like any other article which entered her ports, that Spain permitted our ancestors to be settled in her conquered territories. Thus the vile trade became official in 1595, by means of a contract signed by the King and Pedro Gomez Ravnel.[1] The Negro slave trade, carried on directly with the town of Montevideo, was intensified after the Treaty of Olaguer y Felini (1790). But before this

[1] Venturino, *Sociologia General Americana*, p. 4.

a number of Africans already formed part of the colonial population, having possibly been procured in the great cities of the continent, about the year 1760. In 1763 the Abbé Pernetty was present, in the company of the youthful population, at a Negro dance; and we have been able to obtain documentary evidence showing how in the year 1769 an influential family of the same city bought a 16-year-old slave for the sum of 150 pesos. This specimen of the race was sold three times, and reached as high a price as 300 pesos. It is well to observe that such buying and selling operations were quite customary.

The Negroes formed a part of the population, in a precarious social condition, and their state of slavery caused a third category to be assigned to them. They passed through the long colonial period, during which, according to the tradition, they were "well treated" by the Spanish and colonial elements, whose families they served with the wonted faithfulness of the race. Negro women acted as nurses to the children of these families, in which the white man, as lord and master, always indulged the most exacting of his appetites. Hence the ethnical mixture. The crossing of Negroes and whites was not by any means an exceptional thing, as is clearly proved by the existence of a living document—the brown man. While admitting that the intermarriage of Indians and Negroes was exceptional, we maintain that that of whites and Negroes was common, and it is only the racial prejudice of white historians which causes this fact to be continually denied.

The sacrifice of the Negroes in the eastern part of the Virreynato of the Rio de la Plata is undeniable. Their forces were concentrated and decimated in the period before the declaration of independence. When the Cabildo Abierto of Montevideo ended its conflict with Buenos Aires in 1808, by means of an absolutely revolutionary solution, this was a foretaste of the revolution of 1810.[1] Spanish power in America was undermined, and the first pitched battles began; the Negroes in the ranks, fighting for freedom, served as fodder for the cannons. It may be said that there was not a single movement involving the destinies of the provinces in which the brave nameless Negro soldier did not play a part.

Thus he took part in the battle resulting in the assault of San José en Las Piedras in 1811. He followed the Patriarch Antigas and abandoned him only when he was on his death-bed in poverty and exile, in Paraguay, 1850. Antigas, who, a disappointed man, abandoned his province in 1820, had been supported in the noble enterprise by his captains Rivera and Lavalleja who fought under the same banner of liberty.

In 1825, the invasion of the 33 under the command of Lavalleja was strengthened by two of our men, whose likeness has been left to posterity by the pencil of Juan Manuel Blanes. Thus the Negroes followed the whole movement, shedding their blood in the fields of Sarandi, of Ituzaingo and of Las Misiones, and even the old and infirm pressed on to the final triumph, the freedom and independence of the fatherland.

The sons of Africa had changed their situation as slaves by the law of 1825. And the first Political Constitution drawn up by the state in July 1830 recognised no class distinctions, and established clearly the quality of freedom for all the inhabitants of its territory. But this law did not fully satisfy the ambitions which had taken hold of the people of the new state, threatening the stability of the régime. The former situation of the Negro continued, and even under the republican régime he remained a slave until 1842, when the vile commerce was definitely ended. From there begins the social evolution of the race.

Rituals and "Candombes"

by MARCELLINO BOTTARO

(Translated from the Spanish by V. LATORRE-BARA.)

WHENEVER any attempt has been made to write about the rites practised by the African Negroes, they have been designated by the (Spanish) American term "Candombes" (Negro dances). In reality the greater part of these rites, either choral or eurythmic, are of an entirely different character. There were rites in former times, and "Candombes" in more recent times.

Concerning the primitive people, we may say without fear of contradiction that all their formal practices were rituals, though varying greatly, in most cases, for the very simple reason that African fetishism has many different forms.

[1] Blanco Heredo, *Gobierno Colonial*, p. 247.

Rituals and " Candombes "

Marcellino Bottaro

The merchandise known as " human ebony," which was acquired either by violence or otherwise, was chosen in accordance with no criterion of selection other than the degree of facility with which a good market could be found for it. There was no reason for taking special care to investigate the affinity which may be found between different Negro cults, in order to arrive at a better understanding of these masses, who by a cruel fate, and the necessities of the period, were destined only to be exploited as " things."

It must, therefore, be obvious, even to the least penetrating mind, that if we wish to obtain a reconstruction of these cults we must begin by recalling the confused background of the great gatherings of human beings, when with ardent faith they practised their rites before their multiform deities.

But even within the affinities which it is right to recognise between these gods, it is necessary and inevitable to observe the clash between the virtues attributed to certain among them, and naturally, the defects of hostile or unknown deities, this being invariably the *raison d'être* of all religions.

The clash between these varying aspirations must have caused much anxiety to those who exploited them, especially as the individuals composing this human merchandise made use of gestures and poetic movements, to which they added the difficulties of an incomprehensible language, the import of which could be gathered only from the true or false interpretations which an African confidant would choose to give. Later on, comprehension of what these ceremonies meant gave them free and ample protection.

With the freedom and protection which the African obtained, there arose the meeting-rooms ; from then it was easy to establish with greater clearness the variety found in African fetishism.

The corner stone of the whole system of cults is the racial protection of their adepts. So much so that the deities are definitely classified genii which give protection against all kind of enemies and evil things. This is the age-long story of things which exist in Africa also.

If their gods, examined openly, lack the implacability and voluptuousness with which mystery has surrounded them, the performance of their rites—more commonly called ceremonies—was quite simple and far removed from all supernaturalism. The rites may be reduced simply to invocations, prayers, supplications, offered up in perfect good faith to the primitive gods, and intermingled at times with war-songs plaintively reminiscent of tribal life.

These songs and prayers were always accompanied by contortions and gesticulations of admiration or surprise, which corresponded perfectly to the sounds emanating from the Macu (big drum), to which were added the sonorous and strident sounds of certain devices made from bones, pieces of iron and various metals—instruments by means of which the Negroes reconstructed, as well as they could, the customs to be found in the forests of tropical Africa. And it was this great soul of the African race, simple as it is, which was the background against which such absurd and hair-raising legends were concocted.

Pretending not to know of the original rituals practised by the Africans in their meeting-rooms, various writers concerned with the Negroes of Rio de la Plata have maintained that their gods were those of the calendar of the Church of Rome, but this is not so.

All the Africans were converted to the religions of their masters, and adopted their sacred books as if they had been their own. But they did not on this account renounce the native cult, which even for them became difficult to explain.

It is therefore deduced, with all the force of logic, that their altars were lighted only to illuminate paintings derived from an exotic book of saints, and if this is quite certain, let us not forget that their faith and native cult, the mystic fervour which they felt in their meeting-rooms, were definitely exotic, compared with the images of the divinities overlooking them from the altar.

Those who maintain throughout their chronicles that the Africans had no paintings of their patron gods must have known very few meeting-rooms, for in most of them, where in reality the gods of far-away Africa were worshipped, there were pictures of the patron gods. Let us try to enumerate those of the meeting-rooms which with the passing of time we remember best.

The Magises were one of the most feared sects, not so much because of the cast-iron nature of its organisations as for the absurd legends which gathered around them on account of their ceremonies and mysterious rituals ; a sect which had many divisions and a very large number of meeting-rooms, each one with its saints. Its pictures, the work of crude artists, represented Magis gods, who were all absolutely different in their physical characteristics, as well as in their clothing and their attributes. It appears to be an atavistic law, or an artistic conception, that deformity was a characteristic worthy of deity.

Rituals and " Candombes "

The Congans, known under the name of Bangalas, Luandas, Minos, Molembos or Bertoches, served the same god in their cults and practices. The bodily form and the clothing of their patron saints differed as much as in the case of the Magises. The Mozambiques, who, we may say without exaggeration, inhabited all parts of the Barrio del Cordón and were not less numerous than the others already mentioned, followed their own laws—only one god, but diversely represented.

In some meeting-rooms the god was an armed warrior ; in others he was a gentle shepherd, and there were some who pictured their gods in a truly indefinite form. Apart from the Magises, all the meeting-rooms observed in their ceremonies the same rituals, namely songs, dances and the beating of drums.

It is needless to say that these rituals suffered fundamental changes in the course of time. Not only were their rites capable of being adapted to the usages of the catholic church, but the adepts created within their organisations all sorts of hierarchies among those who officiated, beginning as mendicant-priests and finally becoming the earthly representatives of their deity.

Concerning these adaptations and hierarchies, we must mention in the first place their dismemberment. Sordid material interest had no small part in this, as also the overweening ambition of the initiated. But much more than human defects or aspirations, the thing which destroyed these pseudo-religious organisations was the open opposition of the Montevidean Negroes of average culture, whose action began in the year 1861 or '62, and in '71 culminated with the publication of the first newspaper written for descendants of Africans and children of Montevidean Negroes, *La Conservacion*, which organ proclaimed from its editorial column : " The necessity of finishing once for all with these farces which are not religions, these practices which obey no logical principle, and serve only to indicate the meeting-places where the Negro element meets in order to re-populate the barracks."

This was the war cry of *La Conservacion* against the practices of the elders.

The result of this unequal battle was the gradual secession of the homogeneous African element in the metropolis, with the loss of an exact knowledge of the origin of these pseudo-religions themselves. Still, what must really have been felt is the loss of the extensive property owned by these sects in the form of furniture and cash. This was all property which melted into thin air, being shrouded in the same mystery which characterises these cults. Neither their primates nor their priests can be accused of wastefulness or extravagance, granted the poverty into which all of them fell, and the frugal and restricted nature of the life they led.

These losses are rather to be attributed to the giving up of documents and effects with the greatest possible secrecy, and in good faith, at a time of brusque fluctuations in the life of the country, which shipwrecked more than one honest venture and upset the best-founded hopes.

The practices of these religions having been strangled, the rituals of these cults had to be conformed to the organisations of the " Candombe."

The African considered the " Candombe " as a community of his diverse religions—something to concentrate the adepts of different sects in a common meeting-room, where they could give free expression to their hymns, which are all a heartfelt poem of the reminiscences of Africa.

For a long time this practice continued with the collaboration of the various sects which formed it, without any kind of ulterior aim. It proved capable of being adapted to circumstances, without arousing the rivalry of sects, the desire of some of them to lord it over others, or the project of liberation. In it they used the most cordial and respectful formulas, giving the preference to the elder of their primates, or to the organisers of these meetings. These gave rise to ceremonials, with the singing of songs, and airs which had become popular between them, or, in default of these, whatever was indicated by the man who presided over the ceremonial.

When " Candombes " were first organised, admission to such assemblies was not open to the public to such an extent as some historians of African matters would have us believe. The masters and protectors of the adepts and their families were the only people admitted unconditionally, but the action would be interrupted if at this moment any part of the ritual was to be performed, and this would be substituted by dances or musical items to which no importance was attached.

Public curiosity was very marked in this period of innocent emotions, and it began to express itself in a number of requests for an open door to these performances, and carried with it not only the demand of free admission, but also an official recognition of these various ceremonies which the public pretended to consider magnificent, while in reality believing them to be ridiculous.

It is certain that with these extensions the " Candombes " reached their highest point, but it was now also that the most profound divisions took place. Now no-one spoke with disinterested enthusiasm of a " solemn meeting " to be held on some particular national or religious date, but the only thing with which

people were concerned was the financial success of the " Candombe." Out of the practice of a native cult, and the reminiscences of the far-away home, there was created the trade of cheap-jacks.

Not all the sects yielded to the temptation of easy success. Many were conscious of the fact that their cults should not be turned into a money-making matter, because their aspirations were higher, and were unwilling to resign themselves to this popularity in spite of the great applause consequent upon their commercialisation. The primates left the duties of the hierarchical offices occupied by them in the meeting-rooms in the hands of others, more capable of effectively exploiting them. And if some of them did not close their doors it was because they still trusted that their successors, whom they believed were obliged to follow their wishes in these meetings, might be free to obtain their initiation, and easily learn the rituals.

We shall neither criticise the attitudes of some or others of them, nor apologise for them, but this we shall say *en passant*, that their religions, with their songs and dances and the spectacular atmosphere with which they were surrounded, became an insult to all the elements of the African race.

The meeting-rooms which had been, as it were, the humble sanctuaries of unknown religions, became transformed into unworthy hovels like gypsy caravans, in many of which all sorts of things from exaggerated local colour to fortune telling went on, including the worst and most impudent impostures. The school of dispensers of " love and fortune " and " cure-alls," with their paraphernalia of herbs and twigs for making infusions and beverages, as well as the manipulation of " mambise " (sheep's livers), set up their shops in their midst, this being, for superstitious people, a most suitable place ; while the native faith, the delicate and simple harmony of the African dances, the innocent attraction which these practices have always merited, went down to the gutter, where may be found the most fertile soil for the flowering of the lotus of charlatanism.

The " Candombes " may well be called noble tournaments, where the " ebony princess," by the burning flash of her jet-black eyes, used to inspire either an ardent desire or a heavenly peace in the bosom of the " young ebony princes "—princes who, instead of wearing cruel daggers in their girdles, had no other weapon than the gentle persuasiveness of their voices, ready to break forth in the most exquisite of madrigals. But finally they became market places where a vulgar concupiscence was catered for, with no end in view but lucre. What a sad contrast to the idealism of these places where formerly every suitor before entering the lists would make it known to all that " his heart was moved only by love, and that therefore being stirred to the depths by the call of this gallant adventure, he would accomplish his task with honour and glory."

The intimate and idealistic connection between Africans and Montevidean Negroes being broken, the " Candombe " became a degenerate form of what they wished it to be. It was carried on in such a way that not only did it become ridiculous by comparison with the reverence that these entertainments deserved, but at the same time matters were pushed to extremes. First came the " Ka-llenge " (from *cae gente*) and then the " Ka-chiwenge," burying all these African traditions in the well-known " Piringuirdines."

What is usually known as " Rio de la Plata Negro folklore " has no real interest for the author of a work of this kind. It is unquestionable, not only that the origin and authorship of these songs are quite arbitrary, but also that there are many gaps in our knowledge of them, due to the unrealistic way in which they are approached.

EUROPE

Slavery Papers

annotated by EDGELL RICKWORD

THE impetuous insolence of Europeans, their possession of a supremely formidable insensibility, was best exemplified till 1914 (when they began to slaughter one another on a really grand scale) by their extermination of all the civilisations they had come in contact with. In one respect, one must grant, they observed an exact impartiality; for Inca and Polynesian, Aztec and Hindoo, Chinese and Irish were victims of the same economic exploitation, tormented with equal physical brutality, and massacred with similar promptitude if at last they rebelled against a law which they were never rightly subject to. Only the Negro seems not to have shared the advantages of this impartiality, for owing to a particular set of circumstances the Negro had an additional intensity of torment allotted him. I refer, of course, to the Slave Trade. However evil the conditions under which the African was, and is, exploited in his own continent, without the particular fact that the European countries needed great quantities of labour in their tropical and semi-tropical dependencies, there would have been no Slave Trade. And without the Slave Trade, and the " Middle Passage," one of the depths of human ignominy would have remained unplumbed. For D'Alva and Torquemada had at least the excuse of fanaticism behind their persecutions; the slave-trader merely computed the human anguish in his holds at so much a head and put about fifty per cent. on to his selling price to compensate *him* for casualties *en route*.

It took some two hundred years (the first official English slave-trader was Sir John Hawkins, Queen Elizabeth's much-romanticised sea-dog) for a sufficient number of individuals to become aware of the infamousness of this traffic to make any palpable impression on the political organisation of England, the greatest slave-carrying country. Granville Sharp, Wilberforce, Clarkson and others had for some time been spreading knowledge of the conditions in the Slave Trade when, in May 1787, a Society for its abolition was formed. A great number of petitions to Parliament were sent in from all over the country and in consequence, and through Wilberforce's skilful handling of the intricacies of parliamentary procedure, in 1789 a committee of the whole House was appointed to take evidence with a view to future legislation regulating the Slave Trade. This evidence was collected during 1790–1 and forms the basis of one of the most valuable documents on the subject, a small volume called " An Abstract of the Evidence delivered before a Select Committee of the House of Commons in the Years 1790 and 1791 ; on the part of the petitioners for the Abolition of the Slave Trade " (London, M.DCC.XCI).

Before quoting from this record, one may remark in general its humaneness, its treatment of the subject as a matter between one group of human beings and another, not of helping some inferior species, which is so often the attitude of the humanitarian reformer. Also, it explicitly states that Europeans were responsible for the disintegration of the native African civilisation ; that the African character is by nature affectionate and industrious and only vitiated by contact with Europeans ; that agriculture and all necessary crafts were highly developed there ; in short, that the improvement of moral character (by missionaries) and of the ordinary material life (by European methods) is sheer fantasy, an excuse for intervention and so an instrument of exploitation—a conclusion not yet accepted even by many Africans.

The witnesses whose evidence was taken, and which surpasses in its undecorated horror all the inventions of the fiction writers who have made capital out of the miseries of the captured Africans, were an impeccably respectable lot. Officers of the army, captains or junior officers of the merchant service, a few doctors and several parsons, they were, in fact, pre-eminently bourgeois ; not a proletarian or an escaped slave amongst them. In a number of instances their interests were all against the abolition, *e.g.* there is Capt. Hall, who declared " that when he left the trade he could have obtained the command of a ship in it, which command at that time *would have been a very lucrative one*, but that he quitted it *from a conviction that it was perfectly illegal, and founded in blood*."

The only evidence against abolition not given by the planters themselves, and so that could be called disinterested, was that of " the Admirals." The Admirals belonged to a race of men who when inspecting prisons, workhouses, insane asylums and all the institutions where the socially defenceless are stowed away, are hurried through a specially prepared section of them, and remark jovially that the inmates have a rather good time and are much better off than poor Admirals. As the " Abstract " puts it : " We have

322

no right to suppose that persons of their character had any intention of misleading the publick in a question of so much importance to the interests of mankind ; but we may suppose *that in their situation they had little or no opportunity of observing the treatment of the slaves*. . . . Mr. Ross says . . . he has *often* accompanied *Governors and Admirals* in their tours there [the West Indies]. The estates visited, belonging to persons of distinction, might be supposed under *the best management*. Besides, *all possible care* would be taken to *keep every disgusting object from view*, and *on no account* by the exercise of the whip or other punishments, *to harrow up the feelings of persons of such distinction*."

If any persons of such distinction happen to read the following quotations from the " Abstract," it is possible that their feelings, like those of ordinary people, may indeed be harrowed up. In every case the use of italics corresponds to that in the original text. Many instances of the same abuses, drawn from different islands or districts, are given in the " Abstract," but generally only one example of each is reproduced here.

METHODS OF OBTAINING SLAVES

(*a*) Promotion of war between neighbouring chiefs.
(*b*) Giving goods on credit and so compelling chiefs to make war to supply the deficiency.
(*c*) Legal " frame-ups " resulting in a fine of a slave or the victim himself being sold into slavery.
(*d*) Individual initiative.

" Mr. Dalrymple found that the great droves (called Cassellas or Caravans) of slaves brought from inland, by way of Galam, to Senegal and Gambia, were prisoners of war. Those sold to vessels at Goree, and near it, were procured either by the grand pillage, the lesser pillage, or by robbery of individuals, or in consequence of crimes. The grand pillage is executed by the king's soldiers, from three hundred to three thousand at a time, who attack and set fire to a village, and seize the inhabitants as they can. The smaller parties generally lie in wait about the villages, and take off all they can surprise ; which is also done by individuals, who do not belong to the king, but are private robbers. These sell their prey on the coast, where it is well known no questions as to the means of obtaining it are asked. . . .

" Captain Wilson says, that slaves are either procured by intestine wars, or kings breaking up villages, or crimes real or imputed, or kidnappings. . . .

" It is universally acknowledged that free persons are sold for real or imputed crimes, *for the benefit of their judges*.

" Soon after his arrival at Goree, King Damel sent a free man to him for sale, and was to have the price *himself*. One of the king's guards being asked whether the man was guilty of the crime imputed to him, answered, *that was of no consequence, or ever inquired into*. Captain Wilson returned the man. . . .

" The war-men used to go out, Mr. Bowman says, once or twice in eight or ten days, while he was at Scassus. It was their constant way of getting slaves, he believed, because they always came to the factory before setting out, and demanded powder, ball, gun flints, and small shot ; also rum, tobacco, and a few other articles. When supplied, they blew the horn, made the war-cry and set off. If they met with no slaves, they would bring him some ivory and camwood. Sometimes he accompanied them a mile or so, and once joined the party, anxious to know by what means they obtained the slaves. Having travelled all day, they came to a small river, when he was told they had but a little way farther to go. Having crossed the river, they stopped till dark. Here Mr. Bowman (it was about the middle of the night) was afraid to go farther, and prevailed on the king's son to leave him a guard of four men. In half an hour he heard the war-cry, by which he understood they had reached a town. In about half an hour more they returned, bringing from twenty-five to thirty men, women and children, some at the breast. At this time he saw the town *in flames*. When they had re-crossed the river it was just daylight, and they reached Scassus about mid-day. The prisoners were carried to different parts of the town. They are usually brought in with strings around their necks, and some have their hands tied across. He never saw any slaves there who had been convicted of crimes.

" He has been called up in the night to see *fires*, and told by the townspeople *that it was war*[1] *carrying on*. . . .

" Off Piccanni Sestus, farther down on the Windward Coast, Mr. Dove observed an instance of a girl being kidnapped and brought on board by one Ben Johnson, a black trader, who had scarcely left the ship in his canoe, with the price of her, when another canoe with two black men came in a hurry to the ship, and inquired concerning this girl. Having been allowed to see her, they hurried down to their canoe, and hastily paddled off. Overtaking Ben Johnson, they brought him back to the ship, got him on the

[1] The reader is earnestly requested to take notice, that the word *war*, as adopted into the African language, means in general *robbery*, or a marauding expedition for the purpose of getting slaves. (Footnote in the original.)

quarter-deck, and calling him *teefee* (which implies *thief*) to the captain, offered him for sale. Ben Johnson remonstrated, asking the captain, 'if he would buy him whom he knew to be a grand trading man'; to which the captain answered, 'if they would sell him, he would certainly buy him, be he what he would,' which he accordingly did, and put him into irons immediately with another man. He was led to think, from this instance, that kidnapping was the mode of obtaining slaves upon this part of the coast. . . .

" There are two crimes on the Gold Coast, which seem made on purpose to procure slaves : adultery and removal of fetiches. As to adultery, he was warned against connecting himself with any woman not pointed out to him, for that the kings *kept several who were sent out to allure the unwary*, and that, if found to be connected with these, he would be seized, and made to pay the price of a man slave. As to fetiches, consisting of pieces of wood, old pitchers, kettles and the like, laid in the path-ways, he was warned to avoid displacing them, for if he should, the natives who were on the watch, would seize him, and, as before, exact the price of a man slave. These baits are laid equally for natives and Europeans ; but the former are better acquainted with the law, and consequently more upon their guard. . . .

" Mr. Ellison says, that while one of the ships he belonged to, viz. the Briton, was lying in Benin river, Capt. Lemma Lemma, a Benin trader, came on board to receive his customs. This man being on the deck, and happening to see a canoe with three people in it, crossing the river, dispatched one of his own canoes to seize and take it. Upon overtaking it, they brought it to the ship. It contained three persons, an old man and a young man and woman. The chief mate bought the two latter, but the former being too old, was refused. Upon this, Lemma ordered the old man into the canoe, where his head was chopped off, and he was thrown overboard. Lemma had many war canoes some of which had six or eight swivels ; he seemed to be feared by the rest of the natives. . . .

" Mr. Dalrymple understood it *common for European traders* to advance goods to Chiefs, *to induce them to seize* their subjects or neighbours. Not one of the Mulatto traders at Goree ever thought of denying it. . . .

" Sir George Young says, that when at Annamaboe, at Mr. Brue's (a very great merchant there), Mr. Brue had two hostages, kings' sons, for payment for arms, and all kinds of military stores, *which he had supplied to the two kings*, who were at war with each other, *to procure slaves for at least six or seven ships, then lying in the road*. The prisoners on both sides were brought down to Mr. Brue and sent to the ships. . . .

" THE NATIVES OF AFRICA HAVING BEEN MADE SLAVES IN THE MANNER DESCRIBED . . . ARE BROUGHT DOWN FOR SALE TO THE EUROPEAN SHIPS.

" On being brought on board, says Dr. Trotter, they show signs of *extreme distress and despair, from a feeling of their situation, and regret at being torn from their friends and connections* ; many retain those impressions for a long time ; in proof of which, the slaves on board his ship being often heard in the night, making an howling melancholy noise, expressive of extreme anguish, he repeatedly ordered the woman, who had been his interpreter, to inquire into the cause. She discovered it to be owing to their having dreamt they were in *their own country again*, and finding themselves when awake, in *the hold of a slave ship*. This exquisite sensibility was particularly observable among the women, many of whom, on such occasions, he found in hysteric fits.

" The foregoing description as far as relates to their dejection when brought on board, and the cause of it, is confirmed by Hall, Wilson, Claxton, Ellison, Towne and Falconbridge, the latter of whom relates an instance of a young woman who cried and pined away after being brought on board, who recovered when put on shore, and who hung herself when informed she was to be sent again to the ship.

" Captain Hall says, after the first eight or ten of them come on board, the men are put into irons. They are linked two and two together by the hands and feet, in which situation they continue till they arrive in the West Indies, except such as be sick, whose irons are taken off. The women however, he says, are always loose.

" On being brought up in a morning, says Surgeon Wilson, an additional mode of securing them takes place, for to the shackles of each pair of them there is a ring, through which is reeved a large chain, which locks them all in a body to ring-bolts fastened to the deck.

" The time of their coming up in the morning, if fair, is described by Mr. Towne to be between eight and nine, and the time of their remaining there to be till four in the afternoon, when they are again put below till the next morning. In the interval of being upon deck they are fed twice. They have also a pint of water allowed to each of them a day, which being divided is served out to them at two different times, namely, after their meals.

" These meals, says Mr. Falconbridge, consist of rice, yams, and horse-beans, with now and then

a little beef and bread. After meals they are made *to jump in their irons*. This is called *dancing* by the slave-dealers. *In every ship* he has been desired *to flog such as would not jump*. He had generally a cat of nine tails in his hand among the women, and the chief mate, he believes, another among the men.

" The parts, says Mr. Claxton, on which their shackles are fastened, are often excoriated by the violent exercise they are thus forced to take, of which they made many grievous complaints to him. In his ship even those who had the flux, scurvy and such œdematous swellings in their legs as made it painful for them to move at all, were compelled to dance by the cat.

" He says also that on board his ship they sometimes sung, but not for their amusement. The captain ordered them to sing, and *they sung songs of sorrow*. The subject of these songs were their *wretched situation, and the idea of never returning home*. He recollects their very words upon these occasions.

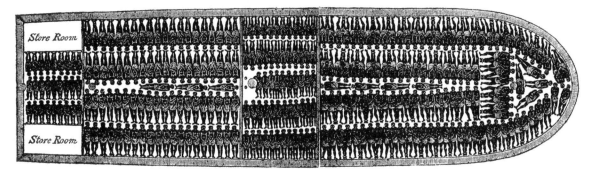

Plan of Slave-ship from a print of 1792

" On the subject of the stowage and its consequences, Dr. Trotter says that the slaves in the Passage are so crowded below, that it is impossible to walk through them *without treading* on them. Those who are out of irons are *locked spoonways* (in the *technical phrase*) to one another. . . .

" When the scuttles are obliged to be shut, the gratings are not sufficient for airing the rooms. He never himself could breathe freely, unless immediately under the hatchway. He has seen the slaves drawing their breath with all those laborious and anxious efforts for life *which are observed in expiring animals, subjected by experiment to foul air, or in the exhausted receiver of an air pump*. He has also seen them when the tarpawlings have been inadvertently thrown over the gratings, attempting to heave them up ; crying out in their own language, ' *We are dying.*' On removing the tarpawlings and gratings they would fly to the hatchway with all the signs of terror and dread of suffocation. Many of them he has seen in a dying state, but some have recovered by being brought hither or on the deck ; others were irrecoverably lost, *by suffocation*, having had *no previous signs of indisposition*.

" Mr. Falconbridge also states on this head, that when employed in stowing the slaves, he made the most of the room and *wedged them in*. They had not so much room *as a man in his coffin* either in length or breadth. It was impossible for them to turn or shift with any degree of ease. He had often occasion to go from one side of their rooms to the other, in which case he always *took off his shoes*, but could not avoid pinching them ; he has the marks on his feet where they bit and scratched him. . . .

" Mr. Falconbridge says, that there is a place in every ship for the sick slaves, but there are no accommodations for them, *for they lie on the bare planks*. He has seen frequently the prominent parts of their bones about the shoulder-blade and knees *bare*.

" He says he cannot conceive any situation so dreadful and disgusting as that of slaves when ill of the flux : in the Alexander, the deck was *covered with blood and mucus*, and resembled *a slaughter house*. . . .

" The slaves, shackled together, frequently quarrel. In each apartment there are three or four tubs placed for their convenience : those however at a distance find it difficult to get over other slaves to these tubs : sometimes if one wants to go to them, his companion refuses to go with him ; if relaxed, he exonerates while disputing over his neighbours. This causes great disturbance. . . .

" The ships, he says, are *fitted up with a view to prevent* slaves jumping overboard ; notwithstanding which he has known instances of their doing so. In the Alexander two were lost in this way. In the same voyage, near twenty jumped overboard out of the Enterprize, Capt. Wilson, and several from a large Frenchman in Bonny River.

" Dr. Trotter . . . remembers also an instance of a woman who perished from refusing food : she

was repeatedly flogged, and victuals forced into her mouth, but *no means* could make her swallow it, and she lived for the four last days in a state of torpid insensibility.

" A man jumped overboard, at Anamaboe, and was drowned. Another also, on the Middle Passage, but he was taken up. A woman also, after having been taken up, was chained for some time to the mizen mast, but being let loose again made a second attempt, was again taken up, and expired under the floggings given her in consequence. . . .

" Mr. Wilson says it hurt his feelings much to be obliged to use the cat so frequently to force them to take their food. In the very act of chastisement, they have looked up at him with a smile, and in their own language have said, ' *presently we shall be no more.*' . . .

" Some of the slaves on board the same ship, says Mr. Claxton, ' *had such an aversion to leaving their native places*, that they threw themselves overboard, on an idea that *they should get back to their own country*. The captain, in order to obviate this idea, thought of an expedient, viz. to cut off the heads of those who died, intimating to them, that if determined to go, they must return without their heads. The slaves were accordingly brought up to witness the operation. One of them seeing, when on deck, the carpenter standing with his hatchet up ready to strike off the head of a dead slave, with a violent exertion got loose, and flying to the place where the nettings had been unloosed, in order to empty the tubs, he darted overboard. The ship brought to, and a man was placed in the main chains to catch him, which he perceiving, dived under water, and rising again at a distance from the ship, made signs, which words cannot describe, expressive of his happiness in escaping. He then went down, and was seen no more. This circumstance deterred the captain from trying the expedient any more. . . .

" A woman who was brought on board refused sustenance, neither would she speak. She was then ordered the thumb-screws,[1] suspended in the mizen rigging, and every attempt was made with the cat to compel her to eat, *but to no purpose.* She died in three or four days afterwards. Mr. Millar was told that she had said the night before she died, ' *She was going to her friends.*'

" As a third specific instance, in another vessel, may be mentioned that related by Mr. Isaac Parker. There was a child, says he, on board, of nine months old, which refused to eat, for which the captain took it up in his hand, and flogged it with a cat, saying at the same time, ' Damn you, I'll make you eat, or I'll kill you.' The same child having swelled feet, the captain ordered them to be put into water, *though the ship's cook told him it was too hot.* This brought off the skin and nails. He then ordered sweet oil and cloths, which Isaac Parker himself applied to the feet ; and as the child at mess time again refused to eat, the captain again took it up and flogged it and tied a log of mango-wood eighteen or twenty inches long, and of twelve or thirteen pounds weight, round its neck as a punishment. He repeated the flogging for four days together at mess time. The last time after flogging it, he let it drop out of his hand, with the same expression as before, and accordingly in about three quarters of an hour the child died. He then called its mother to heave it overboard, and beat her for refusing. He however forced her to take it up, and go to the ship's side, where holding her head on one side to avoid the sight, she dropped her child overboard, after which she cried for many hours. . . .

" . . . insurrections on the part of the slaves. Some of these frequently attempted to rise, but were prevented . . . others rose, but were quelled, and others rose, and succeeded, killing almost all the whites. . . . Mr. Town says, that inquiring of the slaves into the cause of these insurrections, he has been asked, *what business he had to carry them from their country. They had wives and children, whom they wanted to be with.*

" After an insurrection, Mr. Ellison says, he has seen them flogged, and the cook's tormentors and tongs *heated to burn their flesh.* Mr. Newton also adds, that it is usual for captains after insurrections and plots happen, to flog the slaves. Some captains, on board whose ships he has been, added the thumb-screw, and one in particular told him repeatedly that he *had put slaves to death after an insurrection by various modes of torture.*

" When the ships arrive at their destined ports, the slaves are exposed to sale. They are sold either by scramble or by vendue, *i.e.* by publick auction or by lots. The sale by scramble is thus described by Mr. Falconbridge. ' In the Emilia, (says he) at Jamaica, the ship was darkened with sails, and covered round. The men slaves were placed on the main deck, and the women on the quarter deck. The purchasers on shore were informed a gun would be fired when they were ready to open the sale. A great number of people came on board with tallies or cards in their hands, with their own names upon them, and rushed

[1] To shew the severity of this punishment, Mr. Dove says, that while two slaves were under the torture of the thumb-screws, the sweat ran down their faces, and they trembled as under a violent ague fit, and Mr. Ellison has known instances of their dying, a mortification having taken place in their thumbs in consequence of these screws. (Footnote in the original.)

through the barricado door with the ferocity of brutes. Some had three or four handkerchiefs tied together, to encircle as many as they thought fit for their purpose. In the yard at Grenada, the women were so terrified, that several of them got out of the yard, and ran about St. George's town as if they were mad. . . .

"General Tottenham says . . . he once observed at Barbadoes a number of slaves that had been landed from a ship. . . . Those that were not very ill were put into little huts, and those that were worse were left in the yard to die, for *nobody gave them anything to eat or drink ; and some of them lived three days in that situation.* . . .

"Mr. Newton says, that in none of the sales he saw was there any care ever taken to prevent such slaves as were relations from being separated. *They were separated as sheep and lambs by the butcher.* . . . Mr. Falconbridge says . . . he once heard of a person refusing to purchase a man's wife, and was the next day informed *the man had hanged himself."*

Perhaps these simple, unaffected accounts of the *general* conditions of the slave-carrying business so impressed the assembled legislators that with a great cry they rose up and put an end to the possibility of such a thing for ever? The dignity of professional legislators forbids any such precipitate translation of justice into reality ; besides, the revolts in Haiti and Martinique had impressed the rich (and the rich ruled a little more directly then than now) with the fear of the threat to property that might result from any concession made to the slaves. So manœuvres and counter-manœuvres between the genuine abolitionists and the vote-catching politicians followed, in which the main stages were :

April 18, 1791. A motion was made for the introduction of a bill to prevent more slaves being imported into the British West Indies. It was defeated by 163 votes to 88.

April 2, 1792. Wilberforce moved that the Slave Trade ought to be abolished. A Government amendment providing for its *gradual* abolition was carried. In the end, the Commons decided that the Slave Trade should become illegal after January 1, 1796. But the House of Lords postponed the motion for a year, virtually killing it.

1794. A palliatory bill to prevent British traders supplying other European colonies with slaves was passed by the Commons but thrown out by the Lords.

1806. Twelve years of protests, petitions and propaganda had to be gone through before any appreciable step could be gained. Then, with Fox's support, a motion was carried to introduce a bill " for the abolition of the African Slave Trade in such a manner and at such a period as should be deemed advisable."

March 25, 1807. A bill was enacted which provided that no slave ship should sail for slaves from any port within the British dominions after May 1, 1807, and that no slaves should be landed in any of the British colonies after March 1, 1808.

But the Act was continually being infringed, as the only penalty it provided for was a monetary fine. In 1801 the trade in slaves was made a felony and for a time actually a capital offence.

In many ways, however, the partial reform, as is usually the case, aggravated the evil it had been meant to cure. The only logical course was publicly recognised with the founding of the Anti-Slavery Society in 1823. Much time was wasted by the fact that the Government, knowing the resentment of the self-governing colonies against interference by the English parliament, and fearful, at a time when England was on the edge of revolution, of seeming to suggest that the rights of property even in human bodies were not illimitable, was able to defer the matter by means of a motion, introduced by Canning, that the colonial legislatures should be invited, or even slightly urged, to introduce their own reforms of the abuses of the system, and other palliatives, such as to forbid the flogging of women. Even at that the planters raised an outcry, no doubt asserting then as now that they loved and were beloved by " their niggers " and that outsiders didn't understand them. How right they were may be judged by the following quotations from the " Abstract," chosen from a very much larger number, and chosen again as representing the *general* conditions, not the aberrations of individual sadists.

Africans when Bought, their General Estimation and Treatment

"The natives of Africa, when bought by the European colonists, are generally esteemed, says Dr. Jackson, *a species of inferior beings, whom the right of purchase gives the owner a power of using at his will.* . . .

Labour of the Field Slaves out of Crop.

"The field slaves . . . are called out by daylight to their work. For this purpose the shell blows, and they hurry into the field. If they are not there in time they are flogged. When put to their work they perform it in rows, *and without exception under the whip of drivers,* a certain number of whom are

allotted to each gang. By these means the weak are made to keep up with the strong. Mr. Fitzmaurice is sorry to say, that from this cause many of them are hurried to the grave. . . . They begin, as before said, at daylight, and continue, with two intermissions, one for half an hour in the morning and the other for two hours at noon, till sun-set.

" The above description, however, does not include the whole of their operations for the day, for it is expected they shall range about and pick grass for the cattle. . . Grass-picking, says Capt. Smith, is one of the most frequent causes of punishment. He has seen some flogged, for not getting so great a quantity of it as others and that at a time, when he has thought it *impossible they could have gotten half the quantity,* having been upon the spot.

" It is impossible to pass over in silence the almost total want of indulgence which the women slaves frequently experience during the operations in the field. . . . Mr. Rees, observing the gangs at work, saw a pregnant woman rather behind the rest. The driver called her to come on, and going back struck her with the whip up towards the shoulders. He asked another pregnant woman, if she was forced to work like the rest, and she said Yes. Sir G. Young adds, that women were considered to miscarry in general from their hard field labour ; and Captain Hall says, that, where they had children, they were sent again after the month to labour with the children upon their backs, and so little time afforded them to attend their wants, that he has seen a woman seated to give suck to her child, roused from that situation by a severe blow from the cart whip.[1] . . .

" The above accounts of the mode and duration of the labour of the field slaves, are confined to that season of the year which is termed ' Out of Crop,' or the time in which they are preparing the lands for the crop. In the crop season, however, the labour is of much longer duration. . . . The boilers and others about the works, relieved at twelve at noon, cut canes from shell-blow (half-past one) till dark, when they carry cane-tops or grass to the cattle pens, and then they may rest till twelve at night, when they relieve the spell in the boiling-house, by which they themselves had been relieved at twelve in the day. . . . Mr. Dalrymple, speaking also of their labour in time of crop, says they are obliged to work *as long as they can,* which is as long as they can keep awake or stand on their legs. Sometimes they fall asleep, through excess of fatigue, when their arms are caught in the mill, and torn off. He saw several who had lost their arms in that way. . . .

Their Foods

" The best allowance is evidently at Barbadoes, and the following is the account of it. The slaves in general, says General Tottenham, appeared to be ill fed : each slave had a pint of grain for twenty-four hours, and sometimes half a rotten herring when to be had. When the herrings were *unfit for the whites,* they were bought up by the planters *for the slaves.* Mr. Davis says, that on those estates in Barbadoes where he had seen the slaves' allowance dealt out, a grown Negro had nine pints of corn, and about one pound of salt fish a week, but the grain of the West Indies is much lighter than wheat.

Their Clothing

" The largest allowance in the evidence is that which is mentioned by Dr. Harrison. The men, he says, at Christmas, are allowed two frocks, and two pair of Osnaburgh trowsers, and the women two coats and two shifts apiece. Some also have two handkerchiefs for the head. . . . Woolrich and Coor agree, that as far as their experience went, the masters did not expend for the clothing of their slaves more than half a crown or three shillings a year ; and Cook says that they are in general but very indifferently clothed, and that *one half of them go almost naked in the field.*

Their Houses

" Mr. Woolrich states their houses to be small square huts, built with poles, and thatched at the top and sides with a kind of bamboo and built by the slaves themselves. He describes them as lying in the middle of these huts before a small fire, but to have no bedding. Some, he says, obtain a board or mat to lie on before the fire. A few of the head slaves have cabins of boards raised from the floor, but no bedding, except some, who have a coarse blanket.

Ordinary Punishments of the Slaves by Whip and Cowskin

" In *the towns* many people have their slaves flogged upon their own premises, in which case it is performed by a man, who is paid for it, and who goes round the town in quest of delinquents. But those,

[1] In some estates, it is usual to dig a hole in the ground, in which they put the bellies of pregnant women, while they whip them, that they may not excuse punishment, nor yet endanger the life of the woman or child. (Footnote in the original.)

says Mr. H. Ross, who do not chuse to disturb their neighbours with the slaves' cries, send them to the wharfs or gaol, where they are corrected also by persons paid. . . .

" When they are flogged on the wharfs, they are described by H. Ross, Morley, Jeffreys, Towne and Captain Scott, to have their *arms* tied to the *hooks of the crane*, and *weights of fifty-six* pounds applied to *their feet*. In this situation the crane is wound up, so that it lifts them nearly from the ground, and keeps them in a stretched posture, when the whip or cowskin is used. After this they are again whipped, but with *ebony bushes* (which are more prickly than the thorn bushes in this country) in order *to let out the congealed blood*. Captain Scott, describing it, says that he saw a white man pursue a Negro into the water, bring him out, and take him to the wharf, where he had him hung up to a crane by the hands, which were tied together, and weights tied to his feet. When thus hoisted up, but so as still to touch the ground, another Negro was ordered to whip him with a prickly bush. He walked away from the disagreeable sight. The next day he saw the same Negro lying on the beach, and, with the assistance of another, taking the prickles out of his breech, seemingly swelled and bloody. The Negro assigned as a reason for the whipping, the wharfinger thought *he had stayed too long on an errand*.

" Respecting the whippings, Dr. Harrison thought them too severe to be inflicted on any of the human species. . . . He could lay two or three fingers in the wounds made by the whip. . . . On the frequency of these punishments something may be deduced from the different expressions which the different evidences adopt according to their different opportunities of observation.

" . . . Falconbridge, General Tottenham, and Towne, agree in saying, either that they *hardly ever saw any*, or that *very few were to be seen* without scars or other marks of the whip. . . .

" . . . To the same description belong those unhappy females, who have leave to go out for prostitution, and are obliged to bring their owners a certain payment per week. Handsome women are expected to bring home more money than the ordinary. They *are punished* if they return *without the full wages of their prostitution*.

" . . . General Tottenham observes, that he was at a planter's house when the Jumper came. He heard him ask the master if he had any commands for him. The Master replied, No. The Jumper then asked the Mistress, who replied, Yes. She directed him to take out two very decent women, who attended at table, and to give each of them a dozen lashes. General Tottenham expostulated with her, but in vain. They were taken out to the publick parade, and he had the curiosity to go with them. The Jumper carried a long whip like our waggoners. He ordered one of the women to turn her back, and to take up her clothes entirely, and he gave her a dozen on the breech. Every stroke brought flesh from her. She behaved with astonishing fortitude. After the punishment, she, according to custom, curtesied and thanked him : the other had the same punishment and behaved in the same way. . . .

" Mr. Coor has known many receive on the ladder [to which they were tied] from 100 to 150 lashes, and some two cool hundreds, as they are generally called. He has known many returned to confinement, and in one, two or three days, brought to the ladder, and receive the same compliment, or thereabouts, as before. They seldom take them off the ladder, until all the skin, from the hams to the small of the back, appears only raw flesh and blood, and then they wash the parts with salt pickle. This appeared to him from the convulsions it occasioned, more cruel than the whipping, but it was done to prevent mortification. He has known many after such whipping sent to the field under a guard and worked all day, with no food but what their friends might give them, out of their own poor pittance. He had known them returned to the stocks at night, and worked next day, successively. This cruel whipping, hard working, and starving has, to his knowledge, made many commit suicide. He remembered fourteen slaves, who, from bad treatment, rebelled on a Sunday, ran into the woods, and all cut their throats together.

Extraordinary Punishments of many kinds

" Mr. Dalrymple, in June 1789, saw a Negress brought to St. George's, Grenada, to have her fingers cut off. She had committed a fault, and ran away to avoid punishment ; but being taken, her master *suspended her by the hands*, flogged and cut her cruelly on the back, belly, breast, and thighs, and *then left her suspended till her fingers mortified*. In this state Mr. Dalrymple saw her at Dr. Gilpin's house.

" Capt. Ross has seen a Negro woman, in Jamaica, flogged with ebony bushes so that *the skin of her back was taken off down to her heels*. She was then turned round and flogged from her breast down to her waist, and in consequence he saw her afterwards walking upon all fours and unable to get up.

" Jeffreys, Capt. Ross, M. Terry, and Coor mention the cutting off of ears as another species of punishment. The last gentleman gives the following instance in Jamaica. One of the house girls having broken a plate, or spilt a cup of tea, the doctor, (with whom Mr. Coor boarded,) nailed her ear to a post. Mr. Coor remonstrated with him in vain. They went to bed, and he left her there. In the morning she

was gone, having torn the head of the nail through her ear. She was soon brought back, and when Mr. Coor came to breakfast he found she had been very severely whipped by the doctor, who, in his fury, clipped both her ears off close to her head, with a pair of large scissars, and she was sent to pick seeds out of cotton, among three or four more, emaciated by his cruelties, until they were fit for nothing else. . . .

" Mr. Jeffreys has seen slaves with one of their *hands off*, which he understood to *have been cut off for lifting it up against a white man*. . . .

" Mr. Hercules Ross, hearing one day in Jamaica, from an inclosure, the cries of some poor wretch under torture, he looked through, and saw a young female suspended by the wrists to a tree, swinging to and fro. Her toes could barely touch the ground and her body was exceedingly agitated. The sight rather confounded him, as there was no whipping, and the master was just by seemingly motionless; but on looking more attentively, he saw in his hand a stick of fire, which he held so as occasionally to touch her private parts as she swung. He continued this torture with unmoved countenance, until Mr. H. Ross, calling on him to desist, and throwing stones at him over the fence, stopped it. . . .

" From the above accounts, there are no less than sixteen sorts of extraordinary punishments, which the imagination has invented in the moments of passion and caprice. . . .

" It will appear extraordinary to the reader, that many women, living in the colonies, should not only order, and often superintend, but sometimes actually inflict with their own hands, some severe punishments upon their slaves, and that these should not always be women of a low order but frequently of respectability and rank.[1]

" Capt. Cook states farther, that he saw a woman, named Rachel Lauder, beat a woman slave most unmercifully. Having bruised her head almost to a jelly, with the heel of her shoe, she threw her with great force on the seat of the child's necessary, and then tried to stamp her head through the hole, and would have murdered her, if not prevented by two officers. The girl's crime was the not bringing money enough from on board ship, where she was sent by her mistress, *for the purpose of prostitution*.

" Lieutenant Davison states in his evidence, that the clergyman's wife at Port Royal was remarkably cruel. She used to drop hot sealing wax on her Negroes after flogging them. He was sent for as surgeon to one of them whose breast was terribly burnt with sealing wax. He was also once called to a woman slave who had been tied up all night by her hands, and had been abused with cayenne pepper, by the same mistress, and in a way too horrid and indecent to mention. . . .

" Mr. Forster, examined on the same subject, says he had known a Creole woman, in Antigua, drop hot sealing wax on a girl's back, after a flogging. He and many others saw a young woman of fortune and character flogging a Negro man very severely *with her own hands*. Many similar instances he could relate if necessary. They are almost innumerable among the domestic slaves.

Slaves turned off when Incapable of Labour

" This is the account given by the different witnesses, and accordingly we find some of the super-annuated slaves on the different estates, who *wanted everything*, others *begging*, others *digging in the dunghill for food* and others lying, miserable objects, about *the wharfs and beaches* and in the *roads and streets*. General Tottenham has often met them, and in particular, an old woman, past labour, who told him that her master had *set her adrift to shift for herself*. He saw her about three days afterwards lying dead in the same place. The custom of turning them off when old and helpless is called in the islands ' Giving them free.'

Have little or no Redress against Ill-usage of any sort

" . . . a huckster in Antigua . . . murdered his woman slave with circumstances of the most atrocious barbarity. This man however was tried, convicted—and fined.

" At Grenada in the town of St. George, a mason named Chambers killed a Negro in the middle of the day and Mr. Dalrymple believes in the churchyard, but no notice was taken of it.

" Two slaves, says Capt. Cook, were murdered and thrown into the road during his residence in Barbadoes : yet no legal inquiry ever took place that he heard of.

" He was repeatedly informed by the inhabitants that they did not chuse to make examples of white men there, fearing that it might be attended with dangerous consequences." [2]

And, of course, the insurmountable obstacle to any slave ever obtaining legal redress was the fact that

[1] The Editor feels a reluctance in mentioning women on this occasion, but when he considers how much the explanation of their conduct will show the iniquity of the system of slavery, and its baneful influence on those most disposed to benevolence and compassion, he feels it a duty to proceed in the narration without any farther apology. (Footnote in the original.)

[2] Compare the Southern States of America. Also the recent (1933) Chief Tchekedi and Admiral Evans farcical comedy.

in no circumstances was the testimony of Negroes admissible as evidence at law. Though, as the Southern States, or any region where racial and class discrimination is practised, show, the mere possession of legal rights does not by any means ensure the effective enjoyment of them. The Resolution suggesting to the planters that Negroes with certain " moral and religious " qualifications should be admitted as witnesses in courts of law, was the only one of the Resolutions which the planters would not even pretend to adopt.

PARLIAMENT GETS DOWN TO IT
(From the *Morning Chronicle*, March 17, 1824.)

On March 16, 1824, a most illuminating debate on the subject of Negro Slavery took place in the Imperial Parliament. The Government hoped to satisfy the Abolitionists with an extensive scheme of reform culminating, in some unspecified future, in the mystical disappearance of the state of slavery without any loss to the possessors of the slaves. The planters were stupid enough to combat even this remote appearance of a threat to their interests, and of course, Buxton and Wilberforce fought against it, realising how fatal it would be to their ultimate aim. Canning's speech is a masterpiece of disingenuousness. He was afraid of offending popular opinion on the one hand, and money power on the other. He as much as says that when he supported the abolition of the Slave Trade he thought that that was enough to satisfy conscience, and except that he is being driven to it, he has no impulse to go further. " I hope I do not misrepresent the House of Commons when I say that it displayed no rage for sudden emancipation [hear!] and that it rather looked to the gradual destruction of slavery through the improvement of the Slave Trade, than to the sudden declaration of the liberty of those who could not yet receive it with advantage to themselves or use it with safety to others [hear!]." And then, apologising to the colonists for the Resolutions they had been asked to support : " . . . there was no hostile feeling towards those whose lot is cast in any region bearing allegiance to the British crown, and subject to the superintending care of the British Parliament, but there was an anxious desire, that while we drive forward the ameliorating system with a steady hand, we should not pass the ploughshare over the property, the lives, or the professions of those for whom we were legislating [hear!]." Hence the compensation of twenty million pounds voted the planters on abolition. " If any man ask me whether I am willing to consent to the perpetuity of slavery? God forbid that I should answer in the affirmative! But if any man ask me whether I wish for immediate emancipation? I must, in my answer to him, put into the scale the ruin, and rapine, which would accompany that premature consummation of what we desire, and if of necessity I were called upon to choose between the two courses of perpetuating slavery or precipitating emancipation, I think I should be driven to choose to remain as we are, not that I prefer the state we are in, but that I dread the responsibility of acting. Happily, Sir, between these two extremes there is an intermediate course. . . . The first measure in order, as the first that suggested itself to the feelings of mankind, was the abolition of a practice as unseemly as it was inhuman. The chastisement of females by the whip is to be entirely abolished [hear!]. . . . Next in order came the abolition of the whip as a stimulus to labour [hear!]. . . . By this change the Negroes are raised above the condition of cattle. . . . The whip is not absolutely abolished, but the House will distinguish between the instrument and its application [hear!]—between the cases in which it is intended to operate upon brute nerve as a stimulus to immediate exertion, and when it operates upon the reasoning faculties as any other mode of punishment.[1] . . . It was to be applied only . . . under very important regulations. . . . Of these regulations, it may be said that they raise the Negro from the condition of a brute to that of a human being [hear!]. . . . The first measure in importance, though the next in order (for till something was done to raise the slave in the scale of being above the beasts anything else would be premature), has relation to that object, without which all that can be done for human beings must be incomplete—the institution of religious worship. It is the intention of his Majesty's Government to widen the basis and extend the benefits of the Ecclesiastical Establishment. . . . When, by means of regulations like these, we have succeeded in raising the ideas of the Negro, then at last you may bid him look forward to the participation in the privileges and duties of society . . . we may then deal with the greatest imaginable difficulty in legislating for him, the admissibility of his evidence in Courts of Justice. Sir, it would be as wild to say, that he shall be indiscriminately admitted as a witness, as it would be unjust to say that he should be indiscriminately rejected. . . . "

The perfect balance of the pompous phrases, the sanctimonious solicitude for the interests of the people who are being denied their rights for their own good, make Canning the supreme type of spokes-

[1] This pretty distinction, cheered by the Honourable Members assembled at Westminster, was no doubt a great consolation to the Negro whose reasoning faculties were being operated upon.

man for the policy of inaction, which is always that of reaction. " . . . I am persuaded that the freedom which is acquired by the patient industry and gradual moral advancement of the slave will be a safer and a firmer blessing than if it were given by any sudden enactment. I am persuaded, Sir, that in dealing with the Negro, we should treat him not as a brute but as an infant, an infant of larger growth, and that if we turn him loose in the maturity of his physical strength, in the manhood of his passions, but in the childhood of his morals and his intellect, we shall have before us a being not unlike that which is pourtrayed in a romance of a child of genius, I know not of how recent a date (Mrs. Shelley's *Frankenstein*), a man artificially compounded with the thews of a giant, with a vigour and a mould more than mortal, into which is infused all the power of doing mischief, but into which its Creator fails to inspire a moral feeling, and has his happiness shipwrecked in his rash experiment [hear !]."

I have quoted from this pernicious, dishonest, and ignorant speech at some length because it is typical of the type of argument which has always prevailed, and prevails to-day, against the eradication of social evil. It appeals to fear, self-interest and a sense of superiority. It even hints subtly at the prejudice of which such dastardly use is made in the Southern States, the sex-jealousy which inspires so much of the colour-phobia there, for I cannot see that otherwise Canning's phrase " in the manhood of his passions " has any dangerous connotations.

BELIEVE IT OR NOT

" Mr. Watson Taylor perfectly concurred in the propriety of the owners of estates in the West Indies doing all they could for the benefit of the Negro population in the Colonies. He would not trouble the House with any detail on the subject, but he assured them that on his own plantations he had, during the last eight years, expended in the care of the aged and young, in furnishing lodgings and medecine for the sick, etc., no less a sum than twelve hundred and forty thousand pounds sterling.[1] He had looked at the good of the Negroes as one of his principal objects, and had endeavoured to consult it in every possible manner ; and such he knew to be the general practice throughout the Colonies. . . .

" Mr. Manning read part of the evidence taken before the Committee on the Abolition of the Slave Trade, in order to shew that the situation of the slaves was generally one of comfort, and that they were cheerful and happy. . . .

" Mr. Evans believed that, generally speaking, the Planters were extremely kind and liberal. But it was one of the most lamentable parts of the Slavery of the West Indies, that it was almost beyond the power of any owner of a plantation to confer any permanent benefit on his Slaves. Their moral degradation was much greater than their physical. . . .

" Sir George Rose thought . . . the Christian religion had extinguished slavery in Europe, and he was disposed to expect from its gradual progress in the West Indies, the extinction of slavery there also."

Buxton, Wilberforce and William Smith were the principal speakers on the side of the Abolitionists in this debate. Buxton attacked the Government for having pledged themselves to bring in early and effectual measures for Abolition, and then to have allowed them to be whittled down to the miserable expedients outlined by Canning. " If we are to wait for progressive measures, for what the Right Honourable Gentleman calls ' the light of reason ' [hear ! hear !], I say in answer to that cheer, that if we are to do no more than the law of reason warrants [hear ! hear !]—if we are to delay until the gradual improvement, so much talked of, has accomplished its purpose, ten centuries may elapse before the Negroes are freed from their present state of melancholy and deplorable thraldom. . . .''

It was the untiring efforts of the Abolitionists throughout the country, distributing pamphlets, speaking wherever they could collect an audience, telling the story of the suffering slaves in the country places on market days[2] and at fairs, that at last forced the Government to yield effectively on the principle of Abolition. The royal assent to the bill was given on August 28, 1833. If the result was not so fundamental as it had seemed it must be, that is because, as the Abolitionists did not see, there are more ways than one of enslaving men, as can be illustrated from every section of NEGRO. But there is only one way of freeing them, and the struggle for Abolition shows that it is only the stirring of the people to mass protest that can make any impression on the lethargic and self-seeking instruments of Government.

[1] *I.e.* £155,000 a year. One must credit the slaves with an abnormal appetite for medicines.

[2] "He spoke of the town he represented (Taunton) from personal knowledge. There he had seen, on market days, men come into the town, who related stories and exhibited plates calculated to excite the feelings of any man, and which, nevertheless, he meant to say, were gross exaggerations [hear !]." From the same debate. Note, like so many other recurring symptoms in the struggle, the perennial excuse that descriptions are " exaggerated. '

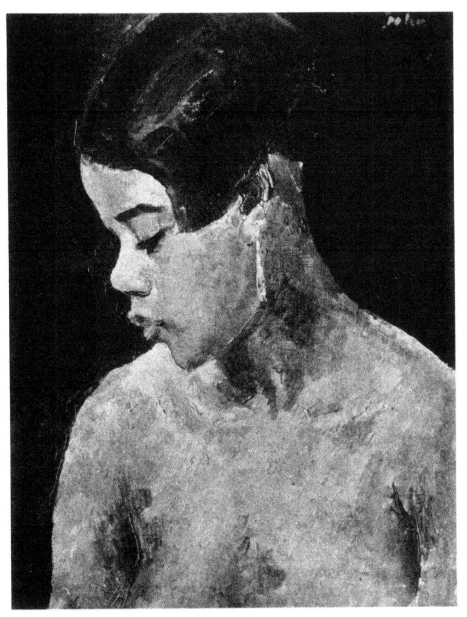

Portrait of Vena, by Augustus John, R.A.
By courtesy of the artist

Pushkin and Peter the Great's Negro

by HAROLD ACTON

How many a Russian friend of mine, yea, the most wholly robust, in reciting Pushkin has burst into tears. Few English, French or Italian poets can have been responsible for such spontaneous flushes of emotion, reckoning even with the strong possibility that we are less sensitive needles to poetry than the Slav. Those who like myself confess ignorance of the Russian language must lament being excluded from the kingdom he evoked, a kingdom which, alas, can send us no direct ambassadors. Certain it is that if we peruse the English renderings of Pushkin—whether T. B. Shaw's or Mr. Maurice Baring's, both praised by Prince D. S. Mirsky—Flaubert's remark to Tourguenieff, " *Il est plat, votre poète !* " is apt to recur to mind. But we must also remember the truism that with poetry there can be no translation. " *Plat* " : and yet, according to Merimée, Pushkin was the last of the Greeks, while Melchior de Vogüe assures us that he belongs to the whole of humanity. The Russians claim him for themselves : his MSS. are still among their greatest treasures, and the Soviet State Press has issued his principal works in a large quarto volume (new spelling, introduced in 1917 ; no capital to the word God).

From the welter of clichés, sweeping generalisations, dead fruit, weeds, encompassing genius inevitably, something will ever emerge to give food for reflection : Georg Brandes, for instance, observed that Pushkin's poetry " smells of Negro." What did Herr Brandes mean, I wondered, wishing he had elaborated this observation, supported it by argument. Olfactory organs differ, and a critic should be more precise. In what sense can poetry smell of Negro? I fancied to detect our old friend, that " antipathy based on differences of colour," a feeling of racial superiority, a reproach.

Perhaps Brandes intended to say that Pushkin's poetry revealed his African blood as his physique, as any study of his life and character, reveals it, from his precocious development until his tragic early death after a duel. For his poetry was first and foremost, by common consent, lyrical. There's the rub ! " As Pushkin's art consists chiefly in the fitness of his words and in the absolute consistency of the sounds and rhythms, even the best translation may give about as much of an idea of the beauty of a poem of his as a good map of the beauty of a landscape." (D. S. Mirsky.) And the Negro's absolute consistency of sounds and rhythms, even in his most unsophisticated forms of expression—whether they be spirituals, jazz, the Blues—is indisputable, a *lieu commun*.

If Pushkin was ingenuously proud of belonging to one of the oldest boyar families on his father's side, he was no less proud of his African ancestry. His mother Nadejda Ossipovna Hannibal, often spoken of as " la belle créole," was, through her father, a grand-daughter of Ibrahim Hannibal, Peter the Great's black godson.

The poet was born in 1799, and since his parents preferred a social to a domestic life, they entrusted him, with his elder sister, to the care of his Hannibal grandmother. The old lady was " a very good example of the somewhat unpretentious but excellent Russian gentlewoman. She was the only one of his relations to whom the poet spoke his native language." (To the others he spoke French.) Mme. Hannibal, who had had more than her share of conjugal grief, lavished affection on her grandchildren. Her husband Ossip Abramovitch, a son of Peter the Great's favourite, had been christened Januarius. " My great-grandmother, however," wrote Pushkin in his genealogy of the Pushkins and Hannibals, " would never consent to giving him this name, which was too difficult for her German pronunciation. ' Ce diaple noir,' she said, ' fait à moi enfants noirs et donne à eux des noms diapoliques.' (' This black devil begets me black children and gives them diabolical names.') "

Ossip became an officer in the navy, and married a cousin of Pushkin's father. " Their union was not happy : the wife's jealousy and the husband's inconstancy were the cause of complaints and quarrels which led to divorce. My grandfather's African temperament, his violent passions aggravated by a terrible rashness induced him into extraordinary aberrations. He married another woman by the expedient of a forged death certificate of his first wife. My grandmother was obliged to have recourse to the Empress, who vigorously intervened in this affair. My grandfather's second marriage was declared null, and my grandmother regained possession of her daughter aged three ; as for my grandfather, he was sent off to serve in the Black Sea. For thirty years they lived apart. My grandfather died in 1807 on his Pskov estate from the consequences of a disordered life. Eleven years later my grandmother died peacefully on the same property. Death reunited them ; they rest side by side in the Svyatogorsky Monastery."

According to Pushkin's elaborate biographer M. Hofmann, Mme. Hannibal and Arina Rodionovna, his nurse, exerted a profound influence over the poet's early years, set light to his imagination with their folklore and historical tales, leading his thoughts into the aromatic past and realms of fantasy. These

vivid impressions on the child's mind, fresh and clear of taint, floated long afterwards about the man and burgeoned into large melody when all else in his life became ashen.

It is improbable that Pushkin met his grandfather: the only son of Peter the Great's favourite with whom we know that he came in contact was the admiral who had commanded the fleet at the Battle of Navarino in 1773, the " Hannibal, before whom, amidst the perilous abysses, the mass of ships blazed up and Navarino fell for the first time." Soon after graduating from the Lyceum of Tsarskoe Selo he went to see this great-uncle, who had retired to his property by the lake at Mikhaylovskoye. He has left us a genial record of his visit to the old seafarer, then aged seventy-five : " Vodka was served. After a glass had been poured out for him he gave orders for me to be served as well. I drank without wincing, which seemed to give great pleasure to the old Negro. A quarter of an hour later he asked for more vodka, and repeated this little trick five or six times before dinner."

Pushkin was then eighteen : at Mikhaylovskoye eleven years afterwards he embarked on his first attempt at a novel, *Peter the Great's Negro*. Did his memory retain any scraps of the conversation during that dinner ; did the young wide-eyed poet question avidly and the swarthy old admiral answer chuckling, spinning long nautical yarns—or was all dissipated in the fumes of vodka? He realised, at any rate, that Mme. Hannibal's tales were far from legendary, that in sooth a Russian came out of Africa whose blood was flowing now fast in his own veins. He was tremendously elated : this actual awareness enlightened so many recesses of his own character, and thereby so much passion was explained.

As half-tiger, half-monkey his schoolfellows had described him ; and one, Komovski, wrote : " Pushkin was sensual to such a point that when he was but fifteen or sixteen years old, at the mere touch of a dancer's hand at the college balls, his eyes blazed, his breathing became sibilant as that of a fiery horse in the midst of a young herd." " This remark," says M. Hofmann, " provoked the indignation of another schoolfellow, M. L. Jakovlev, but rather on account of the form than the idea, and therefore we have no cause to suspect the exactitude of Komovski's observations. A naif sensuality is reflected in many poems of Pushkin, who even at the Lyceum must have appealed to the young beauties by ' the impudent ardour of his desire.' "

Pushkin himself liked to boast in certain boudoirs he frequented that he had the insatiable ardour of a Negro. He never forgot his ancestry : in a letter to Prince Viasemski about Greek independence he wrote (June 1824) : " It is permissible to judge the Greek question like that of my Negro brethren, desiring for both deliverance from an intolerable slavery." Nor did his enemies forget it : they seized eagerly upon it for purposes of insult. Thus Bulharyn, a renegade Pole who had served with Napoleon's army and eventually turned journalist, chose to attack Pushkin in *The Northern Bee*, the only daily paper in Russia then allowed to publish foreign political news :

" It is openly averred that some poet of Spanish America, an emulator of Byron who descends from a mulatto or mulatress, has put it into his head to prove that one of his forefathers was an African prince. In the town-hall it was discovered that of yore there had been a lawsuit between a captain and his mate regarding a nigger whom each wished to appropriate and whom the captain affirmed he had bought for a bottle of rhum. Did he imagine then that a poet would claim lineage from this nigger? *Vanitas, Vanitatum !* "

When Pushkin, " stooping to humble prose," undertook the first Russian historical novel, the subject was already crystallised in his mind : the chief rôle would be allotted to his black great-grandfather. His idea for the main plot was the infidelity of the Negro's wife, who gives birth to a white child and is consequently sent by her husband to a nunnery. The main plot, however, was never reached, for Pushkin left off at the beginning of the seventh chapter, before Valerian, the lover of Ibrahim's fiancée, makes his appearance.

While we may appreciate the narrative, Pushkin's prose must inevitably lose by translation (style again being untranslatable), so that we are forced to rely upon the judgments of his compatriots.

Of *Peter the Great's Negro* Prince D. S. Mirsky wrote : " The first chapter, which deals with the Negro's life in Paris, his success in French society, and his love affair with a French Countess, is admirable and displays almost all the best qualities of Pushkin's prose. The story of the Countess's giving birth to a black child on the eve of Hannibal's departure for Russia and of the way it was replaced by a white one in order not to disturb the unsuspecting Count is particularly good. It is reminiscent of the French novelists of the eighteenth century rather than of Scott. But the following chapters are over-encumbered with historical colour and all the antiquarianism dear to the heart of Sir Walter. There is good reason to believe that it was precisely this that caused Pushkin to leave off in the beginning, for in his later work he never revived the manner."

Pushkin and Peter the Great's Negro

M. Hofmann is more enthusiastic about *Peter the Great's Negro*, more perplexed and disappointed by Pushkin's abandonment of it : " The poet's lapse from interest in his subject (if indeed there be such lapse from interest) is all the more incomprehensible in that this new creation worked itself out with exceptional ease and success, and Pushkin evinced a particular interest in his genealogy, being certain that many traits in his own character, and especially his fiery temperament, arose from his African heredity. And who knows if Pushkin, when he wished but could not decide to marry, did not apply to himself Korsakoff's advice to his ancestor :

" ' There is no dependence to be placed upon a woman's fidelity ; happy is he who can regard it with indifference. But you ! . . . With your passionate, pensive and suspicious nature, with your flat nose, thick lips, and shaggy head, to rush into all the dangers of matrimony ! . . .'

" The most probable explanation is that Pushkin did not finish his novel because he was unwilling to make his family affairs public, and eventually lend himself to comparisons. The novel is not finished, but such as it stands, with its six complete chapters, it is a masterpiece, and from the way it evokes the period of Peter the Great, a true miracle in Russian literature. What strikes one is the indelible colour of the scenes ; life at the French Court under the Duc d'Orléans' regency ; Peter the Great's meeting with Ibrahim ; the assemblies under Peter the Great ; the vestiges of boyar life and, above all, the image of the Great Czar, idol of Pushkin's."

Prince Mirsky maintains that Pushkin gives a romantic version of his great-grandfather's history which has no foundation in known fact. But what could be more romantic than the facts recorded of him in histories of Peter the Great ? Pushkin might easily have embroidered on the vicissitudes of Ibrahim's boyhood, like Othello's,

> . . . of most disastrous chances,
> Of moving accidents by flood and field ;
> Of hair-breadth scapes i' th' imminent deadly breach ;
> Of being taken by the insolent foe,
> And sold to slavery ; . . .

But he never even strays thus far. His novel begins with Ibrahim in Paris " among the number of young men sent abroad by Peter the Great for the acquisition of knowledge indispensable to a country in a state of transition." The only reference to his birth is in Chapter V, when Gavril Afanassievitch Rjevsky, who " was descended from an ancient noble family, possessed vast estates, was hospitable, loved falconry, and had a large number of domestics," informs his outraged family that the Czar wishes his daughter to wed the Negro :

" ' . . . For whom, then, does the Czar want Natasha ? '

" ' For the Negro Ibrahim.'

" The old lady uttered a cry and clasped her hands. Prince Likoff raised his head from the pillow, and with astonishment repeated :

" ' For the Negro Ibrahim ? '

" ' My dear brother ! ' said the old lady in a tearful voice : ' do not destroy your dear child, do not deliver poor little Natasha into the clutches of that black devil.'

" ' How ? ' replied Gavril Afanassievitch : ' refuse the Emperor, who promises in return to bestow his favour upon us and all our house.'

" ' What ! ' exclaimed the old Prince, who was now wide awake : ' Natasha, my grand-daughter, to be married to a bought Negro ? '

" ' He is not of common birth,' said Gavril Afanassievitch : ' he is the son of a Negro Sultan. The Mussulmen took him prisoner and sold him in Constantinople, and our ambassador bought him and presented him to the Czar. The Negro's eldest brother came to Russia with a considerable ransom and——'

" ' We have heard the legends of Bova Korolevitch and Erouslana Lazarevitch.'

" ' My dear Gavril Afanassievitch ! ' interrupted the old lady, ' tell us rather how you replied to the Emperor's proposals.'

" ' I said that we were under his authority, and that it was our duty to obey him in all things.' "

The historians differ in detail, but the outlines are the same : it is generally agreed that Ibrahim was the son of the Emir of Abyssinia, or of the petty king of an Ethiopian tribe in northern Abyssinia— a Negro Sultan, as Pushkin has it. He is supposed to have been born about the year 1696, and abducted at the age of seven to Constantinople, where Count Tolstoi, the Russian ambassador, either stole or bought him out of the Great Turk's seraglio in 1705. Waliskewski relates that through all the course of

336

Pushkin and Peter the Great's Negro

a singularly active life he was haunted by a painful vision, the memory of his beloved sister Lagane, who had cast herself into the sea and swum for a considerable distance behind the ship which was bearing him away from her. On the shores of the Bosphorus he received the surname of Ibrahim, or Abram. During the Czar's visit to Vilna in 1707 he was baptised—Peter standing godfather and the Queen of Poland godmother—and was known thenceforward as Abraham Petrovitch (son of Peter) Hannibal.

He began his Russian life as page to the sovereign, and though he was often beaten, for Peter never spared the rod (application of the *doubina* was almost a token of that great man's affection), his pretty tricks and singularly bright intelligence endeared the little African to his godfather, who supervised his education, and when he suffered from *taenia* gave his treatment personal and active attention. In 1716 he was sent to France to study military science and especially fortification. He had already learnt Dutch, and soon won a reputation in the French army, in the ranks of which he at once took service. He was promoted Lieutenant in 1720, during the war of the Spanish Succession, in the course of which he was wounded in the head. When he returned to Paris he found himself a kind of celebrity, much sought after in the drawing-rooms, where he is said to have had considerable success. Here we find him in Chapter I of Pushkin's novel, and the poet's picture is extremely plausible; even if Ibrahim did not assist at the suppers " animated by the youth of Arouet, the old age of Chaulieu, and the conversations of Montesquieu and Fontenelle," we actually see the curly head silhouetted among the powdered perukes at fêtes and balls, sympathise with the young Negro regarded in the light of a curiosity, stared at and overwhelmed with questions.

" He felt that he was for them a kind of rare beast, a peculiar creature, accidentally brought into the world, but having with it nothing in common. He even envied people who remained unnoticed, and considered them fortunate in their insignificance."

Doubtless he sowed his wild oats, " but his serious tastes soon drew him away from frivolous gaiety." He entered the School of Engineering, and did not leave it until 1726 (or 1722 according to M. Emile Haumant), when he returned to Russia. The Czar gave him a warm welcome: his black protégé had " made good." Soon Hannibal was elevated to the rank of Captain-lieutenant of the Grenadier Company of the Preobrajensky Regiment in which Peter himself was Captain. It was a great honour. " The courtiers surrounded Ibrahim, each in his way trying to flatter the new favourite. The haughty Prince Menshikoff pressed his hand in a friendly manner; Sheremetieff inquired after his Parisian acquaintances, and Golovin invited him to dinner." But, as the Czar's historians have shown, even great honours had their disadvantages in that hurricane's environment:

" The Czar never slept alone, and in the absence of his wife would avail himself of the company of the first orderly officer he could lay his hand on. This individual had to lie exceedingly quiet, under pain of being well thrashed. Peter generally woke up in a bad temper. In the country, when the hour for his daily siesta came, he made one of these officers lie down on the ground, and used his stomach for a pillow. This man did wisely, unless his digestion was an exceptionally quick and easy one, to be in a fasting condition, for on the slightest movement or sound the Czar would spring to his feet and fall upon him." It is not improbable that Ibrahim had to serve in the capacity of a pillow as well as Captain-lieutenant of the Czar's crack regiment.

His domestic life was not happy. He married the beautiful daughter of a Greek merchant who was unfaithful to him, justifying herself by the consideration " that a nigger is not of our race." First he tried to bring her back to her duty by domestic corrections, and then started legal proceedings against her. The trial lasted fifteen years and resulted in her being sentenced to do public penance and take the veil. Ibrahim had the fair-haired child she had borne brought up with every care: he found her a husband, gave her a dowry, but would never see her face. Meanwhile, without waiting for a formal divorce from his first wife, he married the Livonian gentlewoman who became Pushkin's great-grandmother.

Waliskewski summarises him as a very jealous, violent, loyal, upright, and exceedingly avaricious man. After Peter's death he fell out with Menshikoff, like so many others, and was sent into exile. He did not return from Siberia till Elizabeth Petrovna's time, a golden age for her father's familiars, when Hannibal became a General and a rich landowner. All his life he remained attached to the memory and traditions of the Great Emperor. He died in 1781, at the ripe age of 83, leaving 1,500 serfs to his seven lusty children.

A passing strange career, and passing strange to consider that this African's great-grandson was one of the first to discover the genius of the Russian language, and to create a fundamentally national literature. And when the poet died in 1837 he was interred beside his mother, and close to his grandfather and grandmother Hannibal, in the Svyatogorsky Monastery near Mikhaylovskoye.

337

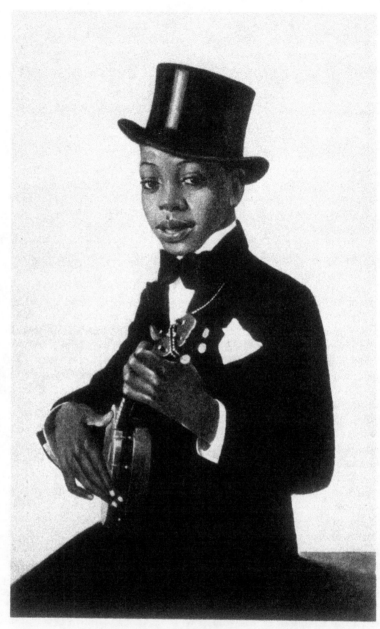

"Snowball," who played in C. B. Cochran's "Year of Grace"
Portrait by Oliver Messel
By courtesy of the artist

338

Anthony Butts's discussion of racial segregation and prejudice in England is similar to Nancy's account in *Black Man and White Ladyship*, although her treatment is considerably more fiery. The photograph (on page 340) was taken in February, 1931, at Obergurgl, in the Tyrolean Alps, where Henry and Nancy went to recoup after their stormy London adventure.

H. F.

There is no " White Superiority "

by ANTHONY BUTTS

I AM convinced that nothing is more false or more unprovable than the conventional British-American assumption that the white races are inherently superior to the coloured ; they have become different, psychically, to some extent, that is all. This assumption is fundamentally bad because it is self-righteous, immoral, and because it can never by any means whatever be proved ; in application it produces nothing but hypocrisy and cruelty. Because the love of man superbly preached by Christ has become, through non-application as an idea, venereal, the exaltation of hatred and vanity as a substitute is not likely to be more productive in the future.

As an individual, I see the Negro as I see any other man : capable of all the virtues and defects of the ordinary man ; sometimes brilliantly intelligent ; more often not, naturally. I do not for a moment believe, however, that the intellectual powers of the average Negro are weaker than those of the average white man. Individually, they seem to me to possess considerable shrewdness, a capacity for loyalty in friendship, a gay cynicism and disillusionment, a disinclination to grumble at their lot unnecessarily, a quickness of perception, admirable vitality, a sense of humour—rather a dry one—a natural sense of affection and tenderness, and a superb capacity for enjoying life, whenever they are given half a chance. If one had the space to create an individual portrait-gallery of Negroes, the diversity and complexity of character displayed there would be remarkable.

Personally, I regard the British colour-bar as peculiarly objectionable, and in fact criminal ; I do not, however, believe in the popular liberal conception of England that all is well with the French Negro for a single instant ; there may be an amelioration of living conditions as regards certain French colonies, but the impression which one gets of French colonial life from as responsible an observer as M. Gide is far from reassuring. Undoubtedly French life in general, and Parisian life in particular, does provide a more reasonable attitude and environment than that of English and London life. I believe that this affects, to some extent, every Negro, however rich, however cultivated, who visits England. From any point of view of decency and humanity, the average Englishman's attitude is intolerable ; but what is far more surprising than its cruelty, which we have learned only too well to expect, is its commercial short-sightedness. With our curious national lack of cynicism and curiosity, we have not realised, as the French have, that it is good business to delude all our subjects into the belief that they all, automatically, possess the rights, privileges and pride of our national citizenship ; it has not even occurred to us that such citizens at once earn and spend more money when they are given reasonable facilities, instead of being, as they are, frustrated at every turn, once they set foot in Merrie England, or on the land that was once theirs. And this entire attitude is " bad business," whether it relates to English or to colonial life. Scratch a colonising European, and you find—a purse with a tendency to emptiness . . . the phrase " goodwill " is supposed to have a symbolic commercial significance. . . .

The best that can be said—and it is far, far too little—for the position of the Negro in any English society, is that that society does not produce some of the more startling anomalies of colonial life in Africa (where I believe the average cost to a white man for the murder of a Negro is about five pounds), such as the amazing fact that the white women who are most insulting to their male native servants, and who are most abusive about natives in general, are usually those who find their white husbands sexually inadequate or unattractive, and who in consequence seduce their Negro servants. Then, should they be in danger of discovery, they cry : " Rape ! Rape ! " and, needless to say, unlike the boy in the fable, they are believed. The Negro's quandary is a difficult one ; if he takes his mistress at her word, he is exposed to the every caprice of a frivolous and heartless woman, and to the—to him—extreme risks of the situation ; and, should he refuse, he will instantly be accused by the woman of attempted or of successful rape,

339

involving the penalty, in the latter case, often of death. It is therefore not surprising to learn that quantities of Negroes secretly run away from domestic service, forfeiting their wages and characters, rather than run the risks dependent upon a white woman's " love." I do not suggest that these conditions are universally prevalent all over Africa; but I do deliberately state that they are only too frequent.

My relations with Negroes are exactly the same as my relations with anyone else, of any colour whatever; that is, they are relations with individuals, simply. There are no nuances peculiar to my friendships with coloured men or women, other than the allowances which one must make for any psychological variation from one's own race-type; and this applies equally to any friend one may have who is not of the same European race as one's self. There are, naturally enough, a number of Negroes whom I have met with whom I find I have nothing whatever in common, in just the same way that I have nothing in common with a number of my fellow-countrymen. When I feel that curious psychic and nervous stimulus which precedes the beginning of a friendship, I can only gauge the indefinable essence of the individual in question by an instinctive, intuitive method, to which I can only later add the complementary methods of reason and selection, in seeking whatever qualities one does seek, as an individualist, from individuals.

Mrs. Woolf says what I mean when she writes:

Brian Howard, Nancy Cunard, Henry Crowder, Sandy Baird, Max, in the Austrian Tyrol, 1931

" How then, she had asked herself, did one know one thing or another thing about people, sealed as they were? Only like a bee, drawn by some sweetness in the air intangible to touch or taste, one haunted the dome-shaped hive, ranged the wastes of the air over the countries of the world alone, and then haunted the hives with their murmurs and their stirrings : the hives which were people."

I have heard people say, who know Africa well, that Negroes are well able to size up a white man or woman, and often more rapidly than a white person of equal intelligence would be able to do. Whether they rely on purely objective evidence, or whether they use their instinct and intuition alone, delicately probing the nature of the person as with a kind of psychic antenna, or whether they use a fusion of both methods, I do not know.

I am perpetually reminded in conversation with Negroes that I have only to close my eyes for it to be impossible for me to discover the pigmentation of the person to whom I am talking. Far from it appearing that Negroes are slow to adapt themselves to a transitional western civilisation, they seem to me to be uncannily quick in acquiring the formula . . . only too quick. I doubt very much whether our own woad-smeared ancestors learned as quickly from the Romans as the African and American Negro has learned from the white man.

I am convinced that our fear and hatred of the Negro comes in the first place from our memory of the untold and atrocious injuries which have been and are still being done to him ; and secondly from our puritan horror and contempt for any human being who dares and desires to be happy, and who can be happy, even in the face of amazing odds.

I have no wish to paint any form of human life, primitive or pseudo-civilised, in the roses and carmines of Renoir's later manner, but no one can deny the African's innate capacity for happiness, despite the barbarities of christian or of primitive tabu ; yet, in a world partly poisoned by the white man's virus, I cannot help believing, perhaps wrongly, that an Africa colonised by, let us say, the Japanese, would be even more of a moral and physical shambles than the Africa of the European partition.

Neither do I believe that the African, left to himself to possess his own lands in peace and honour, would bring about the millennium for himself, but I believe profoundly in his right to try and to fail, and

to go on trying. The natural " ghost," the psychic individuality of any race or any individual, is, or should be, inviolable; for another race to seek to disturb or to decanalise it for the sake of economic exploitation is to commit what has been called the " sin against the Holy Ghost."

But I also believe that the Negroes should look into their own hearts, that they may find hidden there one fatal weakness, or one which has hitherto proved fatal. One sees in African character an inability to co-operate with one another; an inability to unite under one leader; let us hope, one liberator; an inability to conspire in utter secrecy. The white man, in giving certain privileges to Negroes more educated and more cunning than their fellow-men, has driven home a wedge into the body of African society; this it is which divides the interests of Negro against Negro. One Negro can derive material profits from loyalty to the white man, from being a " white man's nigger "; and that material gain robs him of the fidelity which he owes alone to his race. Were this not true, alas, it might still conceivably be possible for a conspiracy to succeed which might clear Africa of every white man, woman and child within her territories. That would be a new Dingaan's Day with a very literal vengeance. . . .

And, lastly, I believe that only if man is as deeply and finally the enemy of man, as he sometimes appears to be, can the hatred and the mechanised power of the white usurpers of Africa prevent the Negro race from occupying that basic position in society, with a completely guaranteed legal security (and the recently discovered Kenya gold-reefs show what the Negro's legal position is worth to-day) from which a whole culture, a natural civilisation, may spring.

Despite her tendency to vilify the English as racists, Nancy admitted in calmer moments that the "general Englishman doesn't see why the black man should be treated differently." And she remembered that a "sailor in the mercantile marine [had] said the black boys were always liked at the Sailor's Hostel in the East End of London, perhaps because of their 'nice nature or sumpthin'—he could not tell, he liked them." She also knew that among her coterie of English friends there was no color prejudice. Anthony Butts reinforced Nancy's observations as well as her contention that no white supremacy existed, only the fact of different races.

H. F.

Colour Bar

by NANCY CUNARD

HERE ARE THE DEFINITIONS BY TWO DIFFERENT LAWYERS OF COLOUR BAR IN HOTELS
AND RESTAURANTS

NOTE ON COLOUR BAR AS AFFECTING HOTELS, RESTAURANTS AND BOARDING HOUSES

An " Inn " is an establishment for the accommodation and refreshment of travellers and it is probably an essential feature of an " Inn " that it should provide sleeping accommodation.

On the other hand a Residential or Private Hotel where no one other than a lodger is supplied with food, is probably not an " Inn." Most hotels are undoubtedly " Inns," whilst Public Houses in which sleeping accommodation is not provided, restaurants and eating houses are not " Inns."

The " Innkeeper " is *under a Common Law obligation to admit persons other than those who are drunk or who behave in an indecent, improper or disorderly manner*, and, therefore, subject to this exception *persons of colour* if they are travellers *have a right to accommodation or refreshment* and the " Innkeeper " *cannot refuse them*. It must be remembered, however, that a person who has come to an " Inn " as a traveller may by long residence or for some other reason cease to retain that character. If the guest loses the character of traveller the " Innkeeper " is entitled on giving reasonable notice to require him to leave.

With regard to Boarding establishments which are not " Inns," Public Houses, Restaurants and Dance Halls, etc., there is no legal obligation on the proprietor to admit any person who applies, the matter being one for their uncontrolled discretion, and there was a case in 1924 which came before the Courts in Canada, where it was held, although the Court was unsympathetic to the action of the Restaurant-keeper, whom they deprived of costs, that the Restaurant-keeper was entitled to refuse admission to a Negro who was the Plaintiff. The Judgment proceeded substantially on the basis of English law.

COPY OF LAWYER'S LETTER CONCERNING HOTEL REGULATIONS IN ENGLAND

There are no Government regulations concerning hotel accommodation. It depends upon Common Law, and the principle may be stated this way :

By the Common Law of England, *every person who keeps a common inn is under obligation* to receive and afford proper entertainment *to everyone* who offers himself as a guest, if there be sufficient room for him in the inn and no good reason to refuse him.

If a person received as a guest remains so long as to lose the character of a traveller, the inn-keeper may require him to leave by giving him reasonable notice.

The relationship of host and guest cannot be terminated abruptly and without notice to the guest. A reasonable time must be allowed for him to carry away all securities and effects.

The definition of an inn is a house where the traveller is furnished with everything he has occasion for *while on his way*.

I fancy that a restaurant, not attached to an hotel, or with a separate entrance apart from the hotel, would be able to refuse admission to unwelcome guests without giving any particular reason.

It will be seen that " the principle stated this way " is full of the most excruciating subtleties. The more so as (see previous definition) it seems hard to tell when an inn *is* an inn and when it is an hotel. One would have to study law to unravel these skeins of meaning. The point lies, of course, in the personal acceptance or non-acceptance of the " inn-keeper."

To return to the " subtleties " : " If there be sufficient room " (for the guest) " and no good reason to refuse him." Those of us who are coloured and those of us who have coloured friends have, I fancy, all encountered the simply unqualifiable reply of " No room " from hotel or restaurant, when in the one case it can be seen that the hotels are half empty, and in the other that there are any number of vacant tables in the given restaurant.

" If a person remains so long as to lose the character of a traveller. . . ." Just how long might that be? Many of us live in hotels entirely. This seems not such an important point as the others; once *in*, it is more likely than not that you will be " graciously permitted " to stay ; and yet cases have occurred to the contrary.

" Relationship cannot be terminated abruptly and without notice to the guest. A reasonable time," etc. What is meant by abrupt termination, and what by reasonable time? Half an hour, or a day or two to find other and suitable accommodation?

342

Colour Bar

And why this difference in Common Law between the inn-hotel and the restaurant that is not attached to either?

The clauses appear to be worded in such a manner as to be able to be twisted to mean simply anything. For instance, "a good reason to refuse" a guest might mean that the colour of his skin did not suit the hotel or restaurant keeper.

This whole matter of hotel, lodging-house and restaurant discrimination is without question one of the most vicious and scandalous actions of the English against people of colour, who (with the exception of the Chinese, Japanese, Abyssinian, Liberian and Haytian, equally discriminated against) are all of them, unfortunately, subjects either of the British Empire or of the other white capitalist nations. This attitude is very largely fostered by Americans, whose colour-complex reaches the proportions of downright insanity, and, of course, by colonials. Why should Negroes and other coloured people have to spend their money, time, brains and labouring strength in England when they are treated in this manner?

Now enters another consideration. How is it that Indian Rajahs are not discriminated against? And how does it happen that society women, and even American-born, frantically prejudiced society women, pose for photo-

graphs in their company when they pretend to faint at the mere thought of a Negro? The answer is so simple . . . *Rajahs have money*, and are "important people," chiefs, etc. Also, India is "dangerous" to England. That is the mentality of these society folk in their utter snobbishness and ignorance. It is, once again, economic. Like the entire question of race prejudice.

The answer the hotels generally give is that *they* (the management) " don't mind so much, but the other guests, you see. . . ." What is to be done about this? Are we to have, as in the Southern States of America, signs " For coloured," or " Dogs and niggers not allowed "? What other humiliation can be devised by the advocates of segregation? The government flatly refuses to make any attempt at intervention (the point was raised by Ellen Wilkinson during the Labour government, supposed to be less antipathetic to coloured races than liberal or conservative governments, and the reply was that it was no concern of the government).

If some hotels put up this colour bar out of so-called deference to what they think their other clients disapprove of, then why are others above this kind of often *doubtfully* justified fear? I could list some hotels, restaurants and public houses on the same street which happen to be situated just opposite each other or in the closest proximity, who respectively serve people of colour like anyone else or refuse to serve or accommodate them.

It is curious that the British purse-mind is so slow at waking up. Does it not realise yet that all the American coloured people (who choose the continent) and that many West Indians and Africans would be more likely to take tickets to England, and that the inevitable result of a ticket to any country, is that money will be spent in that country—instead of going to France, Germany (before the Hitler régime), or anywhere else where they are not subjected to the infamous and insane workings of the so-called " British Public Opinion "?

One might think that the economic lever might accomplish for England what the " Great Colonial Empire " did for France—the understanding that she could not afford to show prejudice against her Negroes, who are such an important part of the whole French army (as see the last war and the number of black troops at present), though this must not be taken to mean that the French ever had any intention of discriminating against black people in social relations. A Negro is as good as anyone else in that country, and is protected, as any other citizen, not attacked. By what agency then does this same Negro, as soon as he strikes English soil, become " a Nigger "? By the same agency that made Charles I lose his head. By the same spirit that made him say " the divine right of Kings." Exactly that. The English hold that they must keep the blacks down ; it is their " divine right."

This last is of course also back of that " no room " in the hotels and eating places. The law is not " subtle," it is sticky and prejudiced on this point. Without question any Negro or coloured person who brings a case, and he can and should, will be under the gunfire of prejudice all the way through. He may win, he probably will, when the facts are clear, but " justice " will be made grudgingly ; the material matters of award and damages, etc., will be less than if a white sued a white, but still he will

343

Colour Bar

have accomplished something. He will have shown that black people are quite determined not to be put upon any more, that they are striking for their rights.

The two letters that follow here are from hotels to which I wrote to have their answers on paper concerning this matter. The Washington is a fairly expensive place in the heart of Mayfair. The Hermitage of La Baule is in Brittany, France. A " Palace " with staggering prices. The letter sent them was to ask for rooms for a white wife and a Negro husband. The answer is a perfect revelation of the advance of American influence in France. (Incidentally, does this mean that Messrs. Diagne and Candace (respectively ex-Secretary of State for the Colonies and present Secretary of State for the Colonies), Senegalese Negro Deputy and Negro Deputy from the Antilles, would be refused accommodation? A pretty scandal! both for these ministers and for the hotel—and both somewhat of the same calibre.) A third high-class hotel, the Ruhl at Nice, replied that of course they made no discrimination. I did not particularly choose any of these hotels : they had sent me their advertisements and I thought they would do as well as any others of their respective classes.

Hotel Washington wrote :

Oct. 1, 1931. I am in receipt of your letter of the 27th ult., and thank you for thinking of us with regard to your friends. However as we have so many American visitors, who, as you know, are so prejudiced against Negroes, I regret very much that we cannot offer accommodation.
I do not know of an hotel about our size who would consider this, but the large hotels would doubtless be able to accommodate.
etc., signed by the Manager.

Hermitage Hotel wrote :

March 5, 1932. We beg to reply to your esteemed demand of information of the 2nd ult. but regret to inform you that it is impossible for us to accommodate your friends at the Hermitage.
A large part of our clientèle does actually consist of members of good New York society and we cannot risk incommoding them by accepting as clients a mixed couple in the same hotel as themselves.
etc., signed by the Director.

Concerning the same matter in restaurants I append here a particularly monstrous case about which the League against Imperialism took such steps as it could by protesting vigorously against the Colour Bar in Britain to the Home Office and demanding that influence should be brought to bear so that such offences should not continue to occur, and by making the case widely known.

To the Secretary of State for the Home Department,
Home Office, Whitehall, S.W. 1.
Feb. 10, 1932.
Sir :—
I am directed by the Executive Committee of the British Section of the League against Imperialism to bring to the knowledge of His Majesty's Government through you the following facts relative to the operation of the Colour Bar in Britain and to request that you will move the competent authorities to take such action as may be possible to convey to the establishment concerned that its attitude towards the Negro Race is objectionable and harmful. The League against Imperialism has been informed by Mr. David Tucker, Master of Arts of Bermuda and now a student of law at the Inns of Court (Middle Temple), who is the Publicity Secretary of the League of Coloured Peoples (Memorial Hall, Farringdon Street, London, E.C. 4), that on the afternoon of December 10th last he invited the Secretary of the British Section of the Workers' International Relief, Mrs. Isobel Brown, to tea at the Essex Street Tea-Rooms, 24, Essex Street, Strand, W.C. 2, which are adjoining the Middle Temple. Mr. Tucker has been so frequent a visitor to this Tearoom with friends of both sexes as well as alone that he might almost be considered a regular patron.
When he entered the Tea-room as usual on the afternoon of December 10th he was informed that he and Mrs. Brown could not be served. No reason for this refusal was given by the management of the Tea-room. This incident is naturally resented and deplored by Mr. Tucker and Mrs. Brown and those associated with them in their work on behalf of the oppressed peoples, and they have brought the facts to the knowledge of the League against Imperialism, which as you are no doubt aware, is an international organisation striving for the freedom and independence of the subject peoples.
Now this instance of race prejudice in Britain is not an isolated instance, confined to one country.
On the very same day that the incident above described occurred in London, December 10th, 1931, the *Evening Standard* reported the lynching at Lewisburg in West Virginia of two Negroes, Tom Jackson and George

Colour Bar

Banks. These men were dragged out of Green Brier County Gaol by a mob of 60 persons and swung up on the telephone post, where bullets were poured into their dangling bodies.

This was the second instance of lynching reported within a week. On December 6th 4,000 people raided a hospital in Maryland and hanged a wounded Negro, who was accused of shooting a resident.

More recently the British Boxing Board of Control has given expression to racial prejudice by deciding that no coloured man shall even be permitted to box for a British title.

There has been another example of this artificially created racial feeling and its disastrous results in the recent murder scandal at Hawaii, which is inflaming opinion throughout the Pacific lands at a time when hostilities have broken out and a great concentration of armed forces is taking place.

I am instructed to express the hope that you will use your influence with a view to avoiding any recurrence of the insulting treatment of which Mr. David Tucker, the Publicity Secretary of the League of Coloured Peoples, and Mrs. Isobel Brown, were the victims on December 10th and to request that you will be so good as to acquaint the League against Imperialism of the action taken.

Copies of this communication have been forwarded to the Lord President of the Council and to the Secretary of State for the Colonies.

I am, Sir, etc.

(Signed by Reginald Bridgeman, Secretary of the Anti-Imperialist League.)

The following reply has been received from the Home Office:

Home Office, 11th February, 1932.

Sir,

I am directed by the Secretary of State to acknowledge the receipt of your letter of the 9th inst., relating to Essex-Stairs Tea Rooms, Strand, Refusal to serve to coloured man and White Woman.

I am, Sir, etc. (signed).

The style of the reply may be particularly noted: " Refusal to serve to coloured man and white woman "—a pair of objects. No-one can think that a government that sends such an answer—which is no answer at all, but a mere chit of acknowledgment—is going to pay the slightest attention to any number of insults to coloured people. " Teach niggers their ' place ' " is as much the government view as it has ever been. If this were not so the government would take a hand in putting a stop to such incidents.

But, someone will say, it is not a government matter. It is private concern between hotel and restaurant managers and clients. So, one might think, would be the right to consume beer and spirits and to pay for the right of spending all night in dancing if one chose to. These are certainly private enough matters, and yet we have semi-prohibition and legislation against enjoyment, both of which are attacks on our personal rights. The government is above interfering in a thing of such magnitude as the Colour Bar. Or—the government is powerless. In which case it is at the mercy of a pack of inn-keepers and publicans.

Now, when some Americans tried to foist their prejudice on to some restaurant and cabaret directors in France, resulting in several cases of insult to coloured people in the last five or six years, the French government immediately acted *and closed* these places, in one instance at least for as long as two weeks. This was not effected after an involved legal operation, but *overnight*. And a cabaret can lose a whole stack of money in a fortnight. The French know that the economic lever is the only one that counts. We should see the difference if it were made to function in England.

Colour Bar Notoriety in Great Britain

by A. ADE ADEMOLA, B.A. (Hons.) Cantab.

ONE of the essential causes of recurrent ill-feeling among Africans against white people in this country is the persistent ill-treatment Africans have to experience repeatedly at the hands of inn-keepers and hotel managers. Negroes from Africa, America, West Indies have been refused admission to, or accommodation in, London hotels. Even Negroes who are so well known that their names have become a household word in this country are not exempted.

A high point in this colour question was reached last March in a simple case of a contract made by a Nigerian student with the proprietor of an hotel in Lancaster Gate, W. 2.

The case in itself as a simple contract case has no significant importance, but as a definite break on the hypocritical way and manner the hotel managers in this country have hitherto treated the question, it has a most distinguished posthumous career. Born in the humble surroundings of Marylebone County Court, and during its life only achieving the modest distinction of an award of 12 guineas damages plus costs, its fame rests in large part not on the theory concerning the point it involves as a simple contract case, but on its own intrinsic value.

The facts in this case are shortly as follows : The plaintiff, Mr. O. A. Alakija, a West African graduate of Oxford University, sued the New Mansion Hotel, Lancaster Gate, for breach of contract made in writing, in respect of accommodation in the defendant's hotel. Several letters passed between the plain-tiff and the defendant's hotel, with the result that it was arranged that the plaintiff should have a bedroom and board for 10 months from August 27, 1931. The appointed day came and Mr. Alakija arrived at the hotel with his luggage. He was taken to his room by a page-boy ; later he was interviewed by the manageress, who told him he could not stay. Mr. Alakija pointed out that the matter had been arranged by correspondence. He was then told that the real ground of objection was his colour. An interview later with the manager or proprietor proved abortive, and after a definite remonstration, he asked that his luggage be brought down and left the hotel. He later found difficulty in getting accommodation in London and was put to great inconvenience and expense thereby, and finally had to take something more expensive than he had bargained for at the New Mansion Hotel.

On behalf of the defendant, the New Mansion Hotel, it was submitted that :

1. Mr. Alakija refused the room because it was too high.
2. He was under a duty to disclose in the correspondence the fact that he was an African, and as the fact was not known to the defendant, who was under the belief that he was in touch with a European, there was no *consensus ad idem*, and therefore no contract.

His Honour, in giving judgment, said he came to the conclusion that there was a contract for 10 months' accommodation ; that though a man may carry on his business in a particular manner best suited to himself, still he is bound by a contract which he makes. There was no duty upon Mr. Alakija to disclose in his letters that he was a West African because he had no reason to suppose that the defendant would object to him in any way.

Looking at this case as a whole, if the second line of the defence had succeeded—that is, non-disclosure on the part of Mr. Alakija that he was an African—there would have been a new chapter added to the law of contract.

In the law of contract, non-disclosure is not fraud and will not void a contract. In this respect, only contracts known as *uberrimæ fidei*—that is, contracts in which one of the parties is presumed to have means of knowledge which are not accessible to the other, and therefore bound to say everything which may be likely to affect his judgment; for example, contracts of insurance and the like—may be vitiated by non-disclosure, and our case does not come under such contracts.

Again, mistake as to the identity of the person with whom the contract is made cannot arise in the case of general offers which anyone may accept, such as offers by advertisement: the New Mansion Hotel advertises in London and West African newspapers, and Mr. Alakija got to know of the hotel's existence through newspaper advertisements.

The question may be asked here, why the defendant should advertise in West African newspapers owned and controlled by Africans, and then refuse to take Africans in his hotel ? *Little did he realise that the newspaper that bore his advertisement in Nigeria has for chairman of the company the plaintiff's father.*

Furthermore, Mr. Alakija had not assumed a false name in order to deceive the defendant. His name, no doubt, sounds foreign enough, and if the defendant had set out to exclude coloured men, the name is

enough to have put him to enquiry before the completion of the contract. Mr. Alakija had therefore done nothing to deceive the defendant and he is not bound to prevent the defendant from deceiving himself.

Having dealt briefly with the defence, though the case has nothing to do with "the inn-keeper issue," it may be an eye-opener to say a few words on the subject.

No one would dream of applying the word "inn" to the larger hotels. Yet such hotels are often inns. In fact, they usually are for most purposes.

We use "inn" now for an inferior sort of house used as a public house. Inn is a house the owner of which holds out that he will receive all travellers and sojourners who are willing to pay a price adequate to the sort of accommodation provided and who come in a condition in which they are fit to be received. An hotel may be an inn. It is in most cases. Lord Esher, M.R., in *Lamond* v. *Richard & Gordon Hotels Ltd.*, [1897] 1 Q. B. 541, said: "I think it is a question of fact what was the intention of those who carried on the business of the hotel."

It would seem that a residential hotel pure and simple where single rooms or suites of apartments are let to lodgers to whom provisions are supplied on demand, but which has no licence and which does not supply refreshments to non-residents, is not an inn, and authorities seem to agree that where persons are tenants of "service flats," where there is a restaurant and lounge where intoxicating liquors are sold to persons from outside as well as residents, such a building is nevertheless not an hotel. But it does not follow that because there are persons residing at an hotel for long periods and on inclusive terms, the hotel is therefore a residential hotel or that the relationship of innkeeper and guest is destroyed.

Whether a private hotel is to be regarded as an inn or a residential hotel or a mere boarding house is of course a question of fact depending upon all circumstances of the case.

Statutes do not play a great part in the Innkeeper laws; the position as it is today is mostly based on precedents or decisions, and like many branches of English law, it is far from being perfect. We cannot even rely on American decisions because they are more confusing on this point.

But why do we treat this case so cavalierly? The truth is not far-fetched. To many Englishmen it is inconceivable that the Negroes do suffer this sort of injustice in the heart of an empire to which by one reason or other many of them belong. The case has focussed the eyes of the world on this sore question which has been causing ill-feeling between the two races, black and white, and has set many people thinking.

The remedy is in the hands of the British Government; legislation on this point is highly desirable, making it an offence for an inn-keeper or hotel manager to refuse accommodation to a man on account of his colour. French legislation has taken a step further in the matter, making such a refusal a criminal offence; why should Great Britain, which owns more colonies among the coloured races than any of the other European Powers, be so tardy in facing this subject?

We Africans naturally, thinking of this injustice among others, do not view with equanimity the anomalous position we find ourselves in today.

347

Sambo without Tears

by GEORGES SADOUL

(Translated from the French by SAMUEL BECKETT.)

THE French bourgeois turns up his nose in disgust at the American who bars the Negro from certain cinemas, restaurants and dance-halls, and proclaims that democratic France makes no distinction between black and white. Why, if that be the case, are Congo piccaninnies taught that their ancestors were Gauls, white-skinned and fair-haired, while French children are still waiting for the news that the first occupants of France were Negroes? This incoherence is all the more curious as the latter doctrine would seem to proceed naturally from the discoveries of Grimaldi.[1]

I have been reading some French papers published specially for children : *Cri-Cri, l'Épatant, l'Intrépide, Pierrot, le Petit Illustré*, each of whose weekly sales runs into hundreds of thousands of copies and which are bought by as many of the offspring of labourer, peasant and petit bourgeois as know how to read. I bought them indiscriminately in a village of small farmers, at *the* shop, and I know that they circulate in all the villages and industrial suburbs of France. I soon realised, without having chosen the numbers, that the Negro who symbolises, in these as in most other publications, colonial peoples of every shade of colour, is the stock hero of these children's papers and one that it is found expedient to put over. Here is the Negro as conceived in the interests of the juvenile mind, the Negro as visualised by the average French bourgeois.

"In his wild state," that is to say, before being colonised, the Negro is a dangerous ruffian. *Cri-Cri* presents one of our good fellows setting out in the direction of Madagascar. But he is captured by the natives and turned into a slave. *L'Intrépide* tells the true story of Major Lang, the English explorer, bound for Timbuctoo. All goes well till two native chieftains, the dirty dogs, take him for a spy, him, Major Lang, a benevolent pioneer, who never heard of guns or bullets, let alone missionaries. The "niggers" kill Major Lang. Just one more before bye-bye : a pair of European pals, "gone to Africa to seek their fortune," are discovered scouring the Sahara in a caterpillar-car. A ferocious maiden of Sudan goes within an ace of butchering them with volleys of rocks.

PLATE 1. *In his natural state the Negro is an assassin*

The white men are kind, they cannot bear to see the Negro running wild, they simply must colonise and colonise quick. Why must they? *Pierrot*, a Roman Catholic organ, lets the cat out of the bag. Only a Berber cat to be sure, but no matter ; when it comes to "niggers," nice distinctions of colour and disposition cut no ice with the French bourgeois. A French officer, noble lad, speaks :

"This silly people seems to imagine that we come to Africa to conquer, whereas of course we come as benefactors. . . . When I first set foot in Tafilelt, where order only now begins to reign, lice were looked upon as sacred and propagated their numbers, on account of public opinion being set against their destruction, with terrifying rapidity. . . . We have organised a campaign against all social ills ; we have created schools with medical instruction . . ." etc., etc. The ninny to whom the brilliant officer addresses this guff is a pacifistic aeronaut. Won over by the oration he soars into the blue on his mission of mercy, which takes the form of spraying the bold black Berbers with bombs. A man is a no more sacred animal than a louse, in death they are not divided. Even a pacified Negro has his faults. He boozes.

The Negro is furthermore slothful beyond belief. He has to be bullied into working.

But the Negro has his qualities. The Negro is a buffoon created by special request for the entertainment of the white man. He is the jester of the French kings.

It is presumably in this capacity, and in no other, that the Negro is elevated into the more rarefied spheres of French society, as groom or purveyor of jazz to the "quality."

The Negro has other qualities. He can be made into a soldier, or even a cop.

[1] Anthropologists have stated that the prehistoric skeletons recently found in the caves at Grimaldi, Alpes Maritimes, were those of a **Negro** race.

These delicious colonials in their caterpillar-car who so utterly confound the Negro policeman are no other than the " Nickleshods," the most beloved and heroic group of men in the whole of guttersnipe literature. They were burglars before the war and codded the police up to the eyes. But when the war

came up they joined, killed any amount of Boches and after the armistice were transferred to the colonies. It has even been rumoured that they became colonial ministers. For this reason the governor of the oasis where they have just arrived does them as proud as he knows how. Who are these women that advance? They are platter Negresses, they ply their white lords with appetisers. (Plates 6 and 7.)

PLATE 2. *The Negro is a drunkard (Cri-Cri)*

PLATE 3. *The Negro is a sloth (L'Epatant)*

And the Nickleshods, having duly looked towards the governor, decorate these faithful servitors. Even so were honours showered on those ignoble lackeys and lickspittles, the Negro under-secretaries of state in the colonies, a class that is as much the pride and the joy of France as are the black whores in her brothels. (Plate 8.)

PLATE 4. *The Negro is a buffoon (L'Intrépide)*

But no matter what the Negro does he will always be an imbecile by white standards of reference. Next we have a whole Negro tribe in kinks of astonishment before the fascinating and ingenious colonial soldier, who is the first to put the darbies on an ostrich in this way. (Plate 9.)

Reading these children's papers that are calculated to turn their readers into perfect imperialists we get an idea of the coloured man as bowdlerised by the French bourgeoisie. But when we find such " distinguished " and " talented " writers as M. Maurice Martin du Gard springing to their feet in colonial fashion and demanding the segregation, and " particularly

the sexual segregation," of the black troops in France, we are entitled to wonder in what respect the treatment inflicted on the Negroes by the French bourgeois differs from the American variety which he finds so shocking. The distinction is a fine one indeed.

A journalist, M. Max Massot, in the *Journal*, 1931, is indignant at the idea that " in Cape Town a Hindu Brahmin, even though he were a member of the high imperial council, may not sit down for a drink next to a white overseer." Thus the scandal of segregation, in the eyes of a French journalist, consists in a bourgeois being denied the privileges enjoyed by a member of the proletariat. But, as we learn

PLATE 5. *The Negro is a soldier (L'Epatant)*

in the course of the same article, " the 115,000 native inhabitants of Cape Town, as distinct from the 130,000 Europeans, furnish the most menial positions and the lowest ranks of non-specialised labour." Surely exclusion from Cape Town cafés applies less to the *Negro* than to the lowest strata of a *class*. I read that article in a café in Nice which refused admission to the drivers of chars-à-bancs parked outside because its genteel clients objected to their costumes and general demeanour. In this country (France), where the proletariat comprises a mere handful of coloured men, segregation is a question of dress. The eccentric bourgeois who tries to get into a " respectable" restaurant or dance-hall dressed like a carpenter is as sure to be evicted as the Brahmin from his café, whether it was in Cape Town or New Orleans. And that seems to be the only shade of difference between the French and American bourgeois.

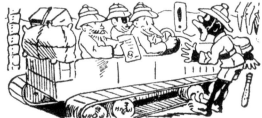

PLATE 6. *The Negro is a cop (L'Epatant)*

With us the most exploited class is recognisable by its dress; with them by its dress and colour. Forty years ago the bulk of the black population of the U.S.A. was composed of peasants very little better off than when they were slaves. They represented the most exploited section of the peasant community and their colour, symbolic of their economic situation,

349

PLATE 7. *The Negro is a slave (L'Epatant)*

was a stain on their character. Great stress was laid on this stigma in order to persuade the " poor whites," just as badly off economically, that their situation was a privileged one. The white and black sections of the impoverished peasantry had at all costs to be prevented from joining forces.

When industry, with the development of its enterprises, began to press more and more Negroes into its service, the bourgeoisie was careful to exploit the rivalry that it had fostered between black and white members of the poor community. In certain industrial areas in France large numbers of Italians, Poles and Arabs are employed at starvation wages. They are segregated from the French proletariat, provided

PLATE 8. *The white man is kind to the Negro (L'Epatant)*

with their own quarters, shops, restaurants, schools, churches, and sometimes even, as is the case with the Algerians, with their own brothels. They are called every vile name from " wops " and " polaks " to " sidis " and " bicots " and made responsible for low wages, unemployment and the high cost of living. These " lousy foreigners " are France's " niggers." Sweated labour, whether denoted by language or colour, meets with the same treatment at the hands of both the French and American industrial systems : racial peculiarities exploited to disunite the proletariat.

Thus we find black and white finally co-ordinate, in the sense that a Pole in France receives the same treatment as a Negro in the States. The whole colour question becomes a question of class. And

PLATE 9. *But the white colonial will always be superior to the Negro (Cri-Cri)*

the solution is the same in either case. Marx prophesied that the chains of the Jews would only fall with those of the proletariat ; the same may be said of the chains of the Negroes.

I am writing this article in Moscow, in this country where the proletariat is dictator. The children's papers that I buy at random in the kiosks present a very different Negro from the assassin, slave and drunkard imposed upon the children of the French bourgeosie.

Here the Negro and the Negro child are shown as victims of white colonisation, the white child and the black child as fighting side by side against capitalism of whatever colour. A paper written in English on sale in these same kiosks, the American communist paper, urges its readers to vote for the two communist candidates, the white man Foster and the Negro Ford, the first coloured nominee in the history of American presidential elections.

It is true, what Lenin said, that the struggle of the proletariat and the struggle of the oppressed races,

symbolised by the Negro, are one and the same ; and that the liberty of the proletariat is indissolubly bound up with the liberty of colonial peoples. And that is why, in spite of the manœuvres of all bourgeois, black and white, and in spite of the Candace[1] or American Negro bourgeois and their pæans in honour of segregation, " source of monumental fortunes " (*St. Louis Argus*, 1931), the proletariat, black and white, will soon be singing with all its voices that admirable chorus that comes to us from America and was taught to me by Negroes as we stood out from the shores of Finland on our way to Soviet Russia :

Black and white we stand united,
Black and white we stand united,
Black and white we stand united,
All the workers are united,
Come !

[1] Black deputy from French West Indies who followed Diagne (Senegalese deputy) as Colonial Under-Secretary.

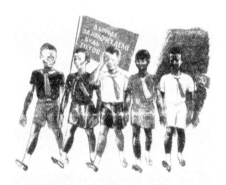

PLATE 10. *Children of every colour battle against capitalism side by side. On the flag : Get ready to fight for the working class. (From a Soviet paper for children)*

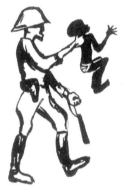

PLATE 11. *How the white colonist treats the Negro child (from a Soviet paper for children)*

PLATE 12. *The white child defends the Negro child (from a Soviet paper for children)*

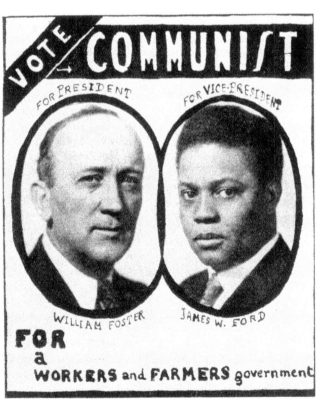

PLATE 13. *From the " American Daily Worker "*

351

Murderous Humanitarianism

by the SURREALIST GROUP in Paris

(Translated from the French by Samuel Beckett.)

For centuries the soldiers, priests and civil agents of imperialism, in a welter of looting, outrage and wholesale murder, have battened with impunity on the coloured races ; now it is the turn of the demagogues, with their counterfeit liberalism.

But the proletariat of today, whether metropolitan or colonial, is no longer to be fooled by fine words as to the real end in view, which is still, as it always was, the exploitation of the greatest number for the benefit of a few slavers. Now these slavers, knowing their days to be numbered and reading the doom of their system in the world crisis, fall back on a gospel of mercy, whereas in reality they rely more than ever on their traditional methods of slaughter to enforce their tyranny.

No great penetration is required to read between the lines of the news, whether in print or on the screen : punitive expeditions, blacks lynched in America, the white scourge devastating town and country in our parliamentary kingdoms and bourgeois republics.

War, that reliable colonial endemic, receives fresh impulse in the name of " pacification." France may well be proud of having launched this godsent euphemism at the precise moment when, in throes of pacifism, she sent forth her tried and trusty thugs with instructions to plunder all those distant and defenceless peoples from whom the intercapitalistic butchery had distracted her attentions for a space.

The most scandalous of these wars, that against the Riffains in 1925, stimulated a number of intellectuals, investors in militarism, to assert their complicity with the hangmen of jingo and capital.

Responding to the appeal of the Communist party we protested against the war in Morocco and made our declaration in *Revolution first and always.*

In a France hideously inflated from having dismembered Europe, made mincemeat of Africa, polluted Oceania and ravaged whole tracts of Asia, we Surréalistes pronounced ourselves in favour of changing the imperialist war, in its chronic and colonial form, into a civil war. Thus we placed our energies at the disposal of the revolution, of the proletariat and its struggles, and defined our attitude towards the colonial problem, and hence towards the colour question.

Gone were the days when the delegates of this snivelling capitalism might screen themselves in those abstractions which, in both secular and religious mode, were invariably inspired by the christian ignominy and which strove on the most grossly interested grounds to masochise whatever peoples had not yet been contaminated by the sordid moral and religious codes in which men feign to find authority for the exploitation of their fellows.

When whole peoples had been decimated with fire and the sword it became necessary to round up the survivors and domesticate them in such a cult of labour as could only proceed from the notions of original sin and atonement. The clergy and professional philanthropists have always collaborated with the army in this bloody exploitation. The colonial machinery that extracts the last penny from natural advantages hammers away with the joyful regularity of a poleaxe. The white man preaches, doses, vaccinates, assassinates and (from himself) receives absolution. With his psalms, his speeches, his guarantees of liberty, equality and fraternity, he seeks to drown the noise of his machine-guns.

It is no good objecting that these periods of rapine are only a necessary phase and pave the way, in the words of the time-honoured formula, " for an era of prosperity founded on a close and intelligent collaboration between the natives and the metropolis " ! It is no good trying to palliate collective outrage and butchery by jury in the new colonies by inviting us to consider the old, and the peace and prosperity they have so long enjoyed. It is no good blustering about the Antilles and the " happy evolution " that has enabled them to be assimilated, or very nearly, by France.

In the Antilles, as in America, the fun began with the total extermination of the natives, in spite of their having extended a most cordial reception to the Christopher Columbian invaders. Were they now, in the hour of triumph, and having come so far, to set out empty-handed for home ? Never ! So they sailed on to Africa and stole men. These were in due course promoted by our humanists to the ranks of slavery, but were more or less exempted from the sadism of their masters in virtue of the fact that they represented a capital which had to be safeguarded like any other capital. Their descendants, long since reduced to destitution (in the French Antilles they live on vegetables and salt cod and are dependent in the matter of clothing on whatever old guano sacks they are lucky enough to steal), constitute a black proletariat whose conditions of life are even more wretched than those of its European equivalent and which is exploited by a coloured bourgeoisie quite as ferocious as any other. This bourgeoisie, covered by the machine-guns of culture,

Murderous Humanitarianism

"elects" such perfectly adequate representatives as "Hard Labour" Diagne and "Twister" Delmont.

The intellectuals of this new bourgeoisie, though they may not all be specialists in parliamentary abuse, are no better than the experts when they proclaim their devotion to the Spirit. The value of this idealism is precisely given by the manœuvres of its doctrinaires who, in their paradise of comfortable iniquity, have organised a system of poltroonery proof against all the necessities of life and the urgent consequences of dream. These gentlemen, votaries of corpses and theosophies, go to ground in the past, vanish down the warrens of Himalayan monasteries. Even for those whom a few last shreds of shame and intelligence dissuade from invoking those current religions whose God is too frankly a God of cash, there is the call of some "mystic Orient" or other. Our gallant sailors, policemen and agents of imperialistic thought, in labour with opium and literature, have swamped us with their irretentions of nostalgia; the function of all these idyllic alarums among the dead and gone being to distract our thoughts from the present, the abominations of the present.

A Holy-Saint-faced *International* of hypocrites deprecates the material progress foisted on the blacks, protests, courteously, against the importation not only of alcohol, syphilis and field-artillery, but also of railways and printing. This comes well after the former rejoicings of its evangelical spirit at the idea

Colonial Negro tailor in a small factory in France

that the "spiritual values" current in capitalistic societies, and notably the respect of human life and property, would devolve naturally from enforced familiarity with fermented drinks, firearms and disease. It is scarcely necessary to add that the colonist demands this respect of property without reciprocity.

Those blacks who have merely been compelled to distort in terms of fashionable jazz the natural expression of their joy at finding themselves partakers of a universe from which western peoples have wilfully withdrawn may consider themselves lucky to have suffered no worse thing than degradation. The 18th century derived nothing from China except a repertory of frivolities to grace the alcove. In the same way the whole object of our romantic exoticism and modern travel-lust is of use only in entertaining that class of blasé client sly enough to see an interest in deflecting to his own advantage the torrent of those energies which soon, much sooner than he thinks, will close over his head.

André Breton, Roger Caillois, René Char, René Crevel, Paul Éluard, J.-M. Monnerot, Benjamin Péret, Yves Tanguy, André Thirion, Pierre Unik, Pierre Yoyotte.

The Negress in the Brothel

by RENE CREVEL

(Translated from the French by SAMUEL BECKETT*)*.

IN every metaphor—and the shining univocal 17th-century metaphor was no exception—an author discovers himself and his public.

Whatever France you are pleased to consider—France vibrating to the Homeric " Get rich " of her Guizot ; France bankrupted before her Poincaré and stabilised in one little sharp erection of that sacrosanct goatee ; France meditating colonial expansion and reprisals and, once a week, after a quick Mass, the charms of her estate—at no period, not even when she cast her legendary woollen stocking in favour of one of artificial silk, did she relax that economy of word and image, that intellectual and sentimental sobriety, that bestowed upon Racine the letters patent of the poetry(?) of love.

It is natural enough that a nation whose practical ethics never lost sight of at least one transcendental proposition : *Un sou est un sou* (a penny's a penny) should gladly remember now, in the fine flower of her genius, the fully licensed purveyor of passion, privileged to apprehend at the court of his King the whines of Princess X and the snarls of Princess Y and the paralysing ballast of falbalas common to them both, who saw fit to crystallise the delirium of their royal gallants and catalogue them : *objects of desire.*

Such a formula had only to become current to set in motion the shabby and pitiful erotic machinery destined to produce a new love and a new notion of love, sapless and withered and lamentable in the bathchair of some preposterous qualification, " divine " for example.

The lecher in his lust to possess, even with the creature of his choice, cannot rise above the simple notion of an act of annexation. And when we find the instinctive articulation of sexual pleasure in such an affirmation as " You are mine " or " I possess you " and in such an acquiescence as " I am yours " or " Take me " it is clear that the idea of inequality has been finally and definitely admitted by and between the elements of the couple. Hence the notion of love-servitude, love-hellfire, if we accept all the implications of remorse on the part of the master who abuses, and recrimination on the part of the slave who is abused. Love-hellfire, only to be expressed in incandescent formulæ :—

Brulé de plus de feux que je n'en allumais—

a grand old high and mighty Alexandrine, but pyrogenous, smelling of roast pork.

Man in the middle, obedient to God, obeyed of women—chaplet of subordinations.

A corporation of hypochondriacs banishes this intimacy from its midst, except in the form of a sacramental privilege. So the libertine is converted and Maintenon exults, and social and religious orthodoxy flourishes within the not intolerably narrow limits of the morganatic union.

So much then for our ideas, our Christian ideas, whose faculty of arbitrary restriction twenty centuries have not exhausted (notwithstanding a God that is the *Supreme Being, Spirit,* notwithstanding a progressive atheism and the thinking that calls itself free), and that still claim the right to direct a world that they have so competently trampled to death. The white male takes his Mediterranean heritage, whose most fascinating characteristics were a contempt for women (prostitution—civil incapacity) and a contempt for barbarism (colonisation), flavours it with a little gospel sauce and proceeds to exercise his millennial prerogatives. In France Norman guile is no longer a regional phenomenon, but general. Which accounts for our national miasma of fatuous credulity as well as for that tolerance which, ever since the Valois, has encouraged an intersexual free trade in ideas and at the same time the poisonous obligation to sneer at every educated woman as a " Précieuse " or a " Blue Stocking." Safely entrenched behind that fine old tradition of French gallantry, they sneer and sneer. *Ergo,* all subsequent social tomfoolery—flirtation, marivaudage, etc.

Objects and subjects of conversation, as their less fortunate sisters were objects of desire, the rich philosophistic ladies incurred the same frustration. There wasn't much good holding the high cards when hearts never turned up trumps. (And how much longer, by the same token, must we wait for the psychoanalysis of games ?). The only escape from the paralysing constraint of their position, unless

Printed at the Utopia Press, London, E.C.2.

354

they chose to be branded à la Récamier, lay in the shilly-shally of an adultery, and adultery, at least in the decrepit theory of our decrepit code, is punishable by imprisonment.

No, for the woman in this society there is neither solution nor evasion, in spite of the patriarchal misconduct of such thinkers as Rousseau and Diderot, who only required the stimulus of a tuppeny-ha'penny notoriety to withdraw, in favour of a polite world, from the humiliating inadequacy of the marriage contracted in youth.

Thus our civilisation splits up into the holy and divided kinesis of :—

> In the Brothel : Sexual intercourse.
> In the Drawing-room : Social intercourse.[1]

"Using" prostitutes translates only one aspect of masculine complexity : establishing foci of contempt and respect in the hierarchy of blue stockings translates another.

On the reverse of the medal we find an aspermatic Baudelaire in the alcove of his official Egeria, Madame Sabatier, the "chairwoman." The chairwoman belonged to the spiritual system, not to the physical, and it was out of the question to pass from the one cosmogony to the other. But she bore him no ill-will, whether out of goodness of heart or a clear vision of our old friend the main chance, for having failed to mitigate her inflammation. And he has merely to refer himself and his indignity to Jeanne Duval, his mistress, the harlot. Not even his enduring hypochondria can prevent him now from acting the male with a sense of superiority, of superiority over the woman, over *his* woman. And with the same stone he kills the suppliant bird of those velleities that were so real a part of him (cf. *Mon Coeur mis à nu*), in so far at least as he anticipates his milk-and-water critics whose mawkish more-in-sorrow-than-in-anger deprecation of his liaison with this whore, an offence doubly deep in the eyes of society since she was not merely a whore but a *coloured* whore, was already in his mind to consolidate the axiom of her subordination. Thus the circumstances of what the æsthetic canaille is pleased to accept as a providential dispensation conferred upon the destiny that suffers to the point of lyricism is no more than the poet's self-imposed ordeal. If we must cling to the worm-eaten image of the cross that was borne, at least let it be applied as a testimony to the naiveté of a humanity that gives itself away even in the most subtle movements of its sharp practice. The father on earth of the Son of God was a carpenter, and of crosses, inter alia : which means, if it means anything, that parents are at some pains to carve and plane and polish the misfortune of their children. The Christian symbol is a statement of that sadism that relates old to young, man to woman, rich to poor, white to black, in the ratio of torturer and victim.

Charme inattendu d'un bijou rose et noir : Baudelaire adores the dark flesh of Jeanne Duval, the charming convolutions of this dark, rose-tinted shell. The Taylor system with division of labour. The other, the cerebral Madame Sabatier, has the monopoly of his ethereal devotion and the proud conviction that hers is the far, far better part.

At last we are beginning to understand, in spite of the torrents of Dostoievskian colic concerning the rehabilitation of loose women, that all these condescensions and artificial gallantries that stoop to the whore for the favour of her caresses are nothing more than a hypocritical servility before things as they are. We are concerned neither with the compassion inspired by the spectacle of a creature in the gutter, nor with any adventitious homage that she may receive from a manifestation of man's so-called sacrosanct "virility", but with the very elementary justice (neglect of codified injustice) that cannot regard this social degradation as of any importance. But since such an attitude is impracticable in capitalistic societies stinking of class consciousness (*coloured men and women being assimilated to the proletariat because they happen to have suffered colonisation*), it becomes necessary to annihilate the imbecile ideology that is precisely the cause and the sanction of that social degradation. In the meantime let no man weep or rejoice because he happens to have desired, enjoyed and perhaps even married a black woman out of a brothel : the very considerable epithelial advantages of such an intimacy absolve it from the need of apology or justification. And finally we may succeed in reducing to its grotesque essentials that pernicious literary antithesis between soul and epidermis, culminating in every case, the Baudelairean not excepted, in the triumph of the church.

What can be wrong with Baudelaire's Negress and the brothel, a home from home, when the Turkish ladies rendezvoused with the Crusaders round the holy sepulchre (which seems to me worth two of

1 Surely the case of the young man who, having met with a misfortune at the outset of his sexual investigations, marries from a need of comfort and security, is identical with that of the licensed free-lance prostitute settling down in a red lamp.

the unknown warrior under his Arch of Triumph) ? Oh I could tell you where the Kimmerians itch when they emerge from their horizons of spleen under a sun in a blue sky.

I think you will agree with me, Victor Hugo, that it was only right and proper that the labours of our blessed company of infected settlers and cut-throat Jesuits, punctuated so gloriously by St. Louis, Lyautey and the Duc d'Aumale (who conferred, by the way, his name and titles of nobility on one of the most highly esteemed propositions in brothelian geometry) should culminate in the colonial anthem of *Les Orientales : Sarah belle d'indolence se balance.*

The very and proudly European bawd claps her hands and calls upstairs : " A customer, Sarah ! Sarah, a customer ! " And Sarah, beautiful and indolent and African, the jewel of the collection, duly imparts tone to the depraved manoeuvres of white erethism. Which brings us back to our object of desire, with this difference, that now, thanks to the scenic organisation of venal love, the object of desire has become an object in the décor of desires. The Negress of the metropolitan brothel, at least, in the eyes of the pertinent consumer, is as appropriately situated as her sister in bronze on the stairhead, holding aloft her light to lighten the red carpet and its golden rods in a petrified testimony to the ineffable self-sufficiency of the 19th and early 20th centuries.

And Sarah need not be homesick. For what are they doing, governors, generals and even the Imperial Roman marshall himself ? Playing with the piccaninnies : which is only **tit for tat**. The heart of so prosperous a family shall not be troubled.

After that I propose to withdraw my subscription from the Society for the Diffusion of the White Man's Moral and Physical Complaints among Savage Peoples.

The mind of the Frenchman who gets clear of his country, of his continent and his continence, experiences a liberation (hence the success of Morand, Dekobra and others). But even when for one reason or another he is obliged to remain at home he demands to be entertained and debauched by the exotic curiosity that lifts him clear of the national fact into an illusion of renewal. Hence the popularity of Martinique jazz, Cuban melodies, Harlem bands and the entire tam-tam of the Colonial Exhibition. *Nowadays the white man regards the man of colour precisely as the wealthy Romans of the Late Empire regarded their slaves—as a means of entertainment.* And of course it is no longer necessary to go to Africa. The nearest Leicester Square, now that our livid capitalism has instituted the prostitution of blacks of either sex, is as free of European squeamishness as was thirty years ago the oasis of André Gide's Immoralist. Then again the average Frenchman who is not interested in depravities, who is merely seeking the picturesque, can go to the brothel and meet a thoroughbred Negress.

Now, if, instead of appropriating the value of his money with the traditional member of his nauseating person, he could be persuaded to approach those hired nymphæ not merely as the exquisite negation of the regrettably proliferous article on tap, so to speak, at home, but rather as the shell that imprisons the music of the sea, it is just possible that he might be favoured, for all his cloacal labyrinth, with the inexorable vibrations of a distant wave that hastens to engulf every capitalistic fortress, from brothel to cathedral.

And then at last goodbye to geographical symbolism. The old saying : *Truth our side of the Pyrenees, falsehood the other*, will appear nonsense even to the survivors of a carious Chartism, and paleontologists will no longer attempt to justify the sordid and implacable imperialism that has the insolence to outrage with its ragbag the naked splendour of black peoples.

AFRICA

Ancient African Empires
of the West Coast

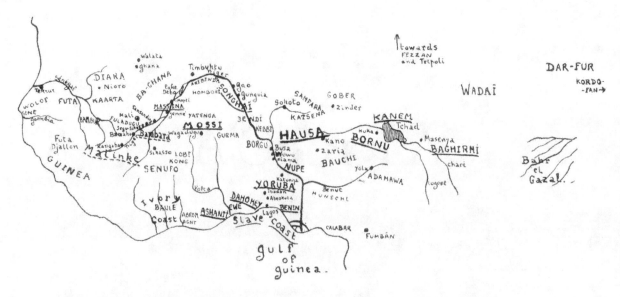

And Regions Flourishing Before
the Coming of Europeans

African Empires and Civilisations

by RAYMOND MICHELET

(Translated from the French by EDWARD CUNARD.)

IT is perhaps too widely believed that the history of Africa merely consists of the strife between a few petty tyrants and of an endless series of massacres—that various civilisations may have followed one another, but never progressed beyond a wild state of barbarism. Nothing could be further from the truth. For instance, the popular idea of Behanzin is drawn from the kindergarten concept of a brainless king with a taste for decapitation, whereas he was actually remarkable for his statesmanship and organising abilities. It is much the same in all the accounts of cannibal kings and their cuisine.

From the first centuries of our era until European colonisation, powerful states had been formed which bear comparison with the great contemporary European empires. Communities developed along far-reaching lines of unsuspected stability, whose civilisation, laws, customs and economic administration were perfectly balanced, and in which, above all, the mode of life was simplified to an extent unknown to the white world.

In his *Dark Africa* Colonel Meynier is obliged to admit that " some of the black communities were at times, without our assistance, far more prosperous and civilised than at the present day." And it was definitely the whites—Arabs, Berbers, Tuaregs and later Europeans—who introduced, wherever they penetrated, the ferment of decay, when they did not actually implacably contrive the destruction of the black states. Mussulman fanaticism, raids, plundering, Arab conquest, European commerce, slave-trade and slavery; it is against this that most of the native states had to struggle and which finally brought about the condition of anarchy and disruption in which the European conquest found them.

I

The Sudanese Civilisations

1. THE EMPIRE OF GHANA (4TH–13TH CENTURY) AND THE SOSSO EMPIRE (11TH–13TH CENTURY)

At the beginning of the Christian Era the Sahara did not extend as far south as it now does; this was less due to hypothetical natural causes than to the fact that the inhabitants of the Sahel, living in great peace, preserved their country against the encroachments of the desert. Ghana was founded in about the year 300—possibly, as Delafosse believes, by a Judaeo-Syrian colony, from which, by miscegenation with the natives, sprang the race of the Fula. In the 8th century the empire of Ghana was ruled by a Soninké king, and Arab merchants related that in those days it reached to the Atlantic. At its zenith, in the 9th century, it stretched almost as far as Timbuktu to the eastward and Bamako to the south; it included Aoukar, Baghana and Sahel. It was the rulers of Ghana who founded Djenne in about 800 and inaugurated the prosperity of the Djennere.

The temptation was irresistible to the Berbers of the Sahara. According to Ibn Khaldoun, a contemporary historian, the Berber king of the Lemtouna, with a force of 50,000 Meharis, raided and burnt the country of Aougam. The wives of the black chieftains committed suicide to avoid falling into the hands of the whites. Again, in 1020, the Berbers allied themselves with the Almoravids (a fanatical Mussulman sect properly called the El Morabethin) and, pretexting a holy war, pillaged everything on their route. In 1054, Aoudaghost, a dependency of Ghana, was captured and its inhabitants massacred. In 1060, the Emperor of Morocco, an Almoravid by birth, again sent the Saharan Berbers to invade Ghana. In this war no quarter was shown.

According to El Bekri, Ghana had, at that time, 200,000 warriors, of whom 40,000 were archers. The town was fairly prosperous and many of the houses were built of stone, which is the exception in Africa; lawyers and scholars were much respected. The inhabitants wore loin-cloths of wool, cotton, silk and velvet. Jewels and weapons of gold and silver were not uncommon. There was much trading in copper, cowries, textile fabrics, dates and gold from the Bambuk, a dependency of Ghana. Ghana was

at that time the repository for the gold from Sudan. El Bekri describes the whole country situated between Ghana and Kayes as highly organised and already possessing a growing commerce.

While the Berbers were capturing Seville, Aboubekr ben Omar was waging a holy war against the Blacks, for Ghana refused to acknowledge Islam. In 1076 Ghana was taken and pillaged. There was a wholesale slaughter of the black Soninké population. Moreover, the rôle of the Berbers and Arabs will be throughout that of unceasingly burning, pillaging and taking advantage of the achievements of the Black emperors, spreading confusion on every side. The Soninké succeeded in recapturing Ghana in 1087, but the empire had fallen. In 1203 Ghana was doomed to become a vassal of the *Sosso* empire.

This empire, established by those Soninké who had settled between the Baoulé and the Niger, had once ranked with the subject states of Ghana. But after the sack of Ghana by the Almoravids it regained its independence and became a more and more powerful state. In 1203 one of its rulers, Soumangourou, annexed Aoukar and Baghana up to the Massina and Diara. Thus the Sosso empire succeeded the Ghana empire and revived its power for a time, until Mali, and later Gao, took its place in the glorious series of great empires.

2. THE SONGHAI EMPIRE OF GAO (7TH–16TH CENTURY)

In the meanwhile, to the east but on the same latitude, the Songhai empire had come into existence and was flourishing. Until the 11th century it was merely the empire of Gounguia, 150 kilometres below Gao. The first important dynasty, that of the Dia, began in 690; originally half-black, half-berber, it soon became entirely black as a result of a series of marriages. The *Tarikh es Sudan* gives the history of a line of fourteen Dia rulers. In about 1010 the reigning Dia was converted to Islamism, but, according to El Bekri, the population remained heathen. In the 11th and 12th centuries the Dia were surrounded by a properly constituted Court. Gao was at that time the centre of the commerce in salt from Taotek, 300 kilometres to the north. There were already large towns: Tirakha, near Timbuktu; Madassa, between Timbuktu and Gao, and described by Edrissi, the historian, as thickly populated and possessing a busy market for rice, millet, fish and gold. It is generally believed that the Songhai civilisation was, at that time, on a par with that of the Habbe and Mossi; it may consequently be highly esteemed. After a temporary subjection to the Mali empire in 1325, which carried the prosperity of Gao to great heights, Ali Kolen regained his independence in 1375, took the title of Sonni and founded the dynasty of the *Sonnis*, which numbered 19 sovereigns from 1335 to 1493. It was the 18th Sonni, Sonni Ali, who finally freed Gao from Mali. For Mali, as will be seen later, was, after Ghana and Sosso, supreme in the greater part of Sudan until about 1470.

Sonni Ali, remarkable both as conqueror and statesman, came to the throne in 1474. Four years later he recaptured Timbuktu, which had been under Tuareg domination for 35 years, and subjected to constant plundering and taxation. He next pushed on to Djenne and occupied it. His schemes were on a large scale: a canal was begun at two points which would link up the Niger with the distant region of Walata, and important irrigation schemes were executed. Himself a heathen, he persecuted the Mussulmans, but recognised the merits of scholars: " without them," he said, " this world would lack pleasure and charm "—and he loaded them with gifts.

In 1493, a Sonninké of pure black descent succeeded the Sonni; he was Mohammed Touré, a former lieutenant of Sonni Ali. Thus began the great dynasty of the *Askias*, whose powers were immense.

Askia Mohammed I (1493–1528) surrounded himself with scholars. He recalled the learned men of Timbuktu from Walata where they had taken refuge. In his reign, Gao, Walata, Timbuktu and Djenne became important centres of learning. Numerous Arab lawyers came to complete their studies in the schools at Timbuktu; and this prosperity lasted under the succeeding Askias. Here, during the 16th and 17th centuries, were drawn up those two great historical miscellanies, the *Tarikh el Fettach* and the *Tarikh es Sudan*. The Askia was in constant communication with the Moroccan reformer, El Merhili.

Above all, he understood the government of his vast empire; he created a regular standing army, divided his country into governments and instituted a Household with duties at court. Thereafter there were governors for Gurma, Dendi (Gunguia), the district between Lake Debo, and that part of Sahel to the west of the Niger, the Aribinda and Hombori; there was also a Master of the Palace, a Commander of the Flotilla, chiefs responsible for tax-collecting, forestry and fisheries; and, though the Askia himself was a Mussulman, there was a native High Priest in charge of the Ancestor and Spirit cult. Each district and town had its own chief and its own tax-collector appointed by the king.

He encouraged the development of the natural resources of the country. Thanks to new wells and

watercourses, the agricultural area was extended far to the north of the Niger. The nomads had to submit or withdraw. Askia Mohammed won power over the whole of the former kingdom of Ghana, which he annexed as well as part of Mali. His empire stretched from near the Atlantic to the Sokoto, and in the south, as far as Mosi and the Upper Niger.

The might of Gao endured after his death. One of his successors, Askia Issihak I, was sufficiently powerful to send an army of 200,000 men against the Sultan of Morocco, who had claimed the surrender of the salt mines at Teghazza. They ravaged southern Morocco as far as Marrekesh.

But in 1591, after three centuries and particularly after the last 120 years of great prosperity, the Gao empire broke up. White Moroccan troops armed with muskets and commanded by Djouba Pasha arrived before the walls of Gao. It was the first appearance of firearms on the Niger, and there was a total panic.

Leo Africanus has left us a description of Gao in the 16th century. It was a large town possessing beautiful buildings and inhabited by a population of farmers, fishermen and merchants. There was abundance of gold and provisions, and manufactories of pottery, cloth and weapons. Taxes were heavy, but as nothing compared with what they were to become under Moroccan domination. Timbuktu had been beautified by each succeeding Askia and was becoming an important centre. Djenne was at the zenith of its splendor. According to Sa'di the country was fertile when Djouder arrived. Peace and security prevailed. With him came anarchy, plundering and depredation. Only a part of the Songhai country to the south of Gao was able to resist the Moroccan attacks and remain independent; Djenne, Timbuktu and Gao were overthrown. To quell the population, the Moroccans filled in the wells and destroyed the cultivated lands. Once again the desert invaded the whole north of Sudan. " Thereafter," confesses Colonel Meynier, " the Sudanese, whom we have seen so full of energy, loses all initiative under the despotic military rod and the constant threats to his life, his family and his possessions. . . . Vast agglomerations of people dwindle into insignificant villages. . . . Even moral standards are relaxed in the midst of this universal distress. For the Niger states, the Arab colonisation denoted the beginning of the end." With great difficulty a few states (Massina, Bambara) will attempt reconstruction at the cost of incessant struggles against the Arabs. This first " colonisation " will have already left its mark.

3. THE MOSI EMPIRE. THE YATENGA, MOSI AND GURMANTCHÉ EMPIRES (11TH–20TH CENTURY)

Between Songhai and the southern forests lies one of the most interesting of all the African empires, a genuine unalloyed Negro empire which always held aloof from all outside Mussulman influence, which was firmly organised and always lived on its own resources. Smaller than the empires of Gao, Ghana or Mali, it has outlived them thanks to its homogeneity and the soundness of its institutions, which have remained unchanged up to our own days. The whole population belonged to the same ethnical group and had the same religion—ancestral worship. In consequence Mosi, unimpaired and untouched by the Arabs, was always considered from the early days of French colonisation as the unrivalled " human reservoir." It was efficiently unsettled and emptied. The timber yards in the forests on the Ivory Coast, the railways in Senegal, Nigeria and the Ivory Coast plantations all took a large number. So too did the army. Mosi thus lost hundreds of thousands of men.

From the 11th–12th centuries it comprised 3 empires. The *Wagadugu empire* (Mosi empire properly so called) was firmly established with five provincial governments and four vassal kingdoms subdivided into cantons and villages. The king, who bore the title of Morho-Nabba, had sixteen ministers and an imposing court. His morning audiences took the place of councils of state, his evening ones that of a court of law. He exercised personal control over the governors and cantonal chiefs and ruled besides with the assistance of the high priests (Hoggons), the leading regional chiefs (Nabbas), and of the council of veterans, whose respective influences counterbalanced each other. It was, for example, the council of veterans which elected the chiefs of the important families from amongst whom the king was chosen, thus avoiding the dangers of hereditary power. This was well-defined civilisation, since the great Mosi families had genealogies which went back for centuries ; it was also homogeneous in structure, since there was no trace of castes.

The *kingdom of Yatenga*. This kingdom was smaller and more warlike because it lay on the frontiers of Gao and Mali. It was organised on the same lines as its neighbour, as was also the *kingdom of Gurmantché* lying to the S.W. and divided into 18 provinces.

The whole country prospered on the cultivation of cereals and the breeding of livestock. Mosi merchants and Mosi produce were known throughout Sudan. In the country, numbers of huge farms, and in the towns, houses of brick and stone remain to testify to this all-round prosperity.

African Empires and Civilisations

The Mali empire (which was known also as Mandé, Mandingo and Malinké) was as powerful and great as Gao, perhaps even more so. Less is known about it because there are no complete annals such as the *Tarikh es Sudan* in the case of Gao. But it had a great reputation amongst the Arabs and Portuguese and was indeed an immense empire, like Gao, comparable with the European empires of the same period, in another sphere.

Ibn Khaldoun relates that, in about 1050, one of its first rulers was converted to Islamism, whereas the majority of the people remained heathen. The first great emperor was *Sundiata Keita* (1230–1255), who is still a legend in Sudan. He assembled a large army, annexed the country of Labe and Futa-Jalon, reached Baule and attempted to open up this country by means of Mandingo settlements. In 1235 he annexed the Sosso kingdom, including the provinces of Ghana and Diara. He founded a new capital, Mali, near the Niger, probably a little below Kulikoro. Lands were reclaimed and improved. He spread the cultivation of millet, cotton and ground-nuts. The empire enjoyed remarkable prosperity. In the meanwhile his generals captured the gold mines at Bambuk and carried the frontiers of Mali as far as the Wolof country.

In 1307 a sovereign came to the throne who was destined to become famous: *Kankan Mussa* (1307–1332). His power was such that in 1324 he was able to make a pilgrimage to Mecca accompanied by thousands of bearers and taking with him a treasure of the value of five million francs in gold. He returned with the Arab poet Es-Saheli. El Mamer, who accompanied him from Ghadames to Timbuktu, related that he had, amongst other retainers, 12,000 bearers dressed in silk and brocade. When he arrived at Gao, subjected to Mali since 1325, he instructed Es-Saheli to build a large mosque, which was still in existence in the 17th century, and at Timbuktu he built several palaces.

At his death, the Mali empire reached from Futa-Jalon to the north of Ghana, from Wolof to Gao and the Hausa country. His dominion even extended north of Gao and Timbuktu as far as Agades, Ghadames and Wargla, that is to say, the oases to the extreme south of Algeria and Tunisia, which paid him tribute. According to the *Tarikh es Sudan*, the empire was divided into three large provinces of twelve sultanates each.

In 1352 the historian Ibn Batuta visited Mali. After Walata (north of Ghana) he found an almost entirely black population. He describes the roads as being perfectly safe from Walata to Mali. Provisions were to be found everywhere in the form of milk, chickens, rice, flour and beans, and as drink, water mixed with flour and honey. In Mali, the capital, there were numerous lawyers. The king (at that time Suleiman) gave his audiences in a hall adorned with gold and silver plaques. The empire was well subjugated. Ibn Batuta relates how the chief of Walata, accused of robbing a merchant, had to come to Mali in person, where he was found guilty and disgraced by the king. Ibn Batuta considered the Mali Negroes to be a very just race.

Commerce was brisk, by means of camel caravans, for horses were rare.

At Gao, which he visited, he found a large town with abundant provisions.

After the 15th century information is scarce. At all events, this prosperity and wealth lasted for two centuries after the great reign of Kankan Mussa. In 1455, the Venetian Cadamosto, who visited Gambia, speaks of Mali's suzerainty over that country. Then followed the first connection between Mali and Portugal; John II of Portugal sent an embassy. Leo Africanus visited the town of Mali at the beginning of the 16th century, *i.e.* when its power was waning and its rulers had to share the supremacy of Sudan with Gao. Mali at that time numbered 6,000 families, which, with the slaves, would make from 80,000 to 100,000 inhabitants. He considered that the town was very well developed.

But by 1433 the Tuaregs had already invaded the north and had settled in Timbuktu, which they laid waste, and where they remained for 35 years. Then Sonni Ali, emperor of Gao, extended his empire as far as Djenne and the whole of the Middle Niger. By degrees the Gao armies annexed the provinces north of Mali to the Askia empire, and in 1545 entered Mali itself, but without destroying anything. Mali was then confined to the Upper Niger and, towards 1670, the capital was transferred to Kangaba, further south. After 300 years of almost uninterrupted sway, during which it had given a tremendous impetus to the prosperity of Sudan, Mali was now almost entirely superseded by Gao. By the beginning of the 18th century no trace remained of the former and now abandoned capital.

On the whole, up to and including the 16th century, Nigerian Sudan—and it will be seen that the same thing was true as far as Lake Chad—had known a civilisation which became more and more clearly defined as it expanded, an era of genuine peace, for it would be wrong to see bloody wars in all the

struggles for succession of these various empires. Often everything passed off as on the occasion of the occupation of Mali by the Songhai troops, after their defeat of the Mandingo troops in.1545 ; the Askia ordered his men to defile his conquered adversary's palace and went away leaving the town unharmed.

Moorish occupation, the arrival of Arab merchants and slave-traders from the north, of white slave-traders from the south, wars to increase the number of slaves incited as much by the latter as by the former, were destined rapidly to demolish the accumulated prosperity of centuries.

5. THE FULA KINGDOM OF MASSINA (17TH–19TH CENTURY), AND THE BANMANA (BAMBARA) KINGDOM OF SEGU (17TH–19TH CENTURY)

When the Songhai empire collapsed after the capture of Timbuktu and Gao by the Moroccans in 1591, the whole of *Massina* was devastated for years by white troops. However, after 1600, it managed to regain, in some sort, its independence. But Hamadou Amin II, who reigned from 1627 to 1673, had a long struggle against the Moroccans before he finally succeeded in consolidating this rising kingdom which lasted on the left bank for two centuries. The Moors retained their hold on the other bank of the river, where they continued their extortions as they will be seen to have done in Timbuktu. From there, moreover, their slave-traders and merchants spread out towards Upper Senegal and Nigeria.

The most famous dynasty was that of the Bari, whose first sovereign, *Sekou Hamed* (1810–1844), subjugated Djenne, the mighty town in Massina which had practically always retained its independence. He set up his capital at Hamdalhabi. His dominions, which were fairly well organised, reached from Sansanding to Timbuktu. He had formed a regular army and system of taxation. He appointed a cadi to administer justice in each canton, and an assembly of lawyers in Hamdalhabi composed the council of state.

It was Sekou Hamed who converted to Islam those Fula who had remained heathen—an act which did not exactly promote peace in Massina.

Types of the Bambara people
Photographed by Carl Kfersmeier on his expedition to the Ivory Coast in 1932

The converted Fula became more fanatically Mussulman than any other Negro people, and thereby formidable oppressors of the tribes which remained heathen. Owing to its fanatical nature, this Fula domination caused almost as much havoc in Massina as did the Mussulman ravages amongst the Hausa. Barth records that, at that time, the Fula only maintained themselves by force and by means of bloodshed. This Mussulman state was entirely artificial and merely hastened the disruption of this rich country.

Later, from 1862 on, Massina came under the rule of El Hadj Omar and his successors ; they still considered the faith of the Fula kings too lukewarm and consequently despoiled three-quarters of the country.

Simultaneously, from the 17th to the 19th centuries, a *Banmana empire* had been set up next to Massina in the region of Segu and Kaarta. In 1660 its ruler, Bitou Koulou Bali, freed himself from his subjection to Mali—which had attempted, though in vain, to re-unite the Upper Niger and Western Sudan under its dominion, after the destruction of Gao by the Moroccans—and from the domination of the Caid of Djenne, who had been a Moroccan for nearly a century. He assembled a large army and a fully equipped flotilla, which enabled this empire to subsist for some time. The country was divided into 60 districts.

In 1750 the capital was moved to Segu-Sikoro, which then developed rapidly and which Mungo Park described thus in 1795 :

This capital of the Bambara appeared to me to contain about 30,000 inhabitants. It consists of 4 distinct towns, two on each bank, surrounded by high mud walls. The houses are built of clay, of a square form with flat terraced roofs and carefully painted white. Some have two stories and high above them rise the towers of the King's palace. . . . The crowd assembled for the market was so great that I waited two hours without getting a place in the ferry which links the two shores. [Whereas he had been robbed and almost killed by the Moors, the King of Segu] as a token of esteem, made me a present of 5,000 cowries (the wherewithal to live for 50 days).

In about 1800, at the zenith of its power, the Bambara kingdom included the whole of Diara, Fuladugu from near Bamako to Kayes, and Kaarta.

On the other hand, the north, the former region of Nioro and Ghana, had become almost a desert under Moorish domination. Mungo Park, who was taken there against his will, saw only " a population of a few unhappy Negroes, degraded slaves, and their brutal masters, the Moors."

Subsequently the Bambara kingdom did not continue to occupy such an extended area, but it was becoming a homogeneous and powerful state whose inhabitants ranked amongst the most gifted and numerous of the African peoples. Of the Bambara country between Segu and Sansanding, Mungo Park says: " The sight of the boats going up and down the river between the two towns, the excellent cultivation, the fertility and beauty of the country and its numerous and active population showed me the state of civilisation nearest to that which I had left in Europe."

Soon, however, it was unexpectedly invaded by the soldiers of El Hadj Omar, who came in the name of Mussulman dogma and in their own interests to ravage and subdue this " slave meat," as they called the Bambaras who had remained heathen.

6. TIMBUKTU AND THE MIDDLE NIGER FROM THE 16TH TO THE 18TH CENTURIES

Timbuktu provides the most terrible example of the struggles of the Negro states and towns, when they began to thrive, against either the Arabs and Berbers from the north, or against the Tuaregs, attracted by their wealth.

Having expanded and grown rich under the Mali emperors, Timbuktu was sacked by the Tuaregs as early as 1433, and they occupied it for thirty years. Then, after reviving under the Gao sovereigns, the town was again taken, in 1591, by the Moroccan army of Djouder Pasha, chiefly composed of Spanish renegades. Sent by the Sultan of Morocco, Mahmoud extended his dominion to Gunguia, and to Dendi, which resisted, although the Askia, whom Mahmoud caused to be treacherously killed, had retreated there after the capture of Gao. Returning to Timbuktu from Dendi in 1593, Mahmoud committed innumerable excesses and, to satisfy his army, tolerated looting, rape and arson. Between 1591 and 1593 the Tuaregs had already taken advantage of the situation to plunder Timbuktu twice on their own account.

In 1594, a column of troops under a christian converted to Islamism arrived from Marrakesh, arrested all the men of note, the scholars and the Cadi, and carried them off to Morocco. Mahmoud was killed in the following year and anarchy broke out.

From 1612 onwards the troops appointed their chiefs and Pashas themselves. There was a series of revolts and murders. Taxation was crushing and famine broke out. At Djenne the situation was the same. After 1660, relations with Morocco were broken off. All that occurred was a constant struggle between the troops acting on their own and the Caids who sought the assistance of the Tuaregs— and in return allowed them to plunder at will. In the 90 years up to 1780 there was a succession of 128 Pashas. According to the *Tarikh el Fettach*, all these Pashas, from the first, and for a long time, were so little Moroccan that they did not know Arabic and only spoke Spanish. The Moors were only driven out of Jenné and that part of Massina after 1810, following two centuries and more of disastrous domination.

Actually, in 1680, the Tuaregs occupied Gao for eight years. They were established as overlords, plundering the herds and caravans. Between 1723 and 1726 they once more occupied and looted Timbuktu. Thus Timbuktu, once a town of one or two hundred thousand inhabitants and the centre of a powerful state, degenerated into what it now is.

All this time, and increasingly towards the end of the 18th century, the Ioulliminden Tuaregs, the Tademelik, were pressing southwards against the disintegrated states and ruining the whole country lying in the loop made by the Niger as far as the frontiers of Mosi.

7. THE TUKOLOR EMPIRE OF EL HADJ OMAR AND THE MANDINGO EMPIRE OF SAMORI

In about 1800, after all these events, Sudan was quite unlike what it was in the 14th, 15th and 16th centuries. The age of great empires had passed, for they had not been able to resist the continued attacks from the north. As a consequence, the provinces lying further south or to the west of Gao, being suddenly left to themselves, became the theatre of countless struggles before they attained a measure of stability or homogeneity. But just when the Bambara and Massina empires were entering on a new period of prosperity, Mussulman fanaticism threatened fresh destruction.

El Hadj Omar, born in 1797, had made a pilgrimage to Mecca in 1820, and only returned to Africa in 1838. By then a bigoted Mussulman, he founded a convent, at the same time laying in a good stock

of ammunition and muskets, intending to impose a ruthless Mussulman domination on the Niger territories. He soon opened hostilities in Upper Senegal and conquered the Fuladugu country. In 1854, after one reverse, he made a second attack on the Bambaras and captured the Kaarta from them. In 1859 he entered Sansanding; two years later he defeated the forces of Massina and, the following year, entered Hamdalhabi. In 1863 he took Timbuktu, but was obliged to retreat. A widespread revolt broke out in Massina, where the burden of his domination was heavy. He persistently persecuted the Bambaras, too few of whom were Mussulman. He died in 1864.

He was, beyond cavil, a very great conqueror, as the rapidity of his conquests proves. He was quick, too, to take advantage of the discord between the various states and petty kingdoms which were the weakness of Sudan. But this attempt to reform Senegal and Nigeria under the sign of the Mussulman religion was too artificial and merely hastened disorders, disruption and civil war throughout these vast territories. The Bambaras, who, for religious motives, were decimated by El Hadj Omar, remember him with terror to this day. On the other hand, the rapidity with which he conquered this empire, and his ability to retain it, could only be achieved at the cost of widespread devastation.

His death was followed by one rebellion after another, and his son Ahmadou had to fight without ceasing to retain the Fula-Tukolor dominion over Nioro, Bambara and Massina, a dominion which lasted, with many interruptions, until 1893. Mussulman fanaticism showed itself to be well adapted to ruthless conquest, but utterly incapable of organisation.

The activities of *Samori*, the Mandingo who also tried to carve out an empire for himself, were concentrated further south, partly between Bamako and the Upper Volta, and as far south as the fringe of the forests on the Ivory Coast. He was also a conqueror of no mean achievement. For sixteen years he withstood the French troops sent to pursue him and ceaselessly defended an empire of never less than 100,000 square kilometres. But his endeavours were fruitless, attended with much bloodshed and doomed to the same failure as those of the Tukolor conqueror.

8. THE KINGDOMS ON THE COAST

The succession of big empires in the interior of Sudan never reached far beyond the edge of the forest; but in this outer zone a number of states was formed. They were necessarily smaller, since the forest prevented any considerable expansion; but they were often extremely powerful.

In Senegal (still to the north of this forest belt), and on the western frontier of the inland empires, there was the kingdom of *Tekrur* (near Podor), the capital of the Negro state of Senegal. In the 10th century, according to Edrissi, the town was very prosperous. This state continued for some considerable time and existed later under a Tukolor dynasty. Next came the three *Wolof* kingdoms, Wala, Jolof, Cayor, and further south of this country, the *Baol* and *Sine* kingdoms (Serere country) were fairly strongly established. But they were destroyed by the Moorish invaders who pillaged the whole of Senegal in the 18th and 19th centuries, just as the Ulad-Sliman will be seen to destroy Kanem. The desert extended south of Senegal and into Gambia.

Lastly, in *Futa*, a mixed race of Susus, Fula and Tukulors, in spite of this medley, established a very united, and in some measure theocratic, state: this was the Futa, so well developed at the time of the French conquest.

And it was also in this state of Futa, where the Fula and Tukulors predominated, that they were carried away by their Mussulman fanaticism and waged bloodthirsty warfare in the name of their religion against their heathen neighbours. In Mungo Park's account of his first voyage there is a particularly interesting story of one of these wars, just as the Scotch traveller heard it from the mouth of a *griot*:[1]

"The Damel of the Wolofs is the greatest of the Kings of the black race, glory unto him! Abdul-Kader, *almamy* of Futa, under pretext of religious conversion, sent an ambassador to the Damel accompanied by two marabouts each carrying a large knife: 'The almamy, after consulting the assembly of the True Believers of Futa, has instructed us to declare that if thou wilt not reform thy conduct and beliefs, as well as those of thy nation, he will compel thee to do so by force. Choose between these two knives: with this one the almamy will shave the head of the Damel if the Damel agrees to follow the law of Mahomet; otherwise he will cut his throat with that one'... 'It does not please me to choose,' answered the Damel. 'Go and take with you my reply: To Abdul Kader, greeting! I need thee neither as barber nor as executioner. Why interferest thou? Knowest thou not that the Prophet has said: "Argue not with those that are ignorant"? Therefore keep thy knowledge and bide in peace. As for me, I remember that this verse from the Koran has been read to me: "Forgive those who insult you."

[1] The *griot* was a sort of living library of reference.

Therefore I send back thy people without having their ears cut off. But do not let them return. Mahomet has also said: " Be resigned to your fate." If thou attack me, I am resigned to defeating thee.'

"The almamy took the field and invaded the Wolofs at the head of a strong army of Fula and Tuculors. At first the Wolofs retired before this flood of invasion, filling in wells, destroying houses and crops. But when they judged the moment opportune . . . they resumed the offensive with such vigour that as the result of a night attack the whole Futa army fell beneath their blows or were taken prisoners. Abdul-Kader was amongst the prisoners. The Damel summoned him: ' If fate had put thee in my place, and I in thine, what would'st thou do?' ' I would plunge my lance into thy heart, and I know that a like treatment is in store for me. . . .' ' Thou art wrong, Abdul-Kader. . . . I might do so, but that would not rebuild my shattered towns or restore to life the thousands of Wolofs who have died in the woods. I will not kill thee but I will keep thee as a slave to work at re-tilling the fields of the Wolofs.' . . . After several months, the Damel generously gave him back his freedom and allowed him to return to Futa. . . ."

In the forest zone, properly so-called, there were some important kingdoms: the states of *Baule* and of the *Agni*, the kingdom of the *Appollonians*, and that of the *Abron*, which is known to have been powerful since the 15th century.

Next came the *Ashanti* kingdom, which was, particularly between 1700–1895, one of the strongest African states, united as was Mosi, and boasting one great sovereign, Osei Tutu, who was the founder of the Ashantis' power.

Then came the *Ewe* kingdom and the kingdom of *Dahomey*, a big and rich state with a considerable army, constitutionally very complex and governed by kings whom European legend considers as ogres, but who were often excellent rulers.

Near-by, lay the great kingdom of *Yoruba*, one of those to attain the highest level of prosperity; it included the largest African Negro cities: Abeokuta, Ibadan, etc. In the past this was the most powerful of all the states and no doubt Frobenius is right in situating Atlantis here, the Atlantis spoken of by the Greeks. The discoveries of Frobenius at Ifa have proved that an extremely well-developed civilisation existed there many centuries before the first Portuguese contacts—it is only through Frobenius that we are able to form any idea of the complexity of this civilisation. At that time, Yorubaland comprised the whole region between the Middle Niger and the sea-coast, and that between the Lower Niger on the east, as far as, and including, Ashantiland on the west. The wonderful cities spoken of by the first white *conquistadores* (see Part III) did not long outlast the period of the early travellers.

Moreover, Yoruba was heathen and from the beginning of the 19th century the object of incessant attacks by the fanatical Fula who had already conquered and annexed Hausa and now laid waste the vast Yoruba country. When Clapperton travelled through it in 1825, villages had been burned on all sides and the chiefs of the towns through which he passed complained to him ceaselessly of the Mussulman intolerance of the Felans (Fula) who had just begun to invade Yoruba (called Yarriba by Clapperton). According to R. Lander, who revisited the country in 1830, there may have been a million killed and as many more in dismal bondage to the Fula, and this without taking the slave-traders into account. . . . The wealth of Katunga, the capital in those days, astonished Clapperton even in 1825. Its walls were fifteen miles in circumference, and to the north, as far as the Niger, lay Kiama and Wuwu—prosperous and, in a measure, vassal states. Everywhere he was received with lavish hospitality.

Conditions were similar in the little state of *Busa*, the centre of the *Borgu* confederation, at that time intact, where the brothers Lander began their journey down the Niger, and where they received a magnificent welcome. . . . They describe the exuberant life and joy of the entertainments at which they were present. " In these three small states, Kiama, Wuwu, Busa," writes R. Lander, " more warlike than Yoruba and as yet unattacked, you come across a village every half hour; there seems to be no end to the corn-fields and the Niger is dotted with boats."

Further north, *Nupe* or *Nufi*, on the left bank of the Niger, situated between the Hausa and Yoruba countries, was, from this time on (1825), crushed by the Mussulman invasions of the Fula. Clapperton writes:

This country, after having long been the most industrious, flourishing and thickly populated in Sudan, suffered from all the horrors of war: one of the sons of the King who had recently died, urged on by the Felans of Sokoto, was converted to Islam and summoned the Fula armies against his brothers and heathen subjects. The unfortunate Nufenis, peaceable farmers and industrious weavers, could not struggle on even terms with the Felan hordes who were accustomed to live by plunder. When we passed through, the latter were enjoying their triumph in the ruins. . . . As for the new convert [adds Clapperton], he was the greatest drunkard and the most shameless beggar that I have ever seen. He is a mere tool in the hands of the Felans. Nufi has now lost those fine silk and cotton factories which brought it riches and fame; and of its industrious population, part has been massacred, part scattered, sold into slavery or fugitive in strange lands.

Between Yoruba and the mouth of the Niger lay the kingdom of *Benin*. It existed, according to Portuguese reports, in the 15th century, and was certainly more ancient still. It was a remarkably powerful and much dreaded state whose inhabitants were highly gifted in the arts of ivory and bronze work and possessed secrets which European industry has failed to discover. The numerous bronze masterpieces of the 15th, 16th and 17th centuries, which are the pride of some of the European museums, are ample proof of the high level of prosperity to which this kingdom had attained. Customs were often violent and bloodthirsty, but would not, of themselves, have brought about the disruption of the state, as it has been asserted. Actually it was first the Portuguese, then the slave-traders and finally the English punitive expeditions who undertook its destruction and wiped out all trace of these ancient glories. The results of the English expeditions in Benin can certainly be compared to those of the Portuguese interventions. Arson and loot were the watchwords of this " punitive " campaign.

As early as the 18th and until the middle of the 19th centuries, all these kingdoms were rendered desolate by the slave-trade, for the coastal districts were the first to be exploited. Even in 1852 a slave-trader was still able to ship 1,200 blacks at a time on the coast of Benin for the Cuban market. Alcohol and gunpowder were the ruin of these states, and the weaker peoples, especially those in Guinea and on the Ivory Coast, were exterminated. Dahomey and the coast of Lagos as far as the mouths of the Niger were soon known simply as the " Slave Coast." A few kingdoms managed with difficulty to subsist, moreover, often, only because they were useful as a base for the slave-traders' expeditions into the interior, or because the Europeans compelled their rulers to round up slaves for the white man's benefit.

9. THE INLAND KINGDOMS—HAUSA, BORNU, KANEM, BAGHIRMI, WADAI

Further inland lay the little kingdoms of *Sikaso* and *Liptako* ; and the kingdoms of *Senufo* and of *Kong*, which were important. The iron and copper industry in particular produced some remarkable works of art in Kong and Lobi.

Hausa deserves a more detailed examination. It included, from the first, several small and very rich states. In the 16th century the cotton and leather from Hausa were known throughout Sudan. One of its big cities, Kano, was very famous in the time of Leo Africanus, as was the highly cultivated country of Katsina. Zaria, probably paramount in the country, thanks largely to one of its principal rulers—a woman—was a great commercial city. Sanfara and Bauchi were equally prosperous. In the 15th century all these little states were united under the directorate of Kebbi. In 1500 Hausa and Kebbi formed a single empire which reached from the Niger to Bornu and which withstood its neighbour, Gao, an extremely prosperous empire at that time, ranking with the Songhai kingdom. But after 1600 it broke up once more into small states which nevertheless remained just as prosperous and enterprising.

Hausa is considered to be the country most thoroughly converted to Islam ; but its conversion on a large scale only dated from the 19th century, and brought about a fresh series of wars. The Mussulman Cheikh, Otman dan Fodie, began the conquest of Hausa in 1801, pretexting the defence of the interests of the Fula colonies scattered through the country. At his death, the kingdom he had thus formed reached as far as Adamawa and Bornu to the east, and Nupe to the south. But this personal and artificial dominion had been acquired at the price of the greatest havoc. Otman dan Fodie, who, moreover, died in a crisis of mystic mania, only succeeded in imposing himself and the Islamite faith by decimating those peoples who remained heathen.

The reigns of his successors were marked by long struggles against the unconverted peoples, struggles which lasted until 1904 and made impossible all opposition to the English invasion. According to Barth, who spent a long time at Sokoto, there were two quite distinct clans in this country—the fanatical Fula conquerors and the natives themselves, the despised and completely subjugated slaves of their Mussulman masters . . . " unfortunate hinds or bands of slaves," he said, " with civil war almost everywhere." The Fula carried their raids and slave-hunting beyond the Niger and also beyond the Benue, as was testified by Dr. Baikie and the members of the expedition which went up the Benue in 1854. The whole kingdom of Sokoto, established by force and divided at the death of Otman between his brother and his son Bello, having lost a large part of its resources, was obliged to continue the same policy in order that its sovereigns might live. " Soon, the only reminder of this vast empire were thousands of ruined villages and entire populations annihilated." (Meynier.) Such was the result of the great Mussulman civilisation which has too often been called the origin of the greatness of the Sudanese Negro states.

Because they were the centre of this empire, the regions of Zaria and Kano alone continued to prosper. According to Clapperton, Kano, the " London of Sudan," was 25 to 30 miles in circumference. But here, too, Islamism had caused slavery to assume alarming proportions ; in this town there were 35,000 or 40,000 slaves for a few hundred masters only ! . . . Then, too, in Clapperton's and Lander's notes,

there is a sharp contrast between the hospitality of the Felans, often aggressive or else non-existent, and that of the heathen black populations, noisy, sympathetic and inexhaustible.

Nevertheless, having experienced centuries of strong and stable government, Hausa is still to-day one of the richest districts in Africa.

Further east, *Bornu* and *Kanem* were also important states, and are a no less remarkable illustration of the ravages caused by the Arabs. In the 9th and 10th centuries, perhaps earlier, Bornu and Kanem were a single heathen state. In the 11th century Islamism was introduced, and in the 12th the power passed into the hands of a Mussulman dynasty. Shortly afterwards Bornu and Kanem fell apart, but the King, or Mai, Edris III (1571–1603), who may be compared with the Songhai rulers, succeeded in reuniting the former empire from Kano to Tchad and Logone. The 16th century was one of immense prosperity. The northern country was opened up by irrigation and the Tuaregs driven back. So that, at this time, the kingdom of Songhai, the Hausa states (or rather the Hausa-Kebbi kingdom) and the Bornu-Kanem kingdom formed a notable chain of empires along the same latitude, and all equally prosperous.

This prosperity lasted for two hundred years, until the beginning of the 19th century, when the Ulad-Sliman, the most ruthless Arab invaders ever known in Africa, appeared. The havoc they wrought was worse than that suffered in Songhai at the hands of the Moroccans. Kanem literally became a desert, and to such an extent that the Ulad-Sliman, themselves unable to live there, were obliged to withdraw.

Bornu, too, had to sustain a ceaseless struggle against the Arab invaders of Kanem and against the fanatical Fula from Sokoto (Otman dan Fodie and his successors). When Clapperton passed through the country in 1822, it was very prosperous and the magnificence of his reception amazed him. Bornu dominion reached as far as the country of Zinder, itself very considerable and described thus by Richardson in 1850 : ". . . villages every quarter of an hour . . . numerous wheatstacks on the plains . . . the whole country-side a succession of cornfields and green hills." But the slave-traders attacks became more and more persistent. In 1851, when Barth passed through Kuka, the capital of Bornu, the town had just been attacked, burned and looted by the people of Wadai. . . . The people of Bornu rebuilt it and Barth found a country industrious once again, and to the south of Kuka, " fertile districts, very beautiful and thickly populated ; but not long afterwards, towns and territories ravaged by the constant raids of which this country is the scene."

But at the end of the 19th century the Mussulman Rabah came to the fore ; though a fanatic, it was especially

Warrior from the Red Sea Hills
From " The Four Feathers." Paramount Photo Film. By courtesy of " Close-Up "

as a slave-hunter and robber chief that he invaded the country, destroyed Kuka, the capital, plundering wholesale as he went. For two centuries Bornu had been struggling against the looters and slave-traders of the Wadai; now they were unable to resist Rabah and disaster overtook them. To-day Bornu and Kanem are incomparably less prosperous than Hausa; they were proportionately so a century ago; but they could not safeguard their prosperity against this tidal wave of plundering and raids.

Baghirmi, which had a flourishing capital, Masenya, already in 1510, suffered the same fate. Subjected at first to Bornu, it became emancipated, achieved a measure of power and was at last ruined by its perpetual struggles against the Wadai. Barth wrote in 1851: " In Baghirmi, ruined and depopulated by repeated invasions, agriculture is on the decline and industry at a standstill." Further on he adds: " its inhabitants can only safeguard a precarious independence by making slave-raids on behalf of the Wadai Arabs." Finally the slave-trader Rabah plundered the country from end to end.

Wadai, inhabited at first by Negro and Arab tribes, was forcibly converted to Islam by foreign conquerors between 1635 and 1665. It then became, with Dar-Fur, the chief centre of the Arab slave-hunters, looters of caravans and ringleaders of forays. Its whole history is that of a series of expeditions to plunder Bornu, Kanem, Baghirmi, and even further afield. Some of its princes have gone down to fame for their atrocities. Tel Sabun ruled from 1803 to 1813 and then murder followed murder during a female regency which lasted until 1829.

Dar-Fur and *Kordofan*, which, to a greater degree than Wadai, were not Negro states but composed of half-castes and Arabs, have a similar history. Rabah, the most notorious of the Arab and pseudo-Arab slave-traders, originated here. He began in 1878 by sacking Bahr-el-Ghazal and exterminating the population. In 1892 he plundered Baghirmi; in 1893, Bornu and Gober; then he turned south again. In 1898, he once more entered Baghirmi and set fire to the capital, Masenya, and obliterated it. For 22 years, until 1900, wherever he passed in the Tchad district, he utterly destroyed everything. During this same time, until 1898, the Mahdi, Mohamed Hamed, was similarly employed in Southern Egypt.

Further north, between Tripoli and Lake Chad, *Fezzan* was another centre of slave-dealers. Clapperton, who followed this route in 1822, wrote: " It is hardly possible to go one mile of the whole journey without coming across the skeletons of Africans. . . ." " One evening," wrote Major Denham, who accompanied Clapperton, " after a long day during which these human remains had never been out of our sight, I counted over a hundred skeletons near a well. . . . The Arabs laughed: Peuh! they were only niggers! A curse on their fathers!"

Moreover, slave-trading for the Arab markets and for America had spread to an appalling extent in all parts for decades. Like the whites on the coast, the Arabs, here, had penetrated everywhere and incited each sultan or chief to raid slaves for export. " Slave-trading," wrote Richardson, AS LATE AS 1850 (it had lasted 2 or 3 centuries), " is extensively carried on in this part of Africa." (He was writing of Zinder and Bornu.) " A selection is sent to Nupe and from there to the coast and America. . . ." Thus Richardson saw 3,000 slaves arrive at one time at Zinder and explains how the Arabs forced the chiefs into this trading:

> The Arabs here are either purveyors to the court or bankers; they sell goods to the " Sultan " at exorbitant prices or lend money for the tax which he has to pay annually to the kings of Bornu. . . . Purveyors and bankers are infamous usurers who take pitiless and ruthless advantage of this poor potentate's straits. On the occasion of my farewell visit, the latter was sadly calculating how many more raids he would have to organise in order to satisfy his creditors. . . .

The number of Negroes carried off as slaves and above all killed in the raids connected with slave-trading in Sudan has been estimated at between 35 and 70 millions. Then came depopulation as a result of European colonisation. Could any civilisation come unscathed through such an experience?

II

Other Civilisations

Information is more scarce regarding the rest of Africa. There are no records like the *Tarikh es Sudan* or the *Tarikh el Fettach*, and fewer travellers' tales. On the whole, no very large states were formed. The forest was an almost insuperable obstacle to the formation of empires comparable to those in Sudan. But it will be seen that this did not prevent these more or less notable kingdoms from achieving as high a degree of civilisation as the latter.

The most important were: the kingdom of *Loango*, which extended from Cape Lopez (Libreville) to

near the Congo; and the *Congo Empire*, mentioned by the Portuguese as early as the 14th century. Its chief, the Mani-Congo, governed from Sette-Cama, to the north of Pointe Noire, to as far as Benguella. In spite of the forest, the empire spread inland as far as the Kasai and Upper Zambesi rivers. The Portuguese spoke admiringly of the capital, which they called San-Salvadore. The kingdom must have been firmly established, for in the 16th century it still reached southwards as far as Loanda, and, though no longer as far as the Kasai, it did still reach to the Kwango. Moreover, the whole of this coast was utterly ruined by the Portuguese, who dominated it for centuries.

Further inland there existed the kingdom of *Ansika*, which roughly comprised the peoples of the Bateke and Bayaka: a territory of considerable size and two peoples whose artistic talents are very remarkable. Still nearer the centre, the *Bakuba* kingdom (or *Bushongo*) is still famous to-day for its unity, the excellence of its administration, its art, its craftsmanship and the beauty of its fabrics and velvets. (See the accounts given by Torday and Hilton Simpson.)

South of the Congo basin, the whole Bechuana territory formed a vast state which actually ruled for a long time over the *Basutos*, the *Zulus*, the *Hottentots* and the *Bushmen*, thus including in a single empire

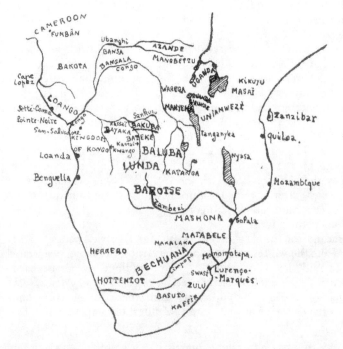

the greater part of the black population of South Africa. Later, when the division occurred, *Basutoland*, *Zululand* and *Swaziland* formed three remarkable Negro states, the two latter being extremely rich. The delicacy and elegance of their beadwork, of which more was done here than elsewhere in Africa, testify to this wealth. Protected by powerful armies and governed by famous rulers such as Cetewayo, the Kaffir and Zulu kingdoms reached a high standard of prosperity. The proximity or harsh rule of the Boers, followed by the no less harsh rule of the English, brought about their ruin. To the west the *Hottentots*, and further north the *Herreros*, were nations of considerable importance. The latter seemed so formidable to the Germans, that they took advantage of a local rising to have a wholesale slaughter of the greater part of the warriors. At a conservative estimate 17,000 men, and perhaps 20,000 or 30,000, were massacred.

In Portuguese Africa itself, between Sofala and Lourenço-Marques, there was an important state— *Monomotapa*; it became legendary even in Europe and to people as remote as M. de la Fontaine, owing to the descriptions of the dumbfounded Portuguese. Further north the *Matabele*, *Makalaka* and *Mashona* peoples formed a single kingdom on the banks of the Middle Zambesi. Here mighty states were growing up. The whites themselves were obliged to admit that " the arrival of the Europeans and their brutal capture of the country was about to change the whole aspect of the problem. Populations were subjugated in a body and lost all individuality. . . ."

Higher north, on the seaboard of the Indian Ocean, came the sultanates of Zanzibar, Quiloa and

African Empires and Civilisations

Sofala. But these were Arab sultanates and the sultans were slave-traders. Zanzibar was nothing but a " slave country " and was a huge repository of human merchandise. The Arab columns started from there on their journeys into the heart of the Congo, to the Zambesi and beyond.

The inland kingdoms, too, were decimated by their invasions from the 17th till the end of the 19th centuries. They were numerous notwithstanding : the kingdom of *Lunda*, the so-called kingdom of *Kasai-Zambesi*, the kingdom of the *Barotse*, the kingdom of *Katanga*—where, from the material point of view alone, as in all the other Kasai kingdoms, the iron industry produced such marvels as the wrought and pierced Kasai axes which European smiths would find it difficult to imitate, and which would be remarkable for their technique alone.

Next come the kingdom of the *Balubas*, the *Manyema* kingdom, specially described by Stanley, the various groups of the *Warega* tribes whose ivory work was so brilliant ; the kingdom of the *Azandes* (or Niams-Niams), who for so long had a senseless European reputation for the utmost savagery ; the kingdom of the *Mombuttu* (or Mangbettu), which Schweinfurth saw in a most thriving condition, prior to the ravages of the slave-traders. In our own day, the art of the Mombuttu, the distinction of their women's hairdressing, last outward traces of one of the most brilliant civilisations, amazed those who, alas ! discovered Africa in 1924 with the Citroen expedition.

The *Monene-Mwezi* (*Uniam-Wezi*) empire lay on the other side of Tanganyka. Its sway extended for a time over the Urundi and Ruanda countries to the north-west, and northwards up to and including Uganda. Whereas, near Kenya, the *Kikuyu* and *Masai* tribes, a mixed race but containing some of the most beautiful African types, formed, without too definite amalgamation, martial and pastoral confederations with a rugged civilisation not without grandeur.

Many other peoples are almost equally deserving of mention : the *Ba-Rundi* (Urundi) and the *Baga-Ruanda* kingdoms, to the east of the Azandes, round the Ubangi river ; the *Bansa* tribes, the *Bangala*—or, between the Ubangi and the gulf of Guinea, the very powerful *Bakota* tribes, whose art, particularly in copper work, still commands admiration, and last of all the kingdoms of Cameroon, in which is the famous sultanate of Fumbân.

Many of these peoples did not always form kingdoms in the accepted sense of the word, for often the tribes composing each people merely lived side by side, without a common chief—except in a crisis. But nevertheless these tribes formed well - defined groups — genuine nations, each with its particular characteristics.

The splendour of these peoples and kingdoms was such that, in spite of Arab, and after 1890, Belgian devastation, Frobenius, whose evidence will be quoted later, was spellbound at the last traces of those civilisations which he encountered

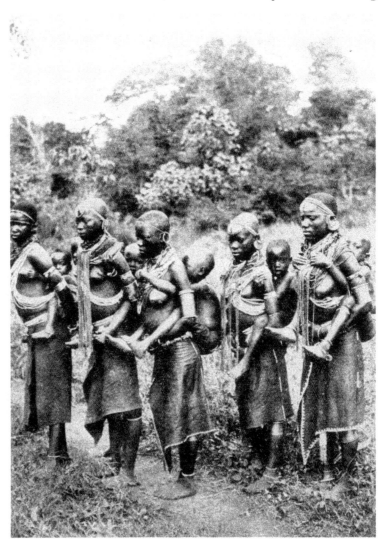

Masai women and children, British East Africa

371

as late as 1905. But this has been followed by the era of " rational colonisation " . . . the frenzied industrialisation of Katanga and the systematic transformation of Kenya and Uganda into " white colonies," etc.

Even before this era, all the states nearest to the coast, and, progressively, the majority of those just quoted were successively ravaged by the small armies of the Arab traders in ivory and slaves who pushed further and further towards and beyond the Great Lakes. In the 19th century the Arab conquerors had established a series of sultanates between the Upper Ubangi and Tanganyka which were nothing but centres from which to exploit and pillage the country. The famous Tippoo Tib rivalled Rabah in his work of destruction. " In the presence of these scourges " (Colonel Meynier writes) " the Negro peoples rapidly broke up. Countries laid waste, races degraded by so much misery, family ties shattered, ceaseless warfare leading to the speedy annihilation of all individuality, these comprise the credit sheet of Arab colonisation in East Africa." It was the same in Sudan before European colonisation. Again, the Pombeiros, Portuguese half-castes, were perhaps more brutal still. In the interior of the Congo the Blacks did not yield at all easily. And so the Portuguese killed them and only kept the women and children. These men came from Angola and joined forces with the Arabs from Zanzibar in the middle of the Congo kingdoms.

Throughout the rest of Africa, as in Sudan, it was the same tale of slaves dragged to the coast—for the trade centres of the Arabs and for those in Angola—for the two Americas and for the West Indies— there was an average of six or eight (and often more) casualties for one slave who reached the coast alive, and the number of those who disappeared or were slaughtered reached several millions ; no doubt 20 or 30 millions is the total of enslaved, dead and disappeared.

It also happened that the arrival of the missionaries provoked fierce civil wars. Thus Uganda and Unyero were decimated by a war between King Mtena, and later by his successor Monanza, whom missionaries had converted to catholicism, and a whole section of their people whom other missionaries had converted to protestantism and suitably roused. This long religious war—first-fruits of the early missions—was not exactly beneficial to the country.

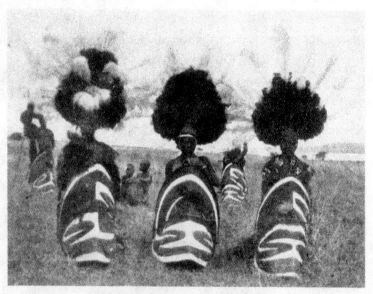

Luo warriors who have adopted Masai head-dress and shields. Uganda
Photo by courtesy of J. H. Driberg

III

Throughout these avatars and up to their final destruction or semi-destruction, all these Sudanese, Central African and South African states enjoyed genuine prosperity, an almost always very high level of wealth, and, above all, easy conditions of life which have disappeared for ever. This has been abundantly clear from reports, already mentioned, of Arab travellers, the early historians and explorers.

True, it was exceptional for the towns to have stone houses, but they were unnecessary; houses built of " pisé," of wood and clay mixed, huts—so much quicker and easier to build and rebuild—were sufficient to their needs. But most of them were decorated with a wonderful sense of ornamentation. There was no lack either of garments, which were unpretentious but fine, or of food. Towns of forty to a hundred thousand inhabitants and more were numerous; to-day the majority have disappeared.

The accounts of the first European navigators agree with those of the Arabs, and the Portuguese are often seen to have been dazzled by their discoveries. Thus Frobenius, writing of the Gulf of Guinea, near Weida, says : " The captains were very surprised at what they saw : streets carefully laid out, planted, league after league, with avenues of trees. Days of travelling showed nothing but magnificent fields, and inhabitants richly clad in materials of their own weaving. . . ." Again : " Further south, in the kingdom of Congo, multitudes dressed in silk and velvet ; great states perfectly ordered down to the last detail ; powerful rulers, flourishing industries, a culture permeated with the natives' very being. . . . Moreover the same conditions existed in the eastern districts, for example on the coast of Mozambique." Let no one dare to speak here of Arab influence ! The Portuguese spoke with amazement of that capital of the Congo (San Salvadore), so big, so comfortable, and where life was so full of ease. . . .

Reverting once more to the admirable comments of Frobenius : " Judging from the accounts of navigators from the 15th to the 18th centuries, THERE IS NOT A SHADOW OF DOUBT that Negro Africa of that period, stretching south from the edge of the Saharan deserts, was in the heyday of an uninterrupted efflorescence of all the arts, AN EFFLORESCENCE WHICH THE EUROPEAN CONQUISTADORS CALLOUSLY DESTROYED AS FAST AS THEY SUCCEEDED IN PENETRATING INTO THE COUNTRY. . . ."

" The story is absolutely true as told by these former captains and commanders, Delbée, Marchais, Pigafetta, or whatever their names happened to be. In the former royal Kunstkammer in Dresden, in the Weydmann collection in Ulm and in others, collections of West African objects of this period still exist. Here are magnificent plushy velvets, made with layers of the tenderest leaves of certain banana plants ; supple and downy stuffs with the delicate sheen of silk, woven from fibres suitably prepared from a raphia palmtree ; ceremonial spears with blades inlaid with the finest copper ; a bow, so graceful in shape and adorned with such designs, that it would be the gem of any armoury ; gourds decorated in the most perfect taste ; sculptures on ivory and wood, admirable in their simplicity of form, in their style. . . . When once the pioneers of the last century had broken through the defences in the rear (of the coast-line) which protected a still inviolate civilisation, they were everywhere confronted by the same pomp which had greeted the captains in the 16th century. . . ."

The foundations on which these conditions rested were the laws and customs of the Africans, their family, social and economic constitution. For each was the expression of an almost perfect adaptability to environment. In this domain, as in the domain of their art and architecture, it has been contended that all the credit was due to the Arabs. This is entirely wrong, and, to-day, no ethnographer supports that theory. Those essentials, the structure and culture of the country itself, existed well before the coming of the Arab scholars. Granted that later a few Arabs played a brilliant individual part in Sudan, as for instance Es-Saheli, who erected the first buildings in Gao in the celebrated " Sudanese style " for the Emperor of Mali ; but he drew his inspiration entirely from the architecture in vogue in the country. This was all. With regard to the Mussulman religion, save in the case of the Fula, it was never more than an external, superadded to the fundamental and genuine Negro morality. A certain Mussulman Askia sovereign was known for his rapid despatch, from the throne, and at one sitting, of all the prayers prescribed for the day ; he would say, addressing the prayers themselves : " you know yourselves by heart ; find yourselves amongst yourselves. . . ." The morality of the Islamic Blacks remained fundamentally the same as that of the Pagan Blacks. Besides, without looking beyond Sudan, a glance at the constitution, the laws and the very life of the Islamic Negro states compared with those of the black states which remained Pagan like the Mosi, where Arab influence never penetrated, is enough to make it clear that we are confronted with customs of Negro origin.

Islamism did not substitute new ideals. For that the whole of the former social organisation and material life of the heathens would have had to change (then, and only then, a new spiritual *modus vivendi* would have been substituted—as was maintained to have happened in the states converted to Islam), but this NEVER happened. Primitive Negro culture always predominated.

What Islamism has more particularly to its credit are : its series of destructive wars of acquisition ; the fanaticism which it inculcated in certain of the black populations, giving rise to the most bloodthirsty wars ; the advent of Arab merchants, money-lenders, slave-traders ; and finally it was Islamism which transformed slavery from the family or domestic system in force amongst the blacks, into that trading in

livestock, those bloody massacres, the same as practised by the whites, the Europeans and the Moors.

To show to what a degree of harmony and wisdom the Negro constitutions attained, it will not come amiss to quote from the interesting pages of M. Delafosse [1] on the collectivism, or primitive communism of the black communities, which is the foundation of their social structure and of their entire civilisation :

> Individualistic notions are foreign to the majority of Negroes. With them collectivism carries the day in every sphere, be it of society, religion, property, economics or even of politics. . . .
>
> Even at the present time, the family does not consist of a couple and their children, as in our European societies, but of all the descendants of a common ancestor living together. In cases where the ancestor was a man, relationship is established through the male line—through the female line where it was a woman.
>
> In neither case was the wife legally incorporated in the husband's family. She is only lent to the latter by her own family in exchange for a pledge. If she dies without the marriage having been dissolved, the pledge becomes the property of her family. In the event of pre-decease by the husband, sometimes the wife returns to her family, sometimes the deceased's heir takes his place as husband. Finally if the union is dissolved, the wife's family return the pledge and take back possession of the latter.
>
> . . . The children normally share the fortunes of the parents from whom they are legal descendants. The family is based not on marriage, but on heredity—which insures it a very different cohesion.
>
> A family in that sense is bound to continue increasing. . . . In practice, a limit is placed to its extension by the area of arable land. When this tract of land becomes insufficient, a part of the family separates itself from the original nucleus, and seeks unoccupied land elsewhere. But all ties are not severed. The two families, and their subsequent issue, form a kind of clan whose original identity is indicated by a sort of title, and by a common taboo instituted by the same ancestor.
>
> As long as they inhabit the same district, these moral ties are strengthened by political ties—the patriarch of the family from which the others issued acting as head of the clan. Several clans form a tribe. . . .
>
> " Thus, throughout Negro Africa," with variations in detail according to districts and areas of civilisation (as Frobenius has shown), " the family constitutes an indissoluble whole the more solid because it remains attached to the local religion, i.e. animism based on the combined cult of the souls of ancestors and the spirits of nature." (Whence the destructive part played by Christianity and European ethics which substitute individualism—even in the family—for this collectivism, and isolate individuals, whereas materially it is in and by collectiveness that they can best fulfil their lives.)
>
> . . . It is true that the Negro family traces its origin back to an individual : the ancestor. But the latter only exists in the eyes of his descendants as the creator of the collective unit which they constitute. From the local divinity he has acquired the family lands, or rather the right and privilege to enjoy them. But he has made this acquisition in the name of the family which he was founding at the same time, and not in his own. He has bequeathed this right and these privileges as a whole to all his descendants, present and future ; and only as a collective unit are they the holders.
>
> . . . The patriarch, who succeeds to the ancestor at many removes, is only administrator for the collective unit ; at the same time, he is manager of the family property and its priest.

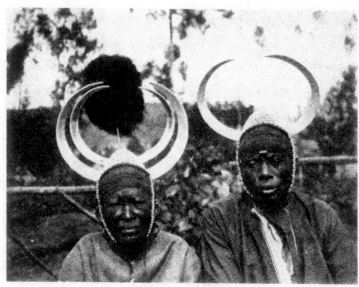

Luo Elders, Uganda
Photo by courtesy of J. H. Driberg

The patriarch is also priest. Now when an individual wishes to obtain from the higher powers a favour, a personal request, revenge, he cannot apply to the patriarch. He must resort to the priests of a particular cult or to a magician. Furthermore, in the first case, he must have undergone the requisite initiation, and the object of his request must be consistent with the

[1] *Les Nègres*, Rieder.

purpose of the brotherhood. Here again the collectivist character of the Negro religion is manifest. Consequently Magic is the only resource of the individual who wishes to influence the unknown powers on his own behalf.

. . . The administration of property is based on the same idea. Nobody, not even the collective unit itself, has the ownership of the land. But this is of little importance in a country where, up to the present, there had been no idea of using land for commercial purposes. The Negro is not interested in his right to transfer property which he occupies, but in his right to farm it and benefit by the cultivation. Now, only collectivism confers the title-deed to this right.

. . . True, the patriarch ranking as " land-lord " may allot the usufruct of the family holding to the various portions of the family, and even to individuals. In this respect, he ensures the justice of the distribution by allotments renewable each year.

. . . He can even authorise strangers to settle on a piece of family ground and farm it. But he is not entitled to grant, transfer or even divide up the prerogatived right to the family holding acquired by the founders of the family.

. . . The principle of the inalienability of titles to land is so engrained in the native conscience, that in their sight, the conquest of a territory in no way implies the acquisition of right to the soil of that territory. Land cannot be an unconditional property. And this also applies to whatever the land yields by natural law.

Work, or rather MAN'S PRODUCTIVE ACTIVITY, IS HELD TO BE THE ONLY TITLE-DEED TO PROPERTY. The source of work may be a collective unit or an individual. . . . In the first case, the ownership will naturally be collective; . . . in the second, individual, but almost always taxed by some contribution to the collective unit which has been robbed of the individual assistance in the collective work. . . .

Trade and manufactures are also, for the most part, in the hands of the corporate collective units or associations. A hoe or a canoe are not the private property of the blacksmith or carpenter, but the collective property of the caste to which they belong (professional caste).

A first slave's descendants belonged to the family of the original owner. Thus slaves became inalienable, and could not, properly speaking, be sold. They were an integrant part of the family, and as well treated as the other members. . . .

All this shows that we are in the presence of a kind of collectivist system fairly complex, but suited to peoples or even tribes able to live solely by their own resources.

. . . The strong partiality of the blacks to their collectivist system was bound to have a marked influence on their political institutions. . . . States exist which are composed of a confederation of clans and tribes where none of these is legally superior to the other; the council only appoints a supreme leader in case of war, and he resigns all control as soon as the crisis is past. . . .

Or else that state is governed by a king. But the king is chosen from one family and always elected by a council. He is further enthroned by another family who may refuse and nullify the election. Moreover, his ministers are obligatorily chosen from certain families. The king is also assisted by a council of leading men, whose sittings are held in public.

The monarchic system has little in common with the blending of authority met with here which betrays the Negroes' instinctive desire to uphold the interests of the collective unit.

All this can be seen to bear out what has been already observed in the organisation and administrative system of several states whose history has been dealt with at greater length.

What Europeans call the intellectual life is no less flourishing. A consideration of the countless artistic manifestations of this life would be out of place here; it will be found elsewhere in this book. The existence of the griots, these living libraries, whose function it was to remember all past and present events, all tales and legends, who were turned to as references, the histories written in Arabic by the historians of the Middle Ages, the great number of songs, tales and legends which have been collected by M. Delafosse, Blaise Cendrars in his *Negro Anthology*, and Frobenius, to cite two or three widely different authors, prove that the intellectual life is on a par with the smooth-running system which has just been considered.

Even more convincing is the fact that the Negroes actually invented absolutely original systems of handwriting :

Two at least are known, and others may exist. The fact is the more noteworthy because, if a White semitic race taught us the art of writing, no alphabet of that Indo-European race to which we are so proud to belong has ever been discovered. . . . An alphabet has been traced to the Vai in Liberia and Sierra Leone who have apparently used, for more than a century, a syllabic writing of their own invention—to the Bamon or Bamum of Cameroon who use a perfectly practicable system evolved, in about 1900, by Njoya, king of Fumban—and lastly to the Nubians in the Karasko and Mahas district, who, according to the English author H. A. MacMichael, make use of a special alphabet more or less derived from an oriental writing. [Delafosse. *Les Nègres.*]

And, incidentally, if evidence is required regarding that other aspect of culture—the moral sense—on the score of which the Negroes have been so heavily indicted, there is, amongst many others, that of W. Seabrooke on the Habbes' conception and punishment of theft and murder, admirable legislation which is not peculiar to them ; that of Frobenius, quoted further on ; that of Delafosse himself, with that example which he quotes and by which European officials, colonials and ethnographers would do well to benefit :

Lying and stealing are not more common amongst the blacks than amongst the other groups of mankind. . . . Each individual in an African-Negro crowd has a dual personality : he is a man and an anonymous fragment of the collective unit. . . .

African Empires and Civilisations

Ask a Negro if there are many inhabitants in his village; his first instinct would very likely be to give you the exact figure of the population, supposing that he knew it. He then reflects that the welfare or harm of the village collectively may depend on his answer; welfare, if for example you intend making a present to each inhabitant; harm, if, as is more probable, you propose taxing the village in proportion to its population; and here the collective moral sense will get the better of the inclinations of the individual moral sense. He will also think that, amongst the taboos which govern his group, and which are so numerous that none can know them all, there may be one forbidding the exact enumeration of its inhabitants, or forbidding that the number should be wrongly stated. Then, to avoid all possibility of mishap, tangible or occult, to his village or to himself, he will answer: " I do not know." If he is a Mussulman, he will extricate himself still better by saying: " Only God knows." Or else, taken unawares and not having time to find a cunning loophole, he will either tell you that there is nobody in his village, or else, that it contains so many inhabitants that they cannot be counted. In the first instance you would consider him a knave, and in the second, a liar or an imbecile. Actually, he is a frightened man who feels that he is weak in the presence of his collective conscience and of yourself.

. . . The accusation of cruelty is no better founded. Individual sentiment inclines the blacks to kindness rather than to cruelty—collective morality leads them rather into indifference.

The reactions of the blacks of the interior of Sudan on their first sight of whites can best be judged from the accounts of Mungo Park, Clapperton, Richard Lander, Caille, Barth, Richardson, and a few others who did not go forward like Stanley, " making gunpowder do the talking ": whereas all these travellers were expecting semi-barbarous conditions, they met, on the contrary—and particularly amongst the heathen populations—with lavish hospitality and sympathetic curiosity, universal and enthusiastic welcomes, and in those parts farthest removed from the track of the raids, a feeling that life was easy and genuine. . . . Who could forget Richard Lander's tone as he describes the festivals and the happiness of the people of Busa, the welcome of the king of Wuwu, or of the " king of the Black Waters " on the great island of Zangoshie, opposite Rabba, " an island of wonderfully happy peoples in the midst of enslaved Africa "—or when he is leaving the region of Kishi where a Fula tribe lived separated from their fanatical brothers of the Hausa and the Niger :

A distinct and isolated tribe, . . . their existence is passed in mutual friendliness, such as their warlike compatriots on the left bank of the Niger have never imagined. . . . The women are so modest and reserved; their conduct reveals such refinement. . . . And then their lovely eyes, black as jet, shining like diamonds, their long and lustrous lashes, the regularity of their features, their perfect figures are altogether most seductive. . . . When the time came for leaving this town, we were agreeably surprised to see our beautiful Felan visitors who knelt as they offered their morning greetings. . . . They had left their homes before dawn to bring the white traveller a parting gourd of fresh milk. This attention, following all those which we received from those lovely black-eyed girls, won our appreciation the more since we realised that it was purely disinterested on their part. . . . And when they called down the blessings of Allah on my head, I felt a tightening of my heart-strings as I thought with sorrow that I should never again see them here below. . . .

How clear, too, is Frobenius' record of his journey to the Congo in 1906 :

And on all this flourishing material civilisation there was a bloom, like the bloom on ripe fruit, both tender and lustrous; the gestures, manners and customs of a whole people, from the youngest to the oldest, alike in the families of the princes and the well-to-do and of the slaves, so naturally dignified and refined in the smallest detail. I know no northern race who can bear comparison with such a uniform level of education as is found amongst these natives.

IV

Slave-traders, fanatical Mussulmans and Arabs had already passed that way. Delafosse admits that

that thirst for plunder which, for about a hundred years, so many conquerors had slaked, making Mussulman fanaticism a pretext for their insatiable and cruel ambitions, accounts for the deplorable state in which the European occupation found so many African countries and peoples. The latter seemed debased and degenerate; they were actually only annihilated by oppression and slavery.

Frobenius is still more accurate when he adds that the first European conquistadors also had a share in the responsibility. . . .

The New Continent, [he adds] America, needed slaves. Africa had them to offer; slaves in hundreds, in thousands, in cargoloads! And yet trafficking in human beings was never easy to legalise. It was then that the Negro came to be considered as half an animal, a commodity. It was then that the word fetish was coined (from feticeiro, a Portuguese word) to symbolise an African religion. It bore the European trade-mark. I, myself, have never found fetishist ideas in any part of Negro Africa. But the idea of a barbaric Negro is an European invention which has, as a consequence, prevailed in Europe until the twentieth century.

The question of the slave-trade is treated elsewhere in this book. We have anyhow seen already a good number of times the ravages caused by the trade. Let this be said as a summary: Dr. DuBois evaluates the total number of blacks massacred in slave drives and carried off to America and elsewhere as reaching the figure of 100,000,000—in any case not under 50 or 60 million.

376

It may well be asked how it is that a great many of these peoples were not wiped out under the stress of such affliction. True, their vitality is remarkable. But often, where peoples were numerous, they were decimated ; towns which numbered thousands, hundreds of thousands of inhabitants, became mere villages or disappeared ; where at one time civilisation had spread peace and beauty, European colonists would often find a diminishing, devitalised and hand-to-mouth existence.

European colonisation has only hastened this desolation, and begun that of less affected districts. The disasters implied in the word " colonisation " are inconceivable. The whites have utterly wiped out the American (Pre-Columbus) and South Sea civilisations. The annihilation of Africa is not complete because it was begun later, and because the Negroes are more numerous, but it is on the way. Frobenius speaks justly of " those African coastal regions with the most flourishing industries which collapsed from the moment they became the theatre of the slave-trade, and in which the visitor to-day meets with little but European trash, Negroes in trousers and little black parasitic officials. . . ." This, moreover, after the passage of invading armies, punitive expeditions, the introduction of christianity, the arrival of companies for mineral and agricultural development, the spread of European customs which are directly opposed to the structure and manner of Negro civilisations. The proletarisation of millions of blacks torn away, by direct or indirect methods, from their country, the confiscation of their lands and forests, have caused the collapse of whole regions, disunited, dismembered and depopulated clans and tribes. Over and above all this, christianity made a direct attack on the harmonious collectivism of the African associations, overthrew this secular institution, and transformed its individuals into a working class the less able to resist and the easier to obtain for colonists and governments.

Delafosse, obliged in his official capacity to weigh his pronouncements, admits that " outside influence has done as much to stimulate the Negro into slipping back as into progressing, if not more. . . ." This last instance of the ruin of the African civilisations is particularly valuable :

Even in 1906 [says Frobenius] I actually found villages in the Kasai-Sankuru territories whose principal streets were lined on both sides for miles with quadruple rows of palm-trees and whose huts were all most delightful examples of plaiting and carving. Not a man but carried magnificent weapons of iron and copper, with inlaid blades and handles covered in snakeskin. On all sides, velvets and silken stuffs. Each drinking-cup, each pipe, each spoon was an object of art worthy of comparison with the productions of the romanesque style in Europe. . . . And on all of this a bloom of astounding radiance and delicacy. [And he speaks of the customs of the people, *vide supra*.] Alas! since then these ultimate " Fortunate Isles " have one and all been swamped by the tidal-waves of European civilisation, and this peaceful beauty has been carried off and swept away.
But not rare are those to whom such impressions have been vouchsafed. Explorers from the high plateaus in the hostile and bellicose wilds of the east and south and north, and penetrating into the lowlands of the Congo, lake Victoria, and the Ubanghi, men like Speke and Grant, Livingstone, Stanley, Cameron, Schweinfurth, Junker, de Brazza, all encountered the same revelation; they came from the country governed by the rigid laws of the African Mars to the land of peace and joy, that joy which is brought about by adornment and beauty. A land of old, established civilisations, civilisations in tune with those of bygone days and harmonious in style.
And was this any different in the vast Sudan? By no means. But in the 19th century a superstition still held which gave an Islamic origin to all that was great in Sudanic culture. Since then we have learnt much; to-day we know that the fine stoles and the beautiful robes of the Sudanese peoples existed before Mahomet was born, before ever an Arab of high culture had trodden ground in the heart of Africa. We have learnt that the original organisation of the Sudanic states existed long before Islam, *and that all the arts that we call scientific agriculture, educational culture, maintenance of the social order—no less than the fostering of the industries of Negro Africa*—are, there, more ancient by several thousands of years than in our own central Europe! Thus, in the Sudan itself, a warm-blooded, truly African culture. We have the right to maintain that in equatorial Africa, Europe has found *ancient and powerful civilisations full of life and freshness—has found them everywhere that Arab domination, the Hamitic race, or European civilisation have not rubbed the bloom from the once beautiful wings of the sable butterfly*. . . . *Everywhere!*

African Exploration

by ARTHUR A. SCHOMBURG

THERE is written in holy writ, " Ethiopia shall soon stretch out her hands unto God." This religious remark is oft quoted by holy and unholy men, who believe the significance has some mysterious omen or comforting application for the unfaltering believer.(1) Africa has been the cradle of human civilisation and notable achievement from as early as " the memory of man runneth not to the contrary." Africa is still considered the Dry Nurse of Lions. " The Ethiopian at Thebes named the stars of the Heavens with names we still use based on some happenings in their country. Behold the wrecks

[1] All note references at end of article.

of her metropolis, of Thebes with her hundred palaces, the parent of cities and monument of the caprice of destiny. There a people now forgotten discovered, while others were yet barbarians, the elements of the arts and sciences. A race of men now rejected from society for their *sable skin and frizzled hair*, founded on the study of the laws of nature, those civil and religious systems which still govern the universe."(2) This is a startling and inspiring picture of her great past. Yesterday, we might say, Howard Carter, an American, opened the tomb of Tut-Ankh-Amen to reveal the greatness of this particular pharaonic dynasty, satisfied his curiosity, then closed it without giving to the world all the facts connected with this Negro pharaoh. There have been ruling kings of Egypt who were black or Negroes.(3) The artistic talent of the early Egyptians descended the Nile and gave the people living on its banks the refulgent rays of a glorious sunset in which can be seen depicted their great achievements of unsurpassed beauty and enduring usefulness.

Africa has been for centuries a closed book. Here and there vestiges of some great event have filtered through and come down to us, awakening dormant human emotions at seeing the almost incredible objects brought back from the land of the Sphinx, exhibiting the delicate workmanship of its talented artisans. By degrees a beam of light, the light of history in the black continent, has come gently and softly to our vision and understanding. What Howard Carter has done in the Valley of the Kings, is just the beginning of greater unfoldings in future excavations. From the bosom of black Africa, we are to see other, greater deeds that will be called marvellous, when Ethiopia stretches out her hands unto God.

From Africa's great lakes and waterfalls mighty rivers flow in many directions to the Oceans, the Nile, Senegal, Niger, Congo and Zambesi. These rivers afforded the Portuguese, Spaniards, Dutch and English splendid opportunities to ascend their navigable waters and streams to view the panoramic landscape of the vast interior as a worthy place to grab, a prelude to plunder, loot, rapine and murder. These were the watery highways that had made it easier for travellers and explorers to ascend and penetrate within her unknown interior. Down these flowing arteries long before recorded history came civilisation by degrees to cities now buried and lost to view and imagination. However, there still remain the ruins of Memphis and the Sphinx, and the lake Meoris that received the inundations of the Nile. When the sun had already cast its rays for many centuries on the Pyramids and older temples like those of Karnac, we may recall that Europe was still veiled in darkness, its people wrapped in skins, living in caves a primitive life, using stones to drive stakes into the ground ; whilst Africa had been using native furnaces in iron-smelting, tempering steel, hardening bronze—in fact, had done beautiful work in plastic arts, weaving, curing leather, domesticating cattle. Linen and cotton goods dyed in brilliant colors were being worn by her sable people.

Much of the early teachings of geography as portrayed in maps was based on the writings of missionaries, who in their zeal for spreading the teachings of their religion, opened the roads for others of their craft to follow and thus help to build up their religious tabernacles. These institutions of learning gave us the foundations of our colleges and universities where today thousands of students enjoy in their fullness the benefits of modern education. The imagination of these men can be noted in the critical remarks made by those who have followed in exploration—here admitting a fact, there denying a description as a figment of the mind carried away by new vistas of quaint or strange customs. The description of the African people by El Bekri, who gave us *Roads and Realms* in the Arabic version (4), and the famous Spanish orientalist Pascual de Gayangos (5), are still extant in their clear and crystalline beauty for us to enjoy. Ibn Batutah was an interesting traveller whose contribution to exploration must be mentioned as laying the ground-work for later discoveries and rectifications. This man was born during the year 1303 and devoted more than twenty years to his pet schemes. Many are still doubtful of the attainments of the black people living across the Mediterranean in North Africa. Across the hot sands existed more than nineteen nations ruled by Negroes that spread themselves to three points of the compass. Most all these nations have declined and fallen except Abyssinia, which by some fortunate fate or divine interposition remains to assure us there was an Al-Negashi kingdom, one of the nineteen enumerated by Ibn Said, who was considered by Ibn Khaldun " a most diligent writer." The Abyssinians still adhere to the title of " King of Kings." At the latest coronation of their king the European crowned heads were invited to a pageantry the world had not seen for ages. After all " History repeats itself " from time to time very softly but positively.

Ibn Hankal, the geographer who wrote around the year 1067, gives a very lucid and succinct narrative of the lands of the Blacks, where a good knowledge of the highly developed intercourse with the Sudanese nations can be studied. Aba Ishak Ibrahim al-Kanemi was a learned Negro poet of the Sudan ; the Arab historian Averrhöes, who held a high office at the court of Mansour in Africa, mentions the praises

he sang to his sovereign. As late as the twelfth century the commercial and art wares of the people of the Sudan had been taken to the Mediterranean ports of Europe. " The college at Fez had no parallel in the known world for size, beauty and magnificence." (6) His description of the various black kingdoms visited gives us tangible evidence of a high culture and the customs enjoyed by these people who, centuries later, were to be called savages. Batutah writes of the kingdom of Mellé, where he found Mansa Musa, a Negro sovereign who was at the zenith of his glory and enjoyed great prestige for his wisdom and human excellencies. It is recorded that he presented to a neighboring king, Abou el Haçen, a copy of the Koran written by himself from memory, encased in several precious jewelled portfolios, the like of which had never been seen. This took place about the year 1360. Mansa Musa kept an abundance of gold dust about his place. The equivalent of more than a million dollars in our money was always on hand for needed emergencies. For twenty-five years he ruled his people and died during the year 1338 regretted and revered. Three hundred years later Ibn Khaldun writes of Musa as one of the most distinguished rulers ; his people and those of the Shonghoi dynasty were still bestowing praises on his memory. (7)

The great city of Ghana had commercial relations with the outside world. Its highways were always glutted with caravans and camels in the march of progressive business intercourse. At Terensa no home was without a cotton plantation ; the African cotton is famous the world over to this day for its wearing qualities and usefulness. They had sugar cane, bananas, plantains and pea-nuts, the oil of which was used in cooking, giving to meats, as a condiment, a delightful flavor. In 1352 Ibn Batutah travelled among the people of the kingdom of Mellé and substantiated the accuracy of Bekri's description of the town of Tegazza, the strategical key to the interior of Africa.

The theory of Ptolemy held that beyond the confines of North Africa was a blanket of sand where nothing could be found that was worth while. This information Ptolemy suggested to Aristotle and such was the early belief shared by the learned men of those days. There is no doubt the early travellers had immense difficulties going forward to unknown places and many never came back to tell the story. It was no easy matter to travel among native people who treated strangers as meddlers in their business. Herodotus, as well as Diodorus and others, has given us information of the African people which even to this day we disbelieve and treat with marked indifference and disregard. It is said that geography is the handmaid of history. An examination of the early geographical and historical records of a country will unfold to the human mind the physical aspects of the country, the habits and customs of its people, the data obtained by missionaries from the natives, the location and description of important places, all of these aiding like stepping-stones in the acquisition of a progressive knowledge and understanding of the natives.

The world owes a great meed of praise to those self-sacrificing missionaries who, while carrying forward the ministrations of their religion, left to posterity a rich legacy in their geographical and historical descriptions of the strange African continent and people. The writings of these churchmen fired the courage and imagination of subsequent explorers from whom we get many florid and descriptive papers : Barbot, Merolla and Battell on the Congo, Proyart on Loango, Adamson on Senegal, Santos on eastern Ethiopia, Mungo Park on the interior of Africa, and a host of others, some seeking information, others wealth or what not. These were soon followed by military expeditions for the opening of Africa and the exploitation of these so-called newly-discovered lands. In other words, lands discovered and peopled centuries ago, in the hands of modern military magicians with spiritual advisers, now became newly-discovered countries. Where the natives offered opposition or resistance to these potential visitors as invading their domains, the wrath of the kingly parasite turned his mind to punitive expeditions as an excuse to obtain his objective. The whole of Africa has suffered ignominiously at the hands of European nations for inexcusable reasons. The terror of oppression and injustice stalks freely in that region of the earth where armed men are a power unto themselves. There is no documentary evidence of any payment tendered for the acquisition of immense territories looted from African natives. We need not open the ulcer for public view. Can we point to any part of the dark continent where the sword has not cleansed its steel sharpness on the hide of inoffensive black men ? The memories of Khartoum, where men tied to cannons were shot to points of the compass to impress the natives with the power of might, are perpetuated in history. South Africa is nauseating with rank injustices, notwithstanding the pleadings of General Smuts in the United States of America, where learned Negroes supinely sat with him to taste bread and salt at Washington, D.C., and showed their obtuse knowledge of history. Meantime, in 1917, Editor Albert T. Marryshow of Grenada, B.W.I., took the Boer general to task in his *Cycles of Civilization* (8), that must have burned by its vitriolic onslaught against injustices. In West Africa the evils are

of long standing and the correction of them seemingly hopeless and almost unbelievable. A change will come only when the Europeans practise justice.

The so-called friendly nations, casting longing and furtive eyes on goodly portions of Africa that they desired to add to their possessions, ostensibly sent travellers, explorers, missionaries and traders as advance agents into these territories. Zones of influence having been thus established, the natives soon found themselves losing their possessions and their rights, until by secrecy and stealth and all the insidious acts of peace and of war they were bereft of their heritage.

Leo Africanus was born at Granada, Spain, a descendant of a black man of the many whom the Arabs and Moors brought there to work, where they held undisputed dominion and sway. After the defeat

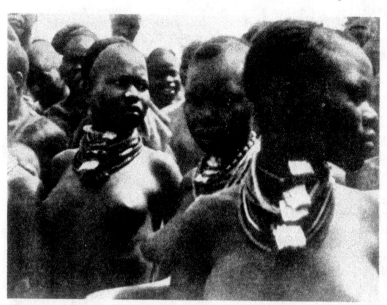

Women of Leré, Lake Chad region, Cameroon

and dispersal of the Moors the Spanish began the work of bringing them within the fold of the christian church. Africanus studied in the schools of his native Granada and took to missionary activities, travelling in North and Central Africa as far inland as Timbuctoo, Jenné and other places, where he found the natives enjoying a unique and remarkable civilisation. In his *Terras Nigritarum* he gives us a vivid description of the places and people he visited and their customs. (9) He stands in the forerank of the early explorers, and his contribution to the knowledge of those misty days cannot be denied. His description of the Sahara has not changed in any degree : " A tract of barren and dry land beginning from the Ocean on the west and extending Eastward to the salt pits of Tegazza." Back of this was Negroland, where the great Central African culture was carefully nurtured and developed. The great emporium of Ghana was visited by Eldrisi, Ibn Batutah, El Bekri, Leo Africanus and others, who have written that the city had more than twenty thousand palm and shade trees. The city of Gao was also visited by the same travellers, who in their day wrote eloquently of its African traditions and culture. The city of Mellé comes in for analysis at the hand of Leo Africanus, who states that all the cities mentioned were flourishing.

At a place called Bersana Negroes were known for centuries as great dealers in gold dust, which was the basic measure of trade. Barbarossa, who defeated the Negro ruler of Morocco, demanded a million dollars worth of gold dust, and this amount was tendered by forty Negro merchants who came to the relief of their king. (10)

Mohammed Koti, a Negro born about 1460, is credited with having been a good scholar, writer and explorer. He gave us the *Tarik-el-Fettach*, or the history of the kingdom of Ghana, Shonghoi and Timbuctoo. This work has been noted by Abderraman Es-Sadi, another Negroid individual who is credited with the Epic of the Sudan, wherein are recorded biographical sketches of a number of distinguished Negro personalities.

Vasco da Gama, the celebrated Portuguese navigator who is credited with the discovery of the Cape of Good Hope, purchased from Antonio Cabrera a Negro named Juan Lopez, who served as an attendant during his explorations. This information has been obtained from a document bearing date, Cordoba, Spain, September 15, 1510, authenticated by Rodrigo Costano, a Spanish notary.

John H. Speke engaged a native black named Mabruki, to whom he gave an inscribed medal in recognition of his unselfish devotion in guiding him in the discovery of the source of the Nile.

These historical incidents prove that the interior of Africa is not so crude and savage as we are made to believe by modern travellers who go over lands long discovered and forgotten. The Mexican authorities are finding today in desolate places, the vestiges of a great civilisation buried centuries ago to have been

African Exploration

the cradle of her primitive culture. The valley of the Aztecs of Mexico, Honduras and Costa Rica will some day give up to the world a marvellous view of their past social culture now in process of being reclaimed by the Mexicans themselves.

Mungo Park, the loving and humane explorer who was nursed back to health by female black hands with tenderness and savage charity, found nothing in the Blacks that was foreign to the human side of life, and expressed no bitterness or resentment to the people living in a primitive state. (11) Livingstone, the missionary of loving kindness, shared his sufferings with the black people he met in his travels. No instrument of punishment nor of death did these two men carry in their baggage during their explorations, but the love of mankind in their dealings with their fellow man. (12)

When Stanley reached Livingstone, this real missionary, unarmed, was carrying his message of peace, good-will and understanding to the black masses of the hinterland of the Dark Continent. This apostle could not understand the military apparel, the fanfare, hum and noise displayed by the pseudo-explorer. We know today the reason why the memory of Livingstone is revered and hallowed by those black people. When their white friend passed on to pleasanter regions, black men lifted on their shoulders the dead body, and marching across the continent, brought their charge to the sea. Nowhere in history is there recorded a greater self-sacrificing episode than the conveyance and delivery of Livingstone's body to the white people. For more than two thousand miles, two black men, Chuma and James Susi, faithful to the white friend who had done well by the black people, and sustained by unfailing devotion to his memory, toiling under the scorching equatorial sun, facing dangerous and ferocious animals, scaling hills, fording streams and crossing chasms, bore the unembalmed body of Livingstone onward to the sea, so that it might have decent burial. To them it was " a charge to have and a trust to keep."

The period just covered has been forgotten entirely. Cobwebs have covered the narratives so densely that the mind's eye fails to grasp the vision. We exult in the deeds of Henry M. Stanley, who, without any methodical preparation, rushed pell-mell into exploration to find Livingstone. Before this he was a newspaper correspondent for the *New York Herald*. Now he is acclaimed a roaring Central Africa Nimrod. (13) We cannot let Stanley pass without bringing to light the peculiar character of Tippoo Tib, who really knew the interior of Africa, worked, schemed, fought, became a slaver and was cruel; but who must be given credit as a successful native African who helped Cameron, Wissmann and Stanley to know the African primeval forests. Tippoo Tib met these men, whom he guided for a part of the journey, towards the end of the year 1876. Wissmann he escorted to the coast. Dr. Brode writes : " He was a faithful guide to Cameron, Stanley and Wissmann and had no small share in their success, though it must be admitted that his relations with these eminent explorers were not unruffled." (14) We find that Stanley renewed in 1887 his dealings with the arch-slaver, for he needed this man's services in his quest for the lost Emir. Tippoo Tib accepted this appointment on behalf of the king of the Belgians. He was not only known to the above persons but also to doctor Junker, Baron Von Bülow and others in the field of exploration. The early days of Stanley are clouded with some peculiar phases. Known as Rowlands, he changed his name to Stanley. We find him next in America as a cabin boy on a ship from England to New Orleans, La.

Few persons are acquainted with the exploits of Tippoo Tib, pre-eminently the most practical explorer that has set foot in the interior of that obscure land. Tippoo Tib was a faithful guide who had no small part in the success of the three pioneers.

The reason why Tippoo Tib is not generally known as a black man is due, in a measure, to the peculiar method of the white man's determination to look out for himself and the devil take the hindermost. He has been put down as an Arab, but the fact that his father, an Arab, married a Negro woman makes him, in the American construction of racial identity, a Negro. From this marriage sprang Hamed bin Muhammed, surnamed Tippoo Tib. A fellow explorer (15) relates an interview that in the light of present happenings is very enlightening. In this interview, Tippoo Tib foretold of the great war over divisions of African territory ; then Swann goes on to relate with intense satisfaction the capitulation of Tippoo Tib, Central Africa's greatest man-hunter, comparing it with the capitulation of Sedan !

Tippoo Tib said, " Tell Europe Stanley lies, and ask them if they have forgotten justice, as you say, to compensate me for stealing my country." " The modern work of civilisation continues to be an enormous and continual butchery." (16) When we reflect that these words were uttered in the Belgian Parliament that grips the Congo like an octopus, we are compelled to remain silent,[1] hoping some day the prophecy in the Psalms will be revealed, in all its glaring crudeness, by divine intercession.

[1] Emphatically we cannot agree on this point that silence must be maintained, or that " divine intercession " will ever have anything to do with the matter. ED.

African Exploration

Samuel Adjai Crowther, "a kidnapped slave in 1821, a rescued slave in 1822, a mission schoolboy in 1823, a baptised Christian in 1825, a college student in 1826, a teacher in 1828, a clergyman in 1843, a missionary to the country whence he had been stolen in 1845, the founder of a new mission in 1857, the first bishop in 1864." (17) Explorer of the Niger and Tshadda rivers. He wrote many works in the field of exploration and on the customs of his people. (18)

Paul Belloni du Chaillu, who gave adequate service in the annals of zoology, ethnology and geography, must be mentioned. His picturesque descriptions of the African character, and his hunt of the gorilla, place him in a very unique position. He was hailed as a conquering hero and Edwin Swift Balch has put him down as an American white man. (19) But let us quote Clodd as to the ancestry of this distinguished explorer. "A not less secure place in the affection of our little group was held by Paul Belloni du Chaillu, known only as Paul. Like more than one eminent man, he invented more than one birthplace for himself; one day it was New York, another day it was Paris, while according to the obituary notice of him in *The Times* it was New Orleans. (20) The truth is that he was born in the island of Bourbon or Réunion. His father was a Frenchman, clerk to a Gaboon trader, and his mother was a mulatto." (21)

Every nation that has entered Africa has by dishonest exploitation and rapacious acquisition robbed the natives of their rights and possessions, reducing them to serfdom and making them pariahs in their own land. Today these people cannot travel in their own country without passports and identification cards.

Just take a look at an early map of Africa by Bluew or DeLisle, it does not matter which, then take another look at the changes that have taken place in that continent, from the time of the Arabs down to 1884 in Berlin, when Over-Lords sat in judgment at the diplomatic conference to divide Africa into spheres of influence. This was the beginning of difficulties that ended in warfare and the taking over of native territories without any semblance of equity. The modern corsairs were again in power! Now

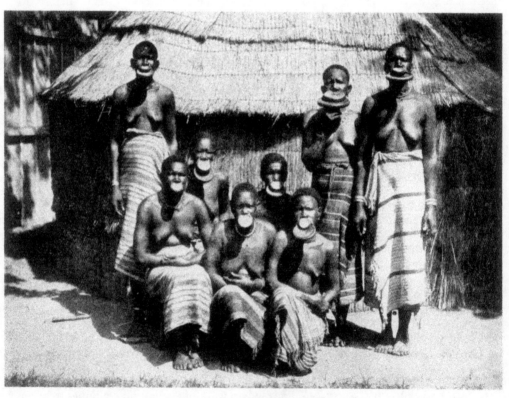

Women of a Sara tribe. Fort Archambault, Ubangi-Shari

Various reasons for the platters fixed in their lips have been given, but the exact reason of these is not established. Some say they are a sort of tribal mark, others that they were invented to render the women who wear them distasteful to the Arab raiders, hence safe from them. That at least is said to be the origin of this custom, which still prevails amongst some of the Sara people

382

look at Abyssinia, one of the original nineteen Negro nations, still pursuing her primitive ways, unmindful of the noise of the world, a sentinel of the weird forest, marking time against avaricious neighbors and untrustworthy friends. The European cataclysm does not seem to teach a moral lesson. Like the German kaiser when at the zenith of his power, the nations are after the weak in their selfish lust to rule. Let us turn back the pages of history and take to heart its bitter lessons, " for even that which you have will be taken away."

The legacy of the explorers in their various works shows a remarkable galaxy of names covering most every field of human energy. Can we find space to list each and every one? Impossible! But in a book of this nature it is fitting to bring to the fore writers such as Burton, Caillé, Denham, Barth, Lady Lugard, Felix DuBois; among Negroes, Delany and Campbell and a few others.

The Black Man's Burden is well represented in the mythological Atlas supporting on his back the world's misery. The people of the world have left their imprints on African sod, only silently stopping long enough to see the mighty ruins of the Great Zimbabwe, within the walls of Monomotapa, where they trod over disintegrating quartz and gold-bearing rocks that had given fabulous wealth to all the known nations of those days. Down on the Guinea coast England coined and named its gold the Guinea in memory of having found this precious metal there. Priceless wealth has been poured into the world from the mines of South and South-west Africa. In the days of Solomon it was the charm of the ruby; today it is the lustre of diamonds; tomorrow something more precious will evolve from nature's store-house.

REFERENCES

(1) Holy Bible, Psalm lxix, v. 31; (2) Volney's *Ruins of Empire*, N.Y. 1926, pp. 14-15; (3) Budge, E. A. U., *Egyptian Soudan, its Hist. Monum.*, Phila., Pa., v. 1, pp. 414-559; (4) El Bekri, " Roads and Realms," in *Jaubert Reçueil des Voyages et Memoirs*, v. 2; (5) Gayangos, Pascual de, *Mohammetan Dynasties in Spain*, p. 324; (6) Cooley, Wm. D., *Negroland of the Arabs*, London, 1841, p. 116; *Inner Africa Laid Open*, London, 1852; (7) Lugard, Flora, *Tropical Dependency*, London, 1905, pp. 65-75; (8) Marryshow, Albert T., *Cycles of Civilization*, Grenada, 1917; (9) Africanus, Leo, *Africae*, Elzevir, 1632; *Purchas his Pilgrimage*, London, 1613, p. 537; (10) Morgan, John, *History of Algiers*, London, 1728, p. 373; (11) Park, Mungo, *Travels in the Interior of Africa*, London, 1799; (12) Livingstone, David, *Missionary Travels in South Africa*, London; (13) Stanley, Henry M., *Darkest Africa*, N.Y., 2 vols. 4to; (14) Brode, H., *Tippoo Tib, The Story of His Career in Central Africa*, London, 1907; (15) Swann, A. J., *Fighting the Slave Hunters in Central Africa*, 1910; (16) Monsieur Lovant, *Belgian Parliament*; (17) Page, Jesse, *The Black Bishop, Samuel A. Crowther*, N.Y.; (18) Crowther, Samuel Adjai, *Journal of an Expedition up the Niger and Tshadda Rivers*, London, 1855; (19) Balch, Edwin Swift, " American Explorers of Africa," in *Geographical Review*, 1918, v. 5, p. 274; (20) *New York Times*, May 1, 1903; (21) Clodd, Edward, *Memoirs*, London, 1916, p. 71.

The Solidarity of the African Race

by PRINCE A. ADE ADEMOLA, B.A., Hons. (Cantab.)

Prince A. Ade Ademola, B.A., Hons. (Cantab.)

THE term " Solidarity " as applied to a people covers a very wide field, but as far as this article is concerned, I propose to launch out here into a very simple argument based on historical facts disclosing close blood relationship existing between the Africans as a whole, particularly between the West Africans, the Afro-West Indians and the Afro-Americans.

Today, it is a well-established fact that the indigenes of Africa and all persons of African descent who are outside Africa are of common origin just in the sense that all persons of the Caucasian stock are of common origin; but the opinion is not yet popular that these Africans, generally termed in anthropology Negroes, with varying degrees of development, are not only of common origin but also of strictly blood relation, a feature which is sure to render the solidarity of the whole of the African Race almost as impregnable as the rock of eternity.

In an essay of this sort, the scope of which is much limited by space, one should not expect a sceptic to be as satisfied as his curiosity might demand, but in order to reduce the scepticism of such readers to a minimum, I propose to go into some detail in the history.

The first point in my argument will endeavour to set out how the West African tribes have from time immemorial been closely related one with the other. It is admitted all round that

The Solidarity of the African Race

Africa is the home of the Negroes, so that any race other than the Negroes, found in Africa, may be deemed to be an alien. It is also admitted that thousands of years ago the Valley of the Nile held within its confines groups of Negroes with varying cultures, part of which had, at one time, gone to build up the ancient Egyptian civilisation, and another portion, at another time, to form what today is known as Abyssinian culture, whilst the bulk of the Negroes themselves migrated at some time either from Upper Egypt or some part of the Nile Valley to the western parts of the Sudan, where they founded various Negro kingdoms with varying cultures, whence we have the cultures of the Negro peoples of Bornu, Kano, Katsena, Songhois or Songhays, Melli, Ghana, Zaria, Gobe, Yoruba, Ashanti, Dahomey, Ivory Coast, etc., etc. Each of the above tribes is inter-related. What strikes one first is the fact that among all these tribes there are several manners, customs and institutions which are found to be in common ; such, for instance, as the custom of circumcision, the division of tribes into separate families, the strict interdiction of marriage between families too nearly related, blood sacrifices, with the sprinkling of blood upon the altars and doorposts, funeral obsequies, demoniacal possession, aboriginal religion, and such like. We find next that the kingdoms of Songhay, Bornu, Kano, Katsena, Melli and Ghana were contemporary, whilst trade and regular communications went on between these states.

We come next to the following important traditional history as related by one of the Paramount Chiefs of the Northern Provinces of Nigeria, *i.e.* His Highness Saidu, the late Native King of Jos (Seriki-n-Jos), which establishes a close kindred connection between Hausa and Yoruba, these being among the most leading communities in Nigeria. The late King when approached in 1930 on the question said, *inter alia*, that according to their Arabic historian, the ancestors of both the Yoruba and the Hausa were of the same origin. That both used to live together in the Far East, and were among the 389 Chiefs who were in the habit of sending presents to the King of Mecca. That several years later both with their respective peoples migrated together to the Sudan districts and settled since then on the respective spots where they are found today. (Vide *Nigerian Daily Telegraph* of July 4, 1930.) The above statement of the said Native King of Jos seems to have been corroborated by authorities who derive both the Hausa and the Yoruba from the same origin, viz. Upper Egypt. (*Cf.* Morel, *Nigeria*, p. 81, with Talbot, *Peoples of Southern Nigeria*, vol. i, p. 30.) But according to further research, the culture of Upper Egypt was largely responsible for that famous Negro civilisation built by the Songhois, therefore the conclusion cannot be far-fetched to assert that the Songhois, the Hausas and the Yorubas were originally of the same origin. (*Vide* C. Jean, *Les Tourey du Sud-Est : L'Air*, Paris, 1909, p. 82.)

We now come to the following very striking passage from Clapperton's writing as cited from Sultan Belo's work :

> Yarba (Yoruba) is an extensive province, containing rivers, forests, sands. . . . The inhabitants of this province, it is supposed, originated from the remnant of the tribe of Nimrod. The cause of their establishment in the West of Africa was, as it is stated, in consequence of their driving Yarrooba, son of Khatan, out of Arabia to the western coast between Egypt and Abyssinia. From that spot they advanced into the interior of Africa till they reached Yarba where they fixed their residence. On their way they left in every place they stopped at, a tribe of their own people. Thus it is supposed that all the tribes of Sudan who inhabit the mountains are originated from them as also are the inhabitants of Ya-ory. Upon the whole, the people of Yarba are nearly of the same description as those of Noofee (Nupe).

The substance of the text of the above-cited passage is supported by Joseph Thompson, Mungo Park and Prof. Frobenius. It is what Herodotus, Strabo, Pliny, Ptolemy and a host of Arab writers have stated about the Negroes and the Negroland, particularly the Sudan and the whole of the Niger Basin. This passage appears to have at once established sufficiently the blood relationship between the Yorubas, the Arabs, the Egyptians, the Abyssinians, the Bornuese, the Nupes, the Yaoris, and in short, all the various communities inhabiting the Sudan and the Niger Basin.

When we come to examine the history and traditions of the African tribes inhabiting what is now known as Southern Nigeria, we discover that all the leading tribes in this section are related. For instance, the Yorubas, which include the Egbas, the Oyos, the Ifes, the Ijeshas, the Ondos, the Lagos people, the whole of the Ekitis, the whole of the Aworis, the Popos, the Ketus, a large part of Dahomey and the Benin people, are related to the Ibos, the Sekiris, the Ibibios and the Calabarians. Moving now to Ashanti and Gold Coast, we find that in the first place, as Dr. J. S. Williams, Ph.D., D.Litt., clearly proves in his admirable work entitled *Hebrewisms of West Africa*, the Ashantis, the Jukun of Northern Nigeria and the Yorubas are so closely related to the Songhois in respect to their customs, manners and institutions that they may be said to have descended from the same origin. The Fantis are the nearest kinsmen of the Ashantis and in addition to this the Gas of Accra are Yoruba kinsmen.

384

The Solidarity of the African Race

Proceeding thence to Sierra Leone we find that in the first place about three-fourths of the Kreole population are of Yoruba descent, the remaining one-fourth having descended from either one or other of the other tribes in the Northern or Southern Provinces of Nigeria. As regards the Sierra Leonean aborigines who live in the interior of the country, latest research shows that the leading tribes among them, such as the Mendes, the Timnes, the Limbas, the Mandingoes, the Sus, etc., originally came from some part of the Sudan, bearing relation also with the tribes of the Northern Provinces of Nigeria. The case of Gambia is practically the same as that of Sierra Leone.

Generally speaking, the bulk of the members of the African Race who were transported to West Indies and America during the slave traffic was mainly West African. This is a matter of written history, and anyone who is acquainted with some of the numerous books already written in the German, French, Spanish, Portuguese and English languages, will find no difficulty in accepting this general statement about the close blood relationship between the West Africans, the Afro-Americans and the Afro-West Indians. However, I may mention here one or two specific cases to support my general statement above. Research proves that a large number of the Africans in Jamaica had been drawn from Gold Coast, particularly from Ashanti.

This is admitted by every historian. W. J. Gardner, in his *History of Jamaica*, states :

> The Negroes from the Gold Coast were known generally as Coromantyns. They were strong and active, and on this account valued by the planters. The Spanish and French colonists shunned them on account of their ferocious tendencies, but attempts to prohibit their importation to Jamaica failed.

Dr. J. S. Williams, referring to the above, succinctly put it that " the Koromantyns may undoubtedly be declared the dominant influence in evolving our Jamaica peasants of the present day," and he is in agreement with Sir Harry Johnstone and many others that though the derivation of the term Koromantyns or Coromantyns includes both Fantis and Akims with the Ashantis, the real Koromantyn type was pre-eminently an Ashanti.

It is further reported that within five years, out of 10,380 slaves imported and sold in Kingston by one leading slave-dealer, 5,724 of these were from the Gold Coast. There were also many found in Guiana.

Folklore and present-day customs in Jamaica prove the relationship more vividly. The Jamaica *Anancy* Tales are no doubt of Ashanti origin. It is called " Anansi " (spider) on the Gold Coast. There are many other similarities in customs peculiar to the peoples of the Gold Coast which are prevalent today in Jamaica, and can be easily traced back as having their origin among the peoples of the Gold Coast.

On the other hand it would seem that the greater bulk of the slaves from Nigeria were imported and sold in America. For instance, in 1857, a large number of Afro-Americans in New York, of Yoruba descent, commissioned a certain number among themselves to visit Nigeria with a view to entering into some negotiation with the Chiefs whereby they (the Afro-Americans) might effect their repatriation to Nigeria (Egba or Yoruba country in this instance), their motherland. But for space consideration, I might continue in this way to cite instance after instance from all parts of America and West Indies to prove historically this close relation between the West Africans and their brethren in West Indies and America.

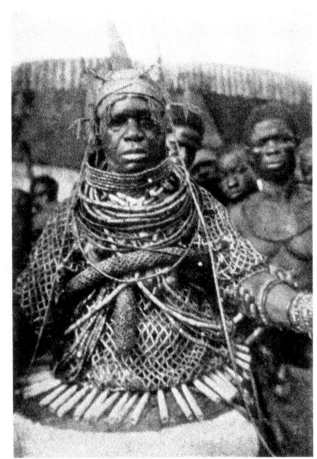

The Obba, Sovereign of Benin Edo tribe, S. Nigeria
Photo from the Trocadéro Ethnographical Museum, Paris

But West Africans are also connected historically with the Africans of South Africa, because some time in the 17th century a company of 400 West Africans found their way into South Africa and have since been absorbed in the communities of their South African brethren.

There is also some historical connection between the West Africans and the East Africans through Abyssinia and Egypt, and with this point I now bring this brief sketch on the subject to a close.

Ethiopia Today

THE MAKING OF A MODERN STATE

by GEORGE PADMORE

IT is less than ten years ago that Ethiopia suddenly emerged out of a condition of isolation. Since then, her orientation towards modernity and her relationship with the capitalist countries of the West has been so rapid, that she is today a full-fledged member of the League of Nations, and maintains embassies in such important capitals as London, Paris, Rome, Berlin and Washington.

The Emperor Haile Sillasie was the first ruler of Ethiopia to leave the mountain fastness of his country and to tour Europe in 1924. He made such a striking impression upon those with whom he came in contact, that on the occasion of his coronation on November 2, 1930, all of the leading powers of Europe and America vied with each other in showering compliments upon this last independent dark-skinned monarch of Africa.

Today, the eyes of the white world, especially England, France, Italy and America, are once more focussed on this black empire, in consequence of the recent commercial treaty between Ethiopia and Japan; an alliance which might have tremendous and far-reaching importance, not only for Ethiopia, but for all *Black Africa*.

That is why European powers with African colonies are all anxiously watching the new developments between Japan, the most aggressive imperialist state in the world today, and her new African ally.

In passing, it is worth while to note certain similarities between these two countries.

Both are among the oldest empires in the world. The Japanese claim that theirs was founded in 66 B.C. by the first Emperor Jimmu Tenno, and that the dynasty established by him still reigns up to this day.

The Ethiopians, whose history is one ranging over thousands of years, claim a line of sovereigns dating back to 4,530 B.C. In this list of over 300 rulers is included that celebrated historic character, the Queen of Sheba, from whose son by Solomon, Menelik I, the present dynasty claims direct descent.

Japan, although an industrialised capitalist country, is still politically dominated by the feudal class from whom the military caste, the real rulers of Japan, are recruited. Ethiopia, on the other hand, is essentially a feudal land, ruled over by powerful princes, known as Rases, who, like those of Japan, form the military caste, the dominant elements in the affairs of the nation. The present rulers of both countries—the Japanese " Son of Heaven " and the Ethiopian " Lion of Judea "—are more than ornamental monarchs. They are both in their respective spheres important personages, wielding such absolute power over their peoples which in Europe it would have been difficult for the Occidental mind to understand, were we not living in an age of Fascist dictatorships.

Furthermore, the Ethiopians, like the Japanese, are a proud and independent people, jealous of their national freedom and conscious of the fact that they were the first non-European peoples since the Haitian Revolution to defeat the white race at arms—the Abyssinians over Imperial Italy in 1896 ; Japan over Czarist Russia in 1905.

Last, but not least, the Ethiopians, like the Japanese, knowing that all other colored people are under the yoke of white imperialist domination, are very suspicious of the white man. This, apart from economic and political reasons to be discussed later, is an important psychological factor which must be taken into consideration in explaining the new eastward orientation in the foreign policy of Ethiopia towards Japan. However, before dealing with this aspect of the question, it is necessary to give a brief historic review of Ethiopia, and of the social and economic forces at work towards the making of a modern state.

* * * * *

With the exception of the little west coast Republic of Liberia, Ethiopia, or, to give it its more popular name, Abyssinia, is the last remaining independent black State in Africa. Even Liberia is economically

mortgaged to the Firestone Rubber Company, thanks to the machinations of Yankee dollar diplomacy.

Ethiopia lies in the north-eastern corner of the Continent, between the Italian colony of Eritrea on the north, Anglo-Egyptian Sudan on the west, Uganda and Kenya on the south, British, French and Italian Somaliland on the east. It covers an area of about 350,000 square miles, or more than one and a half times the size of France. The country is divided into a number of States, or provinces, the chief of which are : Gore, Tigre, Gondar, Donakil and Lastra in the north-east; Amhara, Gogam and Shoa in the center; Kaffa in the south and Hara in the south-east.

The geographical location of Ethiopia also plays a very important factor in influencing its foreign policy. Anyone familiar with Ethiopia and its people knows that although they might find it convenient to participate at Geneva, they will never feel quite at home. They will always have their eyes on their white neighbours, Great Britain, France and Italy. For they feel that white men who enslave black men in other parts of Africa cannot at the same time love black folks in Ethiopia. Any people in their place would be equally distrustful. This has already created much friction between Ethiopia, Great Britain and Italy.

The political structure of Ethiopian society is feudal. Each province is under a *Ras*, who holds sovereignty over minor chiefs within his principality. All the Rases in turn swear fidelity to the Emperor, whose official title is Kadowawi, *i.e.* The Power of Trinity, King of Kings.

Ethnologically, Ethiopia is a land of mixed races. Although the Ethiopians are a dark-skinned people, they are made up of a number of racial strains—Hamitic, Semitic and Negroid—reflecting social, linguistic and religious differences. According to Diodorus Siculus, " the Ethiopians conceived themselves to be of greater antiquity than any other nation ; and it is probable that, born under the sun's bath, its warmth may have ripened them earlier than other men. They suppose themselves also to be the inventors of divine worship, of festivals, of solemn assemblies, and every religious practice. They affirm that the Egyptians are one of their colonies."

The total population of Ethiopia is estimated to be between ten and thirteen million, comprising Amherics, Gallas, Danakils, Guragues, Somalis, Falashas, Shankallas and several other smaller ethnic groups, including several thousand black Jews. There are more than seventy languages spoken throughout Ethiopia, but *Amaric*, which has over 250 alphabetical characters, is the official language of the State. The Amherics, who number about 3 million, inhabit the provinces of Amhara, Gogam and Sheo, where they constitute, politically and socially, the dominant class.

*　　　　*　　　　*　　　　*

Ethiopian society, based as it is upon a feudal structure, can roughly be divided into four main classes : (1) the nobility, headed by the Emperor, the great feudal princes (Rases), military chieftains and ministers of State ; (2) the clergy, adherents of the Coptic faith, the oriental branch of the Christian Church, at the head of which is the *Abune* or Archbishop, who until a few years ago was appointed by the Patriarch of Alexandria ; (3) soldiers and free men ; and (4) slaves and serfs.

The ruling dynasty, the Rases and the clergy are exclusively Amherics. They are the only people who can read and write ; for illiteracy is widespread in Abyssinia. The Amherics, who were christians at a time when the so-called Aryans were still savages, can always be distinguished from other Abyssinians by their distinctive dress, which consists of a tight-fitting tunic with long sleeves and trousers, held tight at the ankles, made out of white cotton or silk according to the wealth and station of the individual. They also wear a long, broad-shouldered mantle held tight at the neck by a lion's mane. The wealthier ones sport patent leather shoes and broad felt sun hats, which combine to give them a rather picturesque appearance.

The poorer Amherics, however, generally go about bare-headed. The love of liberty among Amherics in general is so pronounced, that every man, rich or poor, owns a gun, which he struts around with, with the same seeming pride that a Londoner takes in his umbrella.

The other non-Christian Abyssinians, Moslems, Jews and pagans, who inhabit the Northern and Southern Provinces, wear less clothes than the Amherics and are usually armed with long, home-made knives, spears, and other primitive weapons.

Apart from the Abyssinians there are several thousand foreigners, mostly Greeks, Armenians, Arabs and East Indians, in Addis Ababa, the capital, where they conduct restaurants, cafés and shops.

Since wealth, position and power are determined by the amount of land and serfs one possesses, the Church, which has controlled over one-third of the land since the thirteenth century, and the feudal lords combine to form a mighty bulwark of reaction.

Haile Sillasie, Emperor of Ethiopia

It is against this formidable opposition that the Emperor, an enlightened monarch who favours the progressive modernisation of his country, has to carry on a struggle. These reactionaries fear that any change away from their century-old forms of life will deprive them of their unlimited power. This is a fact which critics of Ethiopia must keep in mind. That is why the task of the Emperor and his handful of progressive ministers in Addis Ababa is such a difficult one. We shall discuss some of these difficulties more concretely elsewhere.

* * *

The Emperor Menelik II, uncle of the present ruler, was the first monarch to attempt reforms. As Ras of the Province of Shoa he was proclaimed Emperor of all Ethiopia in 1889. However, at the beginning of his reign his authority did not extend very far outside of his capital, for the other Rases, each controlling large private armies, paid very little respect to his writs. His first task, therefore, was to crush the semi-independence of these provincial rulers and to consolidate and strengthen the central administration.

This was no easy job. Revolt after revolt flared up. But Menelik finally curbed the Rases and united the various provinces under a strong military dictatorship, presided over by men loyal to him.

He modernised his army, which became an effective weapon, not only in maintaining internal peace and order, but such that in 1896, at the head of 150,000 men he vanquished, with a thoroughness both devastating and complete, the Italians at the battle of *Adawa*.

Menelik died in 1913 and was succeeded by his grandson, Lij Yasu, whose reign, however, was characterised by misrule and chaos. The son of a daughter of Menelik and Ras Micehl, chief of Wallo-Gallas, a Mohammedan people, Lij Yasu had strong Pan-Islamic tendencies. This led him into constant conflict with the Amherics and his other non-Moslem subjects.

When the World War broke out, Lij Yasu began to give open political expression to his Mohammedan sympathies by intriguing with Turkey, Germany and the " Mad Mullah " of the Sudan against Great Britain. The British found a more sympathetic ally in the present Emperor, who at that time was known as *Ras Tafari*. With the aid of the British and the Entente Powers, Tafari mobilised an army among the Amherics and declared a revolt against Lij Yasu. A bloody civil war followed which cost over fifty thousand lives. The forces of the Emperor and his father were completely vanquished at Segono in 1916. Lij Yasu was captured and made a state prisoner. Since then, he has made occasional attempts to regain his throne; the last effort being in 1932, when he escaped from his custodians and started a rebellion in Gaffan across the Blue Nile, which, however, was quickly crushed by the Government forces.

After the deposition of Lij Yasu in 1916, *Waizeru Zanditu*, another daughter of Menelik II, was proclaimed Empress. She was crowned on February 11, 1917. *Tafari*, as leader of the anti-Yasu movement, was named Heir to the Throne and Regent. Eleven years afterwards, on October 7, 1928, he was proclaimed Emperor and Joint Ruler with the Empress, Zanditu, and on her death in 1930 crowned sole ruler of Ethiopia. During the lifetime of the Empress Tafari tried to make innovations, but found little support from his co-ruler, who was strongly under the influence of the reactionary elements, especially the clergy and the foreign intriguers at the Royal Court. It was only after her death that the Emperor

388

was able to launch far-reaching reforms. It was in order to acquaint himself with modern conditions that he made his European tour in 1924.

Tafari is a man of broad vision, an indefatigable worker, imbued with modern ideas, and with readiness to learn. Since his return home he has invited a number of foreign advisers and technical experts to Addis Ababa to co-operate with him.

As an agricultural country, Abyssinia is completely dependent upon the outer world for all manufactured commodities. Outside the capital, a town of about 100,000 inhabitants, all productive activities are carried on by mediaeval methods. What little cloth is made is ginned by hand, on home-made looms, operated with the feet. Agricultural implements are centuries old. Roads are mere bridle paths. The automobile, telephone, radio, electricity and other amenities which we are wont to associate with modern life are unknown outside of Addis Ababa. The truth is, Abyssinia today hardly differs from what it was thousands of years ago—a beautiful, rich plateau, varying in elevation from 5,000 to 10,000 feet, with gorgeous scenery, fertile valleys, teeming with coffee and other tropical products, and unexploited mineral resources. In short, a veritable Eldorado !

The fundamental question before enlightened Abyssinians is : How can these natural resources be developed without flooding the country with rapacious foreign capitalist exploiters, and at the same time safeguarding its national independence?

Men by far more experienced in the intricacies of imperialism and the manipulations of international finance-capital have not been able to solve this problem, except Soviet Russia, the only country with a non-capitalist economic system. Liberia and Haiti, before Ethiopia, also had to face this problem. The world knows what has been the result. These Republics, like many others, are today mortgaged to Wall Street bankers, and their rulers are mere puppets in the hands of powerful financial interests.

With all these factors in mind, the Emperor of Abyssinia is trying to steer his ship of State. The sea upon which he has embarked is a stormy one. Shoals are many and he has few competent navigators of his own upon whom to rely. Furthermore, the ubiquitous imperialist sharks, thanks to the world economic crisis, are more rapacious than ever. Whether the Ethiopian ship will arrive at its destination safely, only history will tell.

Our task here is to set forth as briefly as possible the main lines of approach which the Emperor is pursuing in effecting a change in the industrial and social reorganisation of Ethiopia. The latter is absolutely dependent upon the former. For unless the present feudal economic structure of the country is changed, slavery and serfdom, still widespread, can never be liquidated—the League of Nations' resolutions notwithstanding. Slavery as a social institution has its roots in the economic structure and can only be abolished by changing the economic system. That is why the Ethiopian experiment is of such tremendous importance for the thousands of men and women now held in bondage.

In order better to cope with the problems of reform the whole State apparatus has undergone drastic changes within recent years. This is particularly noticeable in the army ; for in a country like Abyssinia, where the provincial governors to a large extent are still semi-independent rulers, with large armed forces at their disposal, a well-disciplined centralised army, loyal and devoted to the person of the Emperor, is the only force capable of guaranteeing peace and order.

The standing army is about 100,000 men, exclusive of the feudal retainers of the various chiefs. The head of the national army is called *Fatwari*, whose function is similar to that of the Minister of War in other countries. There are many foreign military instructors in Abyssinia, most of whom are Belgians. A Frenchman, however, is in charge of the organisation of the air force.

The civil departments are headed by a council of twenty-two ministers. They are supposed to assist the Emperor, but many of these people are staunch upholders of the *ancien régime*, and as such not very enthusiastic about innovations. The Emperor is, however, gradually isolating these people, by replacing them with younger and more loyal men. Among the ministries recently instituted are : Education and Public Health, to which are attached young American Negro specialists.

An anti-slavery department has also been created under the direct supervision of the Emperor, for the purpose of gradually emancipating the slaves and adjusting them to the new social order under construction. Already a decree has been passed declaring all children of slave parents freed.

In order to avoid the danger of open revolt and possible overthrow by the reactionary elements—a danger not to be underestimated, especially when one recalls the fate of Amanhullah, King of Afghanistan— the Emperor is not only adopting the policy of " gradualism," but at the same time has sent a number of students abroad to be trained at the public expense. It is to these young men that he looks for future leadership. Most of them are studying medicine, engineering, scientific agriculture, economics and

military science in France, Italy, England and the United States. Haile Sillasie realises only too well that the future of his country depends upon the youth.

In the meanwhile, a few concessions have been given to foreign capitalists. For example, the Passo, a French company, is now working platinum mines; while an Italian company is exploiting potash deposits in the North-Eastern Province. Three Belgian companies are cultivating coffee, and a French syndicate is developing cotton.

The only railway in the country is a line running from the capital, through French Somaliland, to Jibouti, on the Gulf of Aden, Abyssinia's only outlet to the sea. It is owned by the French-Ethiopian Company, a joint-stock company formed in 1896, but the management is largely in the hands of the French. This railway is already the cause of much jealousy between Italy and France. It may one day be another " Chinese-Eastern Railway," and the cause of conflict between Abyssinia and these powers. In the meanwhile, France enjoys a monopoly of Abyssinian trade.

The official currency in Ethiopia is the Maria Theresa dollar, worth about 50 cents. A Menelik dollar of the same denomination also circulates in the country. The Bank of Abyssinia, founded in 1905 under the chairmanship of the Governor of the National Bank of Egypt, with a subscribed capital of 500,000 pounds, and 125,000 pounds paid up, has recently been taken over by the Ethiopian Government and reorganised.

* * * * *

The foreign policy of Ethiopia can be characterised by two main features: maintaining friendly relationships with all powers, especially her immediate neighbours, Great Britain, France and Italy, on the one hand, while at the same time exploiting the deep-rooted jealousies and economic contradictions among these imperialist powers.

Space prevents us from going into this subject in great detail. However, a few recent examples in the sphere of foreign relationship will suffice to prove our contention. For instance, one of the first things the Emperor did after assuming control of foreign affairs was to renew the 1906 Treaty which Menelik II had signed with Great Britain, France and Italy. According to the terms of this treaty, these powers agreed to respect the sovereignty of Ethiopia and to refrain from intervention in her internal affairs.

Another convention of the same date provides for the prohibition and regulation of the importation of arms and ammunition into Ethiopia. This is a very important treaty, for hitherto it had been the policy of those powers, interested in keeping Ethiopia internally divided, to supply the various Rases and tribal chiefs with arms, just as is being done in China today among the war lords.

Furthermore, in order to keep a watchful eye on international affairs, especially the Slave Question, which directly affects his country, the Emperor entered the League of Nations in 1923. Five years later he re-established diplomatic relationship with the United States, after an interruption of twenty years. Diplomatic relationship has also been established and commercial ties strengthened with most of the European powers.

A few years ago the Ethiopians created quite a consternation at Geneva when they accused Great Britain and Italy of violating their pledge not to enter into secret agreement to obtain dominating influence in Abyssinia complementary to each other. Italy has ambitions for colonial expansion and railroad construction in North-East Africa, while Great Britain has her eyes on the waters of the Blue Nile, which has its source in Lake Tesha, in Ethiopia. British cotton growers in the Sudan and Egypt would like to control Tesha, for, by damming it, extra water could be available for irrigation purposes.

After this exposure at the League of Nations, the Chancelleries in Rome and London denied the charge, but it was afterwards revealed that such an agreement did really exist. African suspicion against the white European powers—a thing very easily kindled—was running high in Addis Ababa, especially against the British, who were considered the greater intriguers. The Ethiopians broke off relationship with the British engineers who were negotiating for the building of the dam, and made a sharp orientation in their foreign policy towards the United States.

The Yankees were not slow in welcoming the overtures made to them. The Wall Street bankers saw good business in the project of the dam, and another opportunity of challenging their British rivals in Africa. A special Ethiopian mission went to the United States in 1928, where Hoover and the politicians in Washington were so enthusiastic that shortly afterwards a Minister Plenipotentiary was despatched to Addis Ababa. His arrival there marked the beginning of American rivalry against the Europeans for commercial privileges.

This whole series of incidents marked Ethiopia's first victory in foreign affairs. For the time being, the

Ethiopia Today

secret alliance between Great Britain and Italy for spheres of influence in Abyssinia was abandoned, and the old imperialist rivals, Great Britain and America, were again at each other's throats.

For some time things looked rather dark for the European powers in Ethiopia. Americans became the most popular foreigners in Addis Ababa. Despite all the assurances of the British that they never intended to impair the sovereignty of the country, by guaranteeing the Ethiopians special conditions, such as riparian rights, substantial rents, the building of roads, employment of native labour at high wages, etc., etc., they were unable to remove the suspicion of the blacks—a heritage of Britain's colonial policy among the darker races. Finally they had to give up the project.

In the meanwhile, the J. G. White Engineering Company of New York was able to allay the fears of the Ethiopians and to complete the preliminary terms of the contract for building the dam. The British, suffering a complete defeat, began to invoke the Anglo-Ethiopian Treaty of 1902, which, they claimed, provides that their consent is first necessary if the dam is to be constructed. The Ethiopians, however, do not seem to be much perturbed over the alleged claims of the British Foreign Office.

The Italians, realising the blunder which they made by entering into a secret alliance with Great Britain, tried to get back into the good graces of the Ethiopians. They have always been very anxious to offset the influence of the French, who enjoy a monopoly in transporting Abyssinian imports and exports over the Jibouti-Addis-Ababa railway.

Taking advantage of the coronation of the Emperor of Ethiopia in 1930, Mussolini despatched Prince Umberto, the heir to the Italian throne, and his cousin, the Duke of Abruzzi, to Addis Ababa. They, however, were not alone. England sent Prince Henry, Duke of Gloucester, third son of King George, while those countries which did not have royal emissaries, despatched high Ministers of State and foreign diplomats as their representatives.

The occasion was a real European caravan moving East. It must certainly have reminded the Ethiopians of those bygone days when their ruler, the Queen of Sheba, and her black entourage journeyed to the Court of Solomon. The Italians are the only ones who seem to have achieved any tangible results. Knowing the love which the Ethiopians have for arms, a fact no doubt emphasised by the memories of Adawa, the Italian mission brought among other gifts a five-ton tank for the Emperor. This seems to have had the desired effect; for by the time the coronation festivities came to a close, they were granted the long-desired railway concession. According to the terms of this treaty a line will be constructed from the north-eastern frontier of Ethiopia to the Italian port of Assab on the Red Sea, where special port facilities will be given to Ethiopia. More important still will be the construction of a line running parallel to the French line to Addis Ababa. This railway when completed will greatly affect the monopoly which the French now enjoy by diverting the trade of Central and Northern Ethiopia over the Italian line. Furthermore, it will open up new avenues of trade to the Italians in Ethiopia and thereby sharpen Franco-Italian economic rivalry in this part of Africa.

The latest move of Ethiopia in the sphere of foreign diplomacy is the commercial treaty recently signed with Japan. The Japanese trade delegation which visited Ethiopia in 1932 has secured a concession of 1,600,000 acres of land for the purpose of cultivating cotton and settling emigrants. The climate of Ethiopia is supposed to be more suitable for Japanese farmers than that of Manchuria with its rigorous winters. This whole commercial alliance grows out of the sharpening of the Anglo-Japanese rivalry for economic domination of the textile markets of the Far East and even East and South Africa. The Japanese capitalists are trying to free themselves from their present dependence upon America and Britain for their supplies of raw cotton. They hope to do this by developing large-scale cotton plantations in Ethiopia. It is stated in well-informed quarters that in return for this concession Japan will help in the programme of industrialising Ethiopia and the reorganising of her military forces.

The Japanese press has given much publicity to the Ethiopian-Japanese alliance, pointing out that it is in the interest of both of these colored nations to establish the closest ties against white imperialism. Because of the racial dangers involved, the European powers in Africa are watching the situation closely.

* * * * *

It is to be hoped that the Ethiopians have no illusions about the Japanese imperialists, who in their internal and external policies are quite as ruthless as the white imperialist nations. The Japanese ruling class, like all other capitalists, are no respecters of race, color or creed, although it might suit their present needs to pose as the " defenders " and " champions " of the darker races. Their record, however, has been too dramatically written in the blood of millions of Koreans and Chinese for us to have any doubts about their true character.

However, judging from the present financial difficulties of Japan—thanks to her military adventurists—

the economic bottom of the Mikado's throne might collapse before General Araki, the present military "dictator," begins to apply his doctrine of Kama, "the Royal Way," on the Ethiopians.

All this is to the future! Meanwhile, Ethiopia having definitely turned her back upon the past, is gradually reconstructing her national life, in the course of which she will undoubtedly throw much light on her great history. For already, Italian engineers engaged in road building have discovered the site of King Solomon's mines which had been lost to the world for over four thousand years.

Semper novi quid ex Africa!

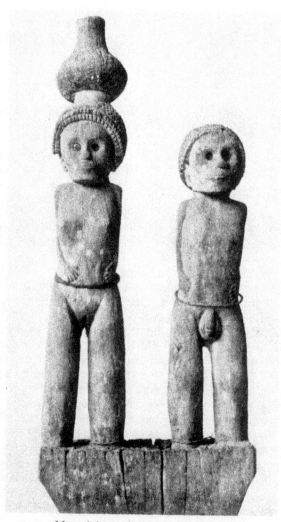

Memorial post, Sakalave, Madagascar
By courtesy of the Trocadéro Ethnographical Museum, Paris

392

Leo Frobenius

by EZRA POUND

A FEW months ago (1931), Blaise Cendrars said I was the first man who had ever mentioned Frobenius to him in conversation despite the fact that all modern Africanologues derived from le Père Frobenius. I forget how long it is since Jozef Bard first told me there was a reason to read German and for how long I have been suggesting to translators and editors the advisability of an Anglo-Saxon version of *Erlebte Erdteile*. The lack of such an edition I can only take as indication of the bestial idiocy of all American and English book manufacturers, sellers and parasites, and as a monument to the utterly unfathomable degradation and imbecility of our university system which makes no provision for works of general or of fundamental interest, and in the which system each inch-minded professor is tied either by inborn nitwit or by sly greed or self-interest or by simple veal-like inertia to mugging up secondary data about his own little line.

To the best of my knowledge there is nothing more odious in the eye of the ang-sax eddikater than a man or book showing unusual perceptive aptitude, and nothing for which it is more difficult to find a place in our stultified and stultifying system.

It is not necessary to be a bad boy and a disturber of somnolence, or that fat old male women should remember you as you were at 16. It is enough that Fenellosa should have heard of China, a subject unfamiliar to Carus, or that Frobenius should have been to Africa before there was a chair of Africanology at Hawvud to delay the reception of either for twenty or forty years.

I should also have more respect for the Afro-American intelligentzia and for the Negro millionaires, etc., that are rumoured to flourish in Harlem if they had shown more alacrity in hearing of an author who has shown their race its true charter of nobility and who has dug out of Africa tradition overlaid on tradition to set against the traditions of Europe and Asia.

" One evening in 1903 I found myself in the African primaeval forest three days from my station and ready to plunge still further. Then the luckless painter of our expedition noticed that he hadn't brought

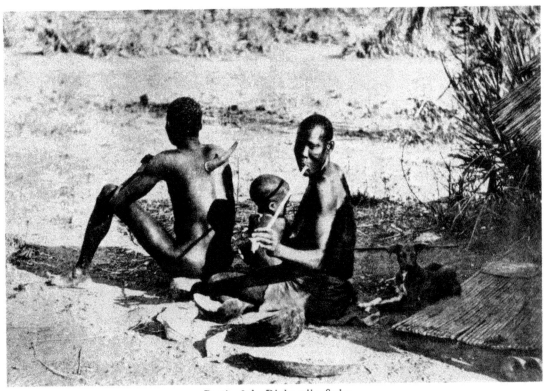

People of the Dinka tribe, Sudan

393

Leo Frobenius

enough drawing paper. We were going to the festival due to take place in two days' time. Consider how many charming sketches such an event . . . and to be held up for lack of paper ! An excess of destiny. Impossible to run back and arrive in time for the show. We were immersed in gloom. But my faithful Capita, gang-leader, laughed : ' Pack your troubles, Tata Bokka, it's easy.' He went to the local chiefling and took him to the riverbank where there was peeled tree-trunk, with one long slit down the middle, laid across a couple of blocks. This is the signal drum. The beater began Tataratata-tatatatatatata-taaa-ratatatara ! The sounding-board of the great spread forest on the other bank took it up and carried it on. An answer sounded out the distance. All received, all done in the time of lightning. The despatch read : ' Bring the box that is in Talatala's house, at the back in the left hand corner behind the door on the iron sheet. Tata Bokka needs it at once.' That night came the answer : ' The box is found ; and a man named Kadjanzi has started out to bring it to you.' Next day we had plenty of drawing paper."

Or of the wild tribes in North Togo : " They don't drum, they blow on little flutes. On these flutes they send the last news from village to village. I researched and found that these people can mention everything by its name, they can indicate every time and hour, every object, every plant, and every animal and they can indicate it as exactly with their flutes as with language."

Frobenius is full of such paragraphs.

This last he calls the most notable act of Frau Musika in Africa, and then thinks better of it and describes a drum concert.

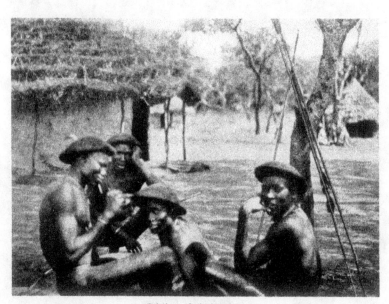

Didinga hairdressing
The admirable shapes are their own hair, a sort of thatch against sun and rain
N. Uganda
Photo by courtesy of J. H. Driberg

Klao Date

Kroo Proverbs and Parables

sent by DR. THORGUES SIE, Kroo Historian

Gbawlope nane a gipo ni ton ne a gipo ta-ton.
Alligator says: we know a friendly from an enemy canoe.

Mah nane nyengba pole wor dwe.
Sea crab says: a cripple hits but once.

Gbe nane nyon ne jele dala ti.
Dog says: you never know what you are called for.

Gbe nane nyon ne da nyon ple oh ne bra'o ne.
Dog says: one has never called a person and then beaten him.

Poli nane kwigle sa nyon de kwa.
Hunter says: darkness robs one of one's rights.

Biyo nane tane nan nè china won ne ko ne nan ne nyuno won.
Army general says: at the place where one drinks sweet there shall one drink blood.

Gilo nane nyenfoe gla oh te maton.
The sea says: a great man settles his affairs at midnight.

Wiefoe daka nane si meen ne je na dia ju.
Old path says: if you don't die you'll see your brother again.

Dene bleebo nan nyon jea wleyo siwe je.
What a traveller has seen an old man has not yet seen.

Nyon ne po nyon kie ple oh ne dalo ki.
A man who has enslaved another man, do not call him a slave.

Brow tron lo, eta ne a ne won oh gike.
The world is too large, that's why we do not hear everything.

Si gie kon ne wro na nu.
If you have no eye then use your heart.

Ewe Proverbs

contributed by R. C. NATHANIELS

African Composer and Historian

Atsu koe ano'fe Tse nadeagbo.
Atsu must needs remain at home for Tse to go and return.
(Atsu and Tse are names given to male twins in Eweland.)
(Twins in Eweland are known to do things inseparably, but necessity demands one to be left behind. Lit. Necessity compels.)

Amegãkunò la kpoe tso zi ne.
The walking stick is the errand boy of the miserly old man.
(Lit. A miser would scarcely pay for the services of anyone.)

A fediavu be, yeduame de nyaxoxowo nu.
I have retaliated for past offences, says an ill-famed house.
(Lit. Tit for tat.)

Adetagbatsutsu be, xexea le ngo gale megbe.
The world is forward and backward, says the gnat.

Ewe Proverbs

Amesi du akpe la alofa méga sonu ne o.
One who has seen a thousand cannot be satisfied with a hundred.

Avé no togbo medzea to nu o.
The forest next to the mountain does not please the mountain.
(Lit. A great man does not like to be obscured by surroundings.)

Afi be, veve wotsone wodea dogbo.
Little by little and then into the hole, says the mouse.

Amedoko la dzme lãe.
The poor are salted meat.

Amekunya menyea avatso o.
News of death is never untrue.

Ade metoa fu o.
The tongue has no bone.

Adegblefetsu be, yemele asiadeke kasa o.
I am not beside any finger, says the thumb.

Adanu mele xoxo me o.
Advice comes not from the aged.

Agbeli be, yeve ame nu yemexo akpe o.
I have no gratitude from man, says the cassava.

(Cassava—a fleshy, tuberous-rooted plant which yields the greatest portion of the native's daily food and is less esteemed than the yam. Lit. To be ungrateful.)

Ahõne be, duna yewotsia dzona.
To him who feeds me shall I render help in putting out a fire, says the pigeon.
(Lit. To do a good turn.)

Ahedo menyõ na o.
The work of the poor is hardly known.

Avatso kala be, yefe adasi le ablotsi.
My witness is in Europe, says the liar.

Dobu mednanu dobu doatsi o.
One stomach cannot suffer flatulence for another.

Dàfèdé be, kunu meno umeko dã o.
The responsibility of a funeral is not perpetual, says the stray snake.

Dunyo mesea gbãgbã o.
A nicely built city never resists destruction.

Dzrovi nkugã mekponu wua afeto o.
The sharp-eyed stranger cannot surpass the landlord in seeing.

Dzogbe dzoki ǵblobe, dinu mesea amenu dina o.
Curses take no time to act, says the antelope.

Dzogbenyiẽ menye avo wonye si nanotatam agano dedem di o.
Good luck is not like a cloth which you can put on and off like a cover.

Deke makpo ye ahosi zu afeno.
The consequence of having none makes the widow a mistress.

Gbeadewo võ yenye gbeadewonyo.
The worst of some days is the best of others.

Kòkò megbe afeade me o.
Mockery is unavoidable in any house.

Ewe Proverbs

Kudidi menye kuku o.
Being thin is not dying.

Hatsekaka hea avuwowo ve.
Much joking brings on quarrelling.

Hotsuito fe kulefe adatsi le mo safui le asi.
At the funeral of a rich man you find tears in the eyes and keys in the hands.

Xolõ dze matekpo la avlie.
An untested friendship is like a ditch.

Lã asike legbe meflo dzo o.
A long-tailed animal should not attempt to jump over a fire.

Movitoe fami zietõ.
He who is stupid tramples thrice on excrement.

Mègbé mekponu o xexe le vuwome.
One cannot see behind one's back, the earth is behind it.

Médoa tefe wodo hehe o.
At the critical point it is useless to sob.

Mègatso kododo gbã yeve xoe o.
Do not impoverish yourself by putting a roof on a *fetish* house.
(To put a roof on a *fetish* house means a lot of expense. Funds are collected from various members of the particular *fetish* where
 this work is to be done—usually over-collected; the balance becomes the property of the *fetish* man who undertakes the roofing.
 Lit. Don't invent unnecessary tasks for your own needs.)

Ne da duwò la nasi voklui.
If a snake has bitten you, be afraid of a worm.

Ne ese dzalõo, ekema ase xedenyuiè hã.
If you hear welcome you will also hear goodbye.

Ne to mesee oa, nku mele ekpokpo dzige o.
If the ears do not hear the eyes will not be inclined to see.

Ne exo he le devi sila, tso ati ne.
If you take away a knife from a child give it a stick.

Nusi le wònume la, towoe.
What you have in your mouth is yours.

Nuyie no adu nuti hafi adu dzea deka.
It is the lip that helps to adorn the teeth.
(Lit. Manners make perfect.)

Nyà gã madze kple fia.
Mighty words cannot be hewn with an adze.

Ndi menyona ne ame wokoa nu o.
One should not be optimistic about his luck in the morning.

Sese mẽ vlia ho kple nunya o.
Might cannot fight against wealth and wisdom.

Tababla la afee wòtsona.
The manner of the tying up of the head is acquired in one's own home.
(Lit. Good example is taught at home.)

Ta kple agbae nye fu na ko.
The head and the load are the troubles of the neck.

Tso to vo hafi nayo lo fenu adzu.
Until you have crossed the river don't insult the alligator's mouth.
(Lit. Safety first.)

Vu meno Ablotsi wo doa nù denú o.
One should not be too hopeful of a ship sailing from Europe.
(Lit. Don't live too much on your hopes.)

Ewe Proverbs

Wo léadu de ta hã wonoa zi.
Even when toothache is felt in the head one can smoke a pipe.

Wome doa to tso ga koa ko dedzi o.
You cannot cross a river with your chest above the water.
(Lit. If you are in difficulties you have to face them.)

Wome ksa afexo yagbãa agblexoe o.
A dwelling-house should not be unroofed to roof an out-house.
(Lit. Take care of yourself before others.)

Wòwó gbõgbõgbõ menye nusẽ o.
Shouting furiously is not strength.

Yiyi be, esi ye gblonya yeme yo amadeke nko o la, yata ye me xoha o.
Speaking generally, mentioning no names, keeps me out of trouble, says the spider.

Ewe Riddles

Two men are racing, neither can outdistance the other.
Answer—The feet.

My father has bought me a large loin cloth which I cannot roll up.
Answer—Road.

I have vacated my palace to dwell in a bunk.
Answer—Grave.

A short woman who suddenly leaps into water.
Answer—Egg.

The grandfather with three plaits of hair.
Answer—Native cooking-stove.

Hũ, Hũ, Hũ (H'm, H'm, H'm).
Answer—Secret thoughts.

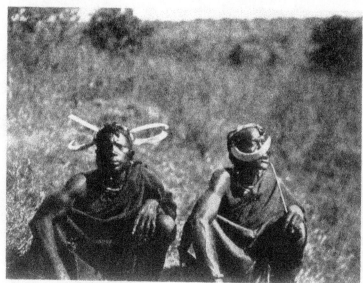

Luo men with hippo teeth head-dress, Uganda
Photo by courtesy of J. H. Driberg

398

A Letter about Arusha

from NORMAN DOUGLAS

(Norman Douglas went to Tanganyka a few years ago, for several weeks, it may have been months. Remembering this I asked him if he would not write his impressions of the natives for this book. He sent me these excellent photographs taken by himself and wrote exactly what follows. ED.)

<div align="right">

FLORENCE,
22 *September*, 1931.

</div>

DEAREST NANCY—

You know I would sell my last shirt to oblige you. Going shirtless—yes, and with joy!—for the rest of my life is a trifle in comparison with what you are expecting me to do.

Just glance, please, over the enclosed letter and then return it to me. You will see that it is dated 24 April, 1925, and addressed to me by a publishing firm of the highest standing on both sides of the Atlantic. They make a seductive offer: for a book dealing with my African experiences they will pay £100 advance for the U.S. and Canadian rights on account of a 15% royalty. What is better: they offer to pay between fifty and seventy-five pounds per article for a previous serialization of the same book in their Magazine. Now, if they printed ten of these articles, I should already have about £600 in hand; to say nothing of the American Edition of the book and, simultaneously, the English one, for which I should receive at least as much again. Quite a tempting proposition, don't you think? Especially as I was so hard up at the time that I went out there on borrowed money.

And yet I never wrote a line for them; not a single line. It could not be done. I was caught up on arrival at Arusha in the English set. Impossible, under those conditions, to learn anything new about the natives at first hand.[1] You are shut out from them; particularly if you know not a word of Swahili yourself.

That was my mistake. I should have left my countrymen alone, and picked up at Mombasa or Zanzibar a native guide familiar with the country and with the English language. Such people are to be found, if one looks for them. I should have avoided all intercourse with white officials—when wanted, they can always be found; I should have camped out, and got my guide to initiate me into the life of the native population. Then one could have learnt something.

Well, it has been a lesson, and that is why I can tell you nothing more about the natives in those parts than what you know yourself, namely, that the Masai is a fine fellow who plasters his hair and body with mutton-fat and brown ochre, eats a whole sheep at a sitting (if he can get it), and is bored to death just now because the English discourage him from indulging in his old amusements of cattle-raiding and fighting. I think I sent you the photo of a Masai girl loaded with bangles. These are made out of our telegraph and telephone wires, of which they cut down a mile or two and then manufacture into such ornaments to the disgust, obviously, of the British postal authorities. Another of these girls refused to be photographed—did I send you that one?—and threw herself on the ground head downwards.

You have the picture of an Arusha boy in his post-circumcision finery; there is a bow in his hand; he is after birds. We took a fancy to each other and should have got on swimmingly if—if I had known a word of his language. As it was, I had to rely on the interpreting of my friend. One thing of interest I learnt from this boy: he declared that they had no God of any kind, neither great nor small. He was positive on this point. The idea of adoring some divine being struck him as comical. That was a good beginning, I thought, if these people were ever to develop a national state of their own; one handicap the less. You would also like the Wagogos whom I saw at Dodoma. The men wear bells or some other coquettish tinkling instrument on their ankles.

And that is absolutely all I can tell you. Please don't be annoyed with me; nobody can be more annoyed with me than I myself am. You will see more charming people—natives, I mean—in the market-place of Arusha than you can see in Europe in a week of Sundays, and if I had learnt Swahili and not tangled myself up in the white set I could have had endless fun and discovered something worth telling you. What do you say to going there together one of these days?

<div align="right">

Ever your loving
UNCLE NORMAN.

</div>

P.S.—I can *invent*, of course, if that is of any use to you. You would be interested, for instance, in the Bimbokulos, one of the most remarkable tribes I came across. When a Bimbokulo woman wants to have a child she wanders about the jungle till she finds a nest of the giant python, which grows to a length of two or three hundred feet out there. She collects the eggs, takes them home, and sits on them till they are hatched. The young serpents are then cooked in an infusion made from the leaves of the mig-

[1] See further on, section IX of Raymond Michelet's *The White Man is Killing Africa*, quoting Georges Simenon on the British in Khartoum.

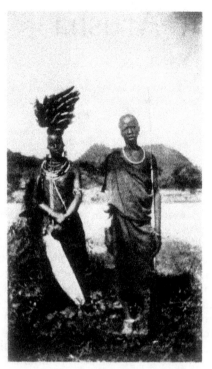

Masai people, British East Africa
Photographed by Norman Douglas

Masai girl, British East Africa
Photographed by Norman Douglas

Masai girl, British East Africa
Photographed by Norman Douglas

*Masai girl, her face hidden in fear of the
camera*
Photographed by Norman Douglas

wamba shrub, and the husband must eat them at sunset. This is regarded as a certain cure for infecundity, which, as you know, is always the man's fault.

There is also a little-known cannibal tribe living on the shores of Lake Wyami; they deserve to be studied by some competent ethnologist. They call themselves Wallawapuplas, or "the festive ones," and are universally feared for their ferocity. I lived with them for four years and seven months and experienced nothing but kindness from young and old; their reputation for cruelty is much exaggerated. Though they file their teeth and smear their faces with white chalk like other cannibals, they devour only children, and them only on the "festive" day—the first Monday of every month. They have also certain polite aspirations; those singing contests, I mean, which are held on that same occasion. They take place at night to the accompaniment (sometimes) of a flageolet called mbuma; a committee of experienced singers decides on the merits of the performers. Whoever gains the approval of this committee with some original and well-modulated song about love or war is presented with three young girls or one freshly slaughtered baby—according to choice. Bad singers are punished by having their fingers cut off, one for each wrong note. It is rare, among the Wallawapuplas, to meet a man with all the ten fingers of his hands complete. But what exquisite voices!

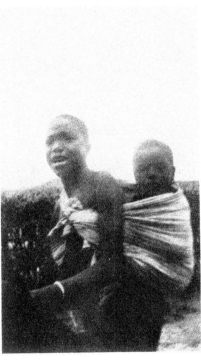

Wagogo woman and child, Tanganyka
Photographed by Norman Douglas

Boy of Arusha in circumcision dress, Tanganyka
Photographed by Norman Douglas

"Clicking" in the Zulu Tongue

by A. V. LESTER

THE Zulu language is one of the most beautiful of all the Native African languages, soft and full of vowel sounds, it is entrancing to the ear when spoken in the deep musical Zulu voice. It is not very easy to learn, because of the curious clicking sounds of the C, Q and X.

First there is the simple click, a dental click of the tongue against the teeth, as in "Caca" (be plain); aspirated as in "Chacha" (cover); hard liquid as in "Gcagca" (dance); and soft liquid as in "Gcoba" (anoint).

" Cwancka," meaning to toast over the fire or burn at the stake, gives us an insight into some of the old Zulu customs. Shaka, a powerful chief, had a great number of his mother's clan, the Elangeni, impaled on a circle of sharpened stakes, the stakes entering the anus and passing through the body up to the neck; the victims were then roasted over fires lighted beneath them.

Q represents the palatal click as in " Qalaza " " (to stare about) ; " Qhalaza " (to behave impudently) ; " Isiqala " (a cow with little milk); and the liquid sounding " Igqhalashu " (a mongoose) and " Isigawazi Sabatonto " (a stabber of tender ones). This is a common appellation for a warrior who has killed a great many women.

" V Guqabadele " is a kind of " isibongo " or praise-name given to the U Nkulunkulu (God of the Missionaries). Literally the name means " He who is knelt down to in supplication and they receive their desire."

X represents the lateral click of which " U Kuti Xa " (spread apart) gives the simple example.

" Ingxabano " (a quarrel), the soft liquid sound.

The deep throat lisp " Dheula " (pass), which can best be represented by the word " smoothly " in English. " Inthlala " (duck) has a similar sound, but flatter.

" Isulubezi " (bad luck) has at least a pleasant-sounding name, and " Impubumpubu " a more musical one than its English equivalent " Great lazy lout."

The Zulus express themselves with great dignity and a rather elaborate grace which is sometimes curiously Elizabethan. They will say " Kanti igcibo yini loco? " meaning " Does that then, think you, look nice? "

The frequent use of such a term as " Li govu isi hangahanga " applied to a loose-charactered young woman who is not content with only one young man is significant.

A Zulu Wedding at a Zulu Kraal
near Durban, Natal

by E. KOHN

OUR ship, the *Edinburgh Castle*, was lying in Durban port and we landed to go and play our habitual cricket match, stewards *v.* firemen and sailors. Some 60 of us went ashore to the usual cricket field about 2 miles outside of Durban, well supplied with ale and ship's rum. As we got near we saw a large crowd in a circle and were informed it was a Zulu wedding going on. 200 of them, men, women and children, and on one side a big red fire roasting a whole half-cow. The Zulus were performing different dances with their tam-tam music for half an hour or so, but we had missed the beginning of the feast. Now we saw a small procession advancing ; the bride and bridegroom and their respective families. The Zulu chief sat on a high wagon on top of some hides, with plenty of pineapples, bananas and mealies (maize) behind him, and in a corner in a big heap.

The procession entered the circle and we could now distinguish the bride and bridegroom. Both were nearly naked, as is the native custom ; only a small ribbon covering their loins. Wound round her head she had some flowers flowing down over her breast and shoulders. In his hand he held a bamboo cane. The chief addressed them for about ten minutes and then all the Zulus commenced shouting wildly. The couple went to the middle of the circle and the bride knelt down on one knee, whereupon the groom lifted his cane and struck her three times, in symbol of his authority. Pretty strong blows, but she did not flinch. Then she got up and they went together all round the circle and stopped before the chief and made their reverences to him, then squatted down amongst their kinsfolk.

More dances now took place and the roasted cow was brought on. They put banana leaves on the ground and began to cut the meat, a large piece being handed all round the circle, 5 or 6 Zulus eating from the same portion, as is their custom. This marked the end of the wedding.

We were told that the first two nights the groom must sleep in the same tent, but that there are two

A Zulu Wedding at a Zulu Kraal near Durban, Natal

women keeping watch to teach him abstinence. The third day he receives the key of happiness, and not before then can he open the apron, which is worn by every woman.

A father who has many daughters is considered a rich man, because he gets 10 cows for each one when she marries. The young Zulu goes for 6 months or so coaling the ships and saves the money to buy the 10 cows. Once married he goes hunting with his fellows and it is the women that do all the work in the fields and in the house, so we were told. On this occasion the Zulu boys got drunk because we gave them nearly all the drink we had brought with us.

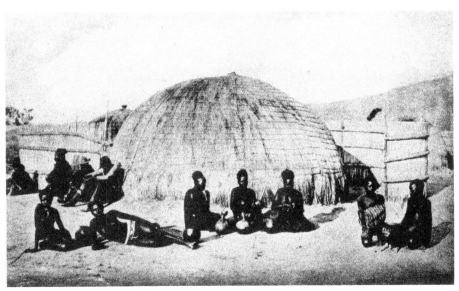

A Zulu Kraal, South Africa

From an African Notebook

by WILLIAM PLOMER

Observation

" I speak of Africa," says a character in Shakespeare, " and golden joys." But the two don't always go together.

Missions to the Heathen

Some Portuguese sailors in Elizabethan days were delighted, on landing in East Africa, near what is now Lourenço Marques, to find a gibbet with putrefying human remains, for they declared that then they knew somebody had been there before them, and had planted in that desolate place the *banner of Christ*.

Epigram

One may perhaps be forgiven for recording yet once more the famous remark of a Bantu intellectual to his white overlords : " When you came, sir, you brought the Bible and we had the land; now you have the land and we have the Bible."

Advertisement

In a South African agricultural journal there appeared the following advertisement :

Wanted, capable all-round white assistant understand cattle, handle niggers. Live in. £3 all found. Drunks save stamps.

It is perhaps worth pointing out that cattle require *understanding*, niggers, only *control*. The last sentence I take to mean that drunks may save themselves the trouble of applying for the position. One is left to wonder whether it is better to be an unemployed drunk or an all-round white expert in bovine psychology and the oppression of a subject race.

From an African Notebook

NICKNAMES

It is well known that the natives have an extraordinary gift for bestowing apt nicknames on their masters. A pompous local commissioner, on assuming his position, ordered the natives to call him *Ingolwana* (= the great lion), but after that they always spoke of him as *Inkonyana* (= the little calf). The Europeans resent their nicknames, and try and avenge themselves by giving the natives humiliating nicknames in return, such as Trousers, Sixpence, Jerry or Cascara. These names are apt to stick, and even to appear in official documents. One of the grandest and most dignified-looking men I ever saw was a Zulu known as Teaspoon. Even with this ridiculous name he remained more impressive than his white master, a Dutchman called Jacobus Ludovicus Stephanus Katzenellenbogen.

THE THREE MODJADJIS

Modjadji, first chieftainess of the Bakwebo tribe, was appointed by her father, who feared that his sons would quarrel over the chieftainship. She was famous throughout South Africa for her rainmaking powers. Even the Zulus came and asked for rain, bringing six girls and a tusk of ivory as an offering. Dying in 1830, she was succeeded by her daughter Modjadji II, who had her own ideas of government. She divided her country among a number of petty chiefs from whom she levied tribute. Each chief had to give her his eldest daughter. The children of these she called her own. She herself lived in polyandry with her councillors. In 1888 her country began to be occupied by the Boers, whom she attacked. When it was necessary for her to treat with white people she refused to appear and her sister took her place, pretending to be Modjadji herself. After her death she was succeeded by Modjadji III, who is still living and makes neither rain nor trouble. Thus in three generations a race that commanded the elements has learnt to obey the colonials.

COMMENT

When I wrote a novel about Africa somebody wrote to me: " On reading your novel I said, An artist catches an effect where tedious people only catch malaria. I always thought Africa was a place where you played tennis and bridge in the intervals of pushing Kaffirs off the pavement. Now I know it."

FIVE TO ONE

The natives in South Africa, who outnumber the whites by five to one, could long ago have regained control of their country if they were capable of working together. But unfortunately it has nearly always happened that when one Bantu attains a position where he could use power for the benefit of his race he is either pulled down by the jealousy and faction of his fellow-countrymen or abuses the power he has obtained, for the sake of fraud or tyranny or excess. This is one of the strongest arguments against the emancipation of the South African native, and is all too firmly based on facts.

IN A LETTER FROM A WHITE WOMAN IN SOUTH AFRICA

" I have come to the conclusion that the treatment of the natives by the whites of this country is entirely a fear complex handed down from father to son. The people who came to this country were of the working classes of a century ago. They had not led at all a sheltered life in England or wherever else they came from, then they landed in a wild and difficult country, and wresting the land from its aboriginal inhabitants (who naturally resisted them violently) thay at last settled, but were continually obsessed by the fear of being murdered, for their consciences were guilty. Intermarriage with other settlers—low and uncivilised Dutch, Scotch, English, German, Portuguese or others—has continued the obsession. Hence this perpetual brutality in thought and deed. But an explanation is not necessarily an excuse."

TRADE FOLLOWS THE FLAG

Many years ago some Scotch traders took their waggons into a part of the South African hinterland where the natives knew nothing of our civilisation. These natives had plenty of cattle which the Scotchmen wanted, and which they managed to get away from them—a mouth organ for a calf, and so on. But worst of all, they told them that buckshot was seeds, and that if they planted these seeds cooking-pots would grow from them, just like pumpkins. The natives trusted them, and lost most of their wealth for a handful of buckshot. If this story is not true, it is just as terrible as if it were, for it is figuratively true.

From an African Notebook

THEOLOGY

When I was a trader in Zululand I was expected to sell JENSEN'S GENUINE HIPPO FAT. This commodity looked like lard, was put up by a local Norwegian, and sold for a shilling a bottle. There were also JENSEN'S BLUE WONDERS, which, so the label testified in Zulu, were indispensable to both young and old. Pills as large as peas and the colour of gunmetal, they were not merely a powerful, but an infallible aphrodisiac. Jensen used the profits of his business to maintain his son at a theological seminary in Oslo.

ZULU

Bishop Colenso, the best authority on the Zulu language, and no mean linguist, admired it greatly, and said that the most subtle and complex ideas could be expressed in it. It is not difficult to learn, logical, sonorous, and as pleasing to the palate as it is to the ear. It is a tongue formed by a race that has known something of the art of living, which includes both discipline and pleasure.

CONCLUSION

The age of credulity on the part of the South African native is now almost over, but there is little evidence that the future will be any better than the past. Meanwhile disillusion by itself is found to be a poor food, like a diet of nothing but bitter aloes.

The Young Race of the Veld

by BEATRICE HASTINGS

A SOUTH AFRICAN dust-storm . . . the desert in the air, whirling in gigantic, roaring waves over the houses and down the hill to the sea . . . to where I knew the sea was, for, on fine days, we could see it from our balcony, and Johanna, black Johanna, often took us there for picnics, with a kettle and sandwiches and cookies. But today, you can't see the sea, and Johanna is carrying me huddled against her breast, fighting her way up steep Leather Lane to get home. I know Leather Lane, I have often been there. It is a cut in the green hill at the back of our house; I used to think it was a grand house, but really it was a cheapish one which my father had bought when the great wool crisis was on, and he had brought back the family there from London where I had been born. And we hadn't many servants, only old Sarah and Johanna and Klein the boy. Johanna was mine . . . she washed me, adored me and sometimes smacked me, but not to hurt. She took me for walks, and we often stopped a minute in Leather Lane in one or other of the weeny houses where the black people lived. I already knew that it was better not to mention these visits at home. Not that my people didn't like the black people. My father, especially, was a friend of theirs and said so, and he had to say "Saka bona!" ever so many times when we were out walking and met Tom or Jan or Klas or old Daddy Dreams, and they said "Saka bona, Inkoos!" and put their right hands up in the air and laughed joyously. Once, much later, at the funeral of a Great Man in the town, father went right behind and walked with the natives, and this made the other whites rather angry, but no-one dared say anything. It was my father who had explained to me that the Devil who was Black and lived in a Hole was not a Kaffir! Johanna had explained to me that, as the weeny houses were smelly, I had better not say that she took me in; this secret was a great bond between us. I smelled the smell, but I liked going in. It was so quiet and mysterious, and the old Mammies talked about the Cockspur Mountain and rolled their eyes and said that Africa went up and up and up-country where there were deserts and forests and swamps and chains and slaves and ghosts, weeping ghosts.

Today, as we bang in and bang the door behind us, it is not quiet. The room is crowded, and it is dark. But I see the man's hands clenched in the air and his face on fire and his eyes, enormous, blazing. He goes on speaking, so fast, so low, so loud, like water running, like iron hammers, tang, tang, tang! The wind roars, but he roars too. He talks Kaffir. I don't know a word . . . and I understand everything. We are up up up-country, in the desert, in the swamps, in the forests. Bang! goes the chain, flewooo the whips, crackkk! The people rush and scream—we all rush and scream—and bleed and die and get up again and fight, and the night comes and the ghosts come and weep in the forest. The man is singing now, and Johanna's and everybody's eyes roll like fiery balls. Every time he stops, we shout

405

something. He looks around and asks a sharp question. And I feel what it means . . . *how long?* How long are we going to bear this? I feel that we all hate, and are bursting. The weeny house is too small and smelly, we'll smash it down. And we have been whipped and are all sore. We won't bear it, won't. Johanna picks me up and I lay my head on her neck . . . so excited, so sleepy.

After boarding-school in England, I am back. Under some flowering oleanders, old Mammies sit crooning together. Suddenly, one shoots up like an aged bacchante and rushes at me, dancing and crying, " Miss Bee, Miss Bee ! The Swart-oche kent ! " (The Dark-eyed child).

I don't know old Sarah, but she knows her baby again.

The Africans have prodigious memories. I saw a man who had been groom to my father twenty-five years before recognise him at an up-country inn ; and he had gone grey. Baas John ! And not a moment's hesitation. This memory serves for other sorts of things, not such pretty ones, either. . . .

Johanna was gone. I the old magic remained in the text-book of colonial regions, I thrilled and fled alive with old horrors and in the weeny houses. My thought I was mad. So wretched society. There the house. She spent a once when I was ill. And I an angry word, a wicked, Johanna, I have repented Unknown, who once lent venture had left me tem- don't think that I was born was careless and lost your have I not wished I

Our town, on the whole, the natives. They came to us, worked when they groups with their blankets and chatted in their wonder- flowing over boulders into whites would have shone of physical poise and for women were far wilder than girls stir the men to fury, the high road outside the women will count as they obeyed the men are

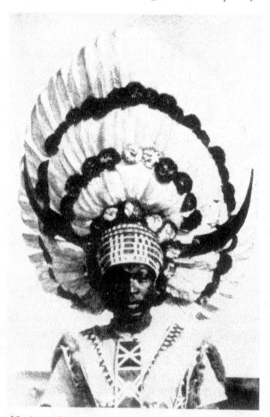

Native of Natal in ceremonial head-dress, South Africa

never saw her again. But me. At day-school, when history mentioned certain in my mind over vast spaces revolt. But I went no more girl-friends would have corrupt we become in this came another Johanna in heartful of devotion on me shot her dead one day with contemptuous word. that many times ! And you, me a suit-case when Ad- porarily down and out . . . mean never to return it ! I address : but how often had it ?

was progressive towards and went freely, lived close pleased, stood in dignified thrown over the shoulder, ful language like water deep pools. No group of beside them for splendour distinguished manner. The the men. I have seen young dancing and leaping along town. In future revolt, the leaders ; the old days when gone.

The white man's chance of peace with the natives is also gone, thrown away by a generation corrupted by usury, gambling, extortion and tyranny. Some years ago, I looked around the world for a peaceful spot to go and finish my days in. The old town ! The same week, the cables told of the massacre in the Market Place—that old Market Place !—of many natives who had come down from the Kraal to protest against the arrest of one of their best-loved headmen. Slaughtered for a gesture of nobility ! It made me sick to read of. Ah, Leather Lane—gone now, the " niggers " have been chased far outside the town— ah ! the whips and the ghosts weeping at night in the forest. No need to go so far away . . . the whips are in the farmers' hands, they may flog with impunity. They may flog the sons of those men who once were at least so happy as not to know the whip. . . .

A group of them came over the veld against the falling sun and stood around the train. I threw out an orange which one caught. He peeled it, and I expected to see him eat it. No. He quartered it and handed a quarter to each of his comrades, and they all accepted their share as quite the natural thing. Communists born and bred.

But, even at the best of South African times, even then, the star of liberty, the star with the five points, the Makara star of regeneration, old as the human world . . . that star was working over the

The Young Race of the Veld

Leather Lanes of the country. Nothing but complete liberty will ever satisfy the young race to whom the Land belongs by right.

" Anybody never give Charlie skoff." I looked at him stirring his pot of mealies over the fire in the hotel yard. A Pondo boy, lured from his home to the mining districts, and heart-broken with nostalgia. He added, in conscience—" You give Charlie skoff (food). Charlie not forget." We often had a chin, Charlie and I. We talked mostly revolution. " And one day, we throw all these houses into the sea."

They have stuck up so many of these houses, these blatant Town Halls, " built at a cost of " (each town trying to go a pound or two, or a thousand, better than its neighbour), these colleges for the ruination of all originality, these ghastly monuments, these banks and buildings stark out of old, lunatic Babel, striking the words commerce and competition against the poetry of the skies . . . so many that Charlie would want a lot of dynamite to blow them all up and let Nature cover the mounds with her healing grass. Still, the nature of the South African is so utterly opposed to our Western madness which takes no note of the rhythm and the art of the cosmos; he so loves space when the terrors of wild beasts, animal and human, do not hinder him, that it is certain he will make a very different civilisation from the one which has been imposed on him. He loves simplicity and leisure and the good, easy things of life. In conversation, the thinking native, especially if he have escaped the grinding of the schools, tends to the metaphysical. This is his natural bent and all the grinding will never grind it out of him, never do more than temporarily force his mind awry. Like the true Hindoo, he really cares nothing for all the mechanical trash the West is so proud of and which will be its Nemesis; he is meditative, a thoughtful being. In the past, this innate respect for thought has made him too subservient to elders and parents, but he has had the luck and merit to escape the sterile doom of a national religion with all the deadly effects of dogmatism. He takes to no religion! Christianity has failed in South Africa. Now, Islam is apparently getting ahead there. I wouldn't stake a penny on its getting *in*. The South African, like a true metaphysician, will listen to everyone and everything . . . but what he cannot reason out from fundamentals and what he cannot test will never enter him more than skin-deep. The logic of the primitive who used to beat his fetish for not doing the job assigned him, was just a sign of his straight-thinking. No perverse adoration of the obviously incompetent here! no whining and praying for favours . . . if the fetish didn't do what he was alleged to be able to do, down he went. The ethical science of the Buddha finds a ready ear, this forbidding any act of faith or compulsion and making no promises, while the moral code is that of all well-disposed humanity.

The native is astoundingly quick at memorising our schedule of education, passes examinations brilliantly, but then he falls back. This is set down to all kinds of reasons, but the real reason is that he doesn't want our kind of education. Why should he? It is of small use even to the Westerner . . . look where it has led us! It is of no use to the South African with the impress of Nature still fresh on him, with his mind untamed by the struggle for wealth and by bigotry. He will make his own education later on and, if he starts with free *children*, as well as free women and men, he should show this old planet something new in human history.

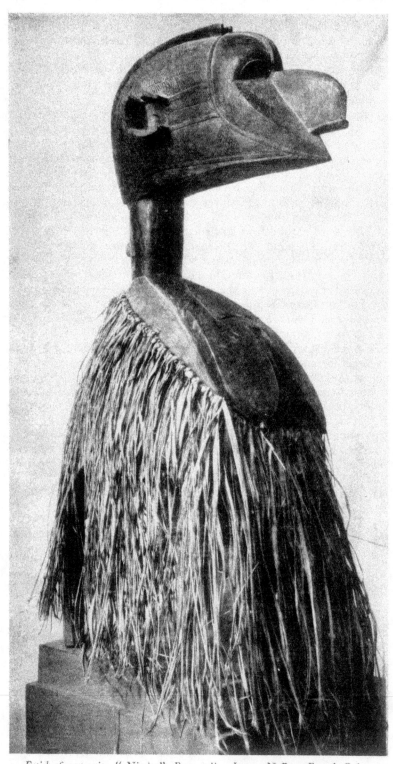

Fetish of maternity, " Nimba." Baga tribe, Lower Nuñez, French Guinea
By courtesy of the Trocadéro Ethnographical Museum, Paris

408

NEGRO SCULPTURE
AND
ETHNOLOGY

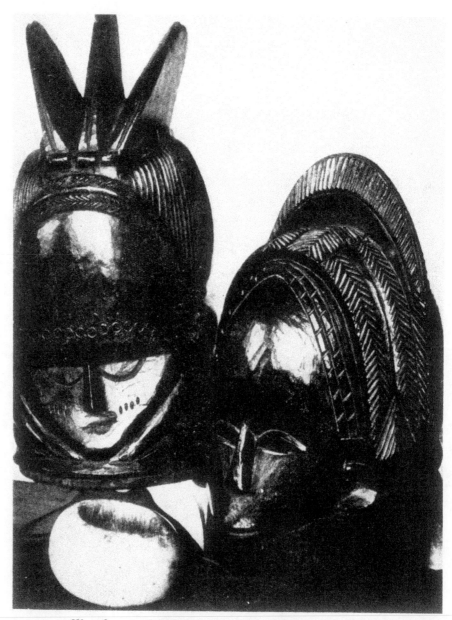

Women's masks of the Bundu secret society, Mendiland, Sierra Leone
Photo by Rolf Ubach, from the collection of Nancy Cunard

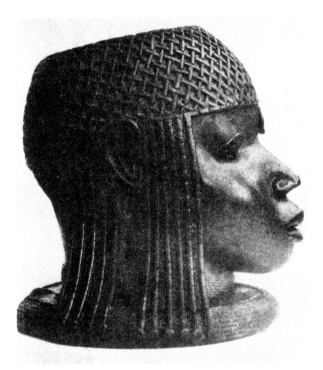

Bronze head, Benin, Nigeria
By courtesy of the Pitt Rivers Museum, Blandford, England

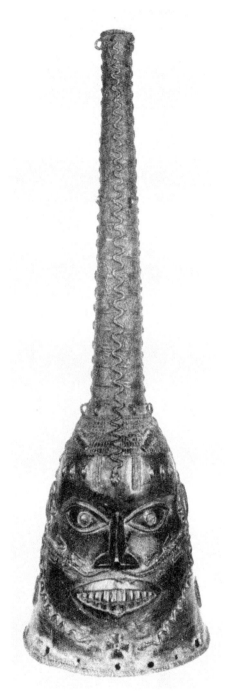

Bronze head, 16th century, Benin, Nigeria
At one time in the collection of Mr. Curtis
Moffat, London
By courtesy of Mr. Curtis Moffat

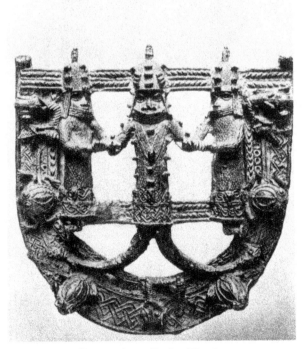

Bronze plaque, Benin, Nigeria
From the collection of Mr. Sidney Burney, London
By courtesy of the owner

411

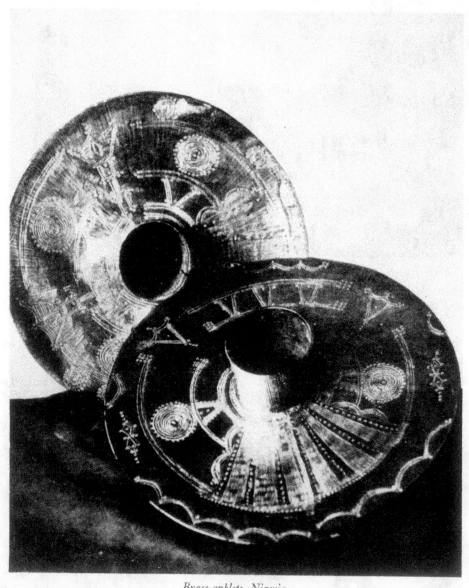

Brass anklets, Nigeria
From the collection of Nancy Cunard
Photo by Rolf Ubach

The Term "Negro *Art*"

is essentially a non-African Concept

QUOTATIONS FROM A PAPER ON NEGRO ART

by LADISLAS SZECSI

WHEN we consider Negro art (and by Negro I mean always the African before the penetration of Europeans and before contact was effected between the two) we are bound to realise that in his sculptures and carvings the Negro did not intend to create " a work of art." He needed diverse material forms and objects for use in his fetishist rites; these he carved out of wood, this being the easiest primary matter obtainable. In making a fetish figure he had no intention whatever to create " a work of art." The figure was made simply for the purpose of " housing " the spirit of his ancestor, who might thus return to guard the members of the family. As to the masks—these are the chief accessories of the dance, quite indispensable in the practice of his cult, and without which this cult could hardly exist, occupying, as it does, a very important place in his life.

The Negro has succeeded in attaining his aim along a straight, a direct, line of creativeness. For instance, one idea and intention was to cause fear to evilly-disposed wandering spirits. This need became associated with certain impressions made upon himself. For, as he knew he experienced fear at meeting a gorilla in the forest, so did the idea of causing fear become bound up with the gorilla's characteristic features. And as soon as this concept began to exist he immediately gave it material shape in the form of a mask composed of the human features allied to those of the gorilla. And these masks were used in the dance-rituals against evil spirits.

The Negroes have been able to create works of art because of their innate purity and primitiveness. They can be as a prism, without any intentional preoccupation, and succeed in rendering their vision with exactitude and without any imposition of exterior motive.

I have found corroboration of this theory also in the study of present-day Negro work, for this last was bound to be as it now is from contact with the Europeans; its purity and primitive quality have been corrupted by this influence. Indeed, compared with work done in the past, what is produced now is an object of horror, from which all signs even of the old technique are gone. The Negroes' plastic vision was broken by the arrival of the white man, their concepts of religion or magic deflected and upset by the missionaries and by the use of tools new to them. Gone is the difficulty of actually carving the wood, the rhythm of their action has suffered, and the intensity and time formerly put into the work have been diminished, cut down to a few hours.

Also when we say " *Negro* art " this is a very vague term indeed, as if we should say " European art." The styles in the art of the African Negroes are very numerous, each race having its own. The difference between the *M'Pongwe* masks and the masks of the *Dan* people of the Ivory Coast is as great as that between a Khmer sculpture from Angkhor and one made in our own pre-Renaissance epoch. There are some 40 different peoples on the Ivory Coast, and I noted 5 distinctive styles used by the *Dan* people alone. The characteristic traits and differences of these styles are immediately discernible. And it is surprising to realise to what extent the diverse races have kept to their own form-traditions while at the same time the ideas expressed were always the same.

I saw men from Loango now living on the Ivory Coast and completely assimilated to the *Senufo* as far as language, customs, etc., were concerned, but whose carvings had kept the same characteristics as those of Loango. One might say that it is their blood which has not changed, and even that mentally there is a very great difference between these races, and that if mental assimilation were to take place their own gestures in art, guided by intuition, would follow only the forms as seen and conceived throughout centuries by the race of their own origin.

A clear example this, to show that those who create may be as a prism, so pure that one might almost say " without volition "—interpreters between conception and achievement.

413

THE DIFFERENT STYLES OF MASKS OF THE IVORY COAST
by R. MICHELET and L. SZECSI

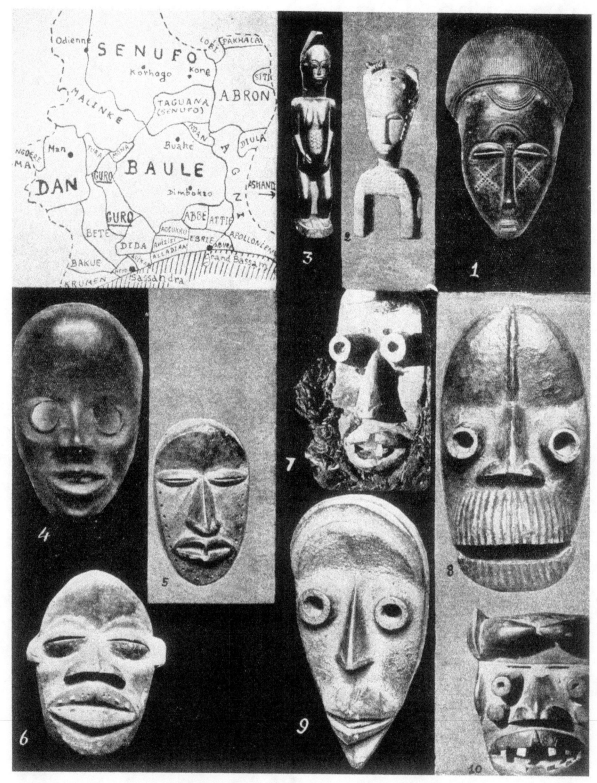

I. 1. Baulé *mask. Particularly in the "naturalist" manner. See other types of Baulé sculpture.* (2) *A bobbin for weaving.* (3) *Figure. The art of the Baulé indicates more or less the western limit of the zone of influence of the naturalist art of Yoruba-Ifé (see Frobenius). It should be remembered that in the past Yorubaland must have stretched as far east as the Baulé, across Dahomey and Ashantiland.*

II. *The masks of the Dan people, who are much more to the west, hardly come under this style or influence. Only the "portrait" mask (4) bears some resemblance. Masks 5 and 6, which are already of an entirely other conception, bring us to those known as "gorilla masks" (different types: 7, 8, 9, 10), masks that are all far more violent and where are mingled the elements both of naturalism and of symbolism, and which are inspired at the same time by human and by animal shapes, entirely re-created through the vision of the Dan sculptor.*
Somewhat similar masks are found amongst the Guéré (or Nguéré).

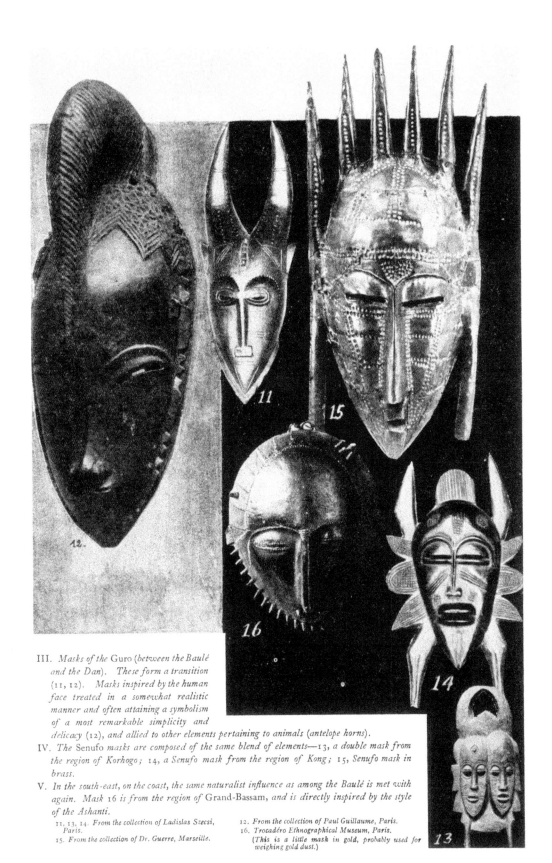

III. *Masks of the* Guro *(between the Baulé and the Dan). These form a transition* (11, 12). *Masks inspired by the human face treated in a somewhat realistic manner and often attaining a symbolism of a most remarkable simplicity and delicacy* (12), *and allied to other elements pertaining to animals (antelope horns).*

IV. *The Senufo masks are composed of the same blend of elements—*13, *a double mask from the region of* Korhogo; 14, *a Senufo mask from the region of* Kong; 15, *Senufo mask in brass.*

V. *In the south-east, on the coast, the same naturalist influence as among the Baulé is met with again. Mask* 16 *is from the region of* Grand-Bassam, *and is directly inspired by the style of the* Ashanti.

11, 13, 14. *From the collection of Ladislas Szecsi, Paris.*
15. *From the collection of Dr. Guerre, Marseille.*

12. *From the collection of Paul Guillaume, Paris.*
16. *Trocadéro Ethnographical Museum, Paris.*
(*This is a little mask in gold, probably used for weighing gold dust.*)

415

Bambara Sculpture

THE FACTS AND OUTCOME OF AN EXPEDITION TO FRENCH WEST AFRICA, NOV. 1931—APRIL 1932

by CARL KJERSMEIER

(Translated from the French by NANCY CUNARD.)

T HE Bambaras are the main tribe of the Sudan, numbering about one million people. Their language has spread widely beyond their tribal borders. It is spoken and understood throughout most of the Sudan. They are not a warrior people and the high status they hold is due solely to their natural, cultural ascendency over the other tribes in the land. They are better workers than other Sudanese natives, an actively agricultural people, polite and honest. But even more particularly are they an artistic people, maybe the most artistically gifted of African populations. There are more interesting customs to be studied amongst other Negro tribes in French West Africa, but artistically none approaches the Bambara. This is manifest even in their raiment. Men and women dress in exquisite taste; clashing colours and exaggerated europeanisms such as sun helmets and silver-headed canes are avoided. It can be seen in the style of their crafts, in their dances and songs, most of all in their art—figures, masks, and the sculptured crests on them.

The main object of my expedition was to study Bambara sculpture. I was able to collect some 150 pieces of characteristic Bambara art—nearly all of these in the hard wood of the *dondol* (bombax cornui), which does not suffer from the ants or the climate; I was able to gather plausible explanations as to the significance and function of these works of art.

The sculptural art of the Bambaras can be divided into three groups: ancestor figures, fecundity fetishes, and the fetishes of twins. The general name given to all three is " the little men of the blacksmiths." Ancestor figures are male and female, and sacrifices are made to them. The fetish of fecundity is always of the female sex. It is given to the girls at an early age to insure fecundity. This is the most numerous group of figures. Less frequent are the fetishes of twins. When one of twins dies his survivor is given one of these figures. It now bears the name of the dead and the survivor keeps it with great care all the rest of his life. When a gift is made to the owner of this figure a lesser present must also be made to the fetish itself. It is also a protector against scorpions.

The Bambara figures are unequal in artistic value, but amongst those brought back from my expedition are some as noble in proportion and bearing as examples of high Egyptian art. Most of the masks belong to the Koré secret society and are used particularly during the ceremonies of incorporation which take place every seven years. They symbolise the heads of different animals: the leopard, the lion, the hyena, the monkey and the dog. They are intended to cause terror to the un-initiate. I brought away some masks of striking fierceness.

The most interesting and the richest part of Bambara art is found, however, in the sculptured crests on top of the stylised ante-lope-masks. These were heretofore rather

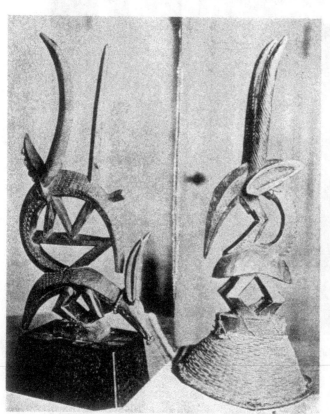

The crests on the antelope-masks of the Bambara tribe, French Sudan Brought back by Mr. Carl Kjersmeier from his expedition in 1932, for his private collection in Copenhagen

By courtesy of the owner

416

Bambara Sculpture

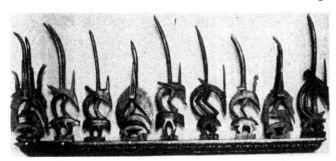

Stylisations in the crests of the antelope-masks, Bambara tribe, French Sudan

Brought back by Mr. Carl Kjersmeier from his expedition in 1932, for his private collection in Copenhagen

By courtesy of the owner

meagrely represented in museums and private collections. The theories concerning them held by European ethnographers were somewhat curious, and it was said that only twelve distinct types were known. Had there been only twelve diverse styles of these sculptured crests this would have sufficed to give them a place in the forefront of Negro art.

It befell me once to have the arranging of ten of these in the Berlin Ethnographical Museum—the greatest artistic event that has happened in my life. Never had I seen such a gift of outstanding variations, so bold an artistic fantasy. These stylised sculptures of the Bambara belong to that form of Negro art which is the most appreciated by the generation that saw the beginnings of Cubism and Expressionism. These geometric and constructive carvings are like the daring work of engineers, and are born from a spirit analogous to that which has made our century an era of motors and flying machines.

The crested antelope-masks are fixed to a small straw bonnet worn by the dancers who imitate the bounds of the antelope. Dadje and Sogoni (the great and little antelope) are thereby symbolised. They are used in the feasts of sowing and harvesting and on each occasion when a new field is to be laid out. "Tchi ouara" (the wild beast of cultivation) is their name.

The crests are male and female, the male being the largest, with long, arc-shaped horns often of one yard's span. The female is smaller, with lesser and straighter horns, rings in the nose and ears, often bearing her young on her back. It would be death itself to separate male and female during the dance. It should be said that the Bambaras have chosen the antelope as the fetish of field cultivation because numerous antelopes leap from the grass each time some part of the bush is burnt down to prepare a new field.

There are no fixed traditions laid down for the shapes of these crests. The artists—the blacksmiths—are forever creating new forms. Often they will invent compositions where we find elements of two, three, or more animals; for instance, a duck with dog's ears, an antelope with long horns, or again a short-horned one. Compositions exist too with small human figures, but these are fairly rare.

In the making of these antelope-masks the fancy of the artist has a free rein and a boldness without compare in other Negro art. It is almost as if each Bambara smith had tried to outdo the other in imagination. From village to village the shapes and the compositions vary. Out of fifty-six pieces brought away with me there are no two alike.

When I went to Africa I had the theory that Negro sculpture was a traditional art, and that all the masks and figures had been created according to a fixed tradition which the tribe laid down to be respected from generation to generation, though naturally with a certain freedom conceded to the gifts and personality of the artist. My studies in the art of the Bambara have convinced me that—like all other Negro art—this, from its origin, is an individual and not a collective thing. In Africa as in Europe, it is the individual man, the artist, who creates the new forms, and not the people (who in Europe include the patrons and collectors), who decides what the art of a people shall be.

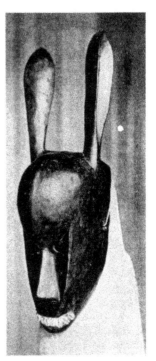

Mask of the Koré secret society, Bambara tribe, French Sudan.

Brought back by Mr. Carl Kjersmeier from his expedition in 1932, for his private collection in Copenhagen

By courtesy of the owner

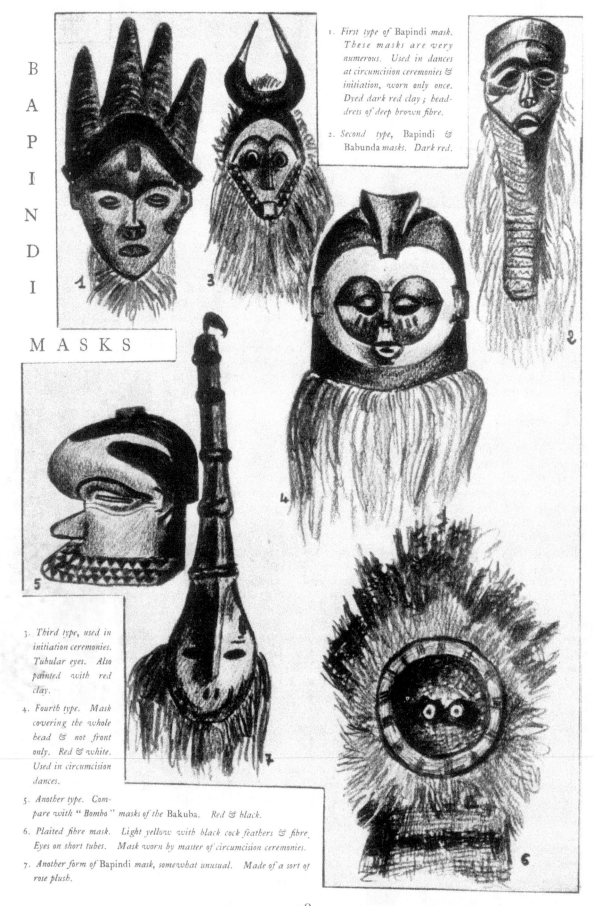

B
A
P
I
N
D
I

MASKS

1. *First type of Bapindi mask. These masks are very numerous. Used in dances at circumcision ceremonies & initiation, worn only once. Dyed dark red clay; head-dress of deep brown fibre.*

2. *Second type, Bapindi & Babunda masks. Dark red.*

3. *Third type, used in initiation ceremonies. Tubular eyes. Also painted with red clay.*

4. *Fourth type. Mask covering the whole head & not front only. Red & white. Used in circumcision dances.*

5. *Another type. Compare with "Bombo" masks of the Bakuba. Red & black.*

6. *Plaited fibre mask. Light yellow with black cock feathers & fibre. Eyes on short tubes. Mask worn by master of circumcision ceremonies.*

7. *Another form of Bapindi mask, somewhat unusual. Made of a sort of rose plush.*

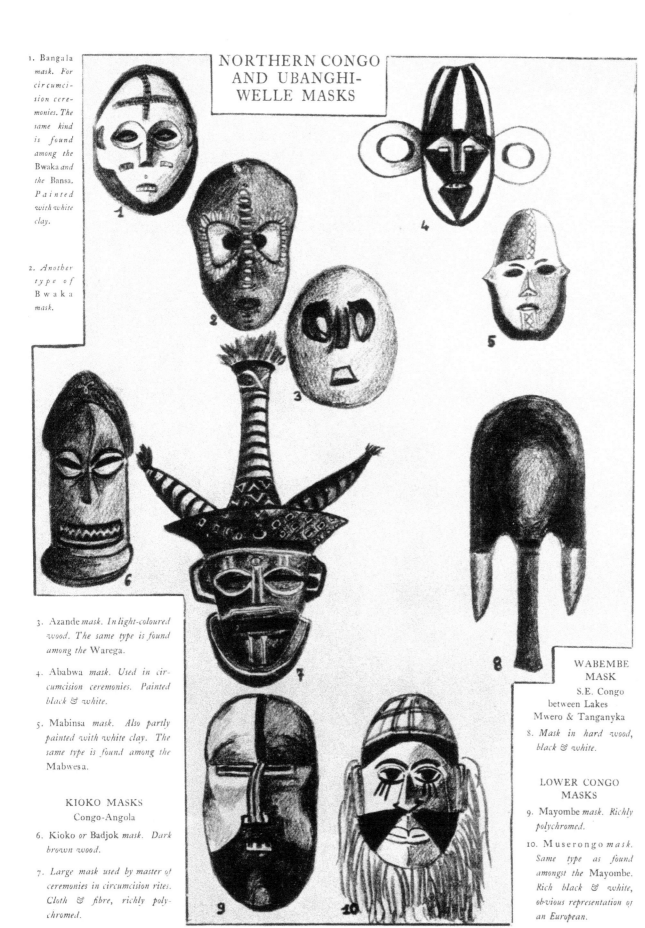

NORTHERN CONGO
AND UBANGHI-
WELLE MASKS

1. Bangala *mask. For circumcision ceremonies. The same kind is found among the* Bwaka *and the* Bansa. *Painted with white clay.*

2. *Another type of* Bwaka *mask.*

3. Azande *mask. In light-coloured wood. The same type is found among the* Warega.

4. Ababwa *mask. Used in circumcision ceremonies. Painted black & white.*

5. Mabinsa *mask. Also partly painted with white clay. The same type is found among the* Mabwesa.

KIOKO MASKS
Congo-Angola

6. Kioko *or* Badjok *mask. Dark brown wood.*

7. *Large mask used by master of ceremonies in circumcision rites. Cloth & fibre, richly polychromed.*

WABEMBE
MASK
S.E. Congo
between Lakes
Mwero & Tanganyka

8. *Mask in hard wood, black & white.*

LOWER CONGO
MASKS

9. Mayombe *mask. Richly polychromed.*

10. Muserongo *mask. Same type as found amongst the* Mayombe. *Rich black & white, obvious representation of an European.*

419

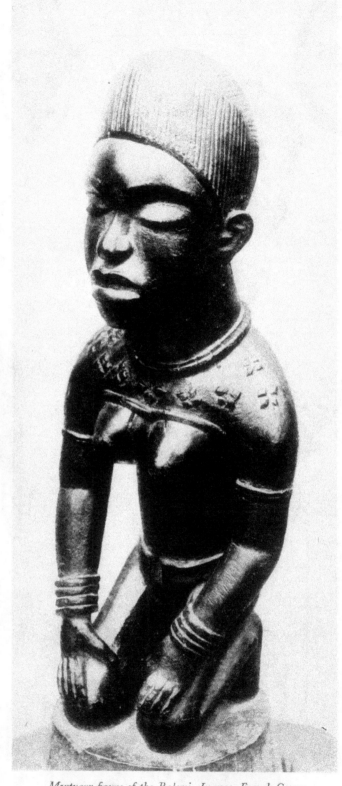

Mortuary figure of the Bakuni, Loango, French Congo
From the private collection of Mr. Henri Lavachery, Brussels
Photo by courtesy of the owner

420

CONGO SCULPTURE

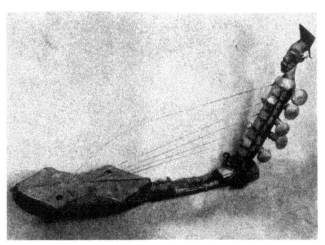

Guitar of the Azande, or Mangbettu, Belgian Congo
From the private collection of Mr. Han Coray
By courtesy of the owner

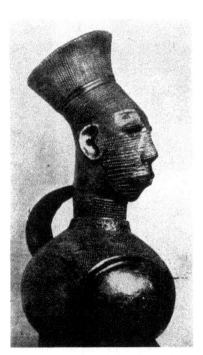

Pottery jug, Mangbettu tribe, Belgian
Congo
From the private collection of Mr. Han
Coray
By courtesy of the owner

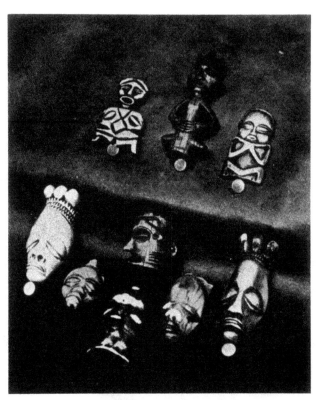

Small ivory amulets against sleeping sickness. Bapindi and other
Belgian Congo tribes
From the collection of Nancy Cunard
Photo by Rolf Ubach

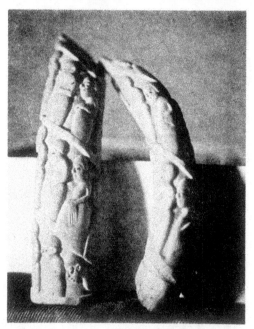

Carved ivory tusks, Loango, French Congo
From the private collection of Mr. Ladislas Szecsi,
Paris
By courtesy of the owner

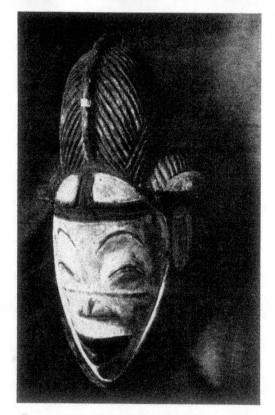

Dance mask, in black, white and red, Balumbo tribe,
French Gaboon
From the private collection of Mr. Félix Fénéon in Paris
By courtesy of the owner

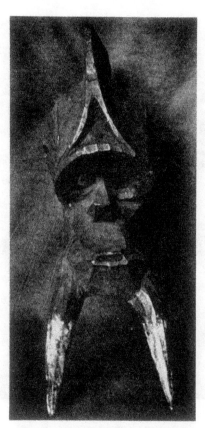

Gorilla (?) mask, Medjamba tribe, Lower
Sangha, French Congo
From the private collection of Mr. Félix
Fénéon, Paris
By courtesy of the owner

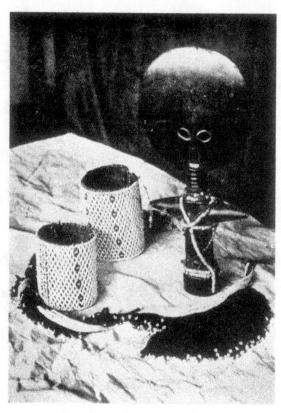

Ashanti doll, Zulu beaded anklets and girdle
From the collection of Nancy Cunard
Photo by Rolf Ubach

422

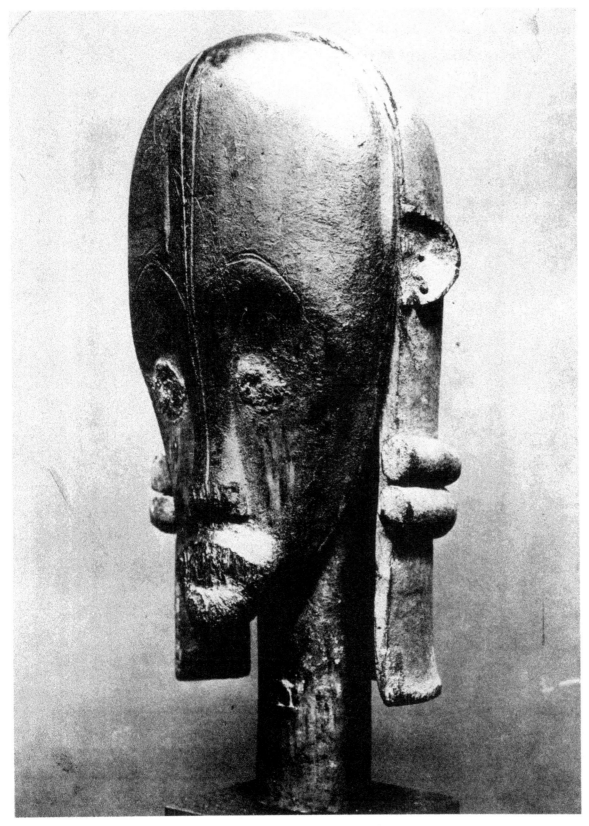

Sculpture of the Pahouin tribe, French Gaboon
From the private collection of Paul Guillaume, Paris

423

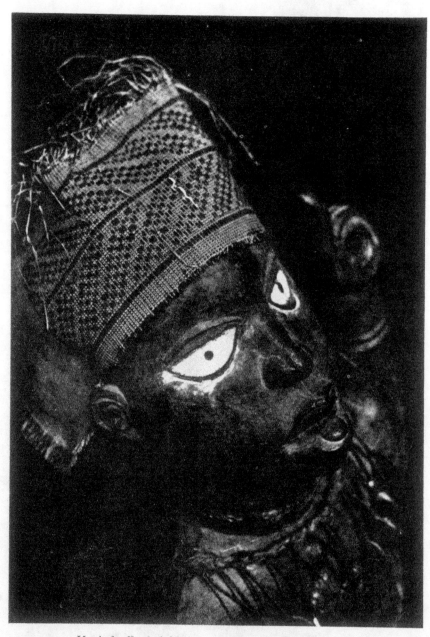

Head of a Konde fetish figure, Bakongo tribe, Belgian Congo
Photo by Rolf Ubach
By courtesy of the Tervueren Museum, Belgium

424

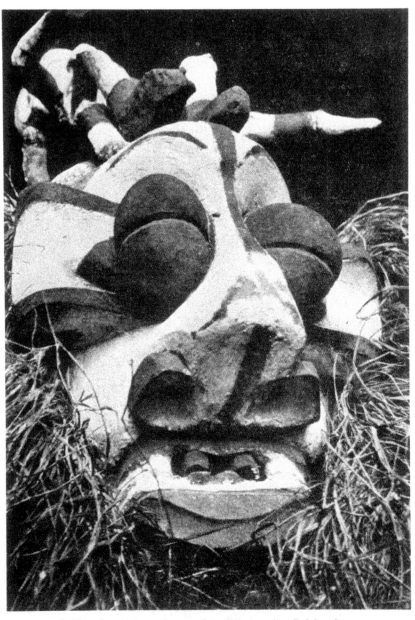

Brilliantly polychromed mask of the Bayaka tribe, Belgian Congo
Photo by Rolf Ubach
By courtesy of the Tervueren Museum, Belgium

425

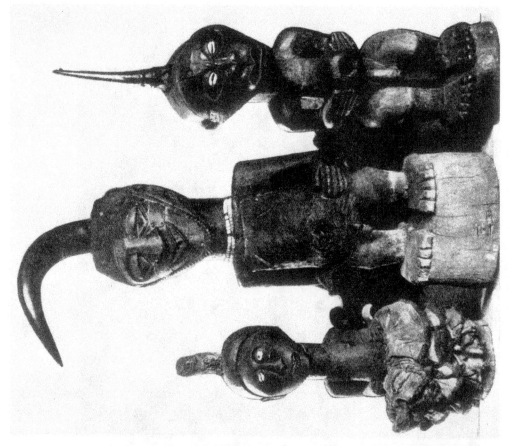

Fetish figures to protect the dwellings

On the left : Bangala tribe ; centre and right : Kasai, Belgian Congo

By courtesy of the Vleeschhuis Museum, Antwerp

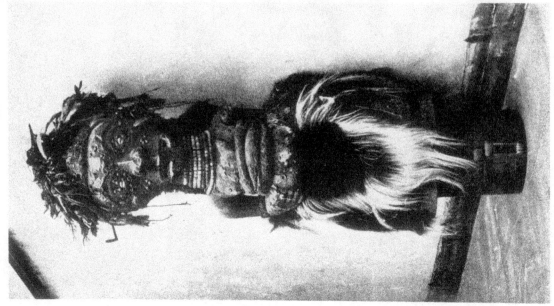

Fetish figure protector of dwellings, Sankuru, Belgian Congo

From the collection of Mr. de Hondt, Brussels

Photo by Ralf Ubach

By courtesy of the owner

426

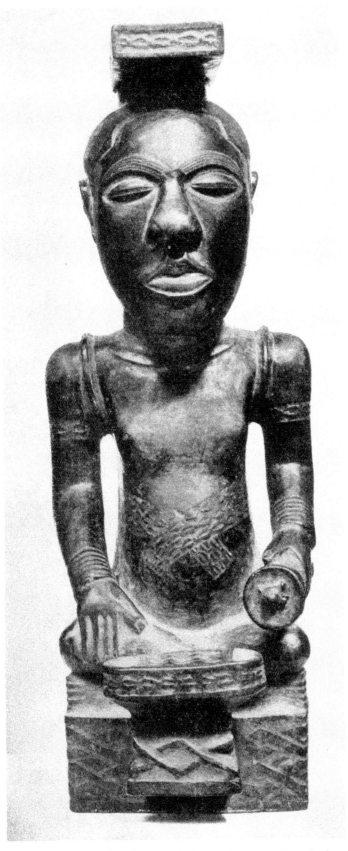

Shamba Boloncongo. Wooden portrait figure, circa A.D. 1600, *Bushongo
tribe, Belgian Congo*

427

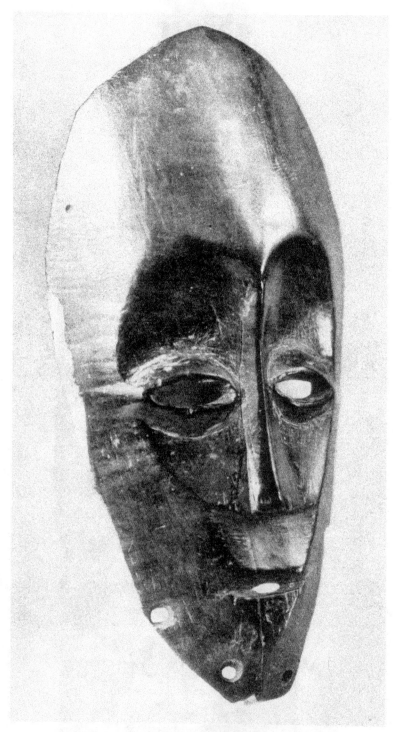

Ivory mask, actual size, Warua or Warega tribe, Belgian Congo
From the private collection of Mr. and Mrs. Stoclet, Brussels
By courtesy of the owners

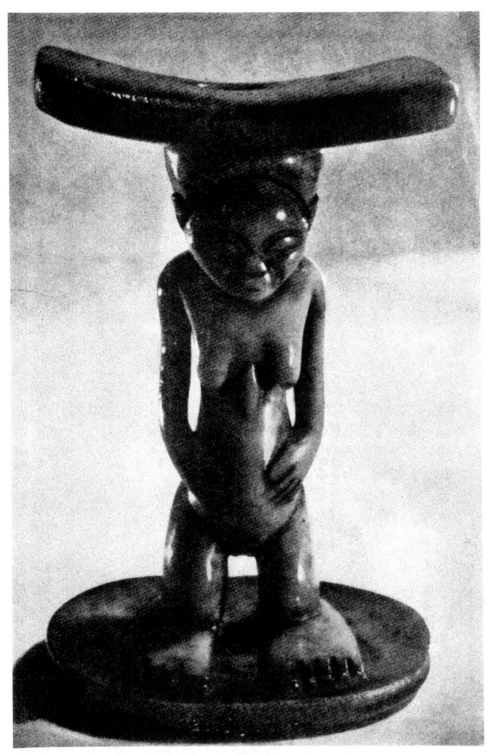

Head-rest in ivory, Wazimba, Belgian Congo
(This is one of the most beautiful pieces known of Negro art)
In the collection of Charles Ratton, lent by him to the Trocadéro Ethnographical Museum, Paris

429

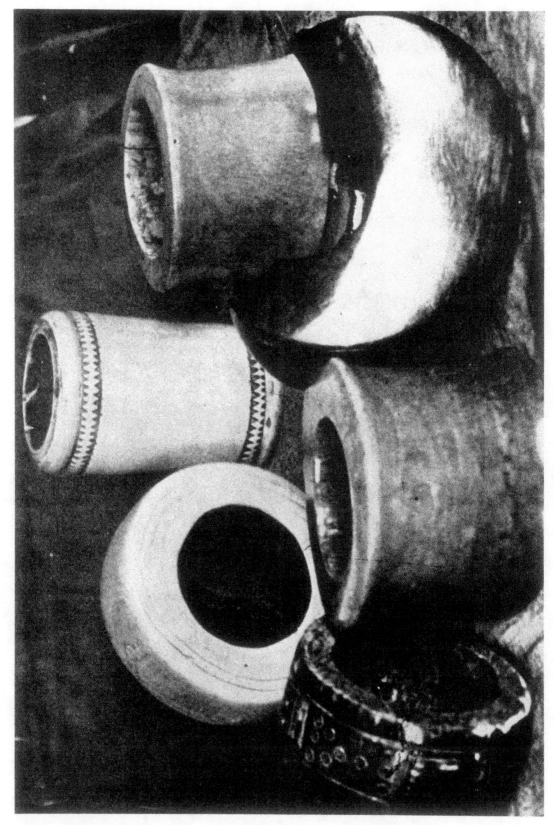

Massive old ivory bracelets from Central and East Africa
From the collection of Nancy Cunard
Photo by Ralf Ubach

430

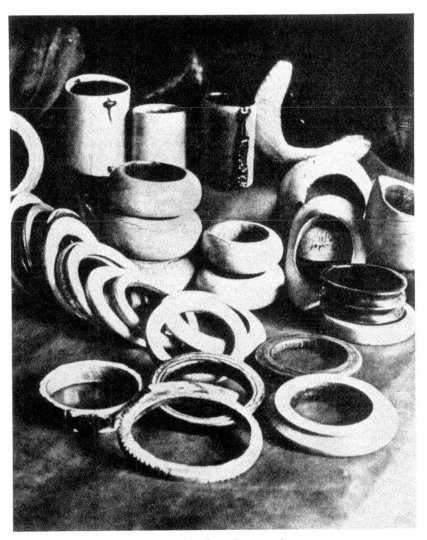

Ivory bracelets from diverse regions
From the collection of Nancy Cunard
Photo by Rolf Uback

" *Amongst the Ibo people in Nigeria the most valuable and the most prized of all forms of adornments are the anklets and bracelets of ivory. These can only be worn by rich women or by such as are of high rank. . . . The anklets are about 9 inches in depth by from 2 to 3 inches in thickness; the bracelets vary in size. . . . Once they are on the limbs (they are forced over feet or hands after a course of powerful massage with oil) they are not removed till death. Young women during their course in* nkpu (*ceremonies that take place after puberty during the pre-marriage period*) *sometimes wear ivory bracelets right up the arm, but this is quite a temporary arrangement. With the older women these ivories are price-less treasures, and they will endure any hardships in preference to degrading themselves by selling them, however great the inducement may be.*"

(Basden, Among the Ibos of Nigeria)

431

White-Manning in West Africa

by T. K. UTCHAY

T. K. Utchay

THE colour question is not a new story. Though the *Nigerian Observer* called it " the eternal question," I will call it a universal one. The practice of prejudice is unchristian, unconstitutional, inhumane and uncivilised ; yet those we look upon as being highly civilised have passed it as usual custom. Clergymen do not preach against it, philosophers do not trouble to point it out as the most barbarous thing in modern civilisation. Though an important factor in successful colonisation, statesmen allow it to thrive in the empire over which they act as brain. Why a practice second to nothing but brutal slavery should be allowed to go unchecked by the world's moral teachers frightens me almost to sickness.

Now, I am a black man and suffer from the evil of colour prejudice. I know of many instances of ill-treatment lately inflicted ; as I write, it is not always natural for a man being tortured with pain to speak at the normal pitch.

The black man will be grateful to the white man's work in Africa if he can only obtain his place and rights as a human being. A great Aro-Chuku chief named Okoroji Oti laid down unto all who wished to be his friends : " If you deny me my due respect your golden gifts are of no use to me." An old Aro-Chuku woman was speaking to a chief and said : " Chief, there is a young man at Ohafia that I know. He is lame, but in all Ohafia town there is no one who makes yam furrows so nicely as he, but it often happens that when he completes the furrows, and wants to get out of them, his lame leg disorders the earth and spoils the work he has so skilfully performed." All the white man's work in Africa amounts to nothing afterwards if he destroys it with the spirit and practice of colour prejudice.

We shall now enter into criticism of a white man's vice which I have named

WHITE-MANNING IN WEST AFRICA

" Selfishness is the greatest curse of the human race."—GLADSTONE.

White-manning is the word employed like a technical word to describe one of the world's strangest actions ever in existence. It is the name for a practice introduced by the white man, by which one man thinks himself superior to the other, not for any reason such as academic or financial qualifications, but simply because by accident he has a white skin. It is also employed to describe the conduct of certain Africans who slavishly imitate the white man and go about despising other black men for reasons they do not know, just because the white man does so. It is the practice by which the white man, like the Stuart kings, deems himself justified in Africa, by virtue of his white skin, to ask and claim first consideration in every walk of life, in health, in position, in comfort and in luxury. It is the conviction in the white man by which he thinks himself superior to and lord of the dark coloured race, no matter what educational, financial or physical qualifications the coloured man has. It is the easiest and simplest ladder by which any white man can elevate his rank in life in Africa. Its practice is so enticing that even European ministers join in the company. They preach and teach that God can enter into the African's heart and that he can be surrounded by the spirit of God, but is unfit to come into contact with their own frail bodies. White-manning has entered through the gates of the churches. Instead of raising it has lowered the white man's prestige ; it makes him immodest, a worshipper of triviality, a slave to self-propensity, and raises suspicions as to his distribution of justice.

Those that practise it are not authorised to do so by law or by the heads of any European establishment in Africa. It is rampant among the lowest ranked Europeans who employ it amongst the more timid to elevate their own position and make themselves feared. The higher a European rises the less he indulges.

White-Manning in West Africa

White-Manning—its History and Origin

There was a time when these conflicting ideas hardly existed. In the good old Victorian days, so maligned by the present generation, my sisters and I had the great privilege of attending the Jersey Ladies' College (in England), where we were the only Africans. But we never knew we were black till we looked in the glass. There was not the slightest difference made in any shape or form between the other girls and ourselves. If anything, we were rather more favoured, because we were strangers in a strange land.—ADELAIDE CASELY-HAYFORD.

White-manning in Nigeria may be a little over 20 years old. There are instances showing how closely the old Bonny and Calabar chiefs dined and drank together with the early Europeans. How colour prejudice came and settled must have had a sad origin and a painful history. First, the white man was a trading friend with the West African. Two mates, each with equal right over his own property, sat side by side in friendship and happiness, ate from one table, drinking their wine and hard at the bargaining. " What is that fine stuff in your box, Jimmy? " said the Nigerian. " Well, Jack, it is a string of beads—lovely ones too," returned the stranger. " Will you let me have it for one cask of palm oil? " enquired the black man. " I shall not part with it for three casks ; yes, I mean it," returned the white man. " I shall give you two," said the black man. " No, take it for four. You cannot find another Chief in the Coast wearing such fine jewels," the white man replied. The beads were now sold for two or more casks of oil. The African is always full of hospitality, and considers it an indignity if he does not entertain his guest satisfactorily with whatsoever he can afford. " He must have been a fool to let go all this quantity of oil for such a small number of beads," thought the white man within himself. " I have never seen anybody wearing such beads in my life ; I think they're worth twenty casks of oil too," the black man thought. The string of beads that was worth nothing more than a shilling had made a fortune for the traveller. " If the black man had been as wise as myself, he would have asked for kegs and kegs of the beads," considered the white man ; "surely he must have been a fool." The first seeds of scorn were thus sown in the mind of the white man. The trader, in order perhaps to stop other traders coming with him to share the profit, exaggerated the conditions of the journey. Talked of unkind and wild Africans, whose heads were two or three on their shoulders and who had faces like those of dogs. " That African can never be a human being," thought the white men at home.

After this stage came the Government period. The white man had obtained the right in some form to rule the land of the black man. The black man did not understand his intentions and ideals. The best sort of white man could not afford to come and work in Africa. Perhaps two or three of the best ones among each hundred of them came out.

" William," said the head of the white administrators, " take charge of the towns contained in the hundred square miles to the north of this place, and deal gently with the people." " Right, sir," replied the newly elevated lord. " These black people, men, women and children, are all my subjects. They cannot speak a word of my language, neither do they know to whom or how to report me if I treat them badly. They fear me, and when I command there is no one to argue against me," said this official to himself when he left his master's presence. The little lord then ventured on an expedition into the interior of his domain. The first person he met was a native chief. He had his fetishes, his jujus, his laws and beliefs handed down to him by his fathers. The native's civilisation according to his fathers is complete. Hence he lived and died happy. Taking the old civilisation away without adequately supplying him with the modern one was depriving him of his beliefs and customs and substituting—nothing. There were sacred days, when no member of his town or village would go to the farms. There were waters and springs from which no human being was allowed to drink, and some animals in his bush which it was expressly forbidden to kill, and so on. There were parts of gates at the entrance of his village through which no woman should pass. The official did not know these things, and did not care to know them. He took little heed of them all and meant to make headway with his own plans—such as opening up the towns for trade, making good roads, etc. He tried to enforce all this without consulting the natives, and thereby violated some of the old laws of the land. The chief demanded that such behaviour should be stopped. The white man determined to push on. The chief barred the way and forbade his advance, but the official forced his way through, and the soldiers burnt the little villages, destroyed anybody and anything they could reach. Those that remained begged on their knees for their lives. The neighbouring black men and chiefs learnt from this no longer to dare resist the white man ; they no longer dared ask him for any rights that even he himself said were theirs. The black man was so panic-stricken for the rest of his life that any schoolboy could come to him and say " The white man wants 20 goats and 300 yams, and men to carry them 15 miles distance." And he obeyed this more than was necessary. He did everything now to save and prolong his life. He regarded the Government as the exclusive concern of the white men, and as a thing

in which he had no part whatever. He accepted, and could not be otherwise convinced, that a powerful body of men had come to his land, conquered him, suppressed his rights and enslaved him. He could only lift up his hands and groan some prayers. What a change from the companionable contact with the travellers to this deplorable condition!

His children were sent to school by the white man, and taught to read and write. The child came home to say a different thing about the white man. " Father, the white man is very kind. He gave me presents and talked of the love of a wonderful man called Jesus Christ and the Great God. He is very good." The old man could only reply : " My dear boy, children do not know sometimes why men throw corn to the fowls they want to catch. You do not know the white man as I know him. His object in coming to Africa he will never tell you. But I know it. He is after wealth and riches and nothing more. He educates you to help him gather these. He divides himself in three divisions : the soldier to fight, conquer and rule you, the missionaries to soften your heart, and the merchants to gather money out of your land. The Government, the mission and the merchant are all one body for one purpose : *exploitation*, my boy ! Mark it and take care how you deal with him." " It is only out of his ignorance that the old man talks," the boy said to himself and left the old man alone.

Time has now brought us to another stage of the white man and his host. The present sees no more of these old men and such thoughts. The black man can now read and write and is employed to work for the white man in various offices. His own children are in turn going to school. He has still the old words of his father in mind. He has proved a few of the points to be wrong. The Government is common property to both the African and the white man. If the African can only drop fear and the white man drop Self . . . the colour question ! Laws give equal rights to all. Though the native knows his rights the white man can with safety use the power at his disposal, *ex-officio*, to his selfish advantage over the panic-stricken African, and threaten and deprive him of some of his rights.

> Certain administrative officers in certain provinces . . . unfortunately lord it as much as they can, and everything seems to be at their command. . . . In some remote places far away from civilization, and not within easy reach of highly placed officials, all sorts of things can and do happen. Sometimes, we are told, some administrative officers do not wish to listen to complaints, they do not want to read petitions. . . . An administrative office should not be converted into a sort of hell on earth, to be dreaded by all those who, by reason of their contributing directly or indirectly towards its maintenance, have a right to go there whenever they are in trouble.—*Nigerian Observer*, March 26, 1932.

The civilised black man has a different trouble from that of his father or of his uncivilised fear-stricken brothers. He works as clerk, teacher, or at some other form of labour under the white man. The white man is at the head of all departments in which the black man serves. His safety and happiness lie in his getting on well with the white man who is at the head. This can never be possible unless he submits to all the white man's wishes, and among the wishes of this latter is to have prestige for his colour ! He has the black man's bread in his hands. Can anybody control a servant more effectively than he who gives and butters his bread? The white man taught the Africans to become clerks, teachers, carpenters, bricklayers. The black man has faith that with these trades his happiness and livelihood are secure. So he forgets and forsakes his father's means and ways of obtaining a livelihood. He copies the white in everything, and like the white, desires to sit and dictate to his juniors. But unfortunately for him, all the trades and education he has had lead to menial ends. He has not learnt anything which can make him independent of the white man and able to earn his own bread. On the other hand, the white man will never employ him unless he is willing to make complete allegiance to his private person and official position. His fate is different from his father's but he is compelled to submit just the same. The black man who was once released from the bondage of slavery has now sunk into another, the bondage of servitude. He needs to go one step higher to bring him to the independent or master-of-himself stage. He wants economic independence before he can safely assert his social rights and claim his social equality with the whites.

The white man is always highly paid. *The black man's salary for* ONE YEAR *is averaged at less than the white man's salary for* ONE MONTH. The black man does not easily get his comforts, but the white has necessaries, comforts and luxuries. Some black men, though working with regular salaries, can hardly buy sufficient food ; medicines in most houses are a difficult problem. It is hard to earn enough money for books, for children's education, for travel or self-improvement. Savings are scanty, hence most Africans who are anxious to get on may resort to tricking their employers or their fellow black men. Africa is full of resources, but the African lacks the capital and training to develop them.

The more the black man is qualified to defend his own interests, the stronger the colour prejudice. Why we saw little of it before is perhaps because the white did not find anything to envy. For, after all,

white-manning is the result of the white man's envy because the black man wants to share in the natural and unlimited liberty enjoyed by the white. The picture used to be the figure of a white boy stooping over his willing black pet. The white man pitied and determined to raise the black man's condition to that of a civilised being, and set himself to work. Every lead of the white man was followed closely and smartly. But whether the white man knew what sort of fruit his activities would bear, I have no idea, from what is happening at the present. Today the picture is a different one; for the figures one sees in it are those of two men, one white and one black, of same height and build. This is the fruit of the white man's work. But in the picture there is no longer the former intimacy and fondness that once existed. Sounds issue from the white man's lips: " The man is black, I am white; he cannot be my equal. How can he be? To me this is insolence." Then what on earth did the white man come to do in Africa with his idea of " civilising," if the black man can by no other means than getting a white skin (which is impossible) become the white man's equal? Is there some perplexing and contradictory idea to follow as an attempt to understand the conduct of a person who is annoyed because his prayers *have* been answered? (!) The white man's conduct can well be termed hypocritical and undependable.

The first report a white man working in Africa gives about a black is that he is good and making remarkable progress. Then comes another report after he has made the " remarkable progress ": they say that education has spoilt him and that he is worse to deal with after he has been educated. Is it not because after his education he is better prepared to defend his own interests and refuses to be bullied that he receives this opprobrium?

It is often stated that white-manning is the result of the " black man's dishonesty and immorality." Show me that crime committed by the black man, and in turn I will refer you to a similar but sometimes graver one committed by the white man. To compare properly, calculate the amount of money spent in educating the white man in universities and colleges, while the black man learns from low and mostly ill-conducted elementary schools, and from copying from the white the harmful as well as the better characteristics.

WHITE-MANNING, HOW PRACTISED, ETC.

(a) Fear and Deserted Rights

" Fear has torment."—ST. PAUL.

Fear plays an important part and occupies the first place in the consideration of how white-manning is usually carried on. The white man successfully, by various complicated means, consciously or unconsciously generates fear in the lives of the Africans. The black man often finds himself entangled in the laws in a way that he cannot always explain, and when his intention is perhaps to do good. He finds that for his safety it will be better for him to steer away from all that concerns the white man. " He that was stung by bees fears even the blue-bottle flies," he says. A simple threat from a white, or even from a black white-manner, makes him give up his right, and he dares not go to law with anyone when he finds that by pursuing his right he may find himself in greater difficulty. There are, however, a few independent blacks in the coast towns who will not yield up their rights to any white man, if they can afford the money to enter into litigation. It is impossible to describe the position of a few years ago, but the white man is becoming more afraid to take advantage of the people's ignorance, *except in the interior towns, where the white man does not want the coast black man to come and teach them civilisation.* (And yet the interior forms by far the largest part of Nigeria.) He knows whom he can take open advantage of, and the sort who, by a little threatening, can be made to forsake their rights.

If a black man finds that a European, or even a high black official, commits a crime or forfeits his rights, whether he himself is in the employment of this European or not, he dares not prosecute for fear of being entangled in some difficulty or other. The recent prosecution of a European for abuse of office at Lagos would not have been possible in the interior towns. There are no places known to me which Europeans have not reached, but I know places where they hardly go—places where the native regards the white as a being entirely different from himself. The people of the interior dare not even complain to the Government. The whole affair amounts to deserted rights by the Africans, and disowned rights picked up by the whites. The black man forsakes his right, and the white makes use of it for his own personal advantage. That is the whole situation.

Moral instruction lessons in the schools on Patriotism, Truthfulness, Courage and Impartiality of Judgment, etc., are valuable subjects where it is expected the children may have reason to believe they have a land to own and love, are free and safe in telling the truth and in being courageous as well as having masters who are themselves impartial and just in all their dealings in life. But in the present

conditions it is like lighting a lamp inside a drum devoid of oxygen for the flame to burn in and for the sustenance of the person's life who intends to use the light there.

The black man fears to give his opinion on any matter with which a white man is concerned. He is himself, by nature, a wonderful psychologist. He can read clearly the white man's mind at sight, and be prepared at any time to tell the white man what he knows he desires him to say. He never submits his own personal opinion on any matter under discussion ; this might be different from what the white man desired, whatever the rights of the case. If he happens to be in a conference with whites his opinions are always reserved and never afterwards given out. His presence there is only to the white man's advantage, for after the conference this has endorsed his consent to anything discussed. I was once a delegate to the Primitive Methodist Senior African Conference at Ikot Ekpene, where we met Europeans. The Europeans first had their private meeting a day previous to ours. Then we had some of them discuss matters with us. I was surprised to see that the other black men spoke little and passed all suggestions brought by the whites. So many matters were discussed that I did not quite agree with the decision. At last I asked permission to give my true opinion. I was permitted. My words were the same as the mind of all the other black men, who echoed them in chorus. The white men, after a time, addressed me as leader of my people. They appeared friendly with me. But in my mind I was neither their friend nor the friend of the black man, but friend only to what my conscience passed as good. I learnt afterwards with regret the wisdom of the ways of the other black men who refused to say anything. For I suffered later and was told that one of the reasons was for my " spoiling the Senior African Conference " at Ikot Ekpene. I did not regret saying what I had said, but I regretted having gone there at all.

Most of the Educated Great African Men, who are highly praised by the whites, are not generally loved by their own brethren and race. These are the sort of people who suppress their true mind and seem to side with the whites. I agree with these men that the black should not be antagonistic to the whites, but should reason with them persistently till equality and friendship are established ; but to wear the mask, or to wear another person's face and to say I am glad when I am burning with rage . . . I pray deliverance from such.

Fear of being sacked from employment, fear of being put into prison, fear of being disliked or hated by the white man and fear of his displeasure make the black man prefer to be false to himself. From fear he will dwindle into a low, sneaky, servile person, whereas his fathers, like Socrates and many men of ancient history, were bold, died bravely, boldly, and in a manly way.

(b) Scorn

This sin (colour prejudice) is rather of omission than of commission ; that is to say that it is seldom expressed in outward action but rather in unspoken contempt for the educated African, who, after all, is the product of our hands.

Major F. H. Ruxton, C.M.G.

Since he is not permitted by written laws to practise white-manning, the white man makes use of scorn. Whoever the black man be, a scornful glance, silence to his appeal and shunning of his company suffice to remind him of his " place," and he quickly surrenders. In the mind of the white his status is already fixed. " Keep the black man in his place and he will be all the happier," maintains an " experienced " white man of the coast to a newly arrived European who has perhaps been shocked by the lack of modesty and the amount of insolence with which the African is treated. The newly arrived white's true self will thus be conquered and his conscience silenced to join in the practice. The white man's place in all walks of life is the *first class*, no matter whether he is employed to recruit in West Africa in a " third " or " fourth class " capacity. He may be a " third class " white man, but he will never be a " third class " nobody. *For in the true sense of classification the white's " third class " is by far higher than the black's " first."* A great man among the blacks may sometimes be " second class," but his status in life is always considered " third."

Keeping the black man standing when conversed with, refusing to continue a conversation if he does not talk just as a black " should," or, if he addresses the white as " Mr." instead of " Sir," speaking to him in the low pidgeon English while he replies with pure, sound, grammatical English, and denying him all etiquette, are but a few of the ways of showing a black man his " place." The progressive African is always the chief victim. The white is much happier to have to deal with a black when he can correct many errors, but not when the black can manage properly, without cause for supervision and correction.

Shunning his company is the practical expression of scorn. Black and white may be good friends in the interior where the black is the only person who hears the white man's talk. But back at headquarters, where the white meets his colleagues, he will be ashamed to let anyone see that he has ever known the

black man. It will only result in a big disgrace to the black man if he approaches the white to say, " Good morning, sir ; I hope you are well today." For he may receive no reply or be looked at with impatience.

(c) Colour Bar in the Government Public Services promotes White-Manning

The government laws in West Africa give equal rights to all races, white or black, with some exceptions, for instance :

In some government departments there are European Reserved Areas where no black man is allowed to reside.

Positions in public offices, spoken of as " Europeans' Posts."

European scale of salaries and allowances, etc.

All these are silent reminders to any conscience-stricken and modest white man that there is something in his colour the prestige of which should be maintained, and which is constitutionally protected, and free from the black man's challenge. If these special privileges are allowed the white because he leaves his home thousands of miles away to work in Africa, then the black maybe should have no cause to complain—but then the black man from the West Indies, and such far-off places, should enjoy these amenities with the Europeans.

Apart from what has been stated above, the government departments do not encourage white-manning, but rather discourage it. As already said, it is an individual sin. A black man in a government department is not dismissed from his service by an individual with whom he works, *as is done in the missionary and mercantile fields.* Before his dismissal from employment the heads of the department in government services must be satisfied in writing that the African is really at fault. An official query will be forwarded from headquarters to the African concerned, for his own explanation and defence. When this is answered the heads of the department will then decide.

The black man in the missionary and mercantile services, though the servant of the society or firm, must also please and be a private servant of the white with whom he works. A black cannot be secure in his employment by mastering his duties alone. He must study the idiosyncrasies and peculiarities of the white man at the head and endeavour to satisfy. For his continuation in the service depends on the will of this one individual.

(d) Missionaries and White-Manning

The question of white-manning by missionaries is of very great importance, as the black people believe that after all it is the missionaries who will heal the wounds in their hearts. It appears that too much was expected from them. The early missionaries did not practise white-manning.

During his sermons or his lectures the European minister or principal of an educational institution will be so absorbed in his duty that, to a careless observer, no trace of white-manning will ever be apparent. The natural discipline of church and school ties everyone to his place, and the need for mixing does not arise, hence there is no clash of any kind. The test is generally outside the building. *Segregation exists even as far as between European and African ministers of the same denomination and of the same rank in holy orders.* They do not dine together or " chum " together. They are business men in principle. White must stay at home with white, and black with black. An African high missionary official, when asked his opinion on this question, said : " If government servants were as bad as the missionaries we would all have died and gone before God for judgment and justice." Evidently he had seen much with his co-workers.

The African is fast losing faith in the European missionaries.

Another African was simple in his opinion : " The government officials are better by far than the missionaries. They who do not even go to church have much godlier hearts than these missionaries." Some other experienced Africans said : " Those who were missionaries have all gone ; the present include a majority of money hunters." And there are many others who express themselves thus.

The illiterate natives depended on the words that fell from the lips of the ministers ; at present they read and compare bible teachings with the lives the ministers live. The colour of the white minister seems to bulge, to obscure, and deprive him of contact with the lives of the black people ; thereby he loses much by not understanding the minds of his congregation so as to adjust himself to their needs. Whereas the black has penetrated into his life. For his houseboy, his cook, his steward, his neighbours, are all black. They study and understand his life more than he does theirs.

Owing to colour prejudice, the European ministers do not succeed in bringing their white brothers (who are mostly merchants and government officials) to church, for they cannot " mix " with the blacks. This leaves a very serious impression in the black man's heart.

White-Manning in West Africa

(e) European Merchants and White-Manning

" The merchant is a nonentity in this matter," said a clerk of one of the biggest trading firms in this country. This does not mean that merchants do not white-man, but that sometimes they do and sometimes they " mix." Merchants of all nations are always slaves to gain and money, for this is their goal in business. For the sake of the money that a black man spends on buying from him, the European merchant will sit at the same table, they will smoke and drink together, and even go so far as dining together, if time allows. The merchants are not always cultured people in etiquette. The merchant and his employee—we have already seen their relationship. The white man brings more of his home life to Africa than any other class. He is the one most responsible for the many mulattoes born in the coast and suburban towns, which he neither claims nor cares for. And strange to behold, he claims superiority to his own blood.

(f) " ' Yes, Sir ' brings no Palaver "

For the amusement of the reader let us see what happens in the West African home of the white man, and join in laughing at the funny side of it, though not at the cause underneath. The black man who speaks to a white must say " Yes, sir " or " No, sir " as the case may be. He must make great use of the word " sir " when he is conversing if he wants to be a " good boy." The omission of the word marks him out as insubordinate, and he will be talked of as having been " spoiled." Among the missionaries such blacks will be regarded as insolent men who will surely lead the others astray. The black man knows why he must not omit this word. You may think he uses it all the time because he accepts every white man in West Africa as a knight of some kind or order, perhaps you may guess which—the Knight Grand Cross of the Order of White Colour. But the " jolly nigger " lets us into his secret : " If you want to be at peace with the white, do as I do. That is, say always ' Yes, sir,' for ' Yes, sir ' brings no palaver. This is how I do it :

White man : Bob !
Jolly nigger : Yes, sir !
White man : Come here !
Jolly nigger : Yes, sir !
White man : Did you swallow heavy balls of foo-foo [1] today?
Jolly nigger : Yes, sir.
White man : Black man, black monkey, big big chap. . . .
Jolly nigger : Yes, sir.
White man : Are you angry?
Jolly nigger : Yes, sir.
White man : You bloody fool.
Jolly nigger : Yes, sir.
White man : Jump away.
Jolly nigger : Yes, sir. (*Jumping out.*)
White man : Come back !
Jolly nigger : Yes, sir. (*Returning.*)
White man : Do you say ' Yes, sir ' to every question?
Jolly nigger : Yes, sir.
White man : You are a fool to do that.
Jolly nigger : Yes, sir.
White man : Go and do your work and be always good boy.
Jolly nigger : Yes, sir.

This is how we go smoothly in this place." In addition to " Yes, sir " the black man is considered overstepping his boundary if he addresses the wife of a European, say a minister's wife, as " Mrs."—he should always say " Ma." [2] " Mr." or " Mrs." should be used by Europeans speaking to Europeans, and not by an African to a European.

[1] A delicious African dish made with meat, rice, suet and hot peppers. ED.

[2] I had to write and ask Mr. Utchay about this—if " Ma " were not perhaps a slip of the pen for " Ma'am." *Indeed no !* This is what he answered : " The word ' Ma ' is not English. It is an Efik word, Calabar. The early missionaries adopted this title for their wives, and another, ' Etubom,' for themselves. ' Etubom ' means ' the father of the boat,' literally ; or in short : captain. ' Etubom ' means a man whose word is final and who has prerogatives over many functions. ' Ma ' is the feminine gender. As the people began to be educated, the word ' Etubom ' became obsolete, and the word ' Sir ' came up prominently, but the word ' Ma ' still stands. If the missionary's wife calls at me I am expected to answer ' Yes, Ma ' ; that is what she prefers to being called ' Mrs.' by any African."

Which shows us that the missionaries have even usurped words of the natives' language and applied them to themselves, considering they have the right to " prerogatives over many functions." ED.

In conclusion, white-manning has given rise to many serious evils. Misunderstanding between the races, lack of co-operation in the right spirit have caused many mistakes which could have been avoided. There are instances where grave errors have occurred from the white man's keeping aloof from the black which have prevented the comprehension of the problem under consideration and its solution. The white man can successfully disculpate himself by making the black man a scapegoat. The moral qualities in the hearts of Africans are suppressed and stifled. Fear chills them and their limited positions in life under the rule of whites keep them down. Another evil is that they unconsciously copy the whites in every respect. Unfortunately for them they have not seen the whites at hard work ; they aspire at copying the ease of the Europeans' life and practise white-manning on their fellow Africans.

And the reaction of white-manning on the white man himself will be great. The black man dislikes being scorned, and once that is done and he is aware of it, the seeds of revenge are sown, and are only waiting an opportunity to ripen, to the disadvantage of him who has offended him.

The Kind of Christianity we have

in Akan and Akwapim Districts on

the Gold Coast

by H. KWESI OKU

H. Kwesi Oku

JUST a few words—as there is not room for more—on one of the things that has done much harm throughout the West Coast, and other parts of Africa, though I shall only speak about my own country, which is the Gold Coast.

Some so-called educated and " civilised " people may still believe that we Africans are to be considered as " thankful " to European " civilisation." But this is not the conviction of one whom these very people would call an " illiterate, ignorant native." I mean one who has the natural judgment and knowledge of life as understood on our own native soil and according to our own concepts. White domination has been very largely based on christianity ; during the great number of years this has been installed in our midst it would have been impossible for us not to have observed and analysed the manner in which it functions.

And what have we seen ? We have seen that race prejudice exists in all forms of christian religion—amongst the catholics as much as the protestants ; it exists also, certainly, amongst the mahomedans, though the difference between christians and mahomedans is that once an " infidel " becomes a mahomedan he is not subject to prejudice. As it is, the mahomedans despise those who are not of their belief, and the christians (although we have been christianised by them) proclaim their white man superiority. They are either " snobbish " or put up a British colour-bar in our own country ; and yet we are supposed to belong to the same category of worship !

There is also the hypocrisy practised against us by these religions. It is both inexcusable and disgraceful—we have had a long experience of this ; it is one of the things that indicates that the sooner the Communist régime, with its abolition of religious power and of all race inequalities, is established among us, the better.

THE COMING OF THE MISSIONARIES

It was as far back as 1828 that the *Basel Mission* sent out its forces and its " dope." As is the case with infectious diseases their " message " affected a great number of people. The most unfortunate and the first to suffer from these dope-traffickers were the Akans and the Akwapims.

The Kind of Christianity we have in Akan and Akwapim Districts

These powerful nations, which up till then had lived on terms of understanding with each other despite their customary civil disputes which were of old standing, these peoples who had their own social organisation and ancient code of *fetish*, who, in a word, had their own civilisation, were now disrupted and brought into a sort of moral captivity by the missionaries.

What was the main object of the missionaries? To try to get a hold on all the native rights and properties. With this aim in view they set to and preached the gospel, and in so doing they actually went so far as to tell the people they had brought the Holy Ghost and the Spirit of Brotherly Love along with

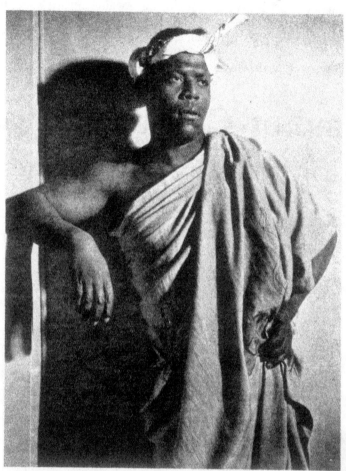

Douglas Quartey Kofi Papafio, Gold Coast
Photo by courtesy of Barbara Ke-Seymer, London

them—sufficiently belied by their subsequent behaviour. They said that the fetish ways must end, that the fetish figures must be destroyed—to make way for the white man to take possession of and "ameliorate" the country. This vicious hypocrisy is on a par with the present-day French term for massacring the natives in French colonies, which term is simply: "pacification."

Those who saw the danger remained antagonistic, but there were many who were completely taken in and who sold their various lands and possessions or gave them over to the missionaries, who thus started building their churches and schools, in the hopes of capturing yet more of the people later. The main object of a missionary school in Africa is to form more and more native preachers and to turn out a further supply of (black) missionaries, who in their own turn will continue the same work.

Those who had been duped began to send their children to the churches and schools. The pupils, some of them almost grown-up, are warned not to miss one single day at school; it is considered a perfect crime if they should miss attending church. They are further warned not to drink, smoke or dance; they are not allowed even to wear shoes, except on Sundays, until they have what is considered sufficient knowledge to acquire the status of teachers themselves—generally with the end of priesthood

The Kind of Christianity we have in Akan and Akwapim Districts

in view. When caught at a dance or at any kind of social gathering they are punished like this : stripped of their clothes, laid on a bench, and, held down by their fellow schoolmates, flogged almost to death.

By now the pupil has learned the ten commandments in English and has taken to reciting them everywhere he goes, and most of all in the company of his playmates, no doubt for their edification as well as his own.

His ambition in school is of course to try his hardest to get to that point where he will be at liberty to wear European clothes, and what is more, to be his own boss. The desire to wear these clothes of white civilisation comes from the snobbery instilled by the white man, who always teaches his pupils to look down on all things African. The desire to be his own master is even more obvious ; he wants to escape tyranny.

So, after elaborate efforts in study of this white " culture," he receives his qualification for the post he has been longing for, and consequently becomes the most eminent among his fellow playmates, whom he now leaves behind, but who however are fast following in his footsteps.

Now, at this point, although he is considered to have the necessary qualifications for his profession he finds himself under new and further restrictions. The alternatives are : either he must marry, or simply decide without further ado to become a monk, failing which he will be dismissed from his post and also thrown out of christian social circles.

About this time the impulses of nature come into his life. It happens that he is attracted to the other sex, he finds someone he loves or likes sufficiently, gets engaged, and prepares to be married. But an interruption occurs ; his fiancée discovers that she is going to have a child. This is considered a " crime " ; he must now expect to take his punishment. The news flies from place to place ; the minister in charge is informed ; the Presbyterian Conference is held to decide on his dismissal. On the following Sunday an announcement is made to a massed congregation and it is agreed that he shall be publicly disgraced. On the next Sunday the decision is carried ; he is sent for and denounced before the massed congregation, and, with a bell rung after him in the chapel, he is thrown out of the church.

What is going to happen to him? His great ambition in life is lost, his marriage is abandoned—that is, unless he chooses to marry under the native law and by native customs. Here again he is up against something. His fellow countrymen who had seen the danger and utter uselessness of the missionaries from the beginning and had retained their normal life, laugh mercilessly at him, saying : " Wo suku ko nè woannyamesem amfa woannu babiara " (Your school ambition and christian civilisation did not take you far).

What is going to happen to this young man and his betrothed? They are not wanted in christian circles, nor among their own, non-christianised, people. The solution is that they leave the town and make their home in some other place, where they will not have to come in contact with revilings or mockery. Or, if they prefer to defy their disgrace and stand up before the massed congregation and confess what is termed their *sin*, the matter of taking them back into the christian fold will be considered—though it may be quite some months before either of them is allowed anywhere near the church (*literally*).

This is just one of the examples of the manner in which religion is administered in these countries. Is it not time for our people to realise what infinite harm christianity has done to them? They have sold their lands, given up properties and possessions to the missionaries " for the love of Christ," and received in exchange the white man's oppression and race prejudice, the destruction of their ancient customs, a garbled form of so-called white culture, and all the insults that ignorance and ill-will are capable of inflicting on their own culture *on their own soil*. All this has been greatly fostered by the missionaries, who acted, moreover, as an entering wedge.

Our people must wake up ; they are indeed beginning to realise that there was no kind of " religion " in it all whatsoever, but only the rawest and most barefaced money-making.

Extracts from "The Anglo-Fanti"

(A psychological study of a type of present-day young Gold Coastian who has been educated partly in the English manner)

by KOBINA SEKYI

This as yet unpublished work, by a well-known barrister of the Gold Coast, is extremely illuminating on the super-imposition of English culture and habits on the native civilisation. The author has traced the life of a young Fanti man, from birth to death—and the result, in its trenchant, severe, and yet just analysis of his reactions, fully justified, is devastating to any thoughtful and in the least sensitive being. ED.

(AT this point Kwesi is leaving school; his education, partly in English and partly in his native Fanti, is finished—he is ready to study in England.)

There exists a sperm of snobbishness in the character of our young friend; it is involved in Europeanisation as it exists in spheres of influence, and shows itself clearly in the feeling of superiority exhibited by the boy in European clothes, or the boy whose parents are educated in the European sense. This feeling is supported by the meek acceptance of the situation which characterises the boy in national costume or the boy whose parents are illiterate. The burden of bad precedent and illegitimate prestige established under the ægis of the early missionaries is too much for the boys on either side. Hence our friend Kwesi, as a teacher in the High School and a cadet of a house of which the members have been educated in the European sense for at least three generations, affects a knife and fork at his meals, boots, collars and ties for daily wear, and aspires to pyjamas for sleeping purposes; only he does not dare to adopt the latter affectation, which would perhaps be too much even for his much Europeanised people. The noon-day sun is too hot for him in his accoutrements; he therefore takes to carrying an umbrella over his head when going to and from school in the hottest hours of the sun.

The sperm of snobbishness develops. Strange conceptions of behaviour proper to Europeans and their satellites are gathered from the many books on European life put forth in Europe by European authors. Kwesi and his companions are convinced that European life is the ideal. Clubs are therefore formed with the avowed object of cultivating the accomplishments of the perfect European gentleman. The acquisition of fluency in speaking English is sought by means of debating societies and daily conversations in English. Boys who have passed through the Low School and are signalising their completed education by discarding the national costume give "breakfasts" at which etiquette as prescribed in books such as *Don't*, and *Rules and Manners of Good Society*, is de rigueur.

Lastly, as a consequence of reading badly selected and poor examples of fiction, our friend Kwesi begins to develop the habit of posing. The absurd super-emotional psychology of the characters in such stories are taken to be worthy of emulation.

In this condition, then, Kwesi Onyidzin, *alias anglicé*, Edward Cudjoe, contemplates the prospect of professional training in England. . . .

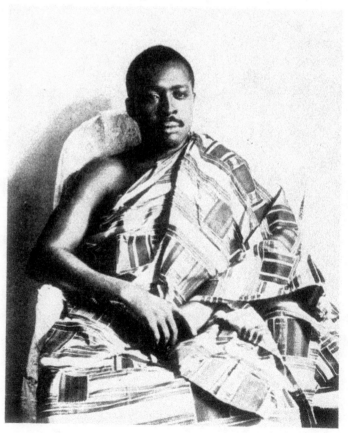

Kobina Sekyi

442

Extracts from " The Anglo-Fanti "

(As he goes on board.) It is time for one of the meals. There seems to him to be too much to eat, and his impressions of the white man's food as prepared by white men suffer a rude shock. For a few days he feels unwell, not because he is a bad sailor, for he does not suffer from sea-sickness, but because of the change of diet. He walks about, nevertheless, and is interested in the various parts of the ship. He has never before been among so many white people, and at first he is uncomfortable. His African sense of respect to his elders, rather than any sense of inferiority in the presence of white men, prompts him to address even the stewards with respect. Before the end of the voyage he has got accustomed to the white men ; but he has nothing to do with them except with the stewards and the captain. . . .

(When he arrives in London.) Someone comes to meet him, his luggage is collected ; he is conveyed to his lodging. Everything is strange. He cannot always understand the landlady when she talks, and it is a long time before it strikes him that the servant talks English ; she seems so untidy that he does not like her to be near him. The food he cannot enjoy. He longs for *nkwan* and *froi* ; he does not want the slices of cooked meat, in parts underdone, lying in a plate of some sort of gravy, bordered with uninviting greens and potatoes. He got used to fish cooked in the English manner on board the steamer that brought him to England, but he avoids the insipid sauce which is served with the fish. . . . In time he begins to be accustomed to the food ; but his old dreams as to European food are over.

His next shock is imparted by the astounding information that he must pay each time he has a bath. He does not mind paying for what he has been brought up to consider an absolute necessity. He soon enough finds out that the bath is not customary, the substitute for it being what is called the " wash." But the " wash " does not satisfy him ; and he shrewdly reflects that there are cases where it is folly to do in Rome what the Romans do. So he clings to his *esaw* and *buredziba*, and pays for his daily bath. But the *esaw* and *buredziba* are a source of very much worry to the landlady ; she thinks they will choke the pipes. It takes Kwesi time to convince the good lady that the *esaw* and *buredziba* do not wear away so quickly as she thinks. The next trouble is with the servant, who is always throwing the bathing materials away. In the end he has to talk to the landlady in order to ensure the required immunity for his precious *esaw* and *buredziba* (native sponge and a sort of indigenous soap).

It does not take him long to find out he is regarded as a savage even by the starving unemployed who ask him for alms. Amusing questions are often put to him as to whether he wore clothes before he came to England ; whether it was safe for white men to go to his country since the climate was unsuitable to civilised people ; whether wild animals wandered at large in the streets of his native town. He concludes that the people of the class to which his landlady belongs are, to say the least, poorly informed as to the peoples of other countries, especially of those parts known as " The Colonies."

But that which most disturbs Kwesi's composure is the indescribable weather. It is spring and he is much struck by the appearance of the bare branches of the trees just beginning to put forth buds. The buds are so fresh as contrasted with the blackened trunks and branches of the trees themselves. He is much depressed by the unceasing rain, the wonderfully muddy streets. It seems to him surprising there should be so much mud in paved streets, but he cannot blind his eyes to the fact that the mud is there. He hardly ever sees the sun, and the houses all have grimy exteriors. Only in the interiors of certain places of amusement and of some houses which he has visited is he impressed by any decorative ability possessed by the English and lacking in his own people. But the greatest surprise is that when summer does come the heat is intolerable even to him who came from the tropics !

On the whole he is much disappointed with England as he has seen it by the time he is six months in England. His countrymen resident in London hear of him. Those of his own age or thereabouts call on him and he calls on them. He complains of his disillusionment ; but some laugh and say he is not the only one disappointed, and others tell him he has not yet seen anything of England. . . . At the educational establishments he notices that there is no better information possessed by his fellow-students respecting " natives " in " The Colonies " than is possessed by those less educated ; the only difference is that the better educated people ask questions that are less rude.

For the next three years at least Kwesi is engaged in qualifying himself for his professional career. He possesses no mean ability for study, therefore his professional course has no terrors for him ; he knows he will finish in time. But the professional is such a small part of the more general training in all sorts of other pursuits and accomplishments which he receives during his sojourn in England. . . . In matters outside his professional course he is self-taught. The ground-work of these by-studies is the belief in the superiority of things European to things non-European, a belief he brought with him to England. It is true that his old ideas of European superiority have been much disturbed since he began to see England with his own eyes ; but of his friends, even those who have been similarly disillusioned have begun

to accept certain disconcerting matters as incidental to civilisation, and, instead of arguing from the unpleasantness of such incidents to the inherent unwholesomeness of that to which they are incidental, they conclude somewhat perversely that whoever cannot explain away such unpleasantness is not civilised. This view, moreover, is much strengthened by the remarks let fall by certain friends belonging to classes reckoned as high, who, speaking from their very insular standpoint, by reason of their pardonable and exclusive appreciation of things English as against things non-English, and of things European as against things non-European, have given Kwesi and his friends to understand that those incidents of civilised life at first sight undesirable to those visiting Europe from Africa and Asia, are hall-marks of refinement.

Nevertheless, there are certain things against which Kwesi's soul rebels. He is convinced more or less that the only way of escaping the domination of aliens is by acquiring the refined tastes of the dominating aliens ; yet he does not feel quite satisfied about these same tastes. In the first place he soon begins to distinguish the various distinct grades of society in England. For example, it does not take him long to observe that teaching in Sunday schools in the slums of London lays one open to all sorts of unwelcome attention, amounting to patronage, by civilised people very low in the social scale. He finds out, for example, that religious enthusiasm is a form of low-class emotion in England, and that the lowest orders are the most religious. The cockney accent gets on his nerves, and he flies from class-meetings where he receives religious ministration in concert with housemaids and domestics. He continues his active connection with the church of which he was baptised a member even to the extent of going out with mission bands and preaching in doss-houses in degraded localities, till the unforgettably plebeian stamp of some of his religious associates drives him out of their company. In the second place, the Fanti ideal of womanhood which somehow has taken root in his soul makes it impossible for him to replace it with the English ideal of womanhood. Kwesi finds that in spite of the attractiveness of their get-up and other allurements, white girls are to him no more than a part of the white man's land. Moreover, he feels that at the back of every white girl's mind is the idea that she is conferring a favour on any black man with whom she associates. Kwesi possesses that unique African pride which is seldom appreciable by non-Africans, often miscalled insolence by white men ; so he has little to do with white girls, unless and in so far as they treat him as a woman treats a man, and not as a white woman thinks she should treat a black man. . . .

(His studies finished Kwesi returns to Africa.) During the perfect isolation which he has unintentionally secured by being the only black first-class passenger on the liner that is taking him home, Kwesi reflects upon his life in England. The civilised man, he has observed, speaks of his life as if it had not a very seamy side ; otherwise he has little fault to find with the well-bred Englishman, who very seldom thinks, or shows that he thinks, that courtesy from a black man means consciousness of inferiority on the part of such black man, or that courtesy to a black man involves condescension on his own part. But many of the Englishmen who are his fellow-passengers are such that he is quite glad they think themselves superior and show their superiority by keeping away from him. He is grappling all along with a problem he cannot yet solve, and he wants all his time for that problem ; he wants to know why, although he feels bound to aid any effort to establish civilised life among his own people, there are many aspects of such civilised life that do not appeal to him. He has read much of the barbarous practices of heathens. Before he left home he had often been told that if the white man had not introduced his most beneficent rule into Africa, he and all his people would be suffering under the most barbaric political mismanagement. . . . Yet he does not feel in his heart of hearts that he can conscientiously support any scheme which designs to substitute *in toto* the ways of civilised life for the ways of life habitual to his people. . . .

At last he is on the Gold Coast once more, and he disembarks. His heart overflows with good feeling when he hears himself addressed in his own language after his long absence. He is glad to see and be among his own countrymen again. He sits in the boat as he is being rowed ashore and dreamily enjoys the song of the boatmen, a song sung in a manner unknown in England and awaking in one feelings and memories no English song can evoke. He recognises among the boatmen boys whom he had known and whose prowess at swimming and riding on the surf he had tried in vain to equal. These boys have now grown into splendid, well-developed specimens of manhood, with whom he cannot compare in physique. With the utmost ease they lift him on to the beach and carry his luggage out of the boat. But his joy is soon clouded. He feels quite upset when certain of his schoolmates who are on the beach and have seen him, appear to be keeping away from him. He suddenly recollects that the prevailing notion is that everybody who returns from a visit to England, especially those who have been studying there, are unapproachable. He feels thoroughly ashamed of the snobbishness displayed on such occasions. He himself makes the first advance, addressing his old friends in Fanti. To his momentary surprise they

444

Extracts from " The Anglo-Fanti "

reply in English. He notices that they are wearing clothes of a better cut than was prevalent in his time, and that they are all wearing topees. . . .

(In his own home.) Here too he observes the same queerness about those in European clothes as he has been noticing all down the coast on his way home. Perhaps the queerness is even more marked here among his own people; for those of his immediate relations who are in European clothes look somehow strange; he has an inexplicable feeling that they are not looking as he expected to see them, although he admits he has always known them to be in European clothes. On the other hand, he has been absolutely captivated by the charm of those in native clothes, especially the women. He is therefore more confirmed than ever that the native idea of clothing suits his people better than the foreign idea of clothing which they have chosen to adopt.

The younger ones among his relations wonder why he always speaks in the vernacular, although he has only just returned from England. In fact they are very much disappointed in him; for example, they say he is wearing no more distinctive material than brown holland, which everyone can buy in the local stores. . . . Some of the women cannot help asking why he does not speak some English but persists in speaking Fanti even when he is addressed in English by the " scholars " who have been to see him. He replies that he has not spoken much Fanti for many years, and therefore he desires to be permitted to speak Fanti now. . . .

He is asked by his younger relations about England. He tells them that England is a great country, a busy country, with strongly built cities containing high buildings and paved streets. He is asked whether it is true that there is no dust in England and that everything there is always nice and clean. He laughs and says that England is only a country on earth after all, and the earth is necessarily dusty. The older people grasp his meaning and are amused. He is asked what makes the streets in England shine as they seem to do in a picture of an English street hanging in the school. He says in reply that they are probably referring to a street wetted by much rain, and that such a street looks better in a picture than when actually seen. The young people think he is joking at their expense; they are quite convinced of this view of theirs when he tells them that once he woke up about half-past three in the morning, and when he looked out it was broad daylight. " It was the moon," they say. " No," he replies, " it was absolute daylight." Therefore, in a spirit of fun, he deliberately flabbergasts them with further information that at certain times of the year, in England, it is not night till about half-past nine in the evening.

Since his return Kwesi . . . feels that if he is to live at peace with those most dear to him he must exercise a great deal of diplomacy. In his own family circle his undisguised partiality for the Fanti mode of doing everything is causing some uneasiness. For example, apparently he wears European clothes with reluctance; more than once he has received visitors whilst in the national clothes, to the politely veiled astonishment of the visitors themselves and to the discomfort of his relatives; he would even have gone in the native dress to pay a visit if the womenfolk of his family had not succeeded in dissuading him from thus exposing himself and them to ridicule. On the point of the national mode of clothing, therefore, the family have had to intimate to him their views: that no one will take any serious objection to his wearing such garb within the privacy of the family circle itself, if he is so whimsical as to prefer that mode of clothing: that if he seeks to go out in the national costume, such a thing may conceivably be permitted *at night*: that he ought not to forget that nobody before him has ever done such a thing as he evidently proposes to do, a course of conduct which, if he persists in it, will assuredly attach to himself the imputation of lunacy, and to them that of incapacity to control one of their children. At length they ask him if he is going to practise his profession garbed in the native manner, implying by their tone that such an argument is unanswerable. He disconcerts them by retorting that if, owing to the precedents established by blind imitators, the members of his profession feel bound to clothe themselves as if they were practising in England, and it is deemed absolutely incumbent on every new practitioner to clothe himself in such a manner, he will consider such absurdly unsuitable clothing a sort of professional uniform; that if now it is proposed to keep him literally an Anglo-Fanti, Fanti as to his internals and English as to his externals, and such a conjunction pleases them, who are responsible for his having lived up to this time to become such a double person, then he will fall in with their wishes. . . .

It hurts Kwesi to see that his people have been led to put their faith so much in externals. Occasionally he seeks to turn their minds from externals to internals. He says to them: " Does it not satisfy you that in my private as well as in my professional life you have no fault to find with me? Why not let me be as spontaneous in my outer as I am in my inner life? Does the fact that I eat Fanti food, wear Fanti clothes, nullify the intellectual development of which my inner organisation has rendered me capable? Had I been born a dunce would any adoption of European externals have availed to bring me anywhere

near what I am today?" "No," they frankly admit, "it is true that externals are less important than internals; sometimes, on our pillows, we see much reason in what you wish to do; but then you are alone in your endeavour, and the nation is not yours alone." . . .

Since he returned he has observed that the Fanti ideal of womanhood is not reflected in the young ladies of his age. In its place is a nondescript ideal, neither Fanti nor European, but supposed to be European, which gives him good cause for believing that no girl of his day will be likely to help him make a stand against the mass of stupid precedent which every day threatens the happiness of his life. On the contrary, he is convinced that when he does marry, as he will have to, that mass of precedent will become heavier in weight as a burden on his life. Everybody, young and old, is of the opinion that he is a young man with a very perverted heart; this he knows well by now. Everybody who cares for him therefore feels it to be his or her duty to correct that perversion. It will be considered a sacred duty, conceived as such, if not by herself, at any rate with the assistance of the minister, for the girl he will select, or whom his family will select for him in the event of his not selecting one approved, to set to work to bring him back to the point at which everybody expected him to be when he returned from England. They re-member that he used to be one of those who most ardently sought to Europeanise themselves. He him-self remembers those days of misguidedness and folly, and is ashamed of what he then did under the impressions that ruled his conduct in those unreflective days. In a measure then he has himself contri-buted to the woes of his present position; in a measure he has helped to make the bed upon which he will in all probability have to lie; if he had not shown promise of becoming a leader of groundless Europeanism he would not now be held to his promise. . . .

With the prospect of a disastrous marriage so immediate Kwesi is unfit for sustained work on that and many subsequent days. He passes in review all the frock girls he knows. They are all in appearance budding types of young womanhood, some beautiful, some pretty, some merely attractive, the rest passable, but all eligible. It occurs to him that although all these young ladies have acquired in some degree the modern accomplishments of reading, writing, playing the piano or the harmonium, etc., yet most of them have had little time in which, during vacations from boarding schools, and, on leaving school, in the intervals between making new frocks and organising and attending parties, to make any practical acquaintance with the manifold problems of housekeeping and with their solution. It seems to him that from the point of view of housekeeping ability the cloth girls are preferable. But he reflects that in the first place the idea of his marrying a cloth girl will be treated with the utmost contempt when it is com-municated to his family; that in the second place cloth girls are also beginning to aspire after the social display of their sisters in frocks. . . .

But that which most moves him against marriage is the fact that his children, if he has any, will be brought up in some such way as that in which he was brought up. The probability, it seems to him, is that they will be worse off because the Fanti ideas of breeding which had held out against the influence of European ideas when he was a child have been dispelled. Each succeeding generation, it seems to him, becomes less Fanti and more European in its habits. . . .

(Kwesi decides therefore that he will not marry.) He communicates his decision to the family. They ask for reasons. He tells them his reasons, but they do not accept them; they say he talks like a book whilst they are talking common-sense. They try to help him out of what they think is the difficulty. They ask him whether he is reluctant to marry because he would much rather have a girl sent to England to be trained to become a suitable wife for him. He replies that if he marries at all he will not marry a girl trained in England. They say they will give him more time. In the meanwhile it is being noised about that he has refused to marry; it is rumoured all over the country that his real reason is that he has a white wife whom he secretly married in England. Even his family begin to accept the rumour as true, and they begin to regard him with suspicion. To allay their suspicion, which hurts him sorely, in the end he decides to marry Esi Ansuadzi, *alias anglicé*, Elsie Joshua, one of the frock ladies pointed out as most eligible. The family are glad. The necessary preliminaries are completed. Kwesi is obliged to masquerade as a European bridegroom and lead a veiled and orange-blossomed bride from the altar to a reception following on the farce in the chapel. Refreshments are served round. The guests wish the couple " *Awarso*," shake them by the hand, and depart. The families on both sides are happy; the people of the town are gratified; henceforth Kwesi Onyidzin and Esi Ansuadzi are known as Mr. and Mrs. Edward Cudjoe. . . .

Kwesi provides his wife with all that is necessary, in his opinion, to enable them to live in comfort, but the wife is often in tears since her husband always places matters in such a position by his fairness that if she does anything out of the way she soon enough wishes she had not done it. Her friends begin

Extracts from " The Anglo-Fanti "

to laugh at her and say she might as well have married a clerk. Many of the frock ladies and their " scholar " swains say that she is being treated as if she had been married under the native law ; and that in submitting to such treatment she is helping to belie her education. For, true to his word, Kwesi has always refused to accompany her to any of the " society " affairs at which " the company of Mr. and Mrs. Edward Cudjoe " is requested on printed or written cards. He tells his wife, on such occasions, that she can go if she likes ; that he finds it easier to work in the evenings than in the day and, therefore, must be excused from attending. He will not attend garden-parties and similar afternoon shows because he is expected to appear in European clothes, and he has decided never to wear European clothes except for purposes of professional practice and attendance at chapel on Sundays. Kwesi's wife is unhappy, but she will not give in. She says it is due to her breeding and position to influence her husband to lead the life for which, in the eyes of the Europeanised people, he is fitted. . . .

(And finally things came to such a point that, as is African custom, the families of both were called in and the wife was taken back by her own people, which solved the situation. In that manner, though they had been married under English law, they were now considered divorced under Fanti law and by the custom of the country.)

He has not yet solved the problem he brought with him from England, namely, why, although he has found out that in many fundamental respects the European mode of life is lacking in soundness, yet in certain other apparently as fundamental respects he feels constrained to copy that mode of life. In his spare time he has been tracing the European mode of life to its sources ; but after groping about among obscure antecedents he has not yet discovered the key to the problem. He has appealed to sociology. He likes the subject, the study of which enables him to understand many difficult points about life in society. At length it dawns upon him that the key to the whole problem is the distinction between the essentials and the accidents of social life. Following out the implications of this distinction he discovers that those aspects of life in Europe which he felt constrained to copy are not essentially European in character, that they partake of the nature of acquired characteristics, that they are later developments in the institutions of society, whilst, on the other hand, those aspects of European life which could not attract him when he was in England are essentially European and require a European psychology to appreciate and maintain them. He understands therefore why he felt ashamed of the snobbishness which had characterised him before he left home for England ; for whilst in matters essential to their life Europeans are natural and spontaneous, he and his friends, in copying such essentials, have been aping Europeans and have therefore been *poseurs*. He is satisfied with the position at which he has arrived in his thought, because it enables him to place on a rational basis the conviction he had felt, since his return from England, that the native customs of his people are not savage customs as white men claim, but, on the contrary, are perfectly rational and natural, and, in that respect, on a par with the essentials of European life. Only, then, in so far as the social organisation of his people lacks the accidents of European life can Europeans refuse to regard them as civilised, because the claim of Europe herself to civilisation stands upon these accidents which, being of comparatively recent development, and being hurriedly superimposed on the essentials, are often in violent opposition to such essentials. . . .

(Kwesi has a nervous breakdown and in his delirium) he cannot recognise any of his people ; he says his mother is not his mother because she wears European clothes ; the woman representing his mother is therefore a white woman who has disguised herself. . . .

(The delirium passes, but Kwesi is so ill that he is dying. As last wishes) he would ask them one favour, namely, that if at any time any other member of the family, trained in England, on coming back, preferred to live as a Fanti man who had merely been trained in England, instead of living as a black Englishman who understood Fanti, they should leave such a one to live his own life as long as he was not undutiful ; they should not seek to constrain him to live an artificial life ; for the Fanti man's life was at least as good as the Englishman's life, and the mere accident of scientific development in the invention of machinery was not sufficient in itself to give any nation ground for calling itself civilised.

447

Liberia : Slave or Free ?

by BEN N. AZIKIWE

HISTORICAL ORIGINS

Ben N. Azikiwe

IN order to better appreciate the barriers before Liberia a brief review of its historical origins appears pertinent. At a time when mankind was prompted by a social consciousness as to the moral wrong of the incarceration of human beings in bondage and servitude, certain individuals and groups, like Paul Cuffee of New Bedford, Massachusetts, and other American philanthropic bodies, moulded public opinion as to the necessity of founding a terrestrial paradise for those who would have the gumption of pioneering to establish a national hegemony of blacks in Africa.

Thus in 1822 colonisation on the Grain Coast of West Africa was an accomplished reality. The difficulties encountered by the founders of this future black republic have been unequalled in the history of any nation, black or white, excepting perhaps the trying experiences of the Puritans in the *Mayflower* days. Forced to become a political nonentity, it was realised that these colonies must either become integrated with the colonial possessions of France and Great Britain, or they must shake off the suzerainty of a private corporation and confederate and assume a *de jure* political existence.

Hemmed in by two avaricious nations which claimed autonomy over a vast district of Africa on the strength of the conventions of the Berlin Conference of 1885, and aided by their rapinage over this virgin soil of undeveloped territory, Liberia was forced to decide for its existence or for its extinction. Led by able statesmen who rank with the world's greatest, Liberia thus proclaimed itself a republic in the year 1847 and drew up a Constitution which guarantees to its citizens not only the rights of life, liberty and pursuit of happiness, but is today the *suprema lex* of the land. Thus was fulfilled the dream of history—that the black man has yet a chance to prove his political capacity. Immediately the great powers of the world recognised Liberia, although it took the United States fifteen years to accept a black republic as its equal in the roster of sovereign states. With this recognition, Liberia signalised its entry into the diplomatic history of nations in accordance with the principles and conventions of international law.

LIBERIAN DIPLOMACY

Realising its physical weakness, the Republic of Liberia depended upon international morality to play a great rôle in its foreign policy. But it was a mistaken notion, for since the dawn of history the fundamental factor in international politics has been that of Machiavellianism. Little by little Great Britain and France encroached upon Liberian territory. While in principle this is a gross contravention of the law governing the intercourse of nations, yet in actuality these powers justified their interventions on the grounds of " prescriptive right " and " effective occupation." Thus were certain treaties and *procès-verbaux* signed, slicing away the western territory of Liberia up to Manoh river to Great Britain, and the eastern boundary up to Cavalli river to France.

Another important factor in Liberian diplomacy is the trampling of its sovereign majesty as is recognised in international jurisprudence. The fact that a Negro republic exists in Africa naturally makes the white man conscious of the psychological effect of this on the self-determination of other indigenous natives. Thus occasionally Great Britain, France and Germany have sent gunboats into Liberian waters, and on several occasions have bombarded some Liberian municipalities without justification, real or imaginary. In one instance, the flouting of Liberia's sovereignty reached its apogee when a contemptuous British officer, Major Cadell, virtually became dictator of Monrovia, in order to enforce certain provisions of a loan pact.

Since its founding, this republic has been entangled in several loans, and due to lack of empirical knowledge of applied finance, it has always been susceptible to victimisation. The loan of 1870 was a reflection of an incompetent and selfish executive later deposed by the Liberian people. The loan of 1906 revealed the white man as a danger to the financial stability of a Negro republic without funds,

arms and power. The loan of 1912 was perhaps the most constructive of all other previous loans, but at that, Liberia had to forfeit some of its sovereign rights.

The Firestone project, with its loan agreement, while in a sense practical, because of its promise for the economic and financial rehabilitation of the country, yet is a unilateral one. It appears that the consideration for the granting of this loan was unconstitutional according to the organic laws of the Republic of Liberia. No doubt the benefit arising out of this project and loan will be made reciprocal, yet its unconstitutionality lies in the fact that the agreement stipulated for the lease of a million acres of land for ninety-nine years. Unless the Constitution of Liberia has been amended to this effect, this, *ipso facto*, violates the judicial interpretation of the Constitution as laid down in the case of *Oliver* v. *Bingham* (1870), where the Supreme Court of Liberia ruled that " A lease of land to an alien for ninety-nine years is an evasion of the prohibition of the Constitution, and it is therefore unconstitutional. . . . For the Constitution prohibits an alien from even an imaginary claim to land, and therefore the law will not give aid to it, however much it may be disguised." Subsequent decisions on such cases as *East Africa Company* v. *Dunbar* (1895), and *West* v. *Dunbar* (1897), further strengthen the principle enunciated in the *Oliver* v. *Bingham* case. So far, unless a legal loophole could be fashioned, the Republic of Liberia could not be bound, unless it chooses to, by the provisions of this unconstitutional Firestone agreement with its limitations on the financial policy of the republic.

SOCIAL PROBLEMS

Outside of these political and economic factors in the history of the Liberian Government, there is also the social factor. Divided into various ethnic groups which range from Grebos, Krus, Vais, Mandingoes, Kpwessis, to the Golas and other clans, social relations have been strained. While the customs of these tribal units are diverse in principle, yet in practice they are identical. Moreover, the influx of immigrants from the New World has made social adaptation difficult. The so-called Americo-Liberians, just from American slavery, were guilty of stratifying themselves into a Bourbon class just as the *soi-disant* blue bloods of New England did, and are still doing in the United States today. Unfortunately the Americo-Liberians failed to appreciate and assimilate primitive Liberian culture, and hence the ever-persistent bugaboo of the native problem.

Besides this, it is apparent that the Americo-Liberian is not very desirous of the Aframerican. In the first place, he is a member of the ruling class. His social atmosphere is dominated by the air of complacency and respectability. On the other hand the Aframerican is too " democratic " in his outlook and has not the modicum of diplomacy to adapt himself to this phase of the social philosophy of the Liberian aristocrat. Thus there is distrust, suspicion, and ultimately aversion. If I may venture an opinion, the failure of T. J. R. Faulkner to wrest political power from the True Whigs Party may be due to this social attitude. Moreover the Americo-Liberian in conjunction with the indigenous citizens of the land, cherish their heritage of liberty and political autonomy. Thus they are conservative and will not tolerate the presence of any group which may endanger their highly prized inalienable rights. This attitude is probably responsible for the failure of Marcus Garvey and his colonisation scheme for Liberia.

FORCED LABOR AND PAWNING

While individuals and officials have indulged in assailing Liberia because of forced labor and the system of pawn as practised under the territorial jurisdiction of Liberia, one forgets that the Government is just as interested in the removal of this stigma as any other nation. Nevertheless, it does not, will not, and must not accept the guilt, if it is to maintain its rôle in the political history of Africa. Call this what you may—ethnocentism or African nationalism, but Liberia must not bear the blame alone while other nations romp in hypocrisy. The practice of forced labor is nothing new in Africa and the Orient. The International Labor Office, the League of Nations and several conventions and multi-lateral treaties and multi-partite agreements, protocols, etc., give sovereign states and quasi-states the right to practise forced labor in certain circumstances. Thus is derived the principle of international diplomacy which is a legal sanction for the practice of forced labor. If, therefore, Liberia avails itself of this legal sanction, as did Great Britain, France, Germany, Spain, Portugal, Belgium, Netherlands and the incompetent semi-sovereign state of the Union of South Africa and the colonial possessions of these powers, including the League of Nations mandates, Liberia should not be too severely dealt with. The flea of international opinion should not make a skating rink out of Liberia's bald head ! That is the tragic situation of Liberia today !

One does not condone forced labor. One does not absolve Liberia even if the International Commission found it guilty in certain respects, but one submits that the real criminal is not Liberia, but Spain. According to the 1914 treaty between Liberia and Spain, the latter agreed to treat Liberians with kindness

449

and also agreed to " punctual repatriation " of the laborers recruited from Liberia. Spain has not effected punctual repatriation according to this treaty, but rather it has devised subversive means for the imprisonment of laborers when their indentures were nearing termination, according to George Schuyler (*vide* New York *Evening Post*, June 29, 1931, p. 2). If, therefore, there is any blame to be preferred by the League of Nations, provided it has that power, then Spain and not Liberia is guilty of forced labor.

So far, several " investigators " and sensationalists have written against Liberia. The fact that they view the matter from one angle makes their charges unfair. Whether Liberia detribalises a village or not, is not a question of ethics. That is nothing new in the study of colonial diplomacy. So long as raw materials are needed, and so long as imperialism is the contemporary international political philosophy, what care the sovereign states as to the rôle of the family as a social unit? European nations have done that and they still do it in Africa and other strongholds of economic imperialism. Recently France imported thousands of Chinese for construction work on its Brazzaville-Ocean Railway. These men are to be supplemented with drafted native labor. Of course one does not exonerate Liberia, but one submits that on a comparative basis its guilt is negligible when compared to that of Spain and the imperialistic powers.

With reference to pawning, this is due to misconception and abuse of the ethics and sanctions of primitive society. To the Western mind, pawning is abhorrent. To the African it is the connotation of a social philosophy misapprehended and misinterpreted by alien writers, and unfortunately abused by certain individuals. Pawning does not indicate or connote slavery in the Anglo-Saxon sense of the word. It has no correlation whatsoever with servitude. The idea is towards a communal security. In other words it is an educational insurance, the indemnity of which is the exchange of free labor for protection and education. The nearest Western practice is the European feudal system of the days of the pre-Industrial Revolution. The difference in the two is that African pawning is socionomic, while the European system is purely economic. After all, frankness demands one's admission that the system is subject to abuse, which is the case in several countries.

Is Negro Government Feasible?

In order to answer the question—Is Negro Government Feasible?—it is expedient to state that today there are only three states in the whole world ruled and governed by black men. These states are Abyssinia, Haiti and Liberia. Certain writers detract from the political capacity of the Negro. They claim that Abyssinians are not Negroes. But one may say that if the term Negro denotes blackness, then Abyssinians are Negroes. There is no patent standard for judging the characteristics of any one race. There are variations no matter how accurate are anthropometrical instruments. Among whites you find Negroid features. Among blacks you find caucasian characteristics also. The safest instrument for this thesis is therefore color and nothing else. A black man with nordic features is a Negro and a white man with Negroid features is a caucasian from the standpoint of color. Nothing else is more definite than color as a criterion for the classification of races.

As to the inherent political incapacity of the Negro, Continental and American writers have exploited this field. Count Gobineau, despite Finot's rejoinder, claims that the Negro is mentally inferior to the caucasian. Benjamin Kidd held that " there never has been, and there never will be, within any time with which we are practically concerned, such a thing as good government, in the European sense," by Negroes. Lothrop Stoddard, ignorant and hopelessly prejudiced, says that " Lack of constructive originality renders the Negro extremely susceptible to external influences," and further adds to this that " unless, then, every lesson of history is to be disregarded we must conclude that black Africa is unable to stand alone." Lord Lugard, the inimitable imperialist, said that the Negro was lacking in political ingenuity and consequently this Britisher endorses economic exploitation of Africa. Monsieur Beaulieu concludes that " The blacks of Africa . . . must be directed, guided, governed for a good number of years by Europeans," because of their political incapacity. (My translation.) Meredith Townsend adds his *coup de grâce* by saying that the black man has " never exercised the smallest influence over peoples not black," because he has not the " capacity to develop civilisation."

The Negro, however, has had his defenders as well. Outside of the scientific expositions of men like Professor Boas of Columbia University, Professor Hooton of Harvard and Professor Dorsey of the University of Chicago, in the fields of sociology and anthropology, relative to the mental equality of the Negro with that of the white race, so-called, others have also become his apologist in the field of political science. No less an authority than Dr. McPherson of Johns Hopkins University postulated that there is a spark of political ingenuity among the statesmen of Liberia. L. Jore, the celebrated French writer, Professor Starr and Sir Harry Johnstone have opined that the ability of the kingdom of Abyssinia

Liberia : Slave or Free ?

and the republics of Haiti and Liberia to withstand the buffets and assaults of imperial countries for several years, shows that the Negro when given a fair chance is capable of directing his political destiny. We shall not discuss the merits and demerits of this issue, suffice it to add that the African is a natural statesman. He has been a political power from time immemorial. His primitive societies are replete with political institutions that are now being patterned after modern states. If his past history reveals such genuine evidences of political capacity, then his future needs no further comments or conjectures.

THE CRISIS OF LIBERIA

After this digression as to the relative ability of the black man to rule himself we come now to the crisis of Liberia. The caption of this article—" Liberia : Slave or Free ? "—staggers the imagination of one who has been used to reading of Liberia, either as a land of free Negroes, or as an asylum of quondam American slaves, or as a protégé of the United States, or as of late, the land of pawn and forced labor. To my belief the answer to the question admits of no mincing of words. Liberia is a free state. Sovereign and politically autonomous. She is recognised in international law as a member of the family of nations. She belongs to the League of Nations and is accorded all rights, honors and privileges due to sovereign states. If Liberia can be anything else but a free state that is an international absurdity. Despite the ruthless propaganda of certain press agents to pave way for a vicious mission of economic imperialism in this last political stronghold of the black man in Africa, excepting Abyssinia, one submits that Liberia is not a slave state. She is sovereign over her territorial limits, subject to the courtesies accorded members of the family of nations according to the principles and practice of the customary conventions which guide the intercourse of states. She is not a protectorate and never has been a colony of the United States. This thesis applies to Liberia in principle and in practice. Take it or leave it.

NOTE : It must be said here that one cannot limit oneself to this purely *legal* interpretation of international law concerning Liberia. This legal interpretation does certainly show up the real character of the indignant anti-slavery outcries in France, England and Geneva which are raised only towards the justification of intervention by the white powers. It demonstrates also that the black bourgeois government at Monrovia does neither more nor less than apply the very same methods of native government as are practised on a larger scale by the white colonial powers, and likewise that the outcries of the latter cannot be qualified otherwise than as a desire of partial or total annexation, and thus in no way in accordance with international law. But two brigands at loggerheads, although they are unevenly matched, are none the less two brigands who must be equally opposed. The Liberian black bourgeois government is increasingly at the orders of its white rival who furnishes it with funds (under the form of loans) without which it would be unable to exist. In recent years the contracts with Spain and France to furnish enslaved workers for Fernando Po and Cameroon ; then the servile obedience to the Firestone Co. and American capital ; and only a few months ago the almost secret agreement with a so-called Danish company, composed in reality of international capitalists, which is preparing to dispense its benefits. . . . The Liberian government? A lesser bourgeois at the orders of a foreign banker who has certainly no " legal international right " over him, but a far stronger right: capital. White capital without which the small Liberian bourgeois could not subsist, and in exchange for which he *sells* his countrymen.—R. MICHELET.

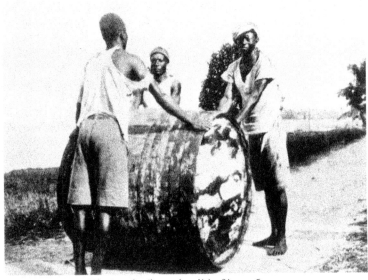

Workers loading palm oil in Sierra Leone

451

Kenya

by JOHNSTONE KENYATTA

General Secretary of the Kikuyu Central Association

Johnstone Kenyatta

ENYA is the most important British colony in East Africa. It covers an area of 225,000 square miles, with a population of over 3,000,000 Africans, 17,000 Europeans, 46,000 Indians and 12,000 Arabs. It is here that capitalism is manifested in its most brutal form. The native population is composed chiefly of the Kikuyu, Kavirondo, Wakamba, Wanyika and Masai; whilst on the coast are to be found Swahilis and Bantu people whose language, Kiswahili, is understood throughout Kenya.

During the past 35 years these people have been robbed of their best land and are today reduced to the status of serfs forced to work on their own lands for the benefit of the white " owners," and even in some circumstances to work without pay or food.

DETRIBALISATION

With alienation and expropriation of the African land, a certain degree of detribalisation has taken place in Kenya.

British imperialism supports the backward form of social relationships in Kenya. The Governor of Kenya " is not of the opinion that at present, or for a considerable time to come, any provision need be made for the representation of detribalised natives." For him, " detribalisation is obviously a tendency to be discouraged by all reasonable means." By operating on tribal differences, British imperialism's age-long policy of " divide and rule " is enhanced, while the Kenya African national liberation movement is arrested.

EUROPEANS IN KENYA

Nearly all the Europeans in Kenya have settled in the country since 1902, in which year the whole white population was about 400 traders, officials and missionaries. Today they number about 17,000.

All Europeans, as such, and however uneducated, have votes. No African, however educated, has one. The education of all African children is restricted to what these European exploiters believe to be good for them; for instance, how to pick coffee with two hands. The most expensive schools, with revenues of £20 a head, admit European children only. Schools of an intermediate type with revenue of £5 10s. admit Indian children, whilst those with the least expenditure, costing the state about five shillings per head and with a very restricted curriculum, are specially reserved for African children.

In social relationships in Kenya, Europeans are masters and Africans servants. The vast majority of these philistine whites in Africa believe that relationship to be an integral part of " the natural order of human society." Anyone doubting this idea would be regarded as a " bolshevik." But if they have, as they claim, a natural inherent " superiority " over Africans, they could have nothing to fear if black children were given the same opportunities as white children.

Education in Kenya is deliberately directed to training European children to become the governing, land-owning, employer class—the dominant race—while Africans are taught only that which the oppressors believe will turn them into good servants and obedient slaves of British imperialism.

The wholly parasitic character of British imperialism in Kenya is best exemplified by an advertisement from the *East African Standard*. This paper, the mouthpiece of the white exploiters, writes : " The European in Kenya, tired after the strenuous exercise of playing golf, cricket and polo, is advised to add a drop of Scrubb's Ammonia to his bath and lie in the warm caressing water that Scrubbs has softened and smoothed. Rest while your body is imbued with new vigour—the penetrating powers of Scrubbs clear and cleanse your pores wonderfully."

A European, describing life in Kenya, writes : " Life out here is divided between sport, extracting as much as we can get out of the country and entertaining our friends. For instance, I am wakened at 7 by my black boy, who brings me a cup of tea and a cracker. At half-past 8 the breakfast bell rings and we go down to a substantial meal of oranges, fried herring, bacon and eggs and marmalade and toast.

Kenya

At one o'clock we have lunch—pea soup, boiled tongue, roast mutton and chicken, curry with rice, ending with a dessert of native fruits and canned Californian apricots. Our dinner at eight will be much the same as lunch, except that if we like we can wash it down with whiskey and soda, wine or beer."

Thus the wealth which the Kenya Africans produce goes to swell the coffers and stomachs of these British imperialists and the white landlord settlers, instead of being used for the development of the people which provides it. This is the kind of parasitism which prevails in Kenya!

TAXES

Another method of robbing the Africans is through taxation. They are made to pay taxes from which they derive little or no benefit. If they refuse to pay they are considered and treated as criminals.

The overwhelming majority of African families in Kenya earn less than £5 a year. Out of this small sum, besides other taxes they must pay an average of 28 shillings in cash to the Colonial Government. The hut and poll taxes of 12 shillings are the main tax. Each male of sixteen and over has to pay 12 shillings on his own behalf, and if he has dependents who live in huts of their own, such, for example, as an aged mother, he has to pay a separate tax on each hut to the amount of 12 shillings. So, even though there are not more than half a million males in Kenya, including the old and otherwise unfit, more than a million taxes are actually paid.

These amounts at first sight seem very small, but it has to be remembered that the average wages of an African worker are from 6 shillings to 12 shillings a month, so that the tax represents the whole of his earnings for as much as two months, even if he does not have to pay, as often happens, for other members of his family.

The total amount paid by the Kenya Africans in 1924 with its population 2¼ millions was £562,000—4s. 6d. a head for every man, woman and child among people whose whole family income is £6 a year.

FORCED LABOR

Despite all denials by the British officials before the International Labor Office and in Parliament, forced labor exists throughout the length and breadth of Kenya.

All roads of Kenya are kept up by the African toilers under the directions of their chiefs, while behind the chiefs are the British officials. Every adult African male and female is subject to a road tax of at least one month's work during the year. The roads built by the Africans enable the European parasites, tourists, travellers and sportsmen, to exploit the country more easily.

One kind of direct taxation paid by Kenya Africans consists of unpaid forced labor. Under the native *Authority Ordinance*, all adult males may be and commonly are required to do six days' unpaid work every three months. The penalty for refusal was formerly a fine of up to £7 10s. But Sir Edward Grigg in 1928 thought that a fine was not punishment enough and since then the magistrate may add a sentence of two months' rigorous imprisonment. Of course this is equal to two months of forced hard labor.

In Kenya forced labor is also called communal labor. It is often asserted in defence of this unpaid forced labor, and the assertion seems to be believed by the Colonial Office, that it is no more than what the tribal authorities always required. This, however, is totally at variance with the facts, for all such forced labor, making and repairing of roads and railroads, bridges and buildings, is done on work that the Colonial governments and settlers, and not the tribal authorities as such, want done. This " communal " forced labor is scarcely if ever employed on work, such as building village schools, that the people themselves want done.

" At least nine-tenths of the forced labor is in the making and repairing of roads and bridges and Government buildings. The District Officer is told that such and such buildings or roads ought to be made or put right. He in turn sends for the chiefs and tells them what he wishes to be done. The chiefs in turn summon the headmen and sub-headmen, telling each how many men he must produce; and they in turn go to the villages and choose the men to be called." (Leys, p. 35.)

At Kisumi, in 1925, the shortage of labor for the loading and unloading of steamers, lighters and wagons was being met by employing " prisoners." (Africans arrested for not paying taxes, trespassing on the European plantations, etc.) After a short time of forced labor in prison the Africans are physically exhausted, sick, unfit and not able to do this heavy work.

If the methods of taxation do not supply the demands of the settler landlords for African labor, the next stage is direct compulsion exercised through the tribal chiefs and headmen who, as we already mentioned, are the paid servants of British imperialism.

Prison labor is even cheaper than forced labor, and it is not difficult to get Africans sent to prison in

Kenya

Kenya. Kenya Africans may now be sent to " detention camps " on the simplest pretext under ordinances relating to trespass, wild birds, fish protection, game, and about a dozen others, besides the Masters and Servants and Native Labourers' Ordinances. This gives a fairly wide field from which a cheap labor supply can be drawn.

That forced labor has no limits under the rule of British imperialism can be seen by the increased use of women and child labor by forcibly sending them on to the alienated plantations of the invading white imperialists.

Thus the chain is complete. The Kenya Africans are robbed of their land, and driven by taxation which they cannot escape to enter into a forced contract, oral or written, as tax earners; if, in spite of everything, they refuse to enter into any such contract they can be arrested and thrown into prison and thereby forced to labor at less than the current rate of wages with which to pay their taxes, which means that they will have to work harder and longer.

FINANCE CAPITAL IN KENYA

One of the largest plantation companies in Kenya is the East African Estates, Ltd. It has a paid-up capital of £260,000 and owns 350,000 acres, including valuable land near the port of Mombasa. It also owns nearly the whole of the share capital of Central Coffee Nairobi Estates, Ltd. The company lately exchanged some of its estates for 20,000 acres of more productive land in the highlands of Kenya. The two largest shareholders in 1925 were Viscount Cobham, who held 15,608 shares, and the Earl of Plymouth, who held 36,610 shares. Viscount Cobham was formerly Private Secretary to the High Commissioner of South Africa and Conservative M.P. for Droitwich from 1910 to 1916.

The British East African Corporation was formed in 1906 to carry out financial and agricultural operations in Kenya and Uganda. It has secured freehold and leasehold grants of Crown land, and owns cotton ginneries, sisal plantations, coffee estates, etc. The company's paid-up capital is £400,000 in 10s. shares, of which 83,333 were allotted as a 16⅔ per cent. bonus for shareholders in 1920. The largest holding of shares in January 1925, was 24,575 held jointly with two others by the Rt. Hon. Reginald McKenna.

In addition to these larger concerns, which are to a great extent investment companies owning shares in railways and mines, there are numbers of plantation companies owned by European shareholders and entirely or mainly engaged in producing profitable crops. The capital of these plantation companies is generally comparatively small, owing to the fact that they were able to acquire land at very low prices.

The identity of interest between the capitalist and the state declares itself with special force when Government servants holding high office and the capitalist drawing profits from colonial enterprises are one and the same individuals. So we find Lord Lugard beginning his career as the leader of private military raids on behalf of British imperialism in Africa, later holding important appointments in the Colonial Service, and finally reverting to commerce as a director of colonial banking and plantation companies.

The Chairman and Managing Director of the Bwana M'Kubwa Copper Mining Co., Ltd., is Mr. Edmund Davis, who is a director of 48 mining and developing companies in different parts of the world. With him on the Board of Directors is Lieut.-Col. C. H. Villiers, who took part in the Uganda campaign of 1893 and the Jameson Raid of 1896 and is now director of 14 companies mostly concerned with African mines.

Even maize crops, for which both the cost of production and the profit per acre is much lower, provides a 10 per cent. return on the whole paid-up capital of East Africa Estates, Ltd. That very substantial profits are actually being made by plantation companies is shown by the record of Dwa Plantation, Ltd., owning 20,000 acres in Kenya, which paid dividends of 10 per cent. for 1923, 15 per cent. for 1924 and 17½ per cent. for 1925. These are the latest figures we could gather.

It is not surprising that the Bishops blessed forced labor, for many clergymen and missionaries are among the shareholders.

THE AWAKENING OF THE AFRICANS

The soul of the African is stricken nigh to death by confiscation of its ancestral lands, the obstruction of its free development in social and economic matters, and its subjugation to an imperialist system of slavery, tax-paying, pass-carrying and forced labor. This policy of British imperialist robbery and oppression aroused the greatest alarm and anxiety amongst the Kenya Africans, the outcome of which was the revolt in 1922, when defenceless Africans, men, women and children, were shot down by these filibusters.

Kenya

In order to undermine the minds of the African masses by hypocritical phrases, an ordinance was passed (*i.e.* the Kenya Native Lands Trust Ordinance of 1930) followed by a Memorandum on Native Policy, in which documents we find *inter alia* :

" Primarily Kenya is an African territory and His Majesty's Government think it necessary definitely to record their considered opinion that the interests of the African natives must be paramount, and that if, and when, those interests of the Africans and the interests of the immigrant races should conflict, the former should prevail."

This sounds well and good on paper, but when it comes to real practice, no doubt it is the interests of the immigrant races (white imperialists) which " prevail."

It was further stated that if land is taken for public purposes other land equivalent in superficial extent, and also, as far as possible, equal in agricultural quality, convenience and market value to that taken away, plus an addition as compensation for disturbance, must be given. In order to cover the cost of reinstatement in new homes, the Government must also meet the cost of removal. But before such an action is taken the natives concerned had to be given ample notice ; and finally, the assent of the Native Councils must be secured.

That was the law of Kenya and a " solemn pledge " till gold was discovered on one of the Kavirondo Reserves in 1931–2. In the presence of that glittering metal the British imperialists could not face their so-called " word of honour."

Immediately, an Amendment Bill was rushed in through the Legislative Council of Kenya, and in a short time it was sanctioned by the Secretary of State for the Colonies, Cunliffe-Lister, who professed to having " the interest of the natives at heart ! " His action allowed the Kenya Government to amend the Native Land Trust Ordinance, and the taking away of native land and leasing it without any obligation to provide equivalent land for the natives concerned. The restriction to " public purposes " is no longer recognised, and lest the Native Local Councils should object to this contemptuous robbery their consent is dispensed with. It is not considered necessary to bring a proposed " temporary " exclusion to the notice of the Local Native Council or the natives concerned.

Cunliffe-Lister, speaking in the House of Commons with regard to this expropriation of native land, said : " Nobody is going to benefit more than the natives." What are these benefits? Since the gold-diggers entered into the Kavirondo Reserve, they have undoubtedly carried out wholesale looting. They have taken away the native land, which the Government declared sacred and inviolable. They are turning young African girls and women into prostitutes in order to satisfy their sensual lust, they are dragging their " honour " in the mud and slush, their civilisation is all in the interest of capitalist greed and imperialist exploitation. African villages have been overrun, their crops have been rooted out without compensation, the villagers have been brutally treated by the gold-diggers. This inhuman treatment is what the honourable gentleman calls " Benefit."

At present there are over 1,000 European prospectors in the country and many others are on their way there. The presence of these gold-hunters in the Kavirondo country is regarded with the utmost hostility by the native inhabitants, who less than two years ago were told that their land had been reserved for their use for " ever," which they innocently believed, therefore, to be free from any alien settlement. But now they suddenly find it overrun by increasing numbers of European gold-hunters who are gathering like flies round a honey-pot in the hope of satisfying their greed at the expense of the natives of Kakamega. Already an area of over 400 square miles is in the hands of the prospectors, they have started damming and diverting the streams for the purposes of alluvial gold washing, and have taken to digging huge pits and trenches all over the place among the native villages and the cultivated fields. They have pegged the whole countryside for their future operations. The area so taken is most densely populated and closely cultivated by the natives. This shows that thousands of them will be homeless and landless. The Government stated that this expropriation of land will be only " temporary," and that is why compensation in land was not necessary. This is just a lie pure and simple, because millions of acres of the best lands were formerly taken from the Africans in this way of " temporary occupation," and never came back. It is quite clear that what the British imperialists want is to create a landless class of Africans, so that they can enslave them in the gold mines and herd them in the compounds just as they are doing in the South African gold-fields.

In addition to the area mentioned above, there is an additional area of 5,900 square miles which might be taken at any time for the benefit of a few individuals who are going out to Kakamega for their selfish gains. What Africans are asking is: Where is the " solemn pledge "? Where is the " sacred trust "?

Kenya

The Struggle for Freedom

It is clear now that the " promises " which have been regarded as " sacred " have already been broken. Every Kenya African should understand that these promises are nothing but a decoy to keep us sleeping while the imperialists are planning for further robberies and exploitation in order to satisfy their own ends. It will be remembered that the policy of imperialists is " divide and rule," thus they have been able to create hatred between various tribes, and thereby they have been able to rob and oppress us separately. Therefore, let us unite and demand our birthright.

Of the contributors to *Negro* for whom Nancy reserved lasting gratitude, George Padmore belongs among the foremost. Born in Trinidad in 1903, Padmore migrated to the United States and joined the Communist Party, and then undertook extensive travels in Africa, Russia, and Western Europe. By the early 1930s, when he first met Nancy, he had held various posts in the Party and had distinguished himself as a prolific pamphleteer. He was also the editor of the *Negro Worker*. Padmore quickly discovered Nancy's passionate interest in the Scottsboro case and asked her to serve as the honorary treasurer of the Scottsboro Defense Committee. Nancy, in turn, told him about *Negro* and asked him to contribute whatever he could. They met often, Padmore always introducing her to more and more of his black friends, and Nancy responding with her usual enthusiasm. In June, 1934, at Nancy's Réanville home, they labored to finish his book, *How Britain Rules Africa,* Nancy marveling at his "capacity for sheer, lengthy hard work." The book was eventually published by Wishart.

A few months after the publication of *Negro,* Padmore received a stinging criticism of one of the four articles he had written. The critic was another contributor, James W. Ford, who contended Padmore had

erred in labeling Haile Selassie "a progressive monarch." Nancy, annoyed, protested: "A lesser man would likely have become a howling counter-revolutionary overnight.... As soon as my *Negro* came out ... and Ford, as contributor of an article, had automatically received his copy, there came to me an article, by him, purporting, you might think, to be some sort of review of the book. It was a diatribe only against Padmore in the *Afro-American*, entitled, 'Padmore Sups with Kings and Emperors.' These 'kings and emperors' turned out to be Haile Selassie, because Padmore wrote a very good piece on Ethiopia for *Negro*, in which he called the Negus 'a progressive monarch.' I suppose that under orders (as yet unknown to Padmore) the word 'progressive' was enough." (Letter to James R. Hooker, February, 1965. Quoted in James R. Hooker: *Black Revolutionary*. New York, 1967).

Nancy and Padmore became collaborators once more during the World War II when both lived in London. This time they explored the meanings contained in Roosevelt's statement of the "Four Freedoms," and attempted to determine how they would affect Britain's future as a colonial power. Their speculations were published as *The White Man's Duty*, in 1942.

H. F.

White Man's Justice in Africa

by GEORGE PADMORE

TSHEKEDI, the Paramount Ruler of Bechuanaland, has been suspended by the British Government because he ordered a white man by the name of Phineas McIntosh to be flogged after he had been found guilty of debauching native women of the Bamangwate tribe in the Protectorate of Bechuanaland.

The politicians, who are ever ready to advance the interests of British capitalists, are utilising the present situation to revive their campaign for the annexation of Bechuanaland and to bring it under the complete domination of the Government of the Union of South Africa. They hope that in this way they will be able to achieve what Cecil Rhodes failed to accomplish—namely, robbing the natives of Bechuanaland of their lands and turning them into slave labour for exploiting the mineral resources of the country, just as has been done in the Transvaal and other sections of the South African Union.

Already General Smuts and Mr. N. C. Havenga, the Minister of Finance, have been discussing with Mr. J. H. Thomas, Secretary of State for the Dominions, the taking over of Bechuanaland.

A military force of two hundred British marines with field guns under the command of Admiral E. R. Evans, commonly known as " Evans of the *Broke*," recently marched into Bechuanaland, took possession of Serowe, the capital, and deposed Tshekedi.

Shortly after the arrival of Admiral Evans, the Acting High Commissioner of Bechuanaland in place of Sir Herbert Stanley, a court of inquiry was instituted for the purpose of investigating the reason why McIntosh had been ordered to be flogged. The commission was composed of Captain H. P. Neal, the Assistant Resident Commissioner, Mr. M. E. Liesching, the political Secretary of the High Commissioner, and Captain G. E. Nettleton, a British magistrate, who, however, excused himself from participating.

457

White Man's Justice in Africa

The court of inquiry held its session under an awning in the shade of a large tree, surrounded by a guard of marines with fixed bayonets. At some distance away behind a wire fence between fifteen to twenty thousand natives squatted on the ground, eagerly watching the administration of "white man's justice."

The principal figure in this whole melodrama was naturally chief Tshekedi, a young man of about twenty-eight, neatly dressed in European attire, bearing all the hall-marks of a cultivated African chieftain. He occupied a seat within the barbed wire enclosure, next to his lawyer, Mr. Douglas Buchanan, K.C., who, however, was not permitted to cross-examine witnesses, nor to address the court on behalf of his client.

After the president of the court had explained the purpose of the inquiry—namely, to find out the reason why the chief had ordered the white man to be flogged—Tshekedi was called upon to give evidence.

He stated that Bechuanaland was not a colony, but a Protectorate of Great Britain ; that the Bamangwate people were never conquered by British arms

George Padmore

and had always reserved the right of administering justice to natives and whites alike, according to the laws and customs of the tribe. He then went on to state that McIntosh was an Englishman who had drifted into Bechuanaland from the Union of South Africa. For years he had lived among the Bamangwate tribe, with whom he had completely identified himself by accepting their native ways and customs. He, however, was a man of loose and dissolute character who had frequently been found guilty by the native court of drunkenness and seducing African women. He was the father of a number of illegitimate children by native girls whom he ill-treated. Realising what a dangerous and demoralising sort of creature McIntosh was, Tshekedi said that he had made representations to the British administrators to have him repatriated, but his complaints to the British officials were always ignored. Recently, the conduct of McIntosh had become so intolerable and was such a menace to the moral life of the natives, especially as he was caught actively engaged, along with another white man by the name of Henry McNamee, selling liquor to the Basuto youths, that he, Tshekedi, was forced to take action himself.

McIntosh was summoned before the *Kgotla*, or native parliament, and after evidence had been given against him, Tshekedi ordered that he should be flogged. The chief's bodyguard, seeing McIntosh walking towards their ruler, and believing that he was about to assault Tshekedi, rushed on McIntosh and struck him several blows.

The remarkable feature about this whole incident is this : when McIntosh was called upon by the chairman of inquiry to state his case, he said that as far as he personally was concerned he was perfectly satisfied with Tshekedi's judgment and had no complaints to make. He admitted drunkenness and encouraging natives to drink. He also admitted assaulting a native who had struck an African girl with whom he was living in a hut as man and wife.

Tshekedi's secretary, in giving his evidence, said, " Recently complaints had been made concerning McIntosh's treatment of a native girl by whom he had a child, and also concerning other girls, many of whom had been enticed away from their native villages. But that the officials paid no attention to his appeal." Furthermore, " *McIntosh lived like ourselves, in native fashion. The only difference was that his skin was white.*" (Emphasis ours.)

458

White Man's Justice in Africa

Although McIntosh did not make any complaints against the chief with whose judgment he expressed satisfaction, as soon as the European officials heard that a white man had been flogged, they immediately mobilised their armed forces and marched into Bechuanaland.

Admiral Evans was away on vacation at the time, but he quickly hurried to the scene in order to demonstrate to chief Tshekedi that a " nigger," no matter how outraged he and his people might be, has no right to judge a white man, even one of the proven character of McIntosh.

The white man's prestige in Africa must be maintained! Furthermore, the imperialists saw in this affair a favourable opportunity for carrying through their long desire for the economic penetration of Bechuanaland.

In order to appreciate the imperialist motive behind this whole affair, it is first of all necessary for the reader to get a clear picture of the relationship which exists between Bechuanaland and Great Britain.

Here is a country with an area of 275,000 square miles; with tremendous unexploited mineral and agricultural resources. Bechuanaland, Swaziland and Basutoland are the only remaining parts of South Africa which have not yet been annexed and reduced to the status of colonies of British imperialism. As Protectorates they still retain a certain amount of political independence.

Bechuanaland is divided up into a number of chieftainships. Bamangwate is the most important. Each chief is responsible for the administration of his own territory, under the " protection " of the King of England, who is represented on the spot by a Resident Commissioner, who in turn works under the direction of a High Commissioner with headquarters in Mafeking, Cape Province. This in brief is the political status of Bechuanaland within the British Empire.

Chief Tshekedi is not the rightful king of the Bamangwate people. He is only acting as regent during the minority of his nephew, Seretse, a boy of eleven, the son of the former king Sekgome, who died in 1925. Tshekedi, however, is the son of *Khama*, the most famous king of Bechuanaland, one of the greatest reformers of Africa. It was during the life of Khama that many administrative and social reforms were introduced and that alcohol was strictly forbidden in Bechuanaland.

Tshekedi was a student at the native university of Lovedale in Cape Colony, but before he could complete his academic career he was called home to assume the leadership of his people on behalf of his younger nephew.

During these years, Tshekedi, loyal to the traditions of his father, has devoted himself with all his energy and resources to improving the economic and social conditions of his people. Like his father, Tshekedi is rightly jealous of the political independence of his country, and has had to fight against all the machinations of the capitalists; especially the *British South Africa Company*, with a capital of £6,570,000, which is not satisfied with the mining concessions obtained in 1930, but is determined to annex Bechuanaland and the other native protectorates and place them under the Union Government so as to open the way for the unhampered exploitation of these territories.

Ever mindful of what his father once wrote to the British Government: " *to fight against drink is to fight againt demons and not against men. I dread the white men's drink more than all the agasses (spears) of the Matabele,*" Tshekedi has had to wage a ruthless fight against the European liquor traders. He has made the consumption of alcohol a cardinal offence.

Conscious of the degradation which all subject peoples are reduced to, once finance-capital gets a foothold in a backward country, Tshekedi has consistently refused to surrender the political rights of his people and be ruled by Negro-hating politicians in Pretoria.

Because of this anti-imperialist attitude Tshekedi is *persona non grata* with the powers that be. He is hated by them, they have done everything possible to undermine his authority; but thanks to his devotion to the enlightenment of his race and the advancement of Bechuanaland, the European officials have never been able to inveigle him into any position whereby they could get rid of him.

Commenting on the hostile attitude of white South Africa towards Bechuanaland and other self-governing native territories, Dr. Raymond Leslie Buell, one of the foremost authorities on Africa, states in his book *The Native Problem in Africa*: " *The people of South Africa have recurrently advocated the annexation of these protectorates.*" (Vol. i, page 191.) Furthermore, in order to ruin the economic basis of the natives, whose chief occupation is cattle raising, the South African Government has imposed an embargo upon their animals. The proclamation states *inter alia*: " It is the policy of the Union Government to prohibit the entrance of cattle from Bechuanaland except the animals weigh not less than 1,000 pounds in the case of oxen and 750 pounds in the case of cows." (Proclamation No. 40 of 1926.)

This shows the extent to which economic warfare has been carried on against the blacks.

The McIntosh incident is now being utilised by the officials who are merely tools of the powerful

White Man's Justice in Africa

British South Africa Company, and its director, Lord Lloyd, former High Commissioner for Egypt and ardent imperialist, to get rid of all opposition. This is most evident, judging from the remarks of Admiral Evans, who, at the close of the inquiry, delivered a most arrogant and bombastic tirade against Tshekedi in which he said : " Although you are known to be a decent, clean-living man, and a clever man, you have frequently flouted the Administration, while professing loyalty and allegiance to the King. You admit flogging a European after judging him in your own native courts. . . .

" *You have set a very bad example to your own tribe and other chiefs. It appears that your overmastering passion is your selfishness and your study of your own personal rights and privileges.*

" For your deliberate and flagrant violation of a Protectorate law well known to you, I shall suspend you from the exercise of your functions as acting chief at his Majesty's pleasure, and you will not be allowed to reside in the Bamangwate Reserve."

This diatribe lets the cat out of the bag ! It affords us the best revelation of the perverted sense of British "justice." Here is a white official, surrounded by the armed might of the most powerful imperialist state of the world, invading the territory of an unarmed and defenceless people, showering abuse upon a native ruler before his tribe. On the one hand, this little Mussolini admits that chief Tshekedi is a man of unimpeachable character—a testimony which even his oppressors are compelled to publicly admit. But his great crime is that he is " selfish " and that he is " jealous of his personal rights and privileges." What are these " personal rights and privileges " ?

Surely Tshekedi cannot be accused of being a despot or a man with any ambitions for personal power. For during the course of the inquiry, the Rev. A. M. Chirgwin, of an English Missionary Society, working among the Bamangwatees, told the commission of inquiry that " *Tshekedi was a hard-working, unselfish ruler, seeking only the good of his people . . . forward looking, cautiously progressive, convinced of the value of education.*

" *He maintains a school of 700 at his own expense. . . . He is not an autocrat but the mouthpiece of his people. . . .*"

This statement is the unanimous testimony of all who knew the young chief—a man who has been entrusted to the Regency of his young nephew and has never manifested any desire to usurp power.

Because Tshekedi is opposed to the absorption of his country within the political jurisdiction of the South African Union, the Government is determined to get rid of him by hook or crook. Furthermore, the white man's prestige must be rigidly upheld. For how can the British imperialists continue to maintain their strangle-hold over hundreds of millions of Negroes, Indians and other coloured races, once it becomes known that an African chief of Bechuanaland in defending the morals of his people and the chastity of their women ordered the flogging of a Nordic ?

The mentality of the British overlords is exactly the same as Hitler's and the Nazis', who are persecuting the Jews on account of their race.

In Africa, a white man is a white man, no matter whether he be the King of England or a drunken degenerate like McIntosh ; while a black man is a " nigger," a despised and contemptible creature to be humiliated and degraded irrespective of the fact that he bears the irreproachable character of a Tshekedi.

Therefore, it is no surprise that the London *Daily Mail*, the mouthpiece of that British fascist, *Lord Rothermere*, writes :

" In such a country as South Africa, where one and a half million whites live among six million coloured people, and in such a protectorate as Bechuanaland, where there are only 1,700 Europeans among 150,000 natives, such conduct as Tshekedi's cannot be permitted."

So white men, rich and poor, high and low, must always stand together to " keep the ' niggers ' in their place."

" Evans of the *Broke* "—Viceroy of Bechuanaland, cock-hatted and spurred, surrounded by the armed might of the best armed imperialist state of the world, has demonstrated by his melodramatic display before the Bamangwate people the true character of British " justice."

Mr. J. H. Thomas, the Secretary for the Dominions, realising the effect which this would have upon the colonial peoples of the Empire, tried to save the prestige of British imperialism by re-instating Tshekedi—but only after the young chief had been forced to sign a statement surrendering his right to try a white man before a native court. No matter how the politicians at Whitehall try to whitewash this affair, the attitude of Admiral Evans has once and for all removed before the whole world the hypocritical mask behind which British imperialists masquerade as the " trustees " and " protectors " of the so-called backward races.

The Negroes in South Africa may well thank Admiral Evans for giving them such a dramatic exhibition of " *white man's justice.*"